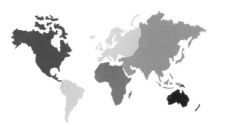

Das Familienalbum des Planeten Erde / The Family Album of Planet Earth / L'Album de famille de la planète Terre

unicef

1000 Families

Uwe Ommer Das Familienalbum des Planeten Erde / The Family Album of Planet Earth / L'Album de famille de la planète Terre

TASCHEN

KÖLN LONDON MADRID NEW YORK PARIS TOKYO

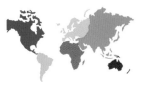

Die Welt
als
Kaleidoskop

zur Fotografie von
Uwe Ommer

Innerhalb von vier Jahren ist es Uwe Ommer gelungen, eine lebendig-bunte, üppige Bilderfolge zu schaffen, die ihresgleichen sucht. Eine Mattscheibe, ein Schacht, ein Spiegel, eine Linse – und ein Mann, der sein Handwerk versteht: So einfach das Prinzip auch sein mag, es fasziniert den Menschen seit beinahe zwei Jahrhunderten. Der eigentliche Zauber geht jedoch nicht vom optischen System selbst, sondern von der unendlichen Vielfalt möglicher Kombinationen aus, Kombinationen erstaunlich einfacher Elemente, die Uwe Ommer von seiner Reise mitgebracht hat. Er fotografiert seit über 30 Jahren sein Lieblingsmotiv, den Menschen, eine Gabe, die ihm in die Wiege gelegt wurde.

Also richtete er seine Kamera auf alles, was eine Familie ausmacht: Kinder, Schleier, Nasenschmuck, nackte Füße, Trauerkleidung, Herrenhüte, Damenfrisuren, Stoffe, Halsketten, Schnauzer, Vollbärte, Haustiere, Hunde, Katzen, Ponys, Ziegen oder Elefanten, Waffen, Farben, Menschen mit dunkler, heller, zarter, matter oder glänzender Haut, ein wenig Polygamie, ein Quäntchen Homosexualität, eine gute Prise Heterosexualität, ein paar Körnchen Endogamie, bestäubt mit etwas Exogamie, Mischehen und deren Nachwuchs, Traditionen, Obskurantismus, Landflucht, Einsamkeit, nackte Haut, Giraffenhälse, Lächeln, Schönheit, Musik und Instrumente und vieles mehr, vor allem aber Liebe, ganz viel Liebe.

Jetzt, wo Sie dieses Kaleidoskop in Händen halten, schütteln Sie es vorsichtig, bevor sie einen Blick hineinwerfen und sich die 1000 bunten Steinchen zu einem Weltbild ordnen, das Sie überraschen wird: Denn all die Menschen aus fernen Ländern und fremden Kulturen unterscheiden sich im Grunde kaum von uns und unseren Familien. Entdecken Sie anhand Tausender winziger Details zahllose Gemeinsamkeiten, aber auch manche Unterschiede – Unterschiede, die jedoch rein zufällig und nicht, wie nach wie vor häufig behauptet, auf Grund der Hautfarbe, Sprache oder Religion entstehen. Sehen Sie genau hin, betrachten Sie die Gesichter, wie sie uns

zärtlich, müde, voller Sorge oder gelassen anblicken, diese Hände, schwielig, geschickt, abgearbeitet oder gepflegt, die Falten, die stummen Worte, ein scheues Lächeln. Öffnen Sie die Augen und lassen Sie sich nicht vom ersten Eindruck täuschen. Spielen Sie mit bei diesem Spiel der vermeintlichen Unterschiede und zufälligen Ähnlichkeiten, bei diesem Lehrstück, das etliche Vorurteile dorthin verweist, wo sie hingehören: in die Mottenkiste. Mit seinem gigantischen Werk, in das er vier Jahre seines Lebens investiert hat, erzählt uns Uwe Ommer etwas über uns selbst. Er zeigt uns einen Weg, wie wir ungeachtet all unseres Scheiterns und unserer Krisen auf diesem Planeten fortbestehen können. Seine Fotos handeln nicht von Krieg, Massengräbern, Vergewaltigung, nicht von dem bodenlosen Unvermögen des Menschen, menschlich zu sein, oder von den Ausgeburten seiner niedersten Triebe. Sie erzählen vielmehr von dem, was uns eint, was uns die Kraft gibt weiterzumachen, von etwas, das jenseits unseres Problems liegt, die Welt und unsere Mitmenschen zu begreifen. Es ist die Rede von der Liebe, von Sehnsucht, Freude und Glück.

Betrachten Sie diese Menschen, die an allen Ecken des Globus beheimatet sind, erkennen Sie in einem Gesicht Ihre eigene Großmutter oder einen Freund wieder, überzeugen Sie sich davon, wie groß die Analogien, aber auch die Divergenzen sind. Durch die Erfahrung mit diesem Bildband sehen wir die anderen mit anderen Augen, lernen, uns nicht von Nebensächlichkeiten blenden zu lassen. Tauchen Sie ein in diese bunte Verschiedenartigkeit, die alle Vorurteile und Schranken über Bord wirft. Allein der einfühlsame Blick von Uwe Ommer hat dieses Porträt der Menschheit zur Jahrtausendwende ermöglicht. Seit ich vor vier Jahren zum ersten Mal in sein Kaleidoskop geschaut habe, kann ich nicht mehr davon lassen. Es bereichert mein Leben Tag für Tag aufs Neue.

Olivier Delahaye / Paris, Mai 2000

Chronik
einer Reise

Ein „Familienalbum" von unserem Planeten – eine tolle Idee und so naheliegend! Meine Freunde waren begeistert. „Außerdem lernst du dabei die Welt kennen!", riefen sie nicht ohne Neid. Das klang einleuchtend. Also krempelte ich die Ärmel hoch und musste feststellen, dass es gar nicht so leicht war, Geld und Sponsoren aufzutreiben, ich
- kaufte ein unverwüstliches Auto,
- legte auf den Straßen und Wegen der Welt und manchmal auch querfeldein knapp 250 000 Kilometer zurück,
- übernachtete in unzähligen Hotels und anderen Unterkünften, die nicht immer unbedingt weiterzuempfehlen waren,
- speckte etliche Pfunde ab,
- sah zu, wie alle Teile, die ein funktionstüchtiges Auto braucht, eines nach dem anderen kaputtgingen und ersetzt wurden
- zerbrach mir den Kopf,
- wehrte die Angriffe hinterlistiger Stechmücken ab,
- feierte Hochzeit in Las Vegas,
- steuerte meinen Wagen je nach landesüblichem Brauch auf der rechten oder linken Spur und auch mal in der Mitte,
- bewies mein diplomatisches Geschick gegenüber den Uniformträgern aller fünf Kontinente,
- traf auf Banditen und Wegelagerer,
- fand neue Freunde,

- fotografierte fotogene Polizistenfamilien,
- brachte kleine Kinder zum Weinen, denen „Bleichgesichter" und „Langnasen" fremd waren,
- versuchte, einem Elefanten ein Lächeln abzugewinnen,
- entwickelte unzählige Filme aller Arten und Formate,
- stieß Hunderte Male auf den Erfolg und die Gesundheit meiner Modelle an,
- geriet in den Verdacht, ein Kinderhändler auf der Suche nach neuen Opfern zu sein,
- blieb mit dem Auto liegen, bevorzugt an Orten, die von der restlichen Welt völlig abgeschnitten waren,
- fand findige und ehrliche (!) Automechaniker,
- aß viel und oft, um meine 1000 Gastgeber nicht vor den Kopf zu stoßen,
- saß stunden- und oft tagelang an irgendwelchen Grenzen fest,
- versuchte, möglichst keine Radfahrer, Schafe, Hunde und Fußgänger anzufahren,
- machte einen weiten Bogen um Kamele, Büffel und heilige Kühe,
- vermied es tunlichst, auf Schlangen zu treten,
- tat mein Bestes, um noch vor Einbruch der Dunkelheit eine Bleibe zu finden,
- bat Bürgermeister, Priester, Schuldirektoren, Imame und Pfarrer um Hilfe,
- engagierte Dolmetscher und versuchte, mich mit ihnen zu verständigen,

- lernte ein paar Brocken in allen möglichen Sprachen und vergaß sie auf der Stelle wieder,
- löffelte nicht die berühmte Suppe, sondern ganze Ozeane aus,
- sprach die Familien an: auf der Straße, im Restaurant, in der Kirche, auf dem Feld, am Strand, beim Golfen, auf dem Campingplatz, per Telefon etc.
- beantragte und verlängerte Visa,
- verirrte mich und landete im Niemandsland,
- verfluchte Straßenkarten,
- bezirzte eine Büffelkuh,
- bedauerte, dass ich so viele vorüberfliegende Bilder und Eindrücke nicht einfangen konnte,
- versprach überall, eines Tages wiederzukommen,

- ließ mich von der überwältigenden Gastfreundschaft der Familien überraschen, die alle mit Feuereifer an meinem „Album" mitwirkten,
- kehrte vier Jahre später gesund und munter nach Hause zurück
- und hatte es geschafft, 1251 Familien zu porträtieren.

Erstaunt fragten meine Freunde: „Schon wieder da? Wie ist es dir auf deiner kleinen Reise ergangen?" „Oh, alles lief wie geschmiert, es war einfach wunderbar!"
Alles Weitere erfahren Sie auf den folgenden 576 Seiten …
Bis bald einmal, an irgendeinem Ort der Welt.

Uwe Ommer

The World as a Kaleidoscope

About Uwe Ommer's photos

Uwe Ommer spent four years making the largest and most beautiful kaleidoscope there has ever been. A focusing screen, a tube, a mirror, a lens, the odd trick – the system is rudimentary and has filled us with wonder for centuries. But if it is magic, what actually intrigues us is not the system but the infinite number of combinations it can produce based on surprisingly simple materials. Uwe has gleaned these materials along the way, during his many encounters. The fact is, he was acquainted with them before: he's been photographing people for 30 years and more, because it's in his blood.

So behind his focusing screen he's put everything that goes to make families – children, veils, pierced noses, bare feet, black clothes, men's hats, women's hairdos, fabrics, necklaces, moustaches, beards, domestic animals, dogs, cats, ponies, goats and elephants, weapons, colours, dark skins, light skins, diaphanous skins, matt and glossy skins, a little polygamy, a hint of homosexuality, a good dose of heterosexuality, a little endogamy here, a dash of exogamy there, inter-marriage, children, traditions, obscure mysteries, migrations, loneliness, bare flesh, elongated necks, smiles, beauty, music and musical instruments, and the odd other thing too – but mainly love, lots of love.

Now you're holding the thing in your hand. Shake it a little, put your eye to the lens and turn it. In Uwe's kaleidoscope you'll see the world differently from how you might imagine it. You'll stop thinking that you're different from people living far away from you, who don't share your culture or your ideas. You'll see how, through a thousand and one tiny details, we are all so alike and so different, and all in a random, haphazard way – not the way you've been taught hitherto, on the basis of colour, language and religion. Take a look at the details, the expressions, the tenderness and the tiredness, the worried and calm-eyed glances, hands calloused or nimble, hands ruined or well tended, the wrinkles, words unspoken, fleeting smiles. Open your eyes, and don't go by what is alleged to be the evidence. In this way you'll play the game of relative differences and random similarities. It's all very enriching, and it will put quite a few accepted ideas where they belong – in the cupboard.

With this titanic project, which has taken him four years to bring full circle, Uwe Ommer opens our eyes to ourselves. Over and above our break-ups and the problems we have living together, he sheds light on the good luck that enables us to go on living on this planet. He hasn't photographed wars, killing fields and mass graves, rape, or people's boundless inability to become human beings. Nor has he photographed the fruit of our basest instincts. He has photographed things that bring us together and help us to perpetuate ourselves, things that exceed our failure to understand the world and other people – and love which, even if gropingly, goes hand in hand with desire, pleasure and happiness.

Look at these faces, and you will rediscover a grandmother, a friend, or an uncle in people you imagine a thousand leagues from you. You'll see how close we all are – alike and yet so different. This experience will teach us to look at other people through different eyes, and not get stuck on the accessory that stops us seeing by making things far too simple. Look at all these details which create a diversity other than that of prejudices and barriers. It took Uwe's loving eye to make this portrait of humankind at the dawn of the new millennium. I've been turning Uwe's kaleidoscope for four years now. I haven't got tired of turning it, and every time I do, I'm the richer for it.

Olivier Delahaye
Paris, May 2000

The Story of a Journey

"A family album for our planet … what a wonderful, simple idea!" exclaimed my friends, adding (not without a tinge of envy) "and what's more, you'll have to go round the world."
So, on the hunch that they could well be right, I set off to
- lose my first bet, and find funds and sponsors easily
- buy an indestructible vehicle
- drive nearly 160,000 miles on roads and tracks and across fields all over the world
- sleep in hundreds of hotels and other distinctly less salubrious places
- lose a lot of weight
- break and repair everything that makes a vehicle work (even an indestructible one)
- see my hair turn white
- fight tireless mosquitoes
- get married in Las Vegas
- drive carefully on the left, or the right, or in the middle, as local custom demanded
- treat everything uniformed with kid gloves, in all five continents
- encounter highway bandits and robbers
- make friends
- photograph families of photogenic policemen
- set infants wailing who aren't used to "pale-faced" and "long-nosed" strangers
- try to get an elephant to smile
- use up thousands of films of every kind and format
- endure and make countless toasts to everyone's success and good health
- be suspected of being a child kidnapper on the lookout for future victims
- break down, preferably in places really off the beaten track
- find honest, Mister-Fix-Anything mechanics
- eat a lot and often so as not to turn down invitations

- get stuck for hours and days at borders that wouldn't budge
- avoid running over cyclists, sheep, dogs and other pedestrians
- swerve round camels, buffaloes and sacred cows
- try not to step on snakes
- try to get somewhere before nightfall
- ask for help from mayors, priests, headmasters, imams and shepherds
- find interpreters and understand them
- learn three words in all sorts of languages and forget them as quickly
- bale out after downpours
- approach families – in the street, in restaurants, in church, in the fields, on beaches and golf courses, by phone, at campsites …
- obtain and extend visas
- get lost in the wilds
- curse road maps
- win over a touchy female buffalo
- regret not snapping fleeting images as they flash by
- promise to come back one day … everywhere!
- be taken aback by the immense hospitality and sincere enthusiasm of families taking part in the 'album'
- get back home safe and sound, four years later
- win my second bet and succeeded in making portraits of 1,251 families.

On my return, scarcely raising an eyebrow, my friends asked:
"Well, how was your little jaunt?"
"Oh, fine, no problems, it was just wonderful!"
To find out more, take a look at the next 576 pages.
See you – somewhere.

Uwe Ommer

Le monde comme un kaléidoscope

A propos des photos de Uwe Ommer '

Uwe Ommer a mis quatre ans à fabriquer le plus beau et le plus grand kaléidoscope qui soit. Un dépoli, un tube, un miroir, une lentille, un peu d'astuce; le système est rudimentaire et nous émerveille depuis des siècles. Mais, s'il est magique, ce qui nous fascine en fait, ce n'est pas le système, mais l'infini des combinaisons qu'il permet à partir d'éléments étonnamment simples. Ces éléments, Uwe les a glanés, chemin faisant, au cours des rencontres. En fait, il les connaissait déjà avant, depuis plus de trente ans qu'il photographie des gens, et avant même, parce qu'il a cela en lui.

Alors il a mis pêle-mêle, derrière son dépoli, tout ce qui fait des familles; des enfants, des voiles, des nez percés, des pieds nus, des vêtements noirs, des chapeaux masculins, des coiffures féminines, des tissus, des colliers, des moustaches, des barbes, des animaux domestiques, chiens, chats, poneys, chèvres ou éléphants, des armes, des couleurs, des peaux sombres, claires, diaphanes, mates ou brillantes, un brin de polygamie, un zeste d'homosexualité, une bonne dose d'hétérosexualité, des graines d'endogamie, de la poudre d'exogamie, du métissage, des enfants, des traditions, de l'obscurantisme, des migrations, de la solitude, des chairs dénudées, des cous rallongés, des sourires, de la beauté, de la musique et ses instruments, quelques autres éléments encore et surtout de l'amour, beaucoup d'amour.

Maintenant que vous avez l'objet en main, agitez-le un peu, mettez votre œil contre la lentille et tournez-le; vous verrez que dans le kaléidoscope d'Uwe, le monde vous apparaît autrement que ce que vous imaginiez. Vous allez cesser de penser que vous êtes différents de ceux qui sont loin de vous ou qui ne partagent pas votre culture ou vos convictions. Vous allez voir comment, par mille petits détails, nous sommes si semblables et si différents, et ce de manière aléatoire, et non comme on vous l'a appris jusqu'à présent, sur la base de la couleur, de la langue ou de la religion. Regardez les détails, les expressions, les tendresses, les fatigues, les regards inquiets ou sereins, les mains calleuses, agiles, abîmées ou entretenues, les rides, les mots retenus, les sourires esquissés. Ouvrez les yeux et ne vous laissez pas aller aux soi-disant évidences. Vous allez ainsi jouer au jeu des différences relatives et des similitudes aléatoires. C'est très enrichissant et cela remet pas mal d'idées reçues à leur place: au placard. Uwe Ommer, avec ce travail de titan qu'il a réalisé sur quatre ans, nous ouvre les yeux sur nous-mêmes. Il met en lumière, au-delà de nos ruptures, de nos difficultés à vivre ensemble, ce qui est notre chance de perdurer sur cette planète. Il n'a pas photographié les guerres, les charniers, les viols, l'incommensurable incapacité des hommes à devenir humains, ni les fruits de nos bas instincts; il a photographié ce qui nous unit, ce qui nous permet de nous perpétuer, ce qui dépasse notre incompréhension du monde et des autres, l'amour, qui va, même de manière incertaine, avec le désir, le plaisir et le bonheur.

Regardez ces visages, et vous retrouverez une grand-mère, un ami, un oncle dans des gens que vous imaginiez à mille lieux de vous. Vous verrez à quel point nous sommes proches, semblables et si différents. Cette expérience nous apprend à regarder les autres autrement, à ne pas nous arrêter sur l'accessoire qui nous empêche de voir en simplifiant à outrance. Regardez tous ces détails qui créent une diversité autre que celle des préjugés et des barrières. Il fallait l'œil amoureux d'Uwe pour faire ce portrait de l'humanité de l'an 2000. Depuis quatre ans, je tourne le kaléidoscope d'Uwe ; je ne m'en lasse pas et il ne cesse de m'enrichir.

Olivier Delahaye, Paris, Mai 2000

Histoire d'un voyage

Créer « *l'Album de Famille* » de notre planète … « c'est une idée simple et merveilleuse ! » s'écriaient mes amis « et en plus tu feras le tour du monde ! » ajoutaient-t-ils à peine envieux.
Pensant qu'ils n'avaient pas tort je suis donc parti :
- perdre mon premier pari : trouver facilement argent et sponsors …
- acheter une voiture incassable
- rouler près de 250 000 km sur routes, pistes et à travers champs autour du globe
- dormir dans des centaines d'hôtel et d'autres lieux pas toujours recommandables
- perdre de nombreux kilos
- casser et faire réparer tout ce qui fait fonctionner une voiture (même solide)
- me faire des cheveux blancs
- combattre des moustiques infatigables
- me marier à Las Vegas
- rouler prudemment à droite, à gauche ou au milieu en respectant la tradition locale
- traiter avec diplomatie tout ce qui porte l'uniforme dans les 5 continents
- rencontrer des bandits et voleurs de grands chemins
- me faire des amis
- photographier des familles de gendarmes photogéniques
- faire pleurer des petits enfants peu habitués aux « visages pâles » ou aux « long nez »
- essayer de faire sourire un éléphant
- exposer de milliers de films de tous genres et formats
- subir et porter d'innombrables toasts à la réussite et à la santé de chacun
- me faire soupçonner d'être voleur d'enfants venu repérer ses futures victimes
- tomber en panne, de préférence dans les endroits les plus isolés
- trouver des mécaniciens débrouillards et honnêtes !
- manger beaucoup et souvent pour ne pas décliner une invitation.
- rester bloqué des heures et des jours aux frontières récalcitrantes
- éviter d'écraser cyclistes, moutons, chiens et autres piétons
- contourner chameaux, buffles et vaches sacrées
- éviter de marcher sur des serpents
- tenter d'arriver quelque part avant la nuit
- demander l'assistance aux maires, prêtres, directeurs d'école, imams et pasteurs
- trouver des interprètes et les comprendre
- apprendre 3 mots dans toutes sortes de langues et les oublier aussitôt
- écoper des déluges
- aborder des familles : dans la rue, au restaurant, à l'église, aux champs, à la plage, au golf, par téléphone, au camping …
- obtenir et faire prolonger des visas
- me perdre dans la nature
- maudire les cartes routières
- gagner l'affection d'une bufflesse
- regretter de ne pas avoir pu capter les images éphémères vues en passant
- promettre de revenir un jour … partout !
- me faire surprendre par l'hospitalité immense et l'enthousiasme sincère des familles à participer à « l'Album »
- rentrer sain et sauf 4 ans plus tard
- gagner mon deuxième pari : remplir « l'Album » de 1251 portraits de famille.

A peine surpris, les amis questionnent : « Alors cette petite balade, ça c'est bien passé ? »
« Oui, sans problème, c'était simplement merveilleux ! »
Pour en savoir plus tournez les 600 pages qui suivent …
A bientôt, quelque part

Uwe Ommer

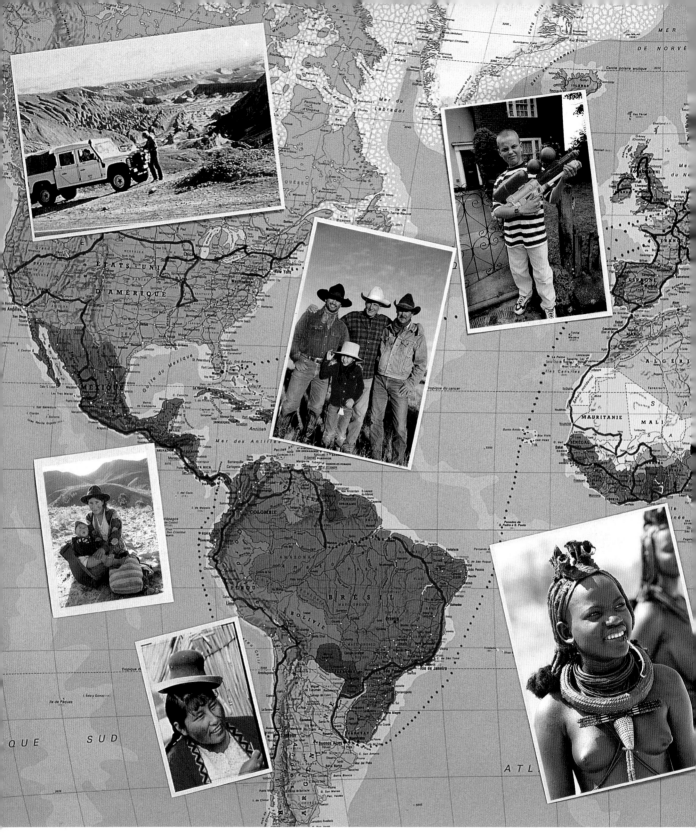

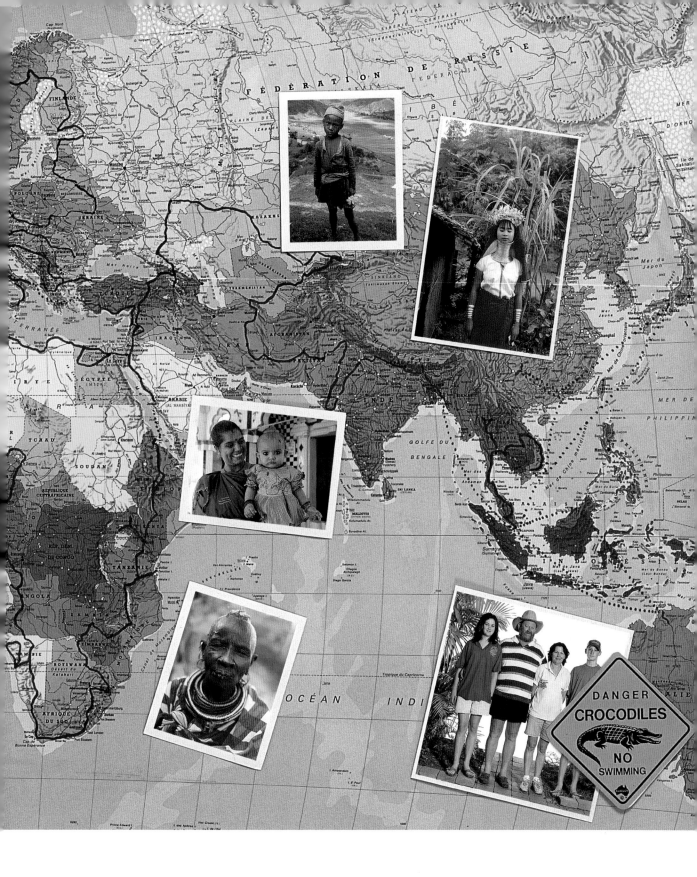

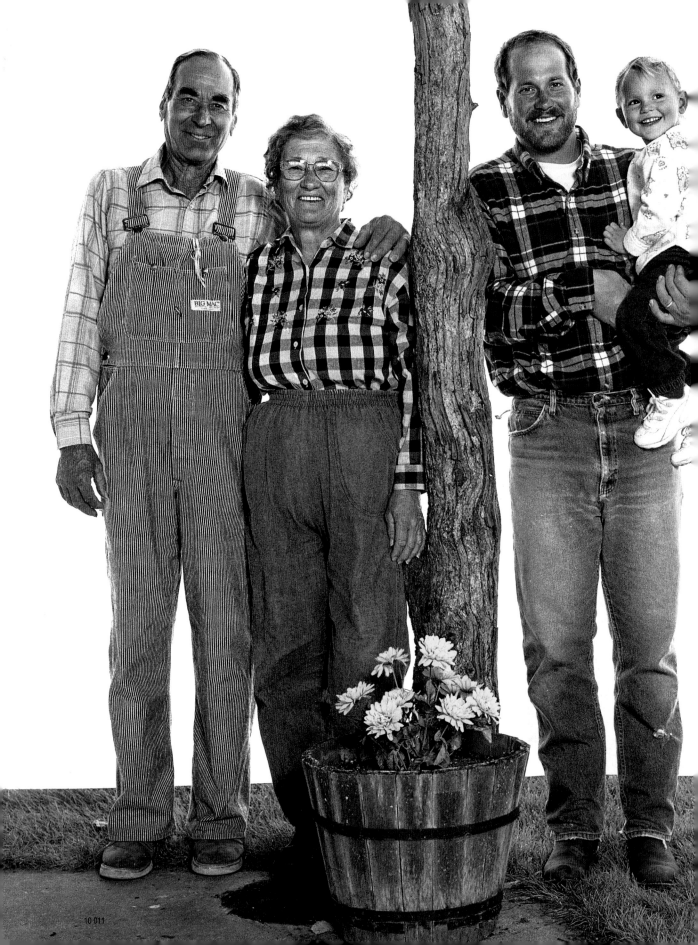

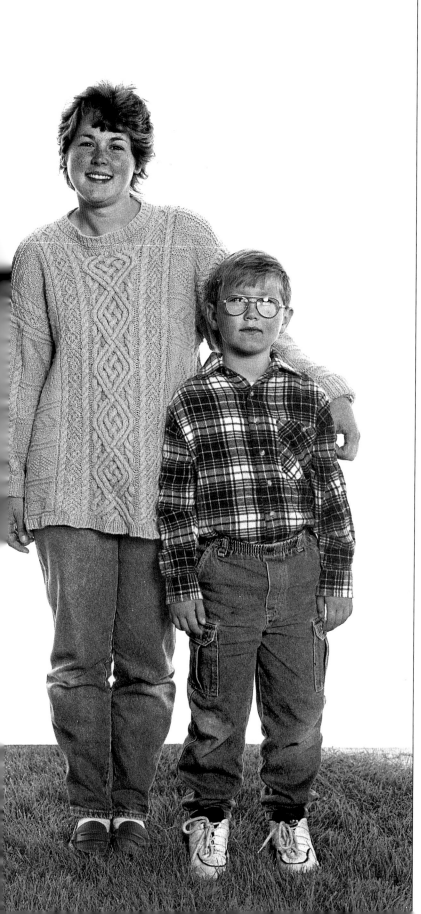

Amana,
Iowa, USA,
10 October 1998

„Ich möchte, dass der alte Sinnspruch ‚Wer etwas verspricht, muss es auch halten' im neuen Jahrtausend wahr wird", sagt Matthew, der in einer Kühl-systemefabrik arbeitet und nebenbei seinen Eltern im Sägewerk hilft. Wendy liebt es, mit ihrem Mann auf die Jagd zu gehen, leider lässt ihr ihre Arbeit bei United Airlines nur wenig Zeit dazu. Ihre Eltern, Mildred und Martin, leben in der Nachbarschaft und sind froh, die meisten ihrer Kinder in der Nähe zu wissen.

"I should like the old adage, which has it that your word is your bond, to become a reality in the new millennium," Matthew tells us. He works in a refrigeration factory and helps his parents in the sawmill they've been running since the year null. Wendy would like to have another child, and in the meantime enjoys going hunting with her husband – in the little free time she has from her job with United Airlines. Their parents, Mildred and Martin, live in the area and are glad to have most of their children near by.

« J'aimerais que le vieil adage qui veut qu'une parole donnée soit une parole tenue redevienne une réalité en l'an 2000 », nous dit Matthew, qui travaille à l'usine de réfrigération et épaule ses parents à la scierie qu'ils exploitent depuis toujours. Le projet de Wendy est d'avoir un autre enfant et de continuer à chasser avec son mari dans le peu de temps libre que lui laisse son travail chez United Airlines. Leurs parents, Mildred et Martin, vivent dans la région et sont heureux d'avoir la plupart de leurs enfants à proximité.

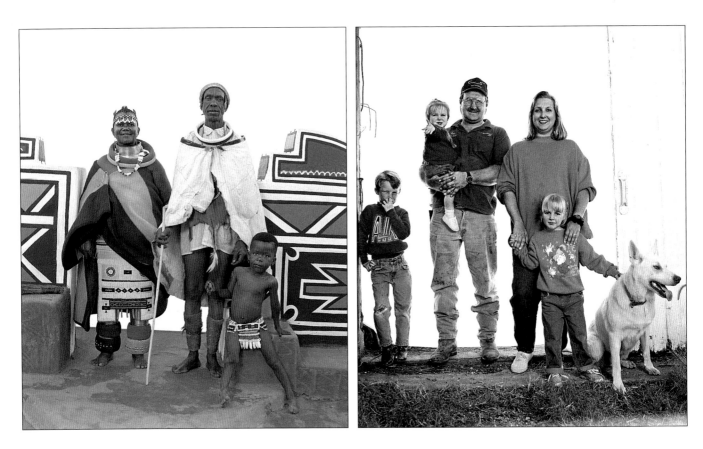

near Middelburg,
South Africa,
9 October 1997

Genau wie die anderen Bewohner dieses eigens für den Tourismus restaurierten Museumsdorfs bewahren auch Dina und Saijen mit ihrer farbenprächtigen Kleidung und den kunstvollen Wandmalereien das kulturelle Erbe der Ndebele.

Like the other inhabitants of this village that's been recreated with tourists in mind, Dina and Saijen are reviving the tradition of their Ndebele roots through their costumes and the decorative paintings on their house.

Comme les autres habitants de ce village reconstitué à l'intention des touristes, Dina et Saijen font renaître à travers leur tenue vestimentaire et les peintures décoratives de leur habitation la tradition de leurs origines n'debele.

Norway,
Iowa, USA,
10 October 1998

Schon als Kind träumte Donald davon, Farmer zu werden. Wir haben ihn im väterlichen Betrieb getroffen, wo er halbtags arbeitet und den er eines Tages zu übernehmen hofft. Cari, die ihr viertes Kind erwartet, wird ihm mit Freude bei der Farmarbeit zur Hand gehen. Sie sind in ihrer Heimat sehr verwurzelt und würden für nichts auf der Welt woanders leben wollen.

Donald has been dreaming of being a farmer since he was a boy. We met him on his father's farm where he works part-time, and which he hopes to take over one day. Cari, expecting her fourth child, will be happy to be able to work with him. They are very attached to their native soil, and they wouldn't live elsewhere for anything in the world.

Depuis l'enfance, Donald rêve d'être fermier. Nous l'avons rencontré dans l'exploitation de son père où il travaille à mi-temps et qu'il espère bien reprendre un jour. Cari, qui attend son quatrième enfant, sera heureuse de pouvoir travailler avec lui. Très attachés à leur terre natale, pour rien au monde ils ne voudraient vivre ailleurs.

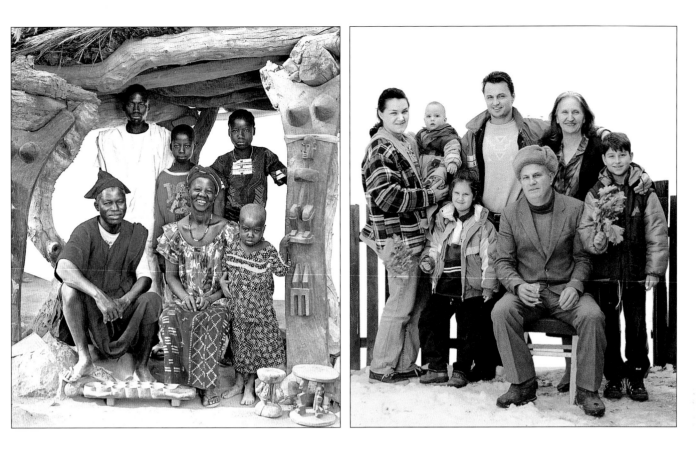

Banani Kokoro,
Mali,
12 April 1997

Sie haben sich in ihrer *Tougouna* oder „Palaverhütte" versammelt. Sie dient als Versammlungsort, an dem die Männer zum Gespräch zusammenkommen. Um Zornausbrüche während besonders hitziger Diskussionen zu vermeiden, ist das Dach absichtlich sehr niedrig angesetzt. Jähes Aufspringen wird dadurch unmöglich gemacht und so werden erregte Gemüter augenblicklich zur Raison gebracht. Domian hat drei Frauen, von denen zwei in einem anderen Dorf leben. Während der Zwiebel- und Tabakernte arbeiten sie alle gemeinsam auf den Feldern.

They are all gathered beneath their *tougouna* or 'council hut'. Basically it's a place for discussion, where the men gather to talk. The roof is built deliberately very low to prevent fits of anger caused by excessively lively discussion – it's impossible to stand up suddenly, so you calm down immediately. Domian has three wives, two of whom live in another village. During the onion and tobacco harvest, they all work together in the fields.

Ils se sont réunis sous leur « Tougouna » ou « Case à palabre ». Ce sont les piliers sculptés qui font la particularité de cette case traditionnelle du Pays Dogon. A l'origine, c'est un lieu de débat, où se rassemblent les hommes pour parler. Afin d'éviter tout emportement lié à une discussion trop animée, le toit est construit très bas. Se lever brusquement devient impossible ou vous calme dans l'instant. Domian a trois femmes, deux d'entre elles vivent dans un autre village, mais tout le monde participe à la récolte des oignons et du tabac.

Kraljevo,
Yugoslavia,
7 January 1997

Heute wird das orthodoxe Weihnachtsfest gefeiert. Die Familie ist zusammengekommen, um die traditionellen Eichenblätter zu verbrennen, und alle wünschen sich Glück für das kommende Jahr. Vater Zoran verdient sein Geld in der „grauen Wirtschaft", sprich auf dem Schwarzmarkt, ein riskantes, aber recht einträgliches Geschäft. Seine Frau arbeitet als Buchhalterin in einem ortsansässigen Unternehmen, der Großvater ist Elektriker, die Großmutter Sekretärin. Sie hoffen, dass der Krieg in ihrem Land ein für alle Mal vorbei ist – worauf wir alle gemeinsam angestoßen haben.

It is Christmas Day in the Orthodox calendar. The family has gathered according to tradition to burn oak leaves and make wishes for happiness in the year to come. Zoran works in the 'grey economy', i.e. the black market, a risky but lucrative activity. His wife is an accountant in a local firm; the grandparents are respectively electrician and secretary. They long for the war in their country to end once and for all. And we all drank a toast to peace.

C'est le jour du Noël orthodoxe. La famille s'est réunie pour brûler les feuillages de chêne, que les enfants tiennent à la main, et former des vœux de bonheur pour l'année à venir. Zoran travaille dans « l'économie grise », ou marché noir, activité à risque mais rémunératrice. Sa femme est comptable dans une entreprise locale, les grands-parents sont respectivement électricien et secrétaire. Ils espèrent la fin de la guerre une fois pour toutes dans le pays et nous avons tous porté un toast à la paix.

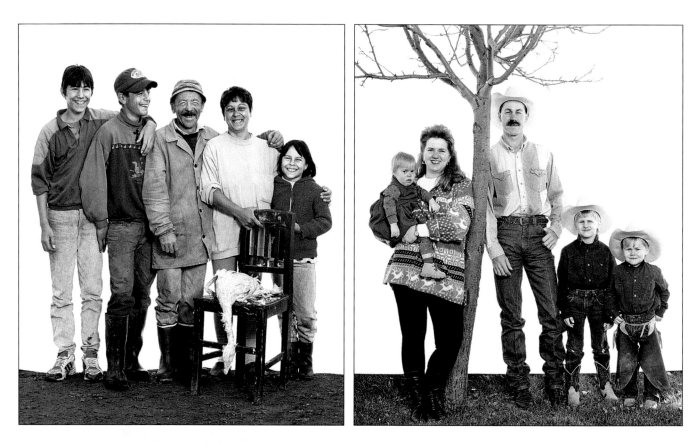

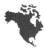
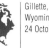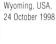

Ohot,
Hungary,
19 October 1996

Diese fünf haben wir beim Gänserupfen angetroffen. Die ganze Familie arbeitet auf einer Gänsefarm. Das Foto hat sie amüsiert und zum Abschied wollten sie uns unbedingt eine frisch gerupfte Gans mitgeben …

They were busy plucking geese. The whole family works on the farm, where they rear poultry for the table. The photo session was a lot of fun, and the family insisted on offering us a freshly plucked goose …

Nous les avons rencontrés alors qu'ils étaient occupés à plumer des oies. Ils travaillent en famille dans un élevage et la photo était une distraction bienvenue qui les a beaucoup amusés. Thomas, le père a absolument voulu nous offrir une oie en souvenir.

Gillette,
Wyoming, USA,
24 October 1998

Michael ist „Teilzeit-Cowboy", sein Traum wie auch der seiner beiden Söhne ist es, diesen Beruf in Vollzeit auszuüben. Der fünfjährige Lothan sitzt bereits fest im Sattel und weiß genau, wie seine Zukunft aussieht: „I'm gonna be a cowboy!"

Michael is a part-time cowboy whose dream, like that of his two boys, is to be a full-time cowboy. Five-year-old Lothan already rides all on his own and has no doubt about his future – "I'm gonna be a cowboy."

Michael, « cow-boy à mi-temps » rêve comme ses deux garçons, d'exercer ce métier à plein temps. Lothan (cinq ans) monte déjà tout seul à cheval et il n'a aucun doute sur son futur : « Je serai cow-boy ! »

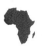

Axim,
Ghana,
7 June 1997

Sein Hobby: Kochbücher „verschlingen". Frank ist Chefkoch und ein leidenschaftlicher Anhänger guter Küche. Sein Traum ist es, noch zwei Kinder zu bekommen, neue Rezepte zu kreieren und sein eigenes Restaurant zu eröffnen, das er dann zusammen mit seiner Frau Peggy – zurzeit Kauffrau – betreibt.

His hobby is "devouring" cookbooks. Frank is a head chef and is truly passionate about good cooking. His dream is to have two more children, invent some new recipes and have his own restaurant, where his wife, Peggy, currently a shopkeeper, could work with him.

Son hobby est de : « dévorer » les livres de cuisine. Frank, chef cuisinier, est un véritable passionné de la bonne cuisine. Son rêve est d'avoir encore deux enfants, inventer de nouvelles recettes et avoir son propre restaurant, où sa femme Peggy, actuellement commerçante, pourrait travailler avec lui.

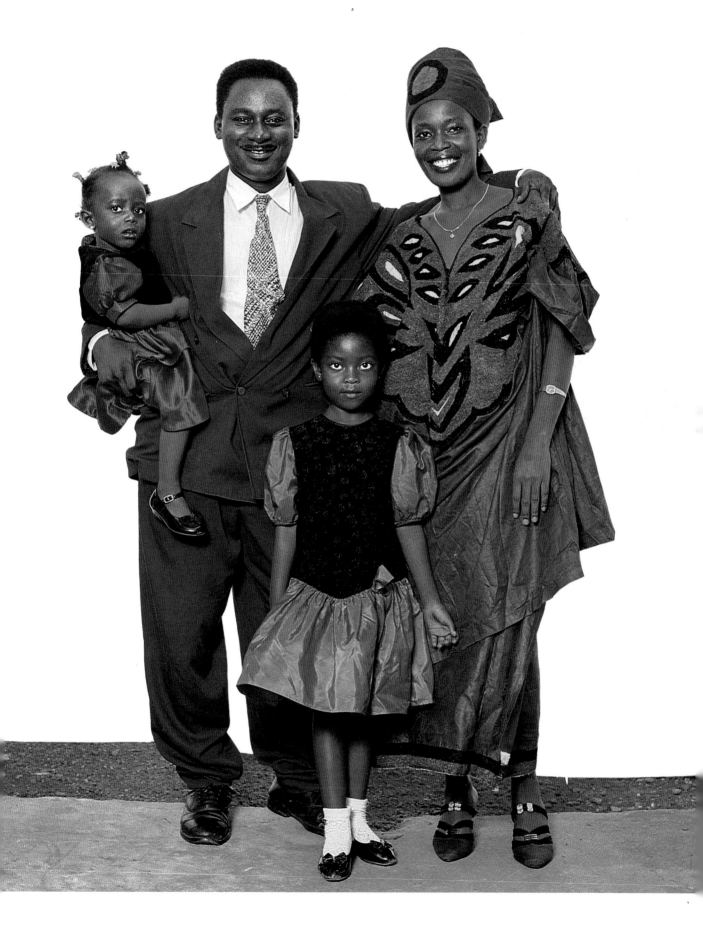

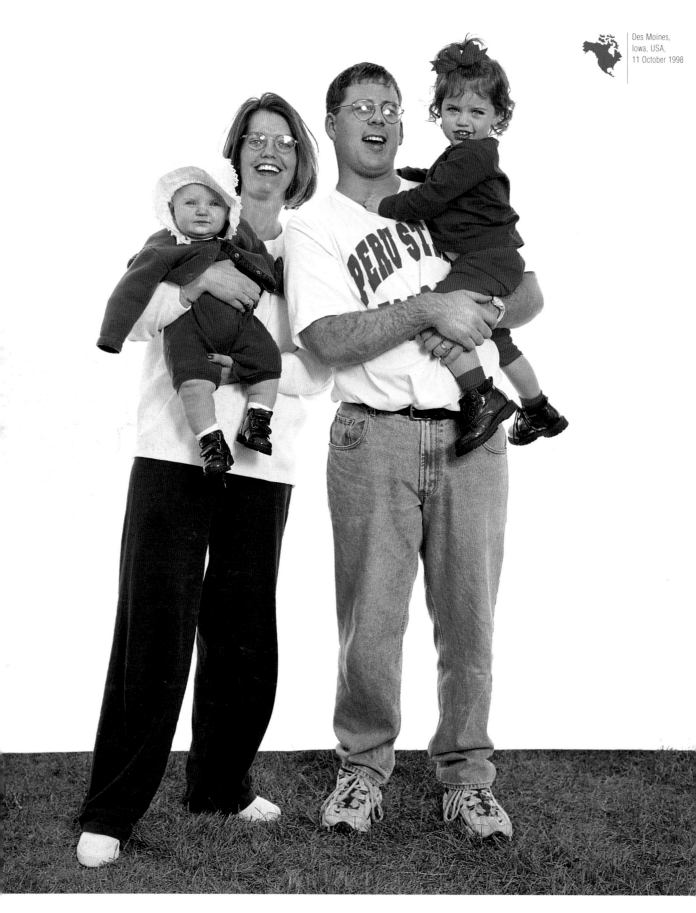

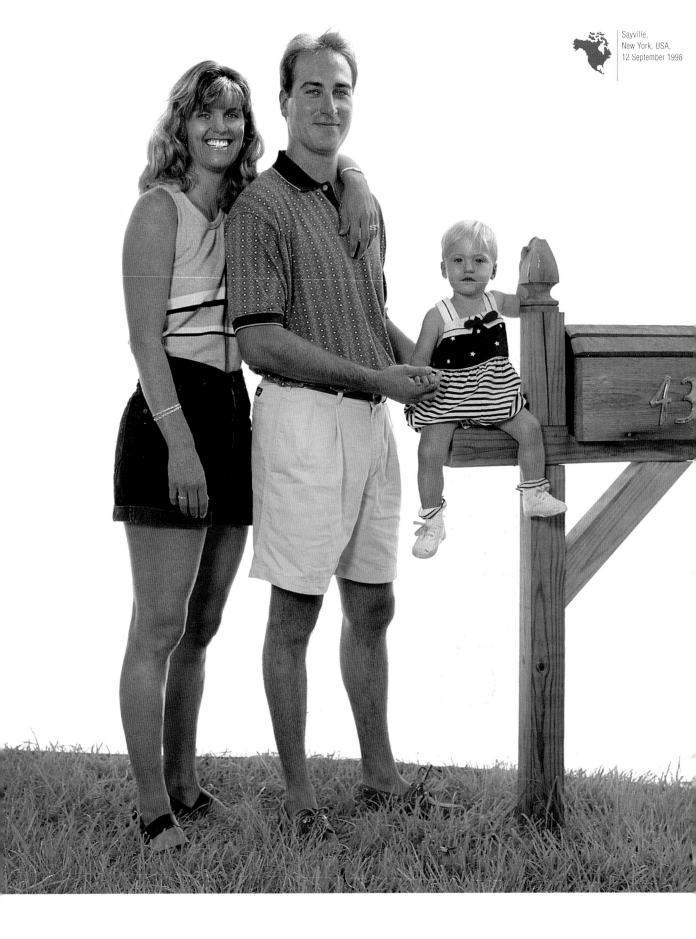

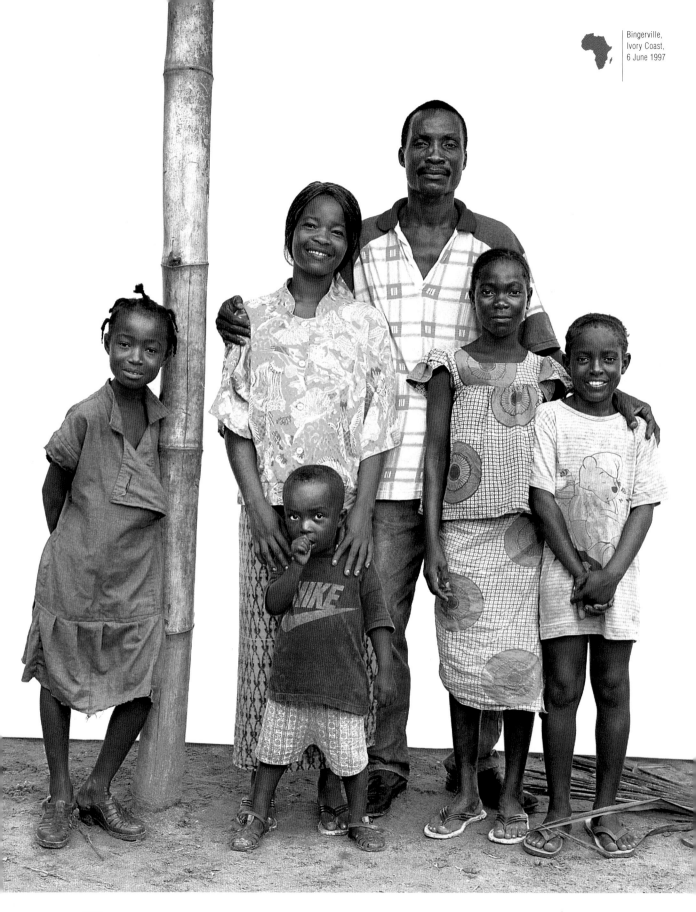

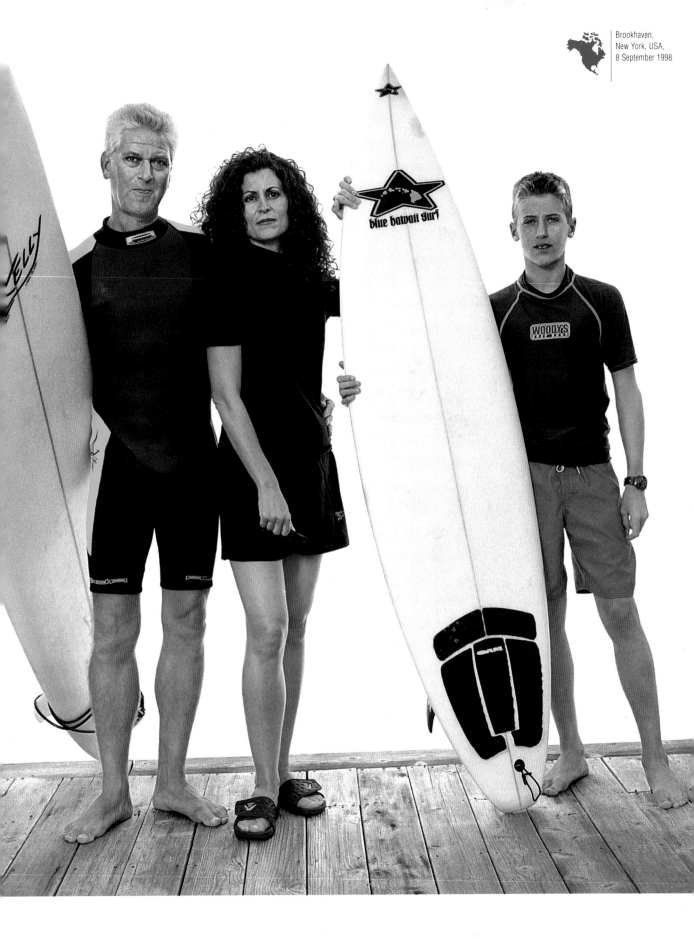

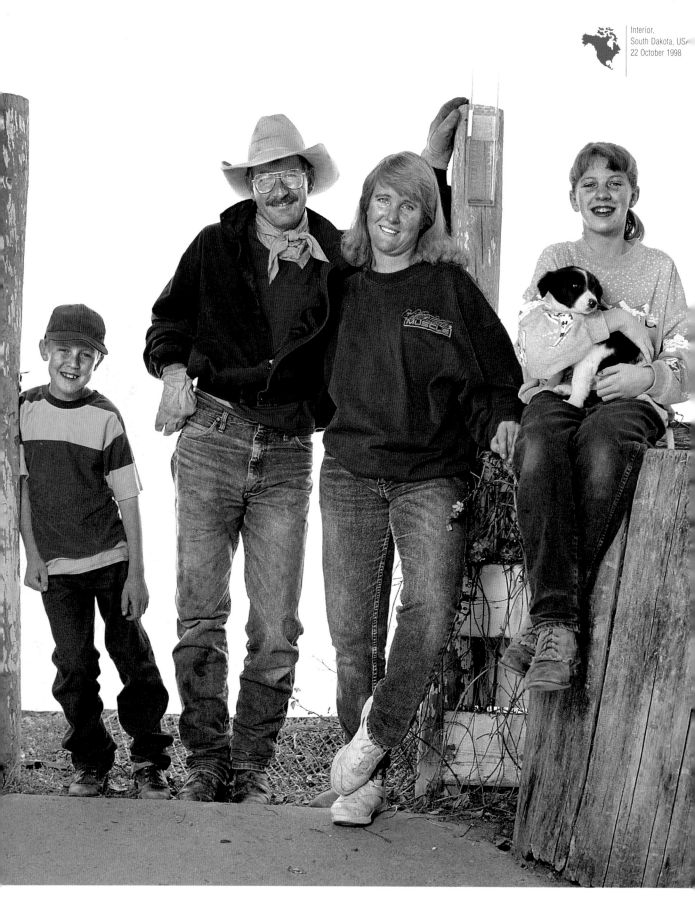

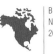

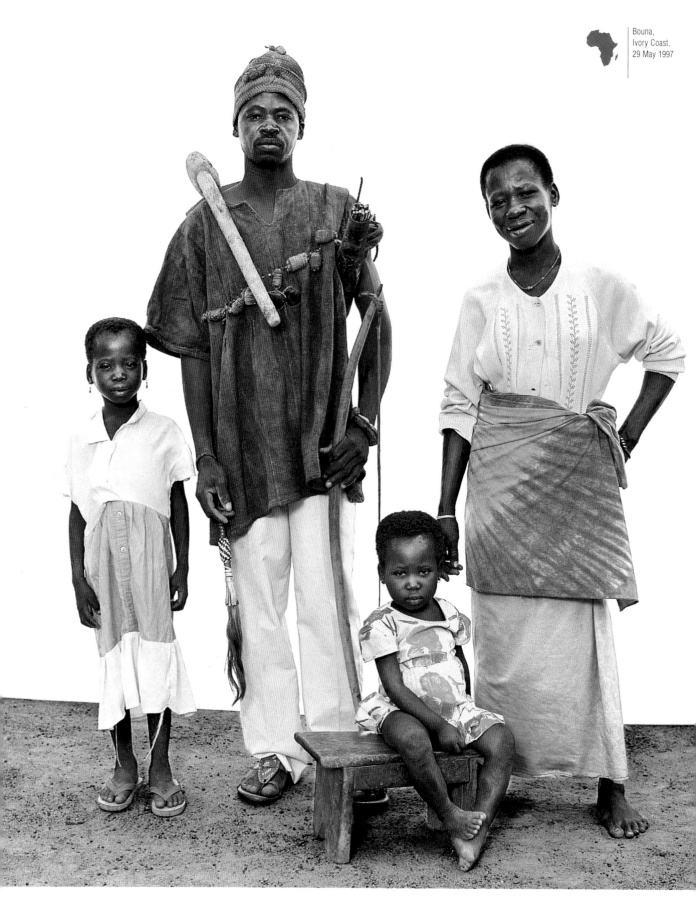

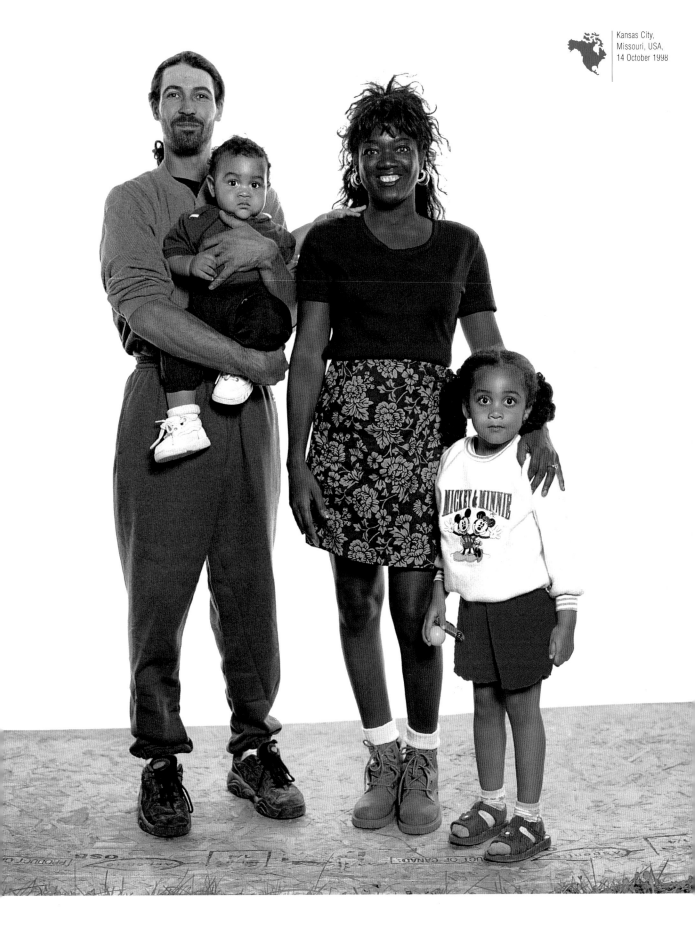

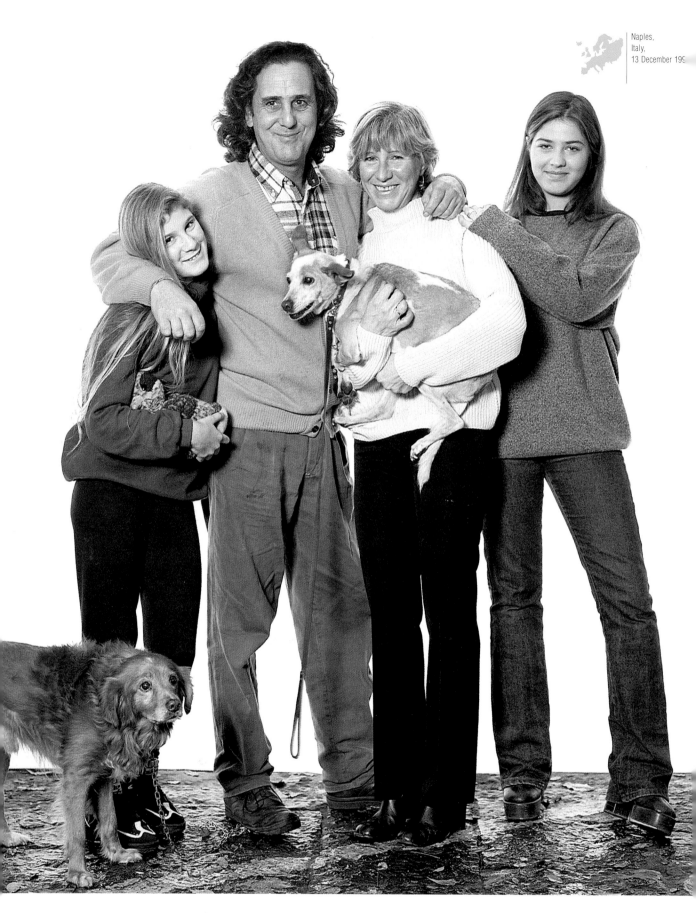

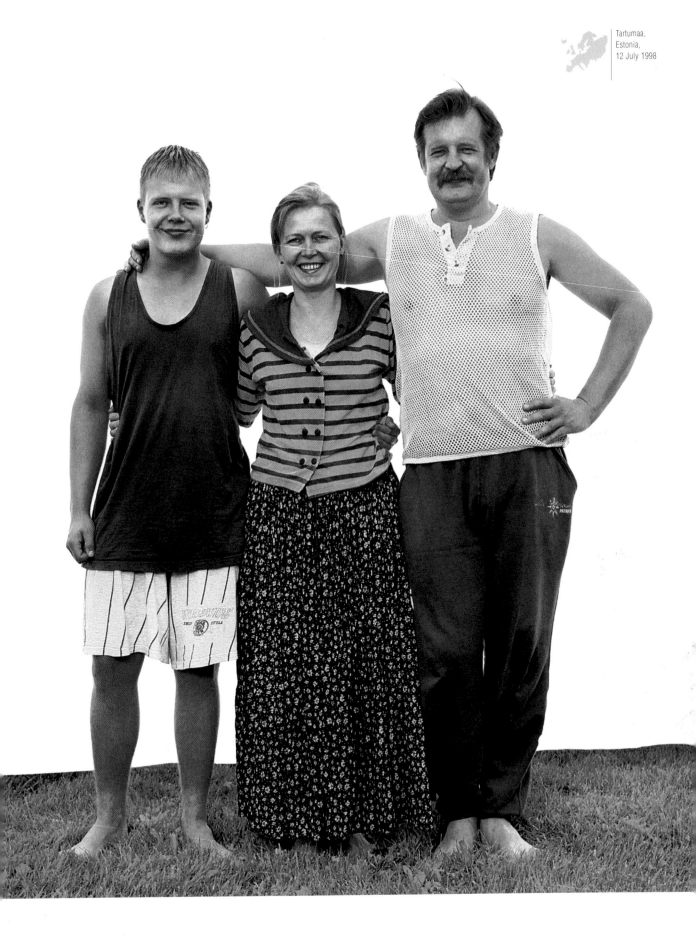

Bei Brent und Sherri gehört der Sonntag der Familie: Morgens geht es zur Messe, am Nachmittag folgen Spaziergang und Picknick. Brent bedauert es ein wenig, das Fußballspiel im Fernsehen zu verpassen, aber die Kinder gehen vor. Ein drittes Kind im Jahr 2000? Warum nicht?

Brent and Sherri have devoted Sunday to the family, beginning with morning Mass, followed by an afternoon walk and picnic in the park. Brent is a bit sorry he can't watch the football match on TV, but the children come first. A third child in 2000? Why not?

Brent et Sherri ont dédié le dimanche à la famille : messe le matin, promenade et pique-nique au parc l'après-midi. Brent regrette un peu de ne pas pouvoir suivre le match de football à la télé, mais les enfants passent avant tout.

Beths und Phils Projekte für das neue Jahrtausend: noch ein Baby und ein Boot, um laut Beth öfter an den Strand und laut Phil öfter zum Angeln zu fahren. Sie sind glücklich, in der Nähe ihrer Angehörigen in einer Umgebung zu leben, die sie für nichts in der Welt eintauschen würden, und blicken optimistisch in die Zukunft.

Beth and Phil have two projects for the new millennium: one is to have another baby; the other to get a boat so they can go to the beach more often (Beth's version) and go fishing (Phil's version). They're glad they live in reach of their nearest and dearest in an environment they wouldn't change for the world. They view the future with an optimistic eye.

Beth et Phil ont deux projets pour l'an 2000 : un autre bébé et un bateau pour aller plus souvent à la plage (selon Beth) et à la pêche (selon Phil). Heureux de vivre à proximité de leurs proches dans un environnement qu'ils n'échangeraient pour rien au monde, ils envisagent l'avenir d'un œil optimiste.

Augustin lebt mit seiner Familie mitten im Wald, wo der Regen regelmäßig die Lehmhütten wegschwemmt. Er baut Mais und Maniok an, schafft es aber kaum, für den Unterhalt der Seinen zu sorgen. „Ich würde dieses Loch gern verlassen, wir bekommen keinerlei Hilfe vom Staat, nur leere Versprechungen! Die Westeuropäer haben uns kolonisiert, also müssen sie uns jetzt auch helfen, und unsere Landsleute in Übersee dürfen ihr Vaterland nicht vergessen." Optimistisch fügt er hinzu: „Auf jeden Regen folgt Sonnenschein."

Augustin lives with his family in the middle of the forest, where rain regularly floods the earth-built huts. He grows maize and cassava, but has a struggle making ends meet. "I'd like to get out of this hole. We haven't had any help from the government, just promises. Westerners colonized us, and now they must help us out. And our fellow countrymen across the sea should never forget their mother country." An optimist, he adds: "Every cloud has a silver lining."

Augustin et sa famille vivent au milieu de la forêt et la pluie inonde régulièrement leurs cases. Il cultive le maïs et le manioc mais parvient difficilement à subvenir aux besoins des siens. « J'aimerais sortir de ce trou, nous n'avons aucune aide gouvernementale, seulement des promesses ! Les Occidentaux nous ont colonisés, aujourd'hui il faut qu'ils nous aident, et nos compatriotes, là-bas, ne doivent pas oublier leur patrie. » Optimiste, il ajoute : « Après la pluie, le beau temps. »

„Das Jahr 2000 ist ein wichtiges Datum. Dann feiern wir unseren 20. Hochzeitstag und Johns 50. Geburtstag und machen voraussichtlich eine Reise nach Hawaii." Diese Familie, durch die Bank begeisterte Surfer, träumt von den Wellen des Pazifiks, und der 13-jährige Johnny weiß schon, dass er einmal einen Beruf haben wird, der mit dem Ozean zu tun hat.

"2000 is an important year. We'll be celebrating our 20th wedding anniversary, John's 50th birthday, and we're planning a trip to Hawaii." This surfing-mad family dreams of Pacific breakers, and 13-year-old Johnny already knows that in due course he's going to have a job to do with the ocean.

« L'an 2000 est une année importante ! Nous fêterons nos vingt ans de mariage, les cinquante ans de John, et nous prévoyons un voyage à Hawaï. » Cette famille passionnée de glisse rêve des vagues du Pacifique et Johnny (treize ans) sait déjà qu'il exercera plus tard un métier en rapport avec l'océan.

Daniels Großeltern siedelten in dieser Gegend zu einer Zeit, als man sich nur niederlassen und ein Haus bauen musste, damit das Land einem gehörte. Daniel, ein echter Cowboy, hat sein ganzes Leben hier auf der Ranch verbracht, mit seinen Pferden und Hunderten von Kühen. Da die Ranch meilenweit von jeder anderen Behausung entfernt liegt, unterrichtet Heidi, von Beruf Lehrerin, ihre Kinder selbst. Sie passt ihren Unterricht der Sensibilität und dem Bedarf jedes Kindes an und bringt ihnen alles bei, was sie für deren Entwicklung für erforderlich hält.

Daniel's grandparents settled in these parts at a time when the land didn't belong to anyone – all you had to do was move in, and build yourself a house, to have your own place. He's always lived here, on his ranch, with his horses and hundreds of cows, like a real cowboy. Because the ranch is miles from the next house, it's Heidi, a teacher by training, who educates the children. She adapts what she teaches to the sensibilities and needs of each individual child, giving each what she reckons it needs to blossom.

Les grands-parents de Daniel se sont installés dans la région, à l'époque où il suffisait de construire sa maison pour être chez soi. Un véritable cow-boy, il a toujours vécu dans son ranch, avec ses chevaux et des centaines de vaches. Le ranch étant situé à la limite du parc national, à des miles de tout autre habitation, c'est Heidi, professeur de formation, qui assure la scolarité de ses enfants. Elle adapte son enseignement à la sensibilité et aux besoins de chacun d'entre eux, leur apprenant tout ce qu'elle estime être nécessaire à leur épanouissement.

Denis ist ein Energiebündel: Lehrer und Allround-Sporttrainer, Surfer, Skifahrer und Sammler alter Traktoren. Er liebt es, mit seinen Maschinen über die Felder seiner Farm in Massachusetts zu rumpeln, wo er Mais anbaut, Heu mäht und Kartoffeln und Heidelbeeren erntet. Julie, ebenfalls Lehrerin, teilt seine Interessen. Sie träumen davon, eines Tages auf ihre Farm zu ziehen, „aber nicht bevor im Haus ein richtiges Badezimmer eingebaut ist", schränkt Julie ein. „Das neue Jahrtausend sollte ein Ansporn für uns sein, einander kennen zu lernen. Unsere Schule, die von schwarzen, weißen und asiatischen Kindern besucht wird, ist ein gutes Beispiel für ein solches Miteinander", sagen sie.

Denis is a ball of fire – teacher, all-round sports coach, surfer, skier, and collector of old tractors. He loves driving his farm machines over the fields of his Massachusetts farm, where he grows maize, cuts hay and harvests apples and blueberries. Julie, who's a schoolteacher, shares all his activities with him. They dream of setting up home on their farm one day, "but not before they get a 'proper' bathroom in the house," Julie says. "The new millennium should encourage us to learn to get to know one another; our school, where we have African Americans, Whites and Asians, is an example of what life together should be like," they say.

Denis est un concentré d'énergie : instituteur, entraîneur « tout sport », surfeur, skieur, il est aussi collectionneur de tracteurs anciens. Il adore conduire ses machines à travers les champs de sa ferme du Massachusetts, où il cultive du maïs, coupe le foin, récolte des pommes et des *blueberries* – les myrtilles. Julie, qui est institutrice, l'accompagne dans toutes ses activités. Ils rêvent de s'installer un jour dans leur ferme, « mais pas avant d'avoir une *vraie* salle de bains dans la maison, qui date du XVIIIe siècle », rappelle Julie. « L'an 2000 doit nous inciter à apprendre à nous connaître mutuellement ; notre école, où il y a des Noirs, des Blancs et des Asiatiques, est un exemple de ce que devrait être la vie ensemble », disent-ils.

„Wenn du keine Familie hast, lebst du nicht." Gourwete legt gemäß der Tradition der Lobi seinen Fetisch-Boubou an, der ihn gegen böse Geister schützt. Der Landwirt und Jäger bestreicht die Spitze seiner Pfeile mit einem tödlichen Gift. „Wenn du dich damit verletzt, stirbst du", sagt er. Die Hütten in seinem Dorf stehen absichtlich weit auseinander, damit die Hühner und Perlhühner ihre Eier nicht beim Nachbarn legen. Früher gab es immer endlose Diskussionen, so erzählt er uns, weil jeder vehement Anspruch auf die Eier erhob und es unmöglich war herauszufinden, wem sie gehörten.

"If you don't have a family, you're not alive." Gourwete is wearing his robe with fetishes, protecting him from evil spirits, in the Lobi tradition. A farmer and hunter, he covers the tips of his arrows with a deadly poison. "If you scratch yourself with it, you die," he says. The huts in his village are intentionally set well away from each other, to avoid mix-ups with hens and guinea-fowl while they're laying. Earlier, he tells us, various owners vehemently claimed the eggs, and because it was impossible to tell precisely which egg belonged to whom, the discussions were endless.

« Si tu n'as pas de famille, tu n'es pas dans la vie. » Nous confie Gourwete protégé des mauvais sorts par ses fétiches, selon la tradition lobi. Cultivateur et chasseur, il enduit la pointe de ses flèches d'un poison mortel. « Si l'on se blesse avec, la mort s'en suit », affirme-t-il. Les cases de son village sont volontairement éloignées les unes des autres afin d'éviter le mélange des poulets et des pintades pendant la ponte. Auparavant, nous raconte-t-il, chaque propriétaire revendiquait son œuf avec véhémence et, comme il était impossible de déterminer avec précision son appartenance, les palabres n'en finissaient plus.

Als „Zeltmeister" überwacht der ehemalige Akrobat Duncan heute den Auf- und Abbau des Soul Circus, der einzigen schwarzen Zirkustruppe in den USA. Seine Frau Emily hat gleich nach der Geburt von Alex das Training wieder aufgenommen und arbeitet an einer Elefanten- und einer Trapeznummer. Zehn Monate im Jahr sind sie auf Tournee, was ihren Wunsch für das Jahr 2000 erklärt: Sie träumen von einem riesigen Grundstück mit einem großen Haus, ein paar Kühen, ein paar Hühnern und vielleicht einem dritten Kind.

Former acrobat Duncan now works as tent-master: he is in charge of putting up and taking down the big top of the Soul Circus, the only Black circus in the United States. His wife Emily has started training again after giving birth to Alex and is preparing two acts: one with elephants, the other on the trapeze. They are on the road for ten months a year, which explains why they dream of a big house with lots of land, a few cows, some chickens – and maybe a third child.

Duncan, ancien acrobate, travaille comme *tentmaster*: il est responsable du montage et démontage du chapiteau du Soul Circus, seul cirque noir des Etats-Unis. Emily, sa femme, a repris l'entraînement après l'accouchement d'Alex et prépare deux numéros : l'un avec des éléphants, l'autre au trapèze. Dix mois par an, ils sont sur les routes, ce qui explique leur rêve d'une grande maison avec beaucoup de terrain, quelques vaches, des poules... et peut-être un troisième enfant.

Zu dekorieren ist ihr Beruf und ihre Leidenschaft. Als gebürtige Neapolitaner fühlen sie sich pudelwohl in ihrer Heimatstadt. Ihre Wünsche für das neue Jahrtausend: „Möge das Leben so schön bleiben wie bisher!"

Decorating is their trade, and they're passionate about it. They come from Naples and feel very happy here. Their hope for the new millennium: "That life is always this good!"

La décoration est leur métier et leur passion. Ils sont originaires de Naples et sont très heureux dans cette ville. Leurs souhaits sont simples : « Que la vie soit toujours aussi belle ! »

„Wir hoffen, dass Estland nicht der Europäischen Gemeinschaft beitritt. Unser Land ist viel zu klein, wir wollen unsere Identität bewahren und unsere wirtschaftliche Lage würde sich dadurch auch nicht bessern." Pilvi hat eine Werkstatt und repariert alles, was fährt: Traktoren, Autos, Motorräder, Rasenmäher. Enn ist bei einer Versicherungsgesellschaft angestellt. Die ganze Familie ist optimistisch und glaubt für die nahe Zukunft an ein erstarktes Estland.

"We're hoping we won't join the European community – we're too small a country. We want to hang on to our identity, and our economic situation wouldn't be any better." Pilvi has a garage and repairs anything that breaks down – tractors, cars, motorbikes and lawn mowers. Enn works for an insurance company. The whole family is optimistic and believes that Estonia will be prosperous in the near future.

« Nous espérons ne pas intégrer la communauté européenne, nous sommes un trop petit pays, nous voulons garder notre identité et notre situation économique n'en serait pas améliorée ! » Pilvi est garagiste et répare tout ce qui casse, tracteurs, voitures, motos et tondeuses à gazon ... Enn est employée dans une compagnie d'assurances. Toute la famille est optimiste et croit en une Estonie prospère.

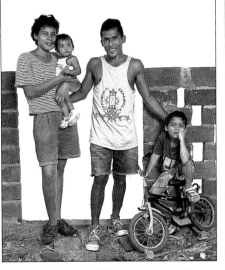
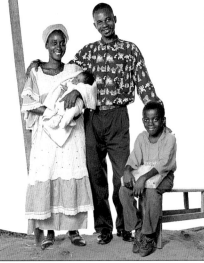
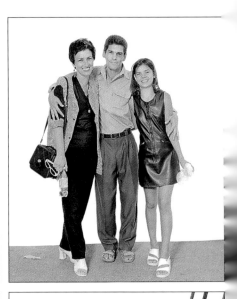
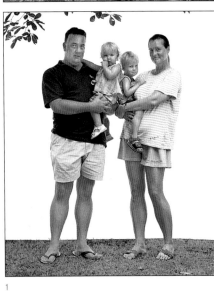
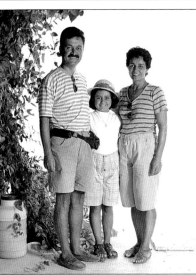
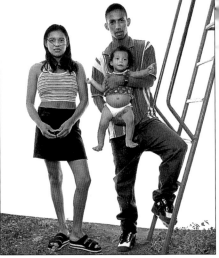

1
7

2
8

3
9

1
San Juan del Sur,
Nicaragua,
18 December 1998

2
Libreville,
Gabon,
20 August 1997

3
Volgograd,
Russia,
29 August 1999

4
Sturt Downs Station,
Australia,
22 December 1999

7
Darwin,
Australia,
19 December 1999

8
Pamukkale,
Turkey,
31 July 1999

9
Granada,
Nicaragua,
16 December 1998

10
Yerevan,
Armenia,
22 August 1999

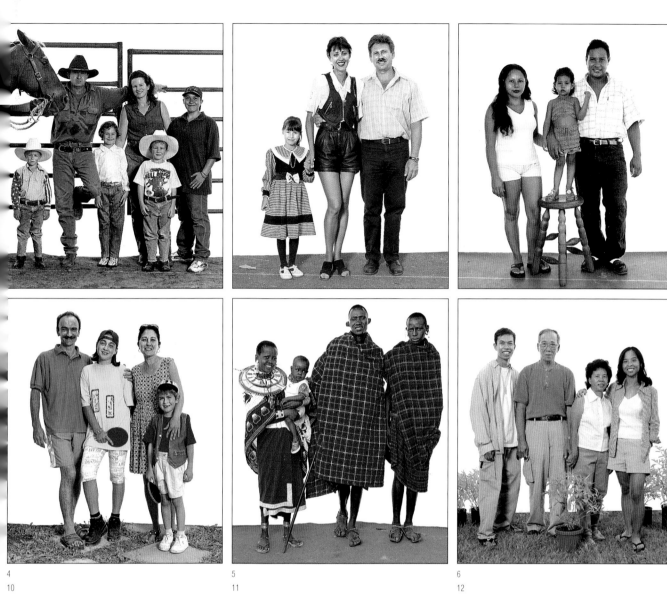

4
10

5
11

6
12

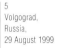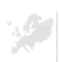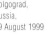

5
Volgograd,
Russia,
29 August 1999

6
Pôrto Velho,
Brazil,
6 March 1999

11
Longido,
Tanzania,
11 November 1997

12
Brookhaven,
New York, USA,
8 September 1998

Assinie,
Ivory Coast,
25 May 1997

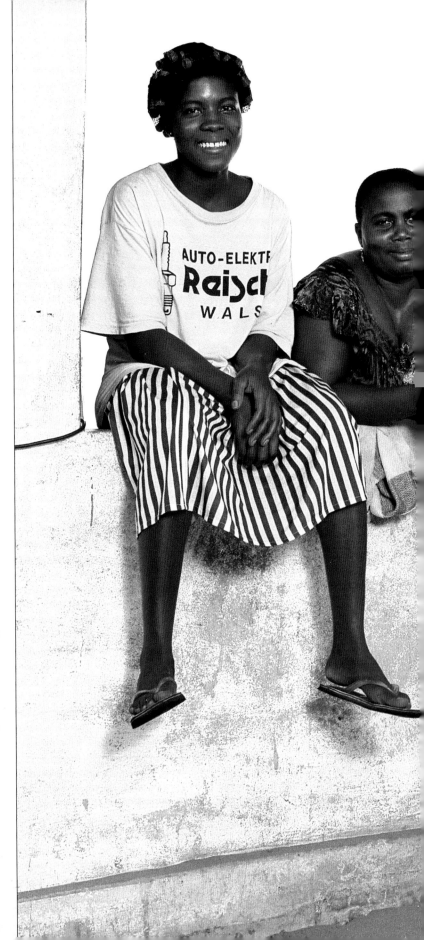

„Meine Spezialität ist *Foufou* [Yamsbrei] mit Getreidesauce", verkündet Mariam mit Stolz. Sie hat die Kochkunst von ihrer Mutter gelernt und betreibt heute ein eigenes Restaurant, Le Nissim, in Assinie. Ihre Schwester Claudine ist Schneiderin, ihr Traum: ihr Atelier in ein Modehaus der Haute Couture zu verwandeln. Nach dem Tod ihrer Eltern übernahmen die beiden die Rolle des „Familienoberhaupts". Sie nehmen das Leben mit philosophischer Gelassenheit nach dem Motto: „Es ist besser, Frieden zu haben und kein Geld."

"My speciality is *foufou* [yam meal] in seed sauce," says Mariam proudly. Initiated in the art of cooking by her mother, she now runs her own restaurant, Le Nissim, in Assinie. Her sister Claudine is a dressmaker whose dream is to turn her workshop into a haute couture house, no less. Both sisters became 'head of the family' after the death of their parents, and they take life philosophically, saying: "It's better to have peace and no money."

« Ma spécialité, c'est le foufou sauce graine », lance Mariam avec fierté. Initiée à l'art culinaire par sa mère, elle tient aujourd'hui son propre restaurant, Le Nissim, à Assinie. Sa sœur, Claudine, est dans la couture, son rêve : transformer son atelier en maison de haute couture ! Devenues toutes deux « chefs de famille » après le décès de leurs parents, elles prennent la vie avec philosophie et précisent : « Mieux vaut avoir la paix et pas d'argent. »

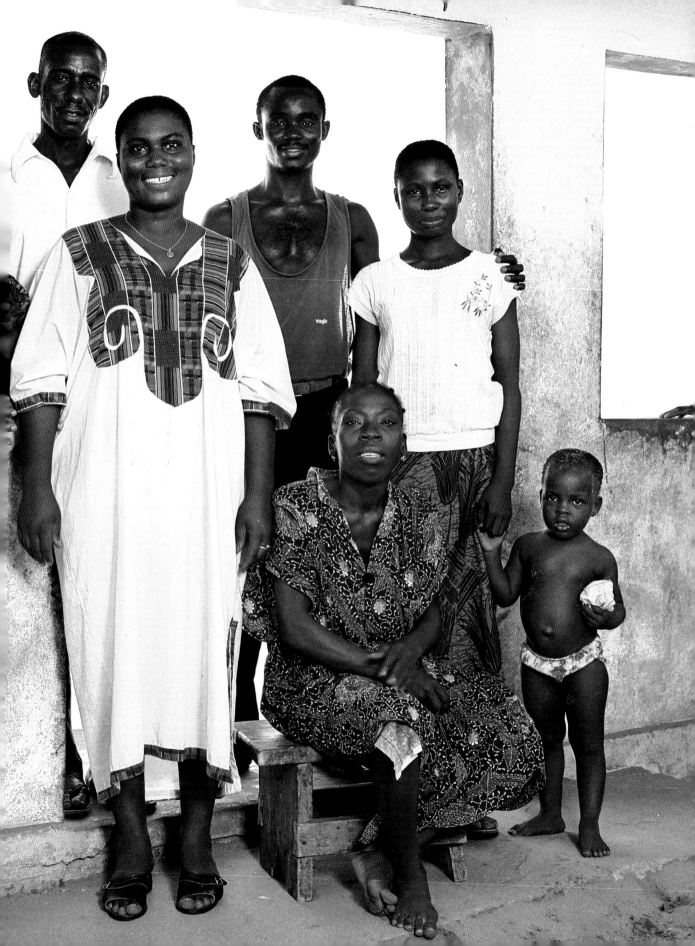

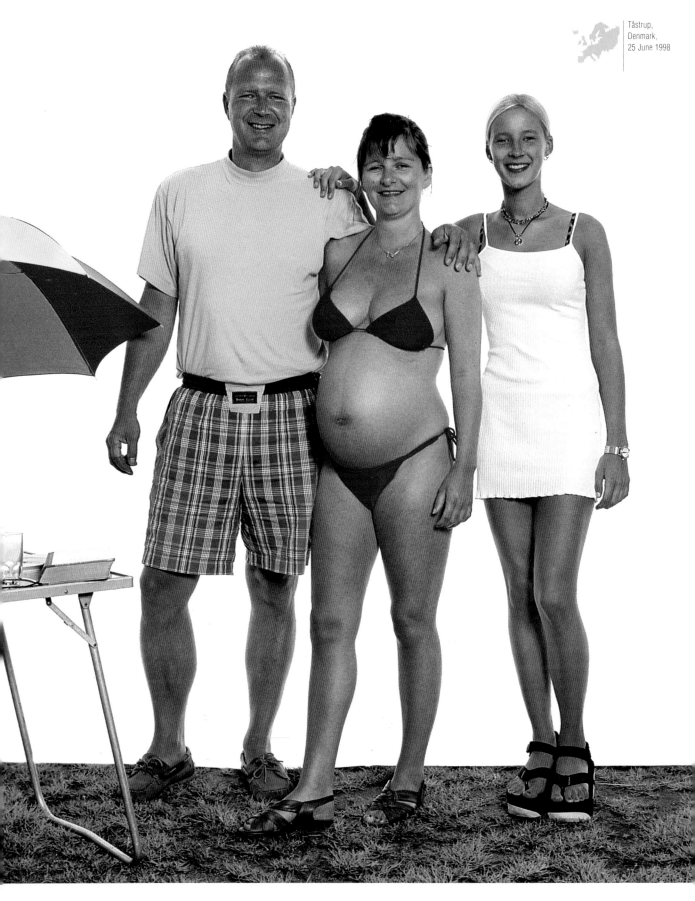

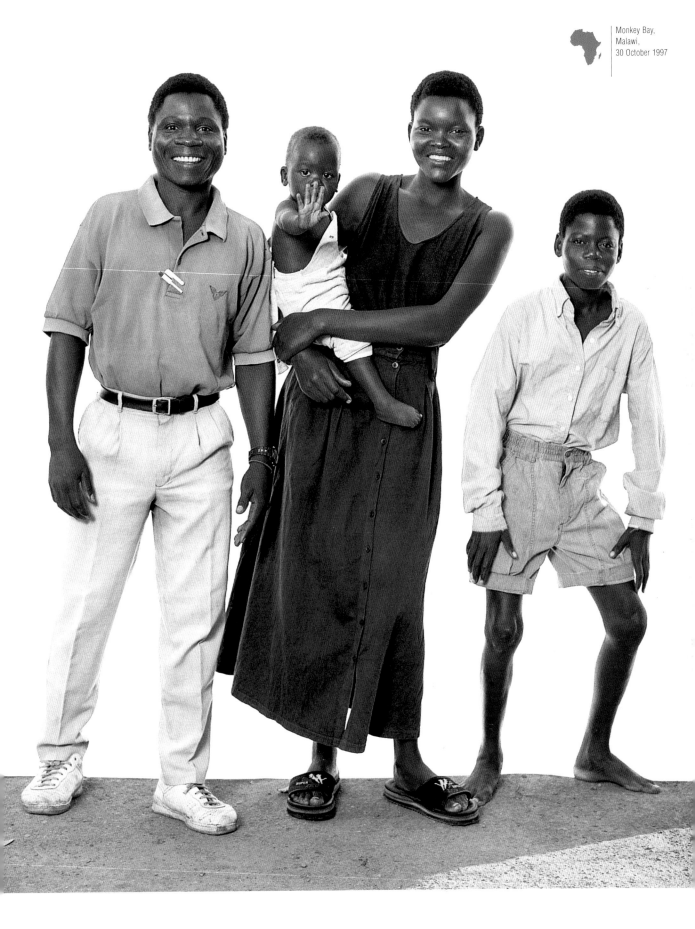

Lars und Maj-Britt lieben Kinder, Freizeit und das Leben im Freien. Ihre Ferien verbringen sie regelmäßig auf einem Campingplatz, aber niemals zweimal auf demselben. Beide arbeiten seit zwei Jahren im Krankenhaus, sie lieben den Kontakt zu anderen Menschen. Sie finden, dass alte Menschen vernachlässigt werden: „Sie brauchen uns und wir dürfen sie nicht vergessen!"

Lars and Maj-Britt love children, leisure activities and the outdoor life. They often go camping and never stay in the same place twice. They both work in a hospital complex, enjoy contact with people and would like to see more concern for the elderly. "Let's help them – let's not pass them by without seeing them."

Lars et Maj-Britt aiment les enfants, les loisirs et la vie en plein air. Ils campent régulièrement et ne reviennent jamais deux fois au même endroit. Ils travaillent tous les deux dans un centre hospitalier, aiment les contacts humains et souhaitent plus de sollicitude envers les personnes âgées : « Aidons-les, ne passons pas sans les voir ! »

„Wie ich die Zukunft sehe? Wenn wir noch mehr Kinder bekommen, ergeht es uns schlecht!", prophezeit uns Budi, hier mit seiner Frau, seinem Kind und seinem jüngeren Bruder. „Ich muss meine eigene Familie ernähren, meine Eltern und meine Brüder. Ich verdiene einfach nicht genug." Als Wildhüter im Lake Malawi National Park engagiert sich Budi für den Naturschutz, insbesondere für den Erhalt bedrohter Fischarten im Malawisee. Die Stelle bekam er nach seiner Ausbildung im berühmten Krüger-Nationalpark (Südafrika), wo er übrigens für das Spitzmaulnashorn zuständig war!

"How do I see the future? I'll suffer if I have any more kids!" prophesies Budi, here with his wife, child and younger brother. "I'm responsible for my own family, my parents, and my brothers, and I don't get enough pay for that." He's a forest warden in Lake Malawi National Park and very involved in environmental protection, more specifically in protecting the rare fish that live in Lake Malawi. He got this job after training in the famous Krüger Park in South Africa, where he was put in special charge of the black rhinos!

« Comment je vois le futur ? Je vais souffrir si j'ai plus d'enfants ! », prophétise Budi, ici avec sa femme, son enfant et son petit frère « J'ai la charge de toute ma famille, de mes parents, de mes frères et mon salaire est trop faible ! » Garde forestier au « Lake Malawi National Park », il est très concerné par la protection de l'environnement et plus particulièrement par celle des poissons rares qui peuplent le lac Malawi. Il a obtenu ce poste après une formation au célèbre « Krüger Park » (Afrique du Sud) où il s'occupait notamment des rhinocéros noirs !

„Er ist weder besonders sanft noch besonders schön, aber er ist ein richtiger Mann und seine Augen machen die Frauen ganz verrückt!" So beschreibt Jurate ihren Ehemann, den sie 1985 geheiratet hat. Mit Verweis auf ihre soziale Stellung fährt sie schelmisch fort: „Aber wissen Sie, er hat vier Angestellte und ich habe 40." Er führt einen Friseursalon und sie ein Transportunternehmen. Ihr Hobby ist es, „durch die Modegeschäfte zu bummeln", sogar der zehnjährige Arnas findet das okay. Jurates Wunsch: „Ein langes Leben!"

"He's not very gentle and he's not that handsome, but he's a real man, and women are crazy about his eyes!" That's how Jurate describes her husband, whom she married in 1985. And remembering their social situation, she goes on mischievously: "But you know, he's got four employees, and I've got 40." He runs a hairdressing salon, she runs a transport company. Their hobby is "shopping for clothes." Even Arnas, who's ten, isn't averse to that. "To live to a ripe old age," is Jurate's ambition.

Jurate, mariée depuis 1985, nous décrit son mari : « Il est ni très doux, ni très beau, mais c'est un vrai homme et les femmes sont folles de ses yeux ! » Et, rappelant leur situation sociale elle continue malicieusement : « Mais vous savez, lui a quatre employés et moi j'en ai quarante ! » Il gère un salon de coiffure et elle une société de transports. Leur hobby : « Faire les magasins de mode » ; même Arnas (dix ans) ne déteste pas. Le vœu de Jurate : « Vivre très longtemps ! »

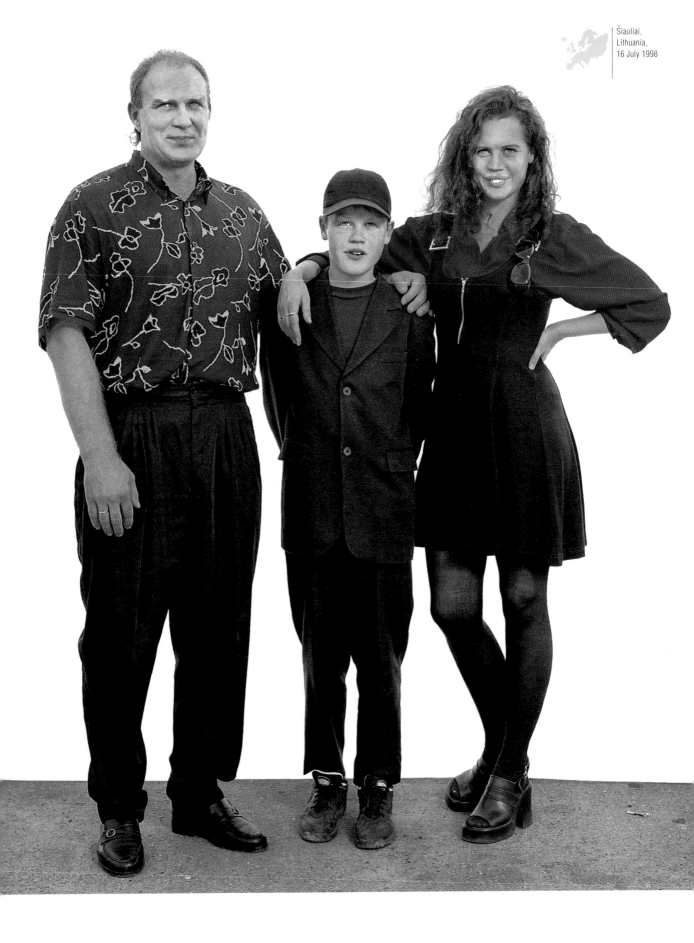

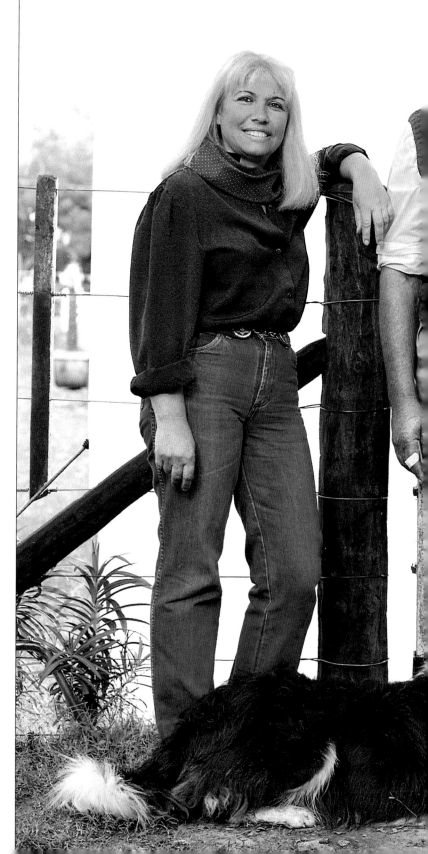

Ernesto ist Chef einer Fabrik für Drahtgitter zur Umzäunung von Feldern, Gärten und Weideland, hat aber auch Pferde, eine Kuh, Hühner, Bienen und ein Maisfeld. Am liebsten vertreibt er sich die Zeit mit Verschönerungsarbeiten in seinem üppig blühenden Garten.

Ernesto runs a company that makes fences for fields, gardens and pasture land in Argentina, but he also has his own horses, a cow, chickens, bees and a field of maize. His favourite pastime is tending to his garden, which is full of flowers.

Ernesto dirige une entreprise de grillages servant à clôturer les champs, jardins et pâturages argentins, mais il possède aussi des chevaux, une vache, des poules, des abeilles et un champ de maïs. Son passe-temps favori, c'est l'entretien de son jardin, très fleuri.

36 037

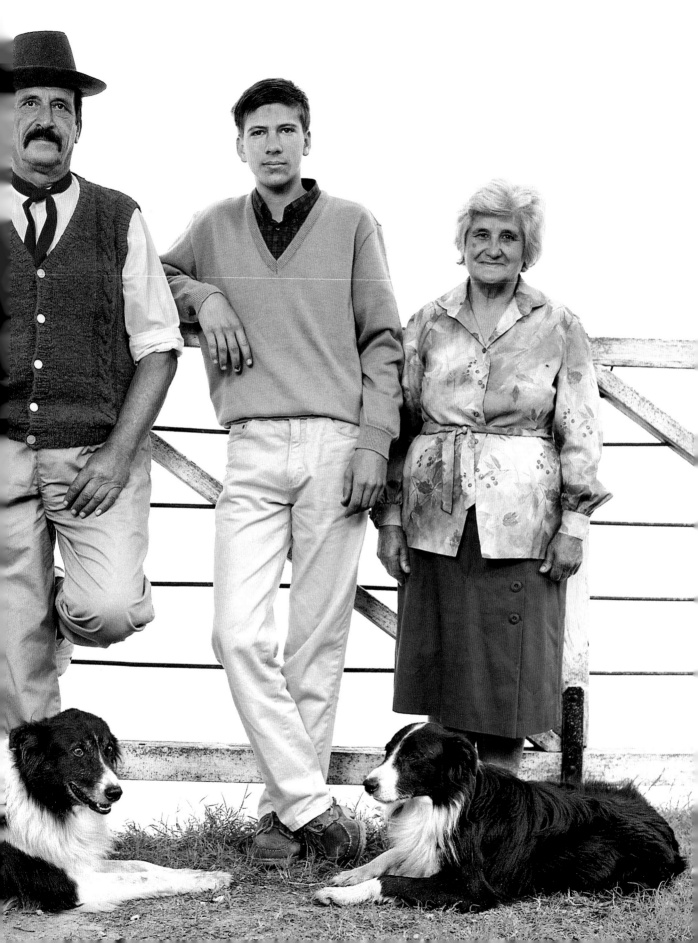

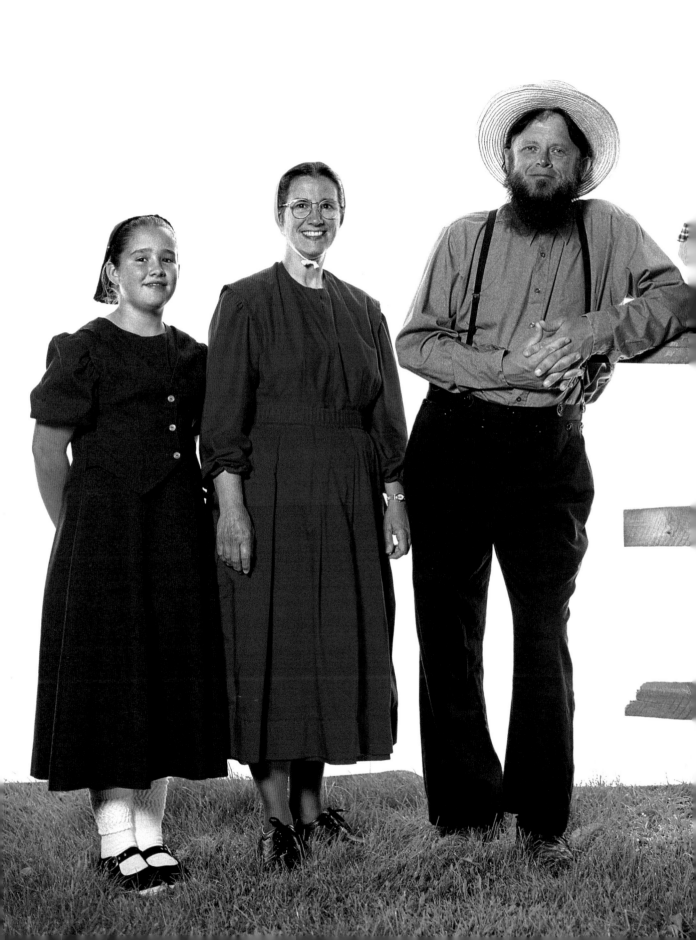

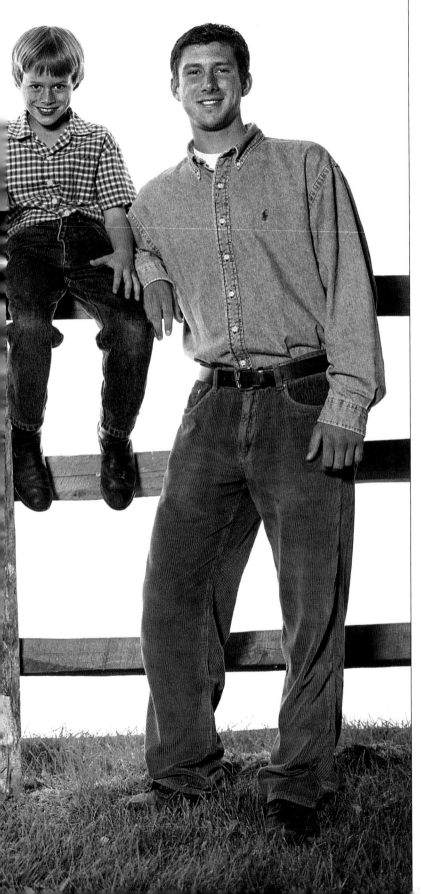

„Ich arbeite hart daran, die Pfunde zu verlieren, die ich bei der guten Küche meiner Frau ansetze", erklärt uns Jack. Dee Dee ist tatsächlich eine ausgezeichnete und berühmte Köchin. Als Autorin eines Kochbuchs organisiert sie regelmäßig Abendessen auf ihrer Farm, bei denen die „English" (jeder, der kein Amish ist) die Amish-Küche kennen lernen können. Jack seinerseits fährt Touristen in der typischen Amish-Pferdekutsche durch die Landschaft von Lancaster.

"I'm trying really hard to lose all the weight I put on by sampling the dishes my wife makes," declares Jack. Dee Dee is actually an excellent and famous cook, and author of a recipe book. She regularly organizes dinners at their farm to introduce 'English' (anyone who's not Amish) to Amish cooking. Jack does his bit by showing tourists round the Lancaster region in a horse-drawn vehicle.

« Je travaille très dur pour perdre le poids que je prends en goûtant les plats que prépare ma femme! », déclare Jack. Dee Dee est en effet une excellente et célèbre cuisinière. Auteur d'un livre de recettes, elle organise régulièrement des dîners dans leur ferme pour faire découvrir la cuisine amish aux « Anglais » (les non-Amishs). Jack, de son côté, fait visiter aux touristes la région de Lancaster dans une voiture à cheval.

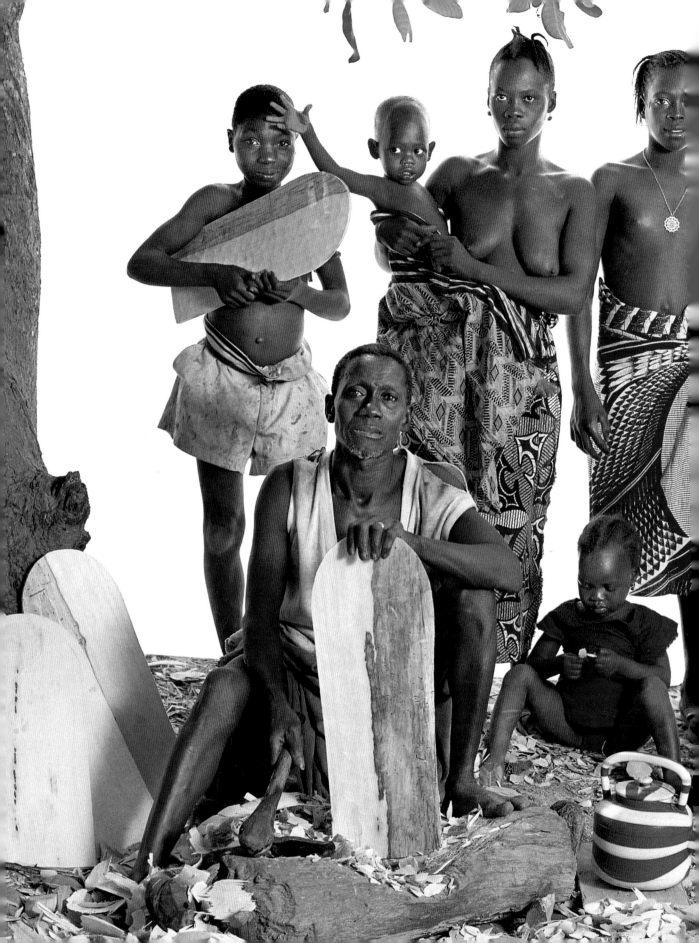

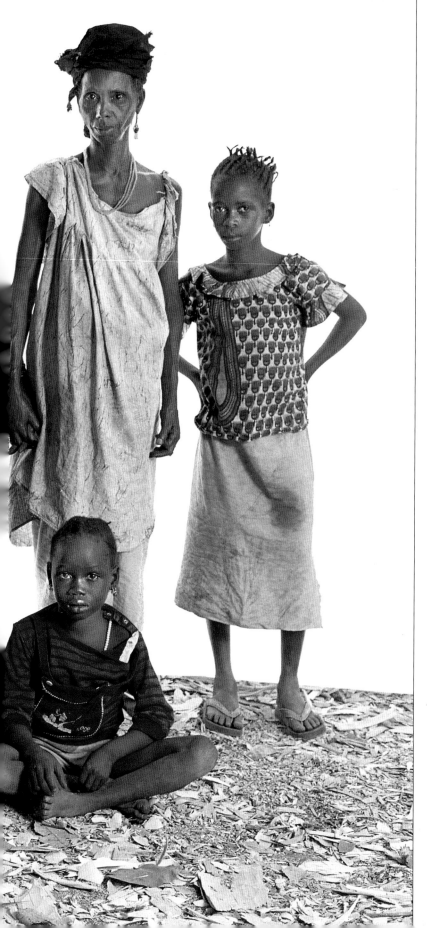

Im Schatten eines *Loukoum* schnitzt Saboubo Korantafeln. Er arbeitet für
den Imam des Dorfs und liefert ihm täglich zwei neue Tafeln für die Kinder
der Koranschule. Seine eigenen Kinder, sechs an der Zahl, besuchen die
staatliche Schule, „damit sie eine bessere Zukunft haben …"

Sitting on a mountain of shavings in the shade of a *loukoum*, Saboubo
carves Koranic tablets. He works for the village imam and every day pro-
vides him with two new slates for the children at the Koranic school every
day. His own children, six in all, go to the official school "to gain a chance
for a better future …"

Assis à l'ombre d'un « loukoum », sur une montagne de copeaux, Saboubo
taille les tablettes coraniques. Il travaille pour l'Imam du village et lui livre
quotidiennement deux nouvelles « ardoises » destinées aux enfants de
l'école coranique. Les enfants de Saboubo, qui sont au nombre de six, vont
eux à l'école officielle « pour leur faciliter un avenir meilleur … »

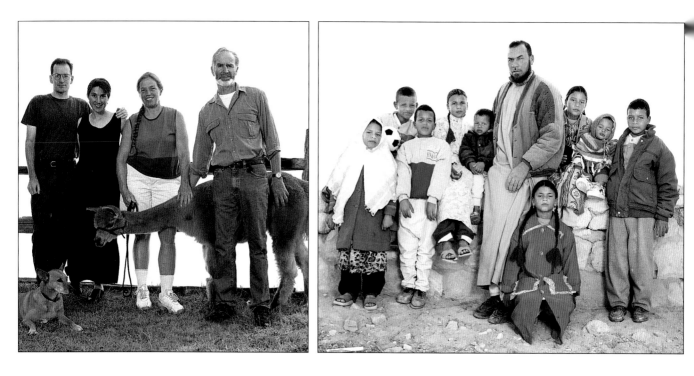

Brookhaven,
New York, USA,
12 September 1998

Pete ist ein vielseitiger Mensch: Er stammt von den Falkland Inseln, wo er zunächst auf einer Schaffarm arbeitete, danach ging er in die Kupferminen Australiens. Jennifer lernte er kennen, als er auf einem Expeditionsschiff in die Antarktis angeheuert hatte. Heute züchten die beiden Alpakas auf Long Island (New York), und arbeiten zudem als Dolmetscher und Fremdenführer auf einem russischen Eisbrecher, der in der Arktis kreuzt. Carin, Jennifers Tochter, ist genau wie ihr Ehemann Tim Schriftsteller. Sie hoffen trotz allem, dass ihr Kind einmal lieber Broker als Autor wird.

Pete is a jack-of-all-trades, originally from the Falkland Islands, where he worked on a sheep farm. Then he went to Australia and worked in the copper mines. He met Jennifer when he was working on a boat doing Antarctic trips. Today, the two of them breed alpacas on Long Island (New York) while carrying on their jobs as tourist interpreters and guides on a Russian ice-breaker plying the Arctic Ocean. Jennifer's daughter Carin is a writer, as is her husband Tim. In spite of everything, they're hoping their child-to-be will go into finance rather than literature.

Pete est un homme à tout faire: originaire des Falklands, il y a travaillé dans un élevage de moutons, puis dans les mines de cuivres en Australie. Il a rencontré Jennifer alors qu'il était employé sur un bateau d'expédition en Antarctique. Tous deux élèvent aujourd'hui des alpagas à Long Island (New York) tout en continuant leur activité d'interprète touristique et de guide sur un brise-glace russe qui croise en Arctique. Carin, la fille de Jennifer, est écrivain comme son mari Tim. Ils espèrent malgré tout que leur enfant à venir évoluera dans la finance plutôt que dans la littérature !

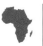

Siwa Oasis,
Egypt,
9 January 1998

Shaker hat viele Talente: Er ist Leiter des Gemeinderats, züchtet Bienen und baut in seinem großen Obstgarten Oliven, Datteln, Aprikosen und Bananen an. Den Wassertank, der zur Bewässerung seiner Felder dient, hat er kurzerhand zum Fischbecken umfunktioniert. Das Oberhaupt einer großen Familie (sieben Kinder) hat auch noch seine beiden Nichten bei sich aufgenommen. Als streng gläubiger Moslem und überzeugter Berber hat er seiner Frau untersagt, mit Fremden zu sprechen. Undenkbar also, sie zu fotografieren …

Shaker is a man of many talents, being the first secretary of the town council, a bee-keeper and a producer of olives and dates. He also has a large orchard with apricot and banana trees. In the tank used for irrigating his farm, he set up a fish nursery without a second thought. He is the father of a large family (seven children), and also takes care of his two nieces. An ardent Muslim and Berber, he doesn't allow his wife to talk to anyone outside the family. It's also unthinkable for her to be included in the photo …

Shaker est un homme doté de multiples talents: premier secrétaire du conseil municipal, apiculteur, producteur d'olives et de dattes, il possède également un verger où poussent abricotiers et bananiers. Dans le réservoir qui sert à l'irrigation de sa ferme, il n'a pas hésité à créer un vivier de poissons. Père d'une famille nombreuse (sept enfants), il veille également sur ses deux nièces. Berbère et fervent musulman, il n'autorise pas sa femme à parler à une personne étrangère à la famille. De même, il est impensable qu'elle puisse figurer sur la photo …

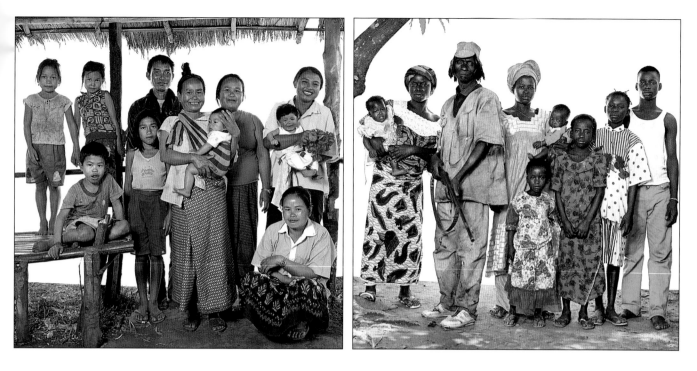

Champasak,
Laos,
29 January 2000

Eine Frau, sechs Kinder und zwei Schwägerinnen, das ist die Familie von Von, seines Zeichens Schmied. Unter einem kleinen Strohdach am Straßenrand fertigt er sechs Macheten am Tag, die er an vorbeireisende Bauern zu verkaufen hofft.

Von's family consists of his wife, six children and two sisters-in-law. He is the local blacksmith, and works on the ground beneath a small straw shelter on the roadside, making six machetes a day, which he hopes to sell to passing farmers.

Une femme, six enfants et deux belles-sœurs, c'est la famille de Von. Forgeron installé à même le sol sous un petit abri en paille, il fabrique six coupe-coupe par jour qu'il espère vendre aux fermiers de passage.

Duékoué,
Ivory Coast,
31 March 1997

Der Gemeindevorstand von Duékoué hat Jäger engagiert, um in dieser Zeit, in der Diebstähle und Gewalttaten an der Tagesordnung sind, für die Sicherheit der Dorfbewohner zu sorgen. Dirassouba gehört zu dieser Truppe und legt sein Gewehr und seine traditionelle Jägerkluft niemals ab. Wir trafen ihn 15 Kilometer von seinem Dorf entfernt, als er, das Gewehr umgehängt, sein mit einem riesigen Sack Bananen beladenes Fahrrad nach Hause schob ...

The municipal authorities of the village of Duékoué have employed hunters to ensure the safety of the villagers in a time of thefts and assaults. Dirassouba is part of this team, and is never without his gun and his traditional hunter's attire. With his rifle over his shoulder, pushing his bicycle bearing a huge bag of plantains, Dirassouba was 15 kilometres [9 miles] from his village when we bumped into him ...

La municipalité du village de Duékoué a engagé des chasseurs afin d'assurer la sécurité des villageois en cette période de vols et d'agressions. Dirassouba fait partie de cette équipe et ne quitte jamais son fusil et sa tenue traditionnelle de chasseur. Son fusil en bandoulière, poussant sa bicyclette chargée d'un énorme sac de bananes plantain, Dirassouba se trouvait à quinze kilomètres de son village, quand nous l'avons rencontré.

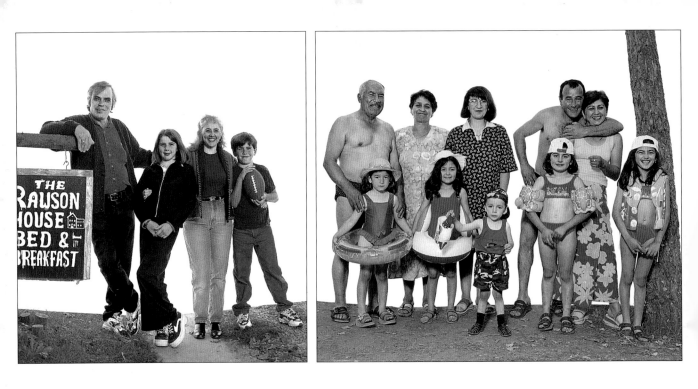

Homestead,
Iowa, USA,
9 October 1998

Die beiden Antiquitätenhändler trafen sich eineinhalb Jahre lang jeden Montagabend bei einer Auktion, bevor Janice den Avancen ihres „Marlboro Man" nachgab, wie sie Richard, der immer noch seinen Cowboyhut trägt, liebevoll nennt. Sie führen ein Möbel- und Antiquitätengeschäft in der nahe gelegenen Stadt sowie ein Bed and Breakfast, das immer ausgebucht ist.

These antique dealers bumped into one another every Monday evening for a year and a half at an auction before Janice gave in to the advances of her "Marlboro man," as she affectionately calls her Richard, who still wears a cowboy hat. They run a furniture and antiques store in the nearby town, as well as a bed and breakfast, which is always full.

Antiquaires, ils se sont croisés tous les lundis soir pendant un an et demi à une vente aux enchères avant que Janice ne cède aux avances de son « Marlboro man », comme elle nomme affectueusement son Richard toujours coiffé d'un chapeau de cow-boy. Ils tiennent une boutique de meubles et d'antiquités dans la ville voisine et un Bed and Breakfast qui ne désemplit pas.

Lake Sevan,
Armenia,
25 August 1999

„Unsere Herzen sind immer in Armenien bei unserer Familie", erklärt der studierte Jurist Gagik, der mit Frau und Töchtern im litauischen Vilnius lebt, wo er als Polizist arbeitet. Die Ferien verbringen sie in Gagiks Heimatdorf, wo sie mit den Großeltern und der Schwägerin das Strandleben am Sevansee genießen. Ob er sich noch mehr Kinder wünscht, wollten wir wissen. „Jede armenische Familie braucht einen Stammhalter. Also versuchen wir es weiter."

"Our hearts are always with Armenia and our family, even though we live abroad," says Gagik. A lawyer by training, he lives with his wife and daughters in Vilnius, Lithuania, where he is a policeman. They are on holiday in his native village, and have come to spend the day at Lake Sevan with his parents and sister-in-law. When asked if he will have any more children, he answers: "Every Armenian family needs a son, so we'll keep trying."

« Nos cœurs sont toujours avec l'Arménie et notre famille même si nous vivons à l'étranger », dit Gagik. Avocat de formation, il vit avec sa femme et ses filles à Vilnius en Lituanie où il est policier. En vacances dans son village natal il passe la journée au bord du lac Sevan avec ses parents et sa belle-sœur. A la question « Aurez-vous d'autres enfants ? », il nous répond : « Il faut un fils à chaque famille arménienne ! Donc on continue. »

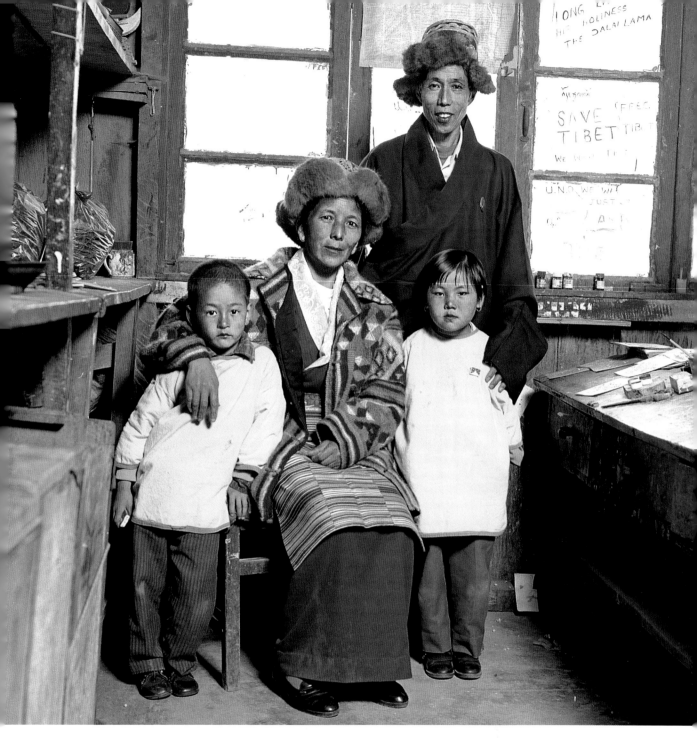

Darjeeling,
India,
18 November 1999

„Wir hoffen, eines Tages mit dem Dalai-Lama in unser Vaterland Tibet heimzukehren." Sie leben mit ihren Kindern in einem Flüchtlingslager. Er fertigt Teppiche und sie malt Bilder und Postkarten. „Wir wollen weder Inder noch Chinesen sein, wir sind Tibeter."

"One day we are hoping to return to our homeland of Tibet with the Dalai Lama." They live with their children in a refugee centre. He is responsible for carpet production and she paints pictures and postcards. "We don't want to be Indian or Chinese: we are Tibetan."

« Nous espérons un jour retourner avec le dalaï-lama dans notre patrie le Tibet. » Ils vivent avec leurs enfants dans un centre de réfugiés. Lui se charge de la production de tapis et elle peint des tableaux et des cartes postales. « Nous ne voulons pas être indiens ou chinois mais tibétains. »

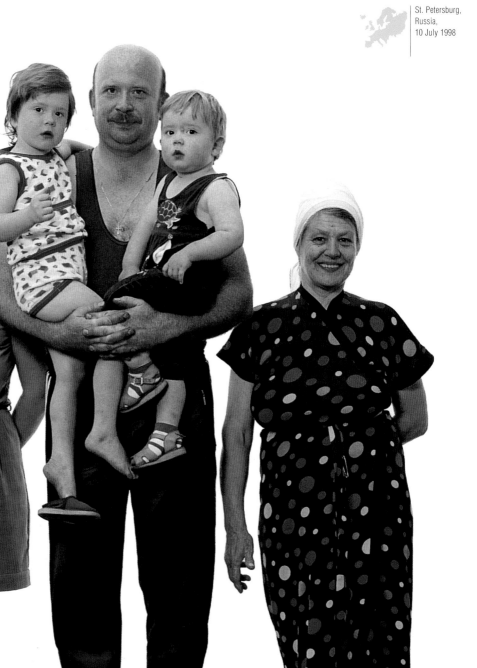

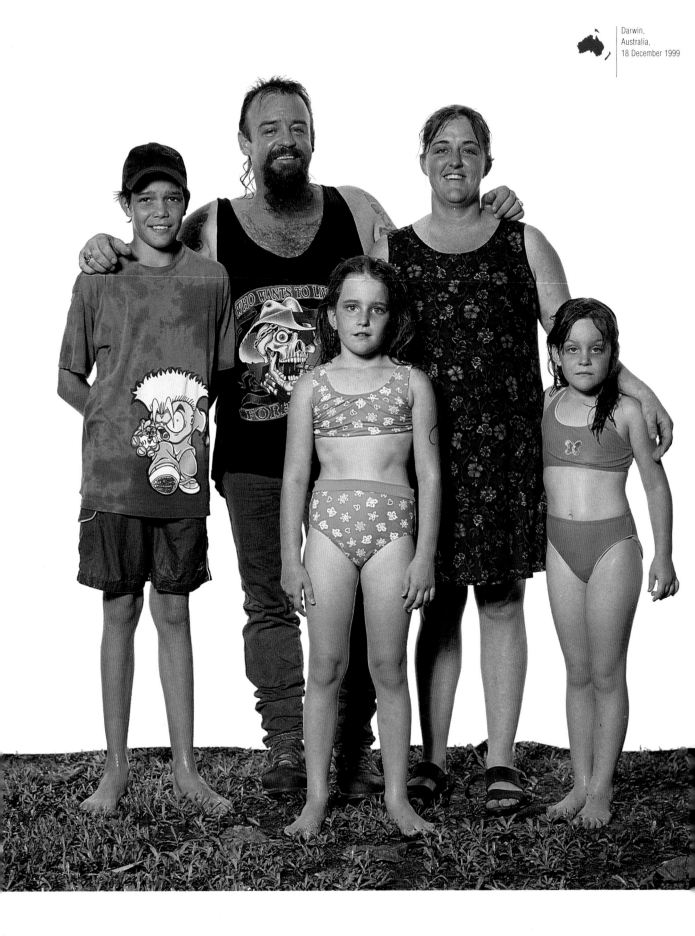

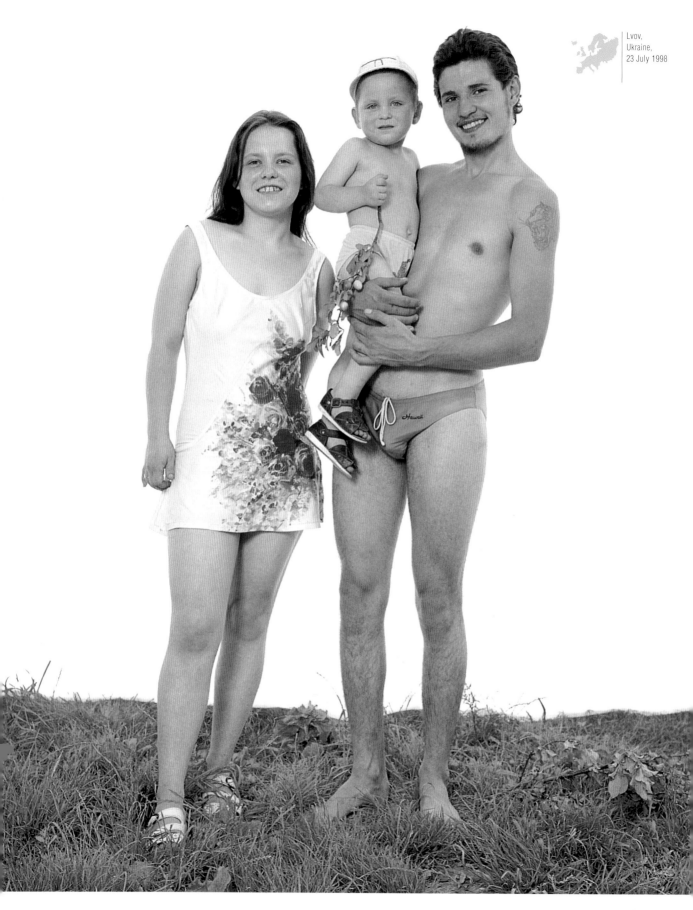

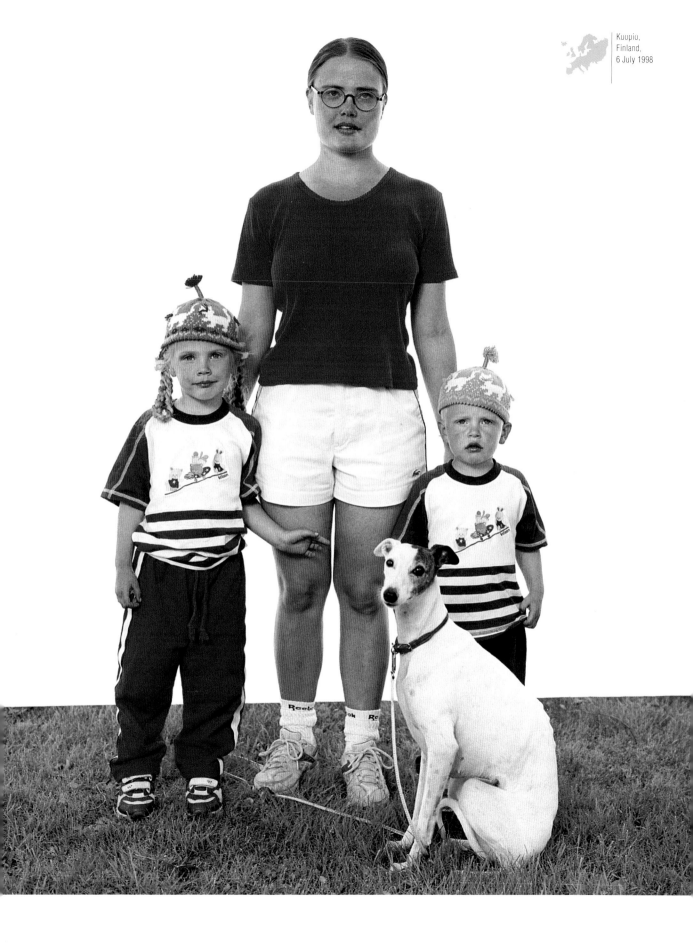

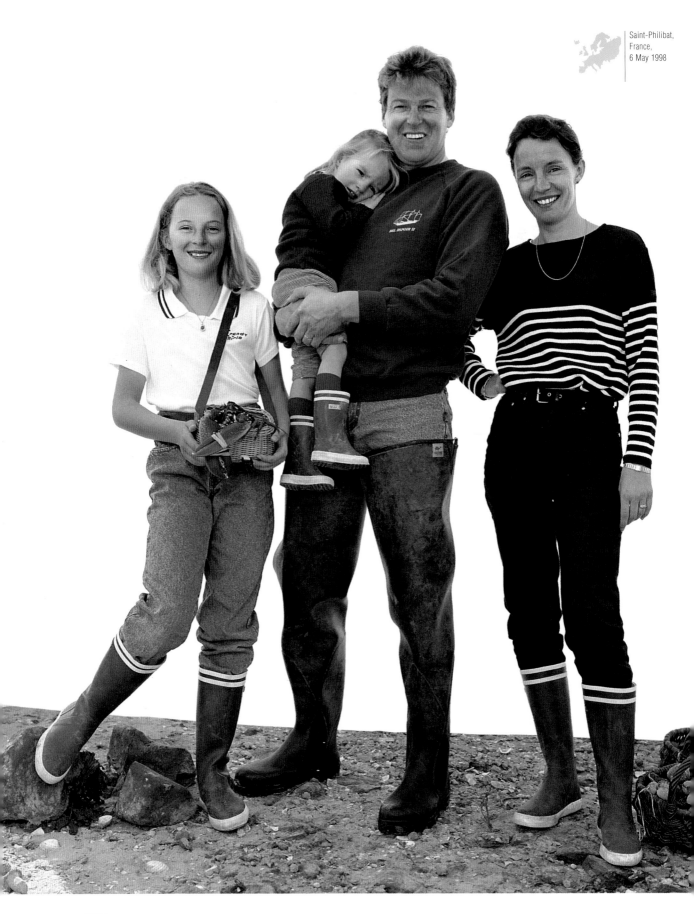

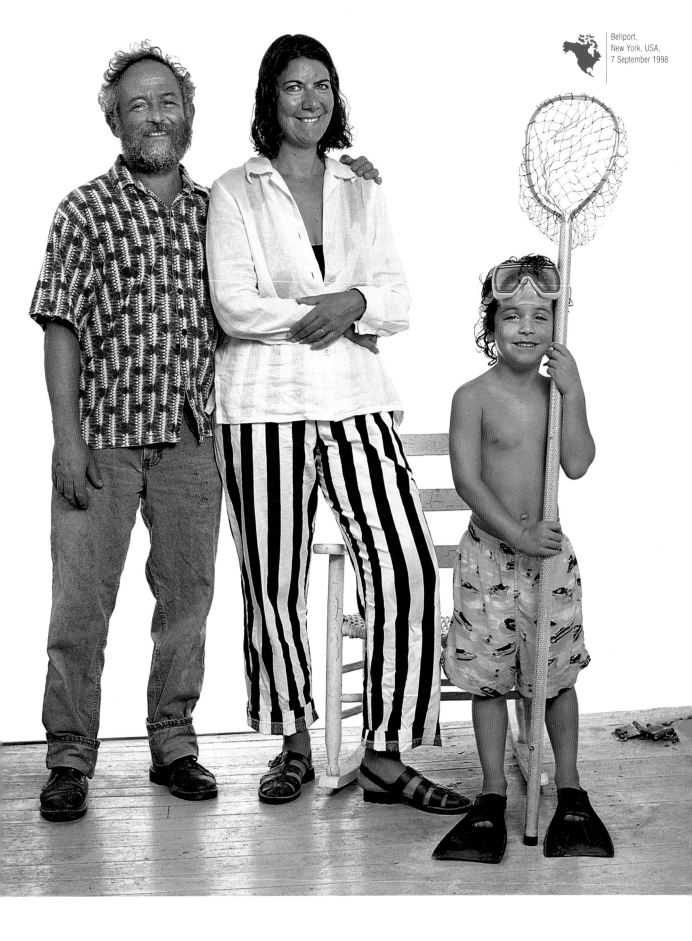

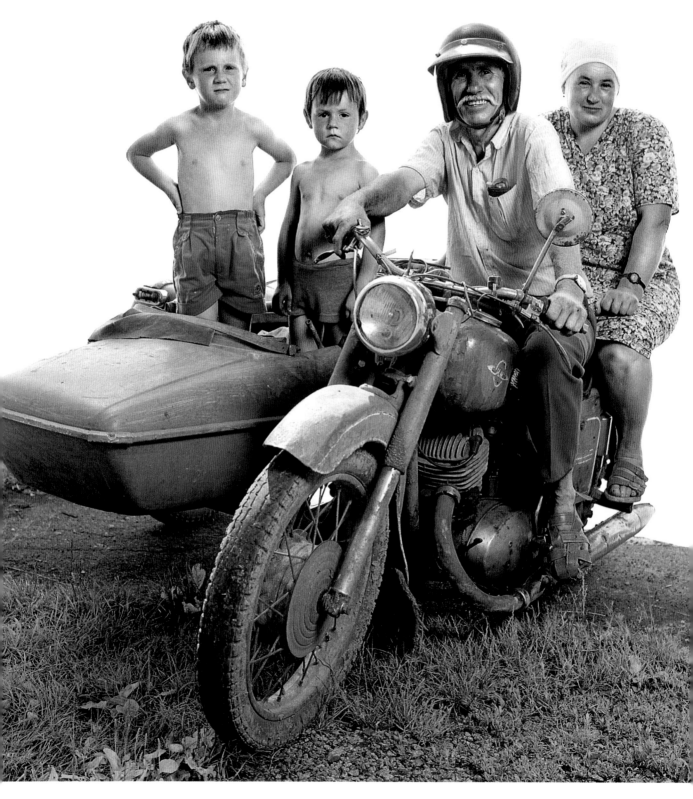

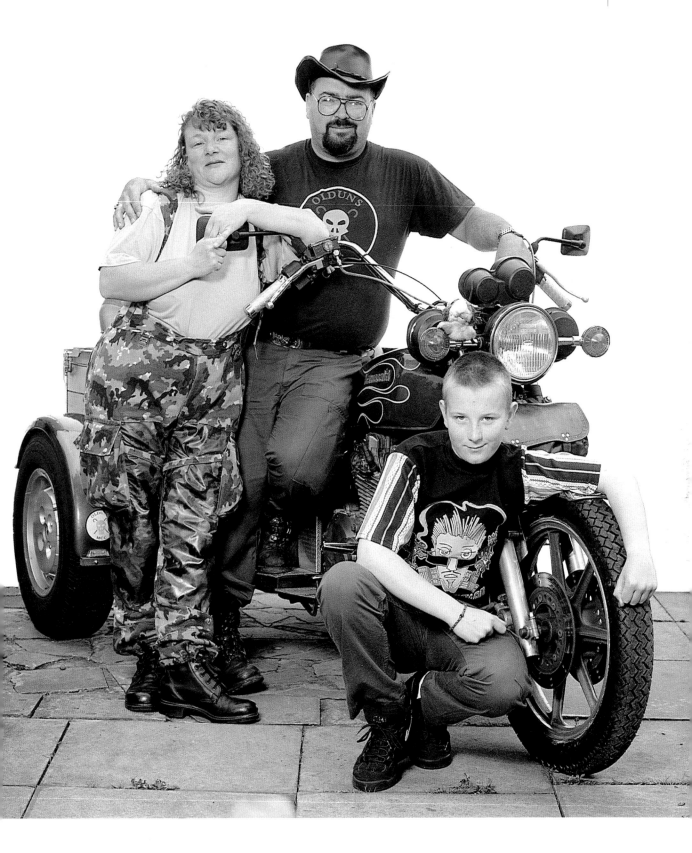

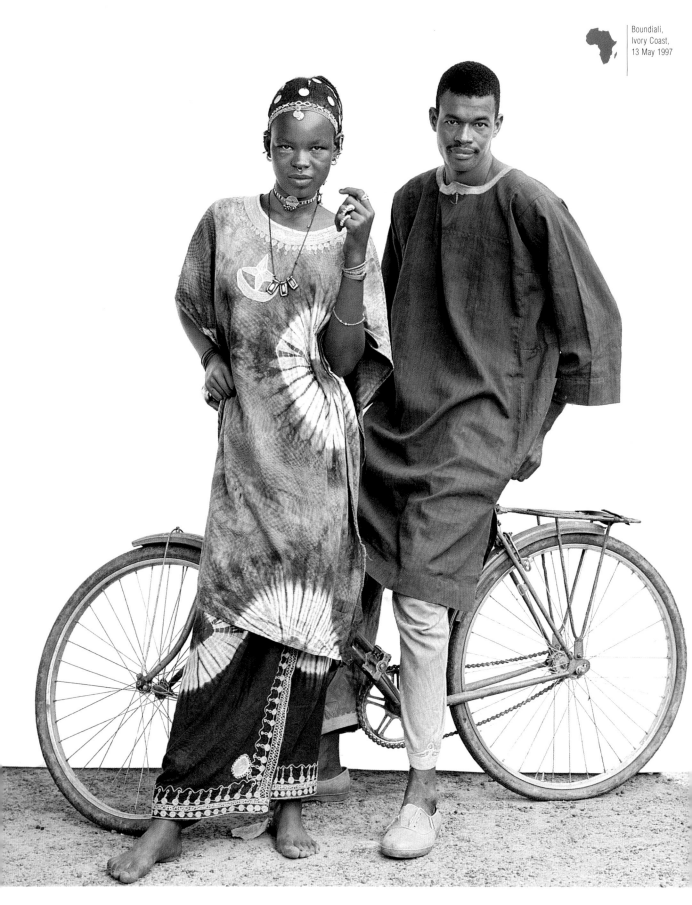

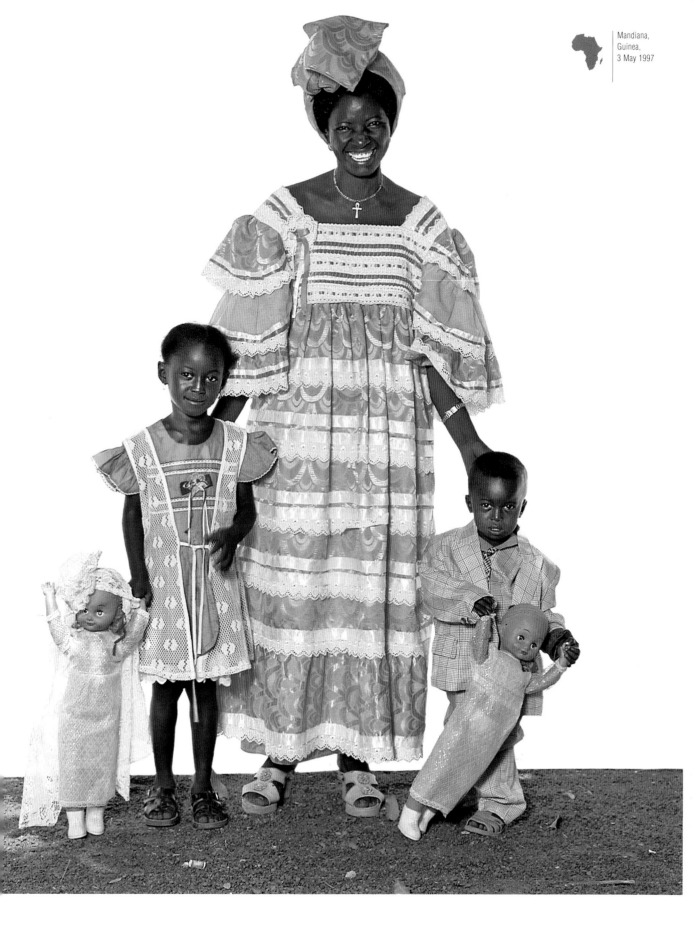

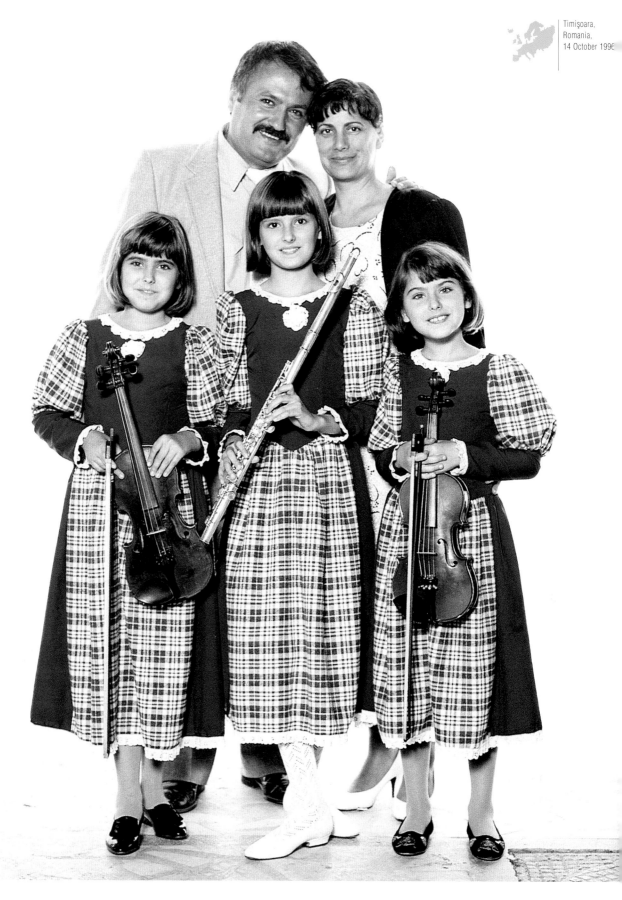

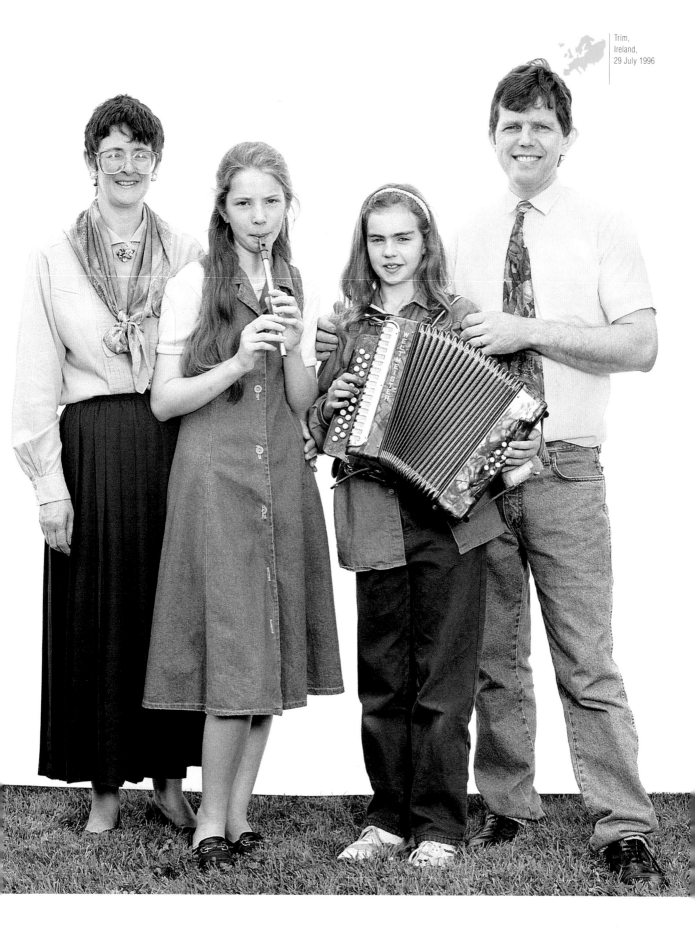

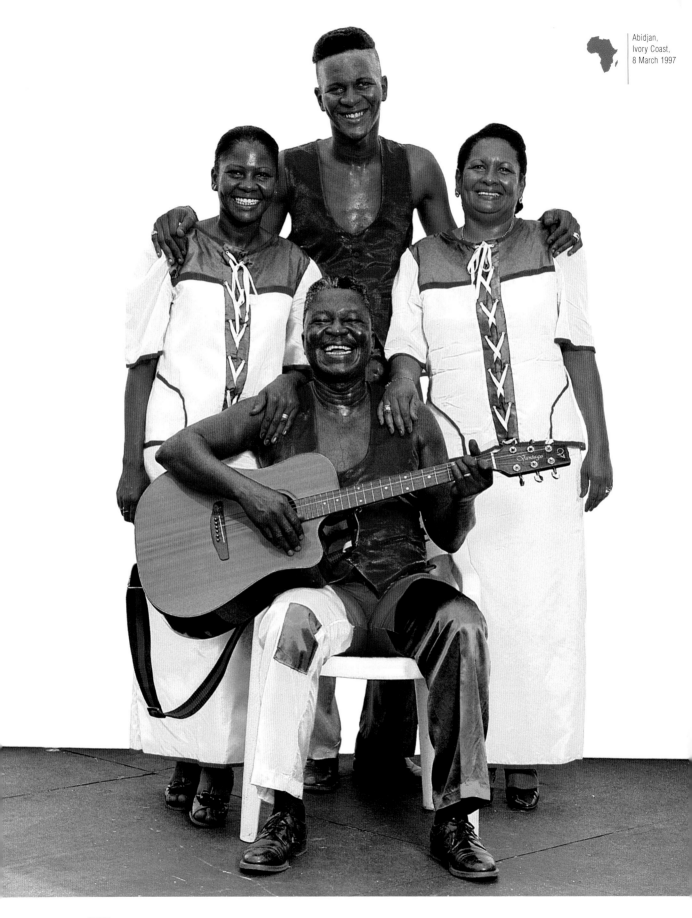

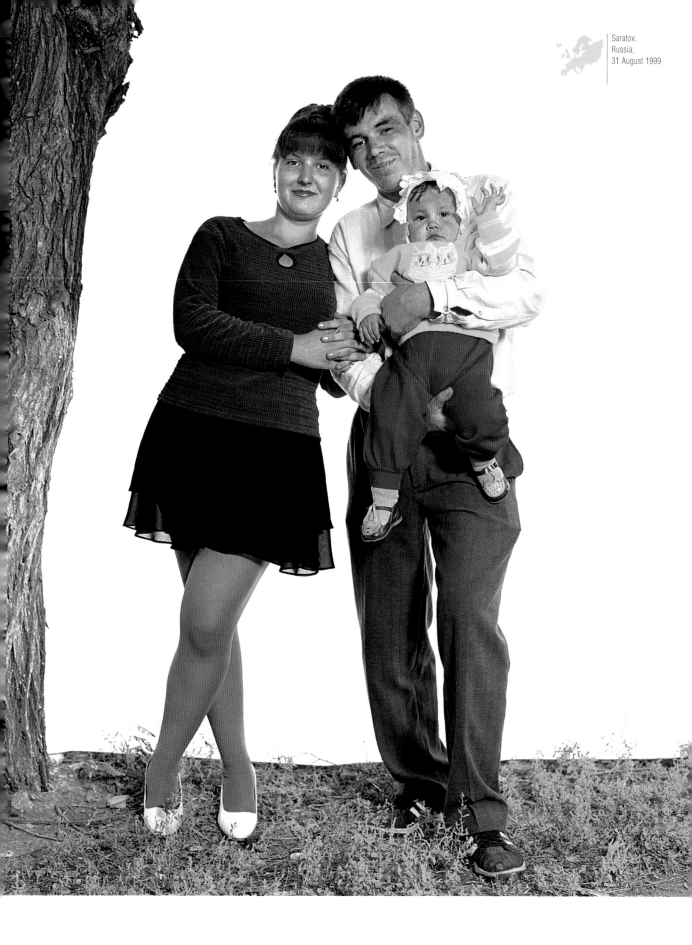

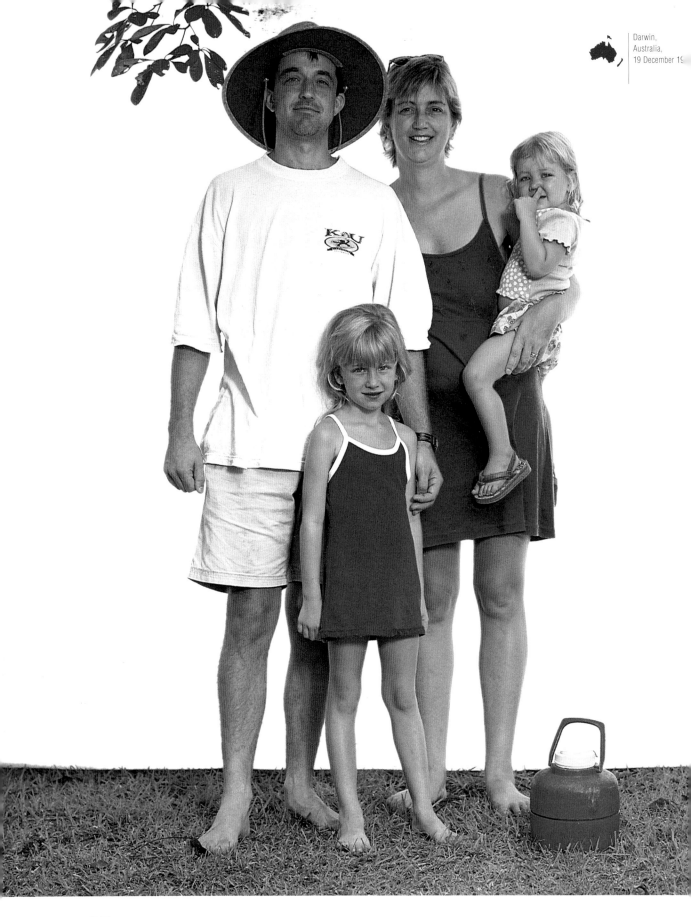

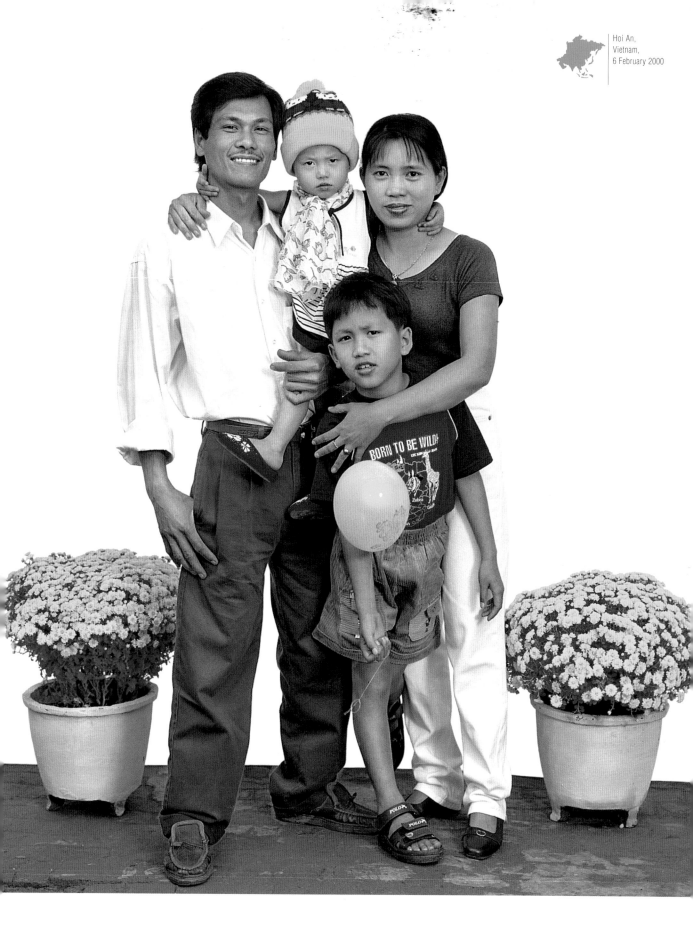

Genau wie sein Vater hat Alexander die Militärlaufbahn eingeschlagen. Er trägt die Uniform seit 19 Jahren. Bevor wir ihn fotografieren durften, mussten w ein regelrechtes Verhör über uns ergehen lassen. Wehmütig erinnert er sich an die kommunistische Ära, als die Militärs noch „hohes Ansehen" genossen und an die er „wunderbare Erinnerungen" hat. Larissa hat er im Militärkrankenhaus kennen gelernt, wo sie als Krankenschwester arbeitet. „Eine Familie hast du dein Leben lang. Diese Devise der kommunistischen Partei gilt auch heute noch", erklärt er. Zum Abschied schenkte er uns eine russische Kamer. mit den Worten: „Das ist etwas Solides. Wenn eure Rolleiflex kaputtgeht, kann sie euch aushelfen."

Like his father, Alexander is a career soldier. He's been in uniform for 19 years and puts us through nothing short of a grilling before posing for the photo and harking back nostalgically to the days when soldiers enjoyed "great prestige." Alexander has "wonderful memories" of that time. He met Larissa at the military hospital, where she's a nurse. "A family's forever. That Communist party slogan still means everything it used to," he explains. As a farewell gift, he offered us a Russian camera, saying: "It's really reliable. When your Rolleiflex is on the blink, it'll help you out."

Alexander, tout comme son père, est militaire de carrière. Il porte l'uniforme depuis dix-neuf ans. Il nous a fait subir un véritable « interrogatoire » avant de poser pour la photo. Il a la nostalgie du temps révolu où les militaires jouissaient d'un « grand prestige » et dont il garde de « merveilleux souvenirs ». Il a rencontré Larissa à l'hôpital militaire où elle est infirmière. « Une famille, c'est pour toujours ! Cette devise du parti communiste a gardé toute son importance et je ne fais rien sans la famille, c'est ma nature ! », explique-t-il. En cadeau d'adieu il nous a offert un appareil photo russe avec ces mots : « C'est du solide, il vous dépannera quand votre Rolleiflex sera en panne ! »

Nachdem er eine Weile auf Fischerbooten gearbeitet hatte, ging Tony nach Darwin, wo er Debbie kennen gelernt und eine Stelle als Stukkateur gefunden hat. Er hofft, in wenigen Monaten seinen Meister zu machen und eine eigene Firma zu gründen. Debbie ist Küchenhilfe in einem Pub in Darwin. Alle fünf lieben die lockere Atmosphäre in ihrer Stadt.

Tony "came up" to Darwin after working on fishing boats and met Debbie. He also found a job as a plasterer. He's hoping to get his certificate in a few months and start his own business. Debbie is the kitchen help in a Darwin pub. They all five like the relaxed atmosphere of their city.

« Monté » à Darwin après avoir travaillé sur des bateaux de pêche, Tony a rencontré Debbie et trouvé un emploi de plâtrier. Il espère obtenir son diplôme dans quelques mois et fonder sa propre entreprise. Debbie est aide-cuisinière dans un pub de Darwin. Tous les cinq aiment l'ambiance décontractée de leur ville.

Für das Foto haben wir sie extra aus dem Teich geholt, an dessen Ufer sie den Samstagnachmittag im Kreise der Familie verbrachten. Sergej ist Bauarbeiter und erhofft sich einen dauerhaften wirtschaftlichen Aufschwung in der Ukraine. Beide sind 21 Jahre alt und hoffen auf eine kleine Tochter im Jahr 200C

For the photo, we lured them from the pond beside which they spend Saturday afternoons with the family. Sergei is a construction worker and hopes there'll be lasting economic improvement in the Ukraine. They are both 21 and are hoping to have a little girl by 2000.

Pour la photo, nous les avons sortis de l'étang au bord duquel ils passent le samedi après-midi en famille. Sergueï est ouvrier du bâtiment et espère une amélioration économique durable en Ukraine. Ils ont vingt et un ans tous les deux et souhaitent une petite fille d'ici l'an 2000.

Kirsi, geschieden, macht gerade eine Ausbildung zur Krankenschwester. Die übrige Zeit widmet sie sich ihren Kindern und ihren fünf Rassehunden, mit denen sie an Dressur- und Schönheitswettbewerben teilnimmt. Und was wünscht sich die Hundenärrin für das dritte Jahrtausend? „Einen ersten Platz für meine Lieblinge!"

Kirsi is a divorced mother and housewife studying to become a nurse. She spends the day with her children and dogs. She has five dogs of the same bree and enters them for grooming and beauty competitions. What would she like for the new millennium? "First prize in a competition for my dogs."

Divorcée, mère au foyer Kirsi partage ses journées entre ses enfants, ses études d'infirmière et le dressage de ses cinq chiens. Ses lévriers participent régulièrement à des concours et son bonheur serait d'obtenir pour eux un premier prix de beauté et de dressage.

An Stelle der Seeohren, die für den Export nach Japan bestimmt waren, züchtet Antoine nun Venusmuscheln. Das Ergebnis kann man im Restaurant seiner Frau Elizabeth kosten, die er bereits auf der Schulbank kennen gelernt hat. Die beiden Töchter hassen jegliche Art von Muscheln! Auf die Frage nach seiner Ähnlichkeit mit Robert Redford antwortet Antoine verlegen: „Die bemerken leider nur ältere Damen!" Elizabeth braucht sich also keine Sorgen zu machen.

After trying his hand at raising abalones for the Japanese market, Antoine has specialized in clams, which you can sample in the restaurant run by his wife Elizabeth, whom he met at school. Both their daughters loathe shellfish. When asked "Did you know you look like Robert Redford?" Antoine answers, blushing, "Yes, but unfortunately it's only old ladies who tell me so" – a regret which reassures Elizabeth.

Après avoir expérimenté l'élevage des ormeaux destinés aux Japonais, Antoine s'est spécialisé dans celui de la palourde que l'on peut déguster dans le restaurant tenu par Elizabeth qu'il a rencontrée sur le banc de l'école. Leurs deux filles détestent les coquillages ! A la question : « Savez-vous que vous res semblez à Robert Redford ? », Antoine nous répond en rougissant : « Oui, mais il n'y a que les vieilles dames qui me le disent ! », ce qui rassure Elizabeth.

Wir entdeckten sie im Swimmingpool ihres Ferienhauses auf Long Island. Jessie ist Künstlerin und illustriert Kinderbücher; außerdem arbeitet sie in der Werbung und in der Schaufenstergestaltung. Ihr großes Ziel ist eine weite Reise mit der Familie, um unterwegs die Welt zu zeichnen. Carl, Physiker und Informatikingenieur, wartet darauf, dass eine kleine Brise in der Bucht von Bellport aufkommt, damit er mit dem Surfbrett hinaus kann. Auf unsere Frage: „Wie kommen ein Wissenschaftler und eine Künstlerin miteinander aus?", antwortet er: „Das ist ganz einfach. Sie hat den Blick fürs Ganze und ich fürs Detail, wir ergänzen uns perfekt."

We found them in the swimming pool at their Long Island holiday house. Artist Jessie illustrates children's books; she also works in advertising and arranges and dresses shop windows. Her big plan is to go off and draw the world – a major trip that she'd like to do with the whole family. Carl is a physicist and computer engineer. He's waiting for a breeze to get up on Bellport Bay so he can go windsurfing. When we ask, "How do a scientist and an artist get along?" he answers in a flash: "It's very easy. She sees the whole picture, I see the details, so we complement each other."

Nous les avons découverts dans la piscine de leur maison de vacances à Long Island. Jessie, artiste peintre, illustre des livres pour enfants; elle travaille aussi pour la publicité ou réalise des vitrines de magasins. Son grand projet est de partir dessiner le monde, lors d'un voyage qu'elle aimerait vivre en famille. Carl, physicien et informaticien, attend que se lève une petite brise sur la baie de Bellport pour sortir sa planche à voile. A notre question: « Comment un scientifique et une artiste s'entendent-ils? », sa réponse fuse: « C'est facile! Elle voit l'ensemble, moi les détails, on se complète! »

Page 052

„Das Motorrad ersetzt das Pferd. Heute beherrschen wir die Technik", philosophiert Vasile und fährt fort: „Das Motorrad ist das Geschenk eines Freundes, der keine Verwendung mehr dafür hat, heute fährt er große Autos." Der Seitenwagen macht das Leben leichter, er ist für alles gut, sei es, um die Kartoffeln aus dem vier Kilometer entfernten Gemüsegarten zu holen oder um ihre Enkelkinder Vadim und Dimitrij, die in den Ferien zu Besuch sind, spazieren zu fahren. Zum Abschied wünschten sie uns eine glückliche Reise „voller Blumen".

"The motorbike's replacing the horse. These days, we're coming to grips with technology," announces Vasile philosophically. And he goes on: "The bike's a gift from a friend who doesn't need it any more. He drives about in big cars now." Life is easier with the side-car, which is used for everything from fetching spuds from their garden two and a half miles [4 km] away to taking their grandchildren Vadim and Dimitri for outings during the children's holiday visits. By way of a goodbye, they wished us a happy journey, "full of flowers."

« La moto remplace le cheval! Aujourd'hui, on maîtrise la technique », annonce Vasil avec philosophie. Et il continue: « C'est le cadeau d'un ami qui n'en a plus besoin, désormais il roule dans de grosses voitures. » La vie est plus facile avec ce side-car, il leur sert pour tout: aller chercher les pommes de terre dans leur potager situé à quatre kilomètres, promener Vadim et Dimitri, leurs petits-enfants, en visite pour les vacances. En guise d'adieu, ils nous ont souhaité un voyage heureux et « plein de fleurs ».

Page 053

Wendy und Andrew, absolute Motorrad-Freaks, gehören einem Biker-Club an, der Musikveranstaltungen zur Unterstützung älterer Leute aus der Nachbarschaft organisiert. Während Wendy Fahrstunden für ihren Motorradführerschein nimmt, baut Andrew gerade in seiner Werkstatt hinten im Garten an einem neuen Beiwagen.

Wendy and Andrew are motorbike enthusiasts, and members of a motorcycle club that organizes musical evenings to raise money for elderly people in the neighbourhood. While Wendy is taking driving lessons to get her motorcycle licence, Andrew has begun building a new side-car in his garden workshop.

Wendy et Andrew sont passionnés de moto et font partie d'un club de motards qui organise des soirées musicales au profit des personnes âgées du quartier. Pendant que Wendy prend des cours de conduite afin de passer son permis moto, Andrew, dans son atelier au fond du jardin, a entrepris la construction d'un nouveau side-car.

Page 054

Nofou, Rinderzüchter im Fulbe-Dorf Boundiali, möchte seine Familie so schnell wie möglich vergrößern. „Ich wünsche mir 20 Kinder", verkündet er. Belustigt erklärt sich seine junge Frau bereit, seinen Traum zu verwirklichen, allerdings nur, so lange genug Platz in ihrer Hütte ist.

Nofou is a cattle farmer in the Fulani village of Boundiali. He is keen to increase the size of his family fast. "I'd like to have 20 children," he says. His amused young wife is ready to make his dream come true, as long as there's enough room in their hut.

Eleveur de bœufs au village peul de Boundiali, Nofou souhaite agrandir rapidement sa famille. « J'aimerais avoir vingt enfants », lance-t-il. Sa jeune épouse amusée consent à réaliser son rêve, mais dans la limite des places disponibles!

Page 055

Sylvie hat ein kleines Hotel mit Restaurant eröffnet, arbeitet aber weiterhin in ihrem erlernten Beruf als Hebamme im Krankenhaus von Mandiana. Als ihr Mann, ein Arzt, sie verließ, weil sie keine Kinder bekommen konnte, adoptierte sie zwei Kinder ihres Bruders. Ihr Traum ist es, eine private Klinik zu gründen und so zum Wohlergehen des Dorfes beizutragen. Auf die Frage, ob sie gern Bürgermeisterin von Mandiana wäre, war ihre Antwort: „Nein, Ministerin!"

Sylvie has opened a small hotel and restaurant, but she also works as a midwife at Mandiana hospital. Her doctor husband left her because she can't have children, so she adopted two of her brother's children. Her dream is to open a real private clinic and help the village develop. When asked "Would you like to be mayor of Mandiana?" she replied: "No. A governmental minister."

Sylvie a ouvert un petit hôtel restaurant, mais elle exerce également son métier de sage-femme à l'hôpital de Mandiana. Abandonnée par son mari, médecin, à cause de sa stérilité, elle a adopté deux enfants de son frère. Son rêve est de créer une vraie clinique privée et aider à l'évolution du village. A la question « Voudrais-tu être maire de Mandiana? », la réponse fuse: « Non! Ministre! »

Page 056

Borel leitet seit 20 Jahren den baptistischen Kirchenchor und das Orchester des Vereins „Jesus, the Hope of Rumania". Radica ist Sozialarbeiterin. Ihre drei Töchter besuchen die Musikschule und bilden allein schon ein kleines Orchester mit Querflöte, Geige und Klavier. Nach dem Fototermin gaben sie im Kirchenschiff ein richtiges Konzert nur für uns.

For the past 20 years Borel has been both choirmaster at the Baptist church and conductor of the "Jesus, the Hope of Romania" orchestra. Radica is a social worker. Their three daughters all go to music school and make up a small orchestra of flute, violin and piano in themselves. After taking the photo, we were treated to a real concert, just for us, in the church nave.

Borel dirige depuis vingt ans le chœur de l'église baptiste et l'orchestre de l'association « Jesus the hope of Roumania ». Radica est assistante sociale. Leurs trois filles fréquentent l'école de musique et forment à elles seules un petit orchestre : flûte, violon et piano. Après la prise de vue, nous avons eu droit à un véritable concert, rien que pour nous, dans la nef de l'église.

Page 057

Sie empfingen uns in ihrem Bed and Breakfast, das Anne betreibt. Ihr Mann hilft ihr in der Pension und unterrichtet die Kinder der „Traveller", die immer nur kurze Zeit an einem Ort bleiben, so dass der Schulbesuch problematisch ist. Ihre Hobbys: Musizieren in der Familie, Lesen und vor allem der Kontakt zu den Touristen, die in ihrer charmanten Herberge absteigen.

They welcomed us to their B&B, run by Anne. Her husband gives her a helping hand as well as teaching the children of 'travellers', who never stay long in the same place, which makes their schooling something of a problem. Their hobbies are family musical evenings, reading and, above all, meeting the tourists who stay at their delightful inn.

Ils nous ont reçus dans leur *bed and breakfast* dont s'occupe Anne. Tout en l'aidant, son mari est instituteur auprès des enfants « du voyage » qui ne restent qu'un temps au même endroit, ce qui rend leur scolarisation difficile. Leurs hobbies : faire de la musique en famille, la lecture et surtout le contact avec les touristes descendus dans leur charmante auberge.

Page 058

Gun Morgan ist ein international bekannter Chansonnier, dessen Besonderheit es ist, mit seiner Familie aufzutreten. Seine Lieder erzählen von Liebe und Toleranz, sie sind die „Waffe", mit der er für den Frieden in der Welt kämpft. Dem Millennium sieht er positiv entgegen: „Im neuen Jahrtausend werden sic die Lebensbedingungen der Menschen verbessern. Ich wünsche mir, dass alle Völker und Rassen zueinander finden, damit die Menschen nicht mehr nur ihre eigenen Interessen, sondern die der gesamten Menschheit vertreten." Seine Frau, Tochter einer französisch-englischen Mutter und eines afrikanisch-japanischen Vaters, hat sich bereits als „Weltbürgerin" qualifiziert.

The distinctive thing about Gun Morgan, a well-known star, is that he sings with his family. Gun sings about love and tolerance. This is the 'weapon' he's chosen to make peace finally reign across the world. He has an international reputation as a singer. As far as the new millennium is concerned, every kind of hope is legitimate: "This new century will usher in a new world where living conditions for human beings will be better. My dearest wish would be for a huge interbreeding among all peoples and all races. In that way, people will no longer protect their own interests, but those of all mankind." Mrs. Morgan, whose mother is half French, half English and whose father is half African, half Japanese, already calls herself a "citizen of the world."

Vedette de renom, Gun Morgan a la particularité de chanter avec sa famille. « Gun » chante l'amour et la tolérance, c'est « l'arme » qu'il a choisie pour que la paix règne enfin dans le monde. Sa réputation d'artiste de la chanson est internationale. « Ce nouveau siècle consacrera un nouveau monde dans lequel les conditions de vie des êtres humains seront meilleures. Mon souhait le plus cher serait un gigantesque métissage de tous les peuples, de toutes les races. Ainsi, l'homme ne défendra plus ses propres intérêts mais ceux de l'humanité tout entière. » Madame Morgan, née de mère franco-anglaise et de père afro-japonais, se qualifie déjà de « citoyenne du monde ».

Page 059

Alexander fährt einen der zahlreichen Omnibusse der Stadt, während Katerina die kleine Diana hütet, die ihren Namen der verstorbenen „Prinzessin der Herzen" verdankt. Das neue Jahrtausend? „Ich wünsche mir einen Sohn, aber Katerina ist noch nicht so weit. Wir werden uns wohl noch etwas gedulden müssen."

Alexander drives one of the city's numerous buses while Katerina looks after Diana, so named in remembrance of a certain princess. And the new millennium? "I would really like to have a son, but Katerina doesn't want to. We'll have to wait a bit."

Alexander conduit un des nombreux autobus de la ville pendant que Katerina prend soin de Diana, nommée ainsi en souvenir d'une certaine princesse ! L'an 2000 ? « Moi, j'aimerai beaucoup avoir un fils, mais Katerina n'est pas d'accord. Il va falloir attendre un peu ! »

Page 060

Der diplomierte Meeresbiologe Gavin arbeitet im Museum von Darwin. Nebenher verbringt er viel Zeit mit der Beobachtung und dem Schutz der Flora und Fauna des Meeres. Trotzdem ist das Angeln sein Hobby. „Ich muss doch meine Familie ernähren", scherzt er. Sein Laster ist das Rauchen. „Im Jahr 2000 werde ich ganz bestimmt aufhören!" Seine Frau Jenny hat zu Hause eine Kindergruppe eingerichtet, in der sie sechs Knirpse betreut.

Gavin has a degree in marine biology and works at the Darwin Museum. He spends a lot of time monitoring and protecting aquatic fauna and flora. In spite of this, fishing is his hobby. "I have to feed my family somehow," he jokes. His main failing is cigarettes. "I really will give up smoking in 2000," he promises. His wife Jenny runs a day nursery at home, where she looks after six children.

Diplômé de biologie marine, Gavin travaille au musée de Darwin. Il passe beaucoup de temps à surveiller et protéger la faune et la flore aquatique. Son hobby est la pêche : « Il faut bien que je nourrisse ma famille », plaisante-t-il. Son défaut, la cigarette : « Je vais vraiment m'arrêter de fumer en l'an 2000 ! », promet-il. Jenny a une garderie à la maison où elle s'occupe de six enfants.

Page 061

Sie sind ein glückliches Paar, der Besitzer einer Motorradwerkstatt, der optimistisch in die Zukunft blickt, und die Schneiderin und junge Mutter. Ihr Wunsch: „Eine Reise nach Kanada." Auf unseren Einwand, dass es dort kalt ist, ist ihre Antwort: „Eben deswegen!"

They make a happy couple. He owns a motorbike repair shop and is very optimistic about the future. She is a dressmaker and contented mother. Their ambition is "to visit Canada." We point out that it's cold there. "Precisely!" they reply.

Ils forment un couple heureux : Lui, propriétaire d'un atelier de réparation de motos et très optimiste pour l'avenir. Elle, couturière et mère comblée. Leur vœu : « Visiter le Canada ! ». Nous soulignons qu'il y fait froid ! « Justement », répondent-ils.

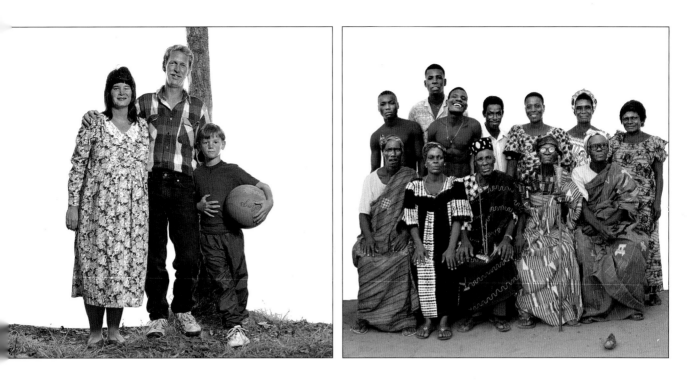

Westport Island,
Maine, USA,
29 September 1998

Tonyas Kind hätte – rein rechnerisch – schon vor drei Tagen geboren werden müssen, aber sie fährt weiterhin jeden Tag eine Stunde mit dem Auto zur Arbeit, als wäre nichts. „Der Arzt hat ihr Bewegung verordnet", beschwichtigt uns Gary. Eigentlich ist er Fischer durch und durch, aber notgedrungen arbeitet er als Zimmermann und fischt nur noch gelegentlich. „Beurteilt unser Land nicht nach den Dummheiten, die man momentan in der Zeitung liest", so ihr patriotischer Appell an die Familien der Welt.

Tonya's been waiting three days to give birth and she's still working an hour's drive from home, as if it was no big thing: "The doctor recommended that she keep busy," Gary replies confidently to our worried expressions. He is a fisherman through and through, but a carpenter out of necessity and these days he only fishes only occasionally. "Don't judge our country from all the stupid things you read in the newspapers right now," they say patriotically to the world's families.

L'accouchement de Tonya se fait attendre depuis trois jours et elle continue de travailler à une heure de voiture de chez elle, comme si de rien n'était ... « Le docteur lui a prescrit de l'activité », répond Gary, confiant, à nos inquiétudes. Pêcheur au plus profond de son âme, il est menuisier par nécessité et ne pêche plus qu'occasionnellement. « Ne jugez pas notre pays d'après les bêtises qu'on lit dans les journaux en ce moment », enjoignent-ils, patriotes, aux familles du monde.

Sassandra,
Ivory Coast,
14 March 1997

„Willkommen im Paradies!", ruft uns Jérôme bei unserer Ankunft im Dorf Godé zu. Ein herrlicher weißer Sandstrand, Palmen und Sonne! Dieser Ort entspricht haargenau den europäischen Vorstellungen vom Garten Eden. Für Jérômes Familie jedoch sieht die Realität anders aus. „Wir waren über viele Generationen Seefahrer, aber dieser Beruf ist ausgestorben. Für unsere Kinder ist es besser, fortzugehen, denn hier gibt es keine Arbeit." Jérômes Vater macht sich Sorgen um die Zukunft der Jugend von Godé. Hinter seiner großen Brille mit den zerbrochenen Gläsern, die seinen Blick verschleiern, wirkt er ziemlich verzagt. Jérôme will davon nichts hören, er ist zuversichtlich. Er will sein Dorf für den Tourismus öffnen und hat auch schon französische Investoren gefunden. Ob Paradies oder Hölle, die Zukunft wird es zeigen!

"Welcome to paradise," Jérôme shouts when we reach the village of Godé – a beautiful white sandy beach, palm trees and sun. This spot tallies perfectly with European specifications for the Garden of Eden. For Jérôme's family, though, reality is quite different. "We were sailors for generations, but that profession doesn't exist any more. It's better for our children to go somewhere else; there's no work here." Jérôme's father talks about his worries about the future of the young people of Godé. His eyes cloudy behind a large pair of glasses with broken lenses, he seems discouraged. Jérôme doesn't listen – he's sure of himself. He wants to turn his village into a tourist haunt. He's already found French investors. Heaven or hell, the future will decide!

« Bienvenue au paradis », lance Jérôme à notre arrivée au village de Godé. Une magnifique plage de sable blanc, des palmiers et le soleil ! Ce lieu répond scrupuleusement aux normes européennes du jardin d'Eden. Mais pour la famille de Jérôme, la réalité est bien différente. « Nous étions navigateurs depuis des générations mais ce métier n'existe plus. Il est préférable que nos enfants partent ailleurs, ici il n'y a pas de travail. » Le père de Jérôme nous fait part de ses inquiétudes quant à l'avenir des jeunes de Godé. Le regard brouillé derrière une grosse paire de lunettes aux verres dépolis, il paraît découragé. Jérôme n'écoute pas, il a confiance. Il veut faire de son village un lieu touristique. Il a déjà trouvé des investisseurs français. Paradis ou enfer, l'avenir le dira !

1

2

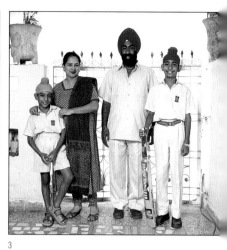

3

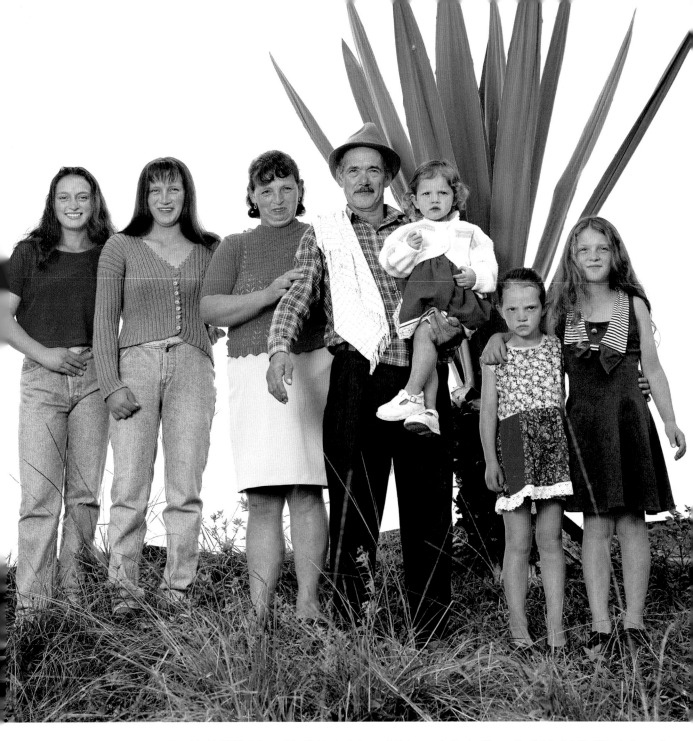

Tabora,
Colombia,
20 February 1999

„Heute habe ich 256 Kilo Bohnen auf dem Markt verkauft, das war die Ernte von sechs Monaten. Die ganze Familie hat mitgeholfen." Eduardo, Bauer und Besitzer einiger Kühe, ist auch ein glücklicher Vater: Er ist von sechs Frauen umgeben und das gefällt ihm sehr!

"Today I sold 256 kilos of beans at the market, that's six months' harvest. And the whole family helped." Eduardo is a farmer with a few cows, and he's a happy father, too – he is surrounded by six women, and that's just fine by him.

« Aujourd'hui, j'ai vendu deux cent cinquante-six kilos de haricots au marché, c'est la récolte de six mois et toute la famille y a participé … » Agriculteur propriétaire de quelques vaches, Eduardo est aussi un père heureux: il est entouré de six femmes et ça lui plaît beaucoup!

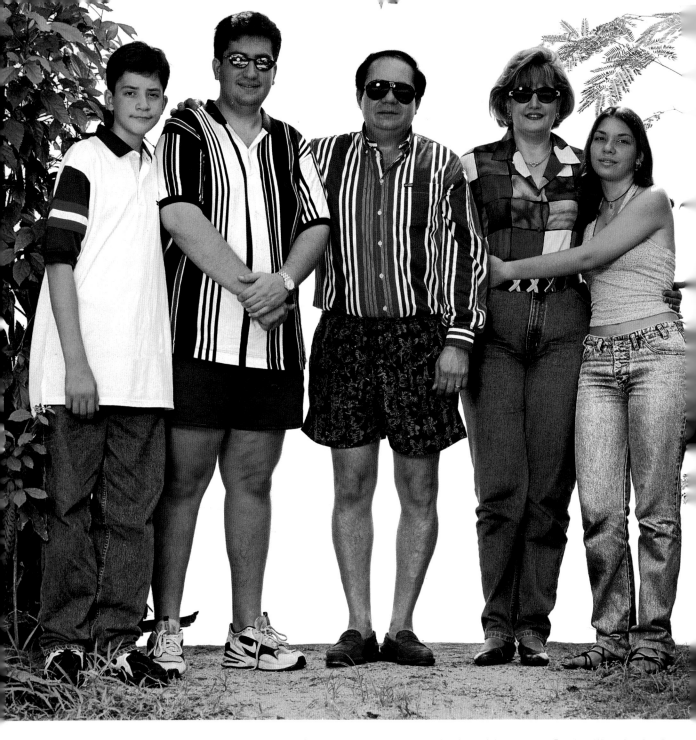

Playa Corona,
Panama,
26 December 1998

Bruno ist der Botschafter Panamas in Chile. Mit Frau und Kindern verbringt er die Weihnachtsferien zu Hause, um Freunde und Verwandte zu besuchen. „Das Jahr 2000 ist ein wichtiges Jahr in der Geschichte Panamas, weil die USA abziehen und uns den Kanal zurückgeben werden", erklärt Bruno mit Blick auf die Interessen seines Landes.

Bruno is the Panamanian ambassador in Chile and is spending the Christmas holidays with his wife and children in Panama to visit family and friends. "2000 is an important year in Panama's history because the United States is going to pull out and hand us back the canal," says Bruno, mindful of his country's interests.

Bruno est ambassadeur du Panamá au Chili, Angela, son épouse, diplômée en finances, l'accompagne dans sa mission. Ils profitent des vacances de Noël pour se retrouver en famille et entre amis. « L'an 2000 est une année importante dans l'histoire du Panamá parce que les Etats-Unis vont se retirer et nous restituer le canal », déclare Bruno, soucieux des intérêts de son pays.

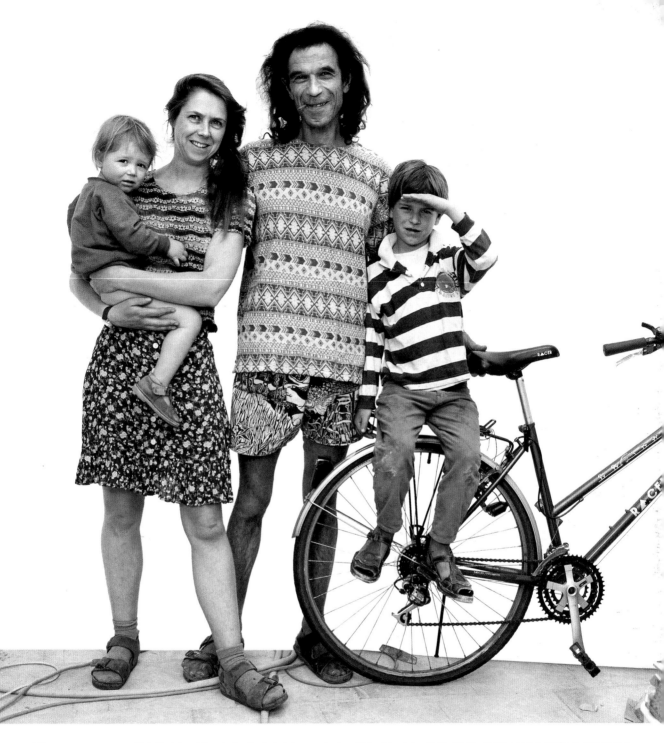

Nîmes,
France,
27 May 1998

Die beiden haben sich an der Kunsthochschule kennen gelernt, wo Olivier sich erst einmal sechs Monate „die Zähne an ihr ausbeißen musste", bevor es ihm gelang, sie zu „knacken". Heute lebt das Paar in einem kunstvoll restaurierten Haus im Stadtzentrum von Nîmes – Oliviers Beitrag zur Verschönerung des Viertels. Mélanie zieht den Nachwuchs groß und gibt Malkurse für die Kinder des Viertels. „Die Familie gibt uns Halt und lehrt uns, in einer Gemeinschaft zu leben."

Their first meeting dates back to the School of Fine Arts, where Olivier "sketched" her for six months before being "drawn." They live in a house that they've decorated entirely on their own in the middle of Nîmes. Olivier has a grand scheme to smarten up the neighbourhood. Mélanie educates her children and runs a drawing and painting studio for local children. "The family is a basis, they say; it's the family that teaches us how to live in a community!"

Leur rencontre remonte aux Beaux Arts où Olivier l'a « croquée » pendant six mois avant de craquer. Ils habitent une maison entièrement décorée par leurs soins au centre de Nîmes. Olivier a un grand projet d'embellissement du quartier. Mélanie fait l'école à ses enfants et s'occupe d'un atelier de dessin et peinture ouvert aux enfants du quartier. « La famille est une base, disent-ils, c'est elle qui nous apprend à vivre en communauté ! »

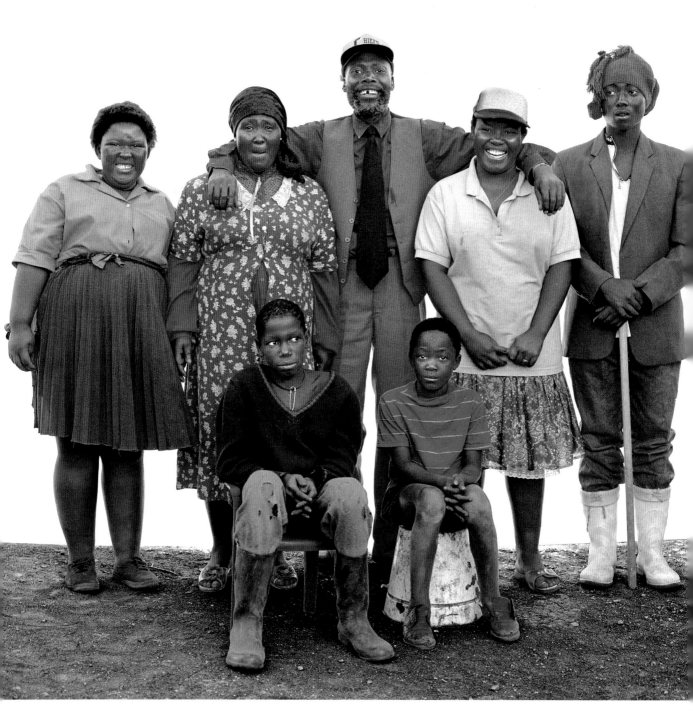

 Malealea,
Lesotho,
7 October 1997

Francis stammt aus Malealea und hat wie fast alle Männer der Gegend im benachbarten Südafrika in den Gold- und Diamantminen gearbeitet. „34 Jahre Plackerei und jetzt stehe ich vor dem Nichts. Keine Rente, kaum Aussicht auf Arbeit." Aber das alles kann seine angeborene gute Laune nicht erschüttern, mit der er die ganze Familie ansteckt …

Francis, who was born in Malealea, used to work in the mines of neighbouring South Africa like nearly all the men hereabouts. "Thirty-four years in diamonds and gold – to end up jobless, without any pension, and not much hope of finding another job," he comments. But none of this detracts from his innate good humour, which has infected his whole family …

Natif de Malealea, Francis comme presque la totalité des hommes de la région, a travaillé dans les mines de l'Afrique du Sud voisine : « Trente-quatre ans dans les diamants et l'or, pour se retrouver sans travail ni retraite et peu d'espoir de retrouver un job ». Cela ne lui enlève en rien de sa bonne humeur naturelle qu'il communique à toute sa famille…

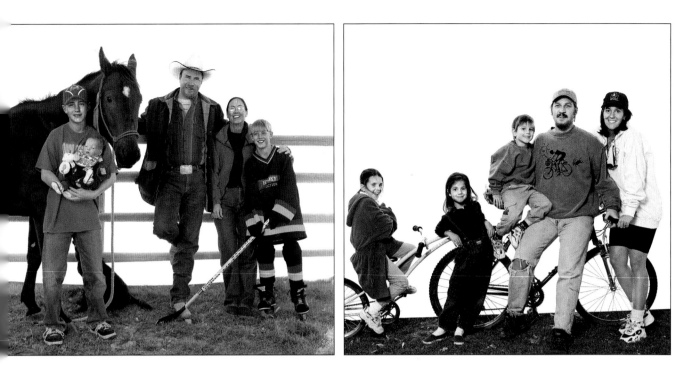

Gillette,
Wyoming, USA,
24 October 1998

Es ist nicht so, wie es aussieht: Cody (13) ist kein Teenager-Papa; er nimmt an einem Schulprojekt teil, bei dem den Halbwüchsigen bewusst werden soll, welche Verantwortung es mit sich bringt, wenn sie in ihrem Alter schon Kinder bekommen. Dafür wird eine Babypuppe mit einem Chip ausgestattet, so dass sie sich Tag und Nacht wie ein Baby verhält. Codys Hobbys sind Eishockey mit seinen Brüdern und Wrestling, er träumt von einer Profikarriere. Sein Vater Shawn ist Bauunternehmer und seine Mutter unterrichtet lernbehinderte Kinder.

Despite appearances to the contrary, Cody is not a young daddy; he's taking part in a school project aimed at making teenagers more aware of the problems of having children at their age. To do this, a baby doll fitted with a chip to reproduce the behaviour of a baby, day and night, is used. Cody plays ice hockey with his brother, and he's a wrestler too. His dream is to become a professional wrestler. His father Shawn is a contractor, and his mother a schoolteacher dealing with problem children.

En dépit des apparences, Cody n'est pas un jeune papa; il participe à un projet scolaire qui sensibilise les adolescents sur les difficultés d'être parents à leur âge. On utilise pour cela un poupon équipé d'une puce programmée pour reproduire, de jour comme de nuit, le comportement d'un bébé. Cody pratique le hockey sur glace avec son frère, ainsi que la lutte : il rêve de devenir lutteur professionnel. Son père, Shawn, est entrepreneur et sa mère, institutrice, s'occupe d'enfants en difficultés.

Toronto,
Canada,
4 October 1998

„Bikes are better", rufen sie unisono. Die ganze Familie unternahm an diesem Sonntagnachmittag eine Radtour. Jason ist Künstler, Bildhauer und „Mädchen für alles". Heather hat ihre eigene Firma gegründet, um in der freien Wirtschaft Sponsoren für die bessere Ausstattung der Schulen zu werben. „Ich hoffe, die Welt denkt darüber nach, was uns die Zukunft alles bringen könnte, vorausgesetzt, wir verhalten uns etwas weiser und bewusster", seufzt Heather.

"Bikes are better," they chorus in unison. The whole family is going for a bike ride this afternoon. Jason is an artist, sculptor and a jack-of-all-trades. Heather has set up her own company to put businesses in contact with schools in order to get better school equipment through sponsoring. "I hope that the world will think about everything we might be able to have in the future, if only everybody behaves with a bit more wisdom and reflection," sighs Heather.

« Bikes are better », disent-ils à l'unisson. Toute la famille se promène à bicyclette ce dimanche après-midi. Jason est artiste, sculpteur et homme à tout faire, Heather a créé sa propre société afin de mettre les entreprises en contact avec les écoles pour obtenir grâce au sponsoring de meilleurs équipements scolaires. « J'espère que le monde réfléchira à tout ce que l'on pourrait avoir dans l'avenir, à condition d'agir avec un peu plus de sagesse et de réflexion », soupire Heather.

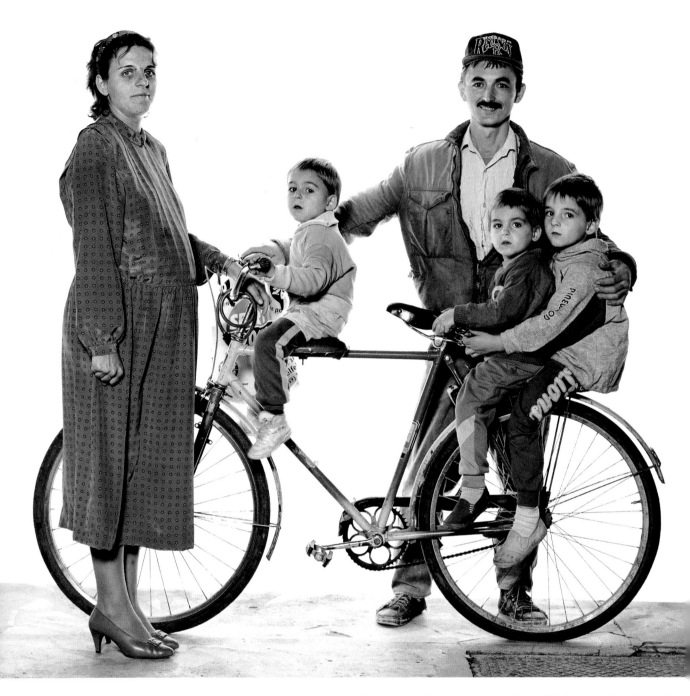

Timişoara,
Romania,
14 October 1996

Der Tischler Dezsö kam mit seinen drei Söhnen auf dem Fahrrad zur Baptistenkirche, wo seine Frau an einer Anti-Abtreibungsveranstaltung teilnahm, die amerikanische Missionare veranstalteten. Sie erwartet ihr viertes Kind und hofft, dass es diesmal ein Mädchen wird. Wir sind nicht sicher, ob sie alle fünf auf dem Fahrrad zurückgefahren sind …

Joiner Dezsö arrived with his three boys on his bicycle at the Baptist church where his wife was attending an anti-abortion lecture organized by American missionaries. She is expecting her fourth child any day, and is hoping they will finally have a daughter. We're not sure if all five of them left on the same bicycle …

Dezso, menuisier, est arrivé avec ses trois garçons sur sa bicyclette à l'église baptiste où sa femme assistait à une conférence anti-avortement, organisée par des missionnaires américains. Celle-ci attend son quatrième enfant pour très bientôt et espère que cela sera enfin une fille! Nous ne sommes pas certains qu'ils soient repartis tous les cinq sur la bicyclette.

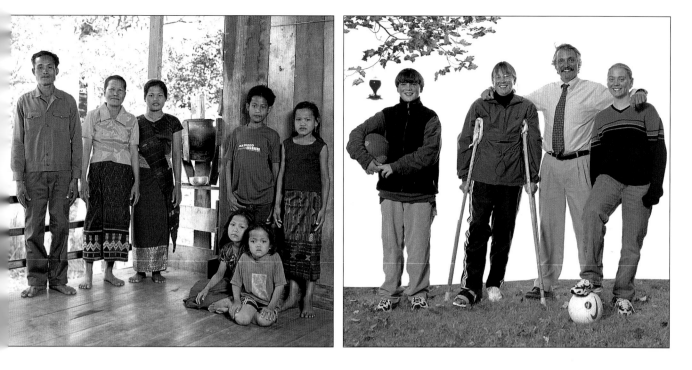

Ban Keit Ngong,
Laos,
30 January 2000

Wir haben das Foto ganz schnell gemacht, um Dorchane, die älteste Tochter, zu einem Schönheitswettbewerb in ein Nachbardorf begleiten zu können! Ihre Eltern sind Kleinbauern und pflanzen vor allem Reis, das Grundnahrungsmittel in Laos. Natürlich besitzen sie wie alle Dorfbewohner einen Elefanten.

We took the photo quickly so that we could drop Dorchane, the eldest daughter, at a beauty contest in a nearby village! Mother and father are small farmers, planting mainly short-grained rice, the staple dish in Laos. Needless to say, they have an elephant like all the other villagers.

Nous avons fait la photo en vitesse afin de pouvoir accompagner mademoiselle Dorchane, la fille aînée, à un concours de beauté dans un village voisin. Papa et Maman sont petits agriculteurs et plantent surtout du riz gluant, plat de base au Laos et possèdent bien sûr un éléphant comme tous les habitants du village.

Westport Island,
Maine, USA,
10 October 1998

Beide, der Beamte und die Lehrerin, lieben die Natur. Ron und Leslie leben mitten im Wald auf einer Insel, in dem Haus, in dem Ron als Kind seine Ferien verbracht hat. „Im Sommer fahren wir Boot, im Winter Ski und ich hacke das ganze Jahr über Holz für den Kamin", erzählt Ron, während er uns seinen Keller zeigte, eine wahre Miniaturbrauerei. Seit 15 Jahren braut er sein eigenes Bier und wir durften uns einige Krüge genehmigen, um uns von der hervor- ragenden Qualität zu überzeugen.

Respectively a government employee and a school teacher, Ron and Leslie are both nature-lovers. They live on an island in the middle of a forest, in a house where Ron came on holiday when he was a boy. "We go boating in the summer, skiing in the winter, and all year round I cut wood for the fire," Ron tells us as he shows us his cellar, a miniature brewery, no less. He has been brewing his own beer for 15 years and offers us a tankard or two to sample the excellent brew.

Fonctionnaire et institutrice, amoureux de la nature, Ron et Leslie vivent sur une île, au milieu d'une forêt, dans une maison où Ron venait en vacances quand il était enfant … « Nous faisons du bateau en été, du ski en hiver et toute l'année je coupe du bois pour la cheminée », nous dit Ron en nous faisant visiter sa cave, une véritable brasserie miniature! Il fabrique sa propre bière depuis quinze ans, et nous avons droit à quelques chopes pour apprécier l'excellence du breuvage …

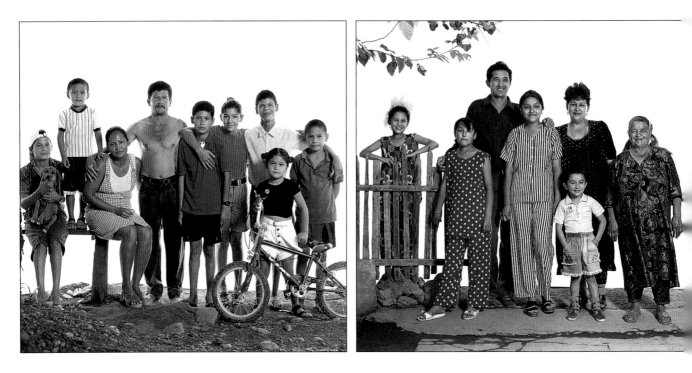

Puntarenas,
Costa Rica,
20 December 1998

Álvaro und seine Kinder waren mitten in einem Fußballspiel auf dem improvisierten Platz vor ihrem Haus. Während er auf seinem kleinen Stück Land Reis, Bananen und Maniok für den Eigenbedarf anbaut, kocht Ivette das Essen für die Besitzer einer Plantage aus der Nachbarschaft und arbeitet als Verkäuferin. Die beiden sind seit 19 Jahren verheiratet und stolz auf ihre sieben Kinder: „Jedes hat seinen eigenen Charakter, seine Persönlichkeit. So viele Kinder machen viel Arbeit, aber sie helfen uns auch." Ihre Lieblingsbeschäftigungen im Familienkreis: „Fußballspielen und Gottes Wort studieren."

Álvaro and his children were in the middle of a family football match on the makeshift pitch in front of their house. While Álvaro grows rice, bananas and cassava for their own consumption on their little plot of land, Ivette prepares meals for the owners of a nearby plantation and works as a sales assistant. They've been married for 19 years and are very proud of their seven children: "They all have a character and personality of their own. That many children is a lot of work, but they help us." When asked what they enjoy doing as a family, they answer in chorus: "Playing football and studying the Word of God."

Álvaro et ses enfants étaient en plein match de foot familial sur le terrain improvisé devant leur maison. Pendant qu'Alvaro cultive le riz, la banane et le manioc pour leur consommation personnelle. Ivette, levée dès l'aube, prépare les repas des propriétaires d'une plantation voisine avant de commencer sa journée de vendeuse. Mariés depuis dix-neuf ans, ils sont très fiers de leurs sept enfants : « Chacun a son caractère et sa personnalité, tant d'enfants c'est beaucoup de travail, mais ils nous aident ! » Lorsqu'on leur demande ce qu'ils aiment en famille, ils répondent à l'unisson : « Jouer au football et étudier la parole de Dieu ! »

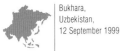

Bukhara,
Uzbekistan,
12 September 1999

„Möge das neue Jahrtausend ein Zeitalter ohne Kriege werden", lautet die Botschaft von Raim, der bereits als Fahrer, Schreiner und Schweißer sein Geld verdient hat und jetzt für die Wartungsarbeiten an der Universität von Buchara zuständig ist. Matlab arbeitet als Archivarin in der Bezirksverwaltung. Ihrem Talent als Schneiderin verdankt sie es, dass sie vor nunmehr 15 Jahren ihren Mann kennen gelernt hat. „Er brauchte einen neuen Anzug und fand die Frau seines Lebens!"

"Above all, no more war in the new millennium," is Raim's hope. He has worked as a driver, joiner and welder, and is currently in charge of maintenance at Bukhara University. Matlab is an archivist for the regional administration and has a great love of sewing. In fact, it is because of her talents as a dressmaker that she met her future husband 15 years ago. "He came in to order a suit and found the love of his life!"

« Surtout plus de guerre dans le nouveau millénaire ! », tel est le vœu de Raim, chauffeur, menuisier, soudeur, aujourd'hui responsable de la maintenance à l'université de Boukhara. Matlab est archiviste à l'administration régionale et a une passion pour la couture, c'est grâce à son talent de couturière qu'elle a rencontré son futur mari, voici quinze ans. « Il était venu commander un costume et il a trouvé la femme de sa vie ! »

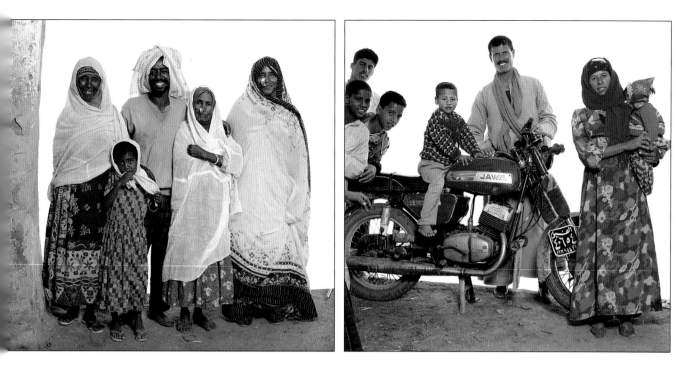

near Keren,
Eritrea,
19 December 1997

Mahmoud lebt im Kreise seiner Frauen: der eigenen, seiner Mutter, der Schwiegermutter und der Tochter. Als Bauer wünscht er sich für das neue Jahrtausend mehr Regen.

Mahmoud lives surrounded by his women – his wife, his mother, his mother-in-law and his daughter. As a farmer, he prays it will rain more often in the new millennium.

Mahmoud vit entouré de ses « femmes » : sa femme, sa mère, sa belle-mère et sa fille. Agriculteur, il prie pour que la pluie soit plus fréquente en l'an 2000.

Al-Fayyum,
Egypt,
4 January 1998

Der Beamte Mohammed ist viel beneideter Besitzer eines Motorrads. Um seine Familie ernähren zu können, bestellt er einen großen Gemüsegarten, denn sein Gehalt lässt arg zu wünschen übrig.

Mohammed is a civil servant and the much-envied owner of a motorbike. To supplement his daily needs, he keeps a large kitchen garden, which helps him to feed his family – his salary isn't quite as much as he'd like it to be.

Mohamed, fonctionnaire, est le propriétaire très envié d'une moto. Pour arrondir un peu son quotidien, il entretient un grand potager, qui lui permet de nourrir sa famille, son salaire n'étant pas tout à fait à la hauteur de ses souhaits.

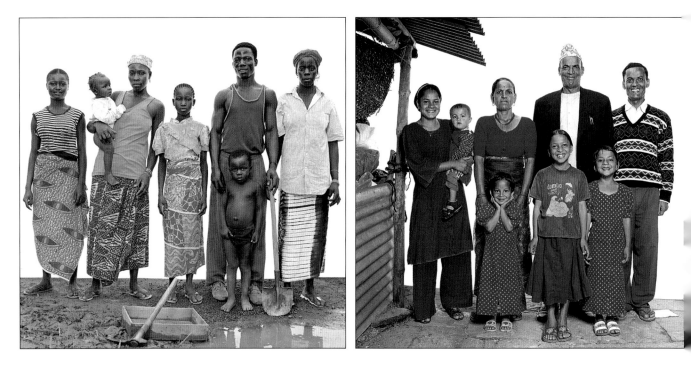

Tortiya,
Ivory Coast,
10 May 1997

Als Diamantensucher im „Wilden Westen" der Elfenbeinküste gräbt und siebt Adamo zwölf Stunden am Tag, in der Hoffnung, „den dicken Klumpen" zu finden, der es ihm ermöglicht, seine Kinder zur Schule zu schicken. Bis dieser glückliche Tag kommt, sind es seine beiden Frauen, die die Familie vom Ertrag ihres Gemüsegartens ernähren.

Adamo is a diamond digger in the heart of the Ivory Coast's 'wild west'. He digs and sifts the earth 12 hours a day, hoping to find "the big one" which will enable him to send his children to school. As he waits for that auspicious day, his two wives feed the family with home-grown vegetables.

Chercheur de diamants en plein « Far West » Ivoirien, Adamo creuse et tamise la terre douze heures par jour, en espérant trouver « le gros caillou » qui lui permettra d'envoyer ses enfants à l'école. Dans l'attente de ce jour faste, ce sont ses deux femmes qui nourrissent la famille avec les légumes de leur production.

Naundand,
Nepal,
13 November 1999

Tek Prasad fährt mehrgleisig. Der gelernte Landwirt hat einen Stoffladen eröffnet und einen Schneider eingestellt, der aus den verkauften Stoffen an Ort und Stelle Kleider und Anzüge näht. Ein weiterer Pluspunkt, der potenzielle Kunden anlockt: In ihrem Geschäft befindet sich das einzige Telefon im Umkreis von Kilometern. Seine große Familie – fünf Kinder und auch schon ein Enkel – hilft ihm bei der Feldarbeit.

Tek Prasad has managed to diversify his business: a farmer by profession, he has opened a fabric shop and employs an in-house tailor who makes dresses and suits from the fabrics sold. Another feature attracting potential customers is the fact that the shop has the only public telephone for miles around. His large family – five children and already one grandchild – help him work the fields.

Tek Prasad a su diversifier ses affaires : agriculteur de métier, il a aussi ouvert une boutique de tissus et embauché un tailleur sur place, qui réalise des robes et des costumes dès que le tissu est vendu. Un autre atout qui attire le client potentiel, le lieu est équipé du seul téléphone public à des kilomètres à la ronde. Sa famille nombreuse, cinq enfants et déjà un petit-enfant, l'aide aux travaux des champs.

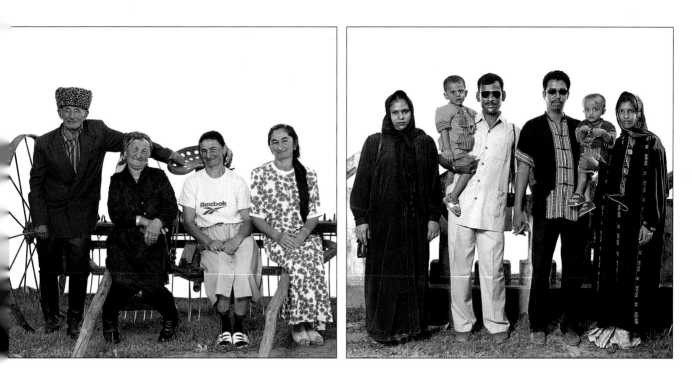

Zhandasovo,
Kazakhstan,
9 September 1999

Liutvi und Siudriat wurden 1944 mit ihren Familien aus Georgien nach Kasachstan deportiert. Zwei Töchter (39 und 40) wohnen noch zu Hause und arbeiten als Buchhalterin beziehungsweise Lehrerin im Dorf. Siudriat hält ein paar Kühe und verarbeitet die Milch zu Joghurt und Butter. Liutvi mäht das Gras noch mit der Sense, wendet das Heu aber mit der Maschine, die hier zu sehen ist. „Dank dieser Maschine haben wir genug zu essen." Ihre Hoffnung für das dritte Jahrtausend ist „Frieden auf Erden und nie wieder Hunger."

Liutvi and Siudriat are Georgians whose families were deported to Kazakhstan in 1944. They have two daughters (aged 39 and 40) who live with them and work in the village as an accountant and a school teacher. Siudriat looks after the cows, and makes yoghurt and butter. At this time of year, Liutvi makes hay, which he scythes and turns over with to dry with the machine in the photograph. He says: "It's thanks to this machine that we can eat." Their hope for the new millennium is "peace in the world and no famine ever again."

Originaires de Géorgie, d'où leurs familles ont été déportées en 1944, Liutvi et Siudriat ont aujourd'hui soixante-sept ans, cinq enfants dont deux filles (trente-neuf et quarante ans) qui habitent avec eux et travaillent au village comme comptable et institutrice. Siudriat s'occupe des vaches, de la fabrication du yaourt et du beurre. En cette saison, Liutvi fait les foins qu'il coupe à la faux et retourne avec une machine pour les faire sécher ; il dit de son engin : « C'est grâce à cette machine que nous mangeons ! » Leur espoir pour l'an 2000 : « La paix dans le monde et plus jamais de famine ! »

Gopalganj,
Bangladesh,
27 November 1999

Zwei Brüder und zwei eng verbundene Familien. Sie haben je ein Kind und hoffen, dass es dabei bleibt. Der eine handelt mit Baustoffen, der andere ist Ingenieur bei der Armee. Ihre Freizeit verbringen sie mit ihren Familien, wenn sie nicht gerade – was sehr selten vorkommt – ein Cricket-Match austragen.

Two brothers and two very close-knit families – they each have one child and hope that's the way it will stay. One has a building materials business, the other is a military engineer, and they spend their free time with their families – apart from rare occasions when they have a cricket match on.

Deux frères et deux familles très unies, ils ont chacun un enfant et espèrent que cela restera ainsi. L'un commerçant en matériel de construction, l'autre ingénieur-militaire, ils passent leur temps libre en famille, excepté les rares fois où ils disputent un match de cricket !

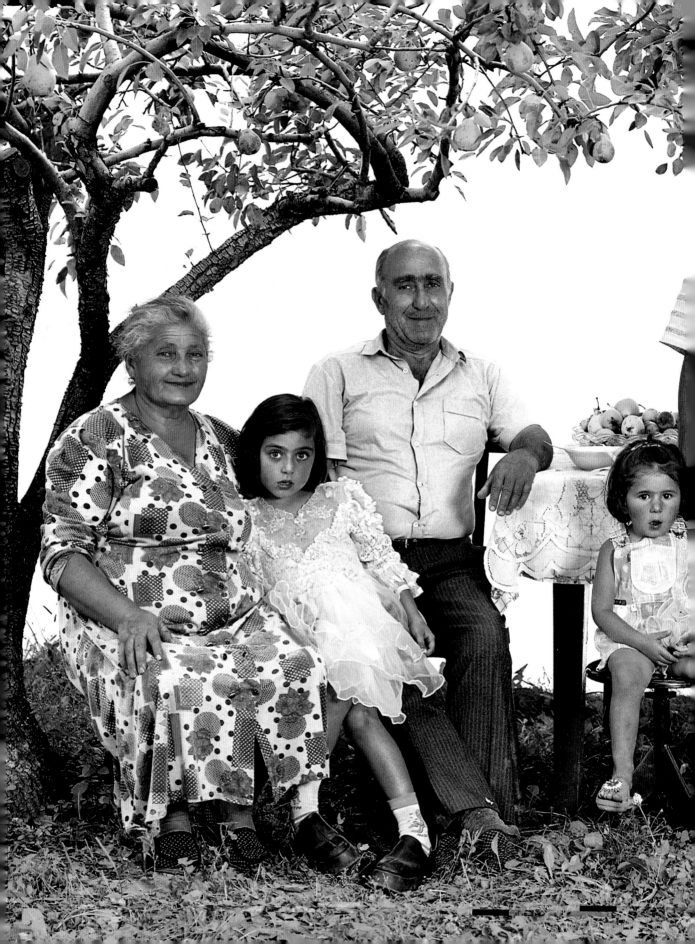

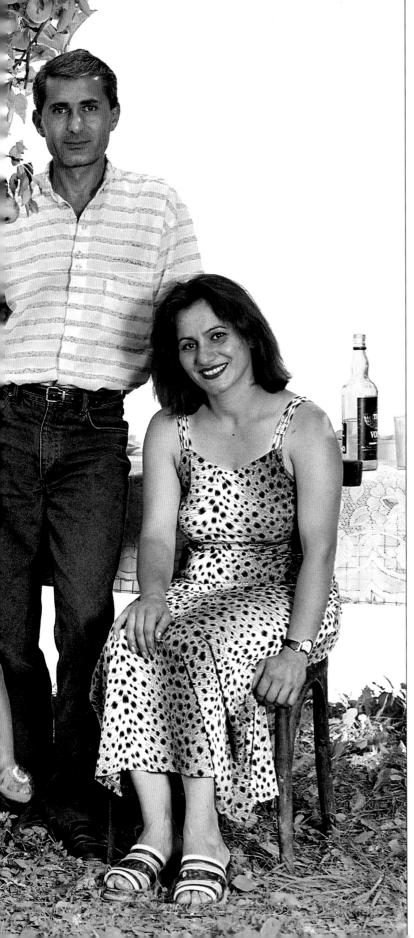

Garrni,
Armenia,
23 August 1999

Garnik ist bekannt für seine „goldenen Hände". Als der Markt für Schmuck zum Erliegen kam, sattelte der Juwelier um und brachte sich selbst das Schuhmacherhandwerk bei. „Ich habe einfach anderen Schuhmachern bei der Arbeit zugeschaut und Kataloge gewälzt." Heute fertigt er mit viel Geschick Schuh um Schuh auf einer einfachen Nähmaschine an. Naira ist Armenischlehrerin am Gymnasium und unterrichtet nebenher Englisch und Französisch an einer Grundschule. „Wollt ihr noch mehr Kinder?" – „Ja, natürlich", antworten beide optimistisch. In ihrer Freizeit packen sie auf den Feldern der Großeltern mit an, die nach 25 Jahren Plackerei in der Schwermetallindustrie von ihrem Gemüsegarten, ihren Obstbäumen und einigen Feldern leben.

People say of Garnik that he has 'hands of gold'. He was a jeweller, but the jewellery market has collapsed, so he's become a shoemaker. "I watched other shoemakers at work and looked through catalogues." He makes shoes with a simple sewing machine and a great deal of talent. Naira teaches Armenian at the secondary school, and she also gives English and French lessons at the primary school. They are very optimistic about the future. "Will you have any more children?" – "Yes, of course," they both answer. They both help the grandparents, who have retired after 25 years in a nickel factory, with the vegetable garden, fruit trees and a few fields, which constitute their main source of subsistence.

On dit de Garnik : « Il a des mains en or ». Il était bijoutier, mais il n'y a plus de marché, alors il est devenu cordonnier. « J'ai regardé travailler les autres et feuilleté les catalogues. » Il fait des chaussures avec une simple machine à coudre et beaucoup de talent. Naira est professeur d'arménien au lycée, elle donne également des cours d'anglais et de français à l'école primaire. Ils sont très optimistes pour l'avenir. « Aurez vous d'autres enfants ? » « Oui bien sûr », répondent-ils à l'unisson. Tous les deux aident leurs parents, retraités après vingt-cinq ans de travail dans une usine de Nickel, à s'occuper du potager, des arbres fruitiers et de quelques champs, qui sont leur principale source de subsistance.

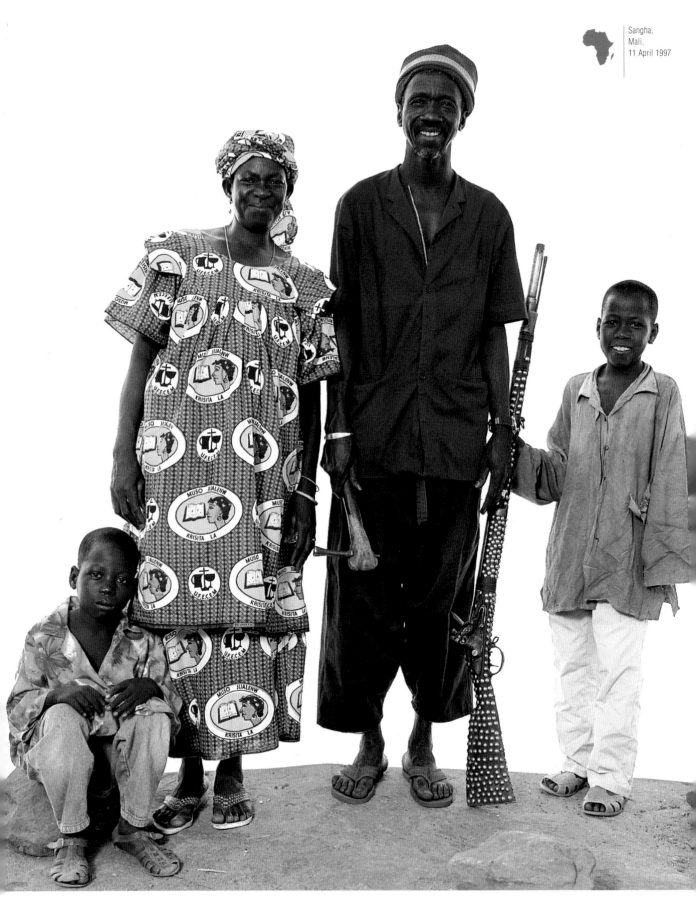

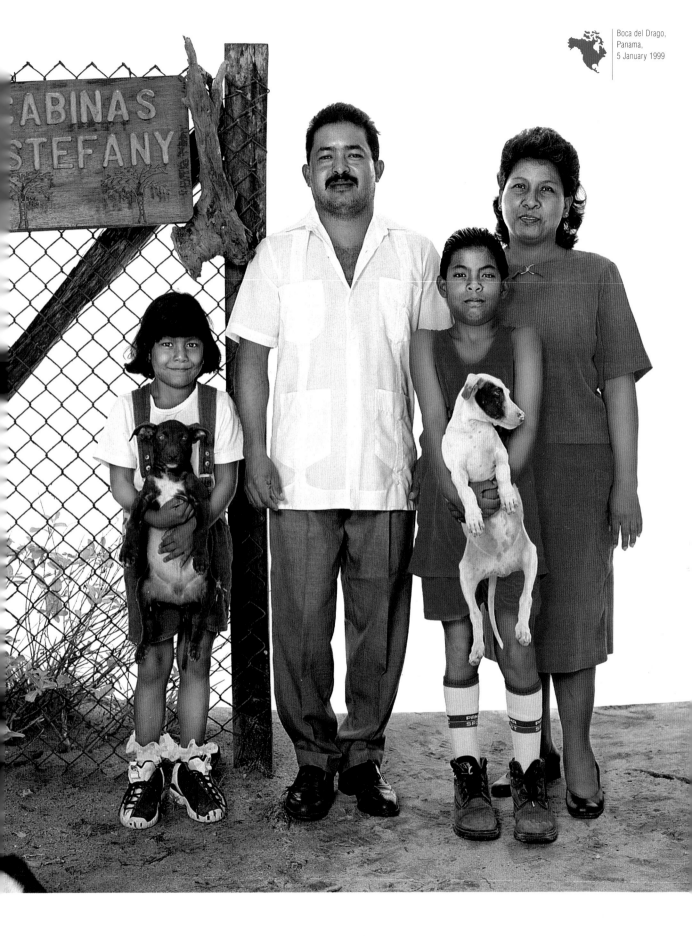

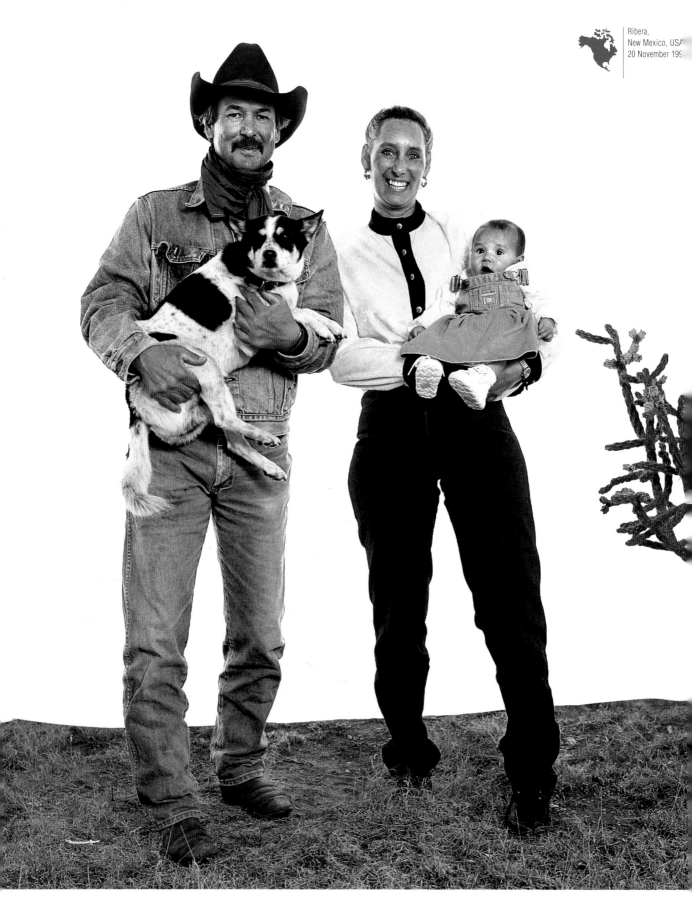

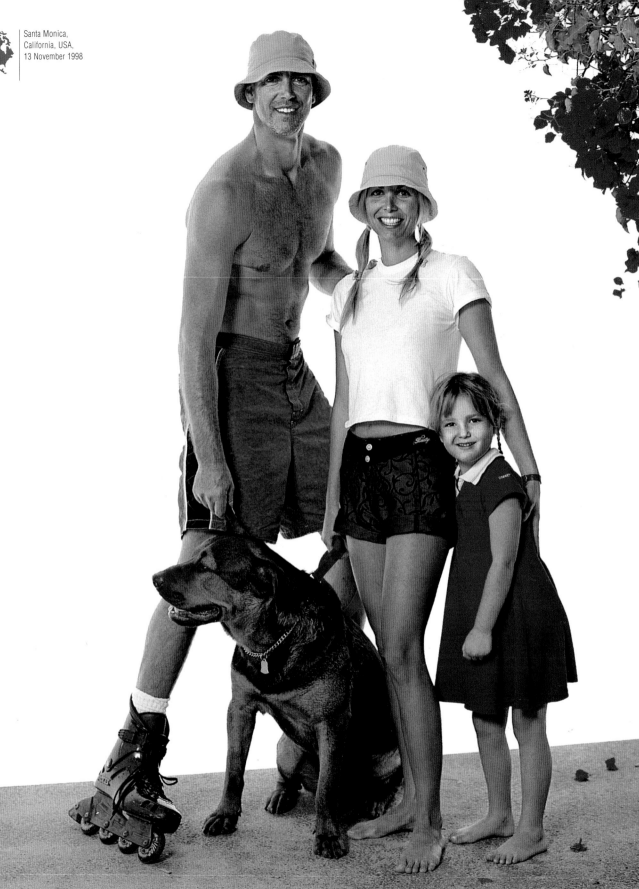

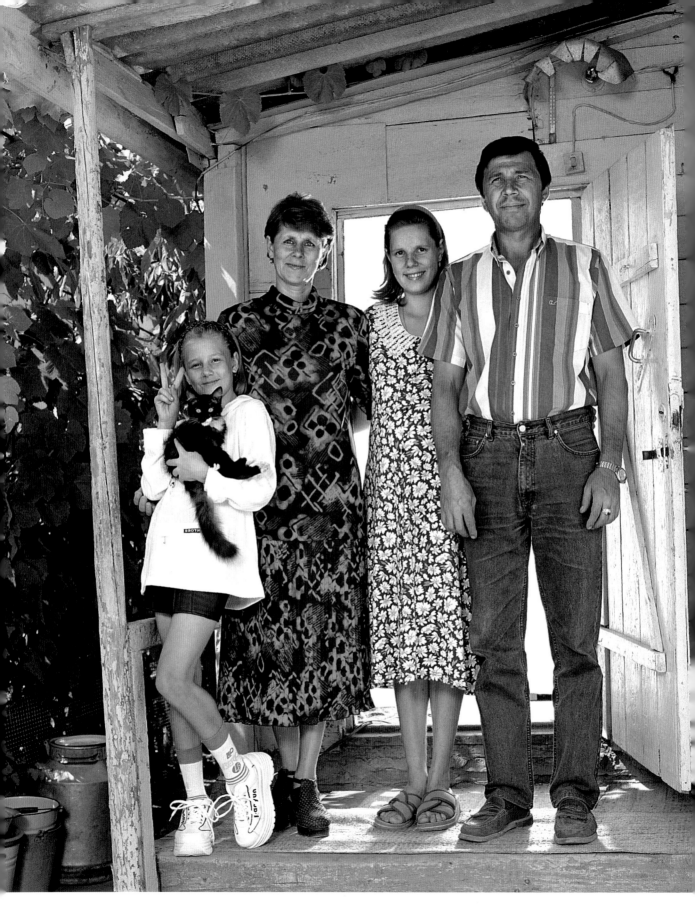

„Jesus hat gesagt, er wird kommen, er hat den Tag nicht festgelegt, aber es wird garantiert bald sein!", sagt Tapli, der Schmied. Er fertigt landwirtschaftliche Werkzeuge an und repariert die Gewehre, die in jedem Haushalt zu finden sind, da es Brauch ist, bei Beerdigungsfeiern Salut zu schießen. Manchmal wird er mit Aufträgen überflutet und die Familie muss mit anpacken. Dann hämmert seine Frau das Eisen und die Kinder schüren das Feuer. „Was bedeutet Familie für Sie?" – „Erstens, dass wir uns verstehen, und zweitens, dass die ganze Familie auf mein Kommando hört."

"Jesus said he would come; he didn't say what day, but it will be soon!" says Tapli, the blacksmith. He makes farm tools and repairs guns. Every family has its own gun, because it's the custom to shoot into the air at funeral ceremonies. At times he has too many blacksmith orders, so his family lends him a helping hand. His wife hammers the iron and his children fan the fire. "What does the family mean for you?" – "Firstly that we understand one another, and secondly that the whole family obeys my orders."

« Jésus a dit qu'il viendrait, mais il n'a pas fixé de jour ! » En tant que chrétien et « surtout protestant », c'est ce qu'attend Tapli pour l'an 2000. Forgeron, il fabrique des outils pour l'agriculture et répare les fusils, chaque famille a le sien, car il est de coutume de tirer un coup de feu lors des cérémonies funéraires. Il est parfois débordé par les commandes. Sa famille lui prête alors main forte. Sa femme martèle le fer et ses enfants attisent le feu. Question : « Que signifie pour vous la famille ? » Réponse : « Premièrement nous nous entendons et deuxièmement toute la famille se soumet à mes ordres. »

Chino hat sehr geschickte Hände. Der frühere Fischer baut heute Holzhäuser und Bungalows, um sie an die Touristen zu vermieten, die sich bis hierher, wo die Piste nach und nach im Schlamm versinkt, vorwagen. Fátima ist Lehrerin an der Grundschule für die einheimischen Kinder aus der Umgebung. „Die Kinder sprechen Gari-Gari, eine Mischung aus Französisch, Englisch und Portugiesisch, und da soll ich ihnen Spanisch beibringen", beschwert sie sich lachend.

Chino can do anything and everything with his hands. Originally a fisherman, he switched to building wooden houses and bungalows, which he rents out to tourists who dare to venture this far, where the track gradually vanishes into the mud. Fátima is a teacher at the school which is attended by native children from roundabout. "The children speak Gari-gari, a mixture of French, English and Portuguese, and it's my job to teach them Spanish," she laments, laughing.

« Chino » sait tout faire de ses mains. Pêcheur à l'origine, il s'est reconverti dans la construction de maisons et de bungalows en bois qu'il loue aux touristes osant s'aventurer dans ce lieu, où la piste disparaît progressivement dans la boue. Fatima est institutrice dans l'école qui regroupe les enfants indigènes des environs. « Les enfants parlent le *gari-gari*, un mélange de français, d'anglais et de portugais et je suis censée leur apprendre l'espagnol. », se plaint-elle en riant.

Ihre erste Begegnung war spektakulär: Beim Zureiten eines Pferdes wurde Doug abgeworfen, fiel über das Gatter und landete auf den Füßen genau vor Patty, die sich unter den Zuschauern befand. Er glaubte an eine Fügung des Schicksals, sie hielt ihn für einen Stuntman … Auf jeden Fall haben sie sich nie mehr getrennt. Heute zieht er als eine Art fliegender Hufschmied von Ranch zu Ranch, und für das Jahr 2000 wünschen sich beide ein zweites Kind. „Keep on riding", gibt uns Doug mit auf den Weg.

Theirs was a spectacular first encounter – Doug was thrown by a horse that he was breaking in. He flew right over the fence and landed on his feet looking straight at Patty, who was among the spectators. He believed in fate; she thought he was a stuntman – in any event, they've been together ever since. These days he's a travelling farrier going from ranch to ranch, and they want to have a second child in 2000. "Keep on riding," Doug says to us as we leave.

Leur rencontre a été spectaculaire : éjecté d'un cheval en cours de dressage, Doug a survolé la barrière et atterri sur ses pieds en face de Patty qui se trouvait parmi les spectateurs. Il croyait au destin, elle croyait qu'il était cascadeur. En tout cas ils ne se sont plus quittés. Aujourd'hui, il est maréchal-ferrant itinérant, de ranch en ranch, et ils ont l'intention d'avoir un deuxième enfant en l'an 2000. « *Keep on riding !* », nous dit Doug en nous quittant.

Beach-Volleyball, Kickboxen, Yoga, Surfen, Inlineskaten, Joggen und Schwimmen sind nur ein Teil ihrer Aktivitäten. Mark arbeitet in einer Produktionsfirma in Hollywood und Allison ist Hausfrau. Beide hegen den Wunsch, die Familie in absehbarer Zeit zu vergrößern. „Kommt uns besuchen", sagen sie, „man kann so viel von anderen lernen."

Beach volleyball, kick-boxing, yoga, surfing, rollerskating, running and swimming are just a few of their pastimes. Mark works in a Hollywood production company, while Allison is a housewife. Both want a bigger family in the near future. "Come and see us," they say; "there's lots to be learnt from other people."

Beach volley, *kickboxing*, yoga, surf, roller, course à pied, natation, ne constituent qu'une partie de leurs occupations. Mark travaille dans une maison de production à Hollywood et Allison est mère au foyer. Tous deux souhaitent agrandir la famille dans un avenir proche. « Venez nous rendre visite, disent-ils, il y a beaucoup à apprendre chez les autres ! »

Jakow arbeitet für eine Fluggesellschaft in Moskau, sucht aber eine Stelle in der Nähe, um mehr Zeit mit seiner Familie verbringen zu können. Alla ist Lehrerin und wird demnächst Großmutter, denn ihre älteste Tochter Olga hat geheiratet und erwartet ein Baby. Die kleine Swetlana ist verrückt nach allem, was vier Beine hat, und möchte Tierärztin werden. Bis dahin muss sie sich mit ihren zwei Hunden, drei Katzen und sechs Kaninchen zufrieden geben.

Yakov works for an airline in Moscow, but is looking for a job in the area so that he can spend more time with his family. Alla is a teacher and about to become a grandmother, because her elder daughter Olga is married and expecting a baby. Little Svetlana loves animals and dreams of becoming a vet. Meanwhile, she looks after her many friends – two dogs, three cats, and six rabbits.

Jakow, employé d'une compagnie aérienne à Moscou, cherche un travail dans la région pour pouvoir passer plus de temps avec sa famille. Alla est enseignante et très bientôt future grand-mère ; l'aînée de ses filles, Olga, est mariée et attend un bébé. La petite Swetlana adore les animaux et rêve de devenir vétérinaire, en attendant elle s'occupe de ses nombreux amis : deux chiens, trois chats et six lapins !

Das Kamel ist ihnen lieber als ein Traktor, denn „es kostet weniger und es gibt keine technischen Probleme". Die erst seit kurzem verwitwete Ram Phool findet Trost bei ihren Lieben – ihrem Bruder, ihren Schwestern und Kindern. Sie leben in einem ehemaligen Jagdrevier der Maharadschas von Udaipur, wo sie Reis und Gemüse anbauen.

They prefer the camel to the tractor: "it's less expensive and doesn't have mechanical problems." Recently widowed Ram Phool takes comfort in her nearest and dearest – her brother, sisters and children. They live in the former hunting grounds of the Maharajas of Udaipur and grow rice and vegetables.

Ils préfèrent le chameau au tracteur « moins cher et pas de problèmes mécaniques ». Veuve depuis peu, Ram Phool vit entourée de ses proches, frère, sœurs et enfants dans un village situé sur les anciennes terres de chasse des Maharadja d'Udaipur où ils cultivent riz et légumes.

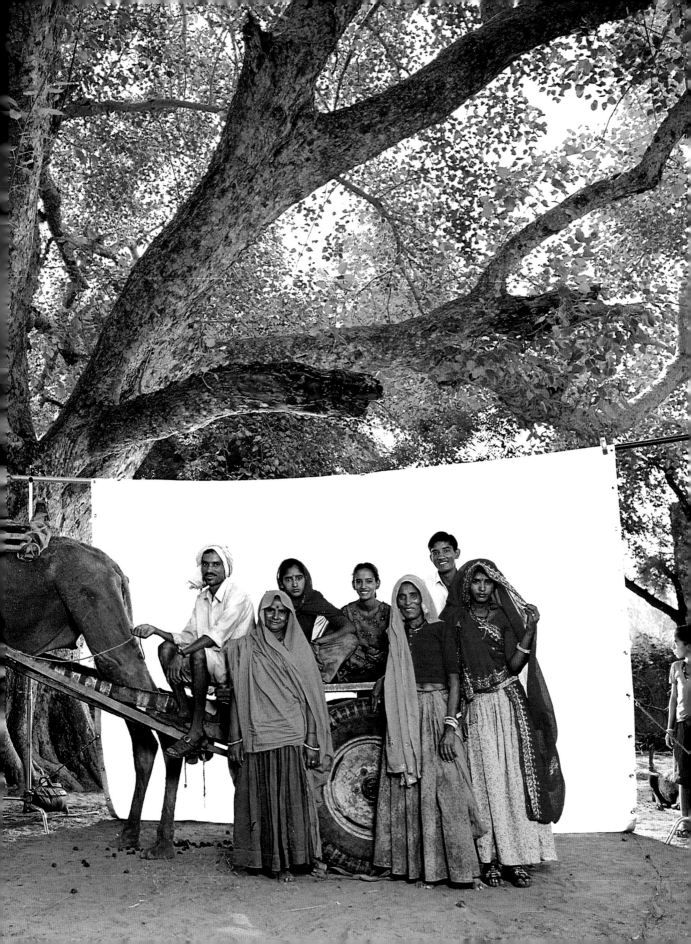

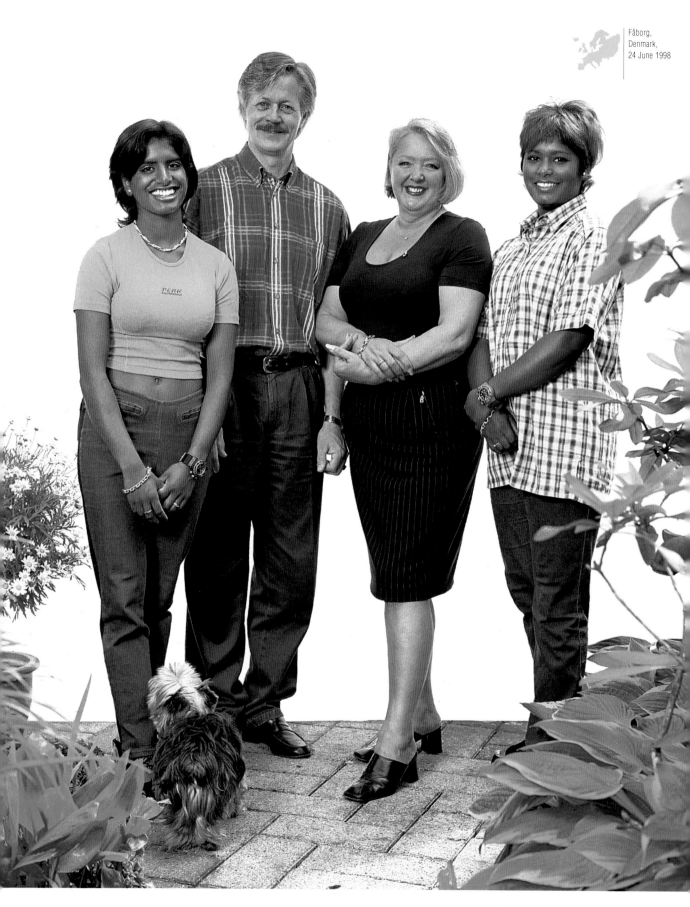

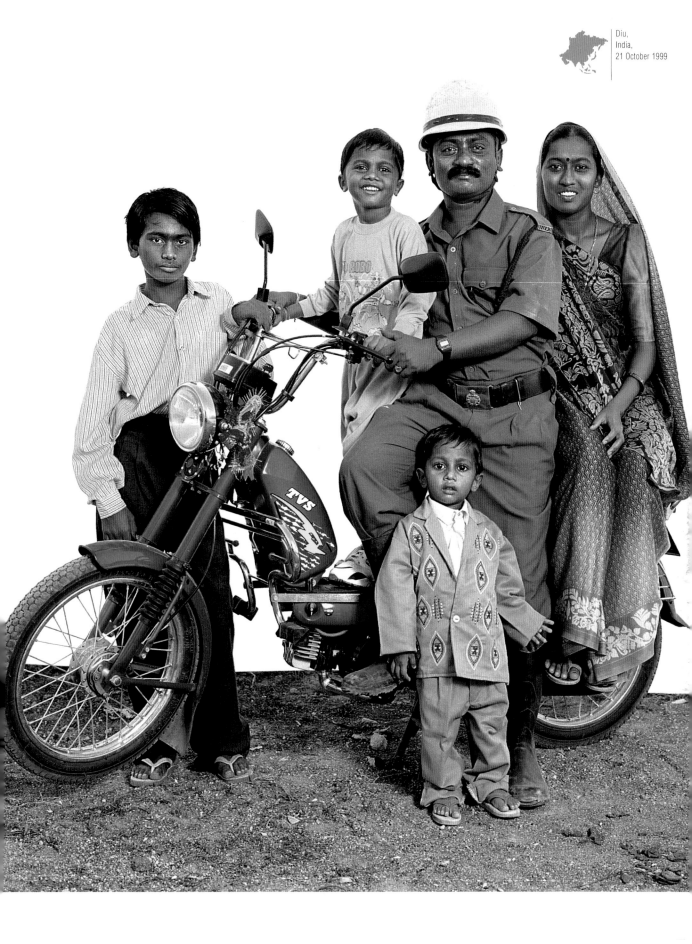

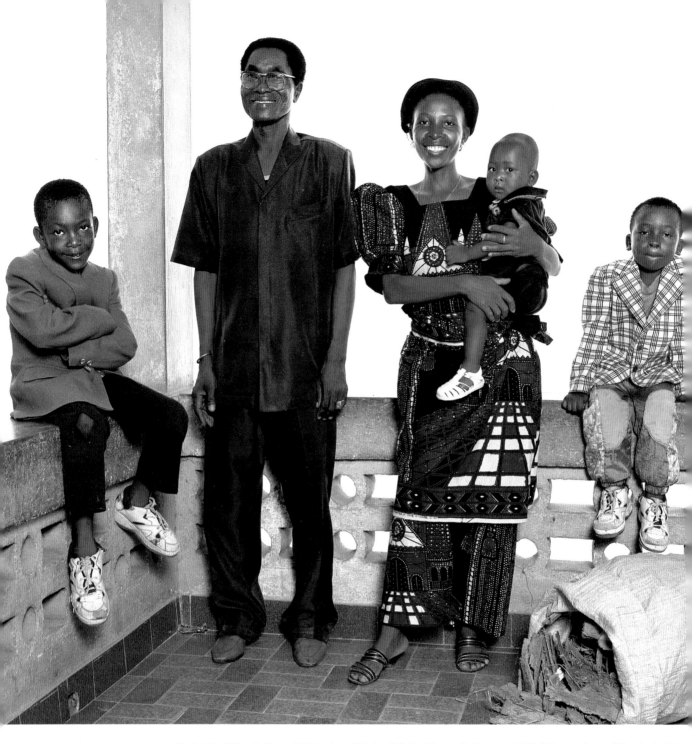

Korhogo,
Ivory Coast,
30 May 1997

Yao hat sich auf Hämorrhoiden spezialisiert und garantiert seinen Patienten 100-prozentige Genesung. „Ich bin Heiler geworden, um Afrika auf meine Art zu helfen." Sein medizinisches Wissen hat er sich in der Natur erworben: „Die Kraft Gottes wohnt in den Pflanzen", sagt er. Seine Geheimtränke stellt er aus der Rinde von über 500 verschiedenen Bäumen her. Für den verheirateten Vater von drei Kindern ist ein Leben ohne Familie unvorstellbar: „Wenn du auf der Welt bist und keine Kinder bekommst, ist dein Leben sinnlos." Für das Jahr 2000 hat Yao Großes vor: „Mein Ziel ist es, ein Heilmittel gegen Aids zu finden. Hat Präsident Bédié nicht gesagt, man müsse dabei auf die Afrikaner zählen? Ich glaube, ich habe die Arznei gefunden!"

As a specialist in haemorrhoidal disorders, Yao guarantees you a 100% cure. "By becoming a doctor, I wanted to help Africa in my own way." He did his medical apprenticeship on his own, in the forest: "The power of God lies in plants," he says. His secret potions are made from tree bark, and he uses more than 500 species. Yao is married and father of three children, and can't imagine life without his family: "When you come into the world and you don't have any children, your life is useless." He's got grand ideas for the new millennium: "My ideal is to find the cure for AIDS. Didn't President Bédié say that we must rely on Africans to find it? I think I've found the right potion."

Spécialiste des maladies hémorrhoïdales, Yao vous garantit 100 % de guérison. « En devenant médecin, je voulais aider l'Afrique à ma manière. » Son apprentissage médical, il l'a fait seul, dans la forêt : « La force de Dieu réside dans les plantes », affirme-t-il. Ses potions secrètes sont réalisées à partir d'écorces d'arbres, il utilise plus de cinq cents essences. Pour l'an 2000, il a de grands projets : « Mon idéal est de trouver le remède contre le sida. Le Président Bédié n'a-t-il pas dit qu'il fallait compter sur les Africains pour le découvrir ? Je pense avoir trouvé la potion ! » Marié, père de trois enfants, Yao ne peut imaginer sa vie sans sa famille : « Quand vous venez au monde, et que vous n'avez pas d'enfants, votre vie est inutile. »

Die beiden Fotografen Steen und Ilse sind ein Team: Er bedient im Laden, sie macht Hochzeitsfotos und Porträtaufnahmen im Studio oder in dem kleinen Garten, den sie eigens für diesen Zweck angelegt hat. Claudia und Camilla sind in Sri Lanka geboren und wurden als Babys von Steen und Ilse adoptiert. Heute fühlen sich die beiden jungen Frauen ganz als Däninnen. Die Lieblingsfreizeitbeschäftigung der Familie sind Bootsausflüge auf die vielen kleinen Inseln der Gegend. „Im Jahr 2000 wäre ich gern schon Millionärin", scherzt die 19-jährige Claudia.

They are both photographers. Steen runs the shop and Ilse takes wedding photos and children's portraits either in the studio or in their small garden specially prepared with plants and flowerbeds. They adopted Claudia and Camilla from Sri Lanka when the girls were just a few months old. Today the girls feel totally Danish. Their favourite pastime is taking their boat and making family trips to the numerous little islands in the region. "I'd like to be a millionaire by 2000," 19-year-old Claudia tells us with a broad smile.

Ils sont tous les deux photographes. Steen s'occupe du magasin et Ilse réalise des photos de mariage et des portraits d'enfants en studio ou dans leur petit jardin spécialement aménagé avec des plantes et des parterres de fleurs. Ils ont adopté Claudia et Camilla au Sri Lanka alors qu'elles n'avaient que quelques mois. Elles se sentent aujourd'hui complètement danoises. Leur occupation favorite est la visite, en bateau et en famille, des nombreuses petites îles de la région. « Je voudrais être millionnaire en l'an 2000 », nous confie Claudia (dix-neuf ans) dans un grand sourire.

Vishveshs „Biker"-Outfit ist nicht der letzte Schrei, sondern seine Uniform – er ist einer der 18 städtischen Feuerwehrmänner. In seiner Freizeit spielt er Fußball, Volleyball und natürlich Cricket – „in diesem großen Stadion, das gut 12.000 Zuschauer fasst". Spricht's und deutet auf eine Wiese mit ein paar versprengten Kühen. Seine Frau Vanita steht allmorgendlich auf dem Markt und verkauft den Fang der einheimischen Fischer.

That isn't the latest fashion in motorcycling gear Vishvesh is wearing, but his uniform – he is one of the town's 18 firemen. He plays football, volleyball and of course cricket "in this large stadium, which holds 12,000 spectators," he explains, pointing at a large meadow with a few cows. His wife Vanita is a trader. Every morning she is at the market selling fish she buys from fishermen.

Vishvesh ne porte pas la dernière mode cycliste mais son uniforme ; il est l'un des dix-huit pompiers de la ville. Sportif, il joue au foot, au volley et bien sûr au cricket « dans ce grand stade qui contient douze mille spectateurs », nous précise-t-il en pointant du doigt un grand pré fréquenté par des vaches. Vanita, l'épouse, est commerçante, elle vend tous les matins au marché le poisson qu'elle achète aux pêcheurs.

„Wir wünschen uns vor allem Wellblech für die Dächer unserer Hütten, denn das Stroh hält nicht lange … Aber wir können nicht in die Stadt gehen, denn wir würden uns verlaufen und nicht mehr in unser Lager zurückfinden", erklärt der Häuptling des kleinen Pygmäenlagers, auf das wir mitten im kamerunischen Regenwald gestoßen sind. Sie sind Jäger mit Leib und Seele und verwenden Armbrust und Giftpfeile für die Jagd auf Affen und Raubkatzen, Fangnetze, die sie zwischen zwei Bäume spannen, für Antilopen und sogar eine alte Flinte (das Problem ist, die Kugeln dafür aufzutreiben …).

"The dream we all have is to get corrugated iron for the roofs of our huts; the straw doesn't last long – but we can't go into town because we'd get lost and never find our camp again," declares the chief of the small Pygmy encampment we found in the thick of the Cameroon forest. With hunting in their blood, they use crossbows (with poisoned arrows) to kill monkeys and wild cats, and nets which they stretch between two trees to catch antelopes, and even an old rifle (the problem is finding ammunition …).

« Notre rêve à tous, c'est d'avoir des tôles pour les toits de nos cases, la paille ne tient pas longtemps, mais nous ne pouvons pas aller en ville on se perdrait et on ne retrouverait plus notre campement ! », déclare le chef du petit campement pygmée que nous avons trouvé en pleine forêt camerounaise. Chasseurs dans l'âme, ils utilisent l'arbalète (avec des flèches empoisonnées) pour les singes et les chats sauvages, des filets, qu'ils tendent entre deux arbres pour les antilopes et même un vieux fusil (le problème c'est de trouver les balles …).

Irgendwann einmal soll es eine richtig große Fischzucht werden. Momentan experimentieren sie noch mit einer Hand voll Jungtieren in einem kleinen Becken, das von einer Quelle gespeist wird. Ansonsten lebt die Familie von der Landwirtschaft und baut Tomaten, Gurken, Erbsen, Äpfel und Birnen an, die sie auf dem nahe gelegenen Markt verkaufen. Vater Alaattin ist mächtig stolz auf sein Motorrad mit Beiwagen, ein russisches Fabrikat, mit dem er die Ernte – oder auch die ganze Familie transportiert.

They plan to set up a large fish hatchery. For the time being, they're doing tests with a few mini-fish in a small tank fed from a spring. Meanwhile, they live off their land, growing tomatoes, cucumbers, peas, apples and pears, which they sell at the nearby market. Alaattin is very proud of his Russian side-car, which comes in handy for going to the fields and transporting the harvest or the whole family.

Leur projet est de créer un vivier de poisson. Pour le moment, ils en sont au stade des essais : quelques mini-poissons, dans un petit bassin alimenté par une source. En attendant ils vivent de leur terre : tomates, concombres, petits pois, pommes et poires qu'ils vendent au marché voisin. Alaattin est très fier de son side-car russe, très pratique pour aller aux champs, transporter la récolte ou toute la famille.

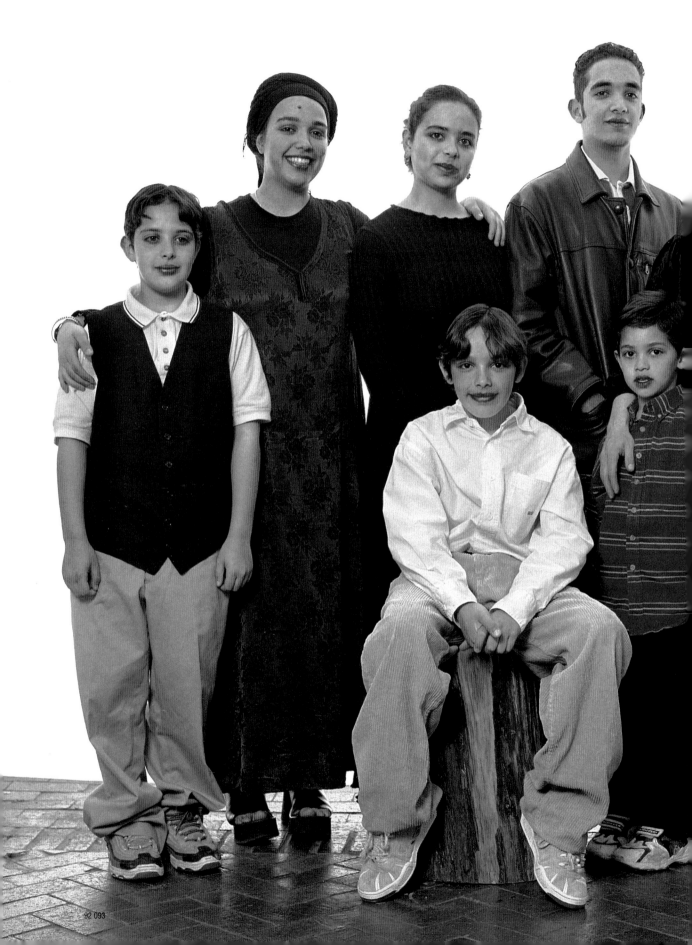

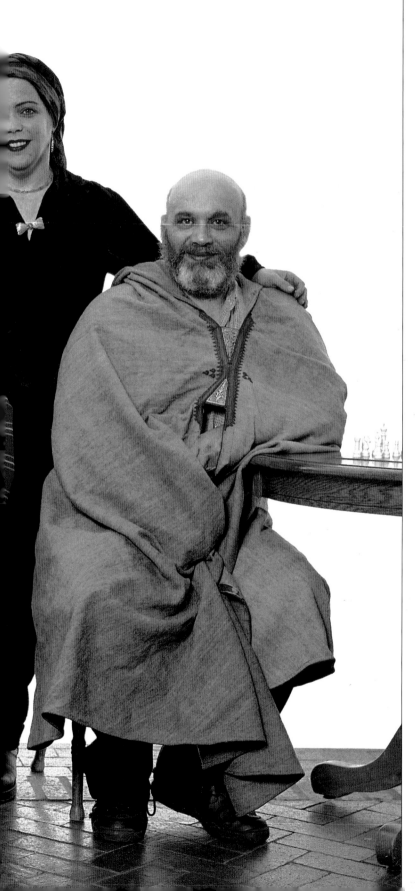

Sie sind ägyptischer und libyscher Herkunft und betreiben ein Café mit dem treffenden Namen „Tribes" im Zentrum von Santa Fe. Ein wahrlich internationaler Treffpunkt mit der entspannten Atmosphäre eines Künstlercafés. „Die verschiedenen Völker müssen aufeinander zugehen und lernen, mit ihren eigenen Traditionen und den Traditionen der anderen zu leben", sagt Zeinab, bevor er sich wieder in sein Schachspiel vertieft.

Originally from Egypt and Libya, they run a café in the middle of Santa Fe which they've appropriately named 'Tribes'. It's a truly international meeting place, within the relaxing atmosphere of a literary café. "Tribes must rub shoulders and learn to live with both their own traditions and other people's," declares Zeinab, before getting back to his chess game.

Originaires d'Egypte et de Libye, ils animent un café au centre de Santa Fé qu'ils ont appelé *Tribus*. C'est un véritable lieu de rencontres internationales dans l'atmosphère relaxante d'un café littéraire. « Les tribus doivent se côtoyer et apprendre à vivre avec leurs traditions et celles des autres », déclare Zeinab avant de se replonger dans son jeu d'échecs.

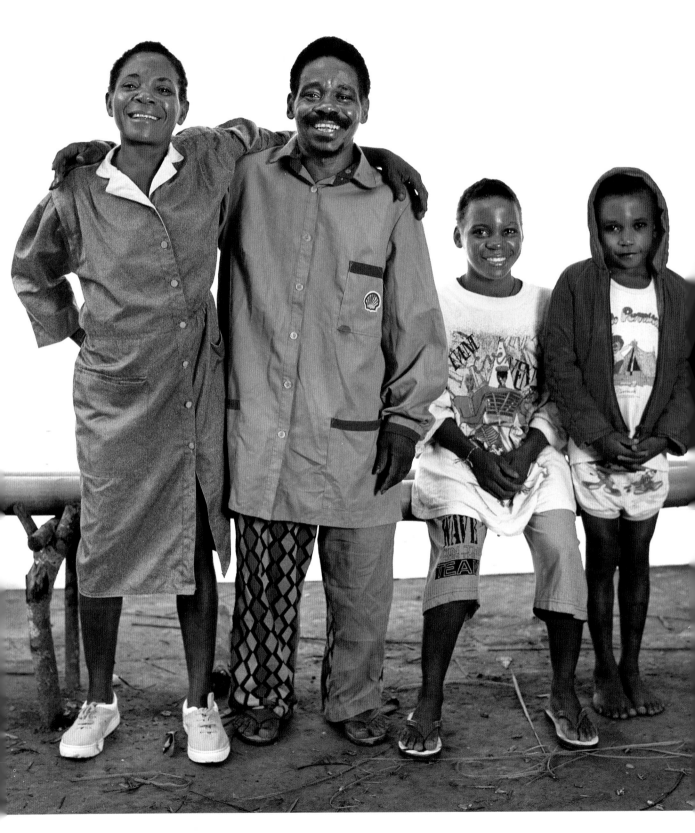

94 095

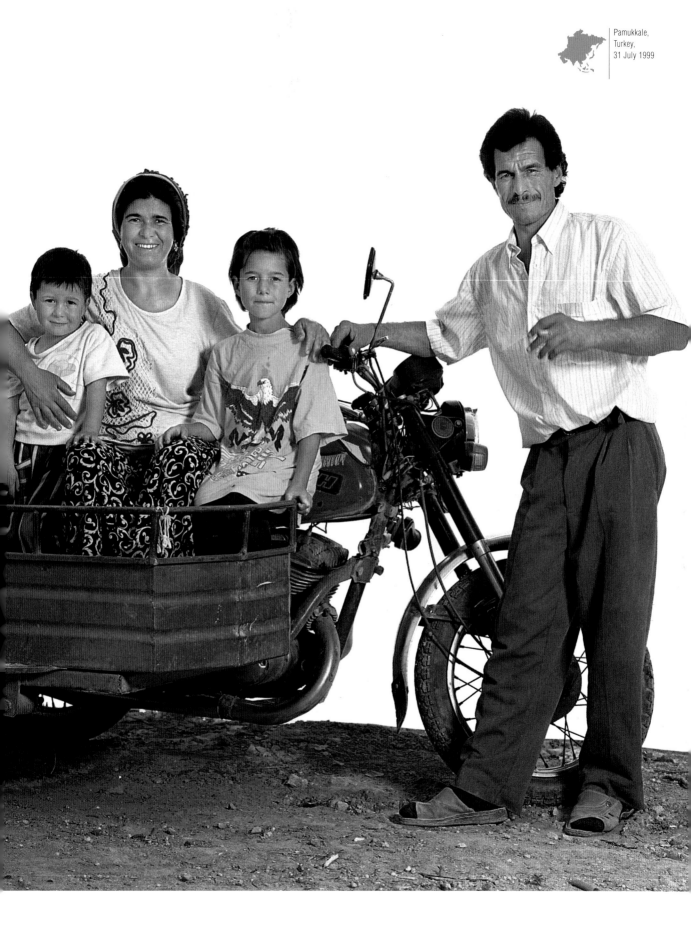

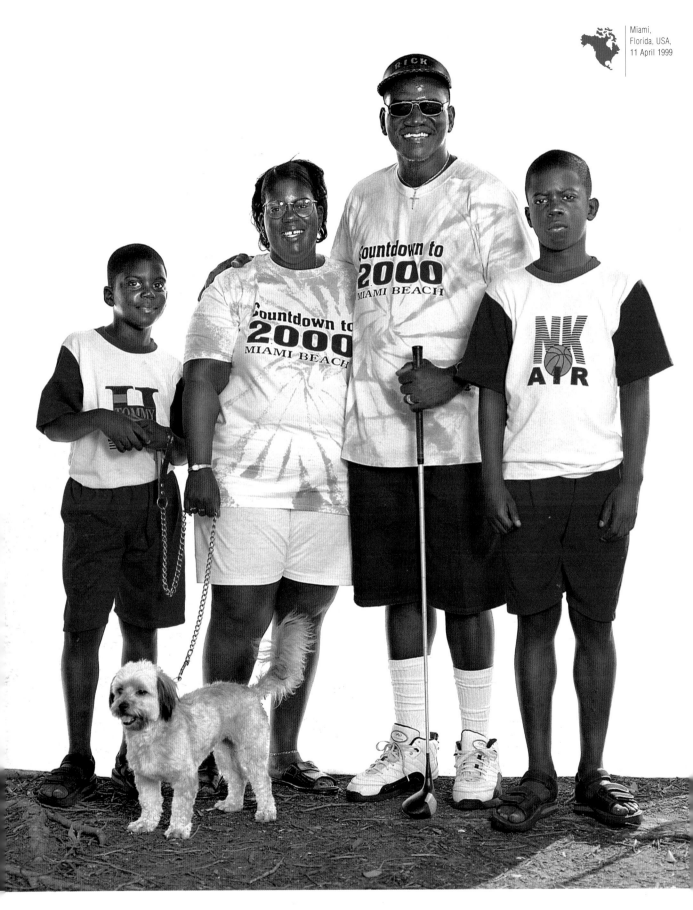

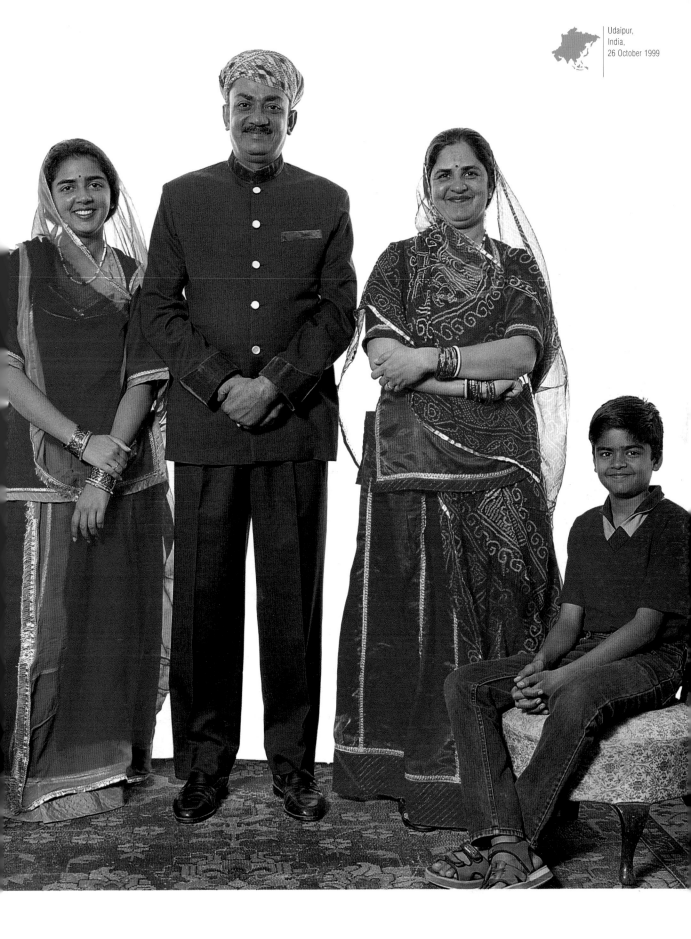

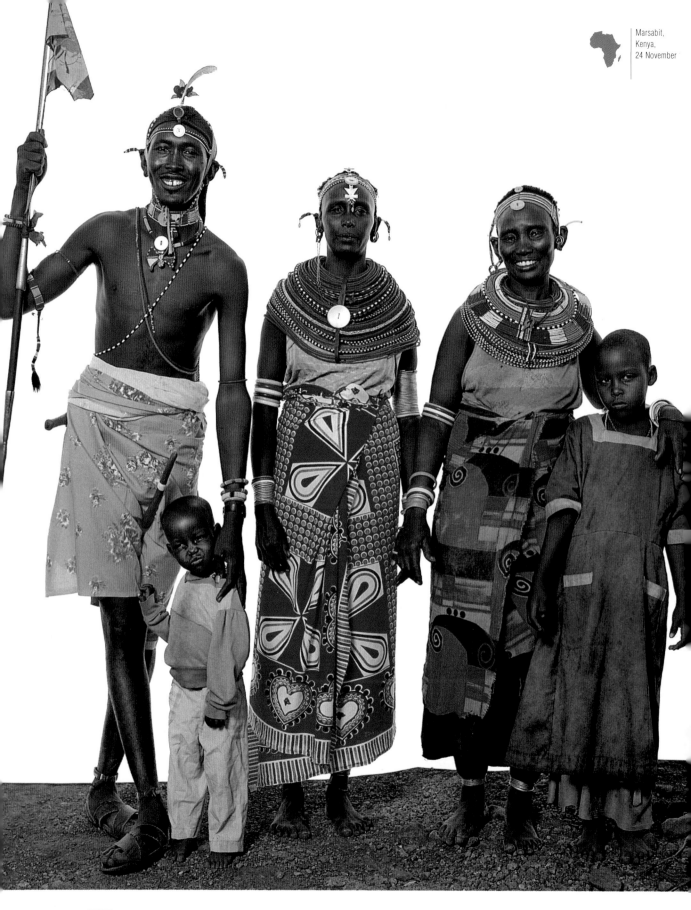

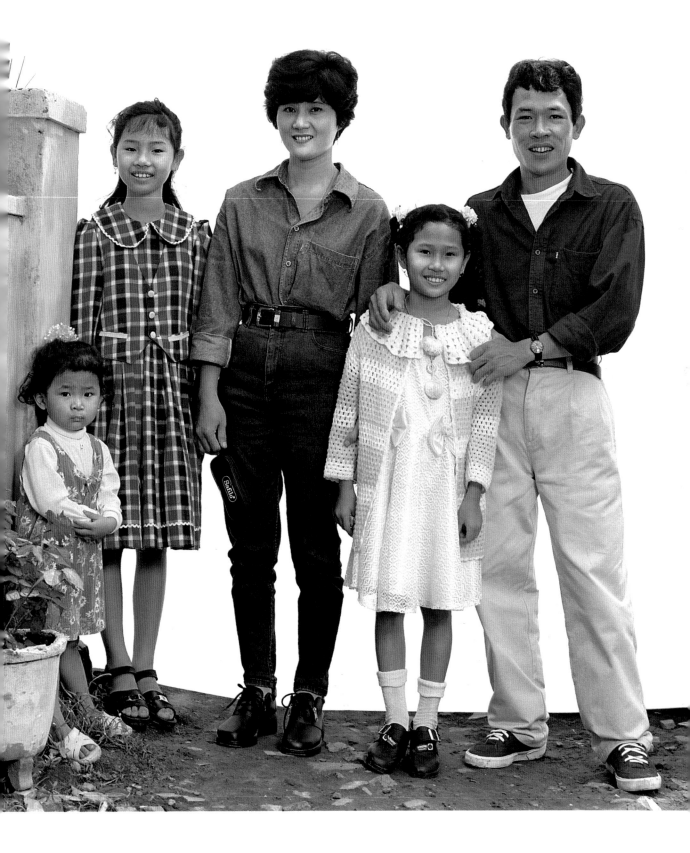

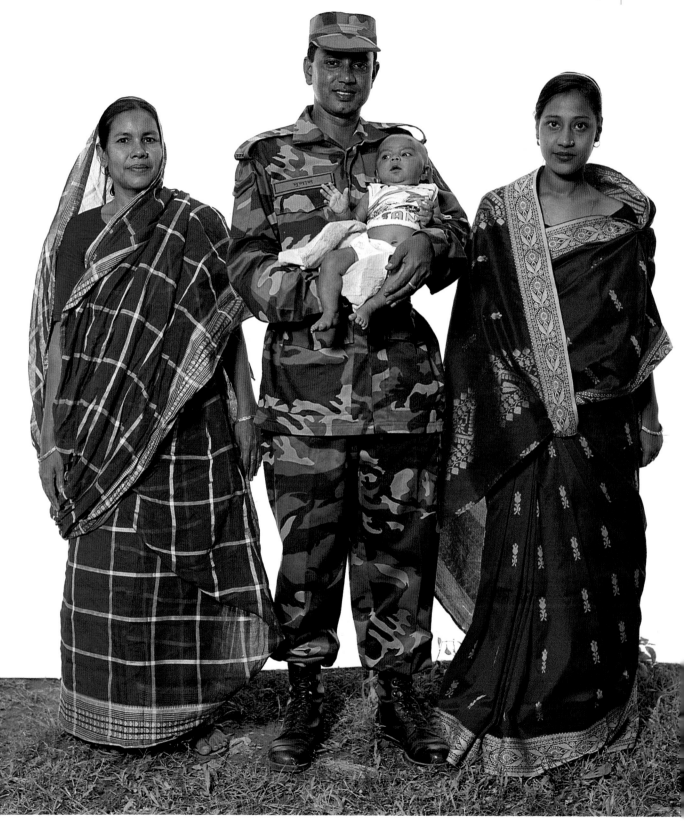

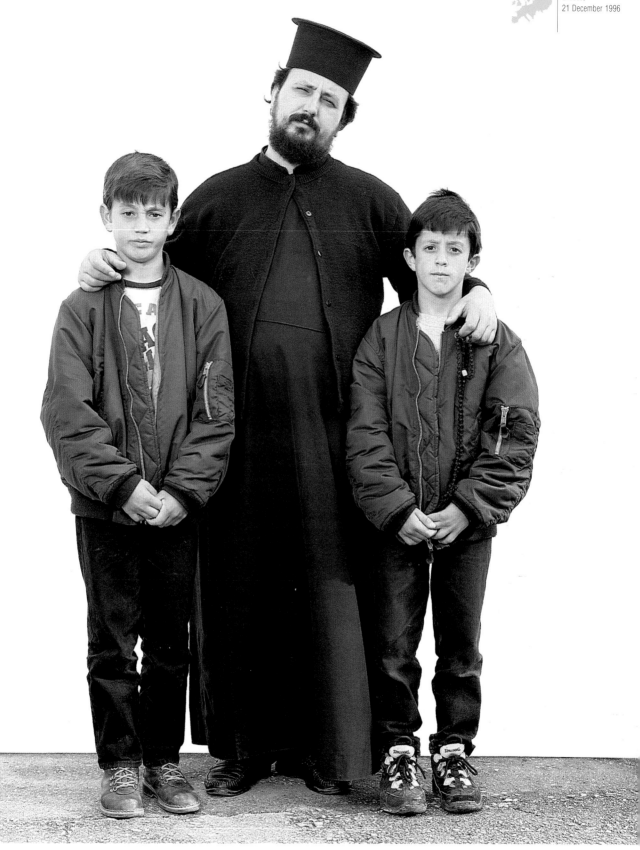

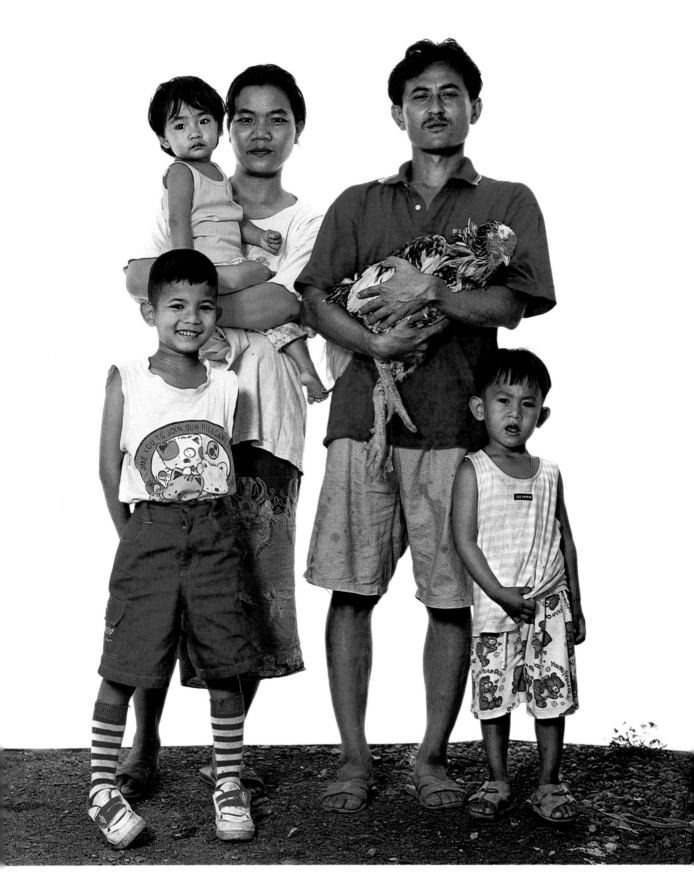

„Nicht länger auf der Überholspur! Ich bin jetzt Familienvater", erklärt Herbert, der frühere Armee Soldat. Nachdem sie zehn Jahre in Georgia gelebt haben, sind sie nach Miami gezogen, „um Joyce einen Gefallen zu tun". Sie sind ganz euphorisch angesichts des neuen Jahrtausends und tragen schon das offizielle T-Shirt: „Wir müssen unsere Einstellung ändern, ein neues politisches System finden, um die Staaten zu regieren. Wenn uns die Computer im Stich lassen, machen wir es sowieso wie früher und strengen unseren Verstand an." Sie haben es erraten: Herbert ist Amateurgolfer, spielt aber auch Fußball, Softball, Basketball und was nicht sonst noch alles.

"No more life in the fast lane! I'm a family man now," says former soldier Herbert. After spending ten years in Georgia, they've settled in Florida, "for Joyce's sake." They're very enthusiastic about what the new millennium holds, and are already sporting the official T-shirt: "We've got to adopt a new mentality and develop new systems for running countries, and if computers let us down, then we'll have to make do like before and work with our heads." You guessed it – Herbert is a golfing enthusiast, but he also likes football, softball and basketball, to name just a few of his sports.

« Fini la vie à toute allure, je suis maintenant père de famille. », déclare Herbert ancien militaire. Après avoir vécu dix ans en Géorgie « pour faire plaisir à Joyce », ils s'installent à Miami. Très enthousiastes à la perspective du nouveau millénaire, ils arborent déjà le T-shirt officiel : « Il faut adopter une nouvelle mentalité, de nouveaux systèmes pour gérer les nations et si les ordinateurs nous lâchent, faisons comme avant et travaillons avec notre tête. » Vous l'avez deviné, Herbert est amateur de golf, mais aussi de football, de *softball*, de basket, et j'en passe.

Die Freundschaft zwischen den Bedlas und den Maharadschas von Udaipur hat Tradition. Was sie jedoch nicht daran hindert, ihrem Ruf als begnadete Hobbyköche alle Ehre zu machen. Seit einigen Jahren sind die beiden gern gesehene Gäste in den Grandhotels Indiens, wo sie ihre Rezepte einem erlesenen Gourmet-Publikum präsentieren. Die gemeinsamen Kinder haben die Leidenschaft fürs Kulinarische geerbt und helfen ihren Eltern, sooft es Schule und Cricket erlauben.

The Bedlas have been connected with the Maharajas of Udaipur for many generations. This doesn't stop them being highly reputed amateur cooks. For a number of years they have also been much sought-after guests at India's grand hotels, where they unveil their recipes to a gourmet public. Their children have the same passion and help their parents whenever their studies and cricket permit.

Les Bedla sont liés à la lignée des maharadjas d'Udaipur depuis de longues générations. Cela ne les empêche pas d'être des cuisiniers amateurs, mais très réputés ! Depuis quelques années, ils sont les hôtes très attendus et sollicités des grands hôtels d'Inde, où ils présentent et font découvrir leurs recettes à un public de fins gourmets. Les enfants sont pris de la même passion, ils aident les parents dès que leurs études et le cricket le leur permettent.

Auf die Frage nach seinem Alter antwortete Lesipia zunächst mit 18, besann sich dann aber eines Besseren und entschied sich für 28! Lesipia, Viehzüchter, hat keine Ahnung, welches Jahr wir schreiben und es ist ihm auch egal! Sein einziger Wunsch ist, in Marsabit zu bleiben und ... einmal reich zu werden. Am Tag unserer Begegnung hat er eine Kuh verkauft und von dem Erlös Kleidung für seine Großmutter, seine Frau und seine Kinder erstanden.

When we asked Lesipia how old he was, he first said 18, then changed his mind and announced he was 28! Lesipia doesn't know what year it is and he doesn't care either! What he wants is never to leave Marsabit, where he was born, and ... to get rich! He is a livestock breeder and sells his cattle in town. The day we met him, he'd sold a cow, and with the money he'd bought clothing for his grandmother, his wife, and his children.

Quand nous avons demandé à Lesipia son âge, il a d'abord répondu dix-huit ans, puis il s'est ravisé en annonçant vingt-huit ans ! Lesipia ne sait pas en quelle année nous sommes et il s'en moque ! Ce qu'il souhaite c'est ne jamais quitter Marsabit où il est né et … devenir riche ! Eleveur, Lesipia vend son bétail en ville ; le jour de notre rencontre, il n'avait vendu qu'une vache et, avec l'argent gagné, acheté des vêtements pour sa grand-mère, sa femme et ses enfants.

„Das Einzige, was uns fehlt, ist ein kleiner Junge. Aber drei Kinder sind genug." Pham und Nguyen arbeiten gemeinsam in ihrer kleinen Werkstatt für Metallarbeiten. Sie glauben, dass das neue Jahrtausend „sehr gut" wird.

"There's one thing we lack – a little boy. But three children is enough." Pham and Nguyen have a small workshop where they work together making metal parts. They think the new millennium will be "very good."

« Il y a une chose qui nous manque : c'est un petit garçon. Mais trois enfants, ça suffit ! » Pham et Nguyen ont un petit atelier de façonnage de pièces métalliques où ils travaillent ensemble et pensent que l'an 2000 sera « très bon ».

Surat Thani,
Thailand,
9 January 2000

Wenn Phatoomsak nicht gerade auf einer der zahllosen Straßenbaustellen im Süden des Landes arbeitet, verbringt er seine Zeit mit der Abrichtung von Kampfhähnen. Wenn seine Schützlinge siegen, beschert ihm der thailändische Nationalsport einen netten Nebenverdienst.

When Phatoomsak is not working on one of the countless road construction sites in the south of the country, he spends his time training fighting cocks. This is a national form of entertainment which makes a significant addition to his salary when his warriors win.

Quand Phatoomsak ne travaille pas sur l'un des innombrables chantiers de routes en construction dans le sud du pays, il passe sont temps à l'entraînement de coqs de combat. C'est un divertissement national, qui rapporte un bon complément de salaire quand ses protégés gagnent !

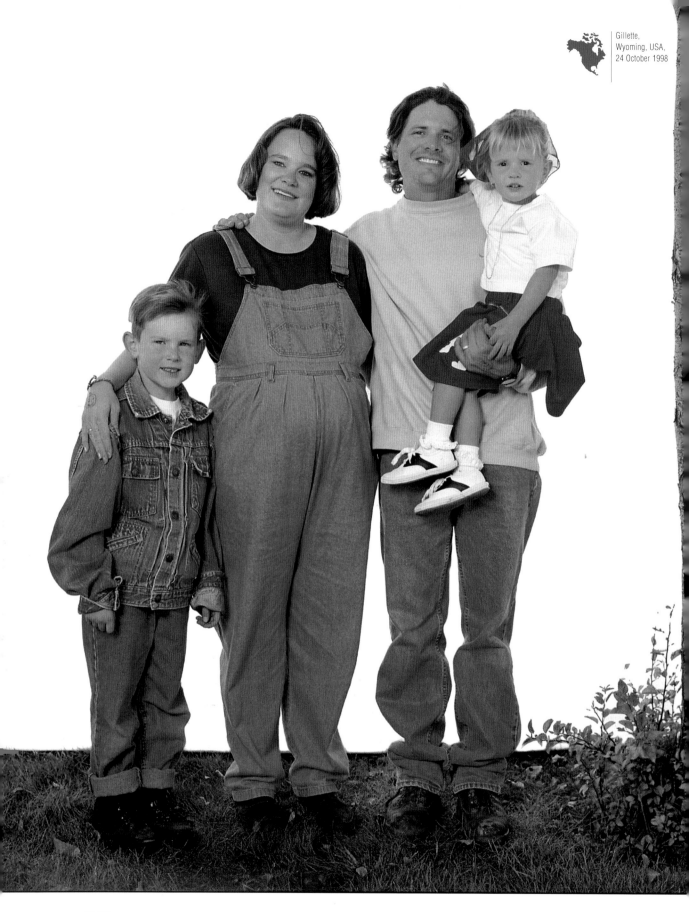

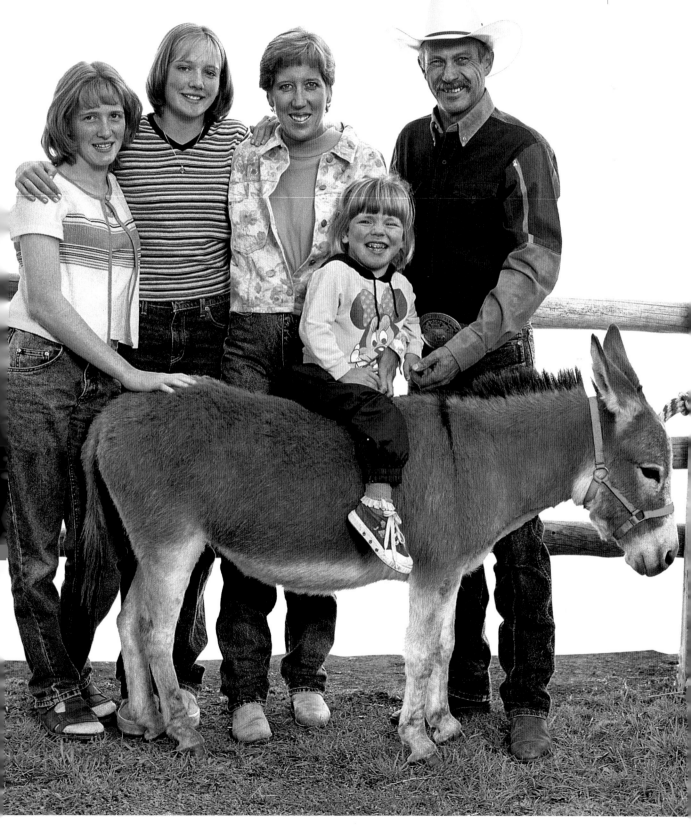

Page 100

Mohammed, Elektriker bei der Armee und frisch verheiratet, nutzt seinen Ausgang für einen Ausflug mit seiner Frau und seiner Mutter. Er bestand darauf, für das Foto sein Baby selbst auf dem Arm zu halten.

A military electrician and recently married, Mohammed is making the most of his leave to take a walk with his wife and mother. He insisted on carrying his baby for the photo.

Mohamed, électricien-militaire, jeune marié, profite d'une permission pour faire une promenade avec sa femme et sa mère. Il a tenu à porter son bébé pour la photo.

Page 101

Katsigianis ist orthodoxer Priester und zieht seine zwei Söhne nach dem Tod seiner Frau allein groß. Sein größter Wunsch ist, dass seine Söhne auch das Priesteramt ergreifen, wie es in seiner Familie seit Generationen Tradition ist. Die beiden haben im Moment ganz andere Dinge im Kopf. Sie sind leidenschaftliche Basketballer, spielen jeden Tag und sehen sich schon als berühmte Champions.

Katsigianis is an Orthodox priest, bringing up his two boys on his own since his wife's death, and hoping that they too will become priests, as has been the family tradition for generations. For the time being, the children's only interest is basketball; they play every day and already see themselves as champions.

Prêtre orthodoxe, Katsigianis élève seul ses deux garçons depuis le décès de sa femme et espère qu'ils deviendront prêtres à leur tour, comme il est de tradition dans la famille depuis des générations. Les enfants pour le moment n'ont de passion que pour le basket-ball ; ils jouent tous les jours, et se voient déjà en champions.

Page 104

Der fünfjährige Skylow ist sich seiner Sache ganz sicher: Er will nicht Lokomotivführer werden, sondern Farmer. Sein Vater ist Ingenieur auf der berühmten Santa Fe Rail Road, auf der Kohle von Gillette in den Osten der USA befördert wird. Allison erwartet ihr „drittes und letztes" Baby. Die Wochenenden verbringen sie auf der elterlichen Ranch, wo sie ihre Geschwister, Nichten und Neffen treffen. Ihre Erziehungsgrundsätze sind einfach: „Erzieht eure Kinder, wie ihr erzogen worden seid, und alles wird gut."

Five-year-old Skylow is absolutely sure that he doesn't want to drive a locomotive – he's going to be a farmer. His father is an engineer on the famous Sante Fe Rail Road, taking coal from Gillette to the eastern United States. Allison is expecting her "third and last" baby. They spend their weekends at their parents' ranch, where they see their brothers, sisters, nephews and nieces. Their principles for bringing up their children are straightforward: "Raise your children the way you were raised, and it'll all be just fine."

Skylow (cinq ans) en est tout à fait sûr, il ne veut pas conduire des locomotives, il sera fermier! Son père est conducteur sur le très célèbre Santa Fé Rail Road qui transporte le charbon de Gillette vers l'Est des Etats-Unis. Allison attend son « troisième et dernier » bébé. Ils passent les week-ends dans le ranch de leurs parents où ils retrouvent leurs frères, sœurs, neveux et nièces. Leurs principes d'éducation sont simples : « Elevez vos enfants comme vous avez été élevés et tout ira bien ! »

Page 105

Masha, die Reiterin, ist drei Jahre alt. Die Flinns haben das Waisenkind aus Russland vor kurzem adoptiert. Dwayne und Barbara züchten exotische Tiere: Miniaturesel, Lamas, indianische Pferde und so genannte *fainting goats*, Ziegen, die bei der geringsten Aufregung in Ohnmacht fallen! Insgesamt 125 Tiere halten die Familie auf Trab.

Rider Masha is three. An orphan of Russian extraction, she's just been adopted by the Flinn family. Dwayne and Barbara breed exotic animals: miniature donkeys, llamas, Indian horses and so-called 'fainting goats', which pass out at the slightest excitement! 125 animals in all – enough to keep the family more than busy.

Masha, la cavalière, a trois ans. Orpheline d'origine russe, elle vient d'être adoptée par la famille Flinn. Dwayne et Barbara élèvent des animaux exotiques : ânes miniatures, lamas, chevaux indiens et *fainting goats*, des chèvres qui tombent évanouies à la moindre émotion ! Cent vingt-cinq bêtes au total, de quoi occuper toute la famille.

Flurlingen,
Switzerland,
3 October 1996

Daniela und Robert kamen gerade aus Paris zurück, wo sie nach 13 Ehejahren ihre zweiten Flitterwochen verbracht hatten. Für sie „ist die Familie das ganze Leben" und ihre Kinder sehen das offensichtlich genauso. Robert gesteht uns, dass er die Schweiz manchmal zu klein findet, um ihren Wissensdurst zu stillen. Als Herausgeber von Zeitschriften und Fotobüchern reist er sehr viel, während sich Daniela um die Einrichtung ihres neuen Heims kümmert (als wir sie fotografierten, wohnten sie vorübergehend im Hotel).

Daniela and Robert have just got back from a second honeymoon in Paris after 13 years of marriage. "Life means family" for them, and their children seem to agree. Robert admits to us that he sometimes finds Switzerland too small to satisfy "their desire to know everything." He publishes photographic magazines and books, and travels a lot, while Daniela copes with getting their new home in order (they were in between homes, staying in a hotel, when we photographed them).

Daniela et Robert viennent de rentrer de Paris où ils ont passé une deuxième lune de miel après treize ans de mariage. Pour eux, « la vie, c'est la famille » et leurs enfants ont l'air d'accord. Robert nous avoue qu'ils trouvent la Suisse parfois trop petite pour satisfaire « leur envie de tout savoir ». Il est éditeur de magazines et de livres de photos et voyage beaucoup, pendant que Daniela s'occupe de l'installation de leur nouvelle maison (ils étaient entre deux logis quand nous les avons photographiés, et vivaient à l'hôtel).

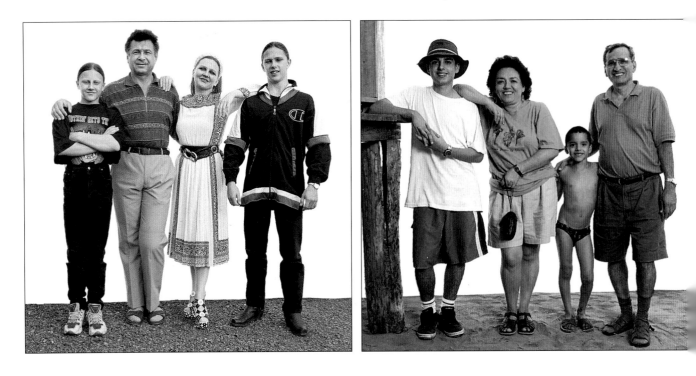

Brussels,
Belgium,
17 June 1998

Allabendlich geben sie sich auf einem Seil zehn Meter über dem Erdboden ein Stelldichein. Die alteingesessene Moskauer Akrobatenfamilie tingelt zehn Monate im Jahr durch die ganze Welt.

Every evening the family ends up on a wire 30 feet [10 m] above the ground. They've been acrobats for generations. Originally from Moscow, they spend ten months a year travelling the world.

Tous les soirs, la famille se retrouve sur un fil tendu à dix mètres de haut. Ils sont acrobates depuis des générations. Originaires de Moscou, ils passent dix mois par an à travers le monde.

Managua,
Nicaragua,
17 December 1998

Sie haben schon in Togo, Peru und Norwegen gelebt und wir trafen sie am Strand von San Juan in Nicaragua. Máximo arbeitet für eine norwegische Gesellschaft zur Förderung kleiner und mittelständischer Unternehmen. Im Jahr 2000 werden sie nach Lima in Peru ziehen. Sonia freut sich darauf, denn dort wird sie bei ihrer Familie sein und endlich Arbeit finden, was in Nicaragua schwierig ist. „Die Familie? Sie ist eine Art Schule für Toleranz und Demokratie", sagt sie lächelnd.

They have lived in Togo, Peru and Norway, and we met them on the San Juan beach in Nicaragua. Máximo actually works for a Norwegian development aid company, assisting small and medium-sized businesses. In 2000 they're moving to Lima, Peru. Sonia is thrilled, because she'll be with her family again, and she'll finally be able to find work – not an easy thing to do in Nicaragua. "The family? It's a kind of school of tolerance and democracy," she says, smiling.

Ils ont vécu au Togo, au Pérou, en Norvège et nous les avons rencontrés sur la plage de San Juan au Nicargua. Máximo travaille en effet pour une société norvégienne d'aide au développement de petites et moyennes entreprises. En l'an 2000, ils s'installeront à Lima au Pérou. Sonia en est ravie car elle va y retrouver sa famille et pouvoir enfin travailler, chose difficile au Nicaragua. « La famille? C'est une sorte d'école de tolérance et de démocratie! », dit-elle dans un sourire.

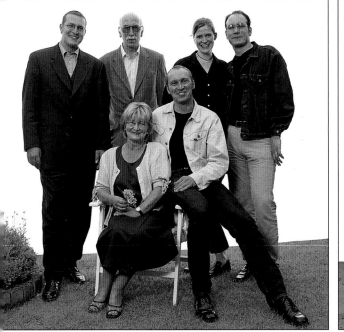

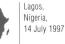
Kürten,
Germany,
31 July 1998

„Wir suchten beide einen Parkplatz und haben uns gefunden!" So beschreiben Helmut und Ingrid ihr erstes Treffen vor 35 Jahren. Ingrid ist stolz darauf, ihren beiden Söhnen das Kochen beigebracht zu haben, auch wenn sie behaupten, niemals auch nur eines der vielen Kochbücher aufgeschlagen zu haben, die sie ihnen geschenkt hat! Diese Meinungsverschiedenheit hatte aber keinerlei Einfluss auf die gute Stimmung und die perfekte Harmonie während unserer Fotosession.

"We were looking for parking places, and we found each other." This is how Helmut and Ingrid describe their first meeting, 35 years ago. Ingrid is very proud of having taught her boys how to cook, even if they claim they've never opened the many cookbooks their mum's given them! This difference of opinion in no way encroaches on the good humour and perfect understanding that reign over this merry portrait session.

« On cherchait une place de parking et on s'est trouvés ! » C'est ainsi que Helmut et Ingrid décrivent leur rencontre, il y a trente-cinq ans. Ingrid est très fière d'avoir appris à ses garçons l'art de cuisiner, même si eux prétendent ne jamais avoir ouvert les nombreux livres de cuisine offerts par leur maman ! Cette divergence n'entame en rien la bonne humeur et l'entente parfaite de cette joyeuse séance de portrait.

Lagos,
Nigeria,
14 July 1997

Friday wurde an einem Freitag geboren. Der arbeitslose Elektrotechniker posierte zur allgemeinen Bewunderung der Dutzenden von Schaulustigen, die sich eingefunden hatten, in traditioneller Tracht, gewürzt mit einer persönlichen Note! Er sieht die Situation in seinem Land eher pessimistisch: „Ohne eine demokratische Regierung wird das Leben für uns niemals leichter", aber er gibt die Hoffnung für das kommende Jahrtausend nicht auf.

Friday was born on a Friday. He's an out-of-work electronics technician, and he poses in traditional dress dolled up with a personal touch – much to the admiration of dozens of onlookers there for the photo session. He has a fairly pessimistic view of his country: "We need a democratic government so that life will be easier for us," but he's hopeful about the new millennium.

« Friday » est né un vendredi. Technicien en électronique au chômage, il pose en tenue traditionnelle agrémentée d'une touche personnelle, à la grande admiration des dizaines de spectateurs qui ont assisté à la photo. Il a une vision assez pessimiste de son pays : « Il faudrait un gouvernement démocratique pour que la vie nous soit moins pénible », mais il garde l'espoir pour l'an 2000.

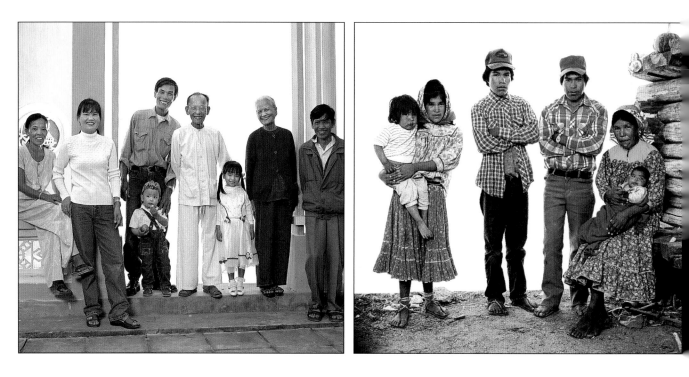

Hoi An,
Vietnam,
5 February 2000

Tran und Thai haben zehn Kinder und bisher 15 Enkelkinder (Tendenz steigend). Der Polizist im Ruhestand ist laut Thai „ein sehr guter Ehemann", erfreut sich regelmäßiger Besuche seiner Kinder und hofft, „noch viele weitere Enkelkinder zu bekommen".

Tran and Thai have ten children and so far 15 grandchildren (the number is constantly rising). Tran is a retired policeman and "a very good husband," adds Thai. He enjoys his children's regular visits and hopes "to see a lot more new grandchildren."

Trân et Thai ont eu dix enfants et jusque-là quinze petits enfants (leur nombre est en augmentation constante). Policier à la retraite et « très bon mari » (précise Thai), il se réjouit des visites régulières de ses enfants et espère « voir encore beaucoup de nouveaux petits-enfants ! »

Creel,
Mexico,
24 November 1998

Wie alle indianischen Familien in der Gegend leben Juan Calistro und seine Familie in einem einfachen Holzhaus mit wenig Komfort und bewirtschaften ein kleines Stück Land.

Like the other Indian families hereabouts, Juan Calistro and his family live in a simple wooden house with just the basics and work a small plot of land.

Comme les autres familles indiennes de la région, Juan Calistro et sa famille vivent dans une maison en bois au confort rudimentaire et cultivent un lopin de terre.

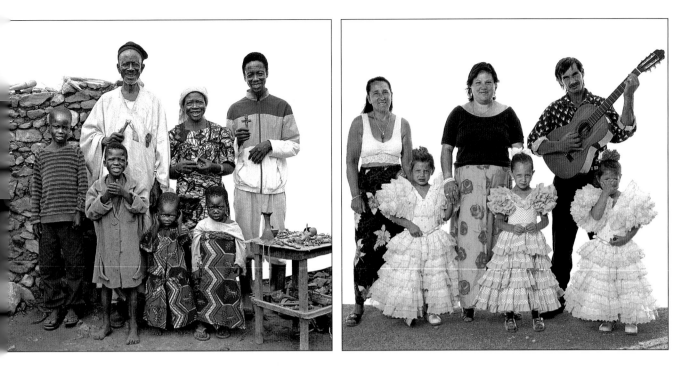

Roumsiki,
Cameroon,
30 July 1997

Sini, Gießer und Schmied, gewinnt seinen Rohstoff in den Hügeln vor der Stadt. Er zaubert daraus diverse Objekte und Figurinen, die er an durchreisende Touristen verkauft. Obwohl er diesen Beruf, den er von seinem Vater gelernt hat, inzwischen seit 50 Jahren ausübt, bringt er nicht genug ein, um seine Familie zu ernähren. Daher hilft er seiner Frau außerdem auf dem Feld, wo sie Mais und Hirse anbauen.

Sini, a foundry owner and blacksmith, gets his raw material from the hills around the village. He fashions it into various objects and small figures which are sold to passing tourists. Even though this has been his profession – taught to him by his father – for 50 years now, it's not enough to feed his family, so he makes sure to help his wife work their field, where they grow maize and millet.

Sini, fondeur et forgeron, va chercher sa matière première dans les collines qui entourent le village. Il la transforme en divers objets ou figurines vendues aux touristes de passage. Bien qu'il fasse ce métier, enseigné par son père, depuis maintenant cinquante ans, il ne suffit pas à nourrir sa famille, il s'organise pour aider sa femme à cultiver leur champ où ils font pousser maïs et mil.

Saintes-Maries-de-la-Mer,
France,
25 May 1998

José ist Roma und sein Haus heißt La Roulotte [Der Wohnwagen]. Seine Frau Marinette, die keine Roma ist, leidet sehr unter der Ablehnung, die ihr seit der Hochzeit sowohl von Josés als auch von ihrer eigenen Familie entgegengebracht wird. Eine schwierige Situation, die aber das Paar nur um so enger zusammengeschmiedet hat. Um ihrer Tochter die Schulbildung zu erleichtern, haben sie sich entschieden, in Saintes-Maries-de-la-Mer sesshaft zu werden. Wie schon seine Vorfahren baut José Wohnwagen im alten Stil, sowohl im Großformat wie auch in Miniaturausführung. Für sie ist der Begriff „Familie" weit gefasst: Onkel, Tanten, Cousins, Paten und sogar die Freunde gehören dazu. Auf dem Foto ist auch Josés Schwester mit ihrer Tochter.

Unlike his wife, José is a Roma and his home is called 'La Roulotte' [The Caravan]. Marinette doesn't like the discrimination she's suffered among the Roma and in her own family ever since the day she married José – a difficult situation that has further welded the bonds between this very close-knit couple. They've decided not to roam any more, but to settle in Saintes-Maries-de-la-Mer to make it easier for their daughters to attend school. Like the elders of his family, José makes old-style horse-drawn caravans, both life-size and miniature. For them the "family" also means uncles, aunts, cousins, godparents and friends. The photo also shows José's sister and her daughter.

José est gitan et sa maison s'appelle « la Roulotte ». Marinette sa femme, qui n'est pas gitane, regrette la discrimination qu'elle a subie chez les gitans comme dans sa propre famille le jour où elle a épousé José. Une situation difficile qui a renforcé les liens de ce couple très uni. Ils ont décidé de ne plus voyager et de se fixer aux Saintes-Maries-de-la-Mer pour faciliter la scolarité de leurs filles. José, comme ses aînés, fabrique en taille réelle et miniature des roulottes à l'ancienne. Pour eux, la « famille » ce sont aussi les oncles, les tantes, les cousins, les parrains et les amis. Figurent ainsi sur la photo la sœur de José et sa fille.

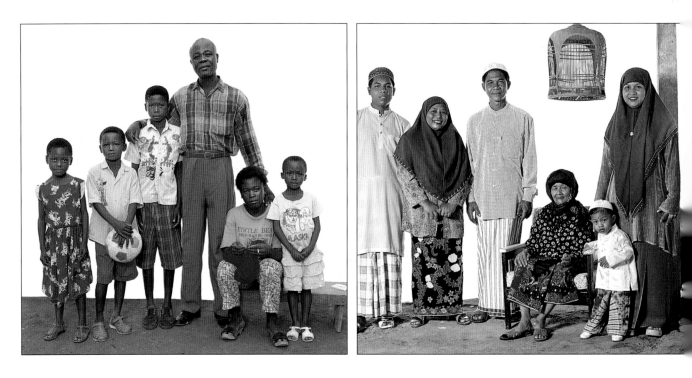

Ebebiyín,
Equatorial Guinea,
15 August 1997

Joaquim ist Gerichtsschreiber beim Zivilgericht von Ebebiyín. Da seine Frau als Händlerin häufig die Nachbarländer bereist, ist Joaquim häufig mit den Kindern allein zu Hause.

Joaquim is clerk of the court at the law courts in Ebebiyín, while his wife is a shopkeeper and travels a lot to neighbouring countries. This is why he often ends up alone with his children.

Joaquim est greffier au tribunal de première instance d'Ebebiyin, sa femme est commerçante et voyage beaucoup dans les pays voisins, c'est pour cela qu'il se retrouve souvent seul avec ses enfants.

Surat Thani,
Thailand,
9 January 2000

Ihr Beruf? Sie betreiben eine Tankstelle für Fischerboote. Jeder hat eine feste Aufgabe: Der Vater leitet den Verkauf, die Mutter macht die Buchhaltung und der Sohn liefert das kostbare Benzin mit dem Kleintransporter.

Their profession? They run a fuel supply business for fishing boats. They all have their jobs: the father is in charge of sales, the mother does the accounts and the son delivers the precious fuel by van.

Leur métier? Ils ont une entreprise de ravitaillement en carburant pour les bateaux de pêche. Chacun y a sa fonction : le père est commercial, la mère comptable, le fils livre le précieux liquide en camionnette.

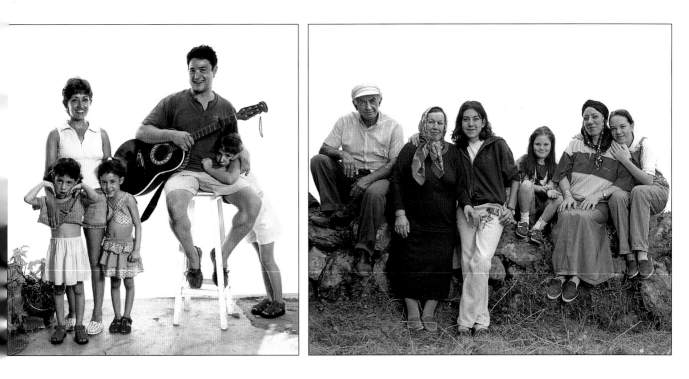

Posadas,
Argentina,
26 March 1999

„Die Familie ist ein Segen und es ist unsere wichtigste Pflicht, sie zu behüten." So denken, kurz gefasst, Miguel, Verwaltungsdirektor, und seine Frau Gladys. Wenn sie sich nicht um ihre Mädchen und das Haus kümmert, führt Gladys ein kleines Keksgeschäft, das sie eröffnet hat, und träumt von einer Reise nach Spanien, der Heimat von Miguels Familie.

"The family is a rich blessing, and our primary duty is to watch over it." This in short is the view of both administrative director Miguel and his wife Gladys. When she's not looking after their daughters and the house, Gladys runs the little biscuit business she's set up and dreams of travelling to Spain, where Miguel's family is from.

« La famille est une richesse, notre premier devoir est de veiller sur elle. » En résumé, c'est la pensée commune de Miguel, directeur administratif, et de Gladys, son épouse. Quand elle ne s'occupe pas de ses filles et de la maison, Gladys gère le petit commerce de biscuits qu'elle a créé et rêve de faire un voyage en Espagne, berceau de la famille de Miguel.

Camlihemşin,
Turkey,
18 August 1999

„Es ist höchste Zeit für eine Wende! Moslems, Christen, Juden – alle Religionen der Welt sollten sich endlich versöhnen", fordert Idris, eingefleischter Junggeselle und stellvertretender Familienvater (hier mit der Frau seines verstorbenen älteren Bruders, seiner Nichte und deren Nachwuchs). Nachdem er 30 Jahre lang rund um die Welt gereist ist und Afrika, Australien und Europa gesehen hat, lebt der 68-Jährige nun wieder in seinem Heimatdorf. Dort hat er am Ufer eines malerischen Gebirgsbachs ein Gasthaus aufgemacht, das jedoch vielleicht schon bald einem Elektrizitätswerk weichen muss – die Bauarbeiten haben bereits begonnen.

"We must stop the way things are going. Muslims, Christians, Jews and all the rest must finally understand one another," 68-year-old Idris tells us. He is a confirmed bachelor and a father by proxy (seen here with his deceased elder brother's wife, his niece and her three children). After spending 30 years exploring Africa and Australia by way of Europe, he returned to his native village, where he opened an inn beside a beautiful mountain river. It is now threatened by a plan to construct a power station – and work on it has already started.

« Il faut arrêter le film! Les musulmans, chrétiens, juifs et tous les autres doivent enfin se comprendre », nous dit Idris, soixante-huit ans, célibataire endurci et père de famille par procuration (ici avec la femme de son grand frère décédé, sa nièce et les trois enfants de celle-ci). Après avoir passé trente ans à découvrir le monde de l'Afrique à l'Australie en passant par l'Europe, il est rentré dans son village natal. Il a ouvert une auberge au bord d'une rivière de montagne magnifique, pourtant menacée par un projet de centrale électrique, dont les travaux ont déjà commencé.

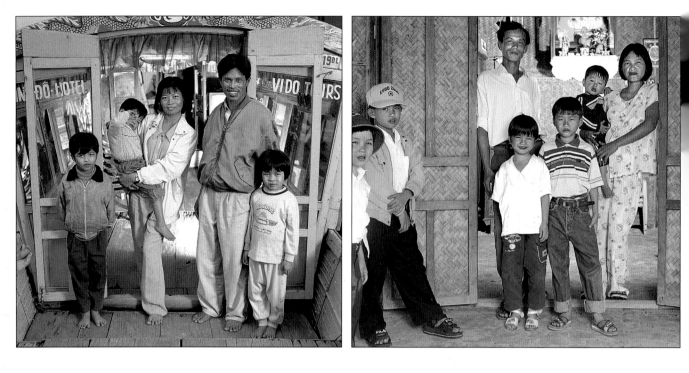

Hue,
Vietnam,
3 February 2000

Der Lastkahn ist ihr Zuhause. Er dient als Ausflugsboot für Touristen, die die Stadt vom Fluss aus entdecken wollen, und als Frachtboot für den Sand, den sie vom Grund des Flusses holen und an Bauunternehmer verkaufen.

Not only does their barge serve as their home and a sightseeing boat for tourists eager to discover the city from the river, but it is also a transport for the sand which they dredge from the bottom of the river and sell to building contractors.

La péniche leur sert de domicile – de « bateau-mouche » pour touristes désireux de découvrir la ville par la rivière et pour le transport de sable, qu'ils récupèrent au fond de la rivière et vendent aux entrepreneurs.

Hoi An,
Vietnam,
5 February 2000

Tran liebt seinen Beruf als Fischer. Wenn er wegen schlechten Wetters nicht aufs Meer hinaus kann, kümmert er sich um den Salat, die Tomaten und die Zwiebeln in seinem Garten. Seine Frau Ho Thi übernimmt den Verkauf des Fischs auf dem Markt von Hoi An.

Tran is a fisherman who enjoys his work. When bad weather stops him going out to sea, he tends the lettuce, tomatoes and onions in his garden. His wife Ho Thi sells his fish at the Hoi An market.

Pêcheur, Trân aime son métier. Quand le mauvais temps l'empêche de sortir en mer, il s'occupe des salades, tomates et oignons de son potager. Sa femme Hô Thi se charge de vendre le poisson au marché de Hoi An.

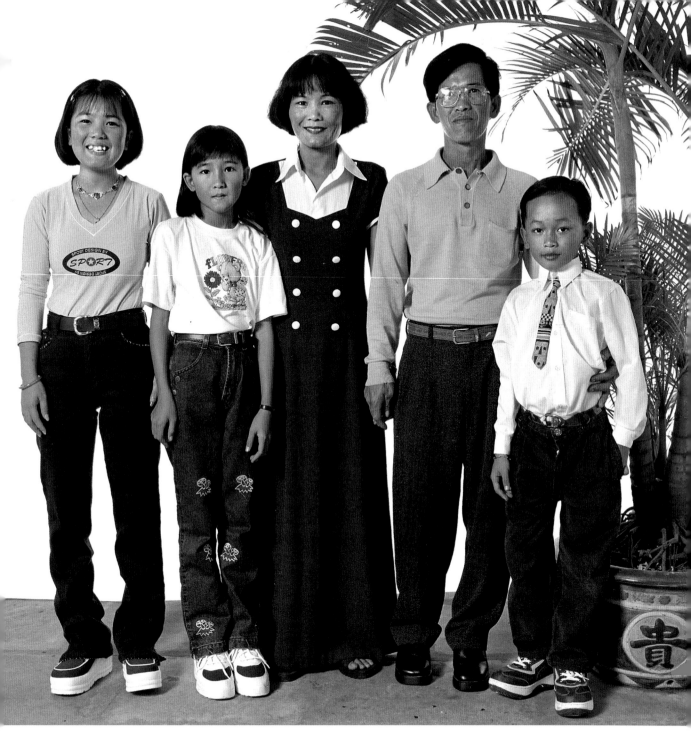

Hoi An,
Vietnam,
5 February 2000

Dung ist 18 und träumt davon, Fremdenführerin zu werden, „um ganz Vietnam zu bereisen". Bis dahin folgt sie dem Beispiel ihres Vaters, einem Vietname-sisch-Lehrer am Gymnasium von Hoi An, und studiert für das Lehramt. Ihre Mutter, ehemals Schneiderin, hat ein Restaurant eröffnet, in dem die ganze Familie mit anpackt.

Eighteen-year-old Dung dreams of becoming a tour guide "so I can visit every part of Vietnam." Meanwhile she is following her father's footsteps (he teaches Vietnamese at Hoi An's secondary school) and is studying to be a teacher. Once a dressmaker, her mother has opened a restaurant, where the whole family gives a helping hand.

Dung (dix-huit ans) rêve de devenir guide « pour visiter tout le Viêt-nam ». En attendant, elle suit les traces de son père, professeur de vietnamien au lycée de Hoi An, et fait des études d'enseignante. Sa maman, ancienne couturière, a ouvert un restaurant où toute la famille donne un coup de main.

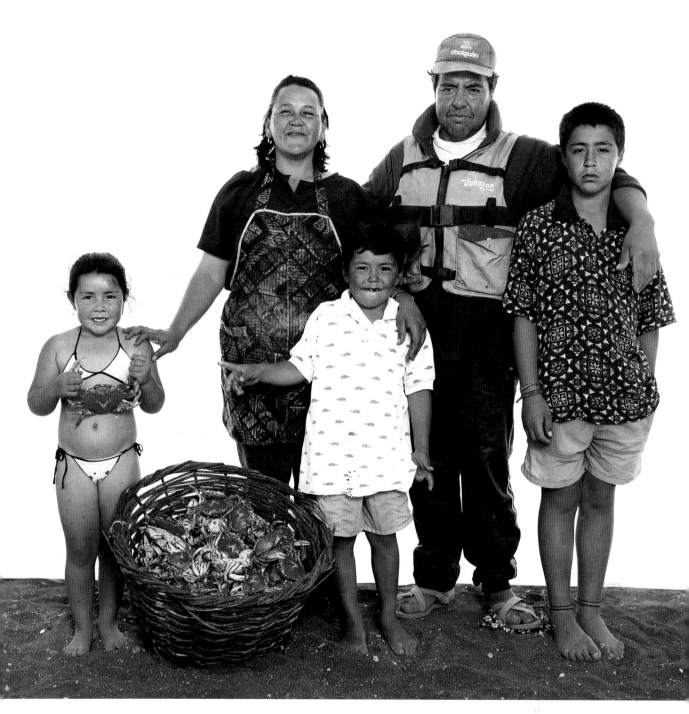

Curanipe,
Chile,
16 January 1999

„Bevor wir an die Küste gezogen sind, haben wir im Landesinneren gewohnt und Gemüse verkauft. Jetzt ist mein Mann Fischer und ich verkaufe den Fisch." Zweimal täglich fährt Ramón aufs Meer hinaus. Sein Fang ist saisonabhängig: Im Sommer fängt er überwiegend Fisch, doch im Winter, wie jetzt, sind es häufig Krebse. „Das einzige, was ich von meinen Kindern verlange, ist, dass sie lernen", vertraut er uns an. Und Adriana fügt hinzu: „Der Mensch denkt, Gott lenkt."

"Before we lived on the coast we lived inland, where we sold vegetables. Today my husband is a fisherman and I sell the fish." Twice a day Ramón goes out to sea. The fishing is seasonal. In summer it's mainly fish he catches, but in winter, like today, he often brings home crab. "All I ask of my children is to study," he tells us. Adriana adds: "We propose, God disposes."

« Avant de vivre sur la côte, nous étions à l'intérieur du pays où nous vendions des légumes. Aujourd'hui mon mari est pêcheur et je vends le poisson. » Deux fois par jour, Ramon sort en mer. Sa pêche dépend de la saison : en été, c'est essentiellement du poisson, mais en hiver, comme aujourd'hui, il ramène souvent des crabes. « Tout ce que je demande à mes enfants, c'est d'étudier », nous confie-t-il. Adriana ajoute : « Nous proposons, Dieu dispose ! »

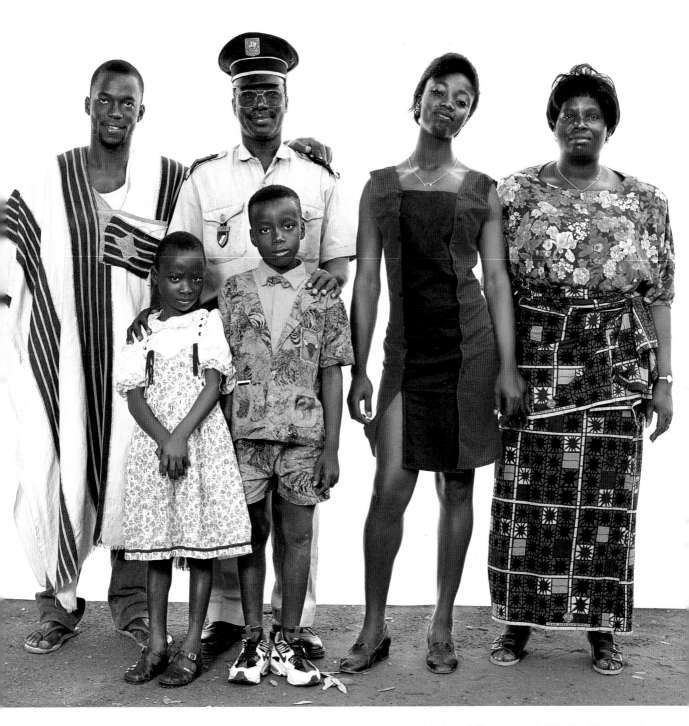

Odienné,
Ivory Coast,
5 April 1997

Robert steht auf seinem Posten an der Ortseinfahrt. Unser Wagen erregt seine Aufmerksamkeit. Als wir ihm unser Projekt erklären, bietet er uns sofort an, mit seiner Familie zu posieren. Seit 1969 im Polizeidienst, lebt er mit seiner zweiten Frau und seinen drei Kindern in Odienné. „Bitte sagen Sie Präsident Bédié, dass wir uns unmöglich auf fünf Kinder beschränken können – wir sind schließlich Afrikaner. Das Kindergeld muss unbedingt erhöht werden. Aber ein Bravo dafür, dass er der Elfenbeinküste Frieden gebracht hat!"

Robert is at his post at the entrance to the town. Our vehicle attracts his attention. We tell him what we're doing, and he immediately offers to pose with his family. He has been a policeman since 1969 and lives in Odienné with his second wife and his three children. "Could you tell President Bédié that we can't keep it down to five children – after all, we're African. They'll have to raise family allowances. But top marks for the peace he's created in Ivory Coast!"

Robert est à son poste à l'entrée de la ville. Notre véhicule attire son attention. Nous lui expliquons notre projet, aussitôt il se propose de poser avec sa famille. Policier depuis 1969, il vit à Odienné avec sa deuxième femme et ses trois enfants. « Pouvez-vous dire au Président Bédié qu'il nous est impossible de nous en tenir à cinq enfants car nous sommes Africains! Il faudrait augmenter les allocations familiales. Mais bravo pour cette paix qu'il entretient en Côte d'Ivoire! »

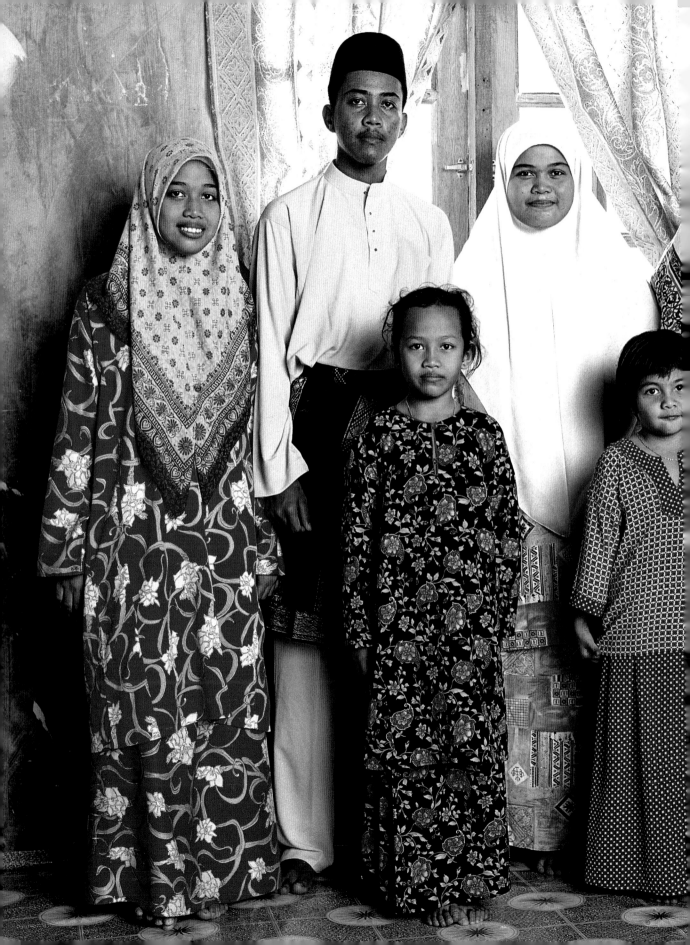

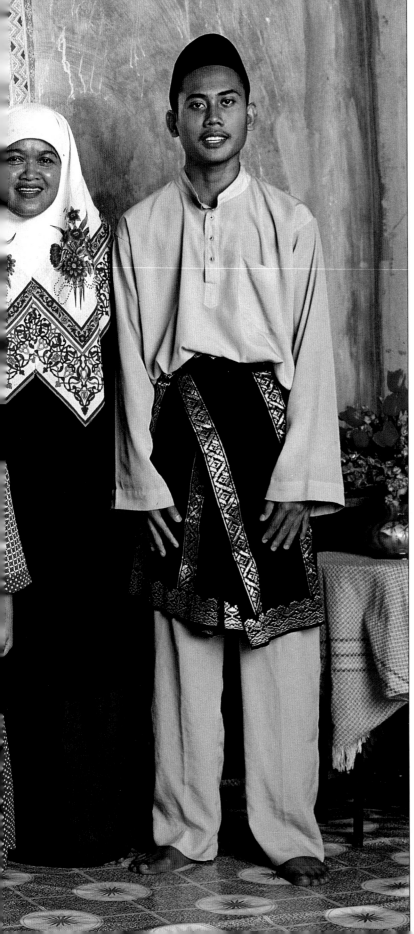

Die Witwe Noriha, hier mit ihren drei Kindern und zwei Neffen, ist Religionslehrerin an der Koranschule. Von ihrer Mutter inspiriert, verfolgen die Kinder alle sehr seriöse Berufsziele: Arabischlehrer, Religionslehrer und Anwalt.

Pictured here with her three children and two nephews, widow Noriha teaches religion at the Koranic school. Her children are inspired by their mother and see themselves in very serious professions – professor of Arabic, professor of religion, and lawyer.

Veuve, Noriha, ici avec ses trois enfants et deux neveux, est professeur de religion à l'école coranique. Ses enfants très inspirés par leur mère envisagent des métiers très sérieux: professeur d'arabe, professeur de religion et avocate.

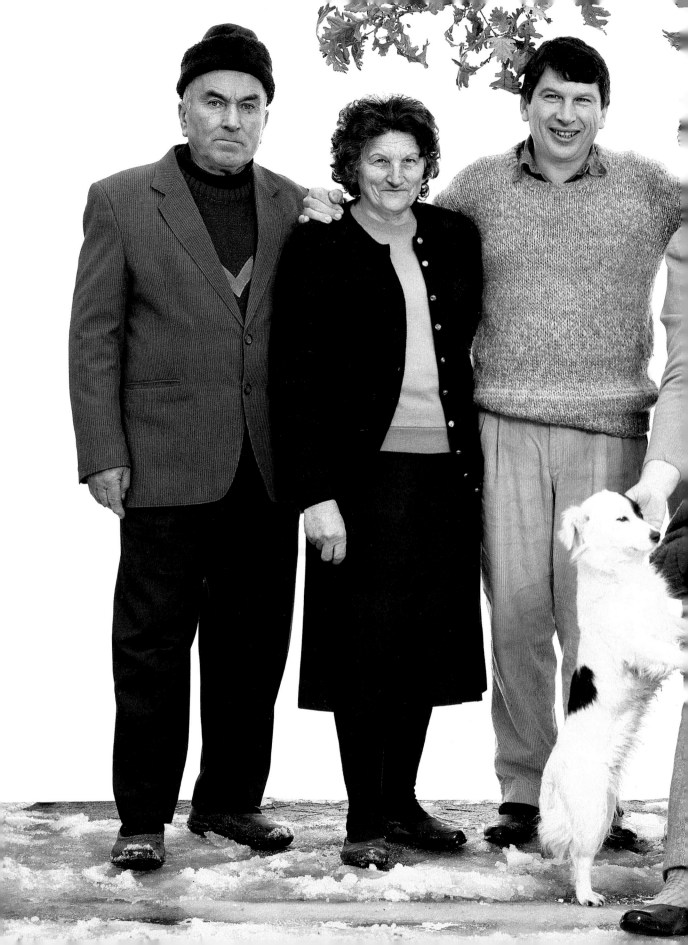

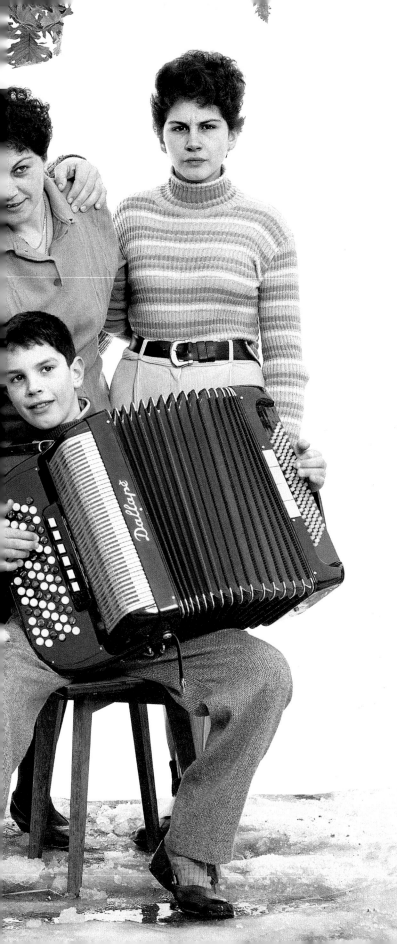

near Kraljevo,
Yugoslavia,
7 January 1997

Sie luden uns ein, an ihrem Festmahl zum orthodoxen Weihnachtsfest teil-
zunehmen. Seit drei Generationen bewirtschaftet die Familie den Hof, dessen
Gebäude und Stallungen wir besichtigen durften, freilich erst nach einer
Kostprobe ihrer hausgemachten Leckereien: Schinken, Würste, Käse, Ge-
müse, Obst … und Schnaps!

They invited us to share their Orthodox Christmas meal. They have been
farmers and livestock-breeders for three generations in the village and
showed us round all the farm buildings after we sampled their home-made
produce: ham, salami, cheese, vegetables, fruit – and schnaps!

Ils nous ont invités à partager leur repas du Noël orthodoxe. Paysans et
éleveurs installés depuis trois générations dans le village, ils nous ont fait
visiter tous les bâtiments de la ferme après une dégustation de produits
maison: jambon, saucisson, fromage, légumes, fruits … et eau-de-vie.

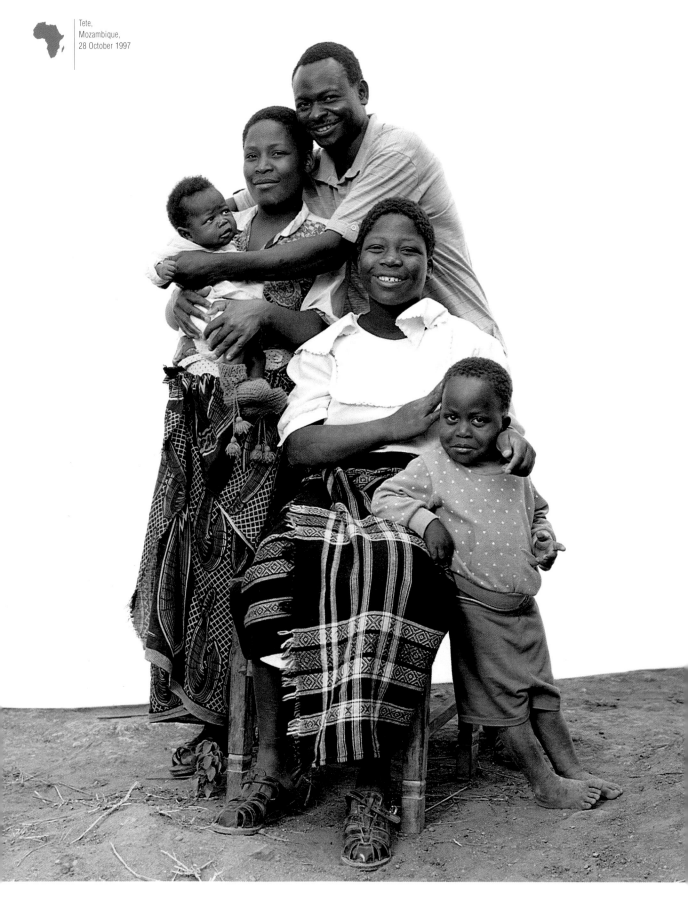

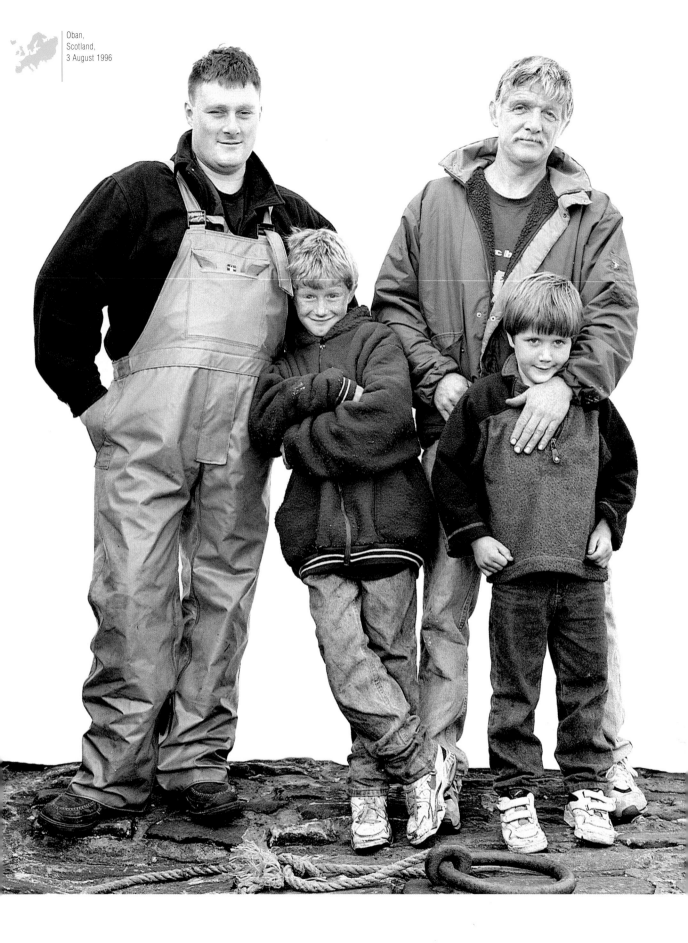

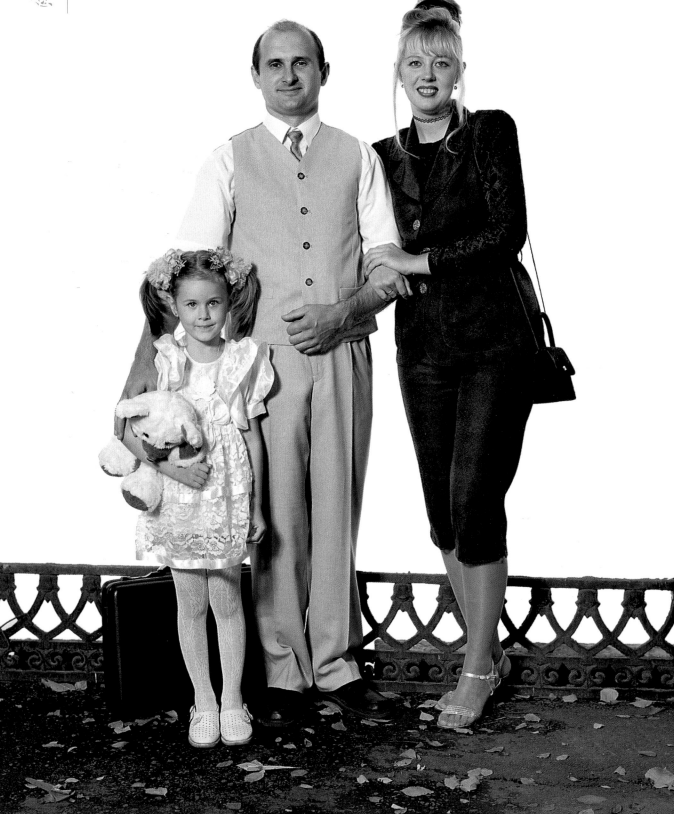

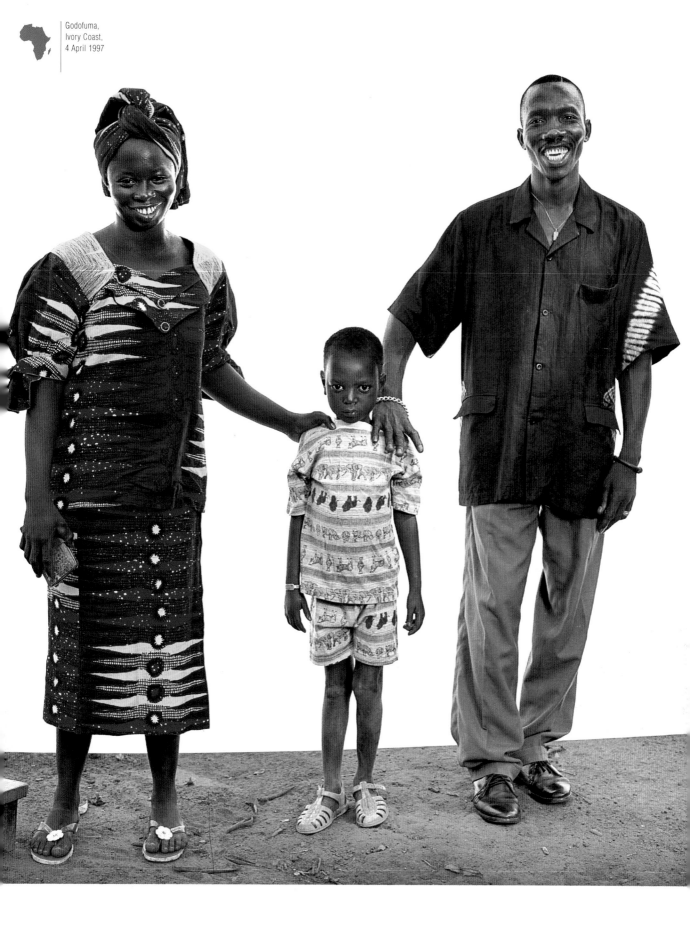

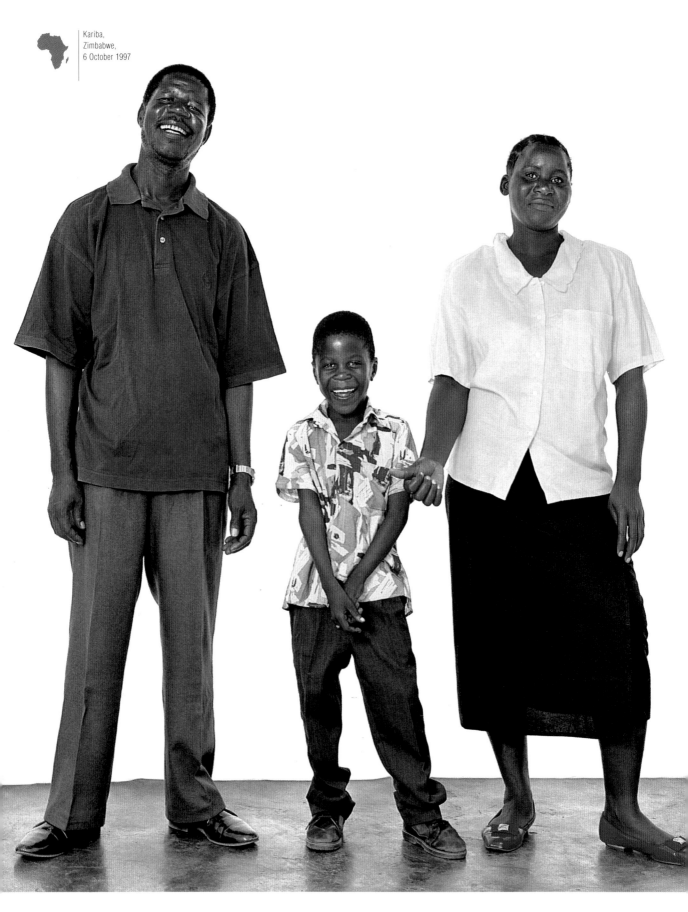

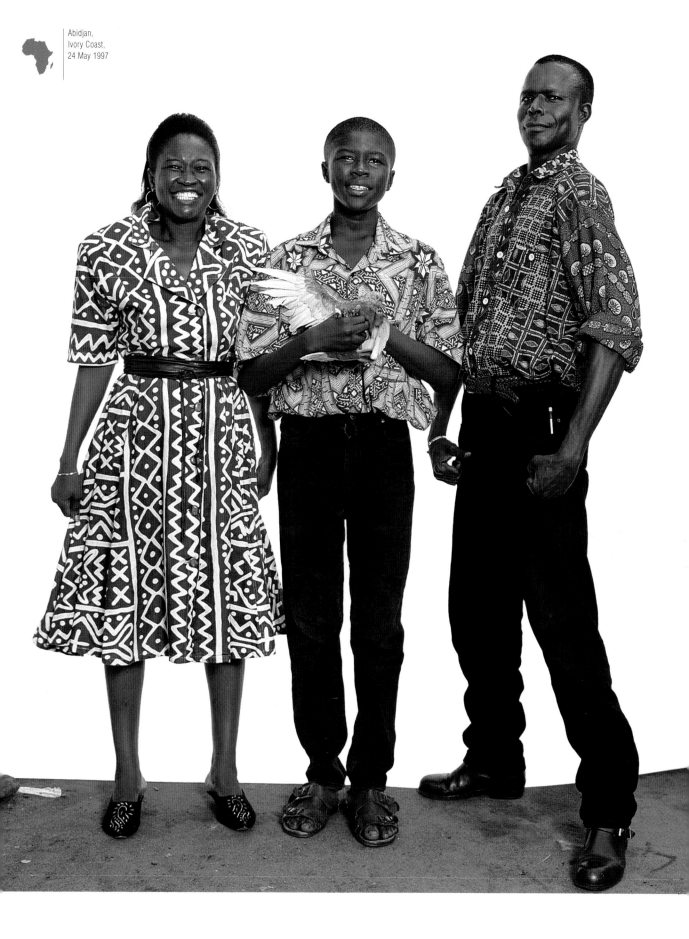

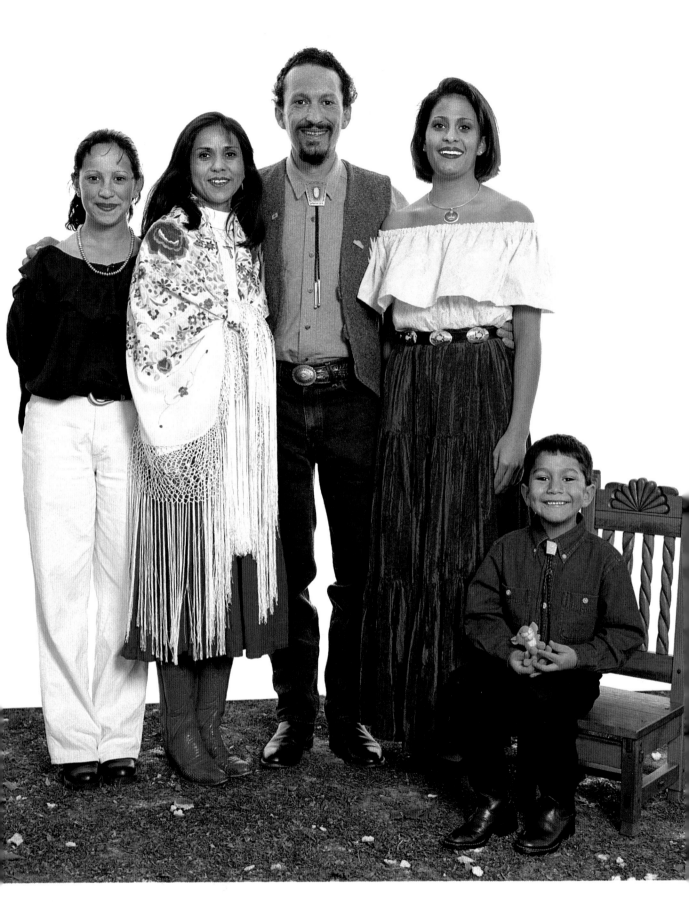

Page 122

João lebt in einer Hütte mit seiner Frau, den Kindern und der Schwägerin … Der gelernte Mechaniker ist momentan arbeitslos, hofft aber, bis 2000 eine eigene Werkstatt zu besitzen.

João lives in a hut with his wife, children and sister-in-law. A mechanic by training, he's currently out of work, but is hoping to have his own workshop by the year 2000.

João vit dans une case avec femme, enfants et belle-sœur … Mécanicien de formation, il est actuellement sans travail, mais espère bien avoir son propre atelier de mécanique en l'an 2000.

Page 123

Drei Generationen Fischer … Wir haben sie fotografiert, kurz bevor sie für drei Tage zum Garnelenfischen aufs Meer hinausfuhren.

Three generations of fishermen … and we photographed them just before they weighed anchor for three days at sea, fishing for shrimp.

Trois générations de pêcheurs … que nous avons photographiées juste avant leur départ en mer pour trois jours de pêche à la crevette …

Page 124

Flugzeugingenieur Juri, der zurzeit in einer Druckerei beschäftigt ist, würde auch nach Russland ziehen, um in seinem Beruf arbeiten zu können. Vera ist Diplom-Ingenieurin und sucht eine Stelle, die ihrer Ausbildung entspricht. Sie wünscht sich ein weiteres Kind, „aber bei unserer momentanen finanziellen Situation ist das nicht drin." Das neue Jahrtausend? „Geld ist nicht alles. Solange es keinen Krieg mehr gibt, sind wir glücklich und zufrieden!"

Yuri works at a printing press, but his real profession is aviation engineering, where he really hopes to find work soon, even if this means emigrating to Russia. A graduate of the Polytechnic Institute, Vera is looking for work and dreams of having another child, "but the economic situation is too precarious at the moment." The new millennium? "Money is not the be all and end all – what we want is peace."

Youri travaille dans une imprimerie, mais son vrai métier est ingénieur dans l'aviation, domaine dans lequel il espère bien retrouver du travail, même si pour cela il doit émigrer en Russie où il a gardé de bons contacts. Vera qui est diplômée de l'Institut polytechnique cherche du travail et rêve d'un autre enfant « mais la situation économique est trop difficile en ce moment ». L'an 2000? : « L'argent n'est pas le plus important, c'est la paix que nous espérons! »

Page 125

„Im neuen Jahrtausend bin ich wahrscheinlich noch immer hier. Ich hoffe, dass ein neuer Wind profitable Veränderungen für die Bauern des Dorfs bringt." So lautet der Wunsch dieses jungen Landwirts. Er, seine Frau und sein Sohn sind zweifellos die kleinste Familie des Dorfs – jedenfalls für den Moment.

"I'll probably still be here in the new millennium. I hope a new wind will usher in profitable changes for village farmers." That is the wish of this young farmer. He, his wife and their son are definitely the smallest family in the village – for the time being.

« En l'an 2000, je serai probablement encore ici, j'espère qu'un vent nouveau apportera un changement profitable aux agriculteurs du village. » C'est le souhait de ce jeune agriculteur. Lui, sa femme et son fils forment sans aucun doute la plus petite famille du village – pour le moment …

Page 126

Passmore ist Kapitän eines Fischerboots, aber Zeit seines Lebens ist er nur auf dem Karibasee gefahren, der künstlich durch den Staudamm am Sambesi geschaffen wurde. „Ich hoffe, dass mein Sohn ein guter Fischer wird, mit einem großen Boot."

Passmore is captain of a fishing boat, but he's only ever sailed on Lake Kariba, which was created by the dam across the Zambezi River. "I hope that my son will become a good sailor, and maybe own a large boat."

Capitaine de pêche, Passmore n'a pas navigué ailleurs que sur le lac Kariba, créé par le barrage sur le fleuve Zambèze. « J'espère que mon fils deviendra un bon marin et même propriétaire d'un grand bateau. »

Page 127

Soro Solo, Kulturjournalist beim Radio, und Ramata, Augenärztin im Krankenhaus von Treichville, sind ein modernes Paar, das dennoch die afrikanischen Traditionen respektiert. Für ihn ist die Ehe das Gegenteil von Freiheit, die Familie ein kleines Gefängnis, aber auch Schutz – von daher kein Bedauern …

With one of them a cultural journalist on the radio, the other an ophthalmologist at Treichville hospital, Soro Solo and Ramata make a modern couple, but also respect African traditions. For him, marriage is the opposite of freedom, the family a mini-prison, but it also offers protection – so, no regrets …

Journaliste culturel à la radio et ophtalmologue à l'hôpital de Treichville, Soro Solo et Ramata forment un couple résolument moderne tout en respectant les traditions africaines. Pour lui, le mariage est l'antithèse de la liberté, la famille une petite prison, mais également une protection … Donc pas de regrets …

Santa Fe,
New Mexico, USA,
21 November 1998

Die Familiengeschichte der Chavez reicht weit zurück: Schon 1492 kamen ihre Vorfahren mit Kolumbus nach Amerika und 1680 ließ sich ihre Familie in New Mexico nieder. Sie leben hier in der 13. Generation und sind stolz auf ihre spanischen Wurzeln. Miguel fertigt Möbel und traditionelle kunsthandwerkliche Objekte. Er versucht, das Kunsttischlerhandwerk als Schulfach einzuführen. In diesem Jahr werden die Schüler einer Klasse ihren eigenen Stuhl entwerfen und signieren. Elena (20) hingegen, die gekürte Queen of Santa Fe 1997, tritt in diesem Jahr für die Wahl zur Miss New Mexico an.

The Chavez family go back a long way: their ancestors arrived in America in 1492, and the family has been living in New Mexico since 1680. They can trace the family back through 13 generations, all proud of their Spanish origins. Miguel designs furniture and traditional objects. He's trying to get cabinet-making included in the school curriculum, and this year the students in one class will be creating and signing their own chairs. Elena, who's 20, was elected Queen of Sante Fe 1997, and is now competing for the Miss New Mexico title this year.

Les Chavez sont une famille historique : arrivée en Amérique en 1492 et installée au Nouveau-Mexique depuis 1680, la famille compte treize générations fières de leurs origines espagnoles. Liz gère le département des ressources humaines à l'hôpital de Santa Fé et Miguel est créateur de meubles et d'objets d'inspiration traditionnelle. Il tente d'inscrire l'ébénisterie artistique au programme scolaire et cette année les élèves d'une classe vont créer et signer leur propre chaise. Quant à Elena (vingt ans), élue *Queen of Santa Fe 1997*, elle est en compétition pour le titre de *Miss New Mexico* cette année!

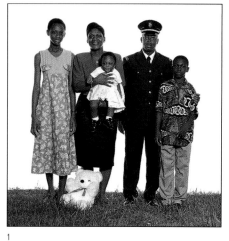

1

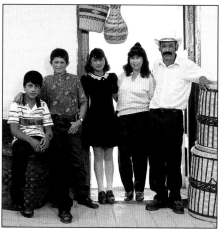

2

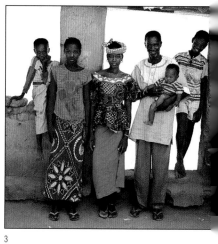

3

1
Abidjan,
Ivory Coast,
29 March 1997

2
Tenza,
Colombia,
20 February 1999

3
Pallenfula,
Gambia,
27 April 1997

4
Champasak,
Laos,
29 January 2000

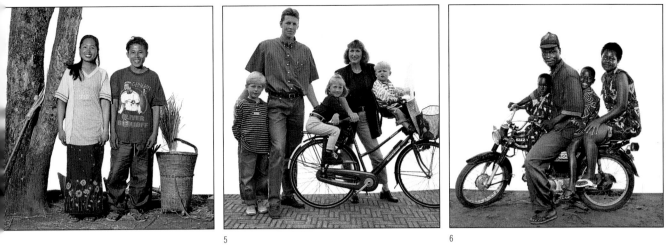

5

6

5
Beesd,
The Netherlands,
19 June 1998

6
Abomey,
Benin,
12 July 1997

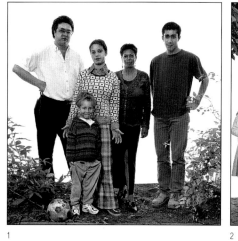

1

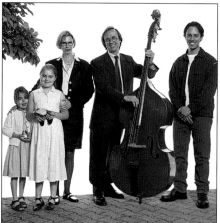

2

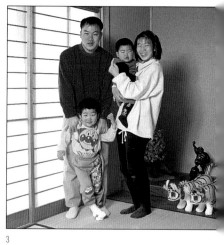

3

1
Brussels,
Belgium,
16 June 1998

2
Lyons,
France,
29 May 1998

3
Kyoto,
Japan,
27 February 2000

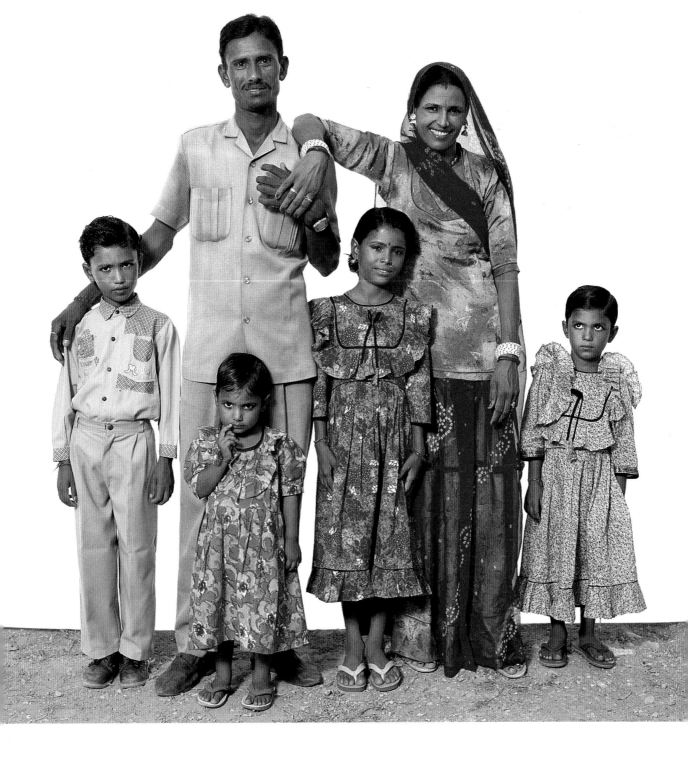

Jaisalmer,
India,
14 October 1999

„Für die beiden kommenden Monate erwarten wir strahlenden Sonnenschein!" Bekharam arbeitet bei der Wetterwarte von Jaisalmer. In seiner Freizeit spielt er Cricket und schaut sich die Übertragungen der großen Spiele im Fernsehen an.

"There'll be sunshine for the next two months," Bekharam tells us. He works at the Jaisalmer meteorological station. When he is not making forecasts, he likes playing cricket and watching big matches on TV.

« Il y aura du soleil pendant les deux mois à venir ! », nous dit Bekharam, employé à la station météorologique de Jaisalmer. Quand il ne fait pas des prévisions, il aime jouer au cricket et regarder les grands matchs à la télé.

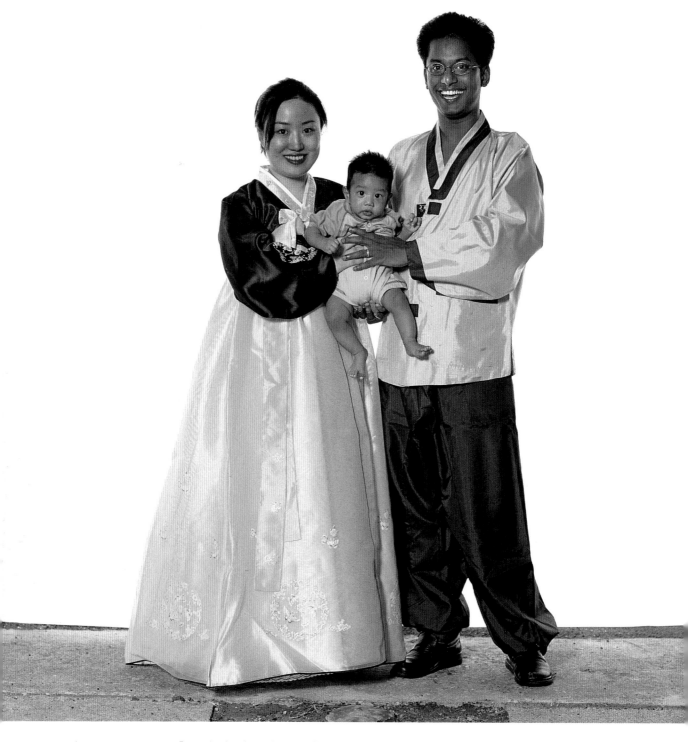

Melaka,
Malaysia,
3 January 2000

„Es war sehr schwer für uns, denn unsere Eltern waren gegen unsere Heirat. Aber inzwischen ist es besser." Der in Malaysia lebende Inder Palani und die Koreanerin Hong Suk Mee haben sich an der Universität von Seoul kennen gelernt und arbeiten heute beide für die malaysische Niederlassung eines koreanischen Unternehmens. In ihrer Freizeit gehen sie am liebsten shoppen. Sie würden gern bald einmal nach Australien reisen.

"It was very difficult for us: our parents were completely against our marriage. But things are better now." Palani (an Indian from Malaysia) and Hong Suk Mee (Korean) met at Seoul University. They work for a Korean company in Malaysia. Their favourite pastime is shopping. They'd like to travel to Australia in the near future.

« Cela a été très difficile pour nous. Nos parents étaient totalement opposés à notre mariage! Maintenant cela va mieux. » Palani, l'Indien malais, et Hong Suk Mee, Coréenne, se sont rencontrés à l'université de Séoul. Ils travaillent pour une société coréenne en Malaisie. Leur passe-temps favori est le shopping. Dans un futur proche, ils aimeraient faire un voyage en Australie.

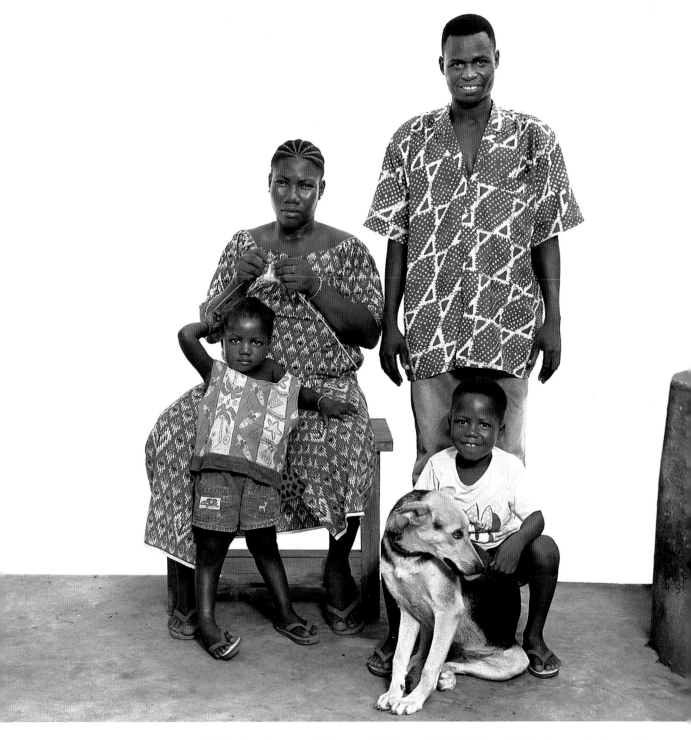

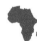

Abidjan,
Ivory Coast,
3 March 1997

Ludovic, der in Burkina Faso geboren wurde, ist „Bremsen-Spezialist". Da er sich jedoch das Werkzeug nicht leisten kann, um seinen Beruf auszuüben, arbeitet er als „Boy" in der Villa eines „Weißen". Jetzt steht allerdings erst einmal Familienzuwachs ins Haus – das Baby soll nächste Woche auf die Welt kommen.

Originally from Burkina Faso, Ludovic is a "brake specialist." Finding it financially impossible to buy the tools he needs to practice his trade, he's got a job as a 'boy' in a villa of a foreign family. Right now he's keen to have a bigger family – a baby is due next week.

D'origine burkinabé, Ludovic est « réparateur de freins ». Dans l'impossibilité financière de se procurer les outils nécessaires à l'exercice de son métier, il travaille comme « boy » dans une villa. Dans l'immédiat, il souhaite agrandir sa famille, un bébé doit voir le jour la semaine prochaine!

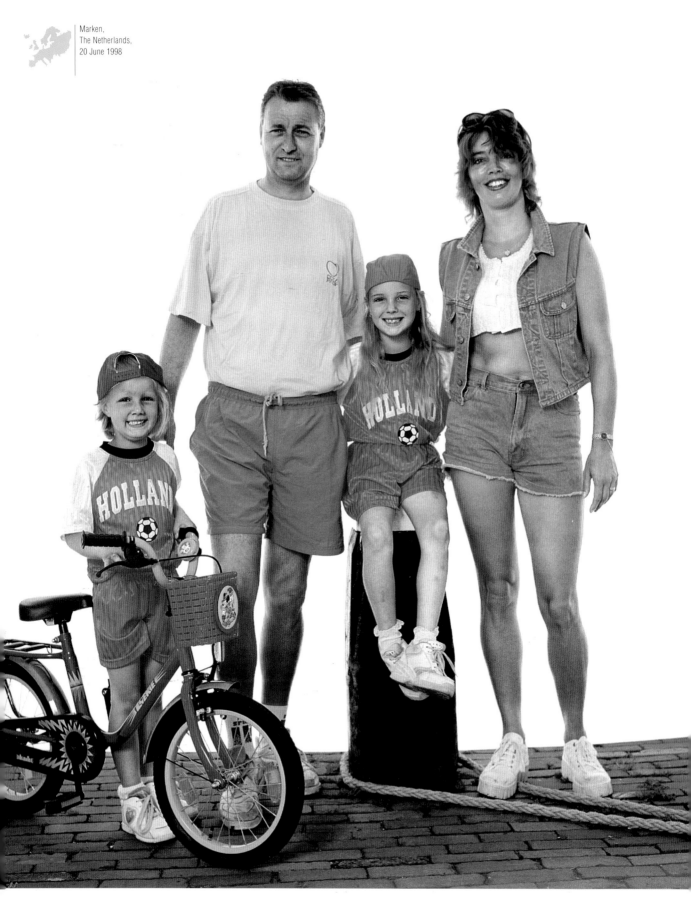

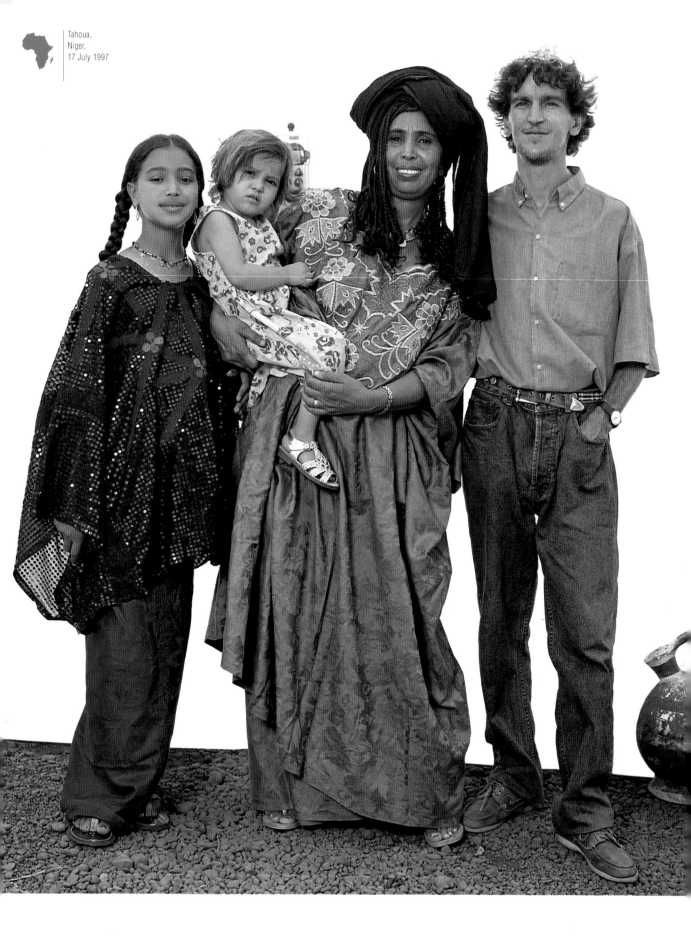

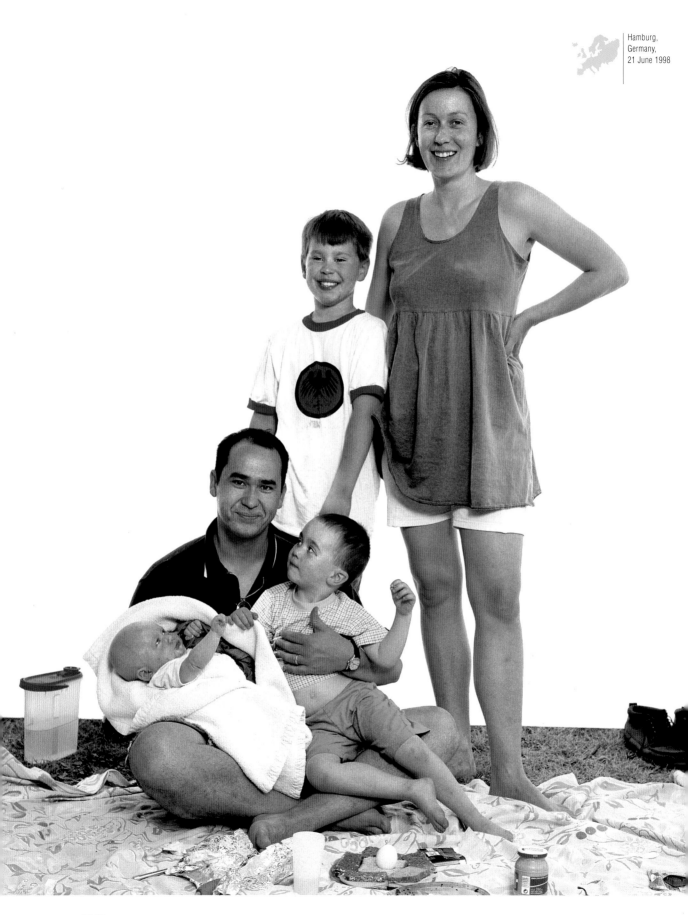

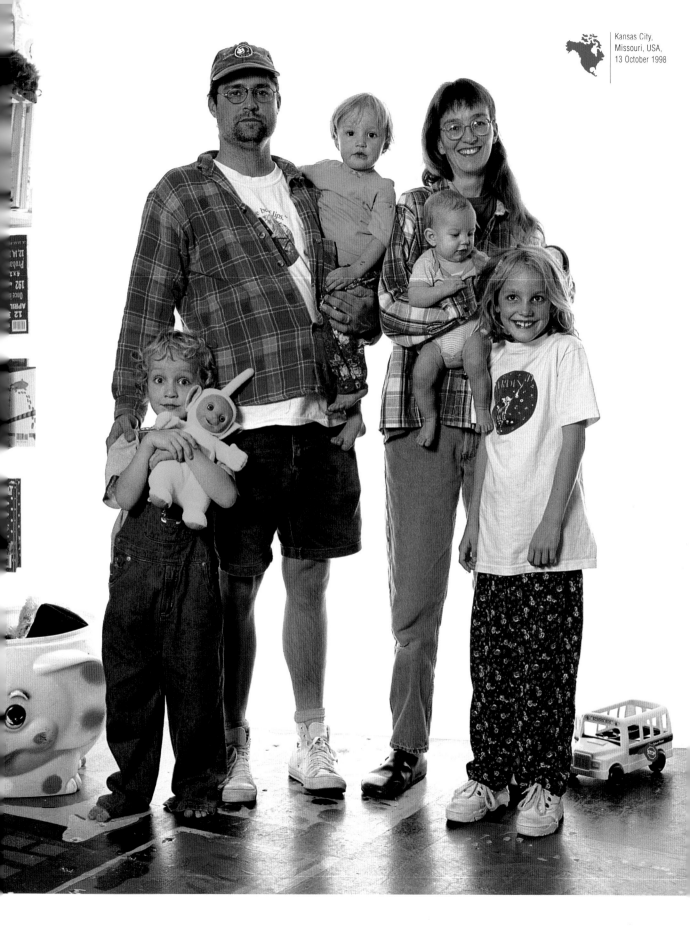

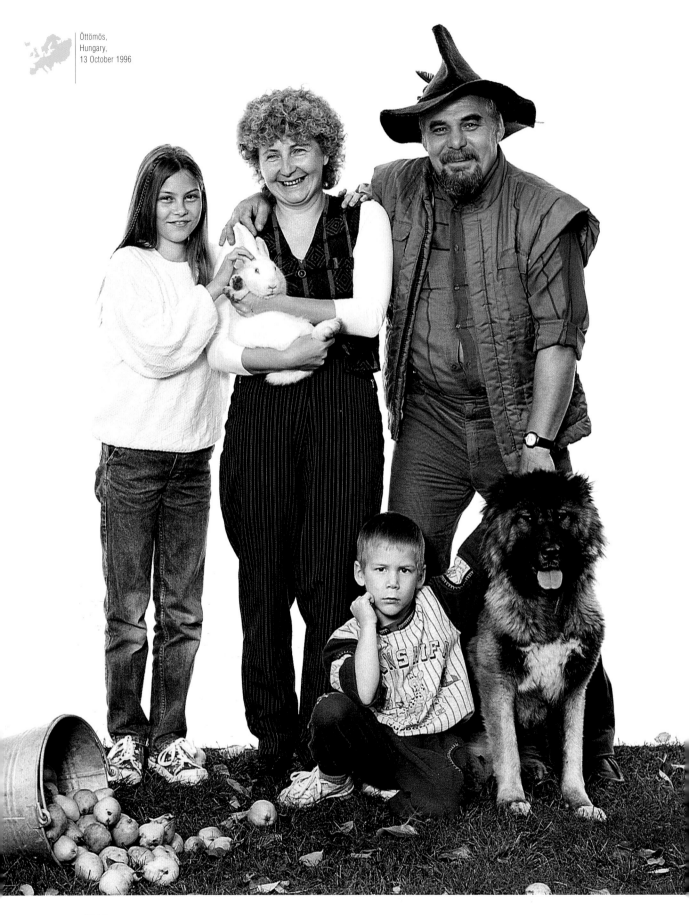

 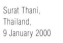

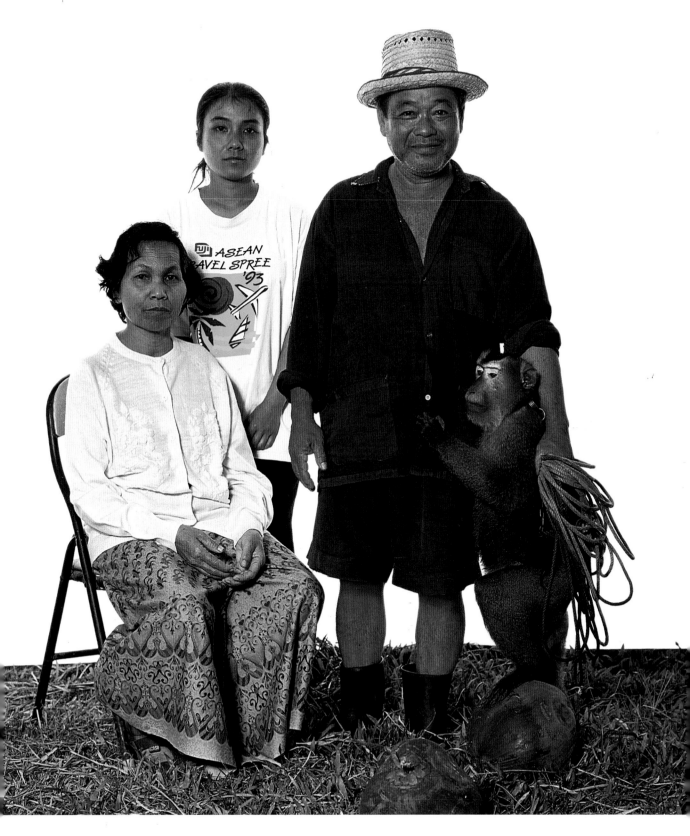

Ed ist Buchhalter und Steuerberater. Grietje kümmert sich um die beiden Töchter, die große Fans der holländischen Nationalmannschaft sind … genau wie die Eltern. Sie sind alle sehr sportlich und sobald im Winter die Kanäle zugefroren sind, werden die Schlittschuhe untergeschnallt.

Ed is an accountant and tax consultant. Grietje looks after their two daughters, fans of the Dutch football team, like their parents as well. They all have different sporting activities, but their favourite is ice-skating, as soon as the canals start to freeze over.

Ed est comptable et conseiller fiscal. Grietje s'occupe de leurs deux filles, fans de l'équipe de football hollandaise, comme leurs parents d'ailleurs. Ils pratiquent différentes activités sportives, mais leur préférée est le patin à glace dès que les canaux commencent à geler.

Vom Abteilungsleiter einer großen Supermarktkette in Frankreich zum Logistikchef für Pharmaciens sans Frontières [internationale Hilfsorganisation für die Bereitstellung von Medikamenten] in Niger, so der wundersame Werdegang von Xavier. Seine Liebe zu Afrika und zu Mélanie, seiner Ehefrau vom Volk der Tuareg, haben ihn zu diesem Schritt veranlasst, der für ihn ein endgültiger ist. „Ich fantasiere nicht über die drei Nullen des Jahres 2000, aber ich hoffe, dass die Menschen mit der Zeit zu mehr Toleranz und Offenheit finden."

Xavier's amazing career has taken him from department manager in a large supermarket in France to a logistics job in Niger for *Pharmaciens sans frontières* [the international medical supplies aid organisation]. His love for Africa and his Tuareg wife Mélanie have helped him to cross this Rubicon, and he never wants to look back. "I don't fantasize about the three noughts in 2000, but I hope that, with time, people will learn tolerance and open-mindedness."

De responsable de rayon d'un hypermarché en France, au poste de logisticien pour « Pharmaciens sans Frontières » au Niger, tel est le parcours étonnant de Xavier. L'amour pour l'Afrique et Mélanie (sa femme touareg) lui ont fait franchir ce pas qu'il veut sans retour. « Je ne fantasme pas sur le triple zéro de l'an 2000, mais j'espère qu'avec le temps les gens apprendront la tolérance et la disponibilité. »

Sie haben uns zu einem Picknick in einem der vielen Hamburger Parks eingeladen. Kim, Sohn einer chinesischen Mutter, ist in Hamburg geboren, wo er eine Galerie für zeitgenössische Kunst führt. Sein nächstes Projekt ist ein Antiquitätengeschäft. Georgia kümmert sich um die drei Sprösslinge – „ein Vollzeitjob".

They invited us to share their *déjeuner sur l'herbe* in one of city's many parks. Hamburg-born Kim, whose mother is Chinese, runs a contemporary art gallery in the city and is planning to open an antiques and decorating shop. Georgia looks after the three little children – "a full-time job."

Ils nous ont invité à partager leur « déjeuner sur l'herbe » dans un des nombreux parcs de la ville. Kim, métisse chinois par sa mère, est né à Hambourg, il y tient une galerie d'art contemporain et projette de monter un magasin d'antiquités et de décoration. Georgia s'occupe « très intensément » des trois petits.

Das „Reading Reptile" ist ein Kinderparadies. Debbie und Pete, Gründer und Betreiber dieser Buchhandlung, lassen sich immer neue Dekorationen oder Themen einfallen, um den Ort für die kleinen Leseratten noch attraktiver zu machen.

The Reading Reptile is a paradise for children. Debbie and Pete, who opened and now run this book shop, are never at a loss for ideas about decorating it and organizing theme days to make the place ever more attractive for young readers.

Le Reading Reptile est un paradis pour enfants! Debbie et Pete, créateurs et animateurs de cette bibliothèque, ne sont jamais à court d'idées de décorations ou de journées à thème pour rendre l'endroit toujours plus attractif aux jeunes lecteurs.

Zoltán ist weit über Ungarns Grenzen hinaus bekannt! Der Jagdführer genießt das Ansehen der vielen italienischen und deutschen Jäger, die hierher kommen. Außerdem ist er Eigentümer einer Jagdhütte, die nebst Unterkunft und guter Küche sogar einen Swimmingpool im Park bietet. Seine nie versiegende gute Laune färbt auf die ganze Familie ab.

Zoltán is well-known across the frontiers! He is a hunting guide much sought after by large numbers of Italian and German hunters. He also owns a hunting lodge offering accommodation, good food and even a swimming pool in the gardens. His inexhaustible good humour rubs off on the whole family.

Zoltan est un personnage connu au-delà des frontières! Guide de chasse, il est très apprécié par les très nombreux chasseurs italiens et allemands. Il est aussi propriétaire d'un « lodge de chasse » qui offre hébergement, bonne table et même une piscine dans le parc. Son intarissable bonne humeur déteint sur toute la famille.

Auf seiner Visitenkarte steht es Schwarz auf Weiß: „Somphon Sae-Kow, Direktor der Affenschule von Thailand." Er ist der Gründer und einzige Lehrer dieser ehrwürdigen Einrichtung, die den Arbeitern in den Kokosplantagen das Leben erleichtert. Die Makaken sind darauf abgerichtet, die Kokosnüsse herunterzuwerfen und erledigen ihren Job überaus geschickt und in einem Affenzahn. Somphon ist 60 und hofft, dass seine einzige Tochter in seine Fußstapfen treten wird.

His business card says in black and white: "Somphon Sae-Kow, Principal of the College of Monkeys of Thailand." He is the founder and sole professor of this venerable institution, which simplifies the lives of coconut planters. Macaque monkeys are trained to drop the nuts, which they do with extraordinary skill and speed. Somphon (60) hopes that his only daughter will take over from him.

Sa carte de visite l'indique noir sur blanc « *Somphon Sae-Kow, Principal du collège* des *singes de Thaïlande* ». Il est le fondateur et unique professeur de cette vénérable institution qui facilite la vie des planteurs de cocotiers. Les macaques sont dressés pour faire tomber les noix et s'exécutent avec une adresse et vitesse extraordinaire. Somphon, âgé de soixante ans, espère que sa fille unique reprendra le flambeau.

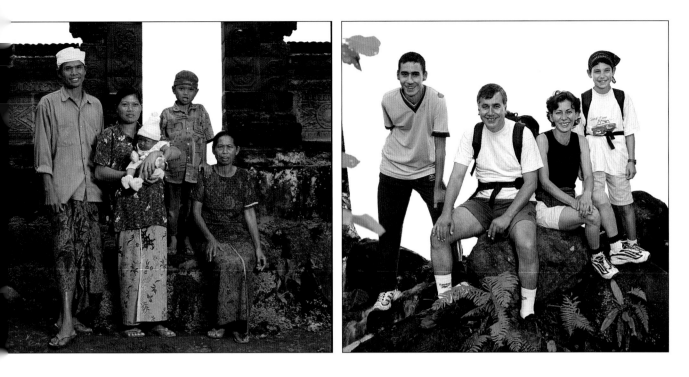

Bali,
Indonesia,
12 December 1999

Pak ist Bildhauer wie unglaublich viele Balinesen. Er arbeitet für ein Geschäft, das ihm all seine Skulpturen abkauft. Seine Frau Made entwirft Schmuck und flicht Körbe und Tabletts für religiöse Opfergaben und Feste.

Like an incredible number of Balinese, Pak is a sculptor. He works for a shop which buys all his sculptures and carvings. His wife Made makes decorations and weaves baskets and trays for religious offerings and ceremonies.

Pak est sculpteur comme un nombre incroyable de Balinois. Il travaille pour une boutique qui lui achète tous ses travaux. Sa femme, Made, crée des décorations, tresse des paniers et des plateaux pour les offrandes et cérémonies religieuses.

Adana,
Turkey,
18 August 1999

Wie immer in den Ferien verbringt diese Familie den ganzen Tag damit, an der frischen Luft zu wandern und zu klettern. Baykal leitet eine Tierfutterfabrik, Ayse ist Zahnärztin. Der älteste Sohn fängt im Wintersemester mit seinem Touristikstudium an und würde am liebsten irgendwo „mitten in der Natur" leben. Das neue Jahrtausend? „Man sagt, 2000 beginnt das goldene Zeitalter!"

They are on holiday, and love nature – walking, climbing and the outdoor life in general – as a family. A chemist by training, Baykal heads a factory producing cattle feedstuffs. Ayse is a dentist. Their elder son is about to start a course in tourism and would like "to live in nature". As for the new millennium – "Mythology has it that it will be the golden age!"

Ils sont en vacances, aiment la nature, la marche, l'escalade, la vie au grand air et tout ça en famille. Baykal, chimiste de formation, est à la tête d'une usine de produits alimentaires pour bétail. Ayse est dentiste. Le fils aîné va débuter des études de tourisme et aimerait « vivre dans la nature ». Et l'an 2000 ?
« D'après la mythologie ce sera l'âge d'or ! »

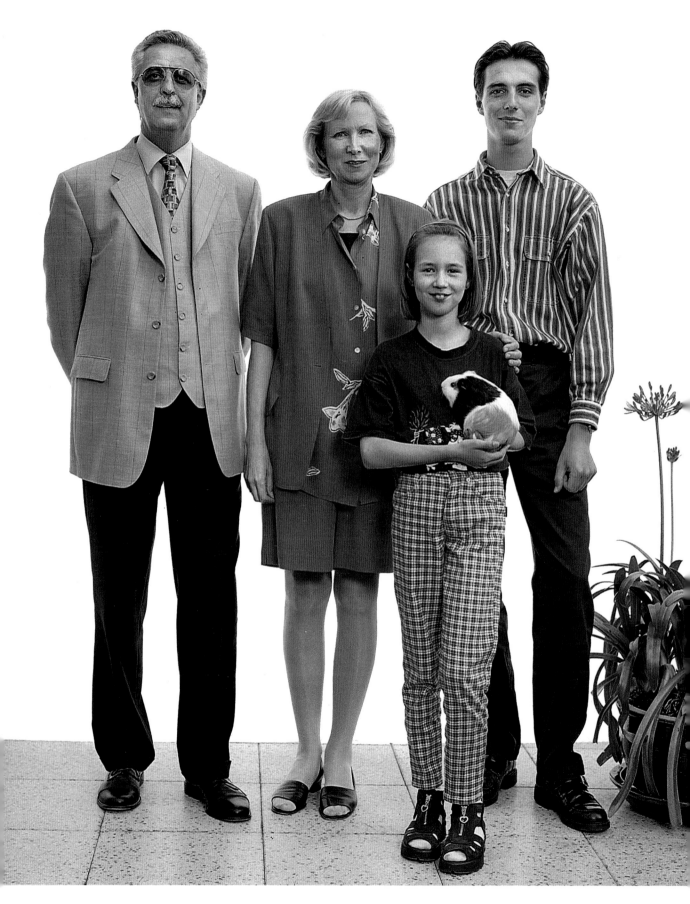

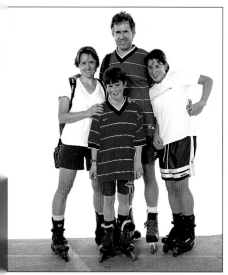

1

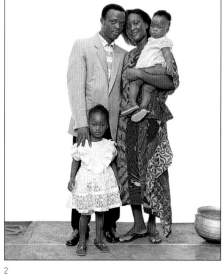

2

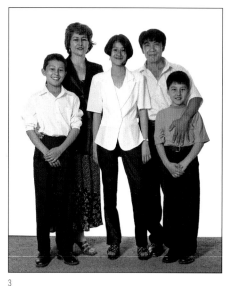

3

1
Kelowna,
Canada,
13 November 1998

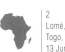
2
Lomé,
Togo,
13 June 1997

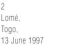
3
Almaty,
Kazakhstan,
9 September 1999

Odenthal,
Germany,
31 July 1998

Laut Ingrid ist Peter ein großartiger Heimwerker, der sämtliche Maschinen in Haus und Garten auseinander nehmen kann, … „und wieder zusammenbau-en", ergänzt Peter. Wenn er nicht gerade werkelt, ist Peter Buchhalter, spezialisiert auf die Programmierung von Verwaltungscomputern, und ein großer Radsportamateur. Ingrids Traum ist die Malerei, doch das Haus, der Garten, Vanessa und eine aktive Teilnahme am Gemeinde- und Schulleben des Dorfs lassen ihr nur wenig Freizeit. Vanessa ist ihrerseits mit ihrem Meerschweinchen, ihrer Briefmarkensammlung und ihren Schulaufgaben gut beschäftigt. Und Christian hat mit seinem Architekturstudium und seinem Lieblingshobby – dem Computer – ebenfalls genug zu tun.

According to Ingrid, Peter's a great handyman. He can take to pieces any household appliance or garden machine you care to mention – "and put it back together again," he adds. When he's not being handy, Peter is an accountant specializing in programming management computers, and a great cycling enthusiast. Ingrid dreams of painting, but the garden, the home, Vanessa and her active involvement in local village and school life don't leave her with much free time. Vanessa for her part is overworked by her guinea pig, her stamp collection and her homework. Christian is also very busy with his architectural studies and his favourite pastime, the computer.

D'après Ingrid, Peter est un grand bricoleur, capable de démonter toutes les machines de la maison et du jardin … « et de tout remonter », précise Peter. Quand il ne bricole pas, Peter est comptable spécialisé dans la programmation d'ordinateurs de gestion, et grand amateur de cyclisme. Ingrid rêve de pein-dre, mais le jardin, la maison, Vanessa et une participation active dans la vie locale et scolaire du village lui laissent très peu de temps libre. Vanessa, elle, est débordée par son cochon d'Inde, sa collection de timbres et ses devoirs d'école. Christian est également très pris par ses études d'architecture et son passe-temps favori : l'ordinateur. Une famille bien occupée, qui rêve de visiter Paris pour l'an 2000.

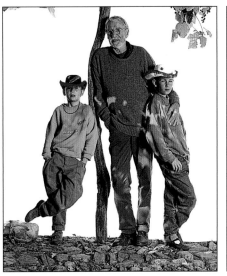

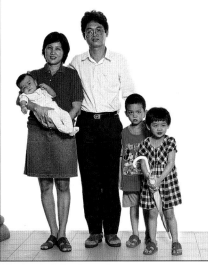

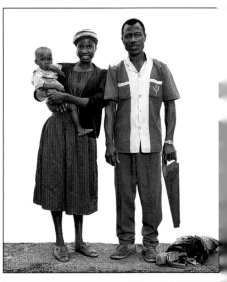

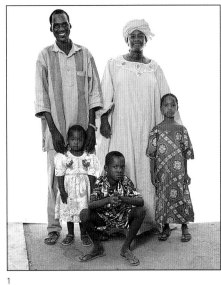

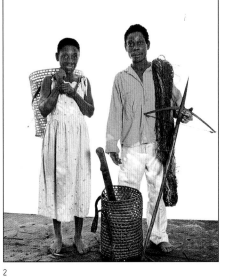

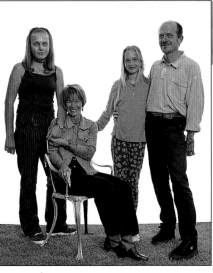

1

7

2

8

3

9

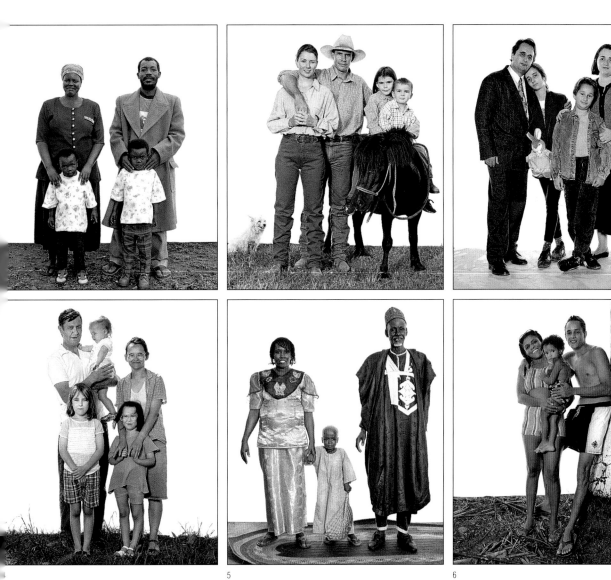

5

11

0

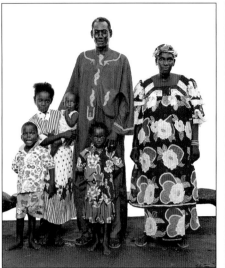
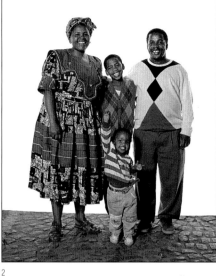
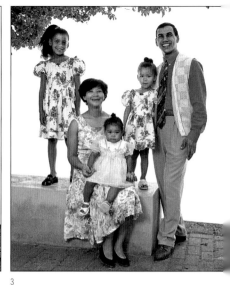

1 2 3

1
Abidjan,
Ivory Coast,
24 May 1997

2
Cape Town,
South Africa,
21 September 1997

3
Cape Town,
South Africa,
28 September 1997

Page 150
Miami,
Florida, USA
11 April 1999

„Wer als Kubaner geboren wird, liebt Zigarren. Mein Urgroßvater hatte einen Laden, meine Großmutter rollte Tabakblätter, die ganze Familie hat sich für das Nationalprodukt interessiert. Ich habe ein Geschäft, aber eigentlich bin ich von Beruf Elektrophysiologe. Ich arbeite im Operationssaal eines Krankenhauses, das ist sehr stressig." Dalia ist Krankenschwester in einem Kinderkrankenhaus und klagt: „In meiner Freizeit fahre ich für meine Kinder Taxi!" Nicolas (15) will dem Beispiel seines Vaters folgen und Arzt werden, während Natasha Lehrerin werden möchte.

"When you're born Cuban, you like cigars. My great grandfather had a shop, my grandmother rolled tobacco leaves, and the whole family is involved in the national product. I've got a shop, but my real profession is electrophysiology. I work in the operating room at the hospital, which is pretty stressful." Dalia is a nurse in another children's hospital and says, half in jest: "During my spare time, I run a taxi service for my children!" Nicolas (15) is following his father's example – he's going to be a doctor, while Natasha wants to be a teacher.

« Quand on est né cubain, on aime les cigares. Mon arrière grand-père avait un magasin, ma grand-mère roulait les feuilles de tabacs, toute la famille s'est intéressée au produit national. J'ai une boutique mais mon vrai métier est l'électrophysiologie, je travaille dans la salle d'opération de l'hôpital, c'est très stressant. » Dalia est infirmière dans un autre hôpital d'enfants et dit mi-sérieuse : « Pendant mon temps libre, je fais le taxi pour mes enfants ! » Nicolas (quinze ans) veut suivre l'exemple de son père : il sera médecin, et Natasha sera enseignante.

Page 151
Awash,
Ethiopia,
4 December 1997

Wie alle Afar verlässt Hassan seine Hütte nicht ohne seine Kalaschnikow, obwohl er die Kugeln völlig überteuert findet. Immerhin kosten sie drei Birr [etwa eine Mark] das Stück. Seine Hauptbeschäftigung: Vieh „besorgen", und zwar bei Raubzügen zum Nachbarstamm der Oromo, die sich ein paar Tage später bei den Afar bedienen, was wiederum einen Gegenbesuch zur Folge hat, und so fort …

Hassan, like all Afar tribesmen, never leaves home without his Kalashnikov, even if he grumbles about the high price of ammunition – three bir a round [about 30p or 50 cents]. His main occupation is organizing raids on the Oromo (the neighbouring tribe) to "look for" cattle. This same operation is then repeated the following week by the Oromo, and so on and so forth …

Hassan, comme tous les Afars, ne se déplace jamais sans sa kalachnikov, même s'il déplore le prix élevé des balles : trois bir pièce (environ trois francs). Leur principale occupation : organiser des raids sur les Omoros (tribu voisine) pour « chercher » du bétail. Opération répétée la semaine suivante par les Omoros et ainsi de suite …

Godofuma,
Ivory Coast,
4 April 1997

Nach seiner Initiation im heiligen Wald fühlte sich dieser junge Mann aus Godofuma zum Tamtam-Spieler berufen. Er spielt bei allen Zeremonien im Dorf. Da er von der Musik allein seine Familie nicht ernähren kann, baut er Reis, Maniok, Kartoffeln und Baumwolle an. Sein Traum: „Mein Instrument bei großen Feiern zu spielen!"

After an initiatory period in the sacred wood, this young man from Godofuma was a 'designated' tom-tom player. He performs at every village ceremony. But music alone doesn't enable him to feed his family, so he grows rice, cassava, potatoes and cotton. His dream: "To play my drums at great events."

Après une période d'initiation du bois sacré, ce jeune homme de Godofuma fut « consacré » joueur de tam-tam. Il est présent à toutes les cérémonies du village. Mais la musique seule ne lui permet pas de faire vivre sa famille, il cultive donc le riz, le manioc, les patates et le coton. Son rêve : « Jouer de mon instrument dans les grands spectacles ! »

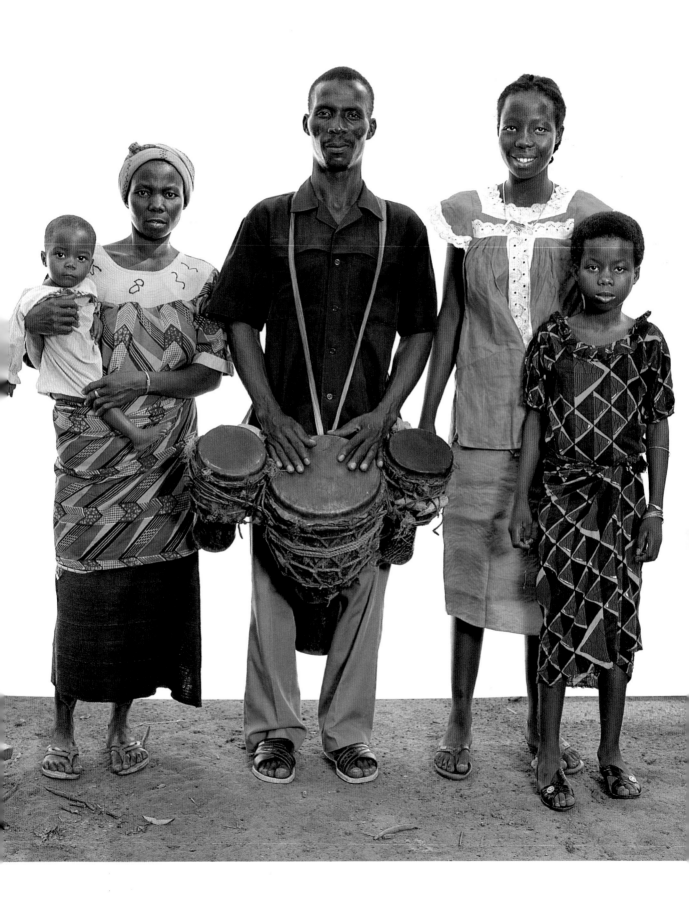

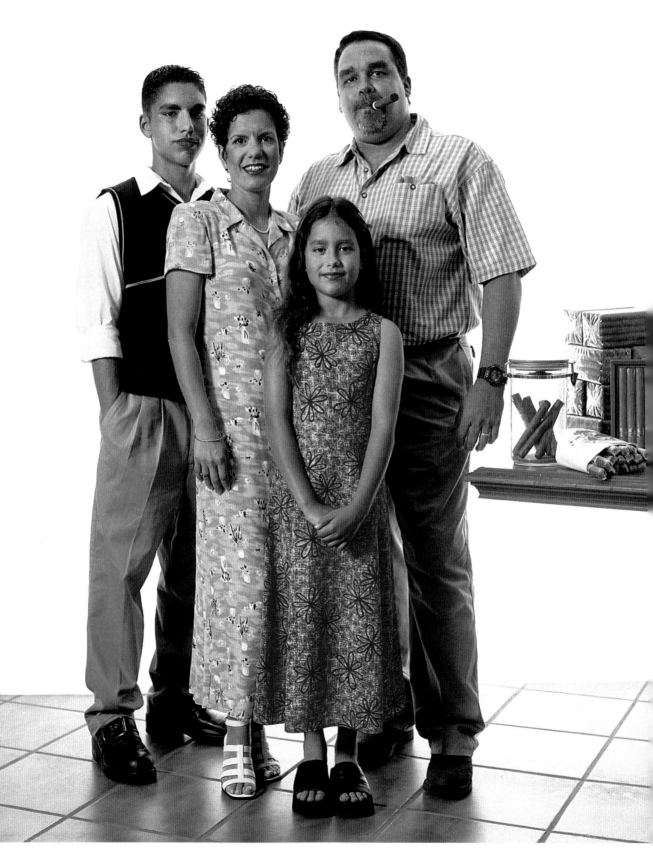

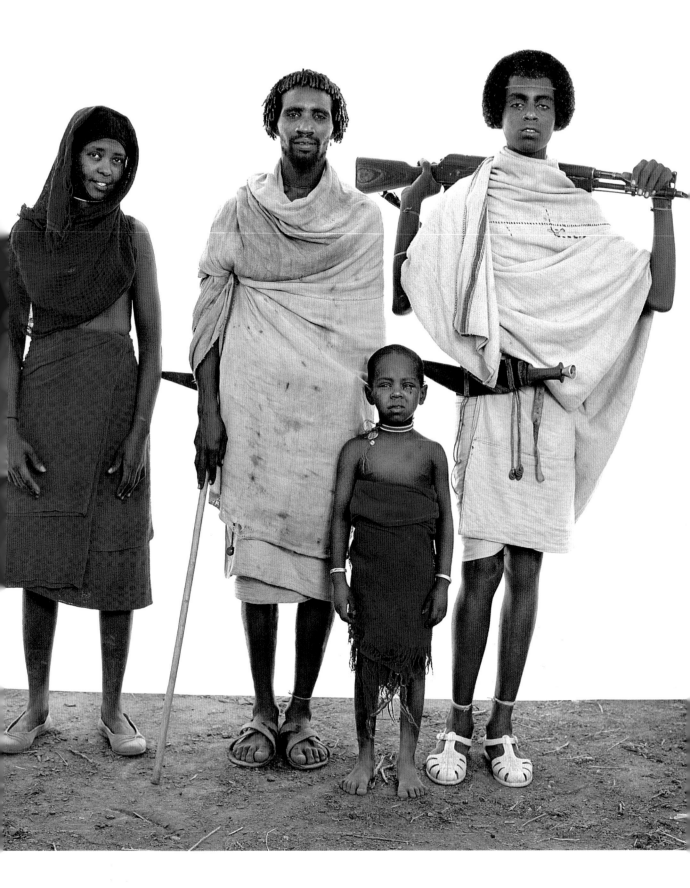

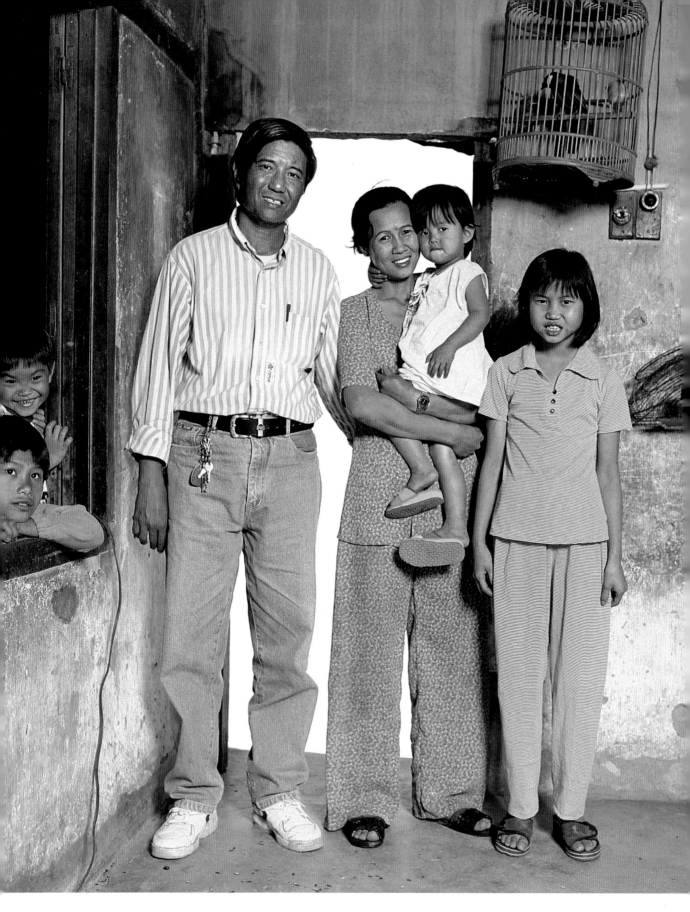

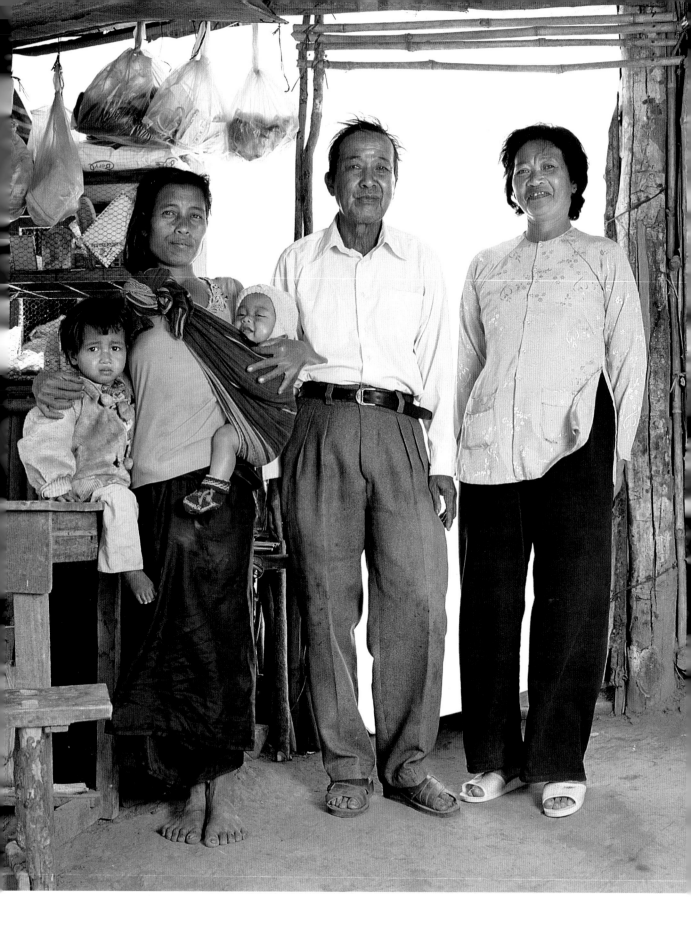

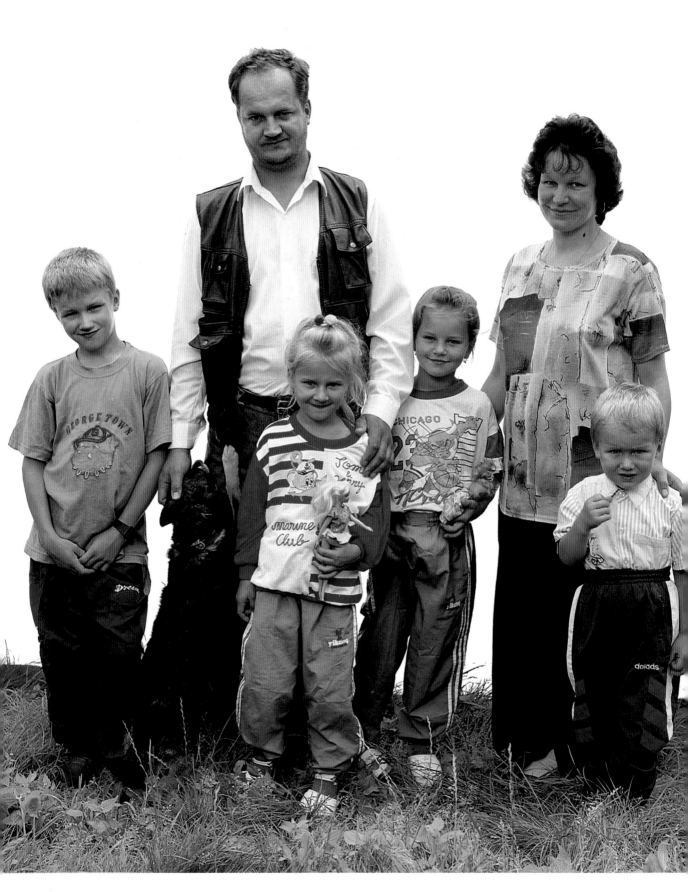

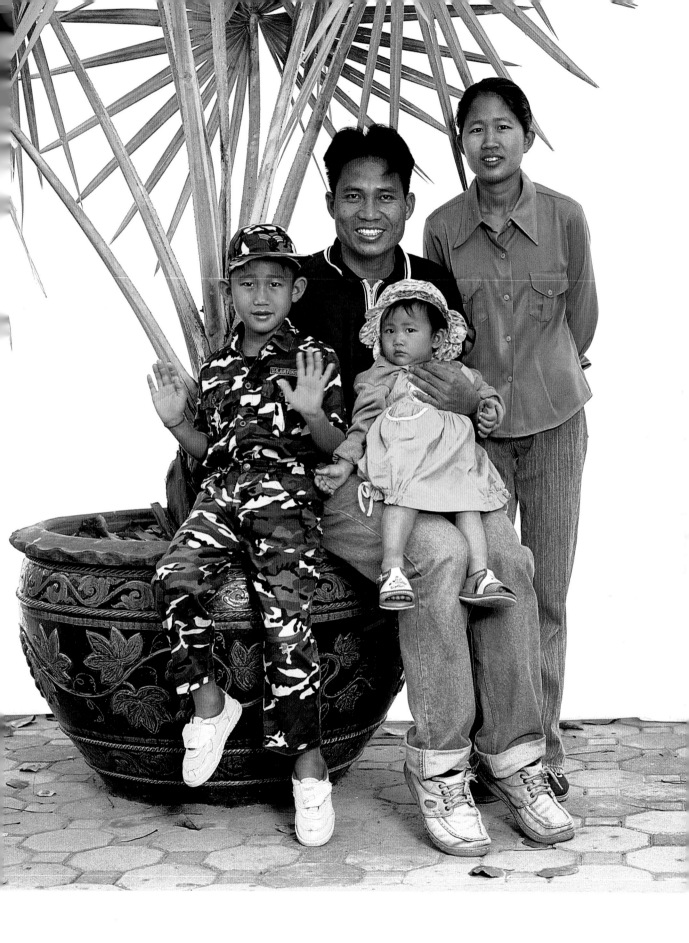

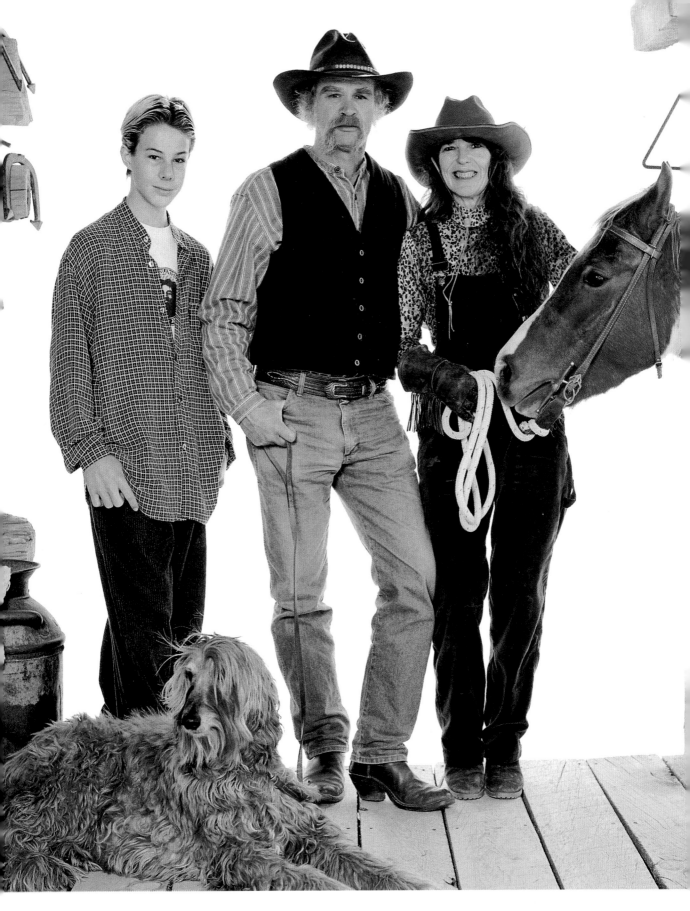

Page 152
Kon Tum,
Vietnam,
9 February 2000

Dr. Le Thuy (Spitzname Tiger) ist deprimiert: „Ich war einmal Millionär, jetzt bin ich pleite!" Sein Leben gleicht einem Roman. Ein Abschluss in Wirtschafts-wissenschaften an der Universität von Princeton, Jagdflieger im Vietnamkrieg, sechs Fluchtversuche aus Nordvietnam mit dem Boot, zusammen mit 36 Frauen und Kindern – sechs Fehlschläge. Heute organisiert er Reisen, ist Fremdenführer, Übersetzer, Dolmetscher und gibt Englischkurse. Um die Familie zu ernähren, muss seine Frau mitarbeiten. Sie montiert Stühle in einer Möbelfabrik.

Doctor Le Thuy (nicknamed Tiger) is depressed. "I used to be a millionaire, but now I'm broke!" His life is like a novel – a masters degree in economics from Princeton University, a fighter pilot during the Vietnam War, six attempts to escape from Communist Vietnam by boat along with 36 women and chil-dren – and six failures. Today he is a travel agent, guide, translator and interpreter, and also gives English lessons. The family also live partly from his wife's work, which involves assembling chairs in a furniture factory.

Dr Lê Thûy (surnommé Tiger) est déprimé : « Avant j'étais millionnaire, maintenant je suis fauché ! » Sa vie ressemble à un roman : master en économie à l'université de Princeton, pilote de chasse pendant la guerre du Viêt-nam, six tentatives de fuite du Viêt-nam communiste en bateau accompagné de trente-six femmes et enfants, six échecs ! Aujourd'hui, agent de voyages, guide, traducteur, interprète, il donne aussi des cours d'anglais, sa famille survit en partie grâce au travail de sa femme qui assemble des chaises dans une usine de meubles.

Page 153
Kon Tum,
Vietnam,
9 February 2000

Jeden Morgen fährt Nguyen mit seinem Fahrrad, bepackt mit Schilf (für die Herstellung von Besen und Bürsten), Bananen oder Wild, auf den Markt. Zurück kommt er mit Ware, die er in seinem Laden verkauft: Salz, Zigaretten, Bonbons, Waschpulver …

Nguyen sets off every morning for the market on his bicycle laden with reeds (for making brooms and brushes), bananas and bush meat. He comes back home with goods to sell in his shop – salt, cigarettes, sweets, detergents …

C'est avec sa bicyclette chargée de roseaux, pour la fabrication de balais, de bananes ou de viande de brousse que Nguyen part tous les matins au marché. Il en revient avec des marchandises qu'il vend dans son échoppe : sel, cigarettes, bonbons, lessive …

Page 154
Tylmanová,
Poland,
26 July 1998

Ihrer freundlichen Gastlichkeit zum Trotz wollte uns diese Familie weder ihren Namen noch ihre Adresse nennen. Ihnen war zu Ohren gekommen, dass Sekten polnische Kinder raubten, um sie betteln zu schicken. Sie ist Hausfrau, er Mechaniker und Schreiner. Ihr Haus haben sie mit der Hilfe von Freunden selbst gebaut. Sie würden sehr gern durch die Welt reisen und fremde Kulturen kennen lernen.

Though welcoming and nice, this family didn't want to give us their name and address. They'd heard of sects that steal Polish children to turn them into beggars. She's a housewife, he's a mechanic and carpenter. They built their house with help from friends and are very keen to travel the world and see life elsewhere.

Cette famille pourtant accueillante et sympathique n'a pas voulu nous donner son nom ni son adresse : ils ont entendu que des sectes volent les enfants polonais pour les transformer en mendiants ! Elle est femme au foyer et lui mécanicien et menuisier. Ils ont construit leur maison avec l'aide de quelques amis. Ils ont très envie de voyager à travers le monde et de voir la vie ailleurs.

Page 155
Chiang Mai,
Thailand,
22 January 2000

Siti Chai weiß mit seinen sechs Jahren schon ganz genau, was er später machen wird: „Shoppen und Fußball spielen." Sein Vater ist Chauffeur, seine Mutter Hausfrau und eine ausgezeichnete Köchin. Sie verdient etwas dazu mit der Nudelsuppe, die sie von zu Hause aus verkauft.

Siti Chai is only six, but he already knows what he wants to do later on: "I shall shop and play football." His father is a driver, his mother a housewife and very good cook. She earns additional income with her noodle soup, which she sells from home.

Siti Chai a seulement six ans mais il sait déjà ce qu'il fera plus tard : « Je ferai du shopping et je jouerai au foot ». Papa est chauffeur, maman femme au foyer et très bonne cuisinière : elle prépare la « soupe de nouilles » qu'elle vend à domicile.

Santa Cruz,
New Mexico, USA,
21 November 1998

Monique ist Stylistin, Bildhauerin, Malerin und gestaltet die Schaufenster der Luxusboutiquen von Santa Fe. Garry ist Musiker und Töpfer und Clay spielt Klavier und … Computerspiele. Alle drei reiten gern, wenn es ihre Zeit erlaubt. Monique stammt aus Holland und fühlte sich schon immer vom Wilden Westen angezogen: „Karl May hat diese Begeisterung geweckt", verrät sie uns.

Monique is a fashion stylist, sculptor and painter, and she also does window dressing for Santa Fe's exclusive stores. Garry is a musician and potter, and Clay plays the piano – and the computer. All three go riding whenever their many activities let up a little. Monique, who comes from Holland, has always felt the pull of the Wild West. "Karl May first aroused my interest," she confides.

Monique est styliste, sculpteur, peintre et réalise des vitrines pour les magasins de luxe à Santa Fé. Garry est musicien et potier et Clay joue du piano et … de l'ordinateur ! Tous les trois montent à cheval dès que leurs multiples occupations leur en laissent le temps. D'origine hollandaise, Monique a toujours été attirée par le Far West : « C'est Karl May qui a inspiré ma passion », confie-t-elle.

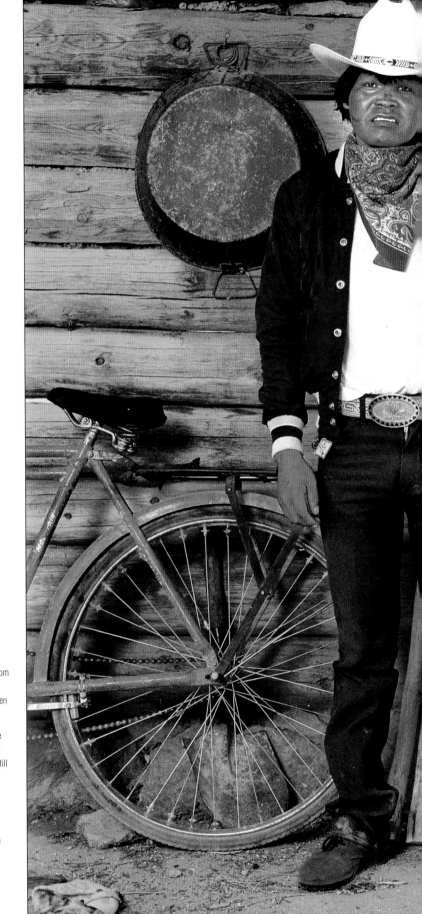

Das Haus von Pedro Martín ist aus Rundhölzern gebaut und besteht aus einem einzigen Raum mit Lehmboden, in dem es weder Wasser noch Strom gibt und der alte Ofen das wichtigste Möbel ist. An eine gewisse Not gewöhnt, bleibt Pedro Martín dennoch optimistisch und bestellt einen kleinen Gemüsegarten, der genügend abwirft, um die Familie zu ernähren.

Pedro Martín's house, made of logs, consists of just one room, where the most conspicuous feature is the old stove. It has an earthen floor, and no water or electricity. Quite used to not having very much, Pedro Martín is still optimistic and has a small kitchen garden, which provides enough vegetables to feed the family.

La maison de Pedro Martin, faite de rondins de bois, se compose d'un pièce unique, où l'élément le plus important est une vieille cuisinière, le sol est en terre battue, il n'y a ni eau et ni électricité. Habitué à un certain dénuement, Pedro Martin reste optimiste et s'occupe d'un petit potager, qui fournit assez de légumes pour nourrir la famille.

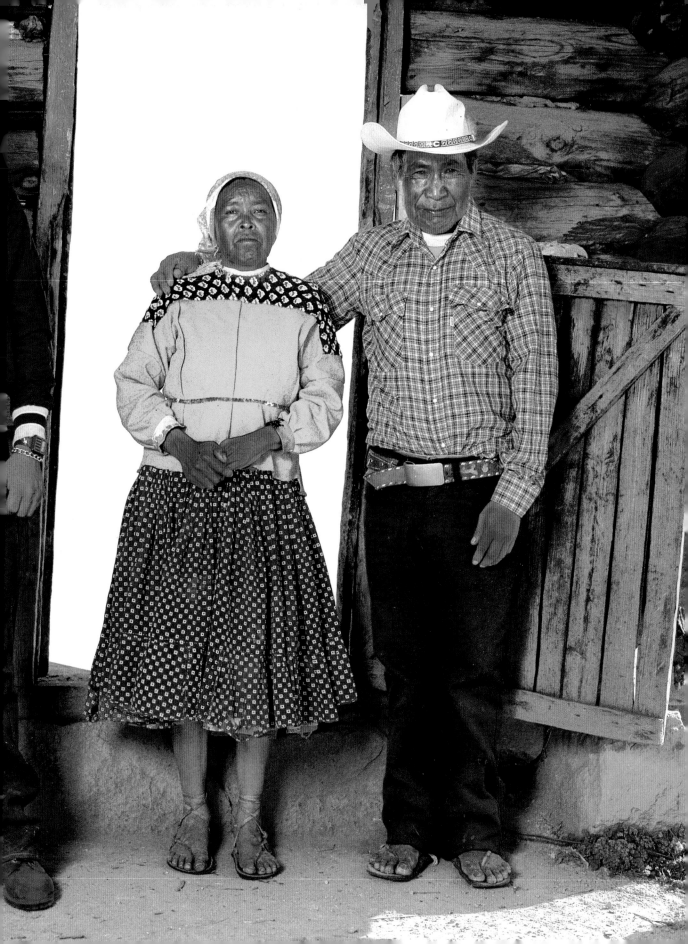

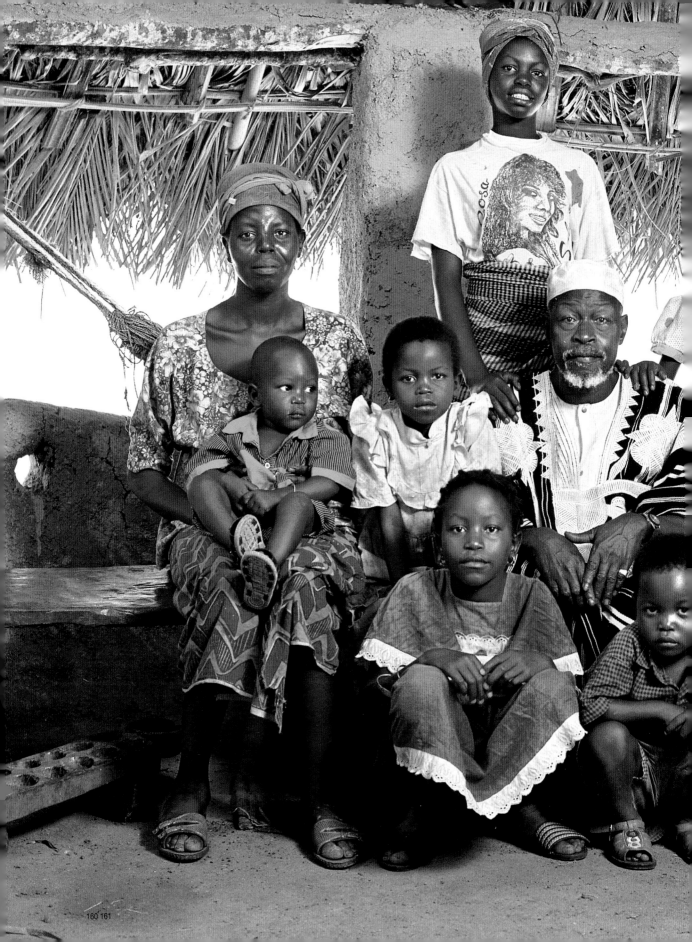

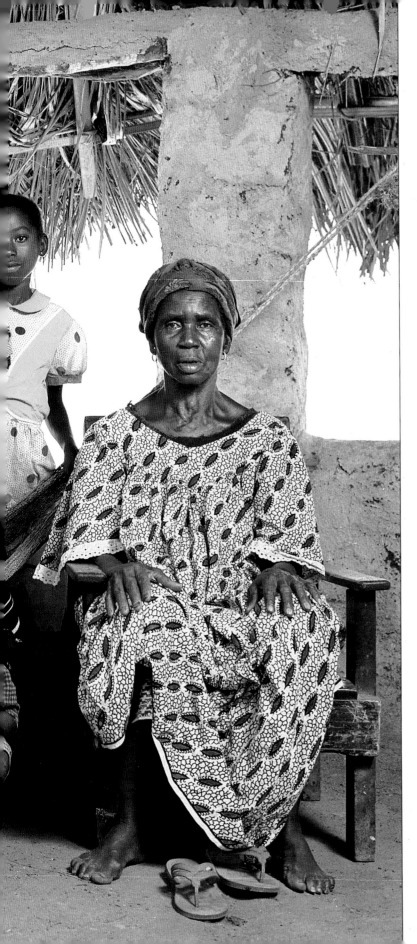

Der Bauer Mamadou kam einst aus dem Norden hierher auf der Suche nach fruchtbarem Land. Er würde gern Landmaschinen kaufen, um die Rentabilität seiner Plantagen (Kaffee, Kakao, Reis und Yamswurzel) zu steigern. Sein Traum für das neue Jahrtausend: „Ein großes Haus für all meine Kinder und ein Haus für dich, mein Freund, gleich neben dem meinen." Mit diesen Worten schickt er seine Kinder los, ein Huhn zu fangen, das er uns als Abschiedsgeschenk überreichen will …

Mamadou is a farmer who came from the north looking for fertile land. He's hoping to buy some farm machinery to make his coffee, cocoa, rice and yam plantations profitable. His dream for the new millennium: "To build a big house for all my children, and a house for you, my friend, right beside mine." With these words he sends out all his children to catch a chicken as a farewell gift for us …

« Il faut attraper le poulet pour mes amis », ordonne Mamadou. L'animal a toute la famille à ses trousses. Affolé par cet engouement soudain, il prend ses pattes à son cou et disparaît dans la brousse. Nous ne pouvions rêver meilleur dénouement, qu'aurions-nous fait d'un tel compagnon? Agriculteur, Mamadou est venu du Nord à la recherche d'une terre fertile, il espère acquérir des machines agricoles pour rentabiliser ses plantations (café, cacao, riz et igname). Son rêve pour l'an 2000 : « Construire une grande maison pour loger tous mes enfants, et une maison pour toi, mon ami, juste à côté de la mienne. »

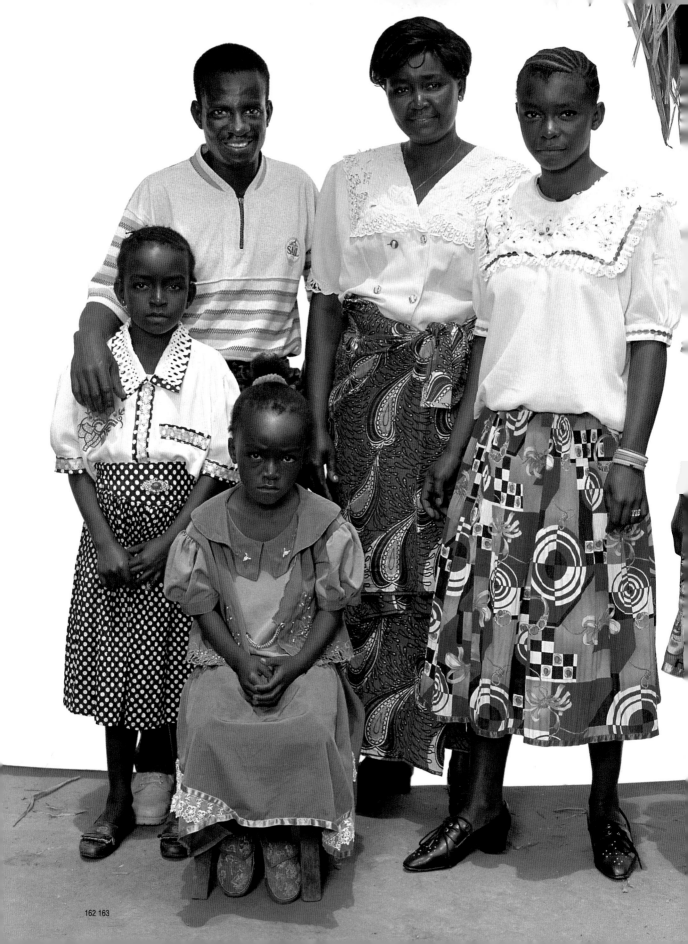

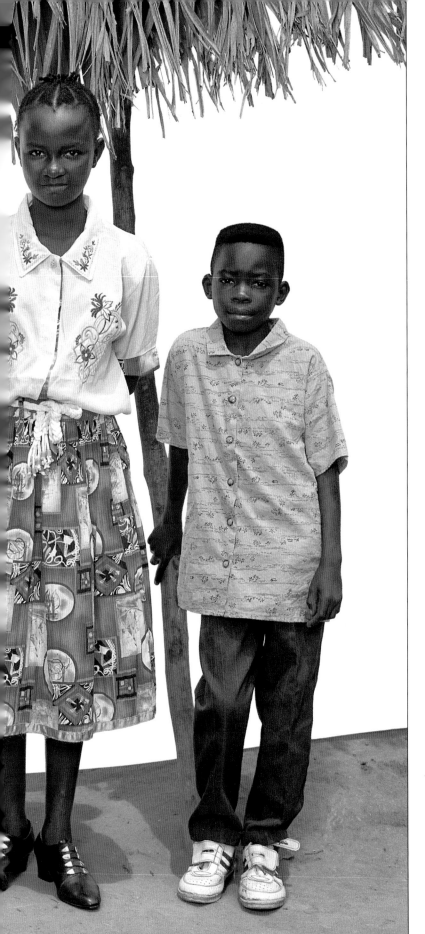

Muanda,
Zaire,
30 August 1997

„Die Fischerei muss immer gut laufen, ohne sie gibt es keine Arbeit", so
die Maxime von André, dem Hochseefischer. Er ist ziemlich stolz darauf, dass
all seine Kinder zur Schule gehen. „Ich will, dass meine Familie mit gutem
Beispiel vorangeht."

"Fishing must always be good, because without it there's no work." This
is fisherman André's favourite dictum. His children all go to school, and he's
quite proud of that. "I want my family to set an example."

« Il faut que la pêche soit toujours bonne, sans elle il n'y a pas d'emploi »,
c'est la maxime préférée d'André, pêcheur en mer. Ses enfants vont tous à
l'école et il en est assez fier : « Je veux que ma famille soit exemplaire ! »

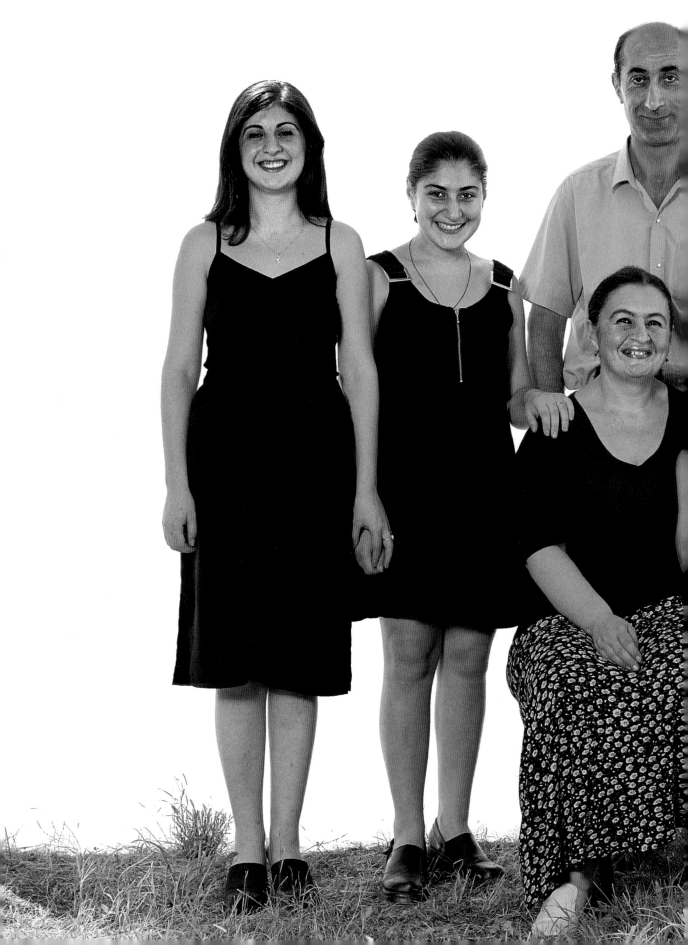

Die 19-jährige Tatja sprüht vor Optimismus: „Junge Frauen haben in diesem Land bessere Chancen, einen Job zu finden als die Männer." Sie will es ihrem Vater gleichtun und Betriebswirtschaft studieren – obwohl dieser in seinem Beruf keine Arbeit gefunden hat und nun als Buchhalter sein Geld verdient. Als Ausgleich zu diesem allzu trockenen Metier keltert Rezo aus den Trauben von seinem eigenen Weinberg rund 500 Liter Wein pro Jahr. Zusätzlich hegt und pflegt er liebevoll ein Dutzend Obstbäume – und natürlich seinen kleinen Gemüsegarten.

Tatia, who's 19, is full of optimism: "Young women find work more easily than men in this country." She wants to study economics like her father (who, despite his economics degree, could not find a job in this field and works as an accountant). In his spare moments, Rezo tends his vineyard, which produces 500 litres of wine a year, and his orchard, which has dozens of fruit trees. And let's not forget the kitchen garden. Plenty to keep his mind off figures.

Tatia (dix-neuf ans) déborde d'optimisme: «Les jeunes femmes trouvent du travail plus facilement que les hommes dans notre pays!» Elle veut faire des études d'économie tout comme son père (qui bien que diplômé d'économie n'a pas trouvé de poste dans ce secteur et exerce comme comptable). A ses moments de liberté, Rezo s'occupe de sa vigne, dont il tire cinq cents litres de vin par an, de son verger planté de dizaines d'arbres fruitiers, sans oublier le potager. Largement de quoi se distraire des chiffres!

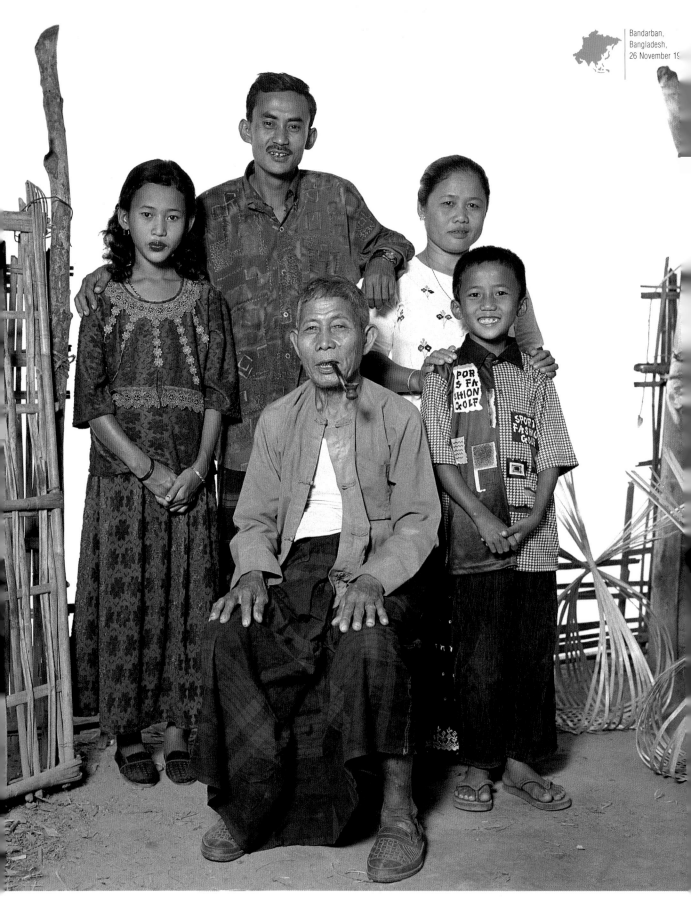

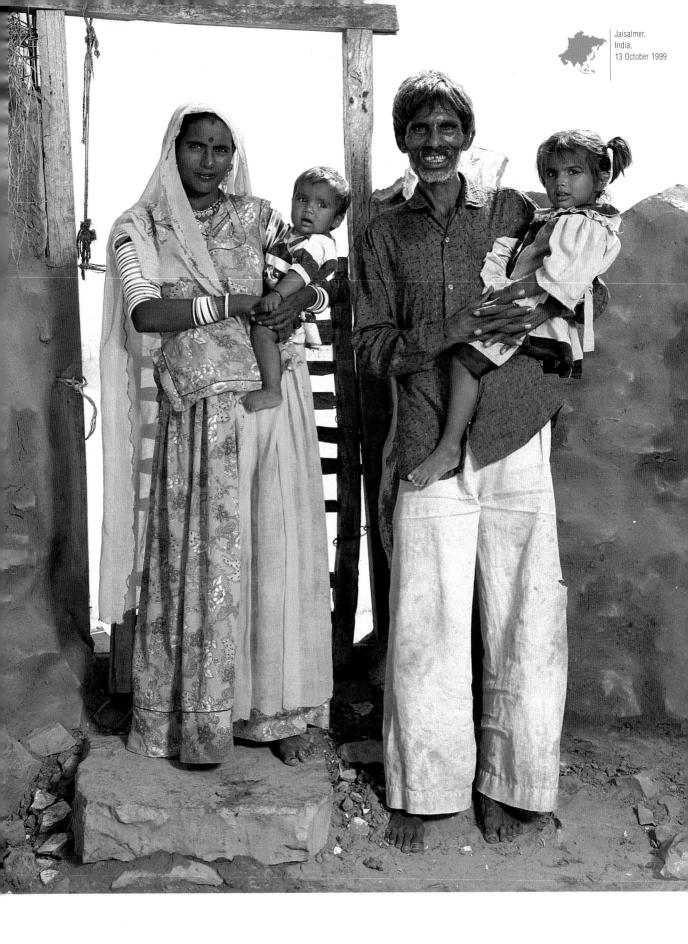

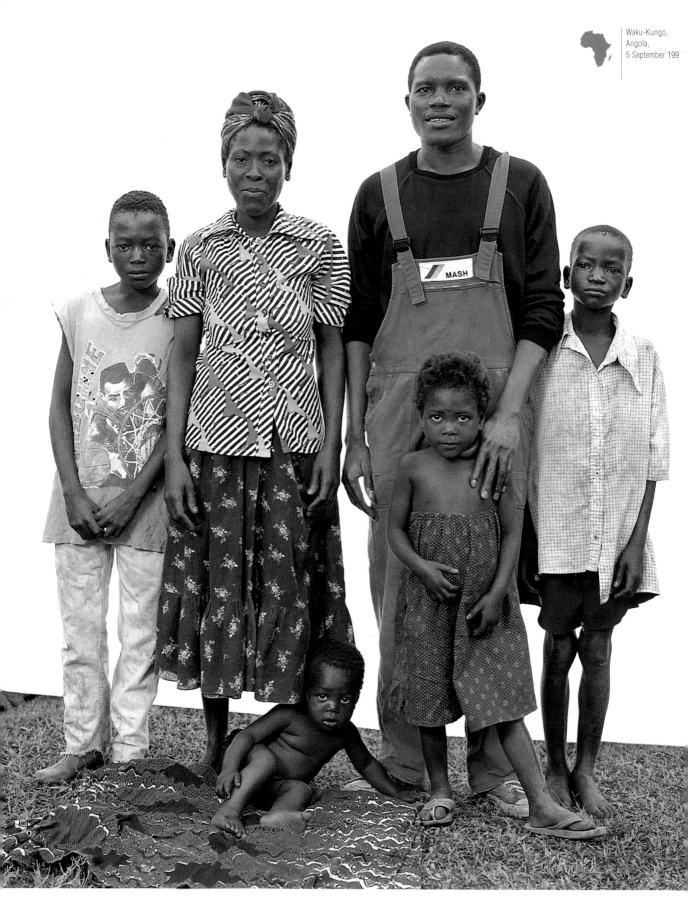

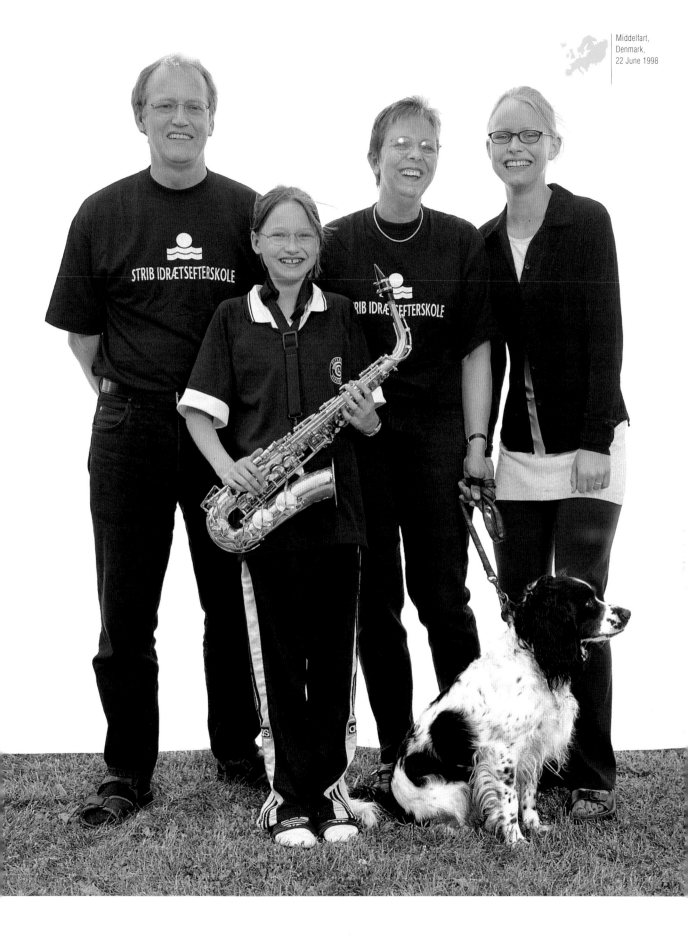

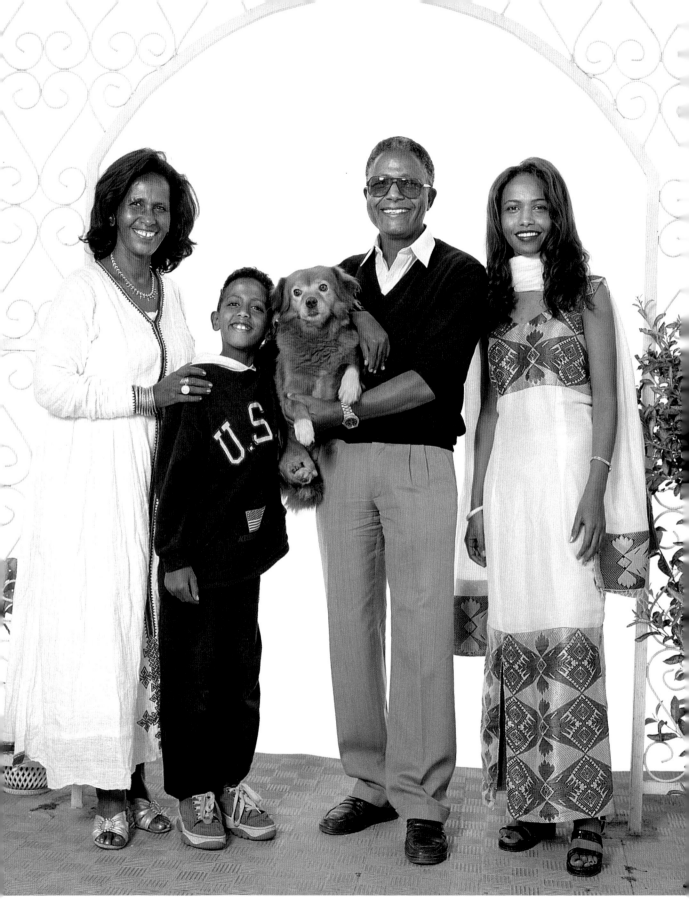

Page 166

Rabindra ist Besitzer eines „Baby-Taxis", eines jener extrem umweltbelastenden Dreiräder, die in Indien gebaut werden. Allerdings ist das Gefährt wegen eines Motorschadens vorübergehend außer Betrieb. Dennoch bleibt Rabindra zuversichtlich: „Ich bin ein guter Chauffeur, aber vor allem ein guter Mechaniker, in zwei Tagen ist mein ‚Baby' wieder auf der Straße."

Rabindra owns a 'baby taxi', an extremely polluting three-wheel vehicle manufactured in India, which is temporarily out of order because of a broken engine. But he remains confident: "I'm a good driver but an even better mechanic, so in a couple of days my 'baby' will be back on the road."

Propriétaire d'un « baby taxi », tricycle extrêmement polluant fabriqué en Inde, provisoirement hors service à cause d'un moteur cassé, Rabindra reste confiant : « Je suis un bon chauffeur, mais surtout un bon mécanicien, en deux jours mon « baby » sera de nouveau sur la route. »

Page 167

Surtaram ist optimistisch. Die Zeiten als Hilfsarbeiter, Schneider oder Gemüsehändler sind endgültig vorbei, seit er sein eigenes kleines „Geschäft" aufgemacht hat. In seinem bescheidenen Lädchen bietet er Kämme, Süßigkeiten, Tomaten, Seife, kurz allen möglichen Krimskrams feil.

Surtaram is full of optimism. After a variety of different jobs – labourer, tailor and vegetable vendor – he has just opened his own 'shop'. It is a modest and tiny hut stocked with combs, sweets, tomatoes, soap and plenty of other indispensable things.

Surtaram est plein d'optimisme! Après avoir exercé divers métiers : manœuvre, tailleur, vendeur de légumes, il vient d'ouvrir sa propre « boutique ». Modeste et minuscule cabanon où il présente pêle-mêle, peignes, sucreries, tomates, savons et bien d'autres objets indispensables.

Page 168

In einem Land, in dem gute Straßen selten sind und überall Landminen lauern, hat Francisco als Kraftfahrer einen sehr riskanten Beruf …

In a country where good roads are rare and land mines two a penny, Francisco has a dangerous job: driving trucks …

Dans un pays où les routes en bon état sont rares et les mines abondantes, Francisco exerce un métier dangereux : conducteur de poids lourds …

Page 169

Die Eltern leiten eine Privatschule und augenscheinlich teilt die ganze Familie (inklusive Hund) die gleiche Vorliebe für schwarzweiße Kleider! Heute beginnen die Sommerferien, die die Familie wie jedes Jahr im Süden Frankreichs verbringen wird. Dort versorgen sie sich mit einigen Flaschen des jüngsten Modegetränks in Dänemark: französischem Rotwein! „Für das neue Jahrtausend wünschen wir uns ein noch größeres vereintes Europa, das sich dem Osten öffnet."

The parents run a private school. The whole family (including the dog) clearly has the same taste in clothes! Today is the start of the summer holidays, and, as they do every year, they're getting ready to head for the south of France. They'll be bringing back a few bottles of the latest 'in' drink here, red wine! "In the new millennium, we'd like Europe to be more united, and open to the eastern countries."

Les parents sont directeurs d'une école privée. Décidément, toute la famille (le chien inclus) a les mêmes goûts vestimentaires! C'est le début des vacances et ils se préparent, comme chaque année, à partir vers le Sud de la France d'où ils rapporteront quelques bouteilles de la dernière boisson à la mode ici : le vin rouge! « Pour l'an 2000, nous souhaitons une Europe plus unie, ouverte aux pays de l'Est.

Asmara,
Eritrea,
21 December 1997

Der Ingenieur Michael baut Häfen, Brücken und Bürogebäude. Wie viele seiner Landsleute hat er eine Zeit lang in Europa und in den USA gelebt. Sein Resümee für das neue Jahrtausend: „Die Menschen haben verstanden, dass sie es besser machen müssen – das ist gut." Er hofft, dass Eritrea der ideologische Führer Afrikas werden wird!

Michael is a civil engineer, constructing harbours, bridges and office buildings. Like many Eritreans, he's lived in Europe and the United States. As for the new millennium, "People have realized we've got to do better … that's a good thing," and he hopes that Eritrea will become the ideological leader of Africa!

Ingénieur civil, Michaël construit des ports, des ponts et des immeubles. Comme beaucoup d'Erythréens il a vécu en Europe et aux Etats Unis. Pour l'an 2000 : « Les gens ont compris qu'il faut être meilleur… c'est une bonne chose » et il souhaite que l'Erythrée devienne le leader idéologique de l'Afrique!

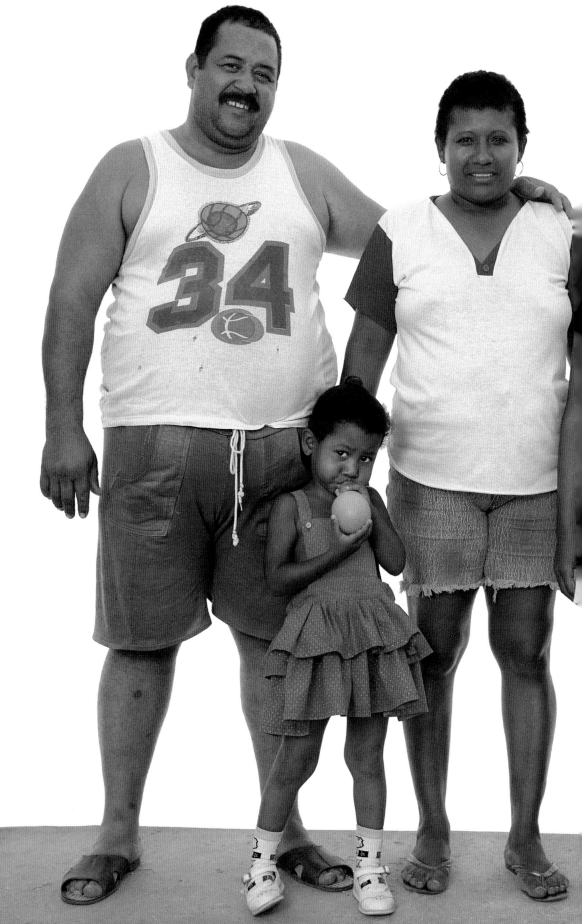

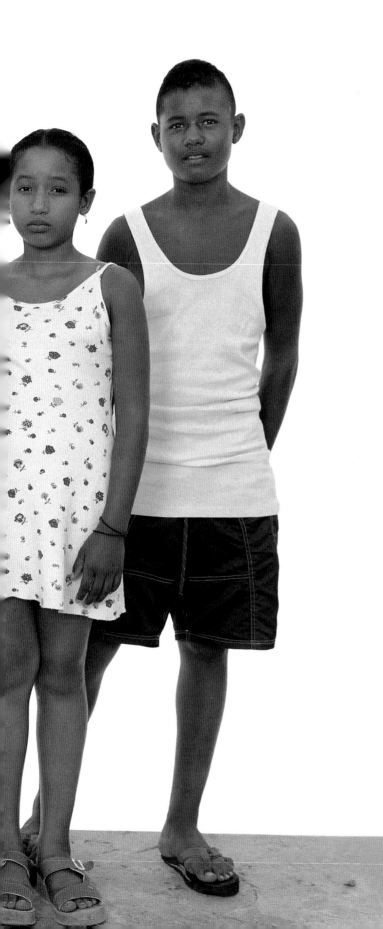

Río Caribe,
Venezuela,
27 February 1999

Antonio hat zwei Hobbys: „Mit meinen Freunden Bier trinken und mit der Familie fernsehen." Er unterrichtet Elektronik an einer Berufsschule und der 15-jährige Adolfo, der in die Fußstapfen seines Vaters treten will, möchte in den USA studieren.

Antonio has two hobbies: "Drinking beer with my friends and watching TV with my family." He teaches electronics in a vocational school, and 15-year-old Adolfo, who's keen to follow in his footsteps, wants to study in the United States.

Antonio a deux hobbies : « Boire de la bière avec mes amis et regarder la télé en famille. » Il enseigne l'électricité dans une école professionnelle et Adolfo (quinze ans), prêt à le suivre dans ce domaine, souhaite faire ses études aux Etats-Unis.

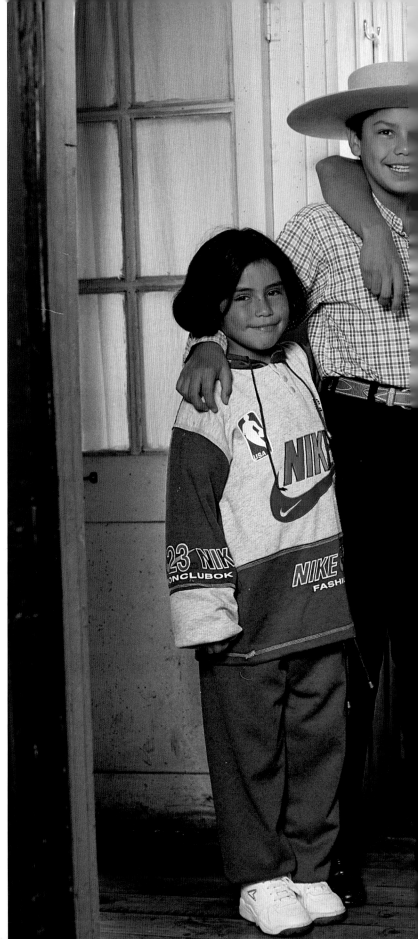

Salvador ist Grundbesitzer und Eigentümer einer Kiefernschonung, doch sein Leben dreht sich um Pferde und Rodeos. Seine Kinder haben andere Ambitionen: César will Arzt, Salvador Förster und Carolina Tennisspielerin werden.

Salvador is a landowner and has a pine plantation, but his life revolves around horses and rodeos. His children have other ambitions: César is going to be a doctor, Salvador a forest ranger and Carolina a tennis player.

Salvador est propriétaire terrien et possède une plantation de pins, mais sa vie tourne autour des chevaux et des rodéos. Ses enfants ont d'autres ambitions : César sera docteur, Salvador, garde forestier, et Carolina joueuse de tennis !

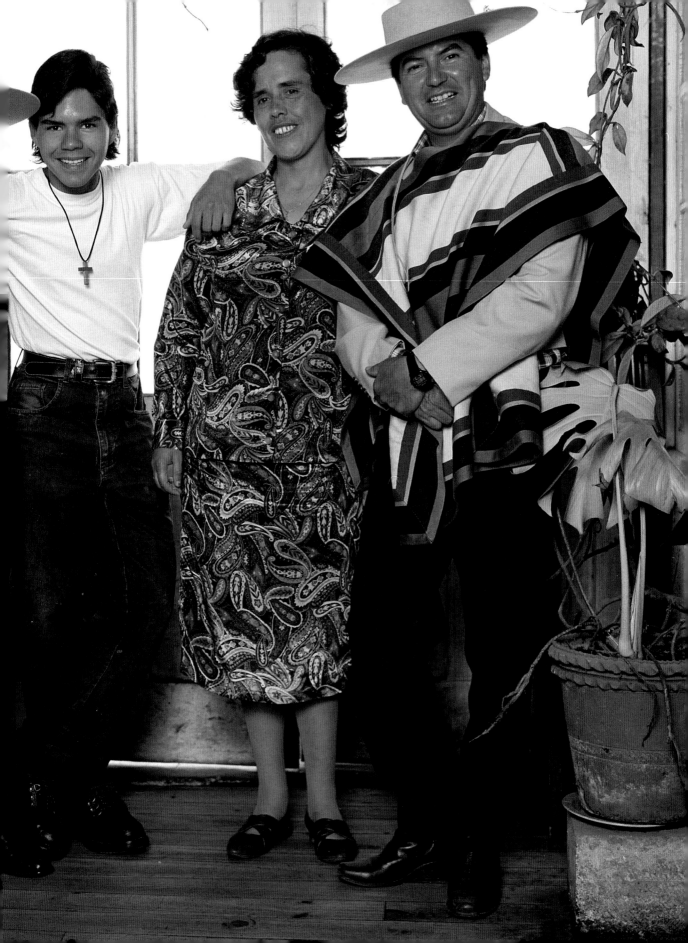

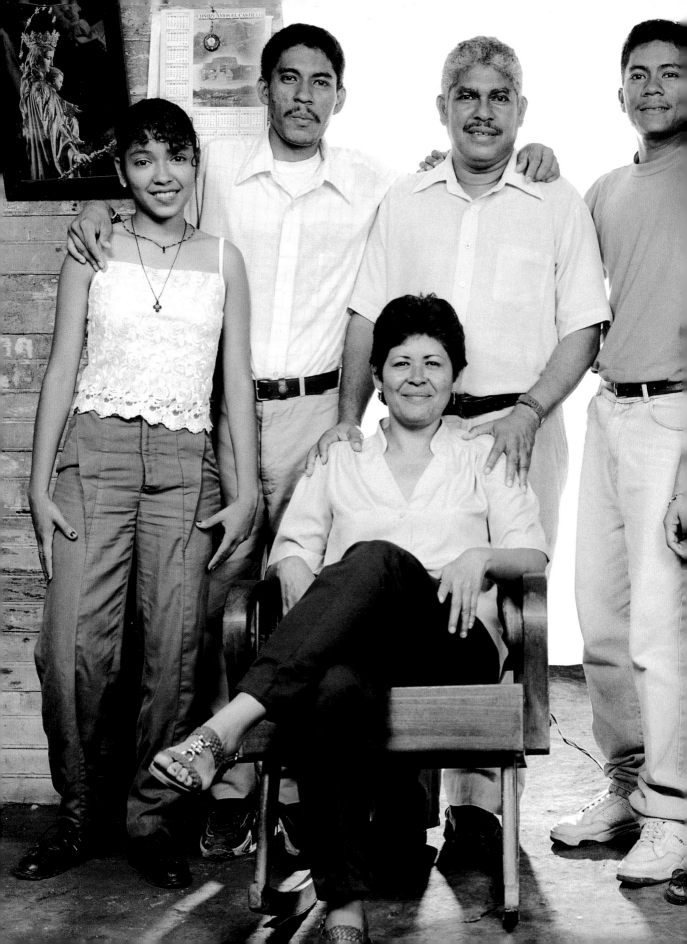

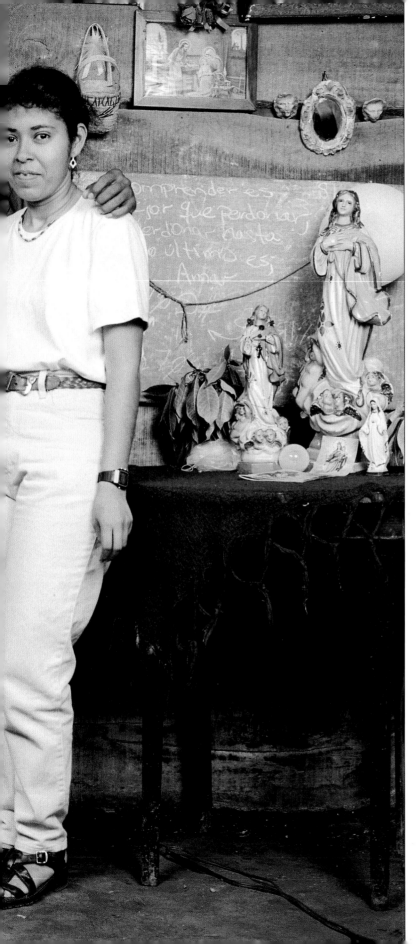

Granada,
Nicaragua,
16 December 1998

Francisco ist studierter Topograf. Da er keine Arbeit finden konnte, ist er vor 18 Jahren in den Lehrberuf gewechselt. Seine vier Kinder studieren Tourismus, Elektronik, Klinische Forschung und Informatik. „Ich bin immer zu Hause gewesen, um mich um die Kinder zu kümmern, und so wird es auch bleiben, bis sie heiraten", vertraut uns Carmen an. Carmens Wünsche gelten ihrer Familie: „Gemeinsam den Jahrtausendwechsel erleben, und wir möchten, dass die Kinder ihr Studium beenden."

Francisco is a topographer by training, but, unable to find work in that field, he switched to teaching 18 years ago. His four children are studying tourism, electronics, clinical research and computer engineering. "I've always stayed at home to take care of the children, and that'll be the way it is until they marry," Carmen tells us. Carmen's hopes are bound up with the family: "We'd like to see out this century together, and we want the children to get their degrees and the younger ones to go on studying."

Francisco est topographe de formation. Ne trouvant pas de travail, il s'est reconverti dans l'enseignement il y a dix-huit ans. Ses quatre enfants suivent des études: tourisme, électronique, recherche clinique et ingénierie informatique. « Je suis toujours restée à la maison pour m'occuper des enfants et ce sera ainsi jusqu'à ce qu'ils se marient ! », nous confie Carmen. Les souhaits de Carmen sont liés à sa famille : « Nous aimerions finir ce siècle ensemble, que les enfants obtiennent leurs diplômes, et que les plus jeunes continuent leurs études. »

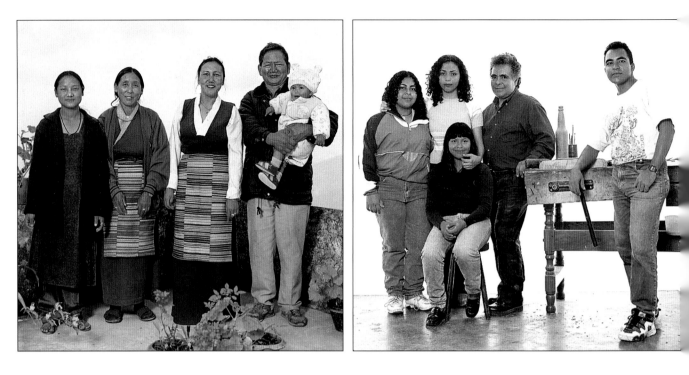

Darjeeling,
India,
18 November 1999

Lakpa Sherpa stammt ursprünglich aus Nepal, lebt aber schon seit 40 Jahren in Darjeeling. Als Träger hat er bis zu seinem 58. Lebensjahr Bergexpeditionen aus aller Welt begleitet. Seine beiden Söhne setzen die Tradition des Bergvolks fort, doch sein ganzer Stolz ist seine Tochter, die eine versierte Bergsteigerin geworden ist. Wir haben ihn mit seinen beiden Schwiegertöchtern und dem jüngsten Nachwuchs fotografiert.

Lakpa Sherpa is Nepalese-born, but has been living in Darjeeling for 40 years. As a porter, he has accompanied mountaineering expeditions from all over the world – or did at least until he was 58. His two sons are continuing the mountaineering tradition, but what makes him proudest of all is that his daughter has become an experienced mountaineer. We photographed him with his two daughters-in-law and the youngest grandchild.

Lakpa Sherpa est d'origine népalaise, il vit à Darjeeling depuis quarante ans. Porteur, il a accompagné des expéditions d'alpinistes du monde entier, jusqu'à l'âge de cinquante-huit ans. Ses deux fils continuent la tradition montagnarde mais sa fierté, c'est sa fille qui est devenue une alpiniste chevronnée. Nous l'avons photographié avec ses deux belles-filles et le petit dernier.

Volcán,
Panama,
31 December 1998

José ist als Bildhauer in ganz Panama bekannt. Er fertigt auch kommerzielle Objekte an, die er mit erstaunlicher Präzision und Schnelligkeit modelliert. Seine Kinder, die eigentlich in Panama-Stadt leben und studieren, sind mit dem Bus hergekommen, um Silvester mit ihrem Vater zu verbringen.

Sculptor José is known throughout Panama. He also makes commercial objects which he sculpts with incredible precision and speed. His children, who are living and studying in Panama City, came by bus to spend New Year's Eve with their father.

José, sculpteur, est connu dans tout le Panamá. Il réalise aussi des objets publicitaires qu'il sculpte avec une précision et une vitesse étonnantes. Ses enfants, qui étudient et vivent à Panamá City, sont venus en bus passer le réveillon avec leur père.

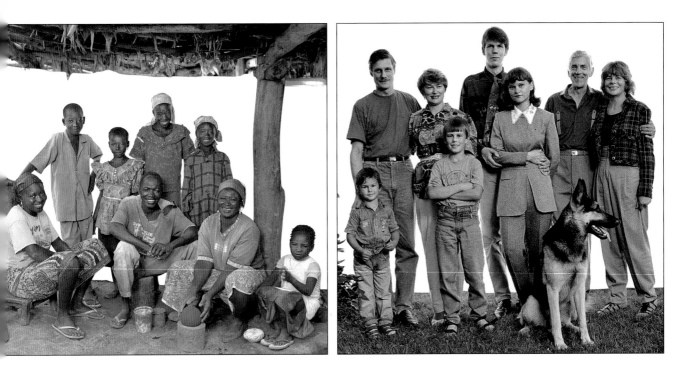

Roumsiki,
Cameroon,
30 July 1997

Marie arbeitet in Roumsiki als Töpferin und entwirft Schalen, Vasen und Teller, die sie in der Trockenzeit an Touristen oder einfach an die Hausfrauen des Ortes verkauft. „Das Schlimmste sind Krankheiten! Deswegen wünsche ich mir für uns vor allen Dingen Gesundheit. Vielleicht geschieht ja etwas im neuen Jahrtausend, aber so ganz glaube ich nicht daran."

Marie is a potter in Roumsiki and makes bowls, vases and plates that she sells during the drought to tourists or simply to local housewives. "Illness is the worst thing in the world! That's why I wish for health above all else. Maybe something will change in the new millennium – but I don't really have very much faith that it will."

Potière à Roumsiki, Marie produit et personnalise des bols, des vases ou des assiettes qu'elle vend aux touristes de passage ou tout simplement aux ménagères des environs. « Rien n'est pire que la maladie, c'est pour cela que je nous souhaite en bonne santé avant tout. Il se produira peut-être quelque chose en l'an 2000… mais je n'y crois pas trop ! » nous confie Marie.

Riga,
Latvia,
14 July 1998

Ihre Geschichte habe „blitzartig" angefangen, erinnert sich Martins und meint damit ihre erste Begegnung vor 36 Jahren. Sie war damals Kunststudentin und er Soldat in der russischen Armee. Heute bewacht Gunta den Parkplatz eines Museums, doch sie vertraut uns an: „Im Jahr 2000 würde ich diesen Job, der nichts weiter als ein Broterwerb ist, gern vergessen und wieder zur Kunst zurückkehren, dem Zeichnen und der Malerei." Martins arbeitet in der Polizeischule, wo er für die Wartung der Ausrüstung, insbesondere der elektronischen Geräte, zuständig ist. „Das Leben wird immer schneller und wir nehmen uns nicht mehr die Zeit, um zu staunen und zu genießen. Dank der Kinder sind wir immer noch Optimisten. Durch sie haben wir erst richtig angefangen zu leben. Übrigens sind die Kinder mein Produkt …", fügt Martins nur halb scherzhaft hinzu.

Their story started "in the twinkling of an eye," Martins recounts, talking about their meeting 36 years ago. She was a fine arts student and he was a soldier in the Russian army. Nowadays, Gunta is in charge of a museum car park. "In 2000," she says, "I'd like to forget all about this job, which is just a way of earning money, and get back to art, drawing and painting." Martins works at the police school, where he runs the equipment maintenance unit and has charge of everything to do with electronics in particular. "Life gets faster and faster, and we don't have time to stop and look at things – no time to savour things. We're still optimistic, thanks to our children. They're the real beginning of our lives. Anyway, the children are my creation …," adds Martins, only half in jest.

Leur histoire a commencé « dans un éclair », raconte Màrtins en parlant de leur rencontre il y a trente-six ans. Elle était étudiante aux beaux-arts et lui militaire dans l'armée russe. Aujourd'hui responsable du parking d'un musée, Gunta nous confie : « En l'an 2000, j'aimerais oublier ce métier qui n'est rien d'autre qu'un gagne-pain et revenir à l'art, au dessin, à la peinture. » Màrtins travaille à l'école de police où il est en charge de l'entretien du matériel et en particulier de tout ce qui est électronique. « La vie va de plus en plus vite et nous n'avons le temps de rien contempler, rien savourer. Nous restons optimistes grâce à nos enfants, ils sont le vrai début de notre vie. D'ailleurs les enfants sont mon produit … », ajoute Màrtins en ne plaisantant qu'à demi.

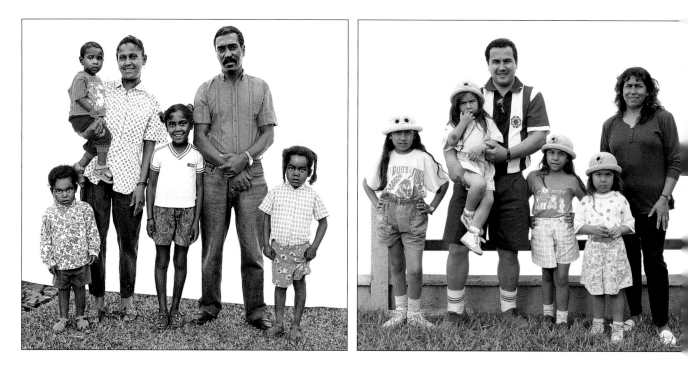

 Waku-Kungo,
Angola,
5 September 1997

Frieden und Fortschritt wünscht sich Carlos, der Hydrauliktechniker, für seine Kinder. In einem Bürgerkriegsland, in dem das Gesundheits- und Bildungs-wesen den absoluten Tiefstand erreicht haben, bereitet ihm das tägliche Überleben echte Sorge.

Carlos, who works as a hydraulic technician, dreams of a life of peace and progress for his children. In a country at war, where health and education are at their lowest ebb ever, daily life is a real source of worry for him.

C'est d'une vie de paix et de progrès dont rêve Carlos, technicien en hydraulique, pour ses enfants. Dans un pays en guerre, où la santé et l'éducation sont au niveau le plus bas, c'est la vie quotidienne qui est une réelle préoccupation pour lui.

Santiago,
Chile,
14 January 1999

Wir vermuten, dass Elizabeth für die Mützen ihrer vier Töchter einen Rabatt ausgehandelt hat. „2000 sollten wir vielleicht mal versuchen, einen Jungen hinzukriegen", erzählt uns Hugo lächelnd.

We suspect Elizabeth negotiated a discount for her four daughters' bonnets. "In 2000, perhaps we'll try to have a little boy," Hugo tells us, smiling.

Nous soupçonnons Elizabeth d'avoir négocié un rabais pour les bonnets de ses quatre filles. « Pour l'an 2000, peut-être devrions-nous essayer de faire un petit garçon », nous dit Hugo en souriant.

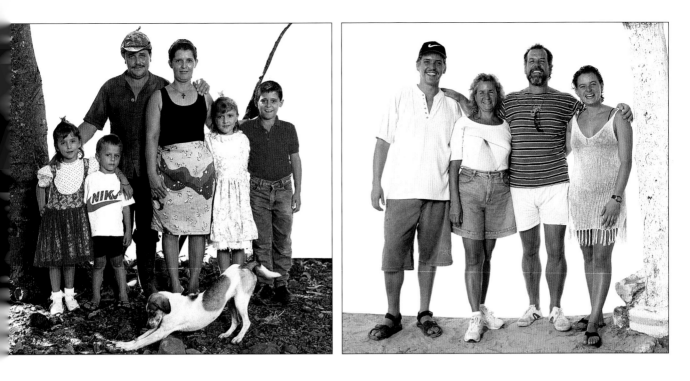

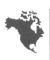

Hatillo de Aguirre,
Costa Rica,
20 December 1998

Juan ist Landarbeiter und versorgt das Vieh auf einer Hazienda in der Umgebung. Vicenta lehrt in der Kirche den Katechismus.

Juan is a farm labourer in charge of the livestock in a nearby hacienda. Vicenta teaches catechism at the church.

Juan, ouvrier agricole, est responsable du bétail dans une hacienda des environs. Vicenta enseigne le catéchisme à l'église.

Praia do Frances,
Brazil,
15 March 1999

Sie hatten die Nase voll von der Stadt, von ihren Berufen als Bankangestellter und Sprachenlehrerin. 20 Meter vom Meer entfernt haben sie ein Restaurant eröffnet, in dem die ganze Familie mit anpackt, überglücklich über diese Veränderung in ihrem Leben.

They've had enough of the city and their jobs as banker and language teacher. Twenty paces from the sea they've opened a restaurant where the whole family work, happy with the way their life has changed.

Ils en ont eu assez de la ville, assez de leur métier de banquier et de professeur de langues. Ils ont ouvert à vingt mètres de la mer un restaurant dans lequel travaille toute la famille, heureuse de ce changement de vie.

Ürgüp,
Turkey,
3 August 1999

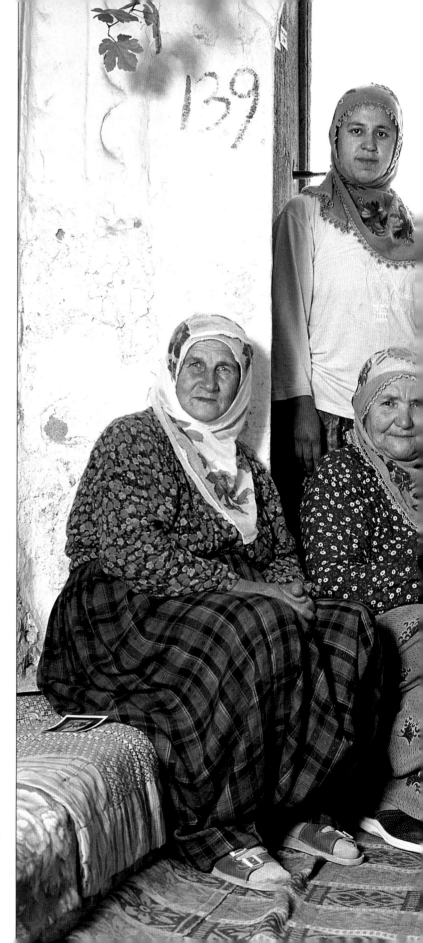

Wie alle Gemeindemitglieder bestellt auch Bürgermeister Muammer seine Felder, auf denen er Zwiebeln, Kartoffeln, Weizen, Wein und Obst anbaut. Außerdem hat er fünf Kühe aus Holland importiert, die jedoch von Tag zu Tag weniger Milch geben. „Wahrscheinlich haben sie Schwierigkeiten, sich an das hiesige Klima zu gewöhnen", erklärt er uns enttäuscht.

Muammer is the village mayor. Like the rest of his constituency, he works in the fields, where he grows onions, potatoes, wheat, vines and fruit trees. He has also imported five Dutch cows, but he's a bit disappointed by their milk yield, which has dropped since they first got here. "They're probably having trouble adapting to the climate, which isn't very 'Dutch'."

Muammer, maire de son village, travaille comme le reste de ses administrés dans les champs, où il cultive oignons, pommes de terre, blé, vignes et arbres fruitiers. Il a aussi importé cinq vaches hollandaises, mais il est un peu déçu par leur « rendement » qui a bien baissé depuis leur arrivée ici, elles ont sans doute du mal à s'adapter au climat très peu « hollandais ».

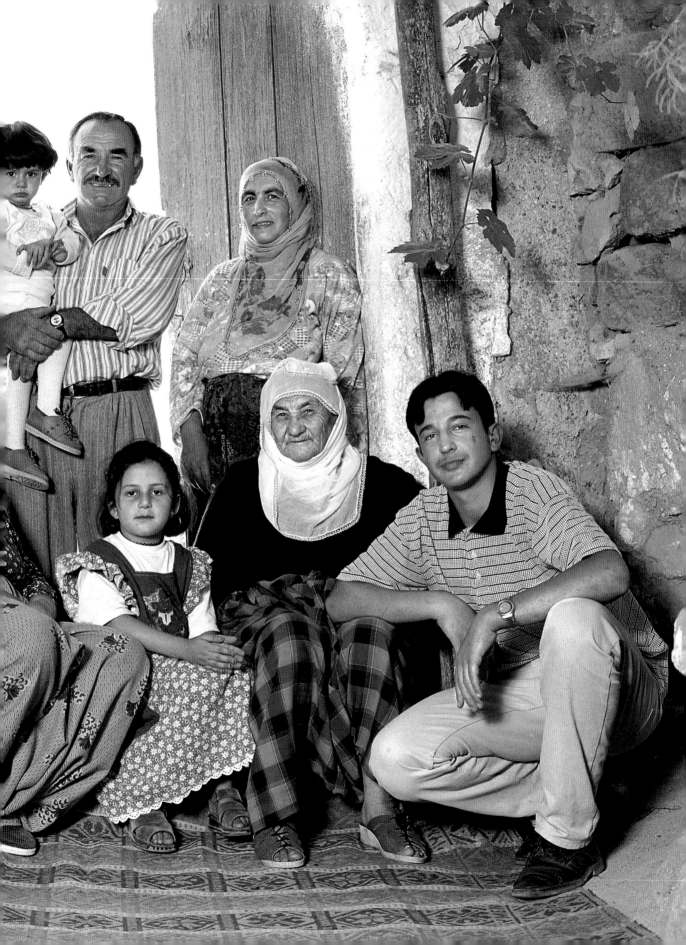

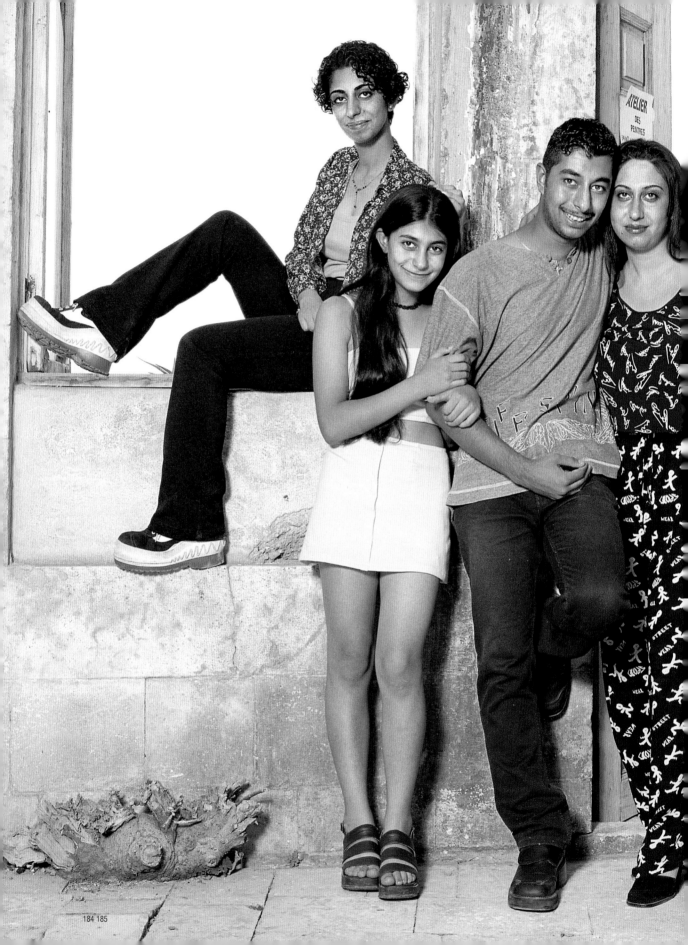

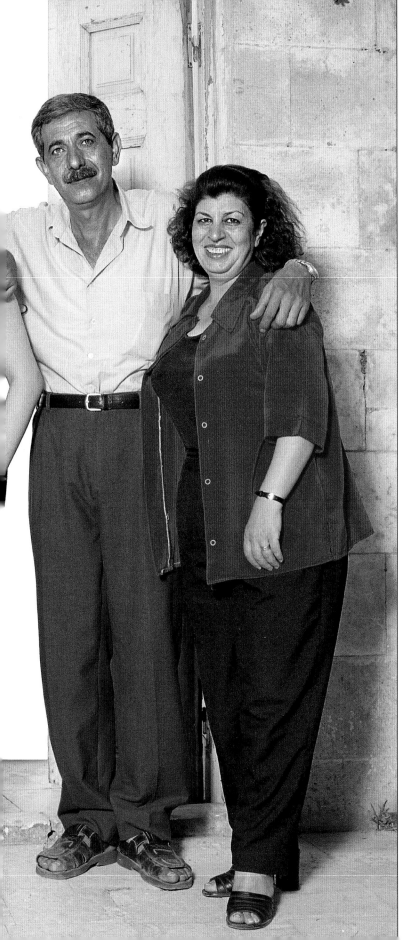

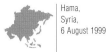

Barakat ist freischaffender Künstler. Er träumt davon, eines Tages in Paris auszustellen. Die 23-jährige Nesree studiert arabische Literatur und sieht sich bereits als Fernsehjournalistin. Nadeen (21, sitzend) studiert Agrarwissenschaften, Fahed (19) wartet auf sein Abiturergebnis. Die zwölfjährige Dima wird später einmal Profibasketballerin, auch wenn sie sich schon zweimal beim Spiel den Arm gebrochen hat. Ihre Mutter Nuhad arbeitet als Sekretärin bei den städtischen Wasserwerken. Die Familie hat ein gemeinsames Hobby: Sie singt im Chor und Nuhad begleitet sie auf der Gitarre.

Barakat is a painter. He dreams of showing his pictures in Paris. Nesree (23) is studying Arabic literature, and sees herself working as a TV journalist. Nadeen (21, seated) is studying to be an agricultural engineer. Fahed (19) is waiting for his school exam results. Twelve-year-old Dima is going to be a professional basketball player, and is showing promise already – she's broken her arm twice. Nuhad, their mother, works as a secretary for the water company. One hobby they all share: family singing, with Nuhad accompanying them on her guitar.

Barakat, ancien prof d'arts plastiques devenu artiste peintre, rêve d'exposer ses tableaux à Paris. Nesree (vingt-trois ans) étudie la littérature arabe et se voit déjà journaliste à la télévision. Nadeen (vingt et un ans, assise) fait des études et sera ingénieur en agriculture. Fahed (dix-neuf ans) attend les résultats du bac. Dima (douze ans) sera joueuse de basket professionnelle, ses débuts sont prometteurs : elle a eu deux fois un bras cassé ! La maman Nuhad prend moins de risques et travaille comme secrétaire à la compagnie des eaux. Ils ont un hobby commun : le chant en famille, ils sont accompagnés par Nuhad à la guitare.

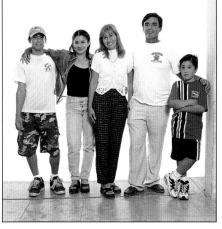

1

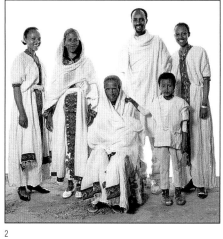

2

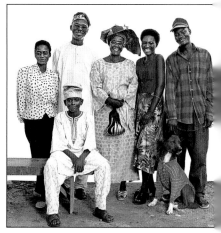

3

1
Mazatlán,
Mexico,
30 November 1998

2
Mekele,
Ethiopia,
14 December 1997

3
Lagos,
Nigeria,
14 July 1997

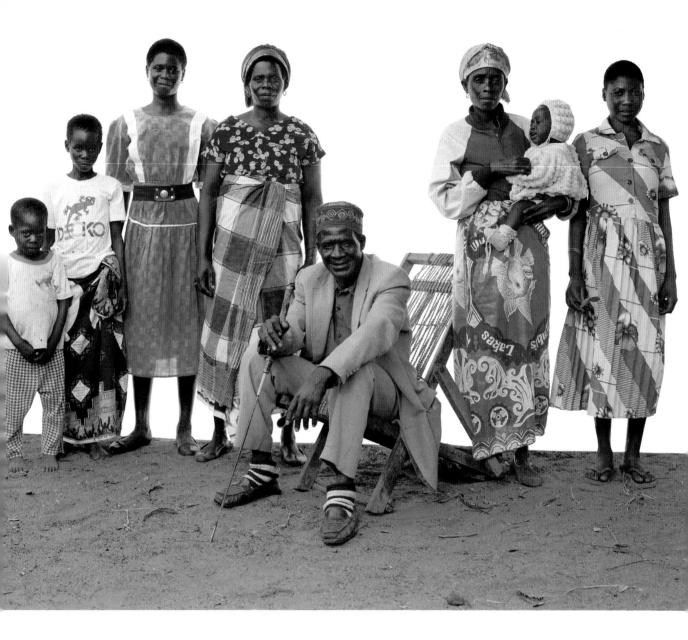

Kasankha,
Malawi,
30 October 1997

Bevor Lexon Oberhaupt des Dorfs wurde, versorgte er als Bäcker die anderen Bewohner 15 Jahre lang mit Brot. Mit seinen zwei Frauen hat er vier Kinder, von denen eines ihn erst kürzlich zum Großvater gemacht hat.

Before becoming village headman, Lexon used to bake bread – he was a baker for 15 years. He's got four children from his two wives, and just recently became a grandfather.

Avant de devenir le chef du village, Lexon en a fabriqué le pain, il a été boulanger pendant quinze ans! Il a quatre enfants de ses deux épouses et est devenu grand-père très récemment.

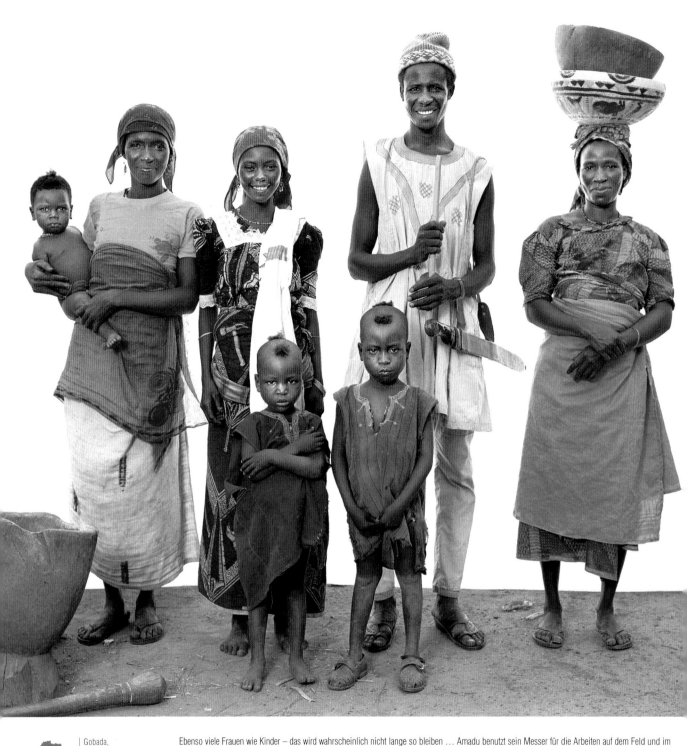

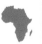 Gobada,
Nigeria,
17 July 1997

Ebenso viele Frauen wie Kinder – das wird wahrscheinlich nicht lange so bleiben … Amadu benutzt sein Messer für die Arbeiten auf dem Feld und im Haus und vermutlich auch, um die Frisur seiner Kinder in Form zu bringen …

As many wives as children – but this is a state of play which may well not last … Amadu uses his knife for work in the fields and around the home, and probably for 'sculpting' his children's hairdos, too …

Autant de femmes que d'enfants, voilà une situation qui risque de ne pas durer … Amadu se sert de son couteau pour les travaux champêtres, domestiques et probablement pour « sculpter » la coiffure de ses enfants …

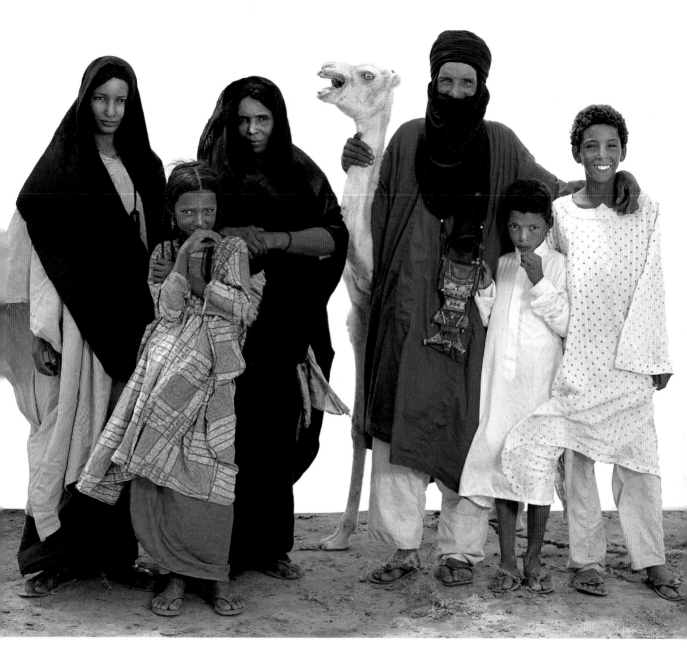

Besseta,
Niger,
20 July 1997

Ahmed ist Schäfer und trotz des vielen Viehs, das um sein Zelt herum weidet, besitzt er selbst nur sehr wenige Tiere. Die Kamele und Kühe gehören vor allem den reichen Haussa-Händlern. Seine Kinder haben nie eine Schule von innen gesehen. Als echte Nomaden ziehen die Familien auf der Suche nach Weideplätzen und Wasserstellen ständig umher.

Ahmed is a herdsman and despite the large number of cattle grazing around his tent, he owns very few head himself. The camels and cows belong mainly to rich Hausa traders. The children don't go to school. These truly nomadic families are constantly on the move, as dictated by the need for grazing lands and watering holes.

Ahmed est berger et malgré le grand nombre de bétail qui paît autour de sa tente, il en possède très peu lui-même. Les chameaux et les vaches appartiennent surtout à de riches commerçants haoussas. Les enfants ne connaissent pas l'école. Véritables nomades, les familles se déplacent en permanence au grès des besoins en pâturages et en points d'eau.

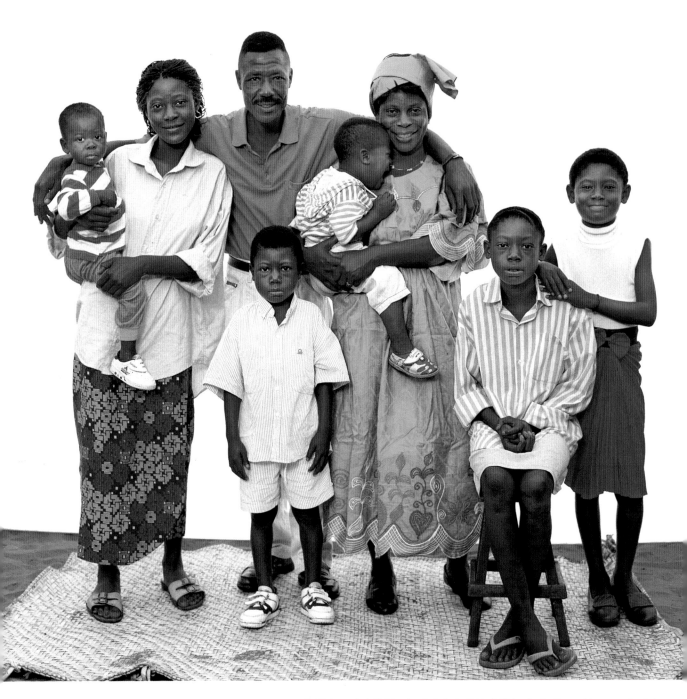

Pointe-Noire,
Congo,
28 August 1997

Mathieu ist Modedesigner, Vater von fünf Kindern und mit 45 Jahren bereits Großvater. Er ist glücklich, seine Familie um sich versammelt zu haben – ganz im Gegensatz zu seinem Filius im Hintergrund, der aus Angst vor dem „weißen Mann" unaufhörlich weinte.

Mathieu is a dress designer, and at 45, father of five children and already a grandfather; he is happy to have a close-knit family. His youngest child was much less happy – he couldn't stop crying for fear of the 'white man'.

Mathieu est couturier, à quarante-cinq ans il est père de cinq enfants et déjà grand-père; il est heureux d'avoir une famille unie. Son petit dernier l'était beaucoup moins: il n'a pas arrêté de pleurer de peur devant l'« homme blanc ».

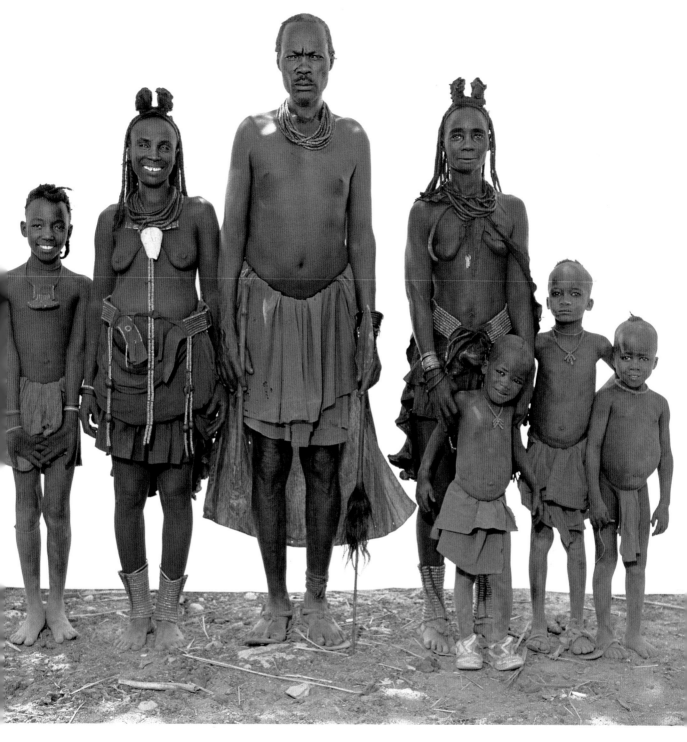

near Opuwo,
Namibia,
12 September 1997

Stolz lässt sich Tjikuro Tjikundi mit seinen beiden Frauen und seinen Kindern fotografieren. Er kann es kaum erwarten, dass sich seine Familie vergrößert …

Tjikuro Tjikundi poses proudly with his two wives and his children, and waits impatiently for his family to grow …

Tjikuro Tjikundi pose fièrement en compagnie des ses deux épouses et de ses enfants et attend impatiemment que la famille s'agrandisse…

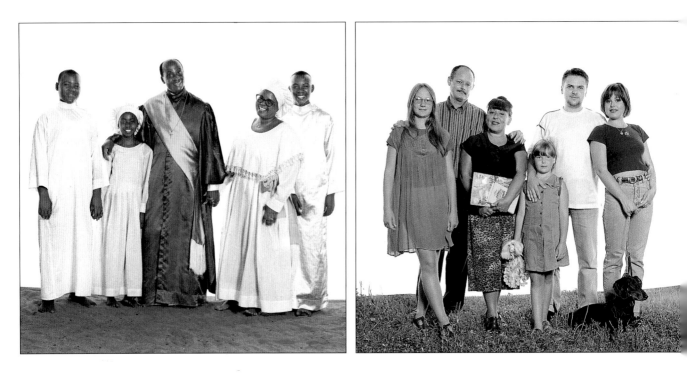

Abidjan,
Ivory Coast,
29 March 1997

Sie beten gemeinsam: der Vorstand der Kirche des Himmlischen Christentums, seine Frau „Mamma Yvonne" und ihre drei Kinder. Es ist heilige Woche, die Zeit des Fastens und der Gebete. Mamma Yvonne ist Deutschlehrerin am Gymnasium von Bingerville und engagiert sich darüber hinaus für die werdenden Mütter in ihrer Gemeinde, die traditionsgemäß den letzten Schwangerschaftsmonat im Schoß der Kirche verbringen. Sie wünschen sich fürs neue Jahrtausend, „dass alle Familien der Welt gemeinsam beten und die Familien der Elfenbeinküste im großen Stadion von Abidjan zusammenkommen und ihr sie dort fotografieren könnt!"

They pray together – the head evangelist, in charge of the parish of the Church of Heavenly Christianity, his wife, 'Mamma Yvonne', and their three children. Mamma Yvonne, who teaches German at the high school in Bingerville, also spends time helping the mothers-to-be in the parish, who come and spend the last month of their pregnancy in the church compound. Their hope for the new millennium: "That all the world's families pray together, and that the families from the Ivory Coast come together in the great stadium in Abidjan so that you can photograph them all!"

Ils prient ensemble : le sénior évangéliste, chargé de la *Paroisse de l'Eglise du Christianisme Céleste*, sa femme « Mamma Yvonne » et leurs trois enfants. C'est la semaine sainte, période de jeûne et de prières. « Mamma Yvonne », professeur d'allemand au lycée de Bingerville, se consacre également aux femmes de sa paroisse, en particulier aux futures mamans, qui viennent passer le dernier mois de leur grossesse à la paroisse. Leurs vœux pour l'an 2000 : « Que toutes les familles du monde prient ensemble, que vous puissiez photographier toutes les familles de la Côte d'Ivoire dans le grand stade d'Abidjan. »

Kiev,
Ukraine,
21 July 1998

Ihre einzige Tochter zieht mit ihrer Familie in die USA. Igor und Marie planen, sie im Jahr 2000 zu besuchen. Bis dahin hofft die Ärztin Marie, genug Zeit zu finden, nicht nur um ihr Englisch zu perfektionieren, sondern auch um die letzten rund 5000 Seiten ihres zweiten medizinischen Wörterbuchs fertig zu stellen. Acht medizinische Handbücher für ukrainische Studenten hat sie bereits geschrieben. Sie sagt: „Meine Leidenschaft für die Medizin kommt von oben, es ist ein inneres Bedürfnis." Ihre Schwester Tatjana und ihre Nichte Olga sind mit auf dem Familienfoto.

In a month's time, their only daughter and her family are moving to the United States. Igor and Marie are planning to see them there in 2000. Between now and then, Marie, a doctor, hopes to have time not only to brush up her English, but above all to finish editing the last 5,000-odd pages of her second medical dictionary. She has already notched up eight medical manuals aimed at Ukrainian students. She says: "Medicine is a passion that comes to me from above – it's an inner need." Her sister Tatiana and her niece Olga are included in the family photo.

Leur fille unique part s'installer avec sa famille aux Etats-Unis. Igor et Marie projettent de les y retrouver en l'an 2000. D'ici là Marie, médecin, espère avoir le temps de perfectionner son anglais, mais surtout de finir la rédaction des quelque 5000 dernières pages de son deuxième dictionnaire médical. Elle a déjà à son actif la publication de huit manuels de médecine destinés aux étudiants ukrainiens. Elle dit : « *La médecine est une passion qui me vient d'en haut, c'est un besoin intérieur.* » Sa sœur Tatyana et sa nièce Olga font partie de la photo de famille.

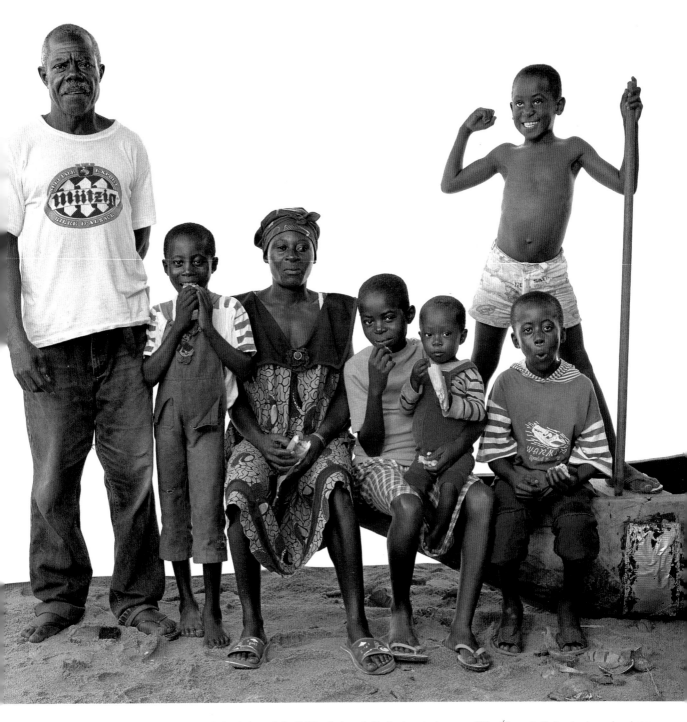

Kribi,
Cameroon,
8 August 1997

„Sind wir nicht alle eine einzige große Familie? Ihr müsst uns ein bisschen besuchen kommen …" Wenn Étienne, der Fischer, abends von einem langen Tag auf dem Meer nach Hause kommt, ist sein Fang meist mager und er hat Mühe, seine Familie satt zu bekommen. Trotz einer ernsthaften Ehekrise gelang es uns, die Familie für die Dauer der Aufnahme zu vereinen …

"We all make up one and the same family, don't we? So you should visit us a bit … " Étienne doesn't get back from his long days out fishing until the evening. His catch is rather meagre, and he is having a problem feeding his family. Despite their serious marital problems, we managed to bring the family together long enough for the photo …

« Nous formons tous une seule et même famille, non?! Alors il faut nous rendre visite un peu … » Etienne ne rentre que le soir de ses longues journées de pêche, son butin est plutôt maigre et il a du mal à nourrir sa famille. En pleine crise matrimoniale, nous avons réussi à recomposer la famille le temps de la photo…

 Arusha,
Tanzania,
11 November 1997

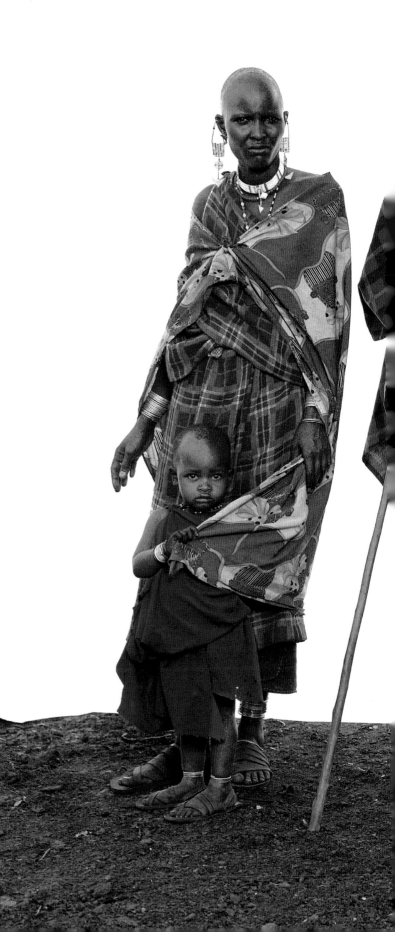

„Gott hat den Massai das Vieh gegeben" – davon sind die Männer dieses Stamms überzeugt. Milia bildet da keine Ausnahme. Einige Tiere seiner Herde hat er von den regelmäßigen Raubzügen zu benachbarten Stämmen mitgebracht … Das neue Jahrtausend? Für Milia gibt es keinen Kalender, aber er hofft, dass seine Kinder einmal eine Schule besuchen können.

"God gave the Masai cattle" – such is the belief of all the men of the tribe. Milia is no exception, and the twenty head of cattle in his herd come partly from regular 'raids' against neighbouring tribes. The new millennium? Milia doesn't know how to count the years, but he hopes that in the future his children will be able to go to school.

« Dieu a donné le bétail aux Massaïs », telle est la croyance de tout homme de cette tribu. Milia ne fait pas exception et les vingt têtes de bétail de son troupeau proviennent en partie de « raids », exécutés régulièrement chez les tribus voisines. L'an 2000 ? Milia ne sait pas compter les années, mais il souhaite que, dans l'avenir, ses enfants puissent aller à l'école.

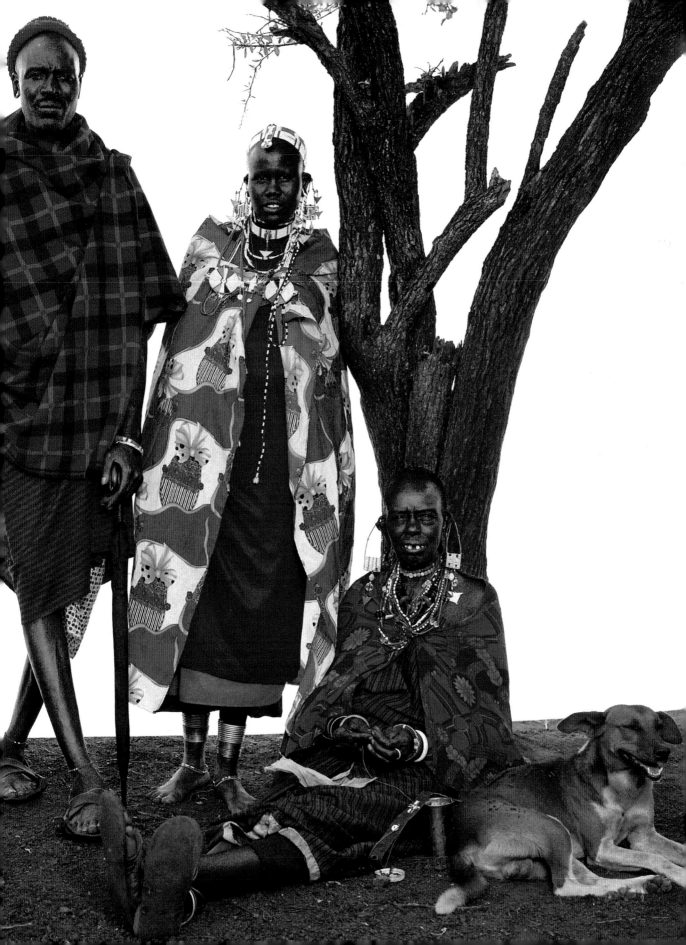

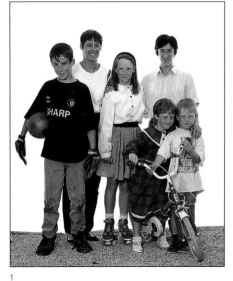

1

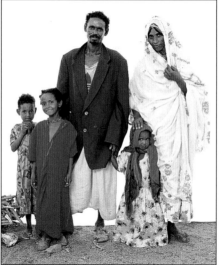

2

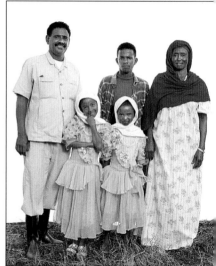

3

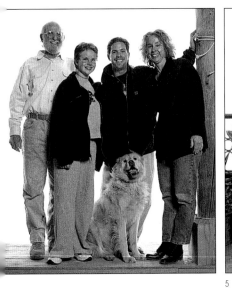

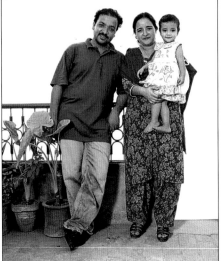

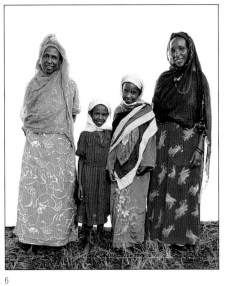

5

6

5
Lahore,
Pakistan,
7 October 1999

6
Marsabit,
Kenya,
24 November 1997

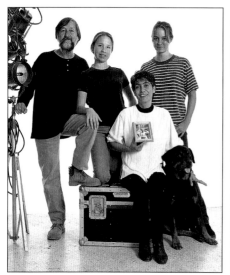

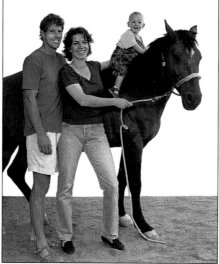

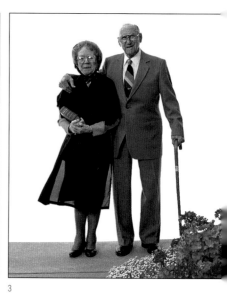

1 2 3

1
Cali,
Colombia,
18 February 1999

2
Rooisand Desert Ranch,
Namibia,
14 September 1997

3
Amana,
Iowa, USA,
8 October 1998

Smuchevo,
Bulgaria,
4 January 1997

Dimitrij (71) und Slawka (67) scheinen noch genauso verliebt zu sein wie am Tag ihrer Hochzeit 1955. Seit er in Rente ist, kümmert sich der ehemalige Maurer um seinen Gemüsegarten, die Hühner und seinen Esel. Ihre drei Kinder sind alle verheiratet und leben in der Stadt.

Seventy-one-year-old Dimitri and 67-year-old Slavka seem as much in love as on their wedding day in 1955. Dimitri is a retired builder who now looks after his kitchen garden, a few chickens and his donkey. Their three children are all married and live in town.

Dimitri (soixante et onze ans) et Slavka (soixante-sept ans) ont l'air aussi amoureux qu'au premier jour de leur mariage en 1955. Maçon retraité, Dimitri s'occupe maintenant de son potager, de quelques poules et de son âne.

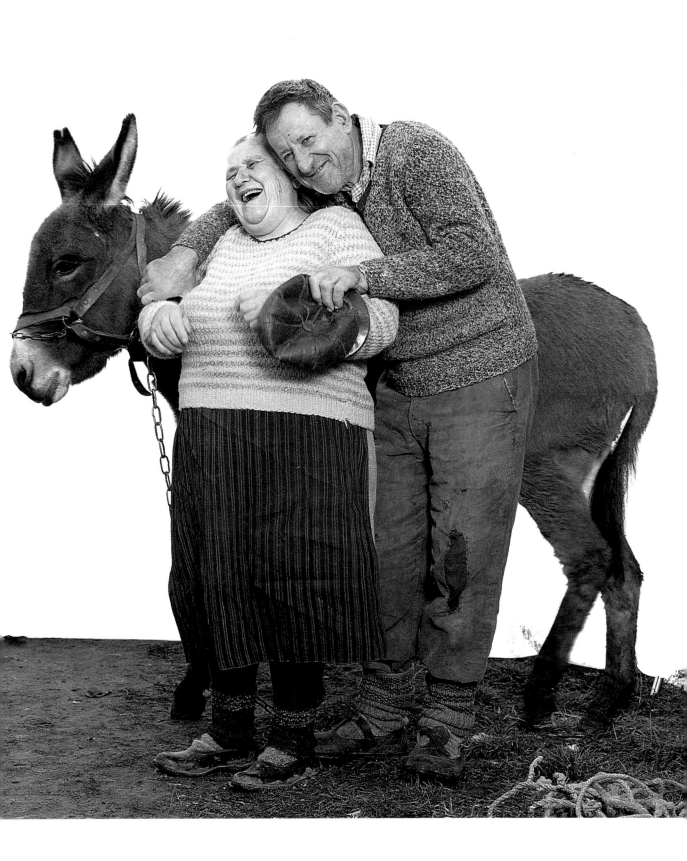

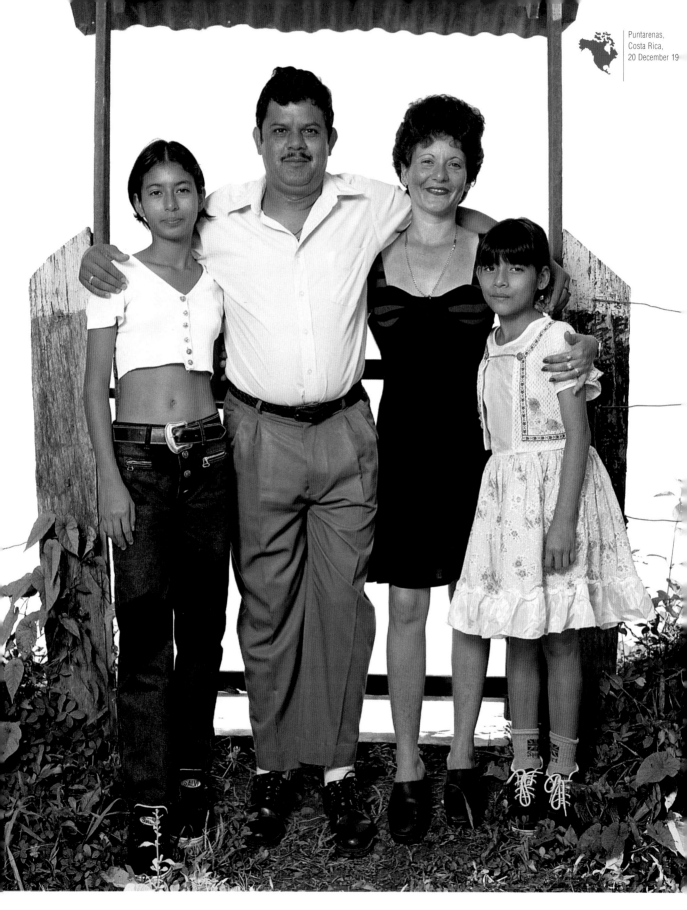

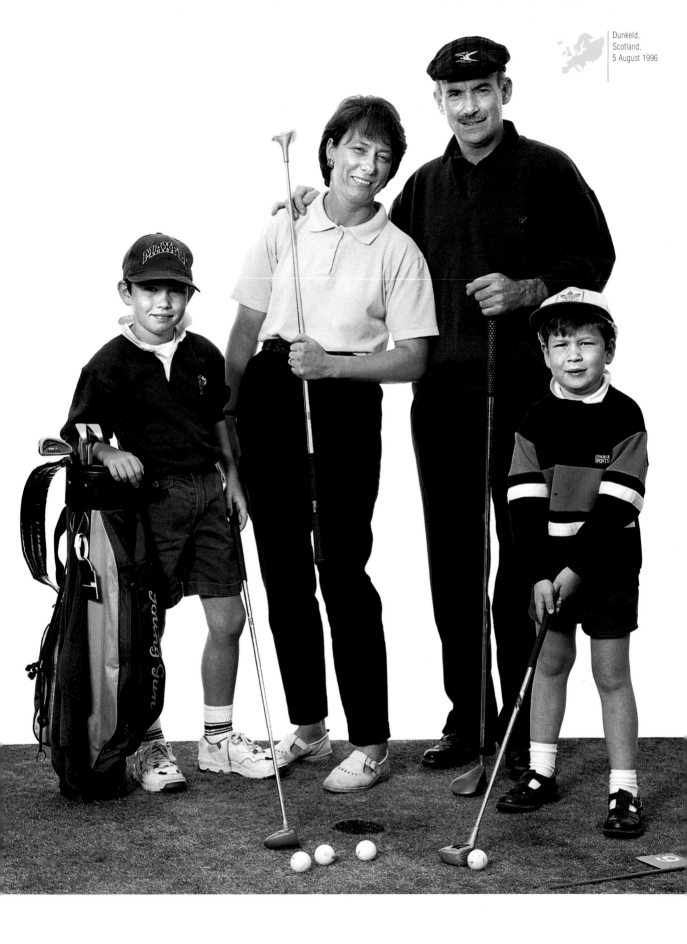

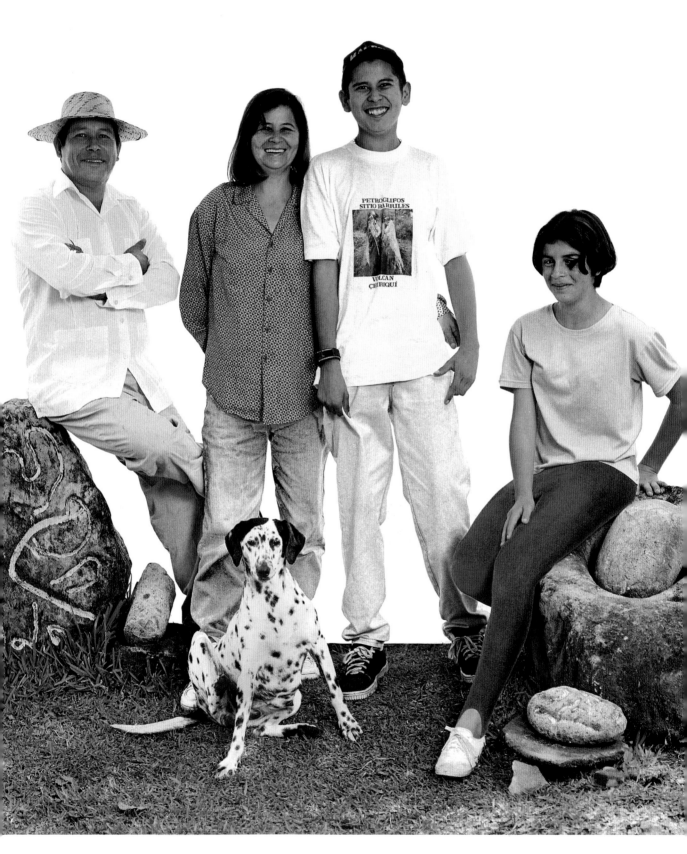

„Ich habe mit 14 Jahren Abitur gemacht", erzählt uns Gina stolz. Sie stammt aus einer Familie mit acht Kindern und wurde, als ihre Mutter starb, von einem Medizinerehepaar adoptiert. José ist Lehrer, würde aber gern Fremdenführer werden. Alexandra (14) will Medizin studieren, während die zehnjährige Jasmin davon träumt, Sängerin zu werden. Die Lieder, die ihre Mutter komponiert, singt sie schon sehr gut.

"I graduated from high school when I was 14," Gina tells us proudly. Coming from a family with eight children, she was adopted by a couple of doctors when her mother died. Teacher José would like to become a tourist guide. Alexandra (14) wants to study medicine, while Jasmin, who's ten, is going to be a singer – the songs her mother writes Jasmin already sings really well.

« J'ai eu mon bac à quatorze ans », nous raconte fièrement Gina. Issue d'une famille de huit enfants, elle a été adoptée par un couple de médecins à la mort de sa mère. José, enseignant, aimerait devenir guide touristique. Alexandra (quatorze ans) veut étudier la médecine et Yasmin (dix ans) sera chanteuse – elle chante déjà très bien les chansons composées par sa mère.

George, Küchenchef in einem großen Hotel, hat nur eine Passion, die er im Übrigen mit seiner ganzen Familie teilt: Golf. Stuart, sieben Jahre, Handicap 25, spielt regelmäßig unter dem wachsamen Auge seiner Eltern bei Turnieren, Ewan ist noch nicht klassifiziert. George gilt als einer der besten Chefköche seiner Generation, bedauert es jedoch zutiefst, dass die Küche ihm nicht mehr Zeit lässt, um sein Handicap zu verbessern. Es ist Evelyn, Handicap 20, die die Kinder mit zum Training nimmt.

George is head chef in a large hotel, with a single passion that he shares with his whole family: golf. Seven-year-old Stuart, with a handicap of 25, plays regularly in competitions under the loving gaze of his parents, but Ewan doesn't have a handicap rating yet. George is reckoned to be one of the best chefs of his generation, but regrets that cooking doesn't allow him time to improve his handicap. Evelyn (handicap of 20) is the one who takes the children to their golf lessons.

George, chef cuisinier dans un grand hôtel, n'a qu'une passion, qu'il partage d'ailleurs avec toute sa famille : le golf. Stuart, sept ans et handicap 25, joue régulièrement en compétition sous l'œil attendri de ses parents, et Ewan n'est pas encore classé. George est considéré comme l'un des meilleurs chefs de sa génération mais il regrette que la cuisine ne lui laisse pas le temps d'améliorer son handicap. C'est Evelyne (handicap 20) qui emmène les enfants à l'entraînement.

Volcán,
Panama,
2 January 1999

José-Luis und Edna sind Gründer, Träger und Wärter ihres eigenen Museums: In ihrem Haus, das im Zentrum einer archäologischen Stätte liegt, stellen sie eine Vielzahl von präkolumbischen Objekten wie gravierte Steine, Töpferwaren und Werkzeuge aus, die sie auf ihrem Grundstück gefunden haben. Sie verfolgen unzählige Projekte zur Erschließung der Stätte und möchten einen Natur- und Geschichtspark einrichten. „Gemeinsam werden wir unsere Ziele immer erreichen", lautet ihre Überzeugung.

José-Luis and Edna are the founders, curators and caretakers of their own museum: their house, which stands in the middle of an archaeological site, is filled with pre-Colombian objects such as carved stones, pottery and tools all found on their land. They are bubbling over with plans for developing the site, and would like to establish a nature and history park. "When we share a goal, we'll always be able to reach it," they say in conclusion.

Jose-Luis et Edna sont les fondateurs, conservateurs et gardiens de leur propre musée : leur maison, située au beau milieu d'un site archéologique, est riche d'objets précolombiens, de pierres gravées, de poteries et d'outils trouvés sur leurs terres. Ils débordent de projets pour la mise en valeur du site et veulent installer un parc nature et histoire où les visiteurs pourront apprendre un peu de leurs lointaines origines. Très unis, ils visitent d'autres sites historiques en famille. « Si nous avons un but, ensemble nous gagnerons toujours ! », concluent-ils.

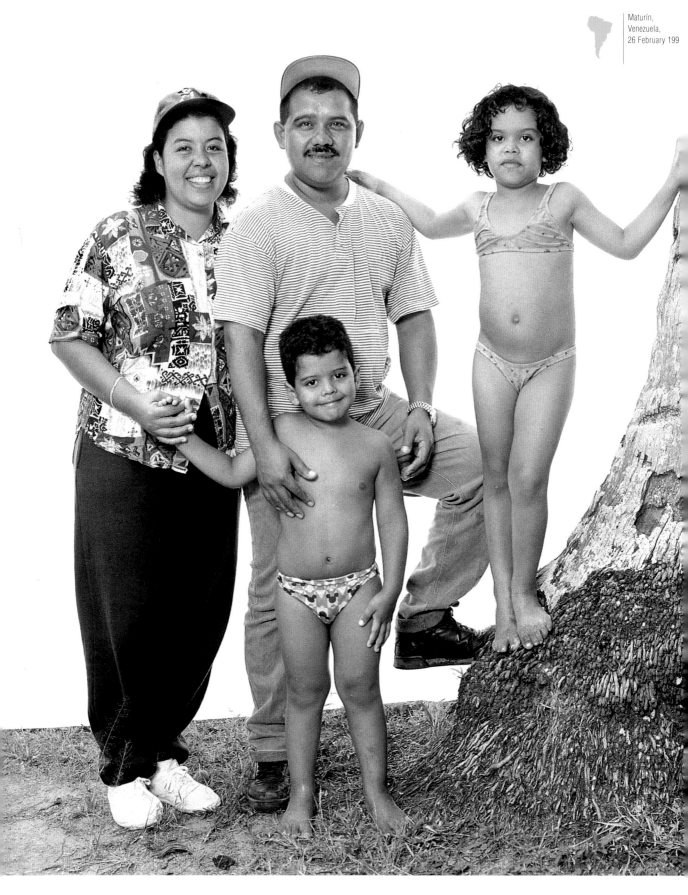

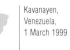

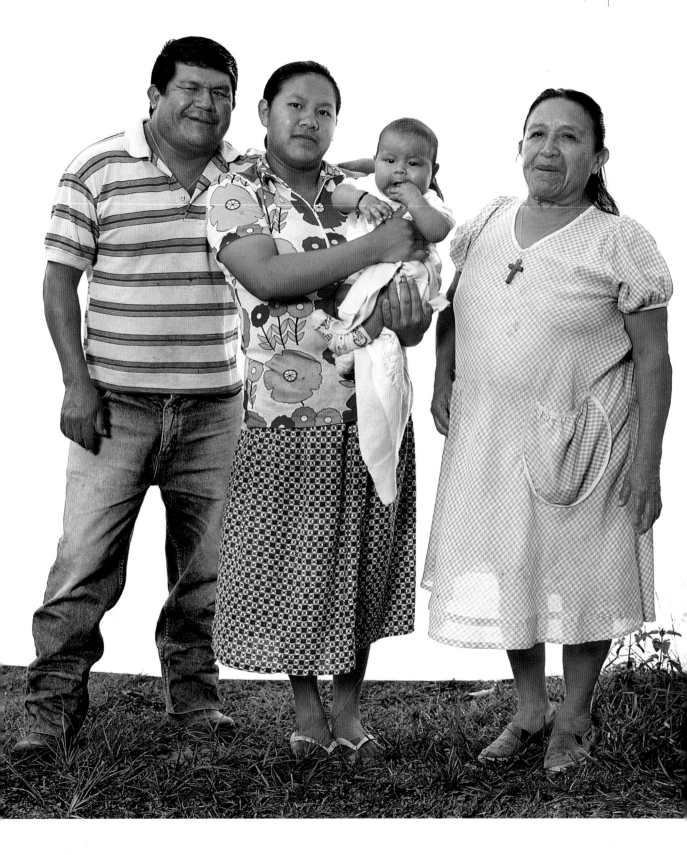

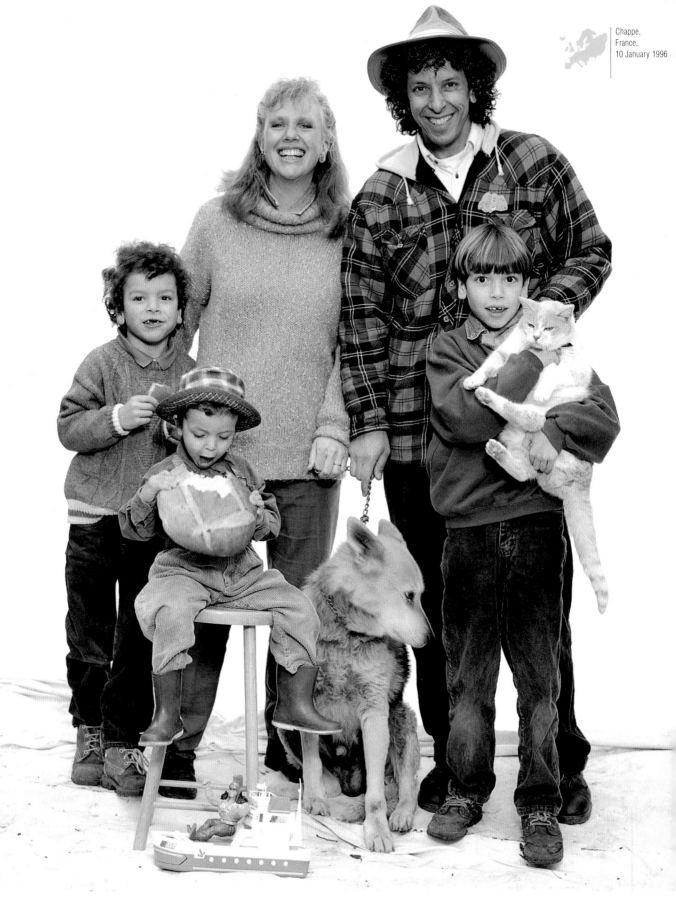

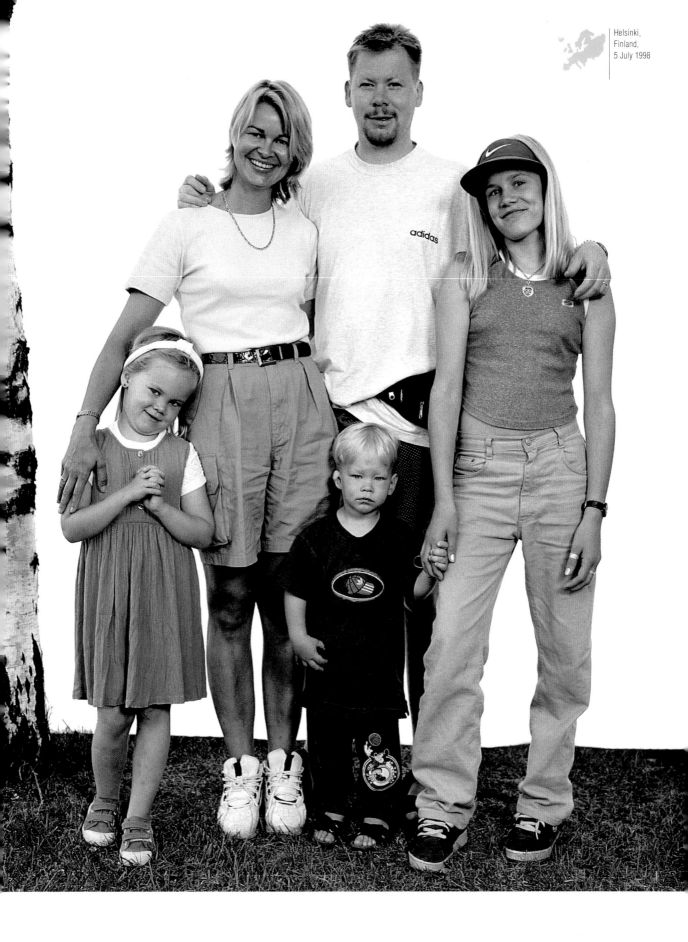

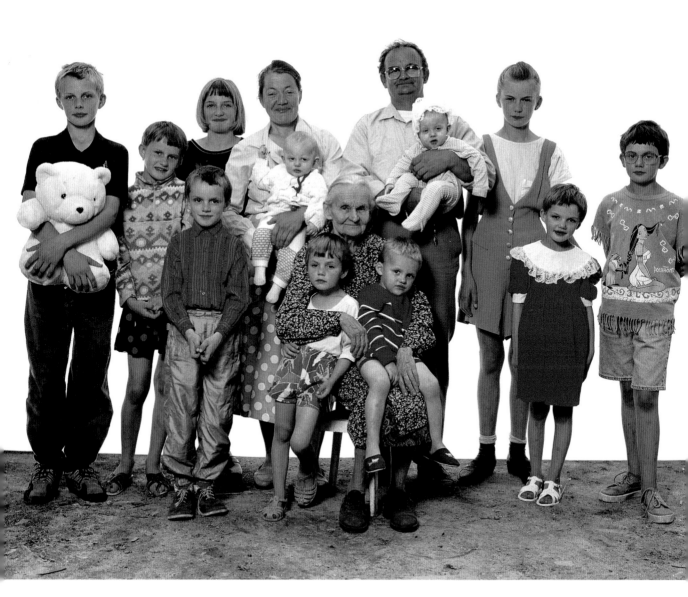

Luis ist Informatiker und Margelis versorgt den Haushalt und die beiden Kleinen. Die Wochenenden widmen sie ganz den Ausflügen mit der Familie. Und kaum war das Foto fertig, stürzten sie sich auch schon in die warmen Fluten der Karibik.

Luis is in computers, and Margelis takes care of the home and the two small children. They devote their weekends to family outings. And no sooner was the photo taken than they all plunged into the warm water of the Caribbean.

Luis est informaticien et Margelis s'occupe de la maison et des deux petits. Les week-ends sont consacrés aux excursions en famille. Et à peine la photo terminée, ils se sont précipités dans l'eau chaude des Caraïbes!

„Wir wissen nicht, was im neuen Jahrtausend passiert. Vielleicht geht alles genauso weiter!" Der unerschütterliche Sanlo ist Maurer und seine Mutter betreibt das Restaurant der Mission Santa Teresita in Kavanayen.

"We don't know what'll happen in the new millennium. Maybe everything will go on just the same." Sanlo is a very philosophical builder, while his mother runs the Santa Teresita mission restaurant in Kavanayen.

« Nous ne savons pas ce qui va se passer en l'an 2000. Peut-être que tout va continuer pareil! » Très philosophe, Sanlo est maçon et sa mère tient le restaurant de la mission Santa Theresita de Kavanayen …

Hacen, Artdirector, Regisseur, Allrounder in der Werbebranche, und seine Frau Helen haben der Stadt den Rücken gekehrt und sind in eine ländliche Gegend gezogen, in der ihre Familie besser gedeihen kann. Ihr Wunsch für das dritte Jahrtausend ist es, „die 1000 Familien zu umarmen".

Art director, film director and do-it-yourself advertising man Hacen and his wife Helen decided to leave the city and set up home in a rural environment where their family could blossom and find greater fulfilment. Their ambition for the third millennium is to "hug the 1000 families."

Hacen, directeur artistique, réalisateur, « homme à tout faire dans la publicité » et sa femme Helen ont décidé de quitter la ville, pour s'installer dans un environnement plus propice à l'épanouissement de leur famille. Leurs vœux pour le troisième millénaire : « Pouvoir embrasser les 1000 familles … »

Die Sekretärin Meri und der Freiberufler Marko haben drei Wünsche für das neue Jahrtausend: ein viertes Kind, eine Reise nach Australien zu den olympischen Spielen und bei dieser Gelegenheit ihre Tochter Sanna-Mari eine Goldmedaille im Judo gewinnen zu sehen.

Meri and Marko, respectively a secretary and a free-lance worker, have three dreams for the year 2000 – to have a fourth child, visit Australia for the 2000 Olympics, and at the same time see their daughter Sanna-Mari win a gold for judo.

Secrétaire et travailleur indépendant, Meri et Marko ont trois rêves pour l'an 2000 : avoir un quatrième enfant, visiter l'Australie durant les jeux olympiques 2000 et par la même occasion y voir leur fille Sanna-Mari gagner la médaille d'or au judo!

Josef ist Landwirt, verbringt aber viel Zeit in der Kirche und verfasst und illustriert außerdem religiöse Gedichte für seine Freunde und Kinder. Mit fast 700 Gedichten und elf Kindern kann Josef nicht über Langeweile klagen. „Wir leben wie die Zigeuner in einem einzigen Raum, bis wir genügend Geld haben, um die Außenmauer für das Nebenzimmer hochzuziehen, wo jetzt noch der kalte Gebirgswind durchpfeift." Die Großmutter scheint den ganzen Trubel zu genießen: „Hier ist ein richtiger Kindergarten!" Auch Josef bleibt optimistisch: „Das Leben ist schön", erzählt er uns. So heißt auch eines seiner Gedichte, das er den *1000 Families* gewidmet hat.

Josef is a farmer, but spends lots of time at church and writes and illustrates religious poems for his friends and children. With almost 700 poems and eleven children to his credit, Josef is not short of work. "We are living like gypsies in just one room until we have a bit of money to finish the outside wall of the next room, which, for the time being, lets the cold mountain air through." The grandmother seems delighted by all the fuss: "This is a real kindergarten here." Even Josef is still optimistic: "Life is fine," he tells us. This is also the title of one of the poems he's dedicated to the *1000 Families*.

Josef est agriculteur, mais il passe beaucoup de temps à l'église et à écrire et illustrer des poèmes religieux pour ses amis et enfants. Avec près de sept cents poèmes et onze enfants, Josef ne chôme pas! « Nous vivons ‹comme de gitans› dans une seule pièce en attendant de disposer d'un peu d'argent pour finir le mur extérieur de la pièce voisine qui, pour l'instant, laisse passer l'air frais de la montagne. » La grand-mère semble enchantée de toute cette agitation : « Ici c'est un vrai jardin d'enfants! » Même Josef reste optimiste : « La vie est belle! », nous dit-il. C'est aussi le titre de l'un des poèmes qu'il a dédiés aux « 1000 familles ».

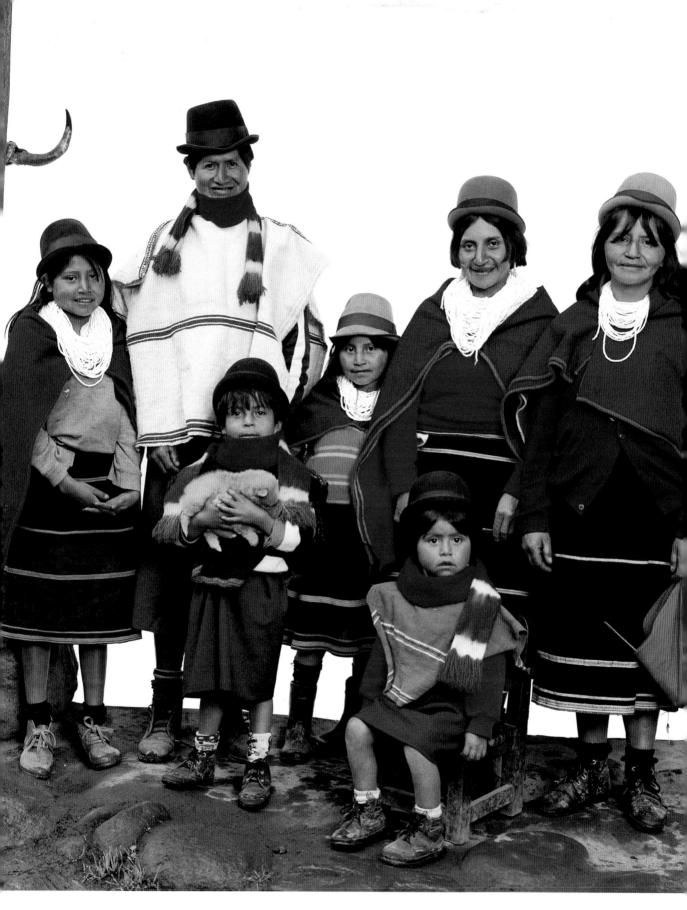

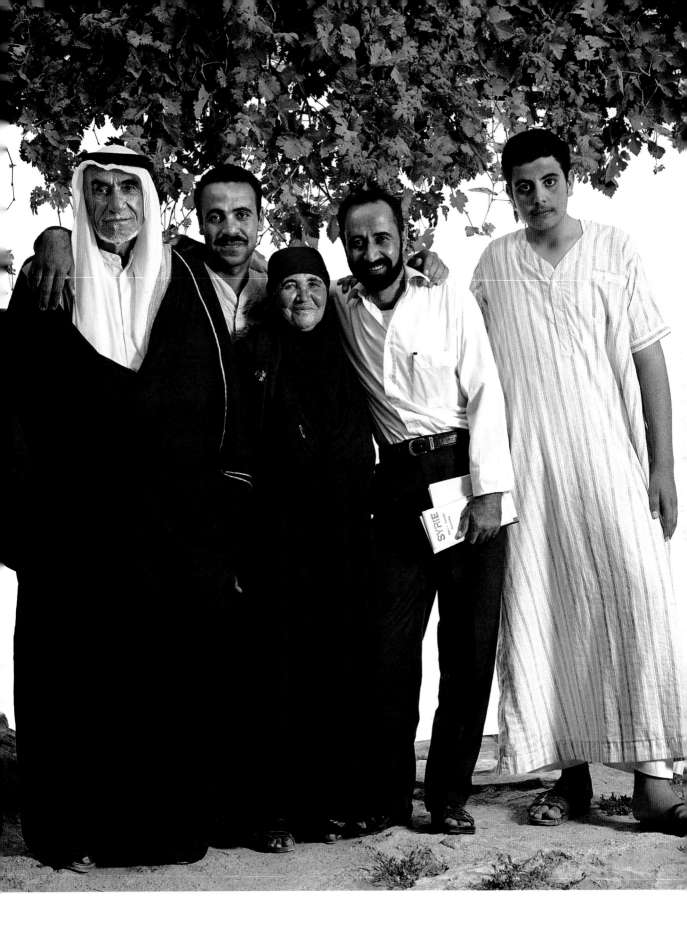

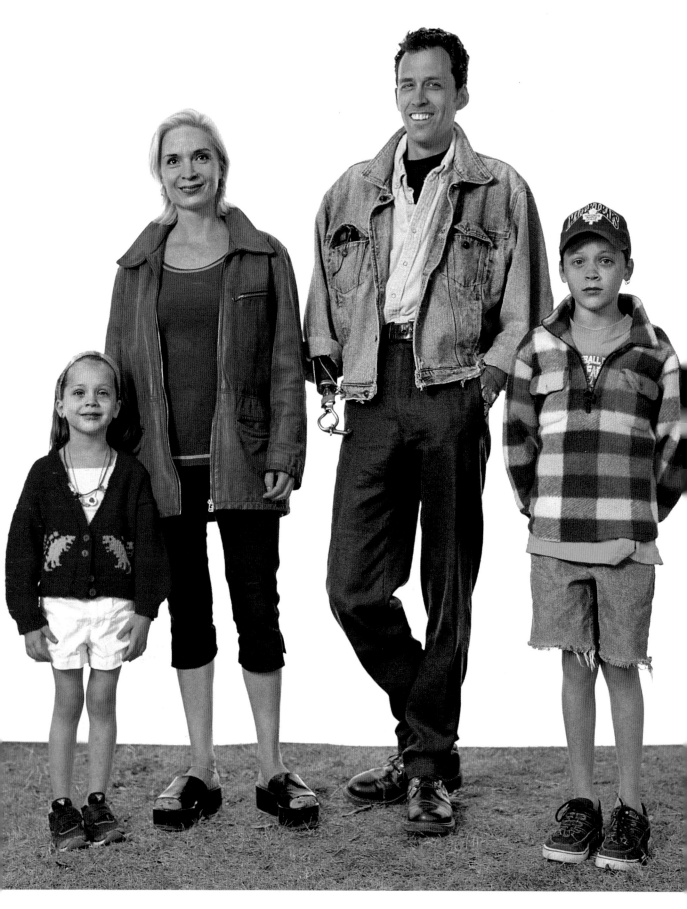

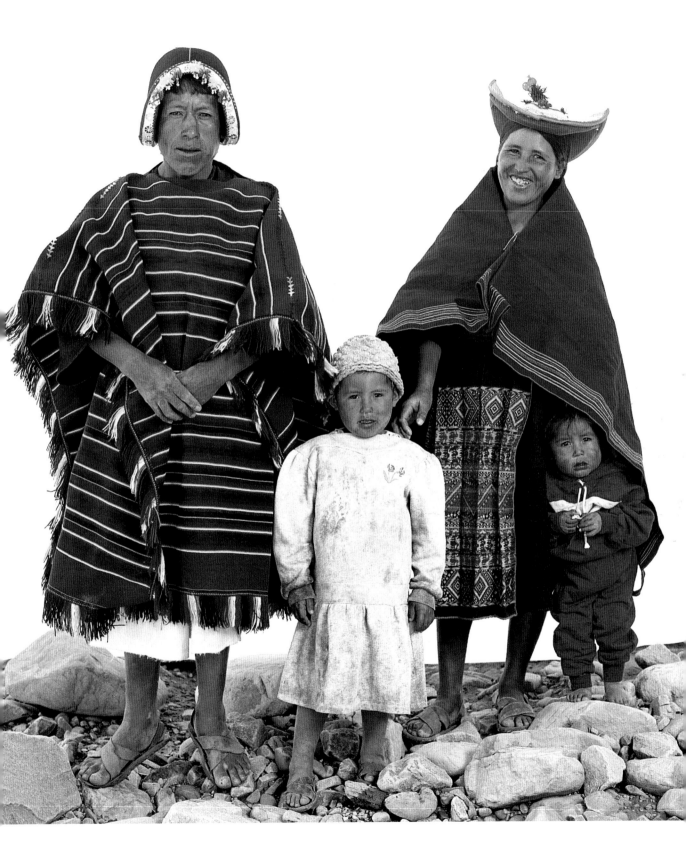

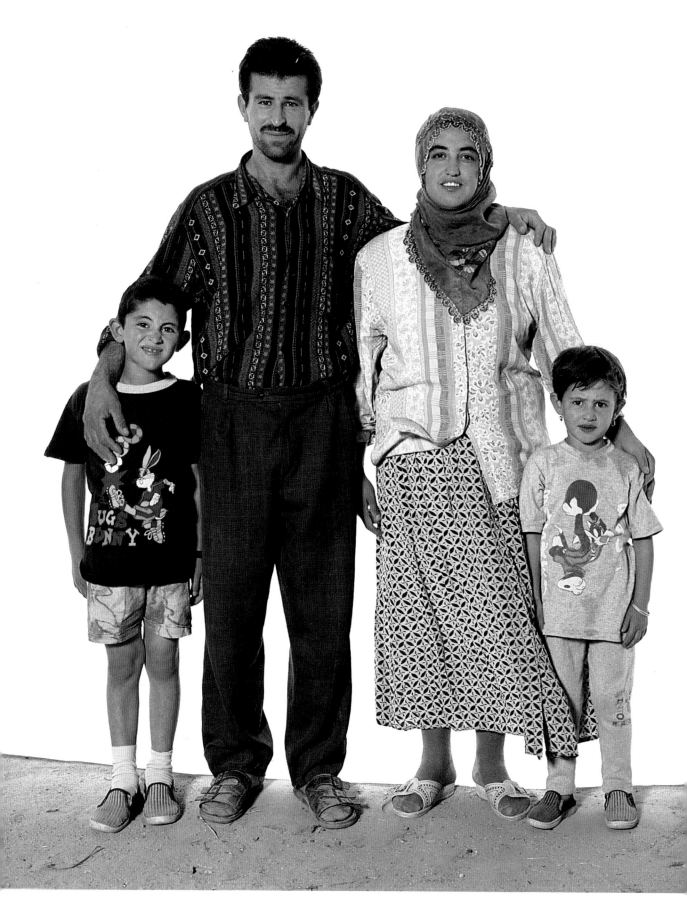

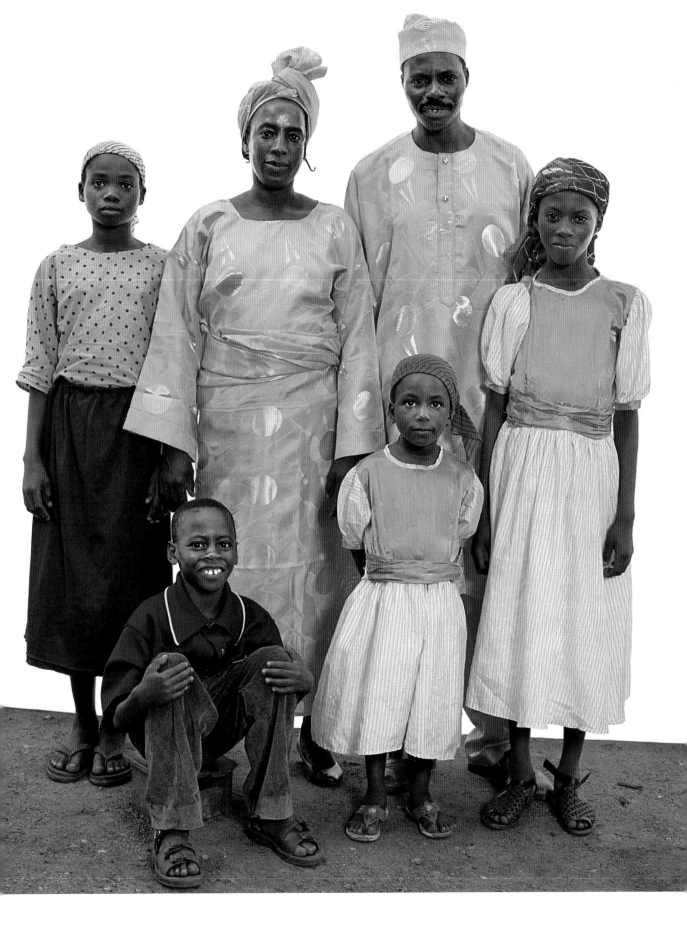

Page 210
Guambia,
Cauca, Colombia,
17 February 1999

Mit Unterstützung seiner ganzen Familie einschließlich der Schwägerin baut Florentino Kartoffeln, Zwiebeln und Gemüse an, das er auf dem Markt verkauf. Seine Familie lebt seit Generationen hier und sie sind stolz darauf, der Gemeinschaft der Guambia anzugehören – jedes Dorf bildet eine eigene Gemeinschaft mit einer typischen Tracht.

Helped by his whole family including his sister-in-law, Florentino works his crops of potatoes, onions and other vegetables, which he sells at market. His family has lived here for generations, and they're very proud of being Guambian – each village has its own community and its own traditional dress.

Florentino, assisté de toute sa famille y compris de sa belle-sœur, travaille ses plantations de pommes de terre, d'oignons et de légumes, qu'il vend au marché. Installés ici depuis des générations, ils sont très fiers d'appartenir à la communauté guambian – chaque village a sa propre communauté et tradition vestimentaire.

Page 211
Dar'ah,
Syria,
8 August 1999

„In den vergangenen Jahren hat es nicht genug geregnet und die Ernten waren schlecht", klagt Abdul Karim, Dorfvorsteher und Landwirt. „Mein Sohn hat gerade sein Diplom als Ingenieur gemacht und findet hoffentlich bald Arbeit in Saudi-Arabien oder den Vereinigten Emiraten. Außerdem können wir es kaum erwarten, dass er heiratet und uns ein Enkelkind schenkt."

"These past few years we haven't had any rain, and the harvests have been poor," says Abdul Karim, village headman and farmer. "My eldest son has just finished his engineering studies, and I hope he'll be able to work in Saudi Arabia or the Emirates. He also must get a wife. We're looking forward to having grandchildren."

« Ces dernières années, nous n'avons pas eu de pluie et les récoltes sont mauvaises », dit Abdul Karim, chef de village et agriculteur. « Mon grand fils vient de terminer ses études d'ingénieur et j'espère qu'il aura la possibilité d'aller travailler en Arabie Saoudite ou aux Emirats. Il lui faut aussi une épouse, nous sommes impatients d'avoir des petits-enfants », concluent-ils.

Page 212
Toronto,
Canada,
4 October 1998

„Es ist schwerer, einen Film zu machen als Kinder großzuziehen." Zu diesem Schluss kommt dieses junge Cineasten-Pärchen. Sie sind Drehbuchschreiber, Regisseure, Produzenten und Schauspieler ihrer eigenen Filme und hoffen, im Jahr 2000 mitten in den Dreharbeiten zu einem Spielfilm zu stecken.

"Making a film is harder than bringing up a child," is the conclusion of this young film-making couple. They write, direct, produce and act in their films, and hope that 2000 will find them busy making a feature-length film.

« Faire un film, c'est plus dur qu'élever un enfant. » C'est le constat de ce jeune couple de cinéastes. Ils écrivent, réalisent, produisent et jouent dans leurs films et espèrent que l'an 2000 les trouvera en pleine réalisation d'un long métrage.

Page 213
Tarabuco,
Bolivia,
25 January 1999

Der Ertrag ihrer Felder reicht gerade eben für den persönlichen Bedarf und den ein oder anderen Tauschhandel auf dem Markt. Der ausbleibende Niederschlag stellt ein großes Problem für die Region dar, und auch Silvestre und Sabina beten zu Gott, er möge Regen bringen.

The harvest from their fields provides just enough for them to eat and the odd barter at market. The shortage of rainfall in the region is posing a major problem, so Silvestre and Sabina pray to God for rain.

Les récoltes de leurs champs suffisent tout juste à leur consommation personnelle et à quelques trocs au marché. La rareté de la pluie pose un grand problème dans la région, aussi Silvestre et Sabina prient-ils Dieu de faire venir la pluie.

Page 214
Ürgüp,
Turkey,
3 August 1999

Das „Haus" von Mehmet und Ayse ist in die Felswände von Ürgüp gehauen. Mehmet arbeitet nachts als Bäcker, tagsüber geht er mit seiner Frau aufs Feld, wo die beiden Obst und Gemüse für den Eigenbedarf anbauen. Außerdem besitzt die Familie eine Kuh und ein paar Hühner, deren Stall ebenfalls in die Felsen gehauen ist.

Mehmet and Ayse live in a 'house' built in the Ürgüp rock face. He's a baker by night, and by day they both work in their field, where they grow fruit and vegetables for their family. Their only cow and a handful of chickens are kept in a stable, also hewn out of the rock.

Mehmet et Ayse vivent dans une « maison » construite dans la falaise d'Ürgüp. Il est boulanger la nuit, dans la journée tous les deux travaillent dans leur champ où ils font pousser fruits et légumes pour leur famille. Leur unique vache et quelques poules sont logées dans une étable, elle aussi taillée dans la roche.

Page 215
Ilorin,
Nigeria,
15 July 1997

„Die Zukunft, das sind unsere Kinder! Die nigerianische Regierung muss ihnen helfen." Sein Wunsch ist ein großes Haus für seine bisherigen vier Kinder und die, die – so Gott will – in den kommenden Jahren noch geboren werden …

"The future is our children. The Nigerian government must help them." His desire is to have a big house for his four children and those which (God willing) will be born over the years to come …

« L'avenir c'est nos enfants! Le gouvernement nigérian doit leur apporter de l'aide. » Son désir : avoir une grande maison pour ses quatre enfants et ceux (si Dieu le veut) qui naîtront dans les années à venir…

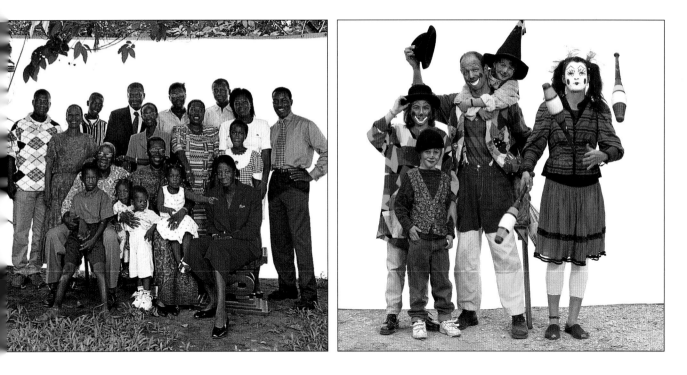

„Schreiben befreit dich von allen unechten Problemen", so der ivorische Schriftsteller Bernard Dadié. Von seinen Lehrern ermutigt, beschloss er bereits mit 16 Jahren, Schriftsteller zu werden. In Paris gewann er den Preis für schwarzafrikanische Literatur, 1963 nahm er an der panafrikanischen Konferenz in Algerien teil. Heute, mit 81 Jahren, veröffentlicht er seine Memoiren. „Wir sind alle gleich, ungeachtet unserer Hautfarbe, und es ist an der Zeit für die Menschen zu verstehen, dass sie zusammen halten müssen."

"Writing rids you of all the phoney problems," says Ivory Coast author Bernard Dadié. From the age of 16, encouraged by his teachers, he decided to devote himself to writing. He won the Black African Literary Prize in Paris, and attended the Pan-African Conference in Algeria in 1963. Today, at 81, he is publishing his memoirs. "We're all alike – colour doesn't count for anything; it's time people understood they must get together."

« Ecrire, c'est se libérer de tous les faux problèmes », précise Bernard Dadié, l'écrivain de Côte d'Ivoire. Dès l'âge de seize ans, encouragé par ses professeurs, il décide de se consacrer à l'écriture. Il obtient le Prix de littérature africaine noire à Paris, et participe à la conférence panafricaine en Algérie, en 1963. Aujourd'hui, à quatre-vingt-un ans, il publie ses mémoires. « Nous sommes tous pareils, les couleurs ne sont rien, il est temps que les hommes comprennent qu'ils doivent s'unir. »

Anne, Gunther und ihre Kinder sind Straßenkünstler. Sie treten auf Dorffesten und Jahrmärkten auf. Ihr Wunsch für das neue Jahrtausend: selbst einen Wohnwagen zu zimmern, der wie anno dazumal von zwei Pferden gezogen wird, und damit auf den Landstraßen quer durch Italien zu fahren …

Anne, Gunther and their children are street artists. They perform at village markets and local events. Their project for the new millennium is to build their own 'old-fashioned' caravan, drawn by two horses, and travel the length and breadth of Italy on country roads …

Anne, Gunther et leurs enfants sont artistes de rue. Ils se produisent sur les marchés de villages, à l'occasion des manifestations communales et pendant la période des fêtes de fin d'année. Leur projet pour l'an 2000 : construire eux-mêmes leur roulotte « à l'ancienne », tirée par deux chevaux et sillonner toute l'Italie par les routes de campagne…

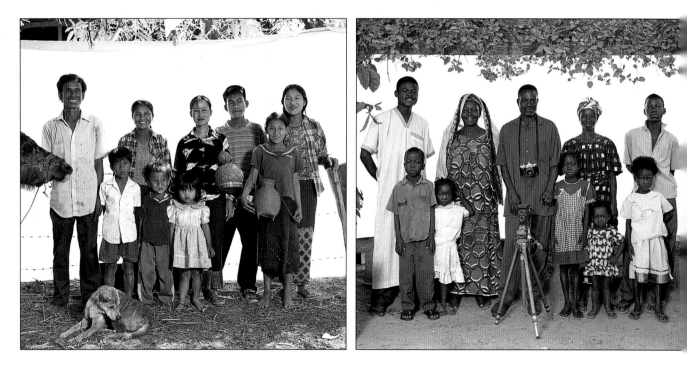

Champasak,
Laos,
29 January 2000

Som bestand darauf, uns seinen „laotischen Traktor" vorzuführen. „Er ist sehr intelligent und versteht Befehle wie links, rechts, geradeaus. Er hilft meiner Frau und meinen Kindern auf dem Reisfeld. Ich selbst bin Schmied und fertige Messer an", erklärt er stolz.

Som insisted on introducing us to his 'Laotian tractor'. "It is very smart and understands left, right, and straight ahead. He helps my wife and children in the paddy field. I'm a blacksmith, and I make knives," he concludes proudly.

Som a tenu à nous présenter son « tracteur laotien » : « Il es très intelligent et comprend à gauche, à droite, tout droit ! C'est lui qui aide ma femme et mes enfants à la rizière ; moi je suis forgeron, je fabrique des couteaux ! », conclut-il fièrement.

Tortiya,
Ivory Coast,
12 May 1997

„Das Geheimnis eines erfolgreichen Fotografen liegt darin, freundlich zu seinen Kunden zu sein." Seit 20 Jahren ist Shittu Berufsfotograf in Tortiya. Als solcher wird er unweigerlich Zeuge jedes familiären Ereignisses in der Stadt. Seine Frau verkauft Schönheitsprodukte und Geschirr. Der leidenschaftliche Fotograf hofft, sich bis zum Jahr 2000 seinen Wunschtraum erfüllt zu haben: „Eine Minolta-Kamera."

"The secret behind a successful photographer is to put on a smile for your customers." Shittu has been a professional photographer in Tortiya for 20 years. As such, he's the inevitable witness at all the town's family events. His wife sells beauty products and crockery. He loves his work, and hopes to achieve his dream by 2000: "Get myself a Minolta camera."

« Le secret d'un photographe qui réussit, être souriant avec ses clients. » Shittu est photographe professionnel à Tortiya depuis vingt ans. A ce titre, il est le témoin incontournable de tous les événements familiaux de la ville. Sa femme vend des produits de beauté et des assiettes. Passionné par son métier, il espère réaliser son rêve en l'an 2000 : « M'offrir un appareil Minolta ».

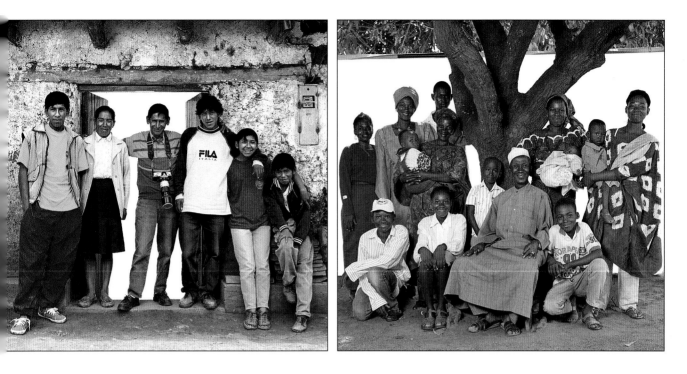

Pisac,
Peru,
3 February 1999

„Das Fotografieren habe ich in Fernkursen gelernt und dann all meinen Kindern beigebracht", strahlt Lucio, der glückliche Besitzer des örtlichen Foto-ateliers, in dem sich die Familie hinter dem Ladentisch ablöst. Sie stellen auch Töpferwaren her und beten als gläubige Christen gemeinsam. Der 21-jähri-ge Carlos zeigt uns seine Bilder: „Ich studiere in Cuzco. Als Evangelist möchte ich durch meine Malerei predigen."

"I learned photography through a correspondence course, and I've taught it to all my children," explains Lucio, photographer and happy owner of the village Studio Photo, where the family helps out behind the counter. The whole family also prays to God and makes pottery. Carlos (21) shows us his paintings: "I'm studying in Cuzco. As an evangelist, I want to preach through my painting," he says.

« J'ai appris mon métier de photographe par correspondance et je l'ai enseigné à tous mes enfants ! », explique Lucio, heureux propriétaire du Studio Photo du village où la famille se relaie derrière le comptoir. C'est également en famille qu'ils prient Dieu et font de la céramique. Carlos (vingt et un ans) nous montre ses tableaux : « J'étudie à Cusco. Etant évangéliste, je souhaite prêcher à travers ma peinture », dit-il.

Ferké,
Ivory Coast,
14 May 1997

„Das gelobte Land liegt hinter dem Jahr 2000, wir müssen nur die Augen offen halten", sagt Yvonne. Die Witwe hat ihre sechs Kinder ganz allein groß-gezogen. „Es war sehr hart, aber wenn Gott uns Kinder anvertraut hat, müssen wir sie auch behüten." Bis zu ihrer Pensionierung war sie Lehrerin und ihre Töchter haben ihre Nachfolge angetreten.

"The promised land lies the other side of 2000, so it's up to us to open our eyes," says Yvonne. A widow, she has brought up her six children alone. "It's been very hard, but if God gives us children, it's up to us to protect them." She is a retired schoolteacher, and her daughters have taken over where she left off.

« La terre promise se trouve derrière l'an 2000, c'est à nous d'ouvrir les yeux », affirme Yvonne. Veuve, elle a élevé seule ses six enfants. « Cela a été très dur, mais si Dieu nous a confié des enfants, c'est pour les protéger. » Institutrice à la retraite, ce sont ses filles qui ont pris la relève.

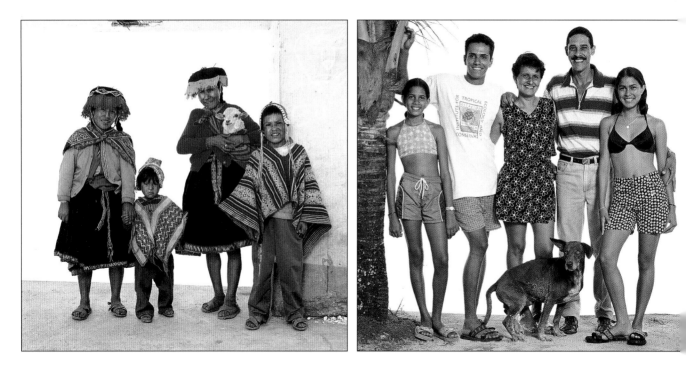

Pisac,
Peru,
3 February 1999

„Wir wohnen zwei Stunden Fußmarsch von hier entfernt. Wir leben vom Kartoffelanbau und halten eine Kuh, zwei Lamas und ein paar Ziegen." Huarca ist mit ihren beiden Söhnen und ihrer Mutter nach Pisac zum Markt gekommen und hofft, dass sie ein bisschen Geld verdienen, indem sie sich von Touristen fotografieren lassen.

"We live two hours' walk from here and grow potatoes. We've also got a cow, two llamas and a few goats." Huarca has come with her two sons and her mother to Pisac market, hoping to earn a little money by letting tourists take snapshots of her.

« Nous habitons à deux heures de marche d'ici et cultivons des pommes de terre, nous avons aussi une vache, deux lamas et quelques chèvres. » Huarca est venue avec ses deux fils et sa mère au marché de Pisac, espérant qu'il y aurait un peu d'argent à gagner en se laissant photographier par des touristes.

Boca del Drago,
Panama,
5 January 1999

Ihre drei Kinder leben in der Stadt und kommen nur in den Ferien nach Hause. „Sie müssen weggehen, wenn sie etwas lernen wollen, denn hier gibt es keine Schule", erklären José und Juana mit Bedauern. Sie leben am Ende der Insel, lieben es, zu fischen und Wasserski zu fahren, und betreiben das einzige rund um die Uhr geöffnete Restaurant.

Their three children live in town, and only come here for their holidays. "They have to go away to get a good education – there's no school here," explain José and Juana regretfully. They live at the end of the island, love fishing and water-skiing, and have the only round-the-clock restaurant.

Leurs trois enfants vivent en ville et ne viennent que pour les vacances : « Ils sont obligés de partir pour recevoir un bon enseignement, ici il n'y a pas d'école ! », se lamentent José et Juana. Vivant au bout de l'île, ils aiment la pêche, le ski nautique et tiennent le seul restaurant à des heures à la ronde.

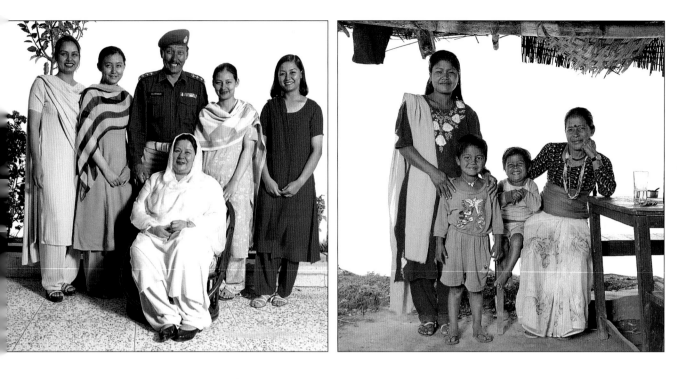

Quetta,
Pakistan,
3 October 1999

Mohammed hat keinen leichten Job. Als Schutzmann versucht er, Ordnung in das tägliche Verkehrschaos von Quetta zu bringen! Die Lebensaufgabe des Familienvaters ist es jedoch, seine sechs Töchter unter die Haube zu bringen – und für die Mitgiften zu sorgen. Zwei sind bereits verheiratet, aber die meiste Arbeit liegt noch vor ihm. Trotzdem verkündet er stolz: „Ich bin der glückliche Vater von sechs betörenden Blumen!" Seine Hobbys? „Früher habe ich Hockey gespielt. Aber bei sechs Töchtern … Heute schaue ich mir die Fußballspiele im Fernsehen an."

Mohammed's job is no sinecure. He is the police officer in charge of traffic in Quetta, where total chaos reigns. Father of six girls, he has the arduous task of finding them future husbands and providing their dowries. He's managed it twice, but the toughest part still lies ahead. He has kept his good humour, nevertheless: "I am a happy man, I have six marvellous flowers!" His hobby? "I used to play hockey, but now with six girls, what can I do? I watch all the football matches on television."

Mohamed n'a pas un travail facile. Officier de police, il est chargé de la circulation à Quetta où règne un chaos total! Père de six filles, il a la lourde tache de trouver les futurs maris et de fournir les dotes. Il a réussi par deux fois mais le plus gros reste à faire et il garde sa bonne humeur: «Je suis un homme heureux, j'ai six fleurs merveilleuses!» L'an 2000? «Je crois en Dieu mais l'amitié est le plus important.» «Mon hobby? Avant je jouais au hockey sur gazon, mais maintenant avec six filles que voulez vous? Je regarde tous les matchs de foot à la télévision!»

Pokhara,
Nepal,
13 November 1999

Mutter und Tochter teilen ihr Schicksal: Ihre Ehemänner haben sich neu verheiratet und kümmern sich nicht mehr um sie. Um über die Runden zu kommen, hat Sita in ihrer winzigen Hütte an der Straße einen Snackstand eröffnet.

Mother and daughter have the same problem – their husbands have taken other wives and no longer look after them. To survive, Sita has opened a snack stall in her tiny roadside hut.

Mère et fille ont le même problème: leurs maris ont pris d'autres épouses et ne s'occupent plus d'elles. Pour survivre Sita a ouvert une buvette dans sa minuscule case en bordure de la route.

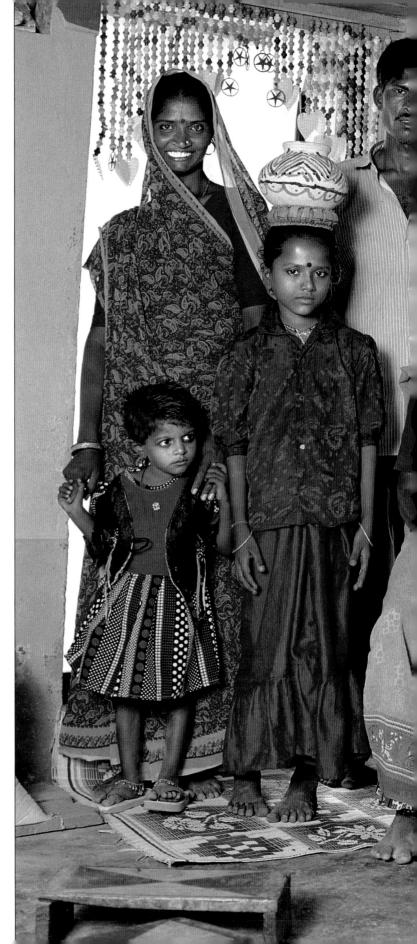

40 Jahre lang war Devgi auf allen Meeren der Welt unterwegs. Seit er der Handelsmarine Lebewohl gesagt hat, lebt er bei seiner großen Familie, der Frau, den Söhnen, den Töchtern, der Schwiegertochter und den Enkeln. Der Sohn scheint sesshafter zu sein als der Vater, er ist Schneider geworden.

Devgi spent 40 years sailing all the world's oceans. He has retired from the merchant navy and lives surrounded by his family, wife, sons, daughters, daughter-in-law and grandchildren. His son has gone into a more sedentary profession – he is a tailor.

Devgi a navigué sur tous les océans du monde pendant quarante ans. Retraité de la marine marchande, il vit entouré de sa famille, femme, filles, fils, belle-fille et petits-enfants. Son fils a opté pour un métier plus séden-taire : il est tailleur.

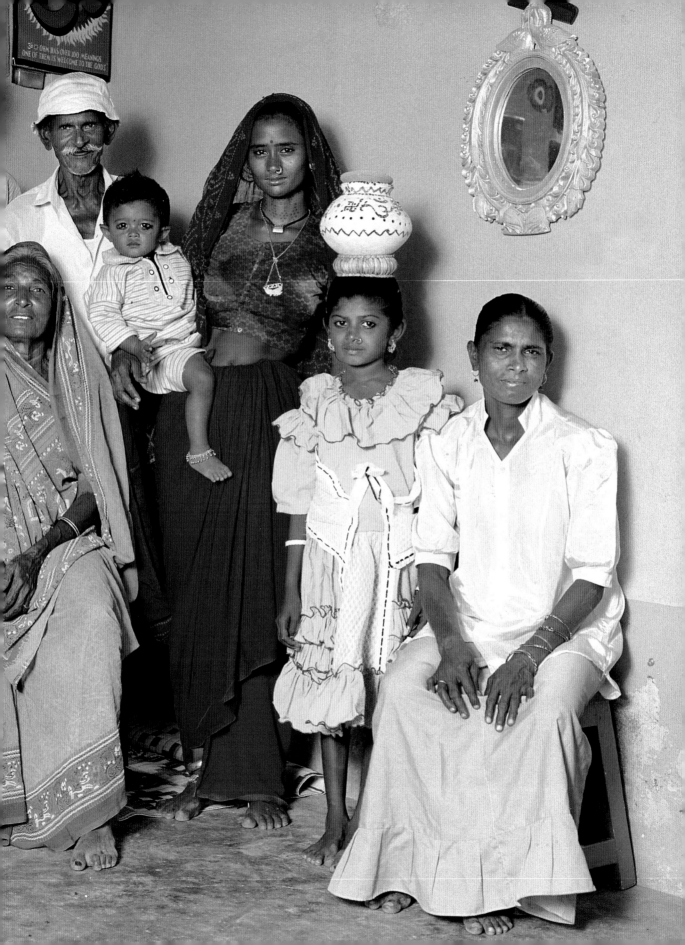

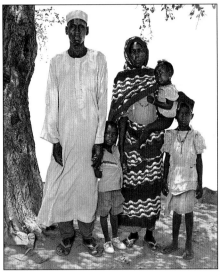
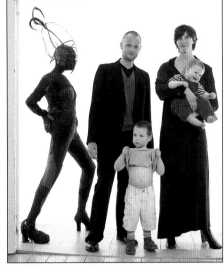
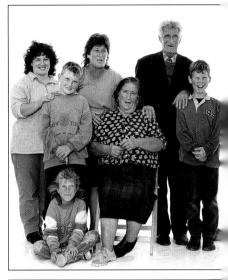

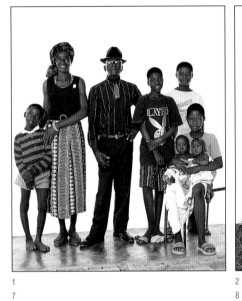
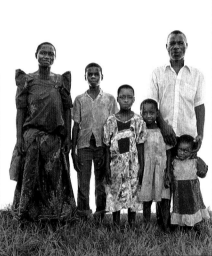
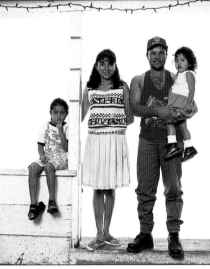

1

7

2

8

3

9

1
Kentédé,
Chad,
26 July 1997

2
Antwerp,
Belgium,
16 June 1998

3
Trim,
Ireland,
29 July 1996

4
Pamukkale,
Turkey,
31 July 1999

7
Kariba,
Zimbabwe,
26 October 1997

8
Jinga,
Uganda,
16 November 1997

9
Alto Lino,
Panama,
29. Dezember 1998

10
Helsinki,
Finland,
6 July 1998

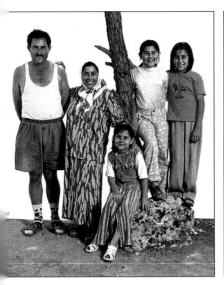

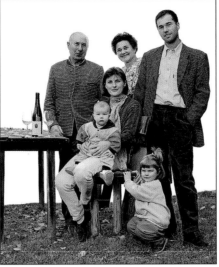

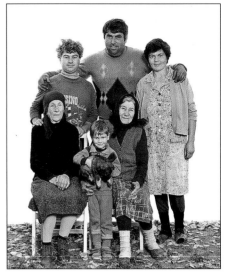

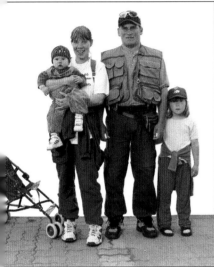

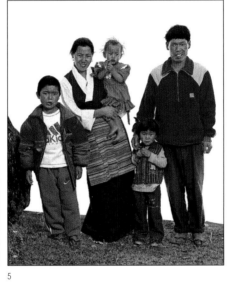

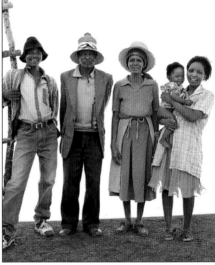

5

11

6

12

)

11

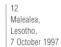

5
Weissenkirchen,
Austria,
9 October 1996

6
Daraşti,
Romania,
17 October 1996

11
Yuksom,
Sikkim, India,
20 November 1999

12
Malealea,
Lesotho,
7 October 1997

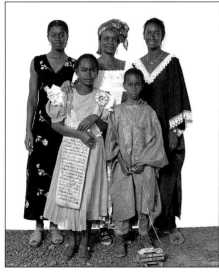

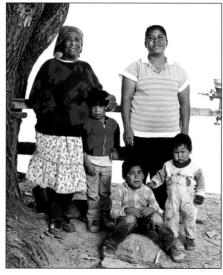

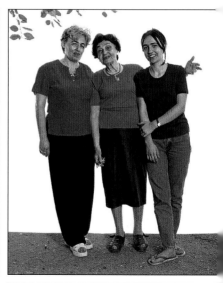

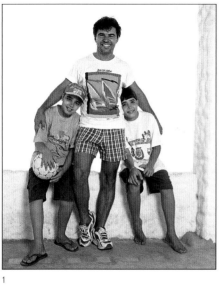

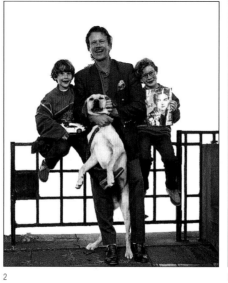

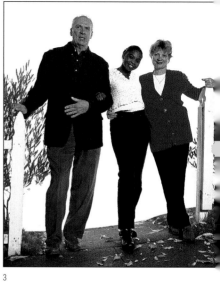

1

7

2

8

3

9

1
Labé,
Guinea,
1 May 1997

2
San Ignacio,
Mexico,
25 November 1998

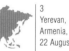
3
Yerevan,
Armenia,
22 August 1999

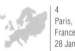
4
Paris,
France,
28 January 1996

7
Maceió,
Brazil,
14 March 1999

8
Brussels,
Belgium,
15 June 1998

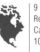
9
Redwood City,
California, USA,
10 November 1998

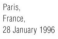
10
Ilorin,
Nigeria,
16 July 1997

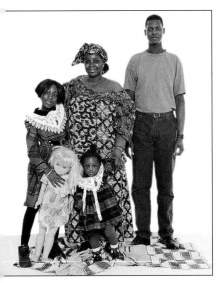

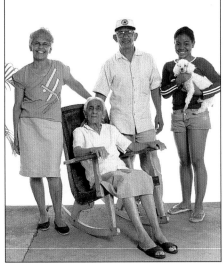

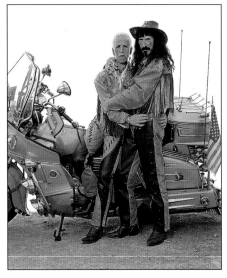

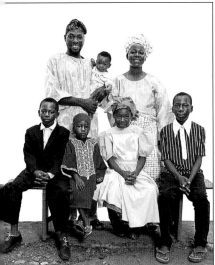

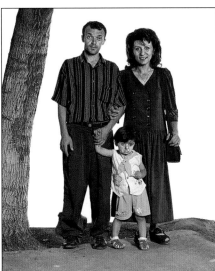

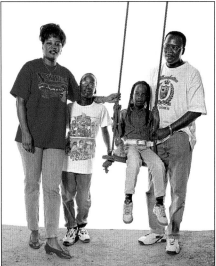

5

11

6

12

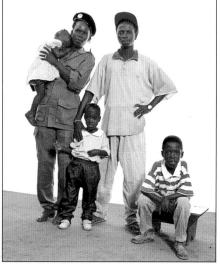
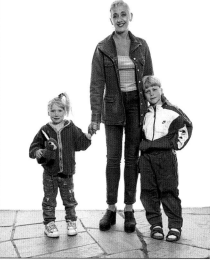
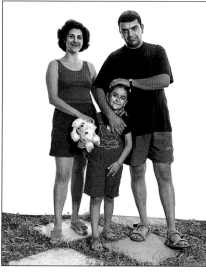
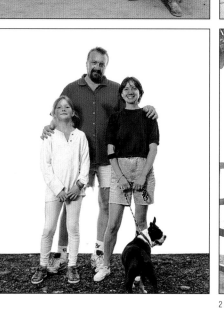
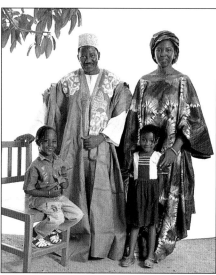
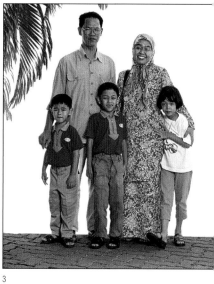

1

7

2

8

3

9

1
Bissau,
Guinea-Bissau,
28 April 1997

2
Trondheim,
Norway,
1 July 1998

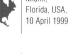
3
Yerevan,
Armenia,
22 August 1999

4
Berry Springs,
Australia,
19 December 1999

5
Keren,
Eritrea,
18 December 1997

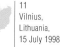
6
Miami,
Florida, USA,
10 April 1999

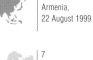
7
Prague,
Czech Republic,
29 July 1998

8
Ouagadougou,
Burkina Faso,
13 April 1997

9
Tutong,
Brunei,
25 December 1999

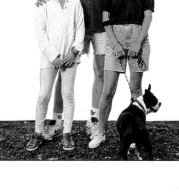
10
Smuchevo,
Bulgaria,
4 January 1997

11
Vilnius,
Lithuania,
15 July 1998

12
Rome,
Italy,
12 December 1996

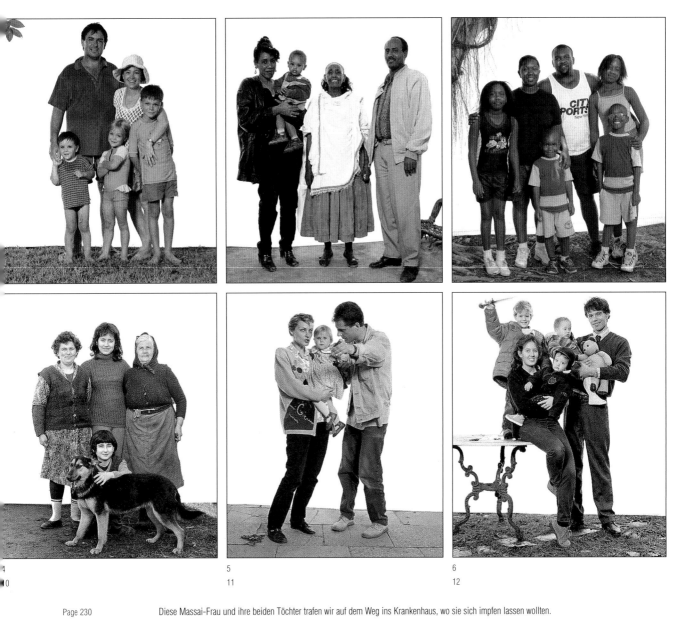

Page 230

Diese Massai-Frau und ihre beiden Töchter trafen wir auf dem Weg ins Krankenhaus, wo sie sich impfen lassen wollten.

This Masai mother and her two daughters were trying to find their way to the hospital to get vaccinated when we came across them.

Cette mère de famille massaï et ses deux filles étaient à la recherche de leur chemin pour l'hôpital, afin de se faire vacciner, lorsque nous les avons rencontrées …

Page 231

Kestas geht mit der Zeit. Sein Hobby, das er übrigens zu seinem Beruf gemacht hat, wickelt er übers Internet ab: den An- und Verkauf von Briefmarken und Umschlägen aus aller Welt. Seine Frau Rasa ist Assistentin des Beraters des litauischen Präsidenten für soziale, kulturelle und Bildungsfragen. Sie glaubt fest an die Zukunft ihres Landes, das im Jahr 2000 seine zehnjährige Unabhängigkeit feiert. Augustinas, der Inline-Skater, und Jeronimas, der Angler, würden sich freuen, bei dieser Gelegenheit Mädchen ihres Alters kennen zu lernen.

Kestas, a thoroughly modern man, uses the Internet as a hobby and in fact as a job – buying and selling stamps and envelopes from all over the world. His wife Rasa is assistant to the presidential adviser on social, cultural and educational affairs. She's very confident about the future of her country, which celebrates ten years of independence in 2000. Augustinas, the skater, and Jeronimas, the fisherman, would make the most of the get-together to meet girls of their own age.

Kestas est un homme moderne, c'est sur Internet qu'il exerce son hobby, qui est d'ailleurs devenu son métier : acheter et vendre des timbres et enveloppes du monde entier. Son épouse Rasa est assistante du conseiller présidentiel aux affaires sociales, culturelles et éducatives. Elle a une grande confiance en l'avenir de son pays qui fêtera ses dix ans d'indépendance en 2000. Ils aimeraient beaucoup que les « 1000 familles » puissent se rencontrer à l'occasion d'une exposition et échanger idées et expériences. Augustinas le patineur et Jeronimas le pêcheur en profiteraient bien pour faire la connaissance de jeunes filles de leur âge.

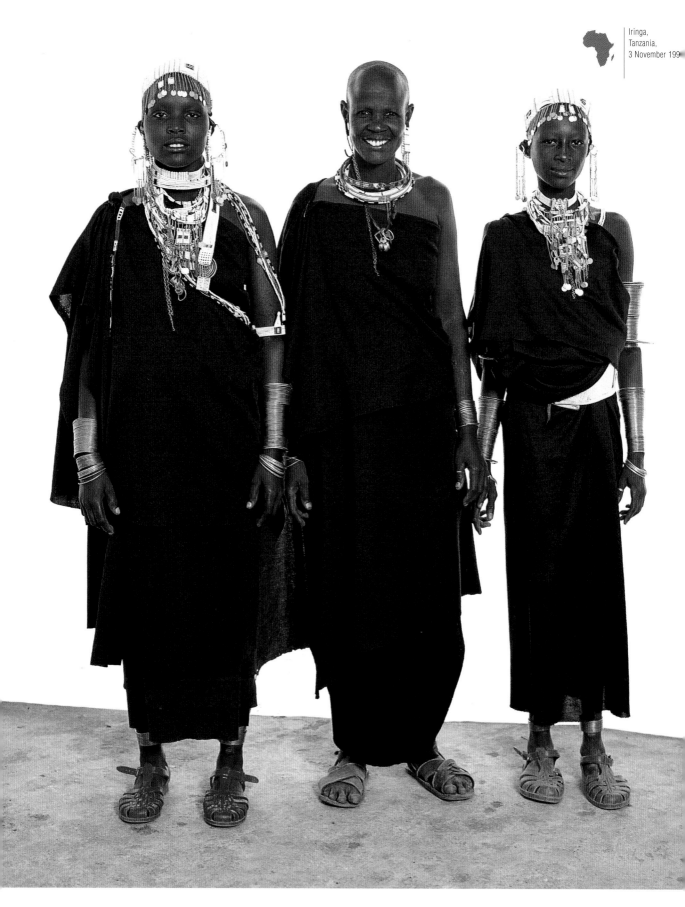

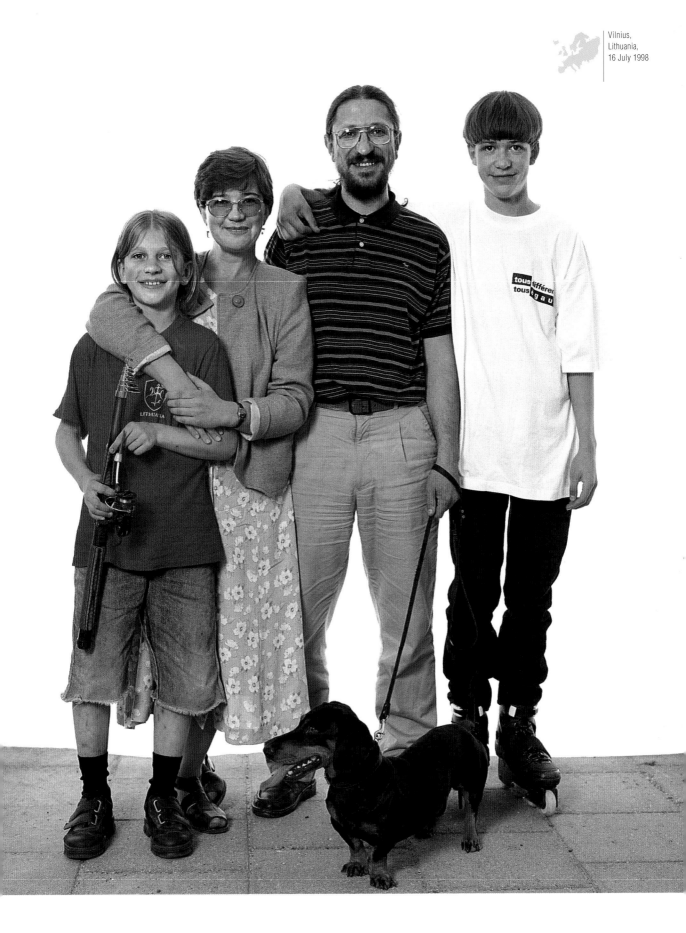

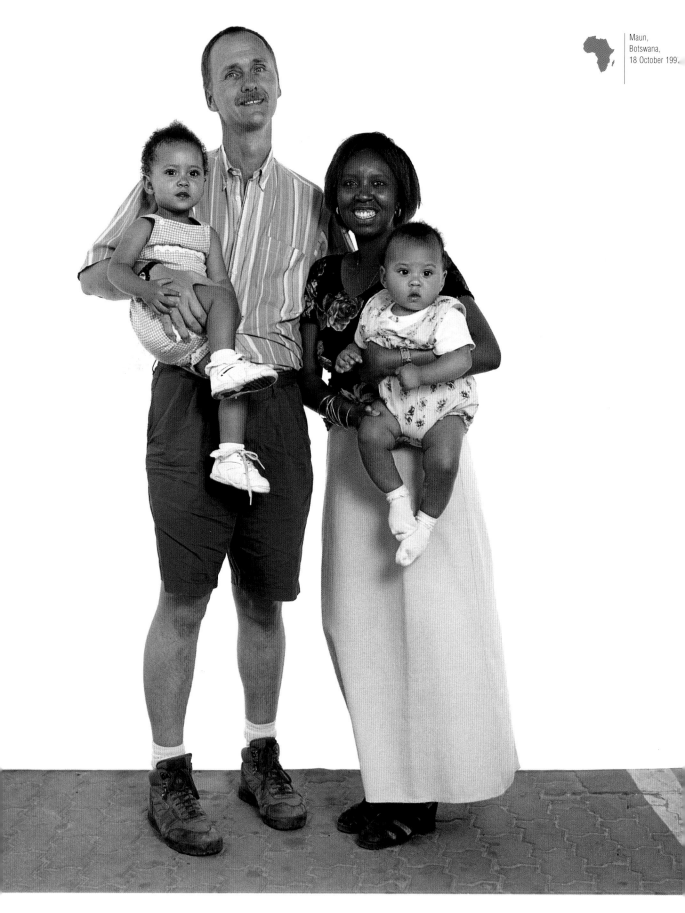

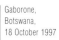
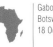

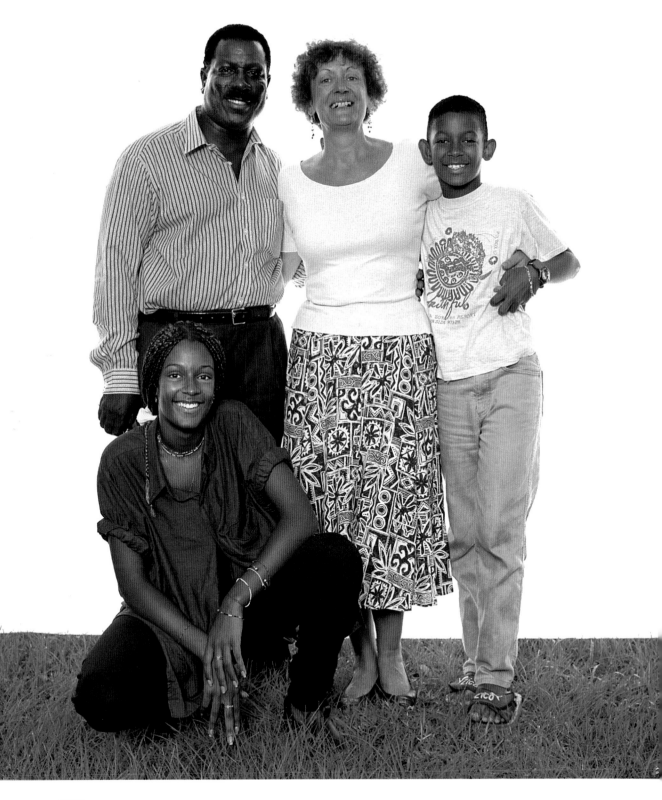

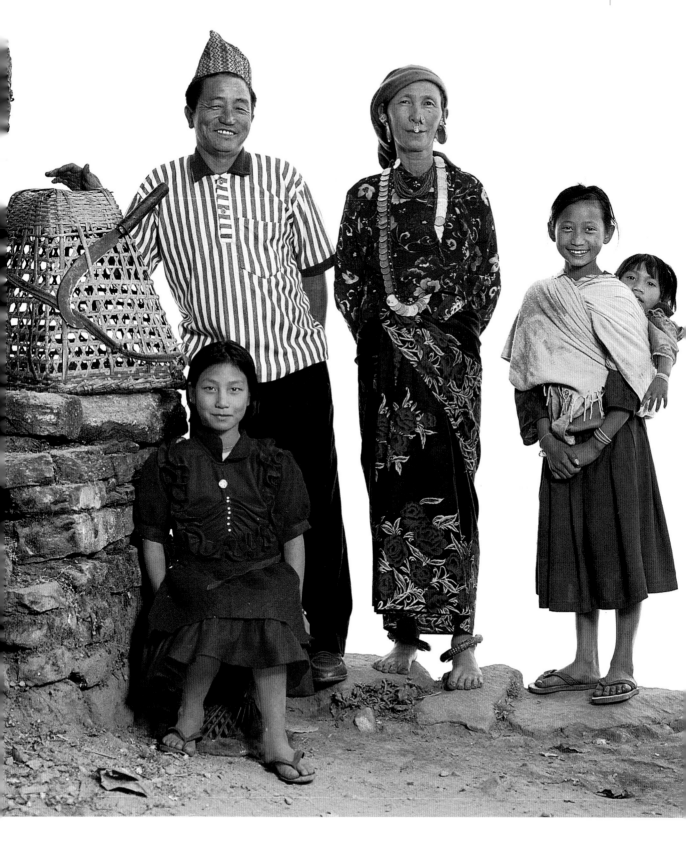

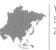

M. D. Lockwood hatte es eilig, zur Arbeit zu kommen. Er ist Projektmanager einer englischen Minengesellschaft in Botsuana. Seine Frau Lebogang schaffte es doch noch, ihn zu überreden, ein paar Minuten für das Familienfoto zu opfern … Sie sind seit fünf Jahren verheiratet und Lebogang hofft, eines Tages im Land ihres Ehemanns zu leben und vielleicht ein weiteres Kind zu bekommen, eine kleine Schwester für ihre beiden Söhne.

M. D. Lockwood was in a hurry to get to his job as project manager with an English mining company established in Botswana. His wife Lebogang managed to persuade him to let us have a few minutes of his time for the family photo … They've been married for five years, and she's hoping to live in her husband's country one day and maybe have another child, a little sister for their two boys.

M. D. Lockwood était pressé de partir à son poste de « project manager » dans une entreprise minière anglaise installée au Botswana. Lebogang, son épouse, est arrivée à le persuader de nous consacrer quelques minutes pour la photo de famille… Ils sont mariés depuis cinq ans et elle espère vivre un jour dans le pays de son mari et peut-être avoir un autre enfant, une petite sœur pour leurs deux garçons.

Maria ist Erzieherin und Keineetse hat einen kleinen Laden, in dem er antiquarische Bücher, afrikanische Kleidung und Musikkassetten verkauft. „In Botsuana sind wir Außenseiter, da die Apartheidpolitik hier immer noch viele Anhänger hat. Wir hoffen, dass sich das bald ändert. Unser größter Wunsch aber ist es, für immer zusammenzubleiben!"

Maria is a youth worker and Keineetse has a shop where he sells second-hand books, African clothes and Afro music tapes. "In Botswana, we are outsiders, because politics here still makes too much of a distinction between Blacks and Whites. We'd like to change all that, but our greatest wish is to stay together forever!"

Maria est éducatrice et Keineetse tient une échoppe dans laquelle il vend des livres d'occasion, des vêtements africains et des cassettes de musique afro « Au Botswana, on vit un peu à part, car on fait une trop grande différence entre noir et blanc … On aimerait que cela change, mais notre plus grand souhait c'est de Rester ensemble pour toujours ! »

Schon als Kind träumte Michelle von Afrika. Gebürtig aus Lille, verschaffte sich die Französischlehrerin einen Vertrag in Odienné und kam so 1979 an die Elfenbeinküste. Dort traf sie ihren Mann Max, einen Plantagenverwalter und das dauert jetzt schon 14 Jahre. „Mein Mann hat afrikanische Gewohnheiten: der Mann auf der einen Seite, die Frau und die Kinder auf der anderen. Ich tue alles dafür, dass er am Familienleben teilnimmt und ich träume von einem Haus wie in ‚Dallas', in dem die ganze Familie unter einem Dach lebt."

French teacher Michelle's childhood dream was "to go to Africa." Originally from Lille, in France, she got a local contract in Odienné and landed on Ivory Coast soil in 1979. She met her husband, farm manager Max 14 years ago, and they're still together. "My husband has African habits, the husband on one side, the wife and children on the other, but I do everything I can to get him to take part in our family life and I dream of a Dallas-style house, with the whole family together under one roof."

Le rêve d'enfance de Michelle : « Venir en Afrique ». Professeur de français, d'origine lilloise, elle obtient un contrat local à Odiénné et débarque sur la terre ivoirienne en 1979. Elle rencontre son mari, Max, directeur d'exploitation, et cela dure depuis quatorze ans ! « Mon mari a des habitudes africaines, le mari d'un côté, la femme et les enfants de l'autre, je fais tout pour qu'il participe à la vie de famille. » Michelle appréhende le départ de ses enfants pour l'université en France. « Je rêve d'une maison à la Dallas, où toute la famille serait réunie. »

Phebras und seine Frau vom Volk der Lepcha, der Ureinwohner von Sikkim, bauen hauptsächlich Mais, Kohl und Süßkartoffeln an. Statt zur Schule zu gehen, packen die beiden Töchter auf dem Feld mit an oder machen sich als Babysitter nützlich – wie hier die jüngere Tochter, die gerade auf eine kleine Cousine aufpasst.

Phebras and his wife belong to the Lepcha tribe (Sikkim's original inhabitants). They live from their fields, where they grow maize, cabbages and sweet potatoes. Their two daughters don't go to school, but help their parents by working in the fields and babysitting – today, for example, their younger daughter is looking after a small cousin.

Phebras et sa femme, de la tribu lepcha (les premiers habitants du Sikkim), vivent de leurs champs où il font pousser maïs, choux et patates douces. Leurs deux filles ne fréquentent pas l'école et aident les parents aux champs ou font du baby-sitting, comme ici sur la photo.

Hanna und Jukka haben sich mit 16 Jahren in der Schule kennen gelernt. Sie studierten zusammen Medizin und arbeiten heute in derselben Praxis. Für das Jahr 2000 wünschen sie sich ein viertes Kind und würden gern eine große Ausstellung der *1000 Families* besuchen, um dort Menschen aus aller Welt zu treffen.

Hanna and Jukka met at school when they were 16. They studied medicine together and now practise in the same surgery. For the new millennium they'd like a fourth child, and they're keen on visiting a major exhibition of the *1000 Families* to meet people from all over the world.

Hanna et Jukka se sont rencontrés à l'école à l'âge de seize ans. Ils ont fait leurs études de médecine ensemble et exercent aujourd'hui dans le même cabinet. Pour l'an 2000, ils souhaitent un quatrième enfant et voudraient visiter une grande exposition des « 1000 familles » où ils pourraient faire la connaissance de gens du monde entier.

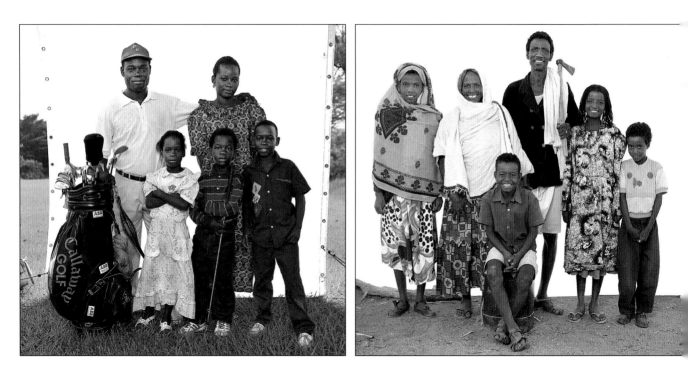

Abidjan,
Ivory Coast,
23 May 1997

„Um Golfspielen zu üben, baute ich mir einen Schläger aus einer Metallstange mit umgebogener Spitze. Ich spielte mit einer Dose für Kondensmilch, in die ich Sand gefüllt hatte, mein Parcours war der Fußballplatz." Heute ist Siméon Golfprofi in Abidjan. Er hat so ziemlich alle afrikanischen Wettkämpfe gewonnen und wird im nächsten Jahr an internationalen Turnieren teilnehmen. „Ich bete jeden Tag für ihn", sagt seine Frau Chantal, die die drei gemein-samen Kinder erzieht. „Im Jahr 2000 werde ich ein großer Golfstar sein und meine Familie wird ein unbeschwertes Leben führen", versichert uns Siméon.

"To train for golf, I made myself a club with a metal bar which I twisted at the end. I would swing at a can of condensed milk filled with sand. My golf course was the football pitch." Today, Siméon is a golf pro in Abidjan. He wins most of the golf tournaments in Africa, and next year he'll be playing at international level. "I pray to God for him every day," says his wife Chantal, who's bringing up their three children. "By 2000, I'll be a great golf star and my family will be well-off," says Siméon.

« Pour m'entraîner à jouer au golf, je m'étais fabriqué un club avec une barre de métal dont j'avais tordu le bout. Je tapais dans une boîte de lait concentré remplie de sable. Mon parcours, c'était le terrain de football. » Siméon est aujourd'hui professionnel et a remporté la plupart des compétitions en Afrique, et l'année prochaine il sera propulsé sur la scène internationale. « Je prie Dieu tous les jours pour lui », dit sa femme Chantal, qui élève leurs trois enfants. « En l'an 2000, je serai une grande star de golf et ma famille vivra à l'aise », affirme Siméon.

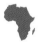

Keren,
Eritrea,
19 December 1997

Yohanes und Mariam sind Halbnomaden und leben mit ihren vier Kindern in einem provisorischen Dorf. Die meiste Zeit des Jahres ziehen sie mit ihren Ziegen und Schafen von einer Weide oder Wasserstelle zur nächsten.

As semi-nomads, Yohanes and Mariam are living with their four children in a temporary village. They move about for much of the year with their goats and sheep, from one pasture or watering-hole to the next.

Yohanes et Mariam sont installés avec leurs quatre enfants dans un village *provisoire*, puisqu'ils sont semi-nomades. Ils se déplacent durant une grande partie de l'année, avec leurs chèvres et moutons, au gré des pâturages et points d'eau.

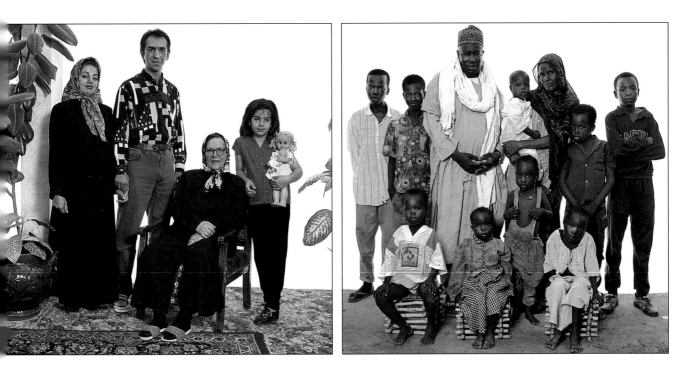

Mashhad,
Iran,
19 September 1999

„Ich glaube an die Zukunft, an den Frieden und an die Liebe unter den Völkern, ungeachtet ihrer Wurzeln oder Religion." Tahid ist ein moderner Denker in einer traditionalistischen Gesellschaft. „Meine Tochter habe ich nach Venus, der schönsten Frau der griechischen Antike, genannt." Tahid unterrichtet Englisch an einem Gymnasium, arbeitet gelegentlich als Fremdenführer und Übersetzer, züchtet Zierfische und hilft seinem Vater bei der Aufzucht der Kampfhähne, von denen etwa 20 den Keller ihrer Villa bevölkern. Kein Wunder, dass ihm wenig Zeit für seine eigentlichen Hobbys bleibt: lesen und Tischtennis. Mit seiner Frau Hama, von Beruf Kinderkrankenschwester, ist er seit zehn Jahren verheiratet. Für das neue Jahrtausend wünschen sich die beiden einen Sohn.

"I believe in the future, and in peace and love between peoples, regardless of their origins and religions." Tahid is a modern man in a somewhat traditionalist society. "I've named my daughter Venus, after the most beautiful female in Greek antiquity." He teaches English at the secondary school and is an occasional guide and translator. He also breeds ornamental fish and helps his father rear fighting cocks, some 20 of which are housed in the basement of their villa. All this leaves him little free time for his hobbies – reading and ping-pong. His wife Hama, whom he married ten years ago, is a nurse at the children's hospital. For the new millennium they would really quite like a little boy.

« Je crois à l'avenir comme à la paix et à l'amour entre les peuples, peu importe leurs origines ou leurs religions ». Tahid est un homme moderne dans une société plutôt traditionaliste : « J'ai appelé ma fille Vénus, la plus belle femme de l'Antiquité grecque. » Professeur d'anglais au lycée, occasionnellement guide et traducteur, il élève aussi des « poissons de décoration » et aide son père à l'élevage de coqs de combat, dont une vingtaine peuplent le sous-sol de leur villa, ce qui lui laisse peu de temps libre pour ses hobbies : la lecture et le ping-pong. Hama, sa femme depuis dix ans, est infirmière à l'hôpital d'enfants. Pour l'an 2000, ils aimeraient bien peut-être un petit garçon …

Mandelia,
Chad,
27 July 1997

Wie sein Vater ist auch Iba Berater des Sultans, aber er träumt davon, ein guter Landwirt zu werden, und hat große Pläne für die Landwirtschaftskooperative, die er leitet. Er wünscht sich ein Geschäft für seine Frauen und dass seine Kinder eine gute Schulbildung bekommen, ist sich aber nicht sicher, ob er über die notwendigen finanziellen Mittel verfügt. „Wir hatten geglaubt, das neue Jahrtausend würde unseren Alptraum beenden, aber im Augenblick sehe ich kein Licht am Ende des Tunnels."

Like his father, Iba is an adviser to the sultan, but he dreams of becoming a good farmer and has grand development plans for the farming co-operative of which he is chairman. He would like his wives to have businesses and his children to be good students, but he's not sure he'll have enough money. "We'd thought that the new millennium would see the end of our nightmares, but for the time being I can't see the light at the end of the tunnel."

Comme sont père, Iba est conseiller du Sultan, mais il rêve de devenir un bon agriculteur et il a de grands projets de développement pour la coopérative agricole qu'il préside. Il aimerait que ses femmes aient un commerce et que ses enfants fassent de bonnes études, mais il n'est pas certain d'avoir les moyens financiers nécessaires. « Nous avions pensé que l'an 2000 serait la fin de nos cauchemars, mais pour le moment, je ne vois pas le bout du tunnel. »

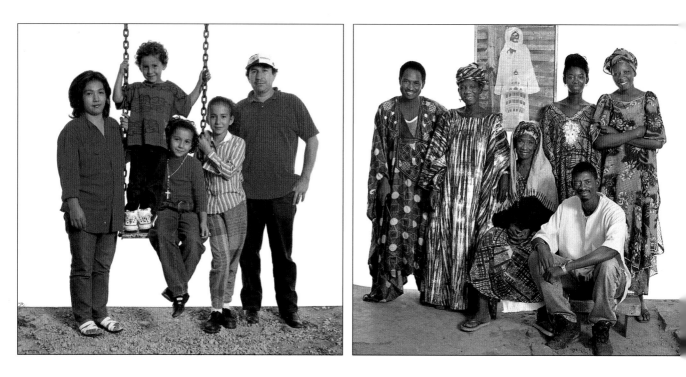

Loja,
Ecuador,
13 February 1999

Elvira versorgt den Haushalt und Juan arbeitet in einer Goldmine. Sie fahren besonders gern ans Meer, besuchen die Familie und gehen mit ihren Kindern spazieren. „Lebt mit der Liebe Gottes und haltet zusammen!", raten sie uns zum Abschied.

Elvira looks after the home, and Juan works in a gold mine. They particularly like going to the seaside, visiting the family and walking with their children. "Live in the love of God and stay together," they advise us before we part company.

Elvira s'occupe du foyer. Juan travaille dans une mine d'or. Ils aiment particulièrement se rendre au bord de la mer, visiter la famille et se promener avec leurs enfants. « Vivez dans l'amour de Dieu et restez unis ! », nous conseillent-ils avant de partir.

Dakar,
Senegal,
26 April 1997

„Das neue Jahrtausend gehört der Jugend, es ist an ihr zu kämpfen!", erklärt Tenine. Seit ihr Mann 1991 an einer Lungenentzündung gestorben ist, erzieht sie ihre Kinder allein. Pape, ihr Ältester, fängt gerade an, als Künstler sein eigenes Geld zu verdienen; er ist voller Hoffnung und hat viele Pläne für seine künstlerische Laufbahn. „Ich bin froh, meine Familie um mich zu haben, und ich wünsche mir, dass alle Arbeit finden", so das Fazit seiner Mutter.

"The new millennium belongs to the young – it's up to them to fight the fight," says Tenine. Her husband died from pneumonia in 1991, and she is bringing up her children on her own. Pape, her eldest son, is starting to earn a living as an artist. He is full of hope and has many projects for his artistic career. "I am happy to be surrounded by my family, and I'd like everybody to find work," concludes his mother.

« L'an 2000 appartient à la jeunesse, à eux de se battre », déclare Tenine, mère de famille. Elle a perdu son mari en 1991 des suites d'une pneumonie et élève seule ses enfants. Pape, son fils aîné, commence à gagner sa vie de son activité d'artiste peintre, il est plein d'espoir et de projets pour sa carrière artistique. « Je suis heureuse d'être entourée par ma famille et je souhaite que tout le monde trouve du travail », conclut sa mère.

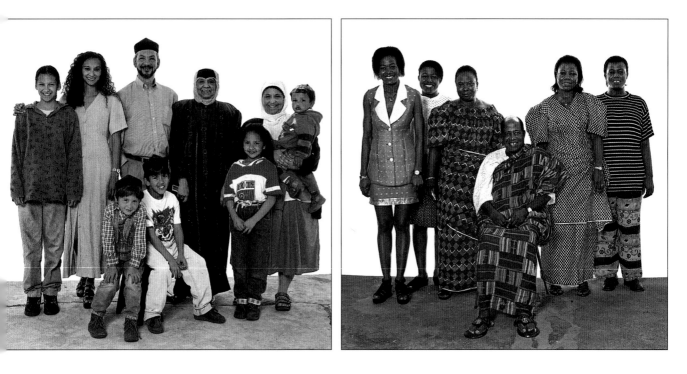

Cape Town,
South Africa,
20 September 1997

Charmaine ist in Kapstadt geboren. Sie lebt mit ihrer Tochter allein und arbeitet zwei bis drei Tage die Woche in einer Fabrik. Auf dem Foto hat sie ihre Mutter, Tante, Nichten und Neffen um sich geschart. „Das neue Jahrtausend? Früher hatte ich nie Träume, weil wir während der Apartheid keine Chance auf eine gute Schulbildung hatten. Aber heute habe ich einige Wünsche für die Zukunft: einen Ort, an dem sich die Jugendlichen treffen können, ein Restaurant und vor allem, dass Kapstadt ruhiger wird und wir bei offenen Fenstern schlafen können."

Charmaine was born in Cape Town, and works two to three days a week in a factory. She lives alone with her daughter. For the photo, she has gathered together her mother, her aunt, and her nephews and nieces. "The new millennium? I never had any dreams because, with apartheid, we didn't have the opportunity or the luck to have a good education. But now I've got a few projects for the future: a place where young people can get together, a restaurant, and above all, I hope that Cape Town becomes a more tranquil city so that we can sleep with our windows open."

Née au Cap, Charmaine travaille deux à trois jours par semaine dans une manufacture. Elle vit seule avec sa fille, elle est ici en compagnie de sa mère, de sa tante, des ses neveux et nièces. « L'an 2000 ? Je n'ai jamais eu de rêves parce qu'avec l'apartheid, nous n'avions pas l'opportunité ni la chance d'avoir une bonne éducation. Mais maintenant j'ai quelques projets pour l'avenir : un endroit pour que les jeunes puissent se rassembler, un restaurant et surtout que le Cap devienne une ville plus tranquille pour que nous puissions dormir les fenêtres ouvertes. »

Abengourou,
Ivory Coast,
27 May 1997

André ist Gefängnisdirektor im Ruhestand. Sein früherer Beruf hat sein Vertrauen in die Zukunft nicht beeinträchtigt: „Ich glaube, dass wir dank des Gesellschaftsentwurfs von Präsident Bédié auf politische, ökonomische und soziale Entwicklung hoffen dürfen." Seine Frau arbeitet im ländlichen Gesundheitswesen. Beide haben sich vorgenommen, „das Jahr 2000 mit der Familie zu feiern."

A former prison manager, André is now retired. His past duties haven't changed his confidence in the future: "I think that as a result of President Bédié's social planning, we may hope for political, economic and social development." His wife is a rural district nurse. They've both made a promise "to celebrate New Year 2000 with the family."

Régisseur de prison, André est actuellement à la retraite. Ses fonctions passées n'ont pas altéré sa confiance en l'avenir : « Je pense que grâce au projet de société du Président Bédié, l'espoir d'un développement politique, économique et social est permis. » Son épouse est fille de salle au district de santé rurale, ensemble ils ont fait un vœu : « Fêter l'an 2000 en famille. »

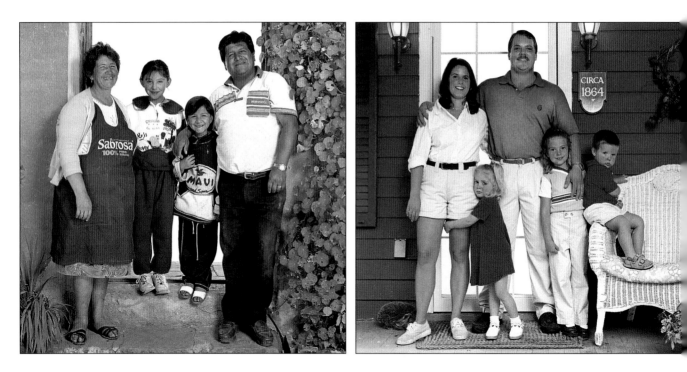

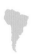

Tarabuco,
Bolivia,
25 January 1999

Victor und Elisabeth fahren mit ihrem Lkw über die Dörfer, um bei den Bauern Gemüse einzukaufen, das sie auf dem Sonntagsmarkt von Tarabuco feilbieten. Sie sind fasziniert von der Vorstellung, dass die ganze Welt sie durch ihr Foto kennen lernen wird.

Victor and Elisabeth own a truck, and go from village to village buying vegetables from small farmers to sell at the Sunday market in Tarabuco. They are delighted by the thought that the whole world will be able to get to know them through their photo.

Victor et Elisabeth possèdent un camion et effectuent le tour des villages, achetant des légumes aux paysans pour les vendre au marché dominical de Tarabuco. Ils sont enchantés par l'idée que le monde entier puisse les connaître à travers leur photo !

Brookhaven,
New York, USA,
7 September 1998

Wie schon sein Vater und sein Großvater ist auch George Polizist. Er kam gerade rechtzeitig von der Nachtschicht in einer Polizeistation in Queens nach Hause, um sich mit seiner Familie fotografieren zu lassen. Seine Frau Julie hatte ihren Beruf als Friseuse und Visagistin aufgegeben, um die drei Kinder großzuziehen, möchte jetzt aber wieder in ihren Beruf zurückkehren. Die beiden wünschen sich, mit ihrer kleinen Sippe im Auto auf Entdeckungsfahrt zu gehen.

George is a police officer, like his father and grandfather before him. He's just got back from his night shift in a Queens precinct to pose with his family. His wife Julie put her career as a hairdresser and make-up artist on hold to bring up her three children, but she now wants to get back to work. They both want to go off and explore their country by car with their little tribe.

Officier de police comme son père et son grand-père, George rentre tout juste de son service de nuit dans un commissariat du Queens pour poser avec sa famille. Sa femme Julie a mis sa carrière de coiffeuse maquilleuse entre parenthèses pour élever ses trois enfants, elle veut aujourd'hui reprendre son activité. Tous deux souhaitent partir à la découverte de leur pays en voiture avec leur petite tribu.

Yamoussoukro,
Ivory Coast,
8 May 1997

Lewa ist Wärter der heiligen Krokodile im Präsidialpalast von Yamoussoukro. Sein älterer Bruder ließ einst auf Wunsch von Houphouët-Boigny ein Krokodilpärchen aus Mali kommen. Inzwischen tummeln sich knapp 30 Tiere im Teich des Palastes. Seitdem Lewa einmal von einem Krokodilbaby in die Ferse gebissen wurde, legt er seinen Talisman nicht mehr ab. So geschützt klettert er unter den entsetzten Blicken einiger Bewunderer sogar auf den Rücken der Tiere.

Lewa is the keeper of the sacred crocodiles at the presidential palace in Yamoussoukro. His elder brother got hold of a couple of crocodiles from Mali at the request of Houphouët-Boigny. Now there are about 30 of them paddling in the lake around the palace. Bitten just once on the heel by a baby crocodile, Lewa has never again gone without his lucky charms. With them to protect him, he gaily climbs on the crocodiles' backs under the horrified gaze of his admirers.

Lewa est le gardien des crocodiles sacrés du palais présidentiel de Yamoussoukro. Son frère aîné a fait venir un couple de crocodiles du Mali à la demande du président Houphouët-Boigny. Depuis, ils sont près d'une trentaine à barboter dans le lac bordant le palais. Mordu une seule fois au talon par un bébé crocodile, Lewa ne quitte plus ses gris-gris. Ainsi protégé, il n'hésite pas à grimper sur leur dos, sous le regard horrifié de quelques admirateurs.

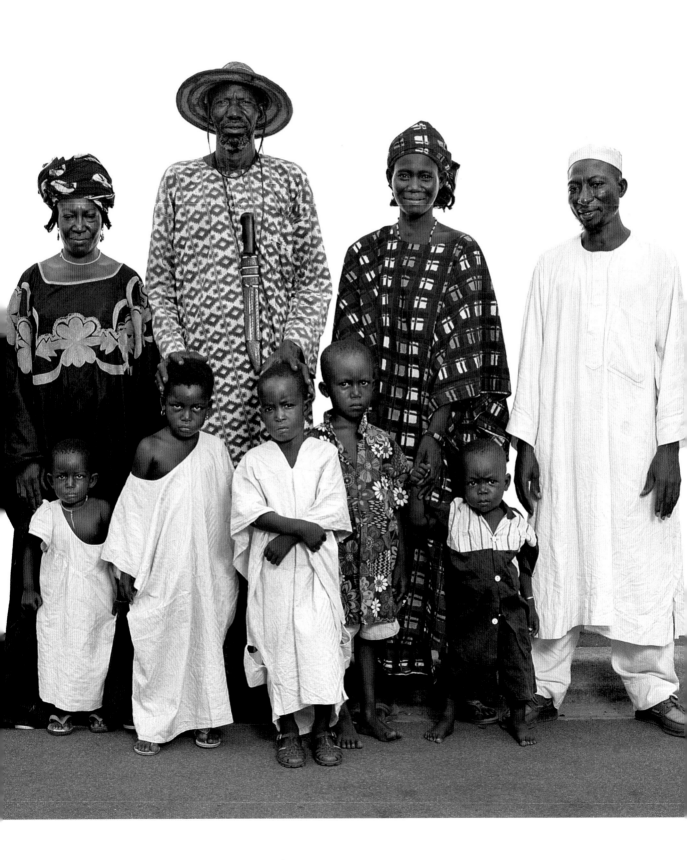

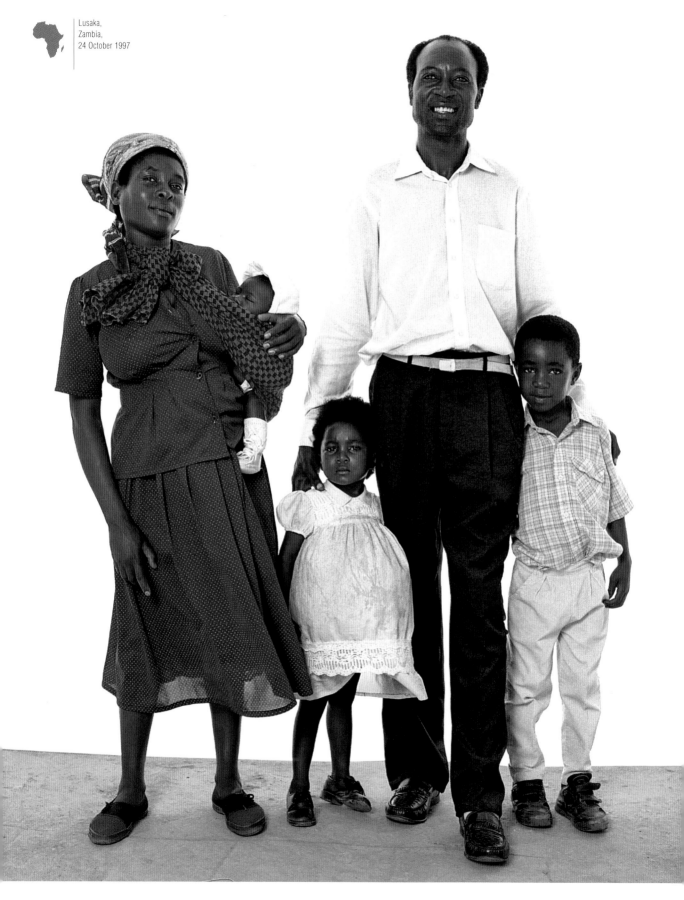

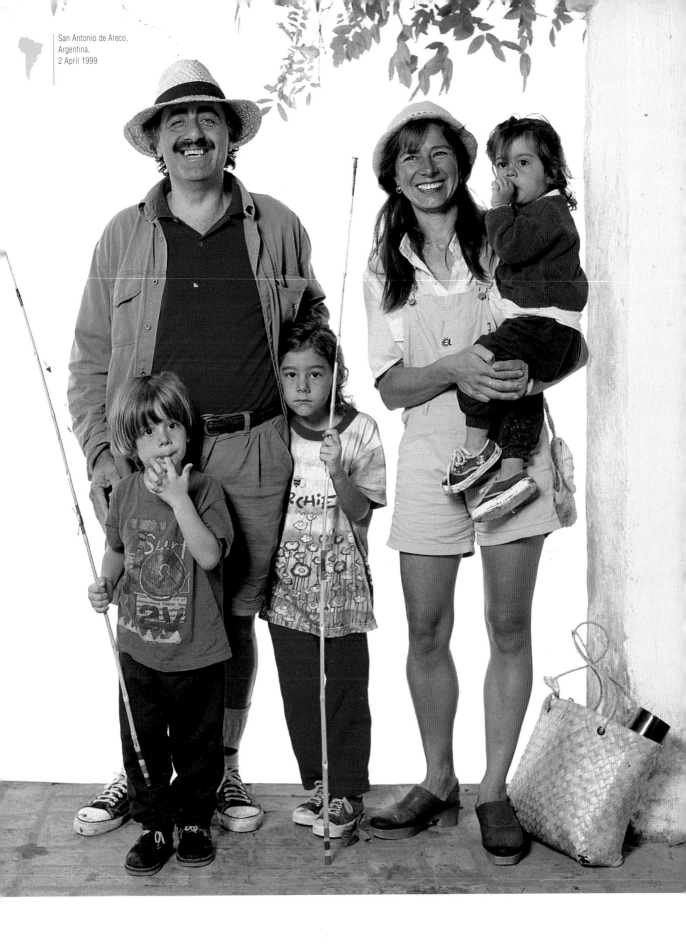

San Antonio de Areco,
Argentina,
2 April 1999

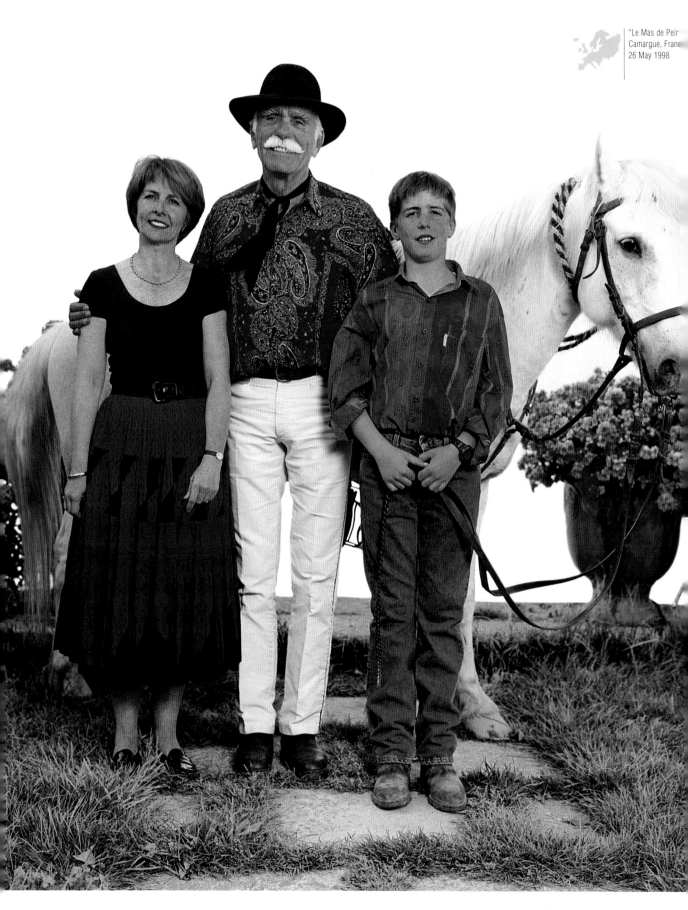

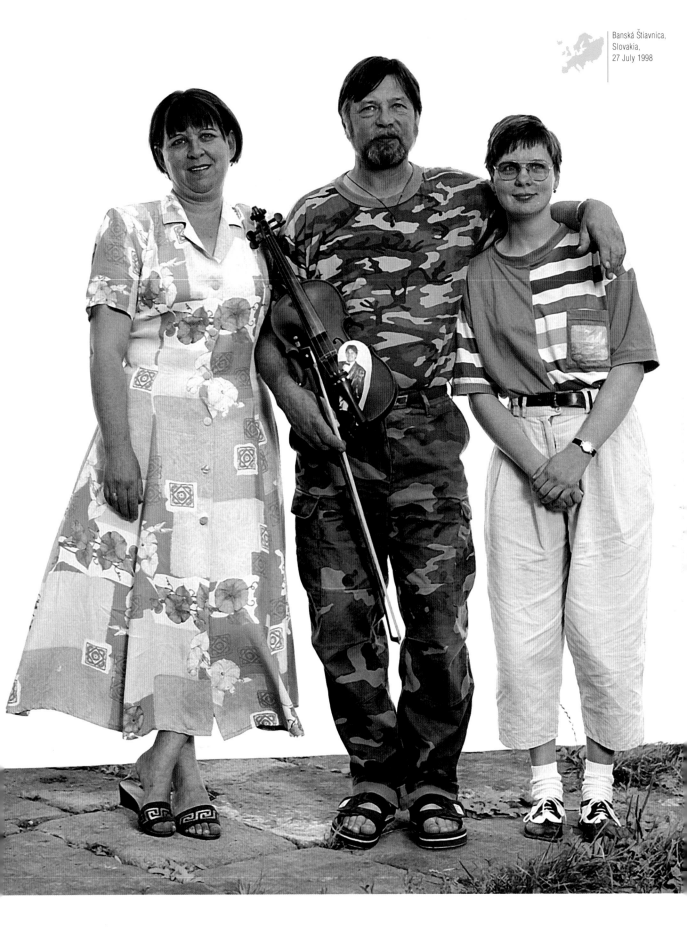

Page 244

Wilfred und seine Familie haben wir kennen gelernt, als sie gerade aus dem Krankenhaus kamen. Sie waren mit Kind und Kegel ins 250 Kilometer entfern[t]e Lusaka gereist, um bei der kleinen Tochter zu sein, die operiert werden musste. Nach seiner Berufsausbildung in Deutschland hat der Lederfachmann nun vor, andere Länder zu entdecken, vor allem die USA.

Wilfred and his family were coming out of the hospital when we met them. Their young daughter has to have an operation, and they all came from their home, 150 miles [250 km] from Lusaka, to be with her during the time. Wilfred is a leather technician; he did a training course in Germany, and would really like to travel to discover other countries – the USA above all.

Wilfried et sa famille sortaient de l'hôpital quand nous les avons rencontrés. Leur petite fille doit subir une opération et ils sont tous venus de leur domicil[e] à 250 km de Lusaka pour le temps de l'opération. Technicien du cuir, il a fait un stage en Allemagne et aimerait beaucoup voyager pour découvrir d'autres pays et surtout les Etats-Unis.

Page 245

Die Angelruten? „Die sind nur dazu da, um den Wurm zu baden", erklärt Hector. Sie sind übers Wochenende hierher gekommen, um dem übervölkerten Buenos Aires zu entfliehen und etwas Zeit mit den Kindern zu verbringen. Gabriela ist Schauspielerin und Hector Regisseur einer Straßentheatergruppe – zurzeit spielen sie *Macbeth* von Ionesco. Ihre Botschaft für die Zukunft: „Nicht auf die Hautfarbe der Menschen kommt es an, was zählt, ist die Kultur."

Fishing rods? "It's only to give the worms a chance to swim," Hector explains. They've come out for the weekend, to get away from overcrowded Buenos Aires and spend a little time with their children. Gabriela is an actress and Hector the director of a street theatre group – right now they're doing Ionesco's *Macbeth*. Their message for the future is: "It's not the colour of humankind that counts, it's culture that matters."

Les cannes à pêche? « C'est seulement pour faire prendre un bain au ver », explique Hector. Ils sont venus en week-end, fuyant le surpeuplement de Buenos Aires, passer un peu de temps avec leurs enfants. Gabriela est comédienne et Hector metteur en scène d'un groupe de théâtre qui se produit dans la rue – en ce moment, ils jouent *Macbeth* de Ionesco. Leur message pour l'avenir: « Ce n'est pas la couleur de l'humanité qui compte, c'est la culture qui importe. »

Page 246

Schon „um der Schwalben willen" wünschen sich Jacques und Lucille, dass die Natur in der Camargue so bleibt wie sie ist. Die beiden leben in einem wunderschönen provenzalischen Landhaus, vermieten erstklassige Gästezimmer, besitzen eine Stierzucht mit 300 Tieren und bauen nebenbei noch Reis und Weizen an. Außerdem waren sie so nett, uns ein wenig ihrer kostbaren Zeit zu schenken, trotz einer heftigen Stechmückenattacke während der Aufnahmen, bei der nicht nur den beiden das Lächeln beinahe vergangen wäre.

To "please the swallows," Jacques and Lucille hope that nature won't change in the Camargue. They live in a splendid farmhouse, let out superb guestrooms, rear 300 bulls, and grow rice and wheat. They kindly gave us a little of their time, despite a massive assault by midges during the shoot, which made it hard to smile.

Pour faire « plaisir aux hirondelles », Jacques et Lucille souhaitent que la nature en Camargue ne change pas. Ils vivent dans un mas magnifique, louent des chambres d'hôtes superbes, élèvent trois cents taureaux, cultivent du riz et du blé. Ils nous ont consacré un peu de leur temps avec gentillesse, malgré une attaque massive de moucherons pendant la prise de vue qui ont rendu les sourires difficiles.

Page 247

Zuzana führt eine Pension in einem sehr alten Haus in der Nähe des Stadtzentrums. Sie lernt Deutsch „wegen der vielen Touristen, aber auch weil es eine schöne Sprache ist", und liebt es, „auf Trödelmärkten und in Antiquitätengeschäften zu stöbern". Währenddessen gärtnert Pavel in Militäruniform in seinem „botanischen Garten", allerdings trägt er die Kluft „ausschließlich aus Liebe zur Natur und nicht wegen des militärischen Geistes!" Die Trompete hat er vor kurzem zugunsten der Geige aufgegeben. Das kleine Foto auf seinem Instrument zeigt seinen Sohn, der als Sänger und Musiker ein Engagement in Südspanien hat.

Zuzana runs a guest-house in a very old building located near the town centre. She's learning German "because of all the tourists, but also because it's a beautiful language," and she loves "bargain-hunting in flea markets and antique shops." While she does that, Pavel works in his "botanical garden" wearing a military uniform, but "only because of his love of nature, not because of any kind of military spirit!" He recently took up playing the violin, having abandoned his trumpet. The small photo on his violin shows his son, a singer and musician, who's got a contract in the south of Spain.

Zuzana s'occupe d'une pension située près du centre-ville, dans une bâtisse très ancienne. Elle apprend l'allemand « à cause des nombreux touristes, mais aussi parce que c'est une belle langue », et adore « chiner dans les foires à la brocante et chez les antiquaires ». Pendant ce temps, Pavel jardine dans son « jardin botanique » en uniforme militaire, une tenue qu'il porte « uniquement par passion pour la nature et non pour le génie militaire! ». Il joue depuis peu du violon après avoir délaissé la trompette. La petite photo sur son violon représente son fils, chanteur et musicien, sous contrat dans le sud de l'Espagne.

Kürten,
Germany,
10 January 1996

Werners Domäne ist der Bauernhof mit Schafen und Federvieh, einem Esel und natürlich Oscar, der Gans im Vordergrund, dem besten Freund der Jungen. Annette arbeitet als Krankenschwester und kümmert sich um Haus und Kinder.

Werner runs the farm – sheep and poultry plus a donkey – as well as Oscar, the goose in the foreground, the boys' best friend. Annette still works as a nurse, and looks after the children and the home.

Werner s'occupe de la ferme: moutons et volailles mais aussi un âne et Oscar, l'oie du premier plan, le meilleur copain des garçons. Annette a gardé son travail d'infirmière et veille sur les enfants et la maison.

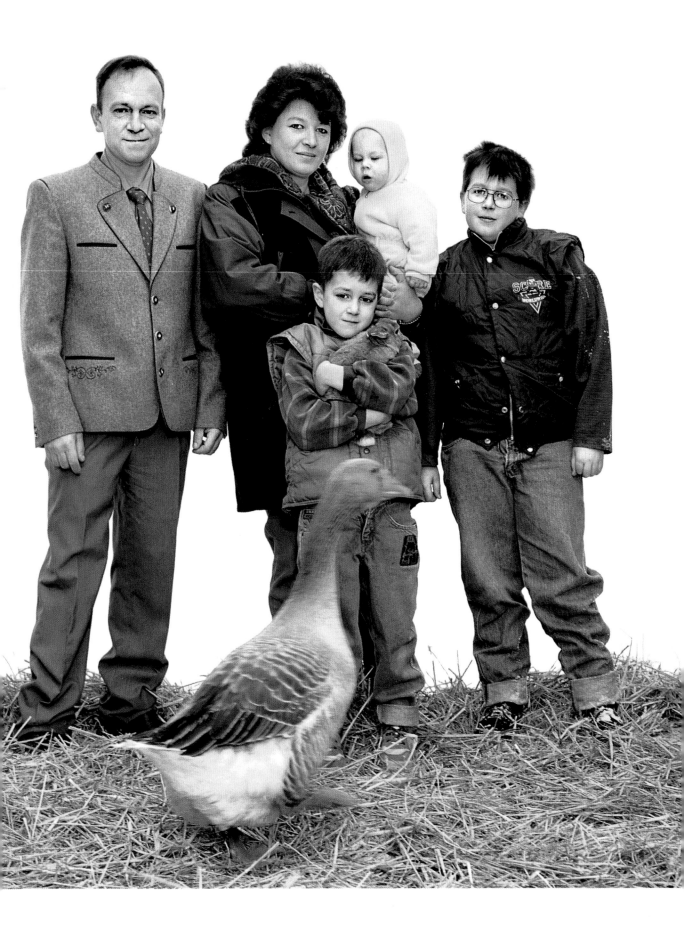

Palong heißt „Paradiesvogel" und ist zugleich der Name ihres Stammes.
Der Grund dafür wird klar, wenn man sich die bunte Kleidung der Frauen
anschaut. Der Großvater (rechts) wiederum geht mit der aktuellen Mode.
Die drei Generationen leben von ihren landwirtschaftlichen Erzeugnissen
wie Reis, Mais, Soja, Bohnen und diversen anderen Gemüsen und halten
Hühner, Enten und Schweine.

Palong means 'bird of paradise', and is also the name of their tribe. The
reason is easy to see when you look at the women's colourful clothing.
Grandfather (right) on the other hand closely follows the latest fashion. The
three generations live off their own farm produce – rice, maize, soya, beans
and various other vegetables – plus chickens, ducks and pigs.

Palong veut dire « Oiseau de Paradis », c'est aussi le nom de leur tribu.
On en comprend la raison en regardant les vêtements colorés des femmes.
Grand-père (à droite) en revanche suit la mode actuelle de très près. Les
trois générations vivent de leur propre production agricole : riz, maïs, soja,
haricots et divers autres légumes, mais aussi poules, canards, cochons.

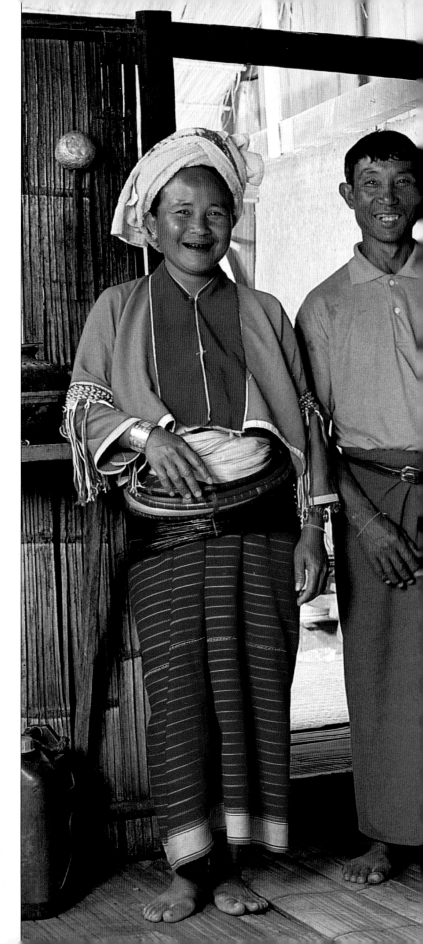

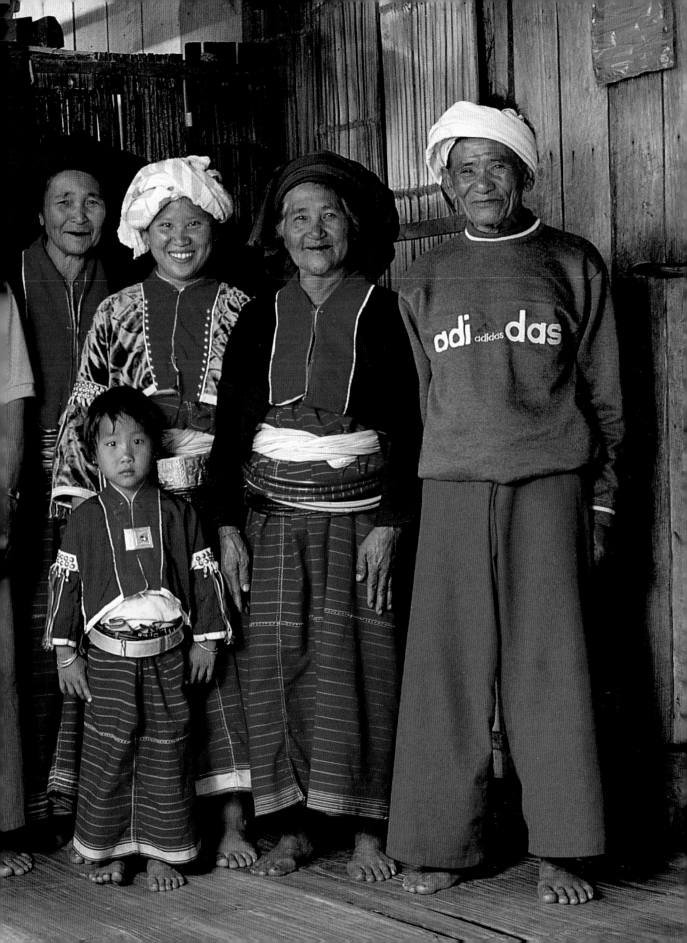

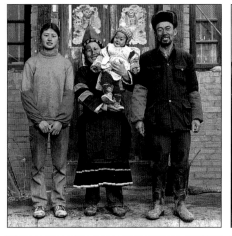
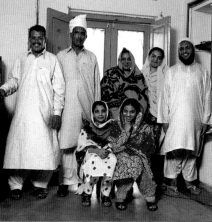
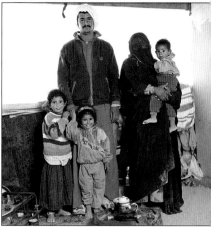

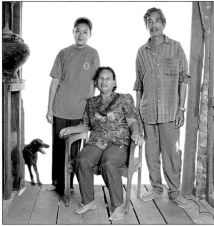
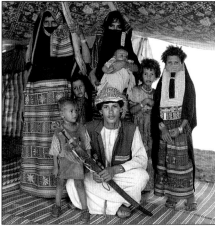
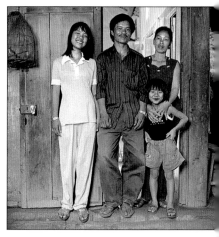

1

2

3

7

8

9

 1
near Guiyang,
China,
2 March 2000

 2
Lahore,
Pakistan,
8 October 1999

 3
Kon Tum,
Vietnam,
9 February 2000

 4
Sarikiz,
Turkey,
16 August 1999

 7
Surat Thani,
Thailand,
9 January 2000

 8
Massawa,
Eritrea,
23 December 1997

 9
Nuweiba,
Egypt,
1 January 1998

 10
Bandarban,
Bangladesh,
26 November 1999

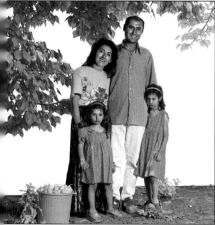

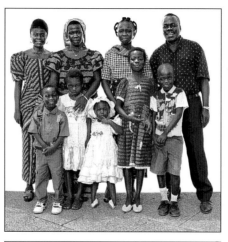

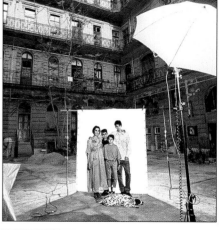

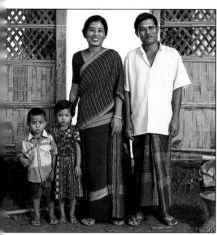

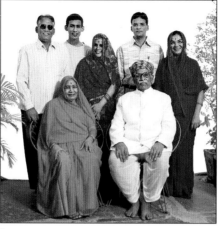

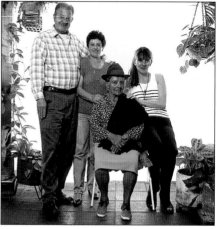

5

11

0

11

6

12

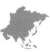

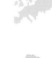

5
Yamoussoukro,
Ivory Coast,
8 May 1997

6
Budapest,
Hungary,
20 October 1996

11
Udaipur,
India,
26 October 1999

12
Bogota,
Colombia,
20 February 1999

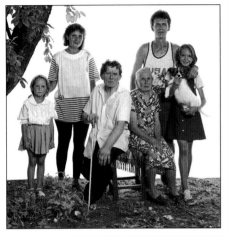
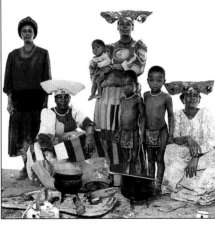
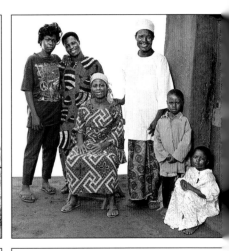

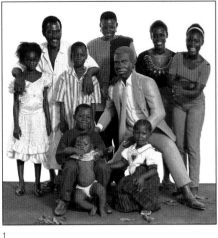
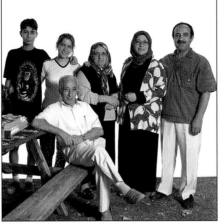
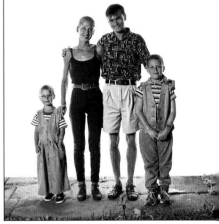

1

4

2

5

3

6

 1
Bohuslav,
Ukraine,
21 July 1998

 2
Opuwo,
Namibia,
12 September 1997

4
Abidjan,
Ivory Coast,
10 March 1997

5
Denizli,
Turkey,
1 August 1999

3
Abomey,
Benin,
12 July 1997

6
Banská Štiavnica,
Slovakia,
27 July 1998

 Volgograd,
Russia,
29 August 1999

Letztes Jahr haben die Urgroßeltern der sechsjährigen Ksenia goldene Hochzeit gefeiert. Die Bauern der Gegend bringen ihre Melonen zu Semjon und Anna, die sie mit tatkräftiger Unterstützung ihrer Urenkelin für eine kleine Provision verkaufen. Der Wirtschaftsexperte und die ehemalige Bibliothekarin sehen die Zukunft eher düster: „Solange es keinen Regierungswechsel gibt, haben wir keine Hoffnung."

These great-grandparents, who have been married for 51 years, dote on little six-year-old Ksenia. She helps them with the melons they sell on commission for their neighbors. Former economist Semyon and librarian Anna are not very optimistic about the future: "Until there's a change of government, there's no hope."

Mariés depuis cinquante et un ans, ils sont arrière-grand-parents de la petite Ksenia âgée de six ans. Elle les aide à vendre les melons que les paysans des alentours leur laissent en dépôt et sur la vente desquels ils prélèvent une commission. Semjon, anciennement économiste, et Anna, bibliothécaire, ne sont pas très optimistes pour l'avenir : « Tant que le gouvernement actuel ne changera pas, il n'y aura pas d'espoir. »

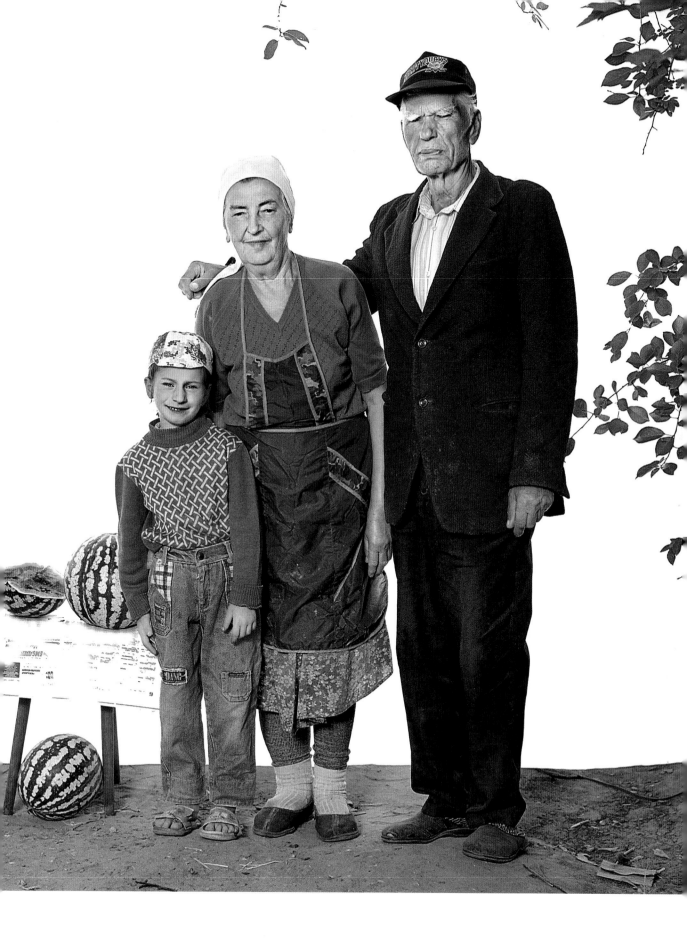

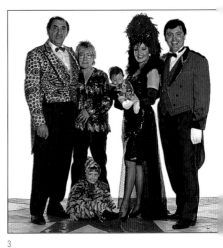

1

2

3

1
Yuksom,
Sikkim, India,
20 November 1999

2
Brataj,
Albania,
17 December 1996

3
Dublin,
Ireland,
28 July 1996

Brookhaven,
New York, USA,
8 September 1998

Sie kannten sich schon als Babys und haben 25 Jahre später geheiratet. Für nichts in der Welt würden sie aus der Gegend, in der ihre weit verzweigte Familie lebt, wegziehen. Mike, Geschäftsführer eines Schrottplatzes, und Michelle, Zahnarzthelferin, machen gern Familienurlaub im Schnee, um Ski zu laufen und Schnee-Scooter zu fahren. Darüber hinaus ist Mike ein begeisterter Meeresfischer und Michelle geht leidenschaftlich gern shoppen (sagt Mike)!

They knew each other as babies, and got married 25 years later. Nothing in the world would induce them to leave the area where their entire large and close-knit family live. Mike manages a breaker's yard and Michelle is a dentist's assistant. They like family holidays in the snow for skiing and snow-mobiling – their two shared passions, apart from Mike's sea fishing and shopping for Michelle (says Mike)!

Ils se sont connus bébés et se sont mariés vingt-cinq ans plus tard. Pour rien au monde, ils ne quitteraient la région où vit toute leur famille, nombreuse et unie. Mike, gérant d'une casse auto, et Michelle, assistante-dentiste, aiment les vacances à la neige et en famille pour le ski et le scooter de neige, leurs deux passions communes outre celles de la pêche en mer pour Mike et du shopping pour Michelle (dit Mike)!

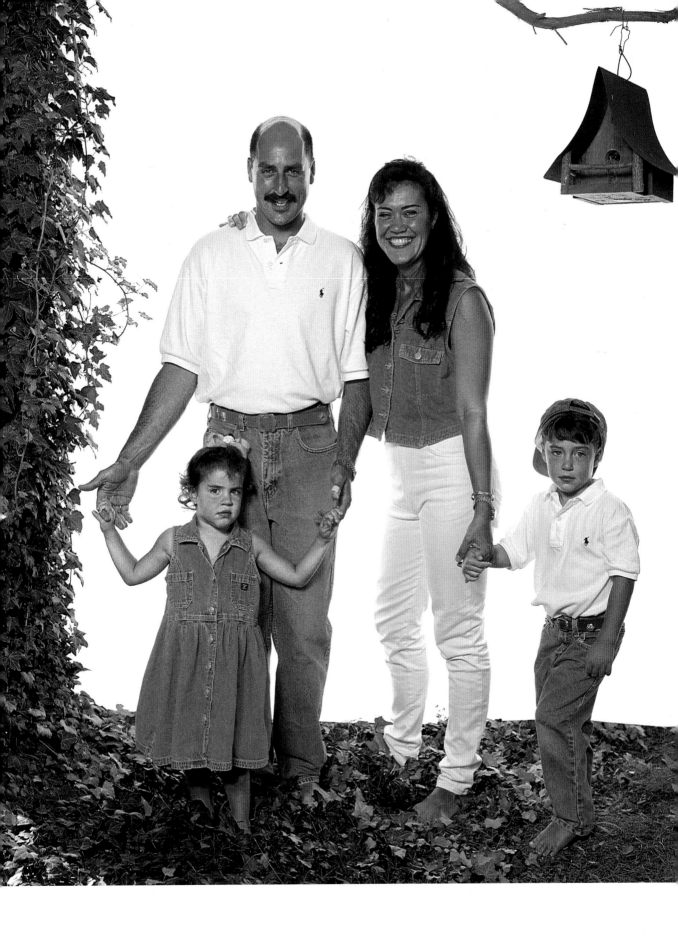

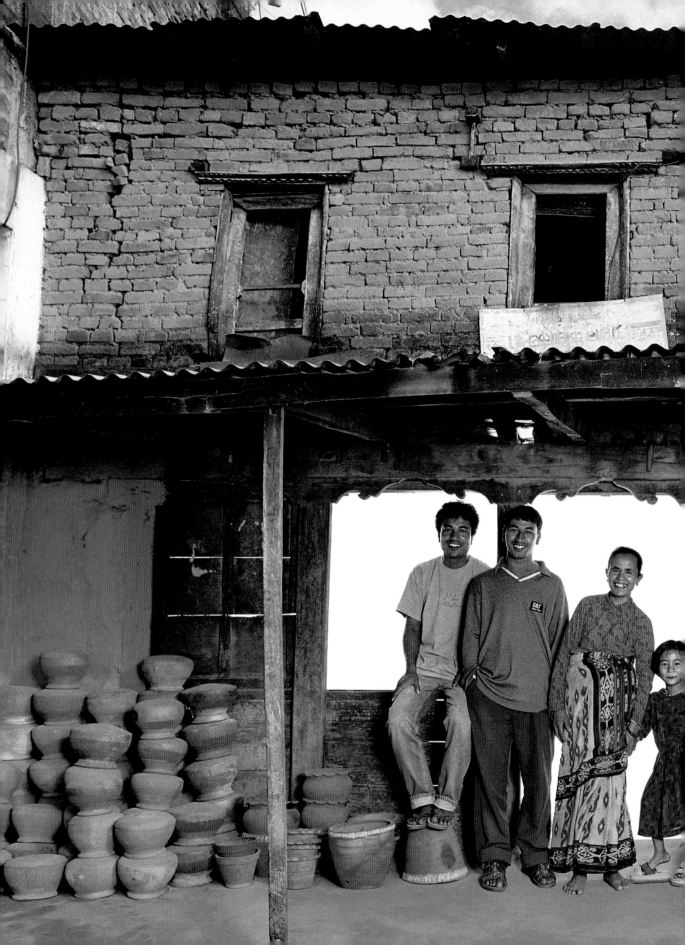

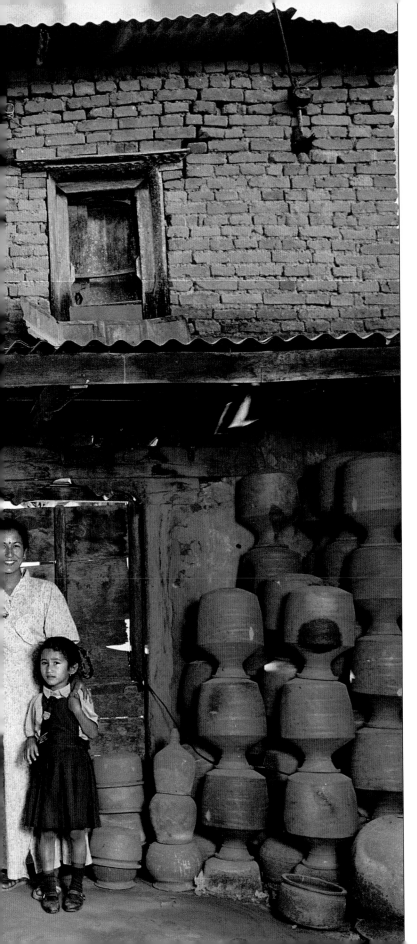

„Das ist eine sehr reiche Familie", erzählt unser Führer, „ihnen gehört dieser Töpferwarenladen, ein großes Haus in der Stadt und eine Menge Ackerland. Aber ihr Leben hat sich nicht verändert, sie sind den Traditionen treu geblieben." Seit 30 Jahren verkaufen sie Gebrauchskeramik, „aber heute kaufen die Frauen immer öfter Plastik- oder Metallgeschirr und unser Geschäft ist rückläufig", erklärt Krishna (32), der seinen Lebensunterhalt außerdem als Fahrer eines Minibusses bestreitet.

"They are a very rich family," our guide tells us; "they own this pottery shop, a large house in town and a lot of farmland. But their way of life hasn't changed – they are very traditional." They have been selling domestic pottery for 30 years, "but these days women usually buy plastic and metal, and our business is dwindling," explains Krishna (32), who also earns a living as a mini-bus driver.

« C'est une famille très riche », nous raconte notre guide, « ils ont cette boutique de poterie, une grande maison en ville et beaucoup de terres agricoles. Mais leur façon de vivre n'a pas changé, ils sont très traditionnels ! » Cela fait trente ans qu'ils vendent des poteries utilitaires : « Mais aujourd'hui les femmes achètent plus souvent le plastique ou le métal et notre commerce décline », explique Krishna (trente-deux ans) qui gagne aussi sa vie comme chauffeur de minibus.

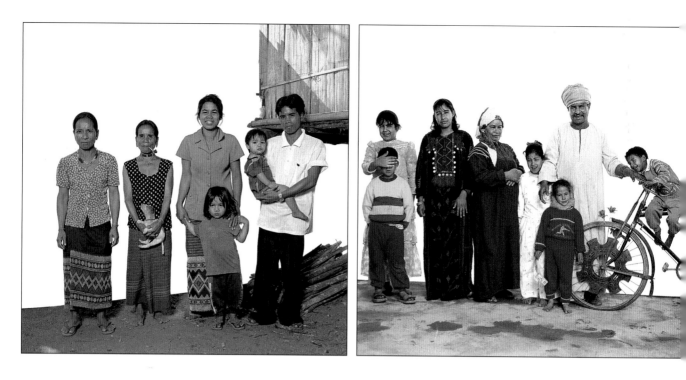

Champasak,
Laos,
29 January 2000

Sue und ihre Schwester bekamen ihre Tätowierungen im Alter von 13 Jahren. „Das ist eine Tradition, die verloren gegangen ist, und sehen Sie unsere Ohren, früher trugen wir sehr schwere Ohrringe aus Elfenbein. Aber wir mussten sie verkaufen, um überhaupt etwas Geld zu haben." Ihr Sohn ist bei der Armee und unterhält mit seinem Sold die ganze Familie. Den Kaffee und den Wasserreis für den Eigenbedarf pflanzen sie selber, aber ihren Pfeifentabak muss Großmutter kaufen.

Sue and her sister were tattooed at the age of 13. "It's a tradition that has disappeared," she says, "and look at our ears – we used to wear very heavy ivory earrings, but we had to sell them to make a little money." Her son is in the army and feeds the whole family from his pay. They plant coffee and short-grained rice for family consumption, but grandma has to buy the tobacco she needs for her pipe.

Sue et sa sœur ont eu leurs tatouages à l'âge de treize ans. « C'est une tradition qui s'est perdue, dit elle, et regardez nos oreilles, on portait des boucles très lourdes en ivoire, mais on a dû les vendre pour avoir un peu d'argent ! » Son fils est militaire et fait vivre toute la famille avec sa solde. Ils plantent du café et du riz gluant pour leur consommation familiale, mais grand-mère doit acheter le tabac nécessaire à sa pipe.

Bawiti,
Egypt,
7 January 1998

Seit nunmehr 25 Jahren führt Baiumi das beste Restaurant der Stadt. Chefkoch ist seine Frau, die ihm außerdem vier Töchter und zwei Söhne geboren hat. Da sie mit einem aufgeschlossenen Mann verheiratet ist, muss sie nicht verschleiert gehen, wie es vor allem auf dem Land Brauch ist. Das neue Jahrtausend? „Möge das Leben weitergehen wie bisher, wenn Allah will!"

Baiumi has owned the People's Restaurant – the best in town – for 25 years. His wife, who has borne him four daughters and two sons, does the cooking. He's a decidedly modern man who doesn't insist that his wife wear a veil, as is normally the custom in these parts. The new millennium? "Let life carry on the way it is, if Allah wills it!"

Depuis vingt-cinq ans, Baiumi est le propriétaire du « Restaurant Populaire », le meilleur de la ville ! Son épouse, qui lui a donné quatre filles et deux garçons, y fait la cuisine. C'est un homme résolument moderne qui n'oblige pas sa femme à porter le voile, comme c'est la coutume dans la région. L'an 2000 : « Que la vie continue comme elle est et Inch Allah ! »

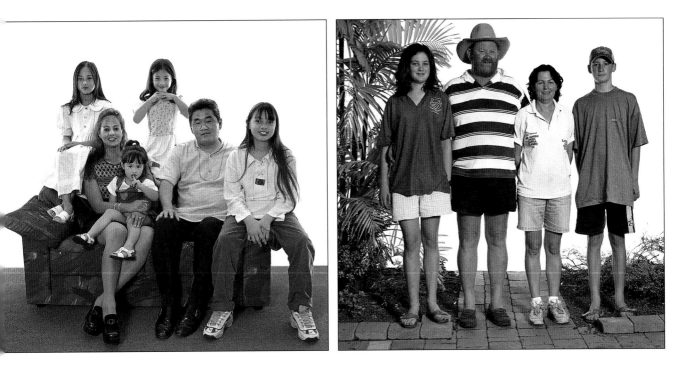

Cape Town,
South Africa,
22 September 1997

Shogo kam vor zwölf Jahren von Japan nach Kapstadt, wo er seine Frau kennen lernte. Er ist im Import-Export-Geschäft tätig, gemeinsam haben sie vier Kinder. „Als ich 1985 in Johannesburg ankam, wurde ich nicht gerade mit offenen Armen empfangen, in Kapstadt war es schon besser. Außerdem gibt es hier eine kleine japanische Gemeinde, in der ich jeden kenne. Unter dem Apartheid-Regime galten wir als Weiße, was das Leben für uns sehr viel leichter machte."

Shogo left Japan twelve years ago to settle in Cape Town, where he met his wife; he works in the import-export business. He and his wife have four daughters. "When I got to Johannesburg in 1985, it was hard, and I wasn't greeted like a guest. Things were better in Cape Town – in addition there's a small Japanese community and I know them all. Under apartheid we were regarded as whites, which made life easier."

Shogo a quitté le Japon il y a douze ans pour s'installer au Cap où il a rencontré son épouse; il travaille dans l'import-export. Avec son épouse, ils ont quatre filles. Quand je suis arrivé à Johannesburg en 1985, c'était difficile, je n'ai pas été accueilli comme un invité, au Cap c'était mieux – et puis il y a une petite communauté japonaise et je les connais tous! Sous l'apartheid nous étions considérés comme des blancs ce qui rendait la vie plus facile. »

Katherine,
Australia,
21 December 1999

Ihre Ehe wurde von einem Wanderpriester im Schatten eines großen Baums geschlossen. Damals gab es in der Region weder eine Kirche noch einen katholischen Priester. Die glücklichen Eigentümer eines Motels und einer riesigen Mangoplantage sehen die Zukunft durch eine rosarote Brille, wie man so sagt.

Their wedding was performed by an itinerant priest in the shade of a large tree. At that time, the area had neither church nor Catholic priest. They are the happy owners of a motel and a huge mango plantation, and see life through rose-tinted glasses, as the saying goes.

C'est par un prêtre de passage, à l'ombre d'un grand arbre, que fut célébré leur mariage. Il n'y avait ni église ni prêtre catholique dans la région à cette époque. Heureux propriétaires d'un motel et d'une plantation de manguiers, ils voient la vie en rose!

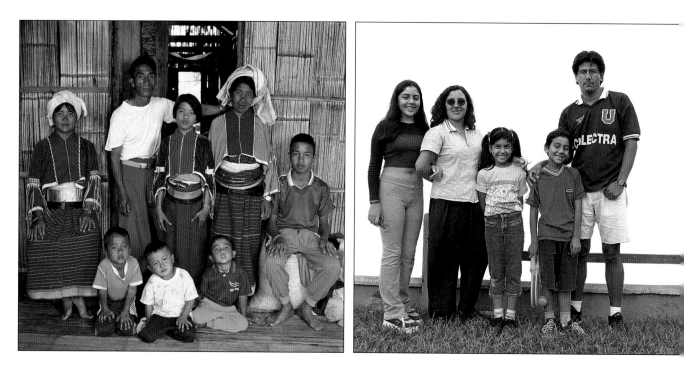

Chiang Dao,
Thailand,
19 January 2000

Sie leben von der Landwirtschaft und teilen ihr großes Haus mit der ganzen Familie, das heißt ihren vier zum Teil verheirateten Kindern und deren Kindern. Die gebürtigen Birmanen haben ihr traditionelles Dorf in Thailand wieder aufgebaut und leben völlig autark.

They live by farming, and share their large house with the whole family – their four children, some of them married, and their children's children. Originally from Burma, they have reconstructed their traditional village in Thailand and lead an autonomous life.

Ils vivent de l'agriculture et partagent leur grande maison avec toute la famille: leurs quatre enfants, en partie mariés, et les enfants de ces derniers. Originaires de Birmanie, ils ont reconstruit leur village traditionnel en Thaïlande et vivent en autarcie.

Santiago,
Chile,
14 January 1999

Sie haben sich am Arbeitsplatz kennen gelernt – er war Ingenieur, sie Angestellte. Drei Kinder später sind sie ein glückliches Paar und wünschen sich, dass ihr Nachwuchs einmal ebenso viel Glück im Leben hat wie sie. Julio ist Basketballfan, aber er mag auch Fußball und trägt stolz das Trikot seiner Lieblingsmannschaft zur Schau.

They met at their workplace – he was an engineer, she a clerk. Three children later, they are a happy couple and would like their children to have the same good luck in life that they have. Julio is a basketball fan, but he also likes football and proudly sports his favourite team's shirt.

Ils se sont rencontrés sur leur lieu de travail – il était ingénieur, elle était employée –, trois enfants plus tard ils forment un couple heureux, et souhaitent que leurs enfants aient la même chance dans la vie. Passionné de basket, Julio aime aussi le football et arbore fièrement le maillot dc son équipe préférée …

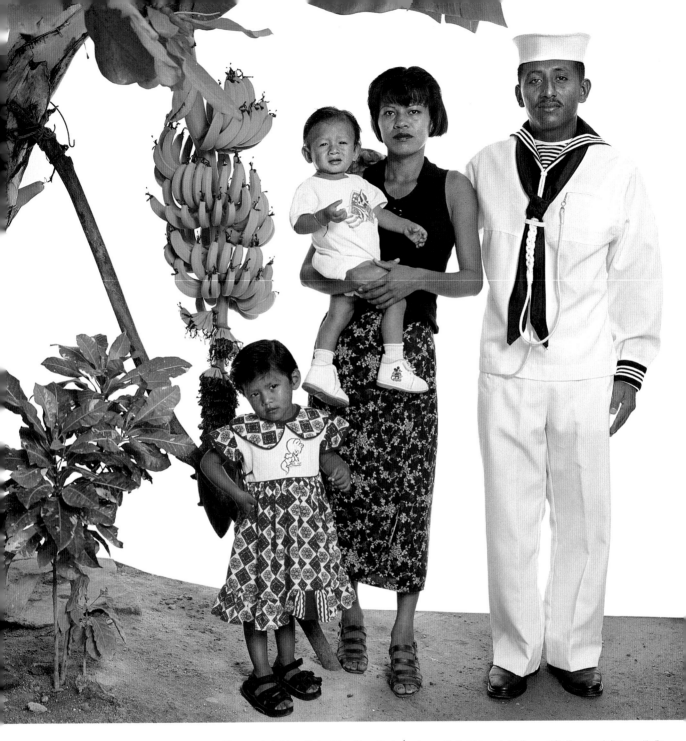

Pochutla,
Mexico,
6 December 1998

Von Beruf ist Isaac Matrose und arbeitet am Marinestützpunkt von Puerto Ángel, wo er für die Wartung der Waffen – und für Klempnerarbeiten – zuständig ist. Azucena versorgt das Haus und die beiden Kinder.

Isaac is a sailor by profession, stationed at the Puerto Ángel naval base, where he's responsible for weapons maintenance – and plumbing. Azucena takes care of their two children and the house.

Marin de profession, Isaac est affecté à la base navale de Puerto Angel, où il se charge de la maintenance des armes … et de la plomberie! Azucena s'occupe de leurs deux enfants et de la maison.

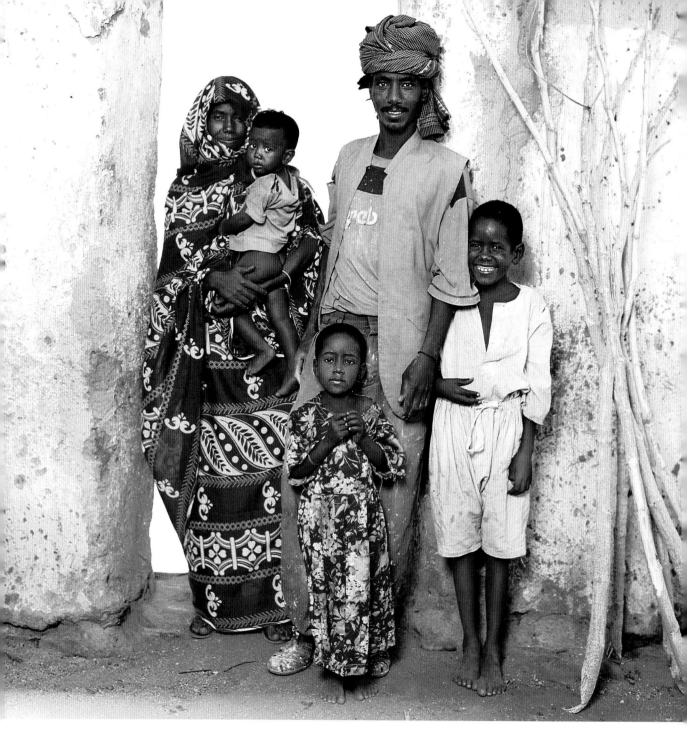

Keren,
Eritrea,
19 December 1997

Nachdem sein Land nach 30 Jahren Bürgerkrieg zu guter Letzt die Unabhängigkeit erklärt hat, ist Mahmoud heute ein glücklicher Mann. Endlich kann er sich um seine Felder und seine Familie kümmern. (Er konnte nicht vorhersehen, dass nur ein Jahr später die Kampfhandlungen wieder aufflammen würden.)

Like all Eritreans, Mahmoud was a happy man in late 1997, when his homeland attained victory and independence after 30 years of civil war. Finally he could return to his fields and family. (He could not foresee that fighting would break out once more only one year later.)

Comme tout Erythréen, Mahmood est un homme heureux, après trente ans de guerre, son pays accède enfin à la victoire et à l'indépendance ; il peut s'occuper en poix de ses champs et de sa famille. (Il ne ve doutait pas qu' à peine un an plus tard, les combats avec l'Ethiopie allaient reprendie.)

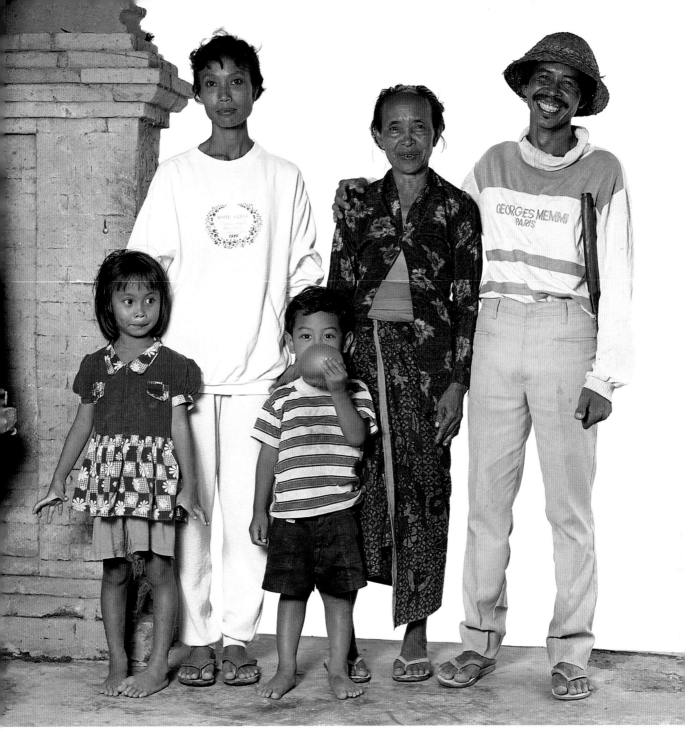

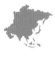

Gianyar,
Bali, Indonesia,
11 December 1999

Nyoman ist Landwirt und arbeitet in seinen Reispflanzungen. Sein Zweitberuf als Holzbildhauer verschafft ihm einen kleinen Nebenverdienst. Seine Frau und seine Mutter versorgen das Haus und die Kinder und packen bei der Reisernte kräftig mit an.

Nyoman is a farmer and works in his rice plantations, but he is also a wood carver, which helps him to make ends meet. His wife and his mother look after the children and the home, and help a lot with the rice harvest.

Nyoman est agriculteur et travaille dans ses plantations de riz. Il est aussi sculpteur sur bois, ce qui lui permet d'arrondir ses fins de mois. Sa femme et sa mère s'occupent des enfants, de la maison et donnent un bon coup de main à la récolte de riz.

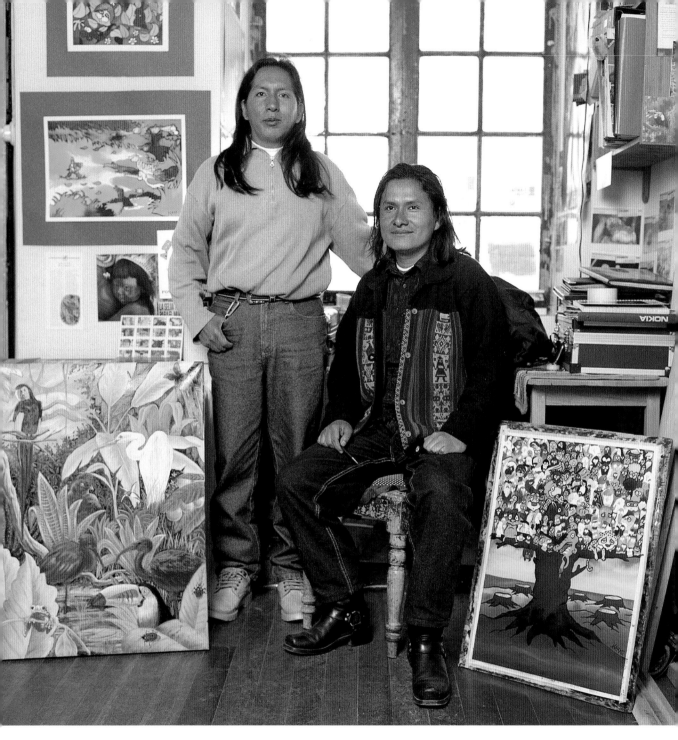

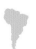
Cuzco,
Peru,
3 February 1999

Marko und Martín, zwei Künstler, schöpfen ihre Inspiration aus der Natur. Sie verbringen regelmäßig mehrere Wochen im größten Nationalpark von Peru. Ihr Verein „Lebendiges Amazonien" bietet Kurse für Kinder an, bei denen sie malend und zeichnend etwas über ihre Umwelt lernen. „Die Kunst ist geeign Kindern pädagogisch etwas zu vermitteln, das ist sehr wichtig", sagen sie.

Marko and Martín are painters who get their inspiration from nature. They often spend long weeks in the largest wildlife and nature reserve in Peru. In the Living Amazonia association they've set up workshops where they teach children about their environment through painting and drawing. "Art helps to get all sorts of educational messages across, which is vital," they say.

Marko et Martin, artistes peintres, puisent leur inspiration dans la nature. Ils passent régulièrement de longues semaines dans la plus grande réserve de faune et de flore du Pérou. Dans leur association « Amazonie vivante », ils ont créé des ateliers où ils sensibilisent les enfants à leur environnement par la peinture et le dessin. « L'art permet de transmettre de nombreux messages éducatifs, c'est capital », constatent-ils.

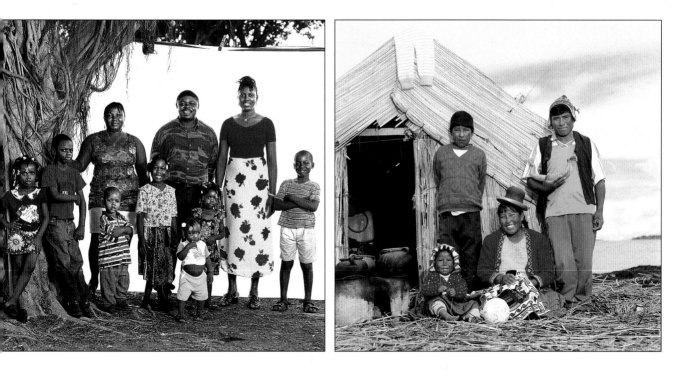

Miami,
Florida, USA,
11 April 1999

Gérard ist Pfarrer und hat nur einen Traum: nach Haiti zurückzukehren und die Schule zu Ende zu bauen, für die er vor zwei Jahren den Grundstein gelegt hat ... Wie jeden Sonntag kommt er nach der Messe mit seiner Schwester, seiner Frau und seinen Kindern zum Picknick hierher. Einstimmig sagen sie: „Das neue Jahrtausend? Da erwarten wir die Rückkehr Gottes."

Gérard is a religious minister and has just one dream – to go back to Haiti and finish building the school he started two years ago. As every Sunday, he's come to have a picnic here with his sister, his wife and his children, now that Mass is over. They both declare: "In the new millennium? We're expecting God to come back."

Gérard est pasteur et ne rêve que d'une seule chose: retourner à Haïti finir la construction d'une école débutée il y a deux ans. Comme tous les dimanches, il est venu pique-niquer avec sa sœur, sa femme et ses enfants après la messe. A l'unisson, ils déclarent: « En l'an 2000? Nous attendons le retour de Dieu. »

Lake Titicaca,
Peru,
29 January 1999

Paulo ist Fischer und fertigt außerdem die typischen Boote des Sees als Miniaturen an, die er in der Stadt verkauft. „Es heißt, im Jahr 2000 wird die Welt untergehen. Wir sind katholisch und wissen nicht, was geschehen wird." Paulo und seiner Familie ist ihre Beunruhigung anzusehen.

Fisherman Paulo also makes miniature boats typical of the lake and sells them in town. "They say 2000 will be the end of the world. We're Catholic, and we don't know what'll happen." Paulo and his family are clearly worried.

Pêcheur, Paulo fabrique aussi en miniature des bateaux typiques du lac pour les vendre en ville. « Ils disent que l'an 2000 sera la fin du monde! Nous sommes catholiques et nous ne savons pas ce qui va se passer. » L'inquiétude se profile pour Paulo et sa famille.

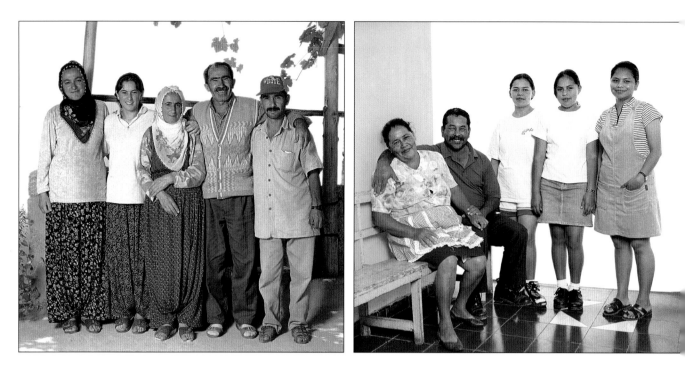

Ürgüp,
Turkey,
3 August 1999

Mehmet ist bester Dinge, als er auf seinem Traktor 15 Säcke frisch gemahlenes Mehl nach Hause bringt, genug, um die ganze Familie ein Jahr lang satt zu kriegen. Mit der Ernte von 15 Hektar Weinbergen, den Feldern, dem Gemüsegarten, den Obstbäumen und der Milch, die seine Kuh gibt, ist für einen abwechslungsreichen Speiseplan gesorgt. Die 15-jährige Arzu hat für die Landwirtschaft wenig übrig, sie möchte später lieber Mathematiklehrerin werden. Mehmet hofft, dass sich im neuen Jahrtausend Christen und Moslems versöhnen. Wenn Allah will …

Mehmet is in a very good mood – he's on his way back from the mill with his tractor laden with 15 sacks of flour, which will feed his family for a whole year. He has 35 acres [15 ha] of vines and fields, a vegetable garden, fruit trees and a cow – all of which complement the flour nicely. Fifteen-year-old Arzu doesn't have much interest in farming. She dreams of being a maths teacher. Mehmet hopes that "the new millennium will bring Christians and Muslims closer together." If Allah wills it …

Mehmet est d'excellente humeur : il revient du moulin, son tracteur chargé de quinze sacs de farine, de quoi nourrir toute la famille pendant une année. Il possède quinze hectares de vignes, des champs, un potager, des arbres fruitiers et une vache ; de quoi compléter agréablement la farine. Arzu (quinze ans) s'intéresse peu à l'agriculture, elle rêve d'être professeur de mathématiques ! Mehmet espère que le « nouveau millénaire rapprochera chrétiens et musulmans ». Inch Allah …

Los Naranjos,
El Salvador,
13 December 1998

Jorge arbeitet auf einer Kaffeeplantage, seine Frau kümmert sich um die gemeinsamen Töchter, das Haus und den Garten. „Das Jahr 2000 ist ein besonderes Jahr, denn wir haben noch nie einen Jahrhundertwechsel erlebt. Vielleicht ist das der Moment, um Gott zu sehen?", fragt sich Ena beunruhigt.

Jorge works on a coffee plantation, while his wife takes care of their daughters, the house and the garden. "2000 is a special year with this change of centuries. We haven't experienced a change of century before – perhaps it'll be the moment to see God," Ena says, a bit worried.

Jorge travaille dans une plantation de café pendant que sa femme s'occupe de leurs filles, de la maison et du jardin. « L'an 2000 est une année spéciale avec ce changement de siècle. Nous n'en avons vécu aucun pour l'instant – ce sera peut-être le moment de voir Dieu ? », s'inquiète Ena.

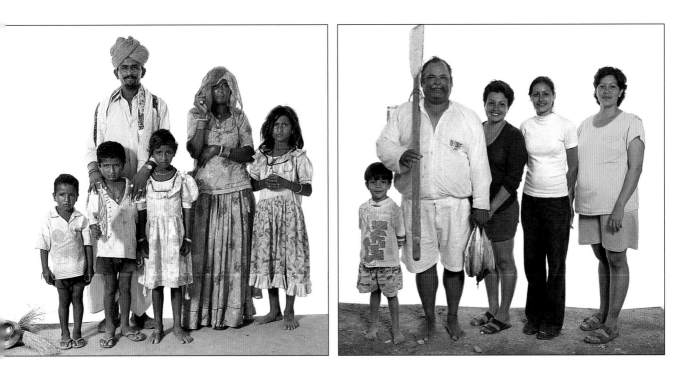

Roopsi,
India,
14 October 1999

Prema Ram unterrichtet so unterschiedliche Fächer wie Kunst, Englisch, Mathematik und Naturkunde und entscheidet sportliche Wettkämpfe unter den Lehrern immer noch für sich. Als Schüler sei er einmal 100 Meter in acht Sekunden (!) gelaufen, die beste Zeit von ganz Rajasthan, erzählt er stolz. „Von meinen vier Kindern gehen drei zur Schule, nur meine älteste Tochter will absolut nichts von der Schule wissen", bedauert er.

Prema Ram teaches drawing as well as subjects ranging from art, English and maths to science. He is also keen on sports, and still does well in competitions among teachers. He tells us that when he was a pupil he won a 100-metre race in eight seconds (!), the fastest time in all Rajasthan. "Three of my four children go to school, but we can't do anything with my eldest daughter – she doesn't like school at all," he says regretfully.

Instituteur de dessin, mais aussi de matières aussi variées que l'anglais, les mathématiques ou les sciences, Prema Ram est aussi un grand sportif, il se distingue encore dans les compétitions entre instituteurs. Il nous raconte que lorsqu'il était élève il a « gagné un 100 mètres en 8 secondes(sic!), le meilleur temps de tout le Rajasthan ! » « Trois de mes quatre enfants vont à l'école, ma grande fille il n'y a rien a faire, elle n'aime pas ça du tout », dit-il avec regret.

Mazatlán,
Mexico,
30 November 1998

Benito kam gerade vom Fischen zurück. Sein Tagesfang: fünf Fische, von denen ein Teil am Abend auf den Tisch kommt. Der Rest wird in dem kleinen Lebensmittelgeschäft, das seine Frau gleich nebenan betreibt, verkauft. Genau wie ihr Vater liebt auch die 16-jährige Belinda das Meer und möchte nach dem Abitur Meeresbiologie studieren.

Benito was returning from fishing with the day's catch: five fish, some of which will feed the family this evening. The rest will be sold in the little grocery his wife runs beside their home. Like her father, 16-year-old Belinda loves the sea and wants to study marine biology after high school.

Benito rentrait de la pêche avec le butin de la journée : cinq poissons, dont une partie nourrira la famille ce soir ; le reste sera vendu dans la petite épicerie que tient sa femme à côté de leur domicile. Comme son père, Belinda (seize ans) adore la mer et veut étudier la biologie marine après le lycée.

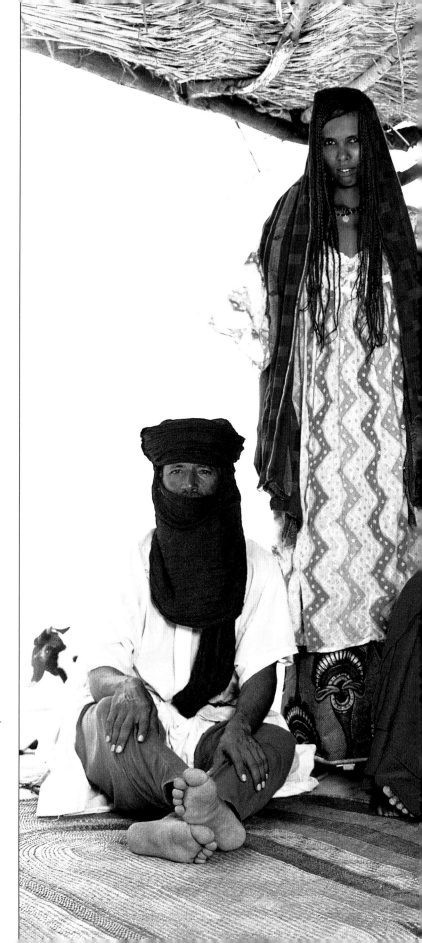

Sidi hat sein Zelt, das aus Matten gefertigt ist, dicht an der Straße aufgeschlagen und ist hier sesshaft geworden. Das Nomadenleben musste er mangels Vieh aufgeben. Er besitzt weder Kamele noch Kühe, sondern lediglich eine Hand voll Ziegen, deren Milch er gegen Hirse und Tee eintauscht, Hauptnahrungsmittel seiner Familie.

Sidi has pitched his tent of mats near the road, where he lives a quasi-settled existence. His nomadic life came to a halt for lack of livestock. With neither camels nor cows, all that's left to him now is a few of goats, whose milk he exchanges for millet and tea, his family's main sustenance.

Sidi a installé sa tente faite à l'aide de nattes près de la route et y vit d'une façon sédentaire. Il a arrêté la vie nomade faute de bétail : n'ayant ni chameaux, ni vaches, il ne possède qu'une poignée de chèvres dont il échange le lait contre du mil et du thé qui servent de nourriture principale à sa famille.

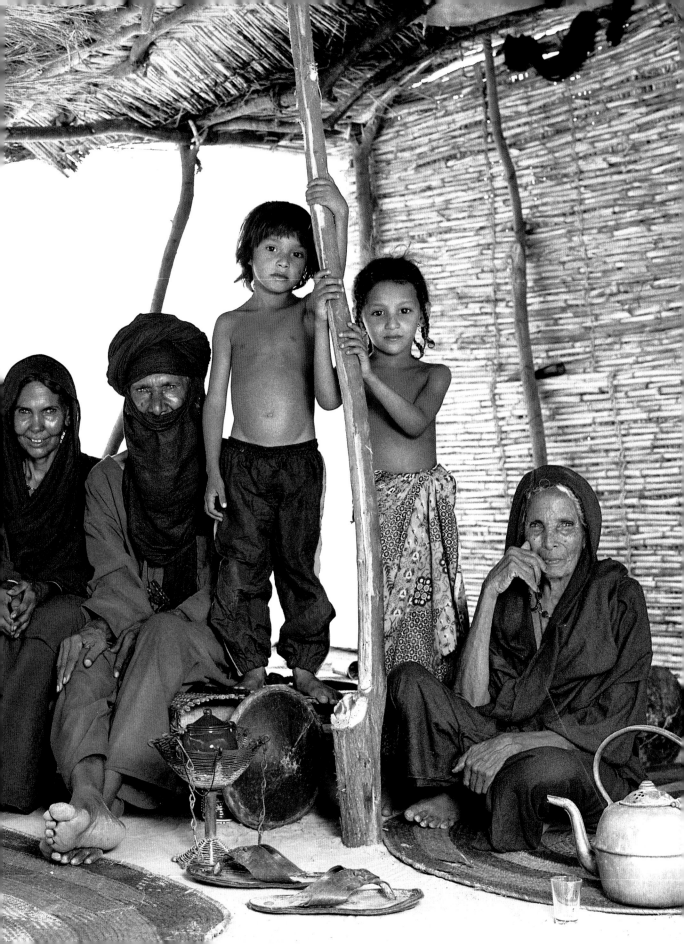

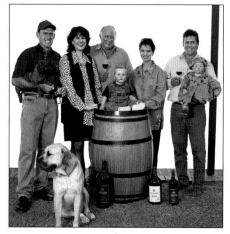
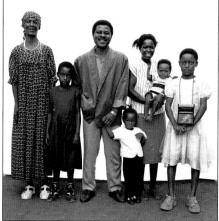
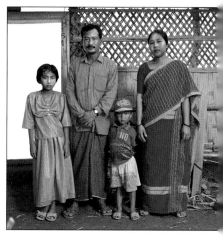
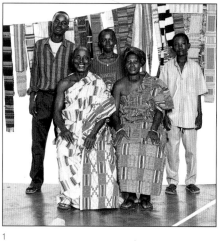
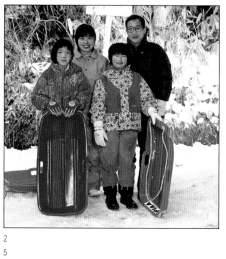
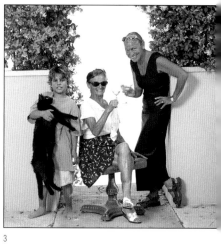

1

2

3

4

5

6

1
Stellenbosch,
South Africa,
1 October 1997

2
Ebebiyín,
Equatorial Guinea,
15 August 1997

3
Bandarban,
Bangladesh,
26 November 1999

4
Grand-Bassam,
Ivory Coast,
7 March 1997

5
Kyoto,
Japan,
26 February 2000

6
Miami,
Florida, USA,
11 April 1999

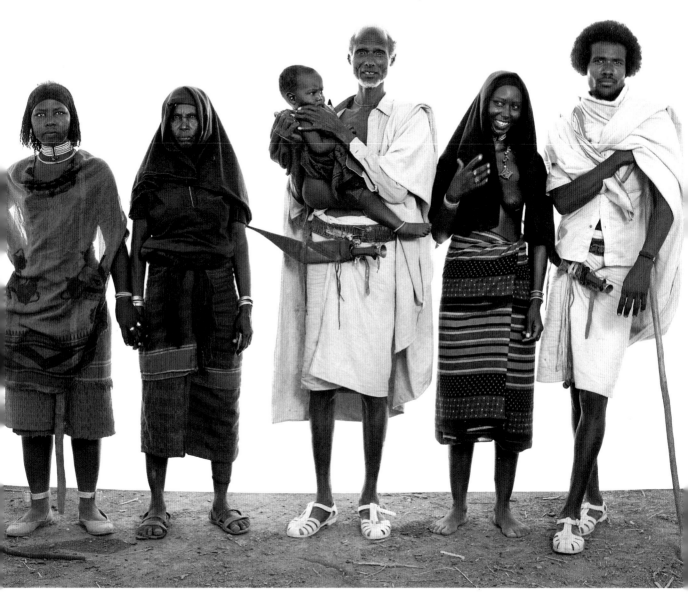

Awash,
Ethiopia,
4 December 1997

Obwohl Gababou Rinder züchtet, leben er, seine beiden Frauen und die drei Kinder hauptsächlich von Sauermilch. Fleisch ist kostbar und geschlachtet wird nur zu besonderen Anlässen wie beispielsweise dem Beschneidungsfest.

Despite his status as a livestock breeder, Gababou, his two wives and three children live mainly on curdled milk. Meat is a rarity, and an animal is only slaughtered for special occasions, like the circumcision ceremony, for example.

Malgré son statut d'éleveur, Gababou, ses deux femmes et trois enfants vivent surtout du lait caillé. La viande est rare et on ne tue une bête que pour les grandes occasions, comme la fête de la circoncision par exemple.

Godofuma,
Ivory Coast,
4 April 1997

Mit einem einzigen Blick kann Yakie die Zukunft voraussagen. Wie zahlreiche Generationen vor ihm ist er Fetischpriester und Heilkundiger und auch sein ältester Sohn wird nach zwölfjähriger Lehrzeit die Tradition fortsetzen. Er sagt, er verfüge über die Kraft, in der Trockenzeit Regen fallen zu lassen, und gibt uns eine wenig überzeugende Kostprobe seiner Kunst, indem er einen Wasserstrahl aus seinem Hemd zaubert … Sein Wunsch: „Vielleicht könnte ich eines Tages auf nationaler und internationaler Ebene beraten." Er hat uns eine wunderbare Reise vorausgesagt … und er hat Recht gehabt!

With a mere glance, Yakie can predict the future. His eldest son, an animist priest and healer like his father, will carry on the tradition after a twelve-year apprenticeship. Yakie claims to have the supreme power of getting rain to fall if there's a drought and gives us a not very convincing demonstration, involving a jet of water coming from his shirt … His wish: "That perhaps one day I'll be able to see patients on a national and worldwide scale." He predicted a wonderful journey for us – and he was right!

D'un simple regard, Yakie a la faculté de prédire l'avenir. Féticheur et guérisseur de père en fils, son fils aîné perpétuera la tradition, après un apprentissage de douze années. Son don exceptionnel est reconnu par les autres féticheurs qui n'hésitent pas à lui demander conseil. Il dit avoir le pouvoir suprême de faire tomber la pluie en cas de sécheresse, il nous fait une démonstration, peu convaincante, d'un jet d'eau qui sort de sa chemise… Son souhait : « Peut-être qu'un jour je pourrai consulter sur un plan national et international ? » Il nous a prédit un merveilleux voyage ! Et il avait raison !

Page 276

Ram Chandra und Santi haben nach 13 Ehejahren und fünf Töchtern die Hoffnung auf einen Sohn endgültig aufgegeben. Er ist Bauarbeiter und sie versorgt das Haus und die Mädchen.

Ram Chandra and Santi have been married for 13 years, have five daughters and have finally given up any hope of having a boy. He is a construction worker, while she looks after the house and their girls.

Mariés depuis treize ans, Ram Chandra et Santi ont eu cinq filles et définitivement abandonné l'espoir d'avoir un garçon. Il est ouvrier dans le bâtiment et elle s'occupe de la maison et de ses filles.

Page 277

Kemi, die ältere Tochter, macht dieses Jahr ihr Abitur und fliegt dann nach Paris, um Literatur zu studieren: „Ich möchte Diplomatin werden und die ganze Welt bereisen; mit 40 kehre ich dann an die Elfenbeinküste zurück." Ihr Bruder Kan tritt in die Fußstapfen seines Vaters, er hat sich für ein Jurastudium entschieden. Die beiden sind der ganze Stolz ihrer Eltern Dominique und Maya Kanga. „Ich hoffe, dass beide ihren Weg gehen, und unterstütze sie dabei", erklärt Dominique, Rechtsanwalt, spezialisiert auf internationales Recht. Das neue Jahrtausend? „Ich würde mich nicht auf dieses Datum festlegen, aber ich denke, dass die Welt in kürzester Zeit größere technologische Fortschritte erzielen wird als in den vorangegangenen Jahrtausenden."

Kemi is the eldest daughter, taking her baccalaureate this year and then flying off to Paris to study literature at university: "I want to be a diplomat and travel all over the world, then when I'm 40 settle down in the Ivory Coast." Her brother Kan is following in his father's footsteps by choosing to go to law school. Their parents, Dominique and Maya Kanga, are very proud of them both. "I hope they'll both find their own niche, and that's what I'm trying to help them do," says Dominique, a lawyer specializing in international law. And the new millennium? "I haven't decided about that, but I reckon that in a very short space of time the world will make far greater technological progress than in all the previous millennia."

Kemi est l'aînée, elle passe son bac cette année et s'envolera pour Paris, suivre des études universitaires de lettres. Déterminée, elle a choisi son parcours : « Je souhaite devenir diplomate et voyager partout dans le monde, puis à quarante ans m'installer en Côte d'Ivoire. » Son frère Kan suit les traces de son père en optant pour des études de droit. Ils font la fierté de leurs parents, Dominique et Maya Kanga, « J'espère que chacun trouvera sa voie et je les aide dans ce sens », précise Dominique, avocat, spécialisé dans l'arbitrage international. L'an 2000 ? « Je ne me fixe pas sur cette date mais je constate qu'en très peu de temps le monde a fait des progrès technologiques supérieurs à ceux réalisés les millénaires précédents. »

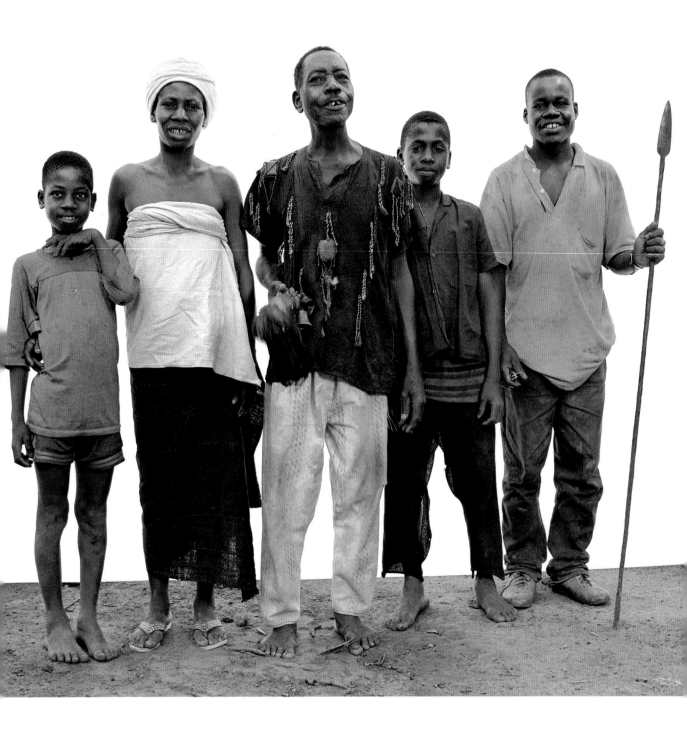

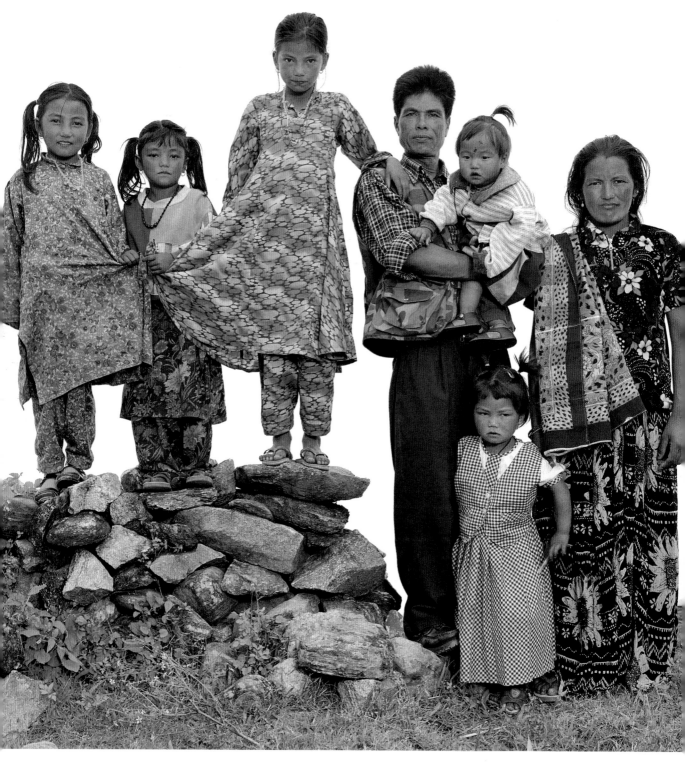

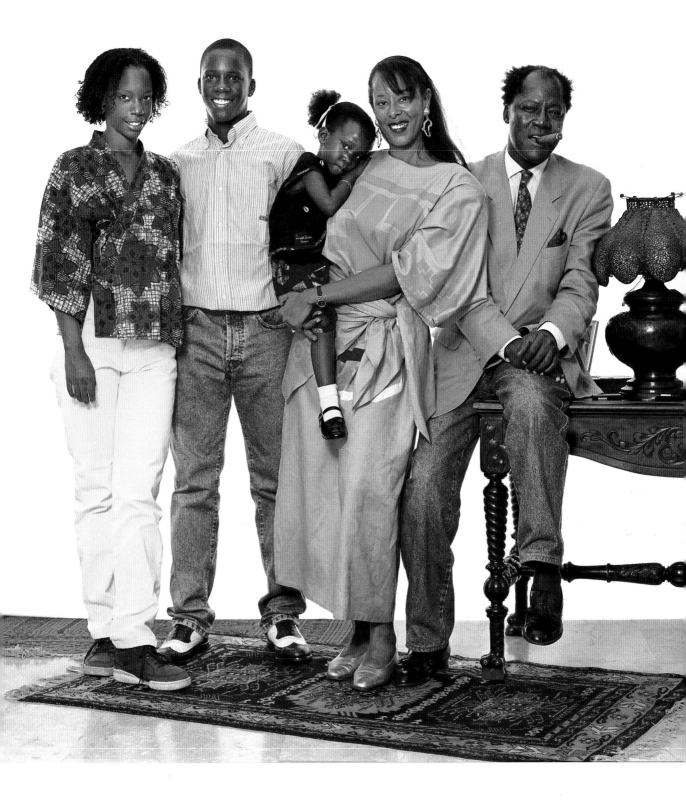
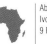

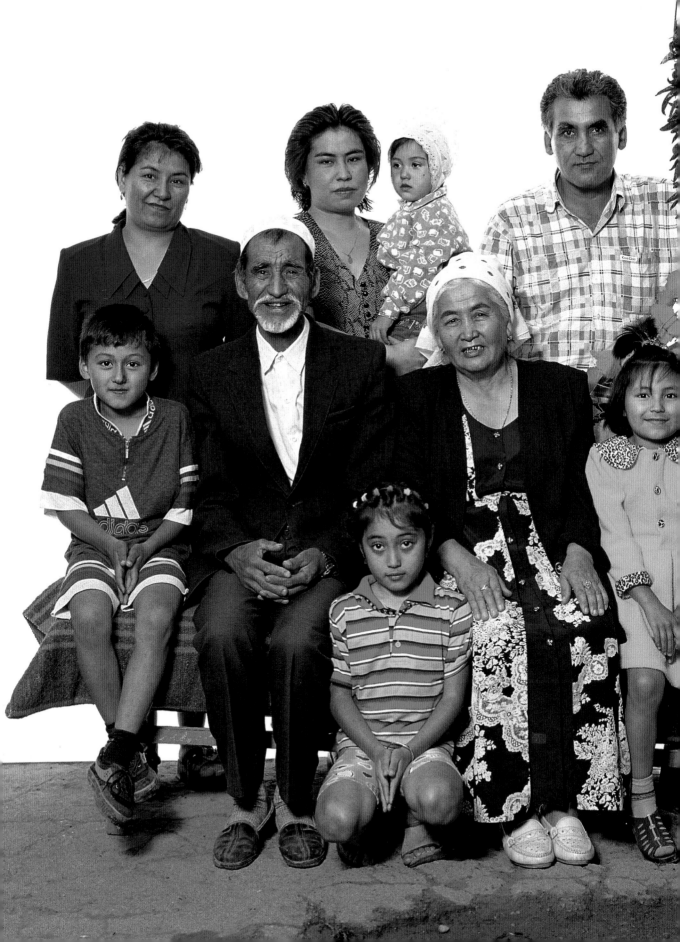

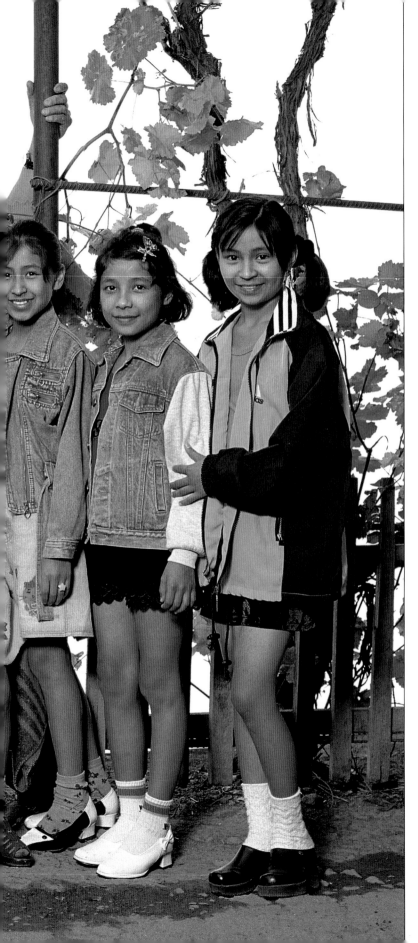

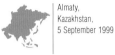
Djumachun und Nurbanum wurden 1958 unter dem kommunistischen Regime aus Xinjiang Uygur (China) nach Kasachstan deportiert, um dort als Eisenbahner bzw. Strickerin zu arbeiten. Im Alter bestreiten sie ihren Lebensunterhalt mit dem Verkauf von Gemüse. Ihr Sohn Adduschkur ist Fotograf und hat ein Studio mit vier Angestellten. Die Zeiten sind hart. „Vor der Perestrojka konnten wir uns vor Aufträgen kaum retten, im Gegensatz zu heute, wo jeder eine Einwegkamera besitzt", klagt er.

Jumakhun and Nurbanum were deported from Xinjiang Uygur (China) in 1958, and during the Communist era worked for the railways and as a knitter, respectively. Nowadays they earn a little money selling vegetables. Their son Addushkur is a studio photographer and runs a workshop with four employees. Times are hard: "Before perestroika there were plenty of customers to take portraits of, but these days everybody's got a disposable camera," he laments.

Djumakhun et Nurbanum, déportés d'Ouïgour (Chine) en 1958, ont travaillé comme cheminot et tricoteuse à l'époque du régime communiste. Aujourd'hui, ils gagnent un peu d'argent en vendant des légumes. Addushkur, leur fils, est photographe de studio et dirige un atelier de quatre personnes. Les temps sont durs : « Avant la Perestroïka les clients étaient nombreux pour se faire tirer le portrait, aujourd'hui tout le monde a son jetable », se plaint-il.

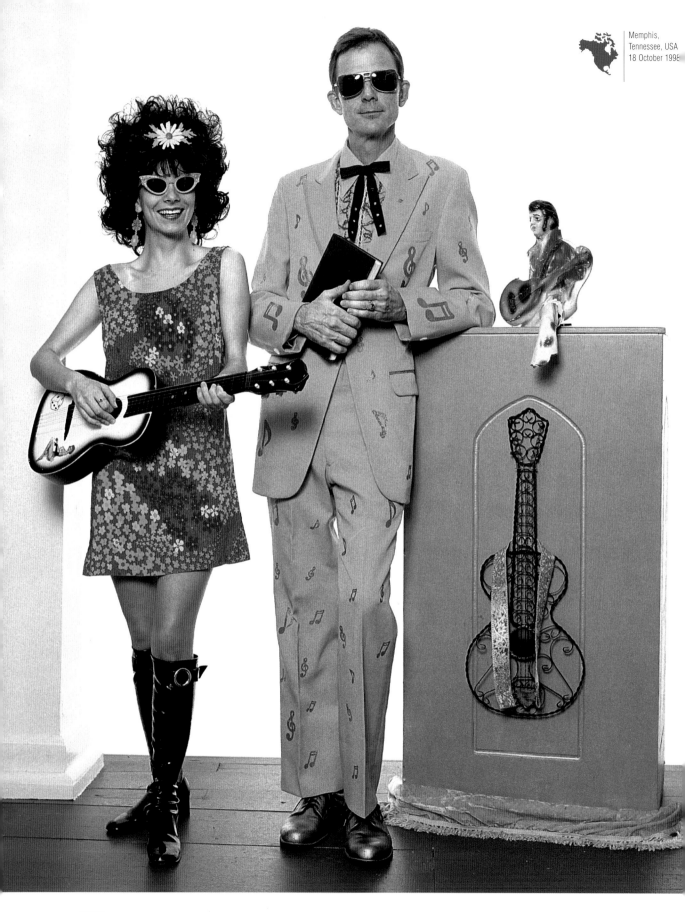

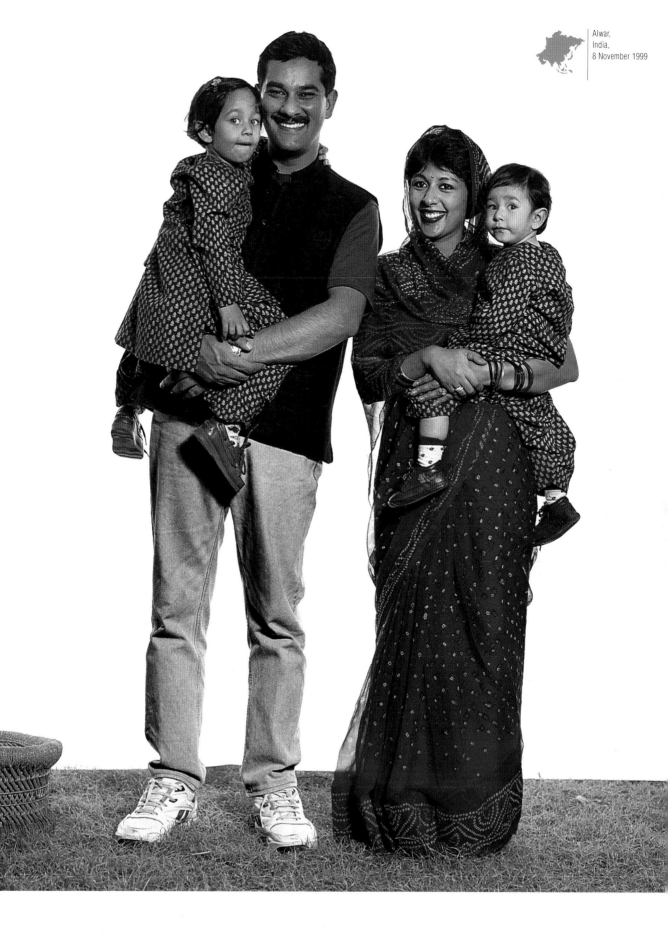

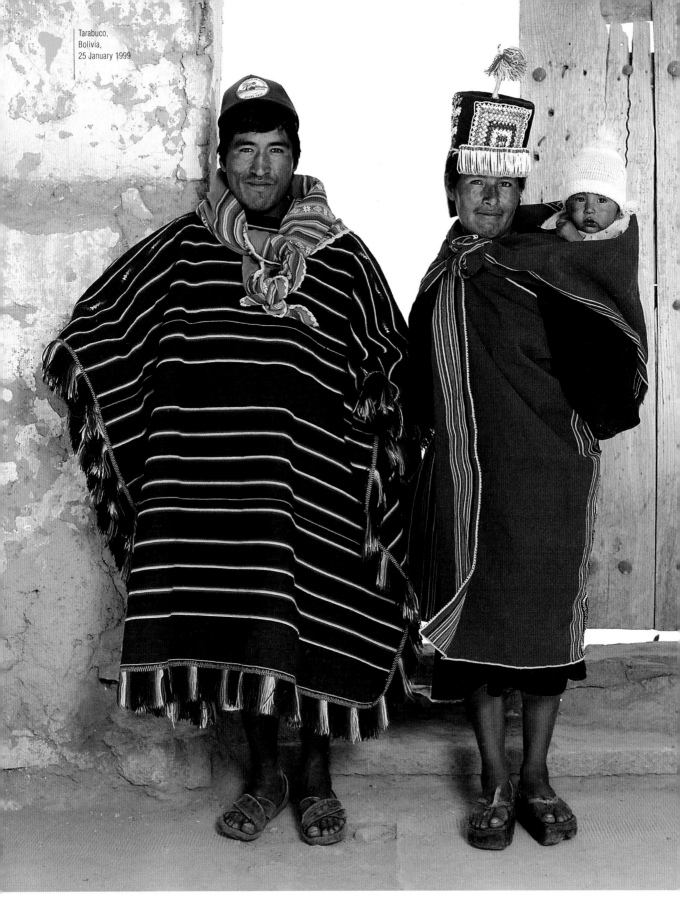

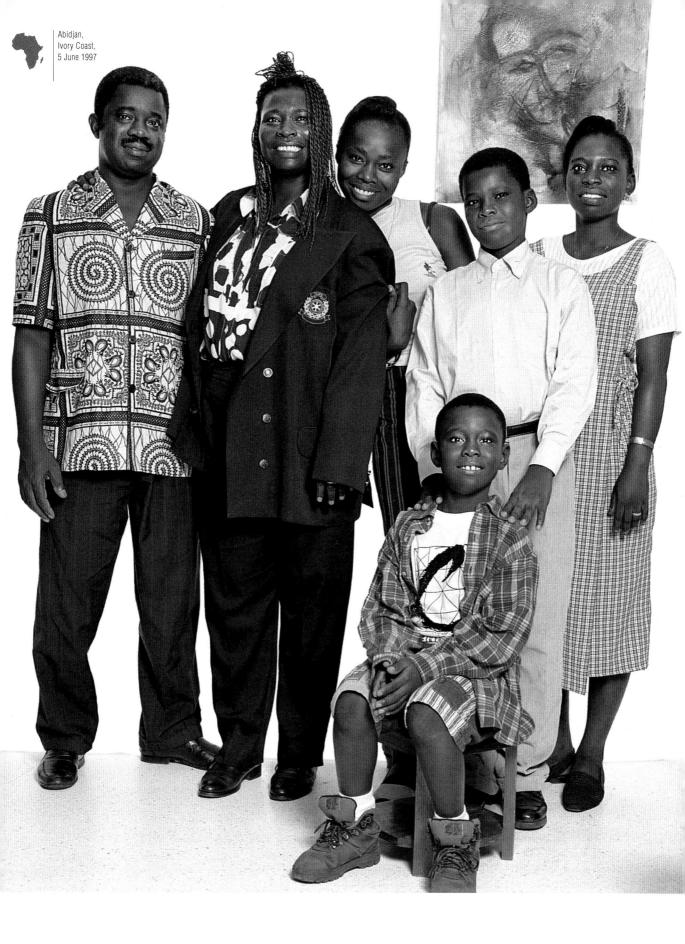

Page 280

Tommy bezeichnet sich selbst als „Artist-Minister". Den Titel „Reverend" hat er für 35 Dollar bei einem Versandhaus erstanden! Mit Hilfe seiner Frau Kat führt er eine Elvis-Nummer bei Schnelltrauungen auf. Im wirklichen Leben ist Tommy Kunststudent und Kat Geschichtsdozentin an der Universität von Memphis. Für das Jahr 2000 träumen sie davon, die rund 300 Paare, die sie getraut haben, zu einer gigantischen Treueschwur-Erneuerungszeremonie in ihrer Viva Memphis Wedding Chapel zu versammeln.

'Artist minister' is how Tommy describes himself. He bought his title of 'Reverend' by mail for $35. With the help of his wife Kat, he performs an Elvis number for soon-to-be-wed couples at their marriage ceremony. In ordinary life, Tommy is an art student and Kat teaches history at Memphis State University. Their idea for 2000 would be to get together the 300-odd couples they've joined in matrimony for a gigantic vow-renewal ceremony in their Viva Memphis Wedding Chapel.

« Artiste pasteur », comme il se définit lui-même, Tommy a acheté son titre de révérend par correspondance pour trente-cinq dollars ! Avec l'assistance de Kat, sa femme, c'est un numéro à la Elvis qu'il propose aux futurs mariés pour leur cérémonie nuptiale. Dans la vie, Tommy est étudiant en art et Kat professeur d'histoire à l'université de Memphis. Ils rêvent pour l'an 2000 de réunir les quelque trois cents couples qu'ils ont mariés en une gigantesque cérémonie de renouvellement de serment dans leur « Viva Memphis Wedding Chapel ».

Page 281

„Mein Wunsch für das neue Jahr ist ein drittes Kind, egal, ob Junge oder Mädchen!", so Ambika, deren Hochzeit mit Jitendra 1994 in Delhi die „Starmagazine" glücklich machte. Jitendra, Parlamentsabgeordneter in Rajasthan, hat viele Eisen im Feuer. Er liebt die Fotografie, die Fliegerei, Motorräder und technische Spielereien (er hat eine eigene Werkstatt), die Natur und natürlich die zahllosen Autos, die er von seinem Großvater, dem Maharadscha von Alwar, geerbt hat.

"My ambition is to have a third child next year – it doesn't matter whether it's a boy or a girl," says Ambika, whose wedding to Jitendra in 1994 in Delhi gained wide coverage in the celebrity magazines. Jitendra is an MP in the Rajasthan parliament, and has many strings to his bow. He likes photography and flying, motorbikes and tinkering with machines (he has his own workshop), nature and of course all the cars inherited from his grandfather, the Maharaja of Alwar himself.

« Pour fêter le réveillon 2000, nous allons camper dans la jungle en famille. Mon vœu pour cette nouvelle année est d'avoir un troisième enfant. Garçon ou fille aucune importance ! », ainsi parle Ambika dont le mariage avec Jitendra en 1994 à Delhi a fait le bonheur des « magazines de stars ». Jitendra, membre du parlement du Rajasthan, a beaucoup de cordes à son arc. Il aime la photo, l'aviation ; les motos, la mécanique (il a son propre atelier), la nature et bien sûr les nombreuses voitures héritées de son grand-père, dont deux Hispanosuza et une Lancaster 1922 équipée d'un volant en ivoire, « longue comme un autobus », fabriquée en un seul exemplaire selon les plans du grand-père, le maharadja d'Alwar en personne !

Page 282

Für Daniel und Ceberina ist der Sonntagsmarkt von Tarabuco ein fester Termin, selbst wenn der Weg von ihrem Bergdorf vier Stunden zu Fuß und per Bus dauert. Auf dem Markt erledigen sie ihre Einkäufe für die Woche, vor allem aber tauschen sie Nachrichten mit den Bewohnern der benachbarten Dörfer aus, bevor sie wieder zu ihren Feldern, Ziegen und Lamas zurückkehren. Das Jahr 2000 ist ihre geringste Sorge.

For Daniel and Ceberina, the Sunday market at Tarabuco is a fixture, even though it's a four-hour trip on foot and by bus from their mountain town. At market they buy and barter for the week's food, but mainly swap news with villagers from the whole region before getting back to their fields, goats and llamas. The new millennium is the least of their worries.

Pour Daniel et Ceberina, le marché dominical de Tarabuco est incontournable, même s'il se trouve à quatre heures de marche et d'autobus de leur bourgade dans les montagnes. Ils y achètent et y troquent les vivres pour la semaine, mais échangent surtout les nouvelles avec les villageois de toute la région, avant de retourner à leurs champs, chèvres et lamas. L'an 2000 est bien loin de leurs préoccupations.

Page 283

„Ich wünsche mir, dass Mama so berühmt wird wie Van Gogh", sagt der elfjährige Rolland, einer der Söhne von Mathilde Moreau. Die Malerin stellte 1985 zum ersten Mal in Abidjan aus und seitdem hat sie Ausstellungen in der ganzen Welt gehabt – Südafrika, Chile, Polen, Schweiz. Sie erinnert sich noch an die schwierige Anfangsphase, als ihre Familie ihrem Berufswunsch sehr ablehnend gegenüberstand. „Die Leute verstehen die Kunst nicht. Es gibt nicht genügend Frauen in der Kunst. Wir afrikanischen Frauen müssen uns durch die Kunst entfalten."

"I'd like Mummy to be famous like Van Gogh," says eleven-year-old Rolland, one of Mathilde Moreau's sons. She's an artist, and had her first exhibition in Abidjan in 1985. Since then she's been travelling the world with her work – South Africa, Chile, Poland, Switzerland. She remembers the difficult early days when her family was against the idea of her becoming a painter. "People don't understand art. There aren't enough women in the fine arts. We women of Africa must blossom and fulfil ourselves through art."

« J'aimerais que Maman soit célèbre comme Van Gogh », affirme Rolland, onze ans, l'un des fils de Mathilde Moreau. Artiste peintre, elle expose pour la première fois en 1985 à Abidjan, puis parcourt le monde pour son travail : Afrique du Sud, Chili, Pologne, Suisse… Elle se souvient de ses débuts difficiles, sa famille était hostile à son désir de devenir peintre, seul son père l'a toujours soutenue. « Les gens ne comprennent pas l'art. Il n'y a pas assez de femmes au Beaux-Arts. Nous, les femmes africaines, nous devons nous épanouir à travers l'art. »

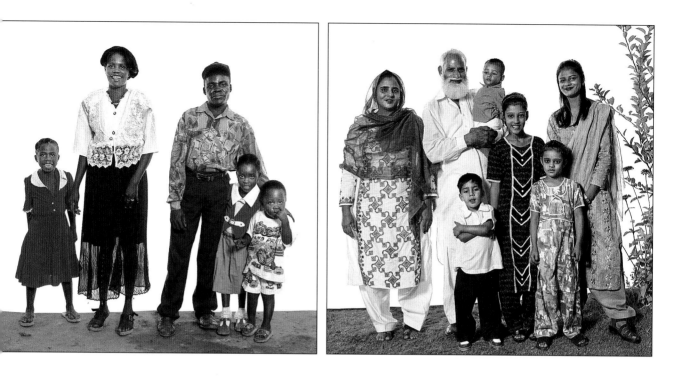

Luanda,
Angola,
3 September 1997

Francisco hat im Bürgerkrieg in den angolanischen Provinzen gekämpft und floh vor fünf Jahren nach Luanda. Obwohl er pessimistisch in die Zukunft blickt, schenkt er uns für das Foto ein kleines Lächeln.

Francisco fought in the civil war in the Angolan provinces and took refuge in Luanda five years ago. Despite his pessimism about the future, he managed a little smile for us, just for the photo.

Francisco a fait la guerre dans les provinces d'Angola et s'est réfugié à Luanda il y a cinq ans. Malgré son pessimisme pour l'avenir, il nous a offert un petit sourire le temps de la photo.

Gujranwala,
Pakistan,
4 October 1999

Auf die Frage nach der Zukunft antwortete Adjilem prompt: „Wir wünschen uns noch ein paar Kinder – wie viele, das liegt in den Händen Allahs!" Der Familienvater importiert Mode aus dem Ausland und verkauft sie in seiner Boutique – allem Anschein nach mit Erfolg. Übrigens: Adjilem ist seit 31 Jahren verheiratet und hat acht Sprösslinge.

Adjilem is quick with his answers: "What do I want? A few more children. My family is too small." And how many? "Allah will decide." He imports clothing from abroad and sells it in his shop. It looks like business is good. A minor detail: Adjilem has been married 31 years and has eight children.

Adjilem n'hésite pas dans ses réponses : « Ce que j'aimerais ? Encore quelques enfants ! Ma famille est trop petite ! » et combien, « ça c'est Dieu qui décide. » Il importe des vêtements de l'étranger qu'il vend dans sa boutique. Il faut croire que les affaires marchent. Petite précision : Adjilem est marié depuis trente et un ans et a huit enfants.

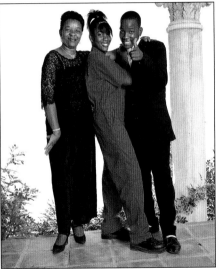
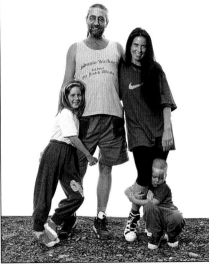
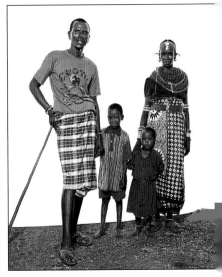

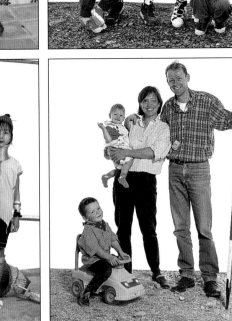
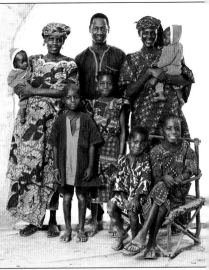

1
7

2
8

3
9

 1
Miami Beach,
Florida, USA,
12 April 1999

 2
Prague,
Czech Republic,
29 July 1998

 3
Marsabit,
Kenya,
24 November 1997

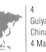 4
Guiyang,
China,
4 March 2000

 7
Muang,
Thailand,
17 January 2000

 8
Mekele,
Ethiopia,
8 December 1997

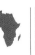 9
Nioro du Sahel,
Mali,
24 February 1997

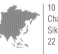 10
Chawang,
Sikkim, India,
22 November 1999

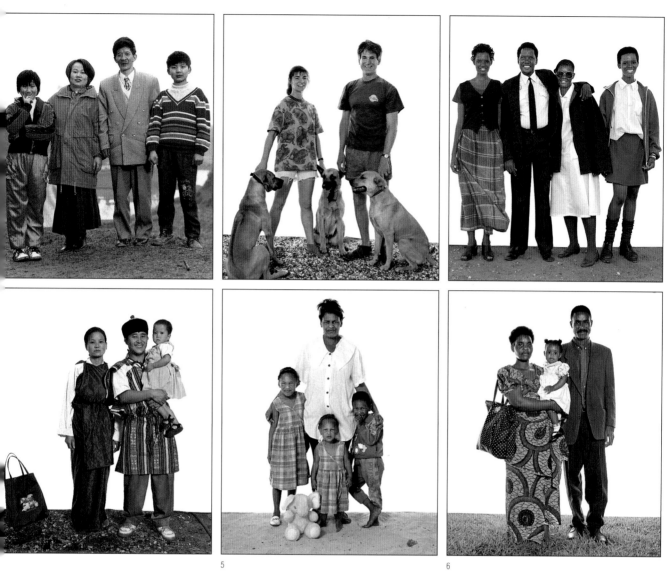

5
11

6
12

5
Windhoek,
Namibia,
16 September 1997

6
Ghanzi,
Botswana,
17 October 1997

11
Delf Suif,
South Africa,
23 September 1997

12
Lusaka,
Zambia,
24 October 1997

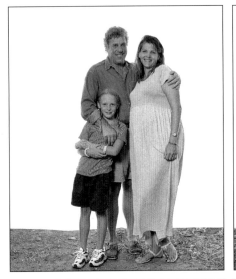

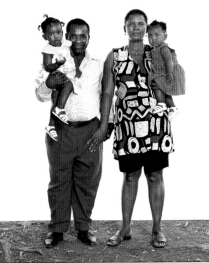

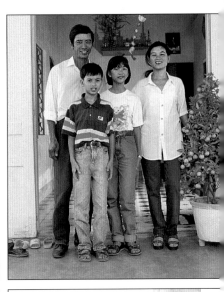

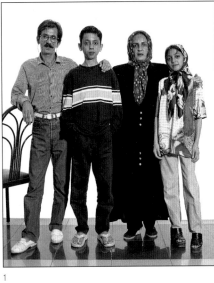

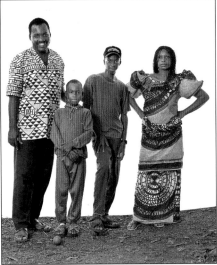

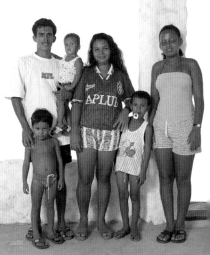

1

2

3

7

8

9

1
Brookhaven,
New York, USA,
6 September 1998

2
Miami,
Florida, USA,
11 April 1999

3
Hoi An,
Vietnam,
6 February 2000

4
Pointe-Noire,
Congo,
28 August 1997

7
Mashhad,
Iran,
18 September 1999

8
Biankouma,
Ivory Coast,
3 April 1997

9
Marechal Deodoro,
Brazil,
14 March 1999

10
St. Petersburg,
Russia,
10 July 1998

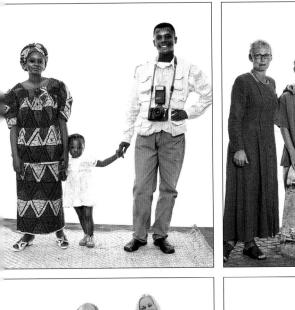

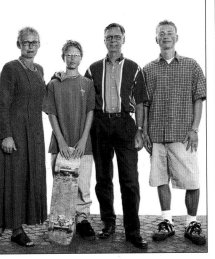

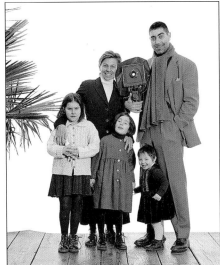

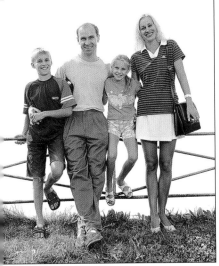

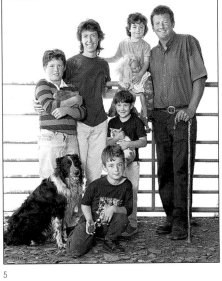

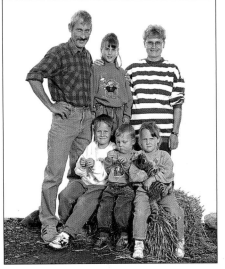

5

6

11

12

 5
Vejbystrand,
Sweden,
26 June 1998

 6
Stia,
Italy,
8 December 1996

11
Ciloerwynt,
Wales,
27 July 1996

 12
Feusisberg,
Switzerland,
3 October 1996

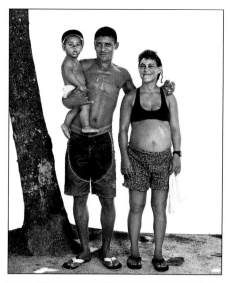
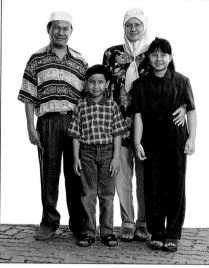
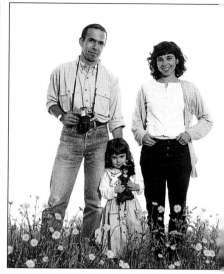

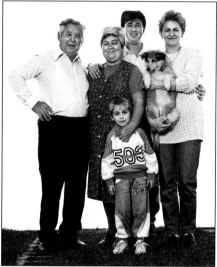
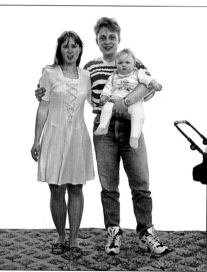
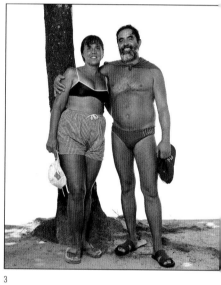

1
7

2
8

3
9

1
Rio de Janeiro,
Brazil,
21 March 1999

2
Bandar Seri Begawan,
Brunei,
25 December 1999

3
Braga,
Portugal,
14 May 1998

4
Katherine,
Australia,
20 December 1999

7
Sármellék,
Hungary,
12 October 1996

8
Hrubínova,
Czech Republic,
29 July 1998

9
Rio de Janeiro,
Brazil,
21 March 1999

10
Roland Park,
Kansas, USA,
13 October 1998

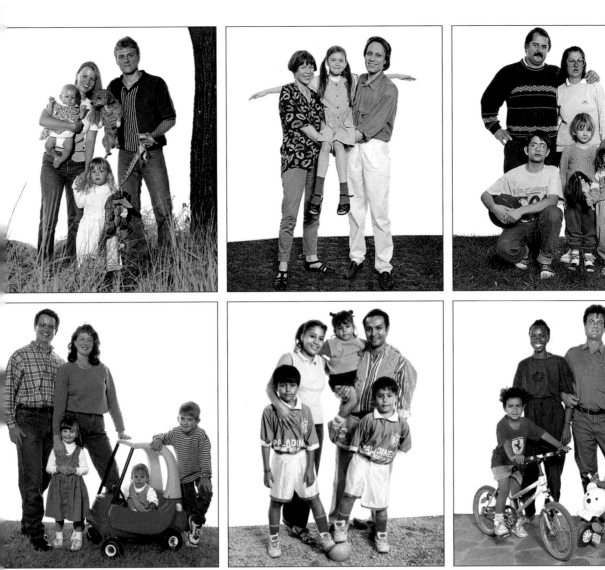

4
10

5
11

6
12

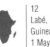

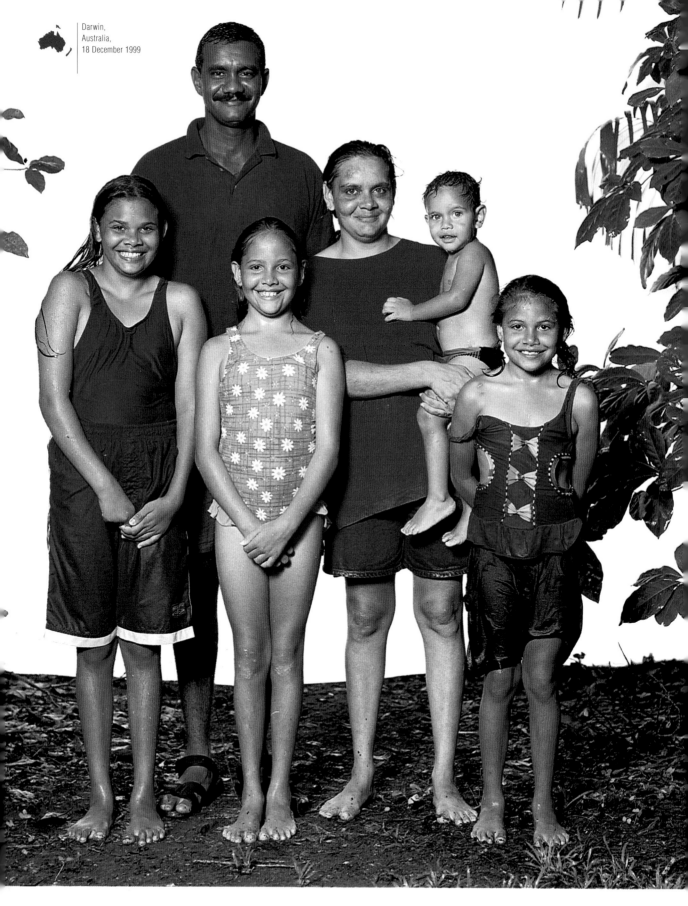

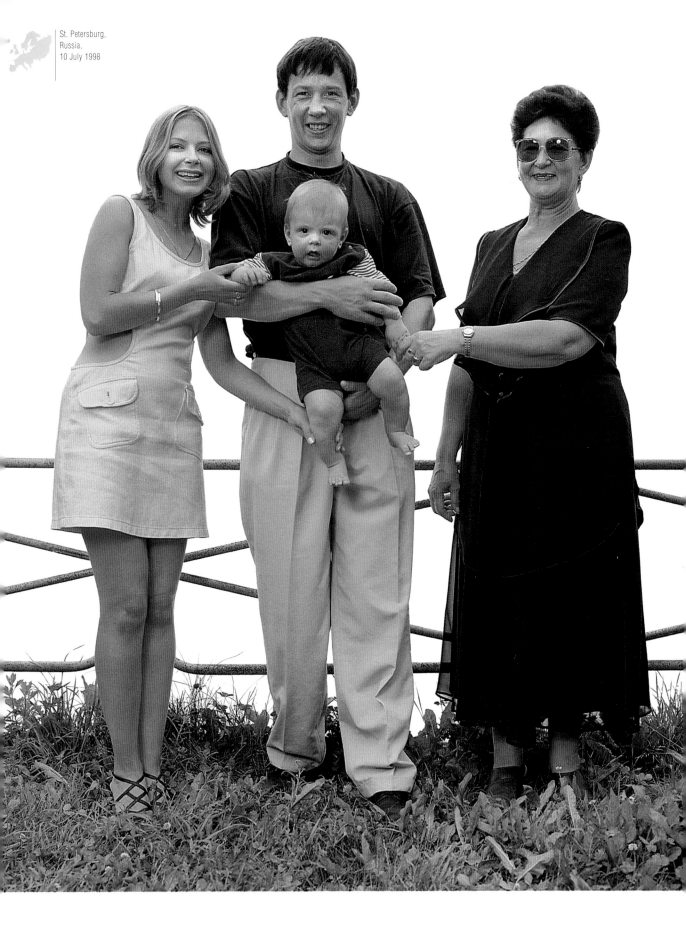

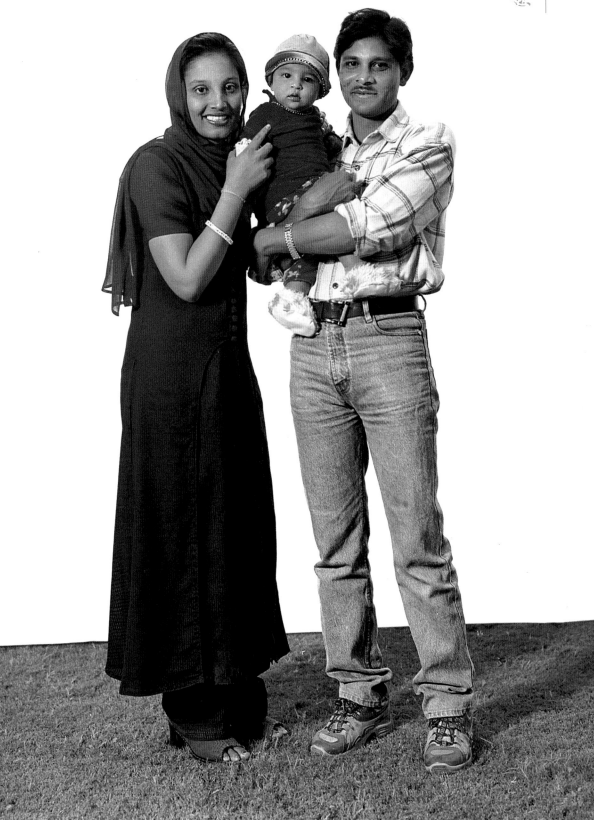

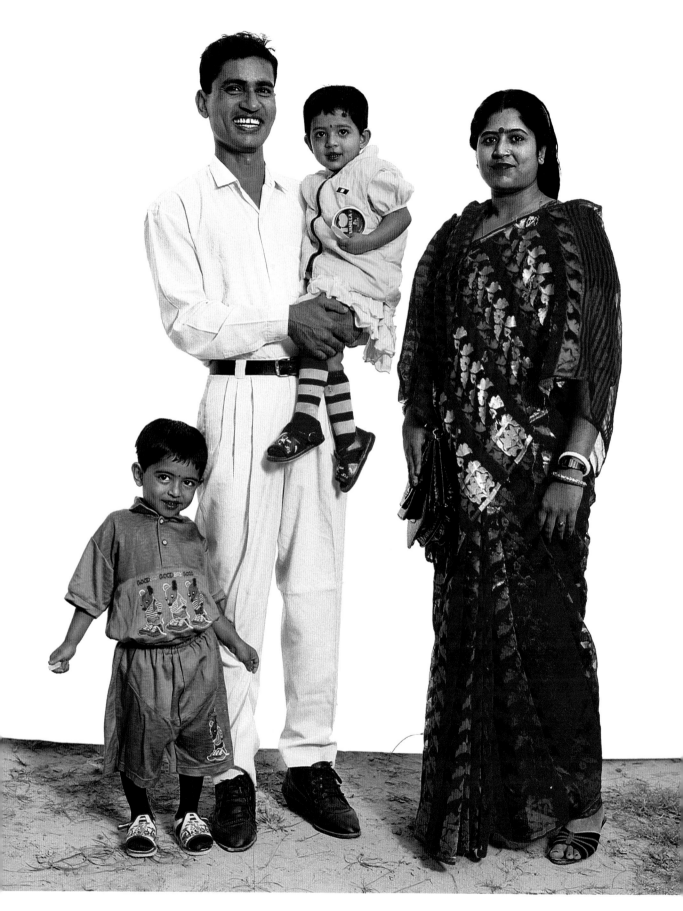

Page 292

„Ich werde Polizistin, dann kann ich meine Familie beschützen", sagt die elfjährige Alice. Papa Lionel ist in der Infanterie und liebt die Wochenenden mit der Familie, an denen die Uniform im Schrank bleibt: „Das Familienleben ist das beste Mittel gegen Stress."

"I'm going to be a policeman and protect my family," says eleven-year-old Alice. Her dad Lionel is in the infantry and loves being with his family at weekends, out of uniform. He tells us: "Family life is the best cure for stress."

« Moi, je serai policier et je protégerai ma famille », dit Alice, onze ans. Papa Lionel est dans l'infanterie et adore les week-ends en famille et sans uniforme. Il nous confie: « La vie de famille est le meilleur remède contre le stress. »

Page 293

Alexej und Larissa sind keine einfachen Interviewpartner. Bei der Frage nach ihrem Hochzeitsdatum antworten sie ausweichend: „Unsere Familie ist so alt wie unser Kind." Und Larissas Alter? „Eine Mutter bleibt immer jung." Gerne erzählen sie uns dagegen von ihrer kürzlichen Reise nach Finnland, „wo mehr Wodka getrunken wird als in Russland." Ihr Wunsch ist „so viel wie möglich zu reisen, um herauszufinden, wie Menschen in anderen Ländern leben."

Alexei and Larissa aren't easy to interview. When asked when they were married, they sidestep the question: "Our family's as old as our child." As for finding out how old Larissa is: "A mother's always young." But they readily tell us about their recent trip to Finland, where "people drink more vodka than in Russia." Their ambition is "to travel as much as possible and find out what people in other places are like."

Alexei et Larissa ne sont pas faciles à interviewer. Interrogés sur la date de mariage, ils esquivent la question: « L'âge de notre famille est celui de notre enfant! » Quant à savoir l'âge de Larissa …« Une mère est toujours jeune! » Mais ils racontent volontiers leur récent voyage en Finlande où « on boit plus de vodka qu'en Russie ». Leur souhait: « Voyager le plus possible, pour découvrir les gens d'ailleurs! »

Page 294

Jean-Jacques kehrte gerade von der Jagd zurück und wir kamen genau richtig, um seinen morgendlichen Fang unsterblich werden zu lassen …

Jean-Jacques was returning from the hunt, and our timing was particularly good to immortalize his morning's bag …

Jean-Jacques revenait de la chasse et nous sommes particulièrement bien tombés pour immortaliser sa prise du matin …

Page 295

„Mein Mann ist der indische James Bond! Er arbeitet beim Nachrichtendienst und manchmal habe ich große Angst um ihn." Yasmeen würde auch gern Geld verdienen, aber einer muss sich um die fünf Monate alte Mini kümmern. „Und dann hätten wir gerne noch ein Baby, so dass wir ein Kind für jeden von uns haben", erzählt uns Yasmeen mit einem breiten Lächeln.

"My husband is the James Bond of India! He works in the Federal Investigation Department, and sometimes I am very afraid for him. I would really like to work too, but I have to look after Mini, who's five months old. And then we'd like to have another baby – that way we'd each have our own," Yasmeen tells us with a broad smile.

« Mon mari est le James Bond indien, il travaille au service fédéral d'investigation et parfois j'ai très peur pour lui! Moi, j'aimerais bien travailler, mais il faut s'occuper de Mini, cinq mois, et puis on aimerait avoir un autre bébé, comme ça chacun aurait le sien », nous déclare Yasmeen dans un grand sourire.

Chittagong,
Bangladesh,
27 November 1999

Biswazit ist Polizist. Er hat mit 19 geheiratet und ist mit seinen beiden Kindern wunschlos glücklich. Der passionierte Sänger hat bereits eine Schallplatte aufgenommen und ist im Fernsehen aufgetreten. Verständlicherweise ist er der populärste Polizist in seinem Bezirk …

Police officer Biswazit has been married since he was 19, and is very happy with his two children. He loves singing and has already made a record and been on national TV. No wonder he is the most popular policeman in his district!

Biswazit, policier, marié depuis l'âge de dix-neuf ans, est comblé avec ses deux enfants. Il a une passion pour la chanson, a déjà enregistré un disque et est passé à la télévision nationale.

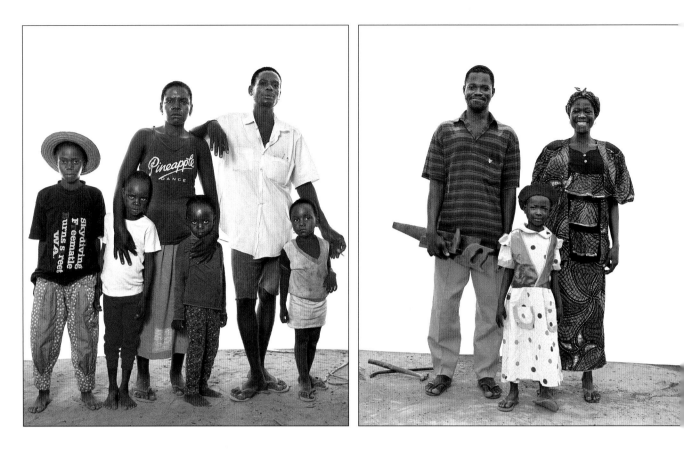

Tete,
Mozambique,
28 October 1997

Louis haben wir auf dem Markt kennen gelernt, wo er amerikanische Zigaretten einzeln verkauft. Ab und an wechselt sogar ein ganzes Päckchen den Besitzer! Er selbst raucht Filterzigaretten, weil das „nicht so gesundheitsschädlich ist".

We met Louis at the market where he sells American cigarettes, singly or sometimes even a whole pack. He himself only smokes filter cigarettes: "It's not as bad for your health."

Nous avons rencontré Louis au marché où il vend des cigarettes américaines à l'unité, parfois même par paquet entier! Lui ne fume que des filtres, « c'est moins mauvais pour la santé » …

Kaduna,
Nigeria,
17 July 1997

Samson hat sich auf den Bau von Hütten und Häusern spezialisiert. Er träumt von einem großen Haus ganz aus Holz für seine Familie …

Samson specializes in the construction of huts and houses. He dreams of a big wooden house for his family …

Samson est spécialisé dans la construction des cases et maisons. Il rêve d'une grande maison tout en bois pour sa famille…

Bocas del Toro,
Panama,
4 January 1999

„Wir sind hier auf der Insel geboren, wir kennen uns seit der Schule und sind seit sechs Jahren verheiratet." Adrian ist Lehrer und gleichzeitig der regionale Direktor für das Erziehungswesen: „Die Eltern sollten wissen, dass Kinder in Harmonie und Liebe aufwachsen müssen!"

"We were born here on Bocas Island. We've known each other since school, and we've been married for six years." Adrian is a teacher as well as regional educational director: "Parents should realize that their children have to grow up in harmony and love."

« Nous sommes nés ici dans l'île de Bocas, nous nous connaissons depuis l'école et nous sommes mariés depuis six ans. » Enseignant, Adrian est également directeur régional de l'éducation : « Il faut que les parents sachent que les enfants doivent grandir dans l'harmonie et la tendresse! »

Windhoek,
Namibia,
15 september 1997

Riaan ist staatlicher Landwirtschaftsausbilder. Der gebürtige Namibier hat vor vier Jahren die Südafrikanerin Marietjie geheiratet. „Mein Traum? Mit meiner ganzen Familie auf einer großen Ranch zu leben, auf der wir nicht nur Vieh halten könnten, sondern auch Wild für die Jagd mit Pfeil und Bogen, ein Sport der hier sehr beliebt ist."

Agricultural instructor in government service, Riaan is a native Namibian. Four years ago he married the South African-born Marietjie. "My dream? To move with my family to a huge ranch where we could raise cattle and also game for hunting with bow and arrows – a very popular sport around here."

Riaan est instructeur agricole au service du gouvernement. Namibien de naissance, il a épousé la Sud-Africaine Marietjie il y a quatre ans. « Mon rêve? Vivre avec toute ma famille dans un ranch où nous aurions non seulement du bétail, mais aussi du gibier pour la chasse avec arc et flèches – un sport très populaire par ici. »

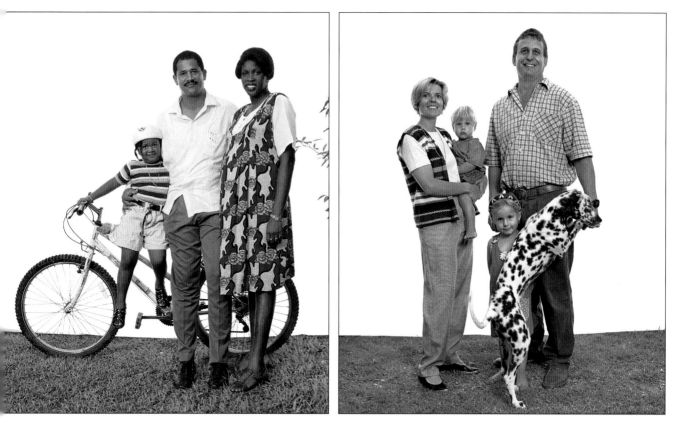

Page 300

Mario, hier mit seiner Mutter und seinen fünf Geschwistern, ist Traktorfahrer. Er hilft seiner Mutter, die Familie durchzubringen, in einer Region, die durch einen langen Krieg völlig verwüstet ist.

Mario, here with his mother and his five siblings, is a tractor driver. He helps his mother meet the family needs in a region ravaged by long years of war.

Mario, ici en compagnie de sa mère et de ses cinq sœurs, est conducteur de tracteur. Il aide sa mère à subvenir aux besoins de la famille, dans une région dévastée par une longue guerre.

Page 301

Calvin mit seiner Frau, seinen Kindern und seiner Mutter, die, wie alle Pygmäen, Pfeife raucht …

Calvin with his wife, his children and his mother, who – like all Pygmies – smokes a pipe …

Calvin avec femme, ses enfants et sa mère qui, comme toute Pygmée, fume la pipe …

Page 302

Palias hat in den südafrikanischen Minen geschuftet, bevor er vor zwei Jahren arbeitslos wurde. Heute lebt er von seinen Ersparnissen und vom Verkauf der Milch, die seine Kühe geben.

Palias worked in the South African mines, but has been jobless for two years. He lives off his meagre savings and the money earned from selling the milk from his cows.

Palias a travaillé dans les mines d'Afrique du Sud et se trouve sans emploi depuis deux ans, il vit de ses quelques économies et du gain retiré de la vente du lait de ses vaches.

Page 303

Von Haus aus Diplom-Landwirt, bekleidet Walerij einen Managerposten bei einer großen Bäckereikette. Polina, Mutter von drei Töchtern, versorgt den Haushalt. Die beiden haben allen Grund, auf ihren Nachwuchs stolz zu sein: Die 21-jährige Leila ist frisch gebackene Diplom-Psychologin und macht nebenbei Übersetzungen ins Russische und Türkische, Fatima (20), studiert Sprachen und will später einmal Dolmetscherin werden, während die 16-jährige Alina gerade einen Preis als beste Schülerin erhalten hat und eine Karriere als Ärztin anstrebt.

Valery is an agronomist, but has a job as manager of an industrial bakery. Polina, mother of three girls, looks after the house. They are rather proud of their children, and rightly so: Leila (21) is about to finish her psychology studies, and does translations into Russian and Turkish. Fatima, who is 20, is studying to become an interpreter, while 16-year-old Alina has just won the medal for best student and is going on to study medicine.

Valerii est agronome, mais occupe un poste de manager dans une boulangerie industrielle. Polina, maman de trois filles, s'occupe de la maison et aide son mari à l'entretien de leur bétail: vaches, moutons, poules …. Ils sont plutôt fiers de leurs enfants et il y a de quoi: Leila, vingt et un ans, termine ses études de psychologie et fait des traductions en russe et en turc. Fatima, vingt ans, étudie pour devenir interprète, Alina, seize ans, vient d'obtenir la médaille de la meilleure élève et va étudier la médecine.

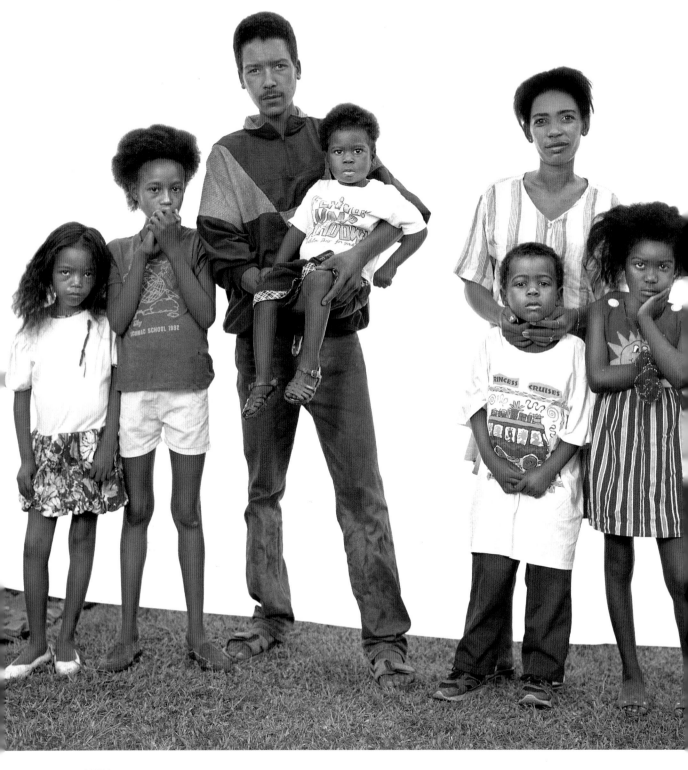

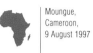

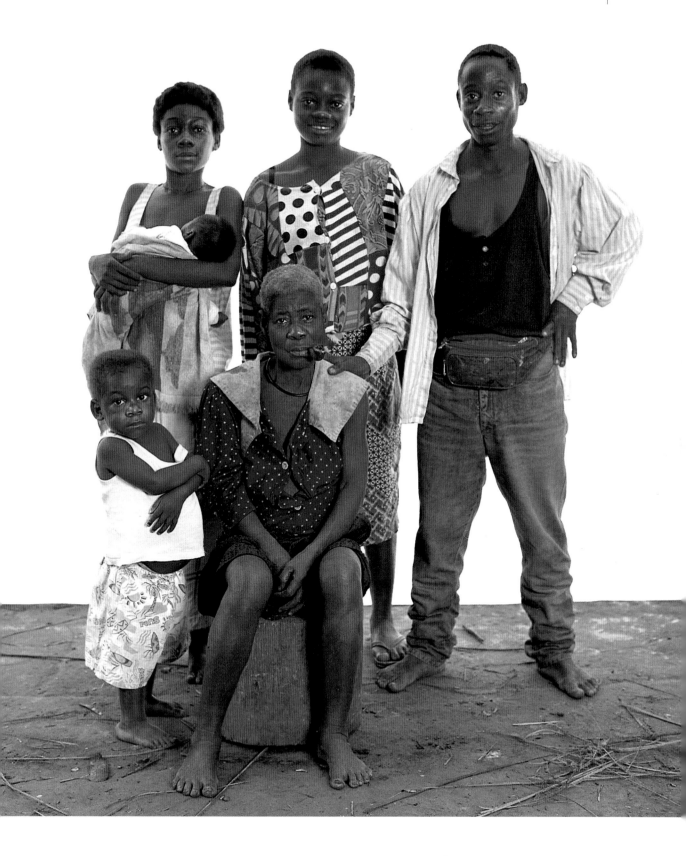

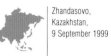

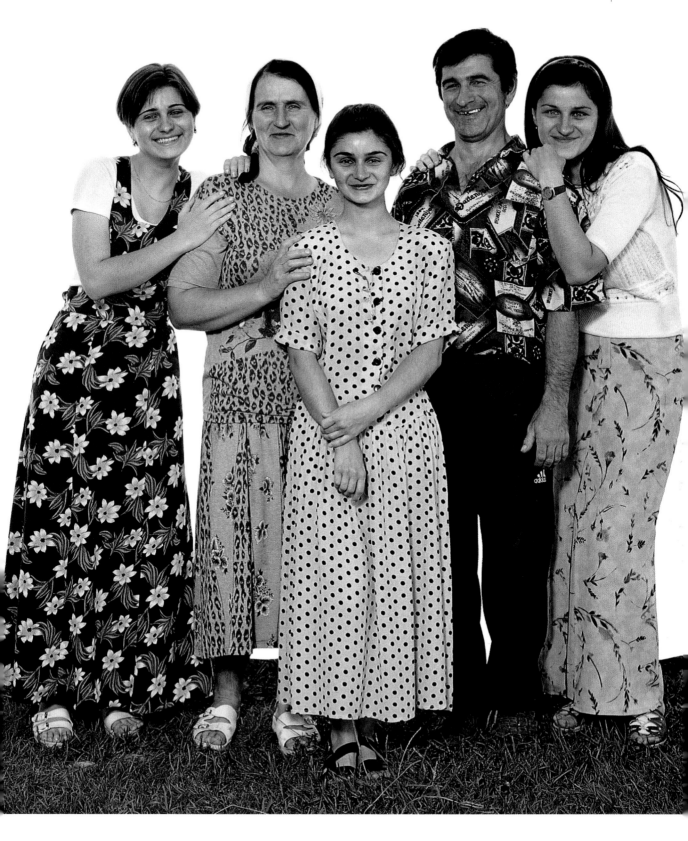

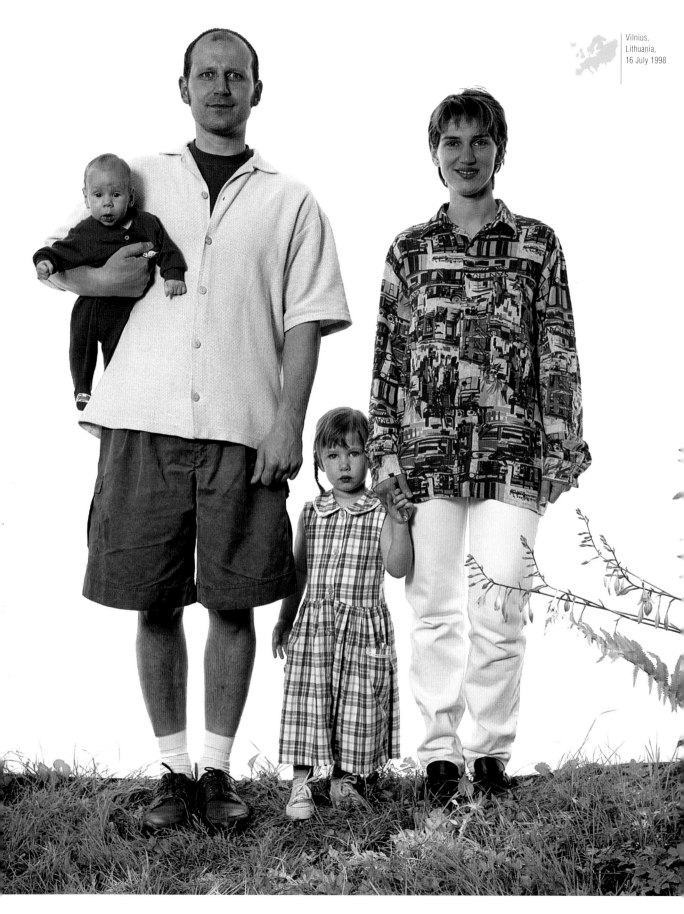

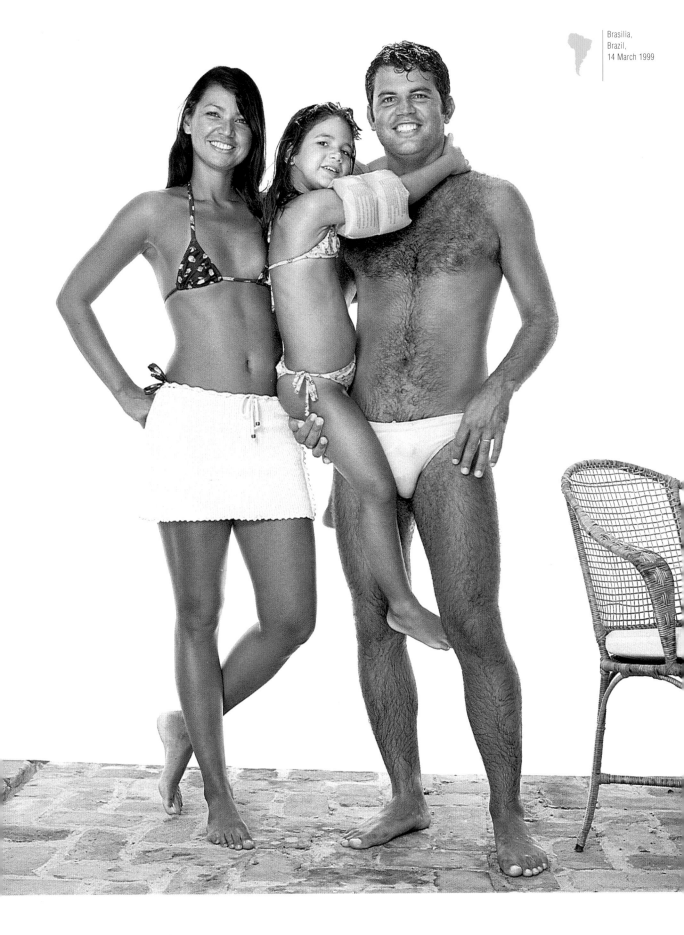

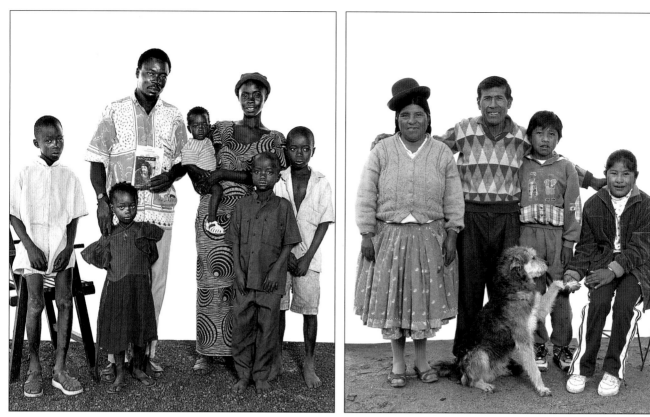

1 2

Page 304

Ricardas arbeitet bei einem Sicherheitsdienst und Jurga ist Soziologin und hofft, in einem staatlichen Unternehmen für Sozialforschung unterzukommen. Das neue Jahrtausend? „Wir haben keine besonderen Pläne, außer arbeiten, Geld verdienen und glücklich werden!"

Ricardas works as a security guard. Jurga's a sociologist and is hoping to find a job in a government-owned firm that handles social data. The new millennium? "We don't have any special plans – just to work, earn money, and try to be happy."

Ricardas travaille comme garde de sécurité. Jurga est sociologue et espère trouver un emploi dans une entreprise publique qui s'occupe de l'information sociale. L'an 2000? « Nous n'avons pas de projets spéciaux, seulement travailler, gagner de l'argent, essayer d'être heureux ! »

Page 305

Marcelo ist bei der Armee und der Wohnort der Familie wechselt mit seinen Versetzungen. Im Moment leben sie in Brasília, aber sie verbringen ihre Ferien am Atlantik. Michellyne ist Sportlehrerin und die vierjährige Kamille ist sehr stolz darauf, so attraktive Eltern zu haben.

Marcelo is in the army, and where the family home changes with his postings. At the moment they're living in Brasilia, but they spend their holidays by the Atlantic. Michellyne teaches physical education, and four-year-old Kamille is very proud of having such attractive parents.

Marcelo est militaire et leur domicile change en fonction de ses mutations. En ce moment, ils vivent à Brasilia mais ils passent leurs vacances au bord de l'Atlantique. Michellyne est professeur d'éducation physique et Kamille (quatre ans) est très fière d'avoir des parents aussi séduisants.

Tortiya,
Ivory Coast,
11 May 1997

„Ein Mann ohne Familie ist ein Mann ohne Grab", erklärt Étienne. Der katholische Missionar von Tortiya unterweist Erwachsene im Katechismus. Er und seine Frau stammen ursprünglich aus Benin und haben sich für die Elfenbeinküste entschieden, um hier ihre Kinder großzuziehen. Ihr Wunsch für die Zukunft: „Dass einer unserer Söhne festen Glaubens ist und Priester wird."

"A man without a family is like a man who doesn't have a grave," explains Étienne. He is a Catholic missionary in Tortiya who teaches the catechism to adults. Originally from Benin, his wife and he have chosen to live in the Ivory Coast to bring up their children. Their wish for the future: "That one of our sons will have a solid faith and become a priest."

« Un homme sans famille, c'est comme un homme qui n'a pas de tombe », explique Etienne. Missionnaire catholique à Tortiya, il enseigne le catéchisme aux adultes. Originaires du Bénin, son épouse et lui ont choisi la Côte d'Ivoire pour élever leurs enfants. Leur souhait pour l'avenir : « Que l'un de nos fils ait une foi bien ferme, et devienne prêtre. »

Uyuni,
Bolivia,
23 January 1999

Erculano ist der beste Mechaniker im Dorf, unser Landrover ist der Beweis. Gelernt hat er in der Praxis: Nach 22 Jahren als Lkw-Fahrer für eine Mine in 5.000 Metern Höhe kennt er alle Tücken der Mechanik. Gregoria hat einen Stand auf dem Markt und verkauft landestypische Kleidung. Das Jahr 2000? „Das liegt in Gottes Hand", sagt sie schicksalergeben.

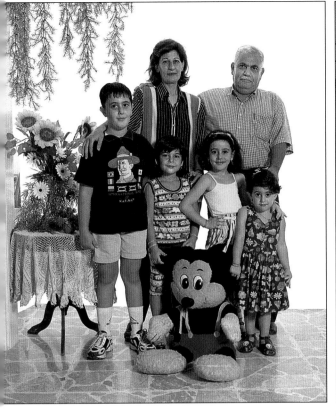
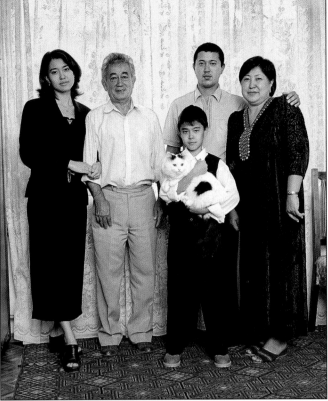

4

Erculano is the best mechanic in the village, as our Land Rover shows. He learnt his trade on the job – after 22 years as a truck driver for a mine 16,000 feet up, he knows his engines inside out. Gregoria has a market stall where she sells local clothing. The new millennium? "God will decide," she says fatalistically.

Erculano est le meilleur mécanicien du village, notre Land Rover peut en témoigner. Il a appris sur le terrain : après avoir été pendant vingt-deux ans chauffeur de camion dans une mine à 5000 mètres d'altitude, il connaît toutes les ficelles de la mécanique ! Gregoria tient un stand au marché où elle vend des vêtements locaux. L'an 2000 ? « C'est Dieu qui décidera ! », dit-elle, fataliste.

Hama,
Syria,
6 August 1999

Die Kassrens leben seit sieben Generationen in Hama und haben sich seit fünf Generationen der Goldschmiedekunst verschrieben. Sie besitzen 13 Schmuckgeschäfte in der Stadt. Muneer hat zunächst in seinem Beruf als Anwalt gearbeitet, bevor er sich entschloss, in die Fußstapfen seiner Vorfahren zu treten. Seine neue Aufgabe macht ihm mehr Spaß und außerdem sind „Geschäfte interessanter".

The Kassren family have been goldsmiths for five generations, and have been living in Hama for seven. They own 13 jewellery shops in town. Muneer practised as a lawyer before returning to the family trade, where he feels happier and "business is more interesting."

Orfèvres depuis cinq générations et habitants d'Hama depuis sept, la famille Kassren possède à elle seule treize bijouteries en ville. Muneer a exercé comme avocat, avant de continuer le « métier familial » dans lequel il se sent plus heureux et où « les affaires sont plus intéressantes ».

Almaty,
Kazakhstan,
5 September 1999

Ursprünglich stammt diese in Almaty lebende Familie aus der Region Xinjiang Uygur im benachbarten China. Tursun ist Schriftsetzer und zurzeit ohne Anstellung. Seine Frau Naïma, von Beruf Lehrerin, arbeitet als Zugehfrau und Köchin beim Legationsrat der israelischen Botschaft. Ihr Sohn, der 25-jährige Aziz, steht auf der Straße, seit die Autowerkstatt, in der er beschäftigt war, dichtgemacht hat. Auch Maja, 21, sucht eine neue Stelle, da die Musikschule, in der sie Klavierunterricht gegeben hat, schließen musste. Sie ist diejenige, die mit ihrer Musik der Familie immer wieder neue Kraft gibt. Das neue Jahrtausend? „Wir wünschen uns keine Reichtümer, nur dass unsere Kinder Arbeit finden."

Originally from the Xinjiang Uygur region of neighbouring China, they now live in Almaty. Tursun is an unemployed typographer and Naïma is a teacher. But because she has no job, she works as a housekeeper and cook for the First Secretary of the Israeli embassy. Aziz (25) is a mechanic, but he has been out of a job since the workshop where he was employed shut down. Maja (21) has also been jobless since the school where she taught piano closed. She hasn't let this get her down, and keeps up the family morale by singing and playing the piano. The new millennium? "We don't dream about becoming rich, we just want our children to be able to find work."

Originaires de la Chine voisine, de la région de Ouïgour, ils vivent à Almaty. Tursun est typographe sans emploi. Naïma est enseignante, à défaut de poste, elle travaille comme femme de ménage et cuisinière chez le premier secrétaire de l'ambassade d'Israël. Asis, vingt-cinq ans, mécanicien, se retrouve sans emploi depuis la fermeture de l'atelier où il travaillait. Maia, vingt et un ans, est elle aussi sans emploi depuis que l'école où elle enseignait le piano a fermé. Elle garde le moral et soutient celui de la famille en chantant et jouant du piano. L'an 2000 ? « On ne rêve pas de devenir riches, mais juste que nos enfants aient la possibilité de trouver du travail. »

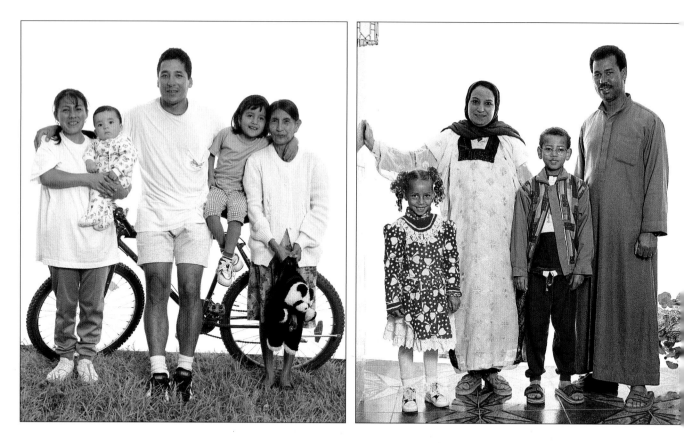

René ist Berufssoldat, Emelina lernte er kennen, als er in eine andere Garnison verlegt wurde. Gemeinsam mit der Großmutter und ihren beiden Kindern (die im Jahr 2000 wahrscheinlich schon einen kleinen Bruder oder eine kleine Schwester haben werden) verbringen sie den Nachmittag im Park.

René is a career soldier who met Emelina when he switched garrisons. Accompanied by grandma and their two children (who may well have a baby brother or sister by 2000), they've come to spend the afternoon in the park.

René, militaire de carrière, a rencontré Emelina grâce à un changement de garnison. Accompagnés de la grand-mère et de leurs deux enfants (qui auront peut-être un petit frère ou une petite sœur d'ici l'an 2000), ils sont venus passer un après-midi au parc.

Mahdi hat seine Frau während des Studiums in Alexandria kennen gelernt. Seit er wieder in seinem Heimatdorf lebt, pflegt er die alten Sitten und Gebräuche der Berber und hilft den Bedürftigen. Er ist Inhaber einer Buchhandlung und leitet nebenher das neu eröffnete Touristeninformationszentrum. Das Foto machten wir an einem Ort, der vor neugierigen Blicken geschützt war, da seine Frau dafür ausnahmsweise den Schleier ablegte.

Mahdi and his wife met in Alexandria when they were students. Back in his village, Mahdi devotes himself more and more to keeping up Berber tradition and helping those in need. He has a bookshop and also runs the brand new tourist office. This family photo was taken in a spot well away from prying eyes, because his wife quite exceptionally removed her veil for the occasion.

Mahdi et sa femme se sont rencontrés à Alexandrie durant leurs études. Revenu au village Mahdi n'a cessé de s'investir dans le maintien de la tradition berbère et l'aide aux nécessiteux. Il tient une librairie et s'occupe également du tout nouveau bureau de tourisme en tant que directeur. Sa photo de famille a été faite dans un endroit bien abrité des regards curieux, puisque sa femme a, très exceptionnellement, enlevé son voile pour l'occasion.

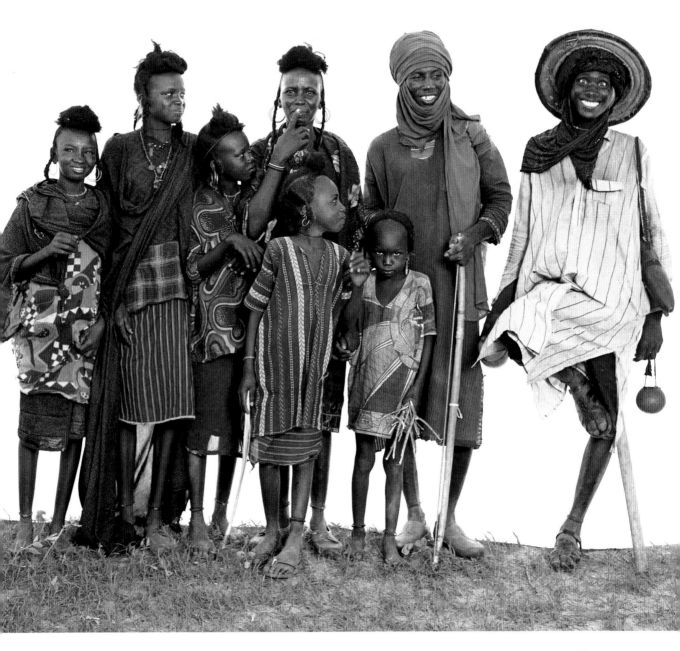

near Diffa,
Niger,
24 July 1997

Wir trafen diese Familie vom Volk der Bororo-Fulbe, als sie mit ihrem Vieh und ihren wenigen Habseligkeiten, die sie auf ein paar Esel gebunden hatten, vorbeizogen. Sie hatten viel Spaß bei den Fotoaufnahmen, wobei sie ständig aufpassen mussten, dass sich die Herde nicht in alle Winde zerstreute …

We found this family of Bororo Fulani on the move, with their livestock and meagre belongings loaded on the backs of a few donkeys. They had lots of fun while we took the photo, the session being a bit disturbed by the herd, which had to be prevented from straying off into the wilds …

Nous avons trouvé cette famille de Peuls Bororo en pleine « migration » avec son bétail et ses maigres possessions chargées sur quelques ânes. Ils se sont beaucoup amusés durant la séance photo, un peu perturbée par le troupeau qu'il fallait empêcher de s'éparpiller dans la nature …

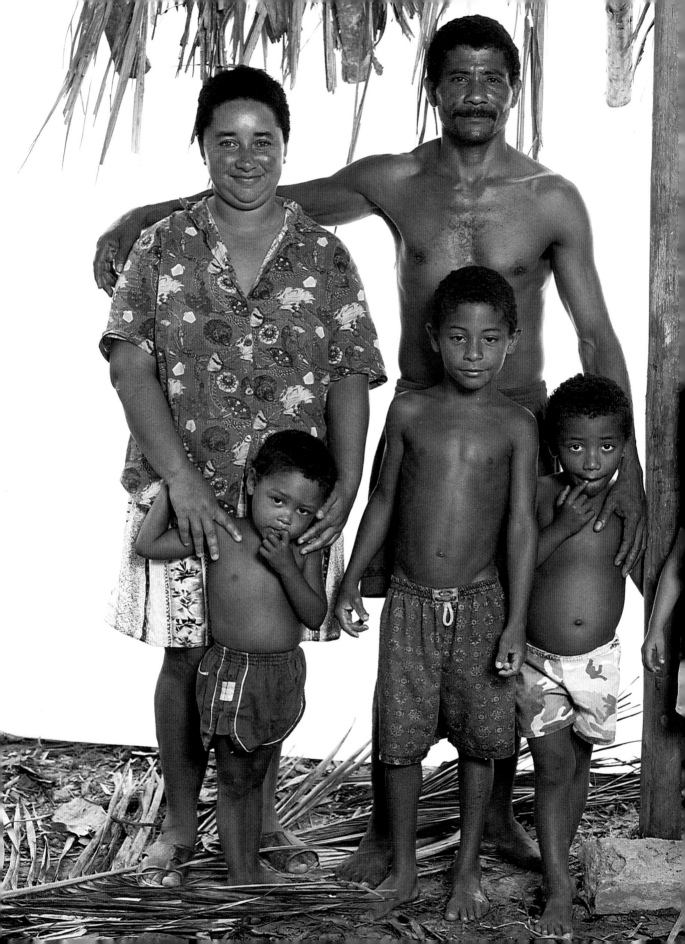

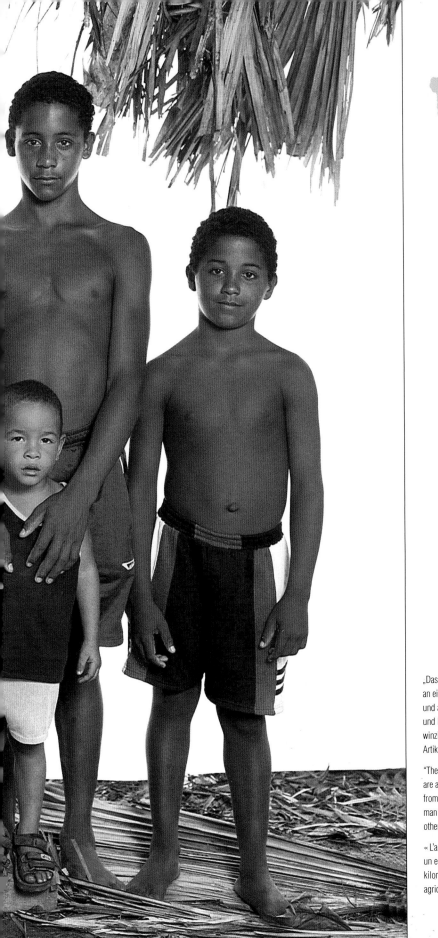

„Das Jahr 2000, das hat keine besondere Bedeutung. Ich würde einfach gern an einem etwas dichter besiedelten Ort wohnen. Hier leben nur zehn Familien und auch die kilometerweit voneinander entfernt", beklagt sich die Mutter und Hausfrau Yolanda. Luis ist Fischer und Bauer und hat außerdem einen winzigen Laden, in dem er „lauwarmes Bier und andere lebensnotwendige Artikel" verkauft.

"The year 2000 isn't that important. I'd just like to live in a place where there are a few more people. There are only ten families here, and we're miles from each other," grumbles mother and housewife Yolanda. Luis is a fisherman and farmer, and he also runs a tiny shop "selling lukewarm beer and other vital goods."

« L'an 2000, ça n'est pas très important, j'aimerais simplement vivre dans un endroit un peu plus peuplé. Ici nous ne sommes que dix familles à des kilomètres à la ronde ! », se plaint Yolanda, mère au foyer. Luis, pêcheur et agriculteur, tient aussi une minuscule boutique « de tout et de rien ».

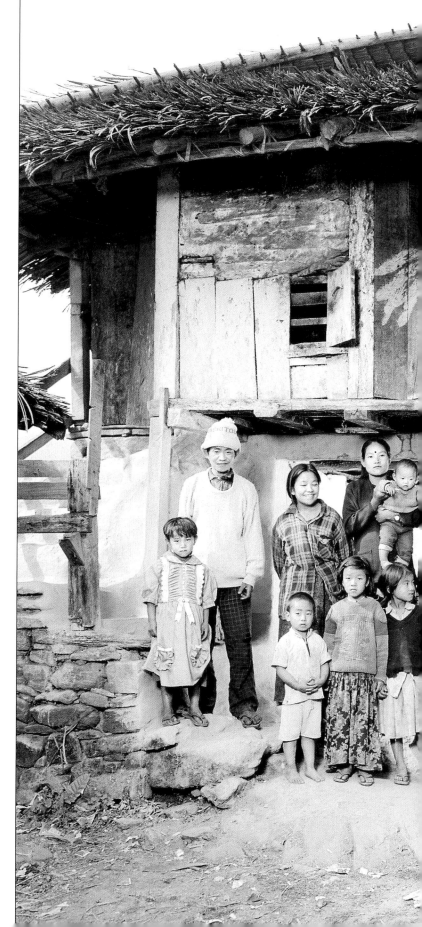

Manbahadur arbeitet beim Elektrizitätswerk und hat eine Heidenangst vor Blutegeln! Er ist für die Wartung der Stromkabel zuständig, die auch durch Gebiete laufen, in denen es von diesen unliebsamen Zeitgenossen nur so wimmelt. Hier posiert er mit „der ganzen Familie": Mutter, Schwestern, Brüdern, seiner Frau und den dazugehörenden Kindern.

Manbahadur works for the electricity company, but what terrifies him most is leeches! He is responsible for power line maintenance, and the lines run through leech-infested fields. Gathered around him is his "reassembled family" – his mother, sisters, brothers, wife and everybody's children.

Employé de la compagnie d'électricité, ce que Manbahadur redoute le plus ce sont les sangsues! Il est responsable de l'entretien des lignes électriques et celles-ci passent à travers des champs infestés de ces bêtes. Il est entouré de « sa famille regroupée », mère, sœurs, frères, sa femme, et les enfants de tout le monde!

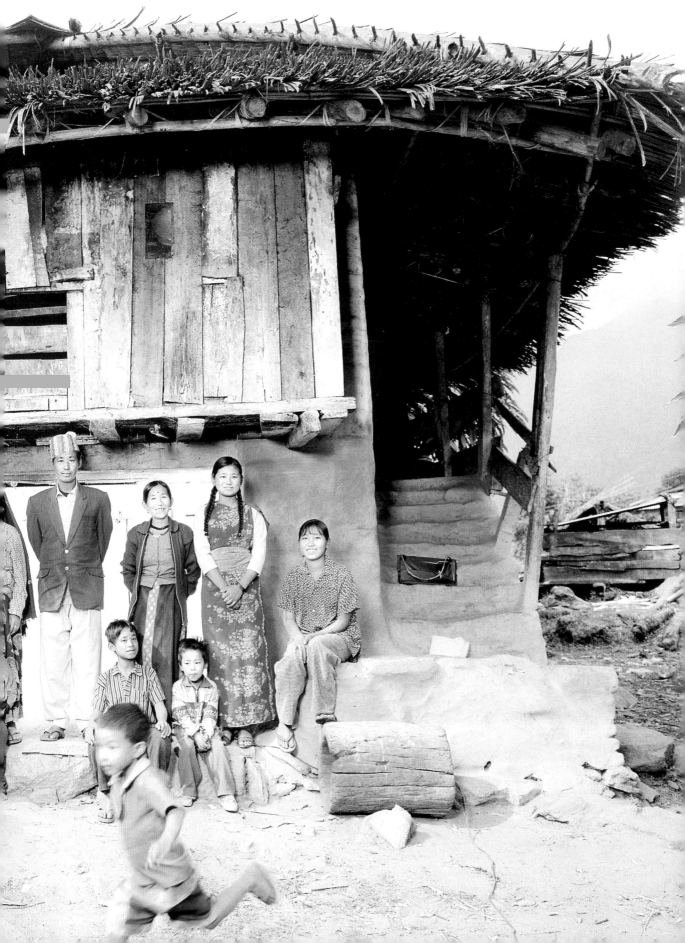

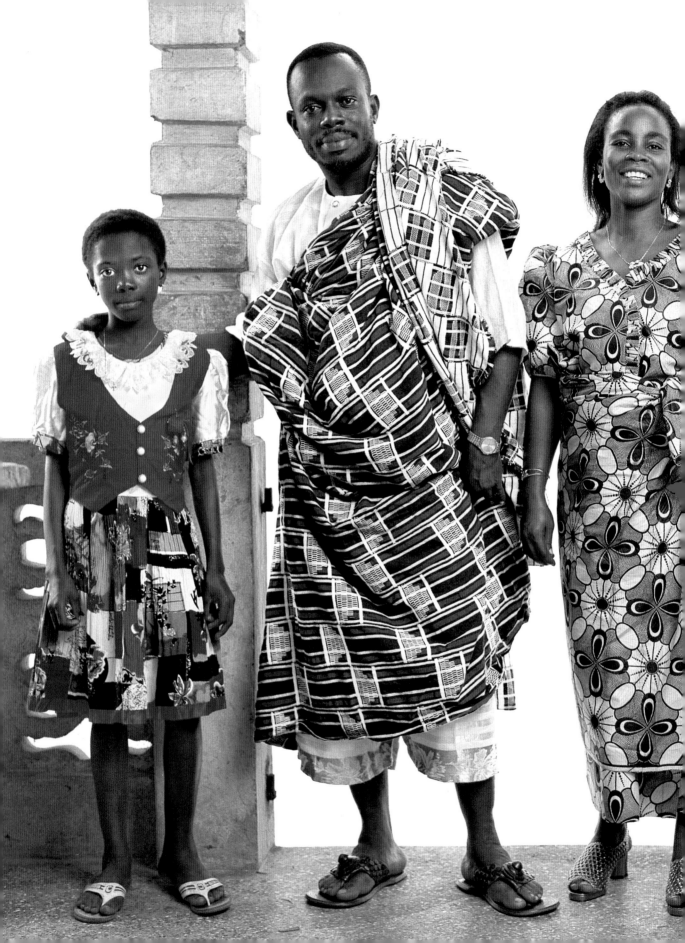

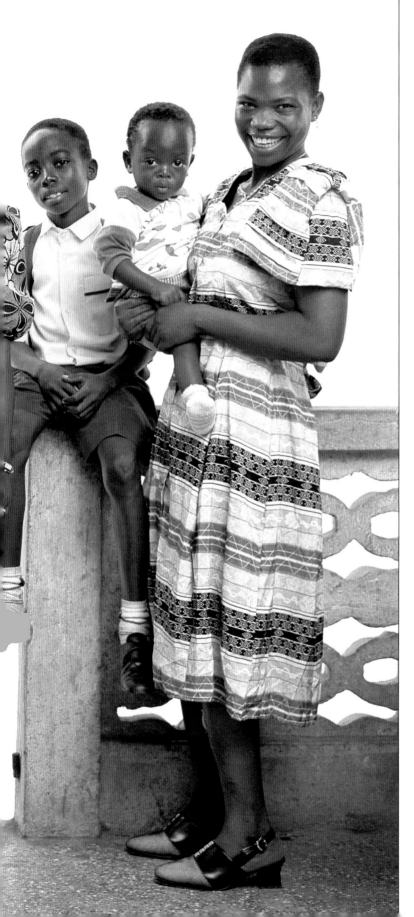

 Axim,
Ghana,
9 June 1997

Samuel Kingslove ist Unternehmer, seine Frau Bäckerin, ein dynamisches Paar voller Ideen für die Zukunft. Das neue Jahrtausend? „Die Bibel prophezeit, dass etwas geschehen wird; vielleicht wird Gott auf die Erde zurückkehren." Samuels Traum ist es, „mein Glück zu machen, Pastor der Pfingstkirche zu werden und von Stadt zu Stadt zu reisen, um Gott zu dienen."

Samuel Kingslove is an entrepreneur, his wife a baker, and together they make an energetic couple, full of ideas for the future. The new millennium? "The Bible says something will come to pass – maybe that God will come back." Samuel's dream is to "make a fortune, become a priest (of the Pentecostal Church) and travel from town to town to serve God."

Samuel Kingslove est entrepreneur, son épouse boulangère, ils forment un couple dynamique et plein d'idées pour l'avenir. L'an 2000 : « La Bible annonce que quelque chose va se passer, peut-être bien que Dieu va revenir ? » Le rêve de Samuel « faire fortune, devenir pasteur (de l'Eglise Pentecôtiste) et voyager de ville en ville pour servir Dieu ».

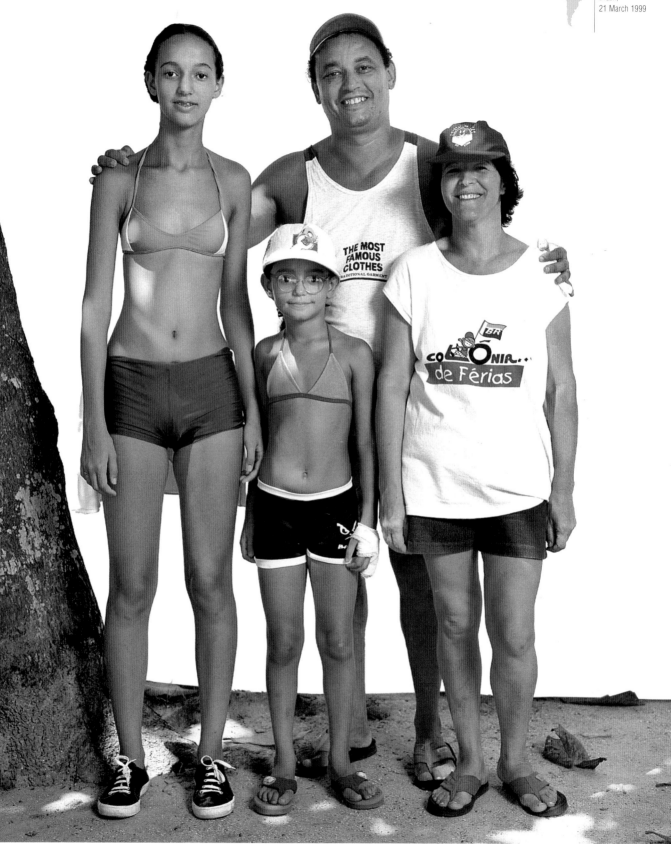

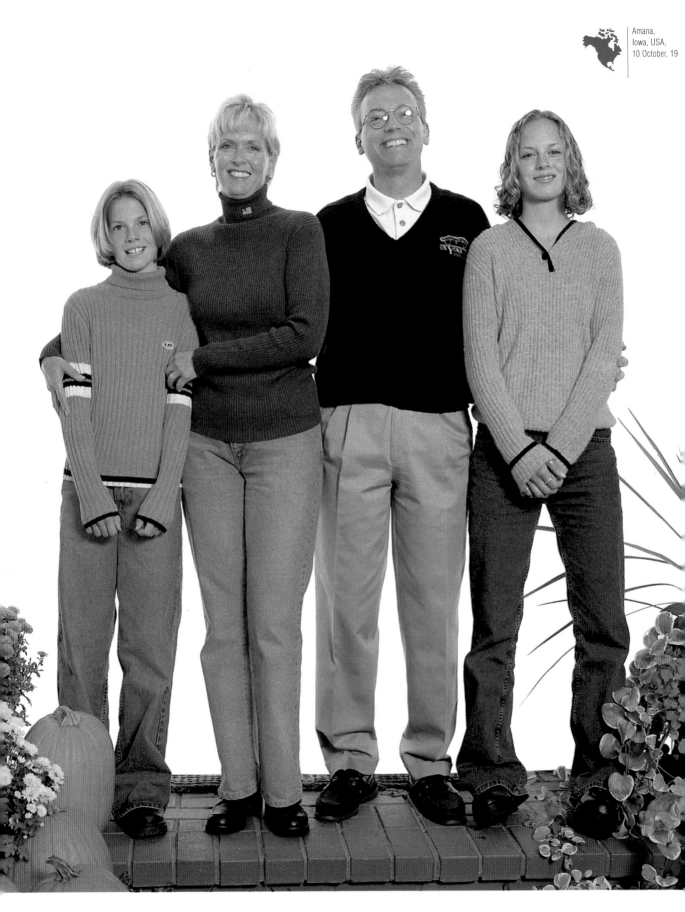

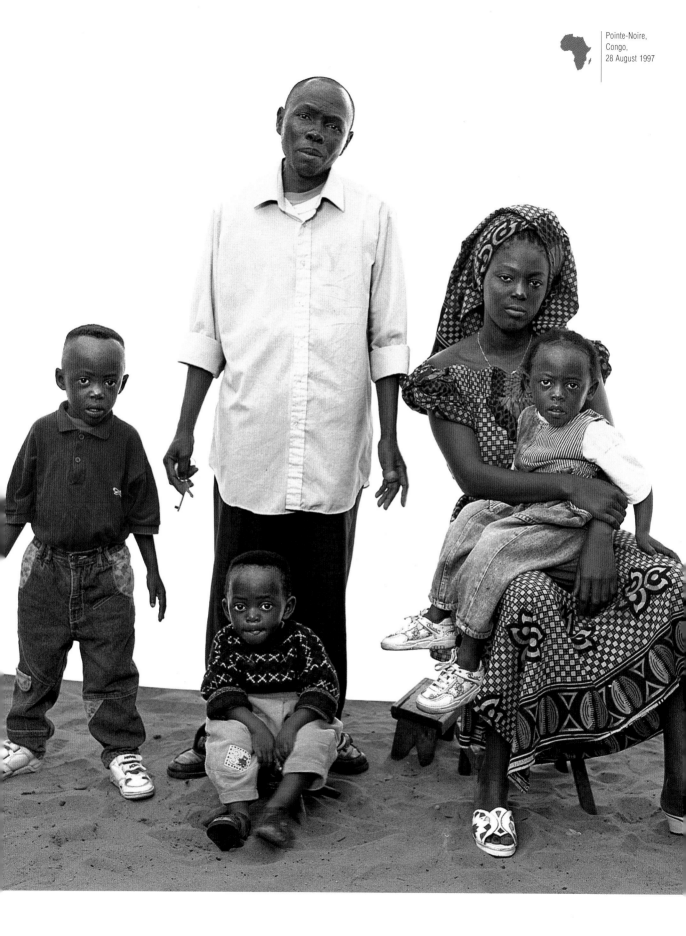

Page 316

Zwei Entscheidungsträger: Er ist Chef eines Metall verarbeitenden Betriebs und sie Managerin eines modernen Möbelgeschäfts. Am Wochenende entdecken sie gemeinsam die Umgebung. Sie selbst sind das beste Beispiel ihrer Devise „Bleibt zusammen und vertragt euch."

A couple of decision-makers: he heads a company dealing in metals and she's the manager of a contemporary furniture shop. Every weekend they go off exploring the countryside. They are the best illustration of their own motto: "Stay together and get along."

Un couple de décideurs: lui est à la tête d'une entreprise de métaux et elle manager d'un magasin de meubles contemporains. Chaque week-end, ils partent à la découverte de leur pays. Ils sont la meilleure illustration de leur devise: « Restez ensemble et entendez-vous! »

Page 317

Eurico ist Geotechniker und arbeitet bei einer brasilianischen Erdölgesellschaft. Seine Freizeit verbringt er mit der Familie. „Die Familie ist sehr wichtig, sie ist der Kern unserer Gesellschaft und Voraussetzung für jeden Fortschritt."

Eurico is a geological technician for a Brazilian oil company and devotes his spare time to his family. "The family unit is very important," he says. "It's the core of our society and the basis of all progress."

Technicien en géologie, Eurico travaille dans une compagnie pétrolière brésilienne et consacre son temps libre à sa famille. « La cellule familiale est très importante, dit-il. C'est le noyau de notre société et la condition de tout progrès. »

Page 318

„Liebe geht durch den Magen", erklärt uns Karen auf Deutsch. Sie hat ihren Mann in seinem Restaurant kennen gelernt, das seine Eltern 1940 gegründet haben. Wie alle Einwohner der sieben Dörfer, die zu Amana gehören, sind sie deutscher Abstammung, sehr heimatverbunden und familienbewusst. Der sportliche Nachwuchs trifft sich fast jeden Abend zum Ball spielen: Fußball, Volleyball, Basketball, Baseball. So bleibt den Eltern keine Zeit für ihr liebstes Hobby: Golf.

"The way to the heart is through the stomach," Karen tells us. She met her husband in his restaurant, which was established by his parents in 1940. Of German stock, like all the people in the seven villages that make up Amana, they are very attached to their region, and life centres around the family. Their children are very sporty and have a ball game practically every evening – soccer, volleyball, basketball, baseball. This keeps their parents so busy that they don't have time for their own favourite ball game: golf.

« L'armour passe par l'estomac », nous dit Karen, qui a rencontré son mari dans son restaurant, fondé par ses parents en 1940. De souche allemande comme tous les habitants des sept villages d'Amana, ils sont très attachés à leur région et vivent centrés sur la famille. Sportifs, les enfants ont un *ballgame* presque chaque soir – *soccer*, volley, basket, base-ball. De quoi occuper les parents qui n'ont plus le temps de s'adonner à leur *ballgame* favori: le golf!

Page 319

Als glücklicher Besitzer eines kleinen Grundstücks, das ihm eine regelmäßige Pacht einbringt, hat Albert keine Sorge, seine Familie zu ernähren. Das hindert ihn allerdings nicht daran, als Kellner in einem Nobelrestaurant zu arbeiten und für das Jahr 2000 von seinem eigenen Restaurant zu träumen …

Albert is the happy owner of a small plot of land which brings in a regular rent, so he has no worries about feeding his family. This doesn't stop him working as a waiter in a "chic restaurant," however, and dreaming of having his own restaurant by 2000 …

Heureux propriétaire d'un petit terrain qui lui rapporte un loyer régulier, Albert n'a pas de soucis pour faire vivre sa famille. Ce qui ne l'empêche pas de travailler comme serveur dans un « restaurant chic » et de rêver à son propre restaurant pour l'an 2000 …

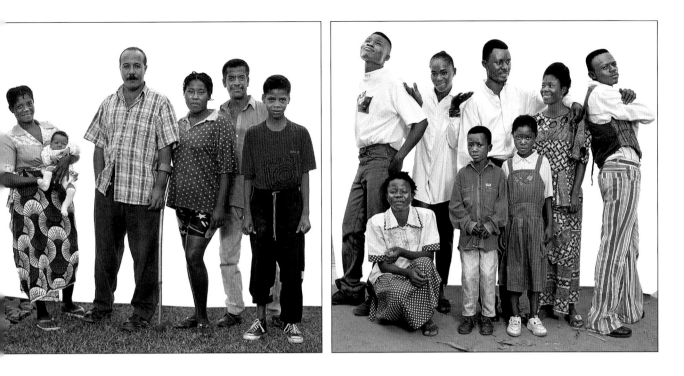

Waku-Kungo,
Angola,
5 September 1997

Fernando hatte das Pech, auf eine Landmine zu treten. Sein größter Traum ist dauerhafter Frieden in Angola.

Fernando had the bad luck to step on a land mine, so his greatest dream is for lasting peace in Angola.

Fernando a eu la malchance de sauter sur une mine, aussi son plus grand rêve est une paix durable en Angola.

Boma,
Zaire,
31 August 1997

Wir haben David in der Kirche getroffen, wo er den Männerchor leitet … Von Beruf ist er Mechaniker, doch seine Liebe gilt dem Gesang. Seine Frau teilt diese Leidenschaft, sie leitet den Frauenchor. Sie leben zusammen mit der Großmutter, der Schwiegermutter, den Schwestern und Neffen …

We met David in the church where he conducts the men's choir … A mechanic by trade, David loves singing above all else – a passion which he shares with his wife, who in turn conducts the women's choir. They live with a grandmother, mother-in-law, sisters and nephews …

Nous avons rencontré David à l'église où il dirige le chœur des hommes … Mécanicien de métier, le chant est sa passion, il la partage avec son épouse qui, elle, dirige le chœur des femmes … Ils vivent avec la grand-mère, la belle-mère, les sœurs et les neveux …

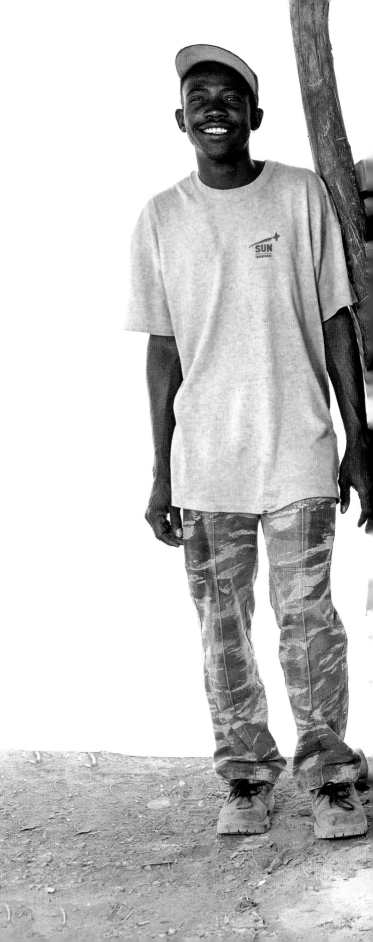

Ben, hier mit seiner Mutter, seinen Brüdern und Neffen, ist Lehrer geworden, „weil ich das große Glück hatte, die Schule besuchen zu dürfen, und weil ich den Herero und Himba in dieser Region helfen will, sich zu verändern, indem ich ihnen lesen und schreiben, aber auch den Gemüseanbau beibringe, damit sie weniger von ihren Kühen abhängig sind, ihrem einzigen Reichtum." Ben für seinen Teil besitzt drei Kühe, die er der Familie seiner zukünftigen Frau als Brautpreis geben muss. Geduldig wartet er darauf, seine Zukünftige kennen zu lernen …

Ben, shown here with his mother, his brothers and his nephews, has become a teacher "because I was lucky enough to be able to go to school and because I want to help the Herero and Himba in this area to progress by teaching them not only to read and write, but also to grow vegetables and thus become less reliant on their cattle, which is their only source of wealth." For his part, Ben has three cows which he will have to offer as a dowry to the family of his future wife, whom he is patiently waiting to meet …

Ben, ici avec sa mère, ses frères et neveux, est devenu enseignant « parce qu'il a eu la grande chance de pouvoir aller à l'école et parce qu'il veut aider les Herero et Himba de sa région à évoluer en leur apprenant à lire et à écrire, mais également à cultiver des légumes et devenir ainsi moins dépendants de leurs vaches qui sont leur seule richesse ». Pour sa part Ben en possède trois, qu'il faudra offrir en dot à la famille de sa future femme, qu'il attend patiemment de rencontrer …

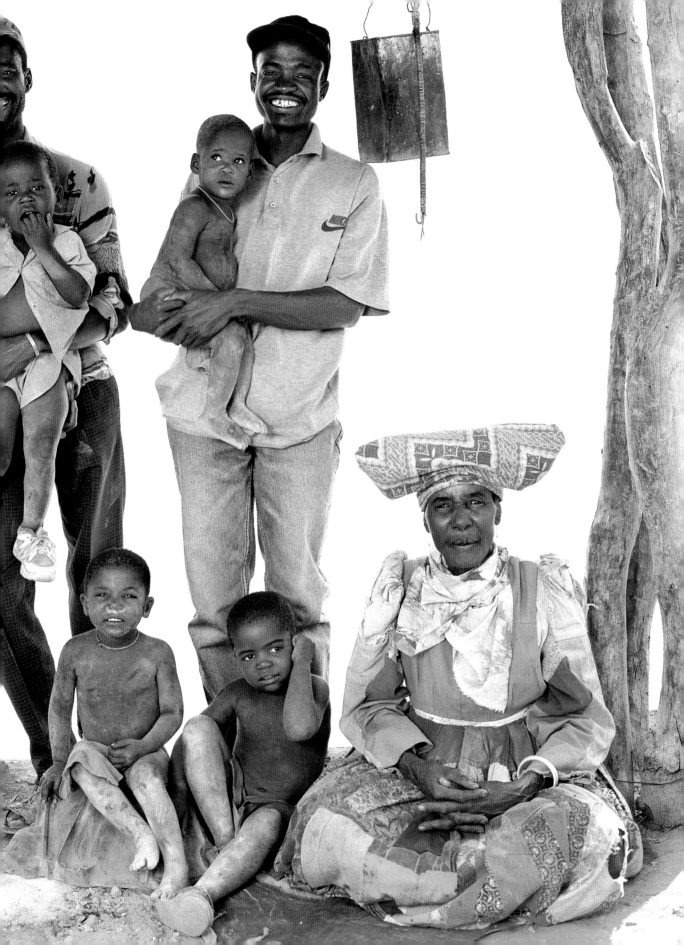

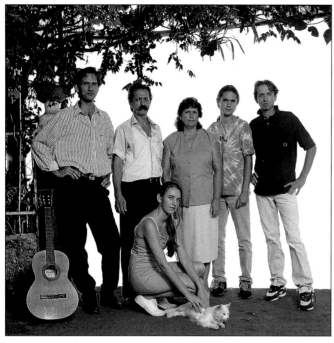

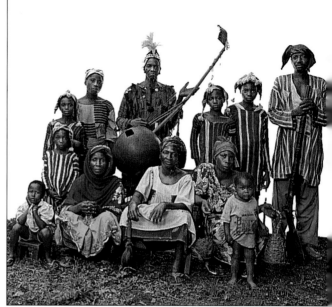

Posadas,
Argentina,
27 March 1999

Juan ist Lehrer, Bibliothekar und Forscher und kennt die Geschichte seiner Provinz aus dem Effeff. Er hat eine sehr gute Beziehung zu seinen vier Kindern, mit denen er seine Leidenschaft für Musik, Bücher, Sport und die Natur teilt. Übrigens sorgen sie sich alle sehr um die Umwelt und die Zukunft unseres Planeten. „Die Erde ist das, was wir daraus machen", sagen sie einhellig. „Jeder Einzelne ist dafür verantwortlich, sie zu schützen, genauso wie wir unsere Familie oder das, was uns lieb ist, schützen."

Juan is a teacher, librarian and researcher. He knows the history of his province inside out. He has very good relationships with his four children, and they all share a love of music, books, sport and nature. They all also feel very concerned with the environment and the future of our planet: "It'll be what we make it," they all agree. "It's our individual responsibility to take care of it, just as we take care of our family and all the things that mean a lot to us."

Juan est enseignant, bibliothécaire et documentaliste. Il connaît l'histoire de sa province sur le bout des doigts. Il entretient d'excellents rapports avec ses quatre enfants, dont il partage la passion de la musique, des livres, du sport et de la nature. D'ailleurs, tous se sentent très concernés par l'environnement et l'avenir de notre planète: «Elle sera ce que nous en ferons», disent-ils d'une seule voix. «C'est notre responsabilité individuelle d'en prendre soin, au même titre que nous prenons soin de notre famille ou de ce qui nous est cher!»

Biankouma,
Ivory Coast,
3 April 1997

Sampka Bamaba, *Griot* [fahrender Dichter und Musiker] und Jäger, steht ausschließlich im Dienst des Dorfoberhaupts. Seine Kinder begleiten seine gesungenen Erzählungen mit traditionellen Tänzen …

The services of Sampka Bamaba, a 'hunter *griot*', are reserved exclusively for the village headman. His children accompany his sung tales by performing traditional dances …

Sampka Bamaba, « griot chasseur » est au service exclusif du chef de village, ses enfants accompagnent ses récits chantés en exécutant des danses traditionnelles …

Beesd,
The Netherlands,
19 June 1998

Von nah und fern kommen die besten Bäcker hierher, um das Biomehl zu kaufen, das Henk in dieser Bilderbuchwindmühle mahlt, die 1826 von seinen Vorfahren erbaut wurde. Für das neue Jahrtausend wünscht sich das Paar „eine kleine Schwester für unsere beiden Söhne".

Renowned bakers come from all over the Netherlands and from other European countries as well to buy organic flour traditionally ground in this magnificent windmill, built in 1826 by Henk's ancestors. Their dream for the new millennium is "to have a little sister for the two boys!"

Des boulangers de renom viennent des Pays-Bas et d'autres pays d'Europe pour acheter la farine biologique moulue traditionnellement par ce superbe moulin à vent, construit en 1826 par les ancêtres de Henk. Leur rêve pour l'an 2000: «Avoir une petite sœur pour les deux garçons!»

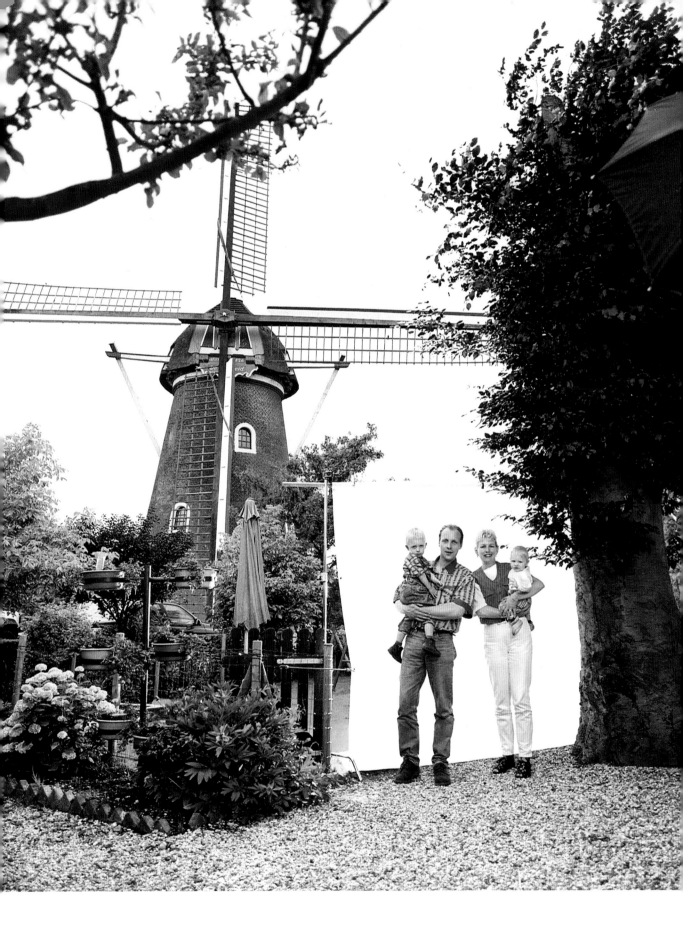

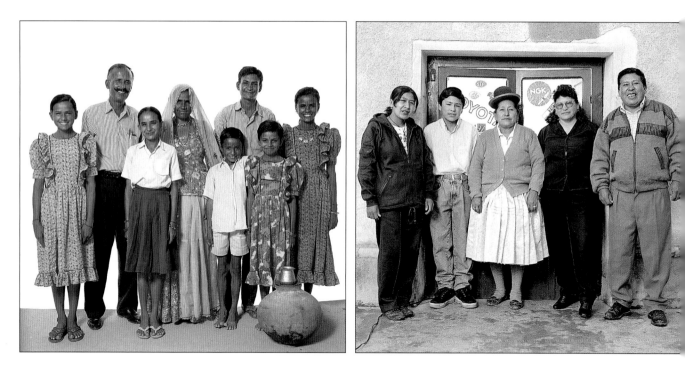

 Jaisalmer,
India,
14 October 1999

Kumbharam, seit 1974 im Fremdenverkehrsamt beschäftigt, erinnert sich: „Damals gab es in Jaisalmer kein einziges Hotel, heute sind es über 100." Alle sechs Kinder der Familie besuchen die Schule, aber für seinen Sohn hat der Vater besondere Pläne: „Ich werde dafür sorgen, dass er studieren kann und später einmal Beamter wird. Sollte er die Schule nicht schaffen, übernimmt er eben unseren Bauernhof."

Kumbharam has worked in the tourist office since 1974. He recalls: "There wasn't a single hotel in Jaisalmer then, but today we have more than 100." His six children go to school, and he has big plans for his son: "I'll do all I can to make sure he studies and gets a good job in the civil service, but if he doesn't work hard, he'll run the family farm."

Employé à l'office du tourisme depuis 1974, Kumbharam se rappelle: « Il n'y avait pas un seul hôtel, aujourd'hui nous en avons plus de cent à Jaisalmer. » Ses six enfants vont à l'école et il a de grands projets pour son fils: « Je ferai tout mon possible pour qu'il puisse étudier et obtenir un bon poste de fonctionnaire, mais s'il ne travaille pas bien, il sera paysan à la ferme familiale! »

 Uyuni,
Bolivia,
22 January 1999

Vidal ist Elektriker und führt zusammen mit Elisabeth, die an der örtlichen Schule Handarbeiten unterrichtet, ein Geschäft für Elektroartikel und Autoersatzteile. Die Kinder gehen zur Schule und Großmutter hilft im Laden. Ihr Wunsch für das neue Jahr? „Wir würden uns gerne mit Familien aus anderen Ländern über unsere Erfahrungen austauschen."

Vidal is an electrician. He and his wife Elisabeth, who teaches manual trades at the local school, also run a shop selling electronic items and automobile replacement parts. Their children are in school, and the grandmother lends a hand with the shop. Their wish for the new year? "We would like to have the chance to exchange views with the families from other countries."

Vidal est électricien, avec Elisabeth qui enseigne les travaux manuels à l'école primaire, ils tiennent un magasin d'articles électroniques et de pièces de rechange pour automobiles. Les enfants sont à l'école et grand-mère donne un coup de main au magasin. « Nous aimerions pouvoir échanger nos expériences avec des familles d'autres pays! »

 Guiyang,
China,
5 March 2000

Eine viel beschäftigte Familie: Die Mutter liebt es, die Börsenkurse im Fernsehen zu verfolgen, der Vater fotografiert mit Hingabe Gebäude, Landschaften und vor allem seine Frau. Die ganze Familie singt beim Karaoke, besitzt gut 100 CDs und eine professionelle Verstärkeranlage. Liu Bao ist Geschäftsführer bei einem Importunternehmen und Wang Kassiererin in einem Autohaus. Ihre Tochter Chin Zing (24) ist Journalistin beim lokalen Fernsehsender.

A very busy family: Mother loves to follow the stock exchange on TV; Father likes to photograph monuments, landscapes and, even more, his wife. The whole family enjoys Karaoke singing, they have at least 100 CDs as well as a professional sound system. Liu Bao is the managing director of an import company, and Wang is the financial manager of a car franchise. Their 24-year-old daughter Chin Zing is a journalist at the local television station.

Maman suit les cours de la bourse à la télé. Papa photographie les monuments, les paysages et surtout sa femme. Toute la famille chante au Karaoké, ils possèdent une bonne centaine de CD et une sono de professionnel. Liu Bao est PDG dans une affaire d'import, Wang est trésorière chez un concessionnaire automobile. Leur fille Chin Zing, vingt-quatre ans, est journaliste à la télévision locale.

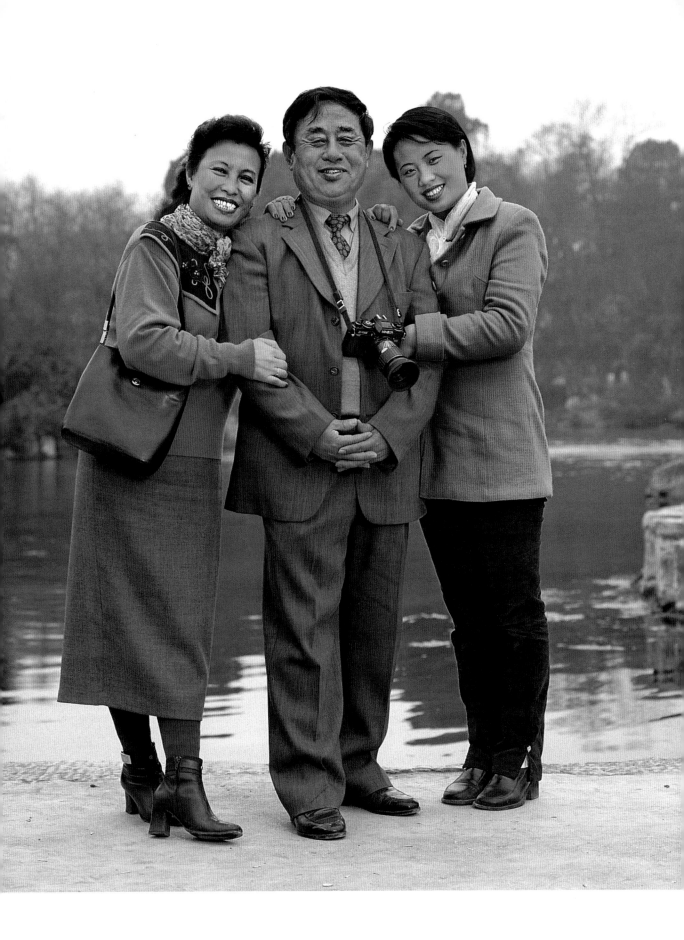

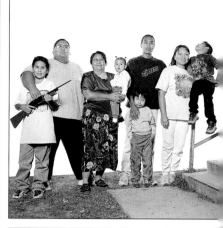

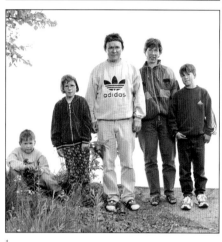
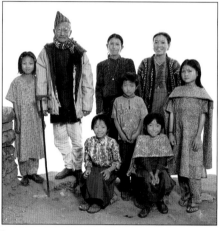

1
4

2
5

3
6

1
Linares,
Chile,
16 January 1999

2
Asadabad,
Iran,
19 September 1999

3
Oglala,
South Dakota, USA,
22 October 1998

4
Tana,
Norway,
2 July 1998

5
Yuksom,
Sikkim, India,
20 November 1999

6
Hue,
Vietnam,
3 February 2000

Tasik Chini,
Malaysia,
6 January 2000

„Eine Mischehe ist nicht immer leicht, aber wir geben uns Mühe", sagt Nor Bt Sema. „Ich bin eine Eingeborene und Yusuf ist ein muslimischer Malaie. Unseren Eltern ist es sehr schwer gefallen, unsere Ehe zu akzeptieren." Die zehnjährige Nadia Devi spricht schon sehr gut Englisch und möchte einmal Fremdenführerin werden.

"Mixed marriages are sometimes very difficult, but we're trying," says Nor Bt Sema. "I am an aboriginal and Yusuf is a Muslim Malay – our parents had a lot of trouble accepting our marriage." Ten-year-old Nadia Devi already speaks very good English and would like to become a tour guide.

« Les mariages mixtes sont parfois très difficiles, mais on essaie », dit Nor Bt Sema. « Je suis aborigène et Yusuf est Malais musulman, nos parents ont eu beaucoup de mal a accepter notre mariage. » Nadia Devi (dix ans) parle déjà très bien l'anglais et aimerait devenir guide touristique.

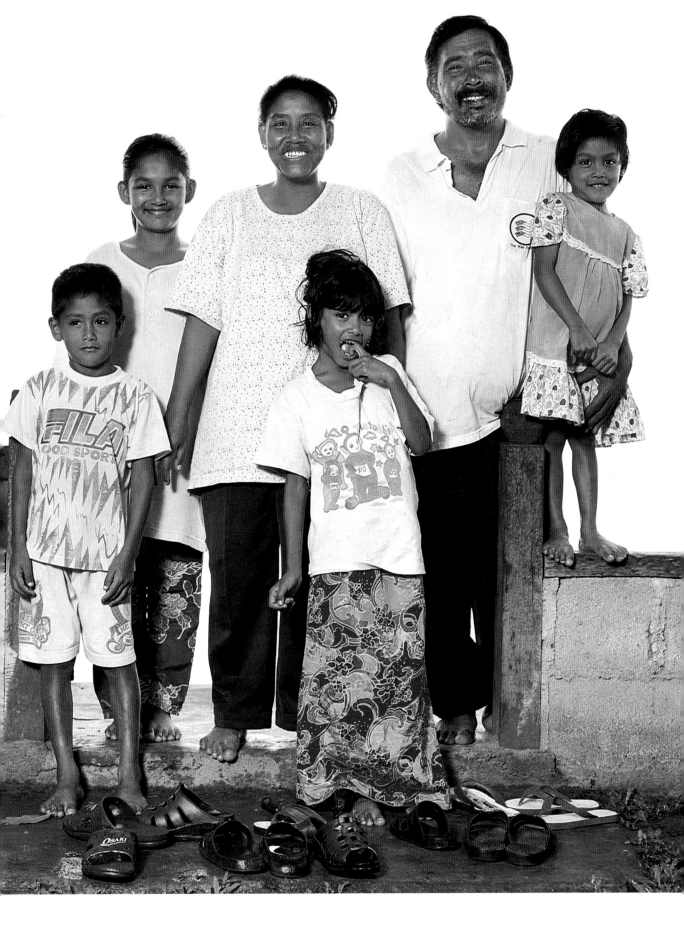

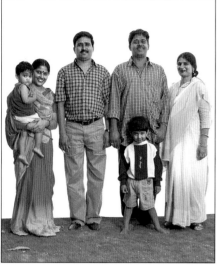

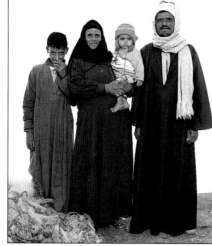

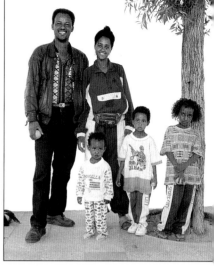

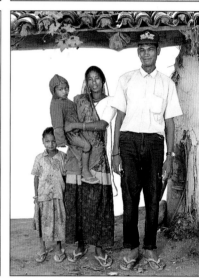

1

4

2

5

3

6

1
Udaipur,
India,
24 October 1999

2
Shakshuk,
Egypt,
5 January 1998

3
Asmara,
Eritrea,
25 December 1997

4
Roumsiki,
Cameroon,
30 July 1997

5
Würenlingen,
Switzerland,
5 October 1996

6
Bardia,
Nepal,
11 November 1999

Puntarenas,
Costa Rica,
20 December 1998

„Ich bin Landarbeiter auf einem großen Gut", erzählt Valentin. Seine Lieblingsbeschäftigung: ein Kopfsprung in den kühlen Fluss, der gleich hinter seinem Haus vorbei fließt. „Im Jahr 2000 würde ich gern fortgehen, um zu reisen und Abenteuer zu erleben!"

"I'm a labourer on a large farm," Valentin tells us. His favourite pastime? To dive into the nearby river. "In 2000, I'd like to go off in search of adventure and travel."

« Je suis ouvrier agricole dans une grosse propriété », confie Valentin qui, dès qu'il a du temps libre, en profite pour piquer une tête dans la rivière.
« En l'an 2000, j'aimerais vivre l'aventure et partir en voyage ! »

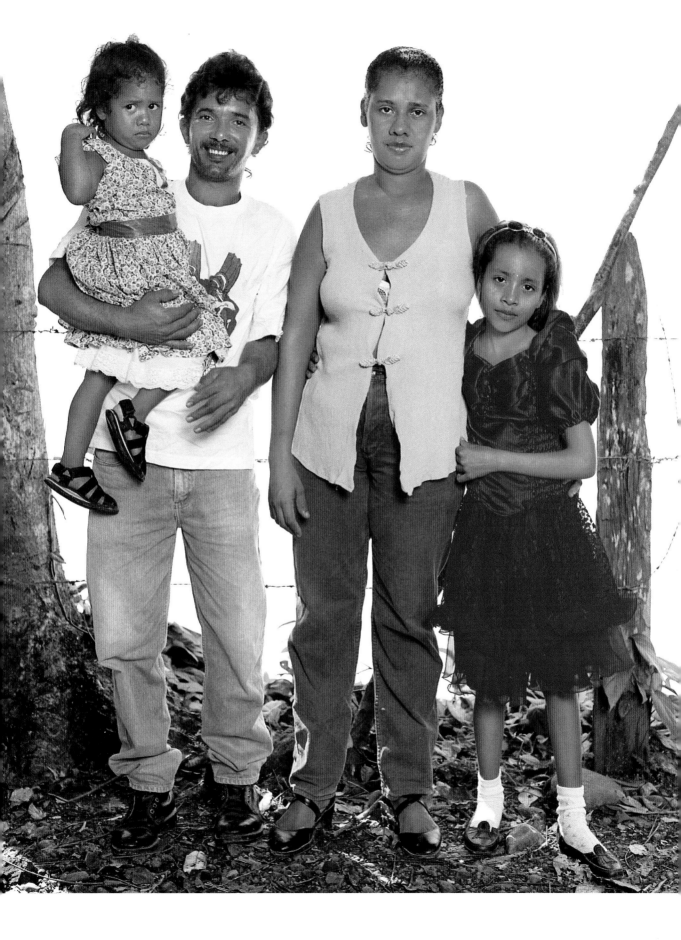

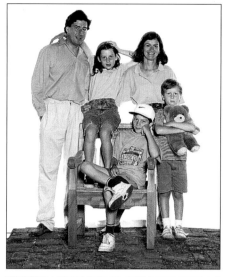

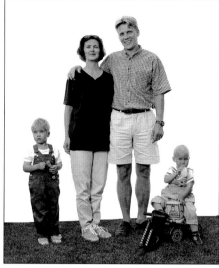

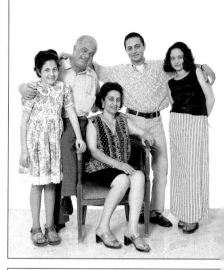

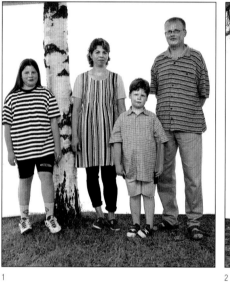

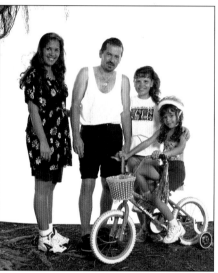

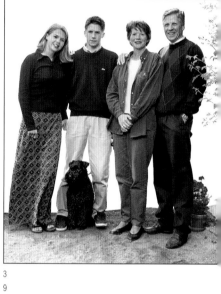

1
7

2
8

3
9

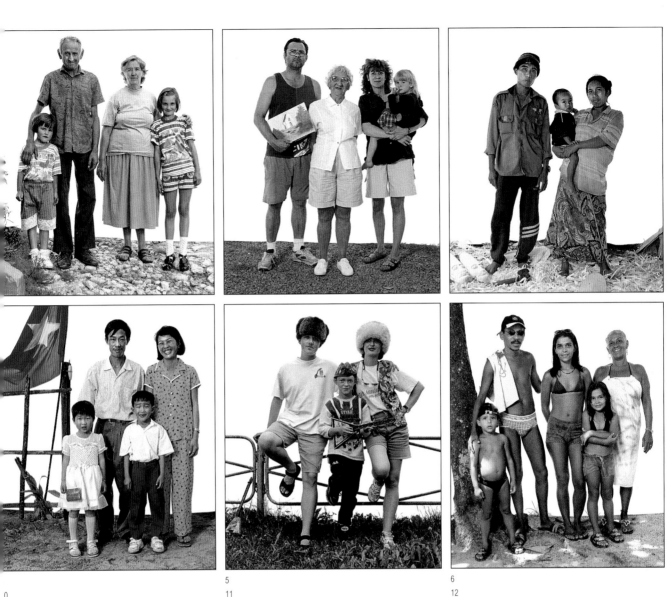

0

5
11

6
12

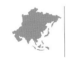
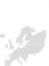

Dominique ist Lohnarbeiter auf einer großen Farm, auf der er mit seiner ganzen Familie lebt. Er ist für die Schweinezucht zuständig und zeigte uns stolz seine beiden jüngsten Erfolge …

Dominique works on a farm where he lives with his whole family. He's in charge of the pigsty, in particular, and very proud to introduce us to his two latest …

Employé d'une ferme où il vit avec toute sa famille, Dominique s'occupe plus particulièrement de la porcherie et il est très fier de nous présenter ses deux derniers …

Page 336

Jafari ist ganze 35, seit 20 Jahren verheiratet und wünscht sich noch mehr Kinder, vorausgesetzt, er verdient genug Geld, um sie zur Schule zu schicken. Er arbeitet auf der Straße als Schuhputzer und ist seit kurzem Großvater, den lebenden Beweis hält seine Frau im Arm …

Jafari tells us he's 35, and has been married for 20 years. He'd still like some more children, as long as he can find the money he needs to send them to school. He's an itinerant shoe-shine man and grandfather "to boot" – the baby in his wife's arms is the proof …

Jafari nous dit avoir trente-cinq ans, être marié depuis vingt ans et vouloir encore quelques enfants à condition de trouver l'argent nécessaire à leur scolarisation. Il est cireur de chaussures ambulant et grand-père (la preuve! le petit dans les bras de sa femme).

Page 337

César stammt aus der Stadt, lebt aber inzwischen auf dem Land, wo er „an einem Sonntagmorgen beim Verlassen der Kirche" Fidelina kennen gelernt hat. Er arbeitet im Bauwesen und sie ist Hausangestellte. Ihr Traum ist es, „mit unseren drei Söhnen nach Disneyworld zu fahren."

César used to be a city dweller, but now lives in the country, where he met Fidelina "one Sunday morning coming out of church." He works in the building trade, and she's a domestic employee. Their dream is "to take our three sons to Disneyworld."

César, d'origine citadine, vit aujourd'hui à la campagne où il a rencontré Fidelina «un dimanche matin à la sortie de l'église ». Il travaille dans le bâtiment, elle est employée de maison. Leur rêve: «Emmener nos trois fils à Disneyworld! »

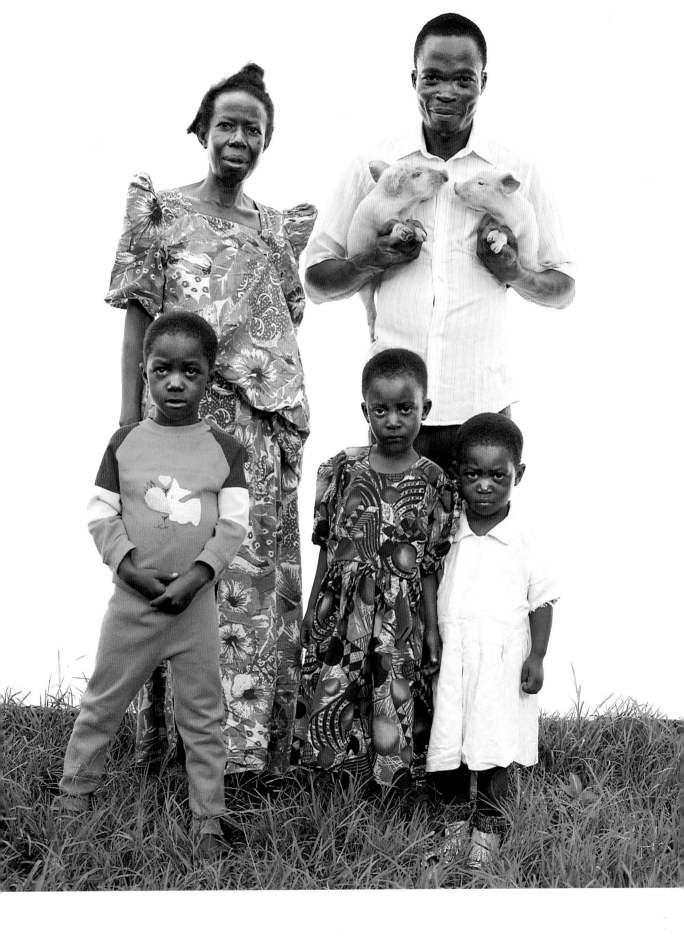

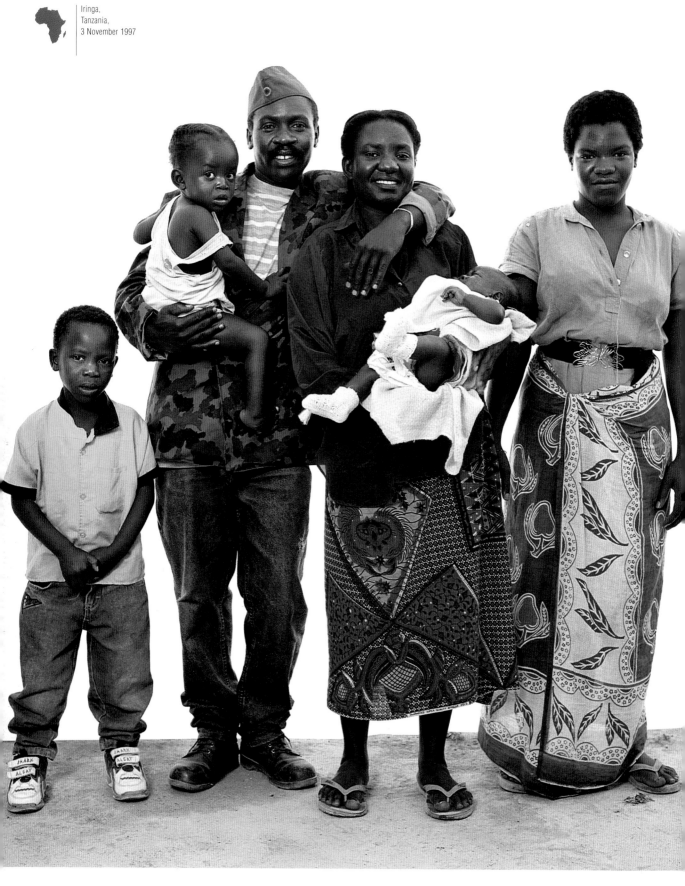

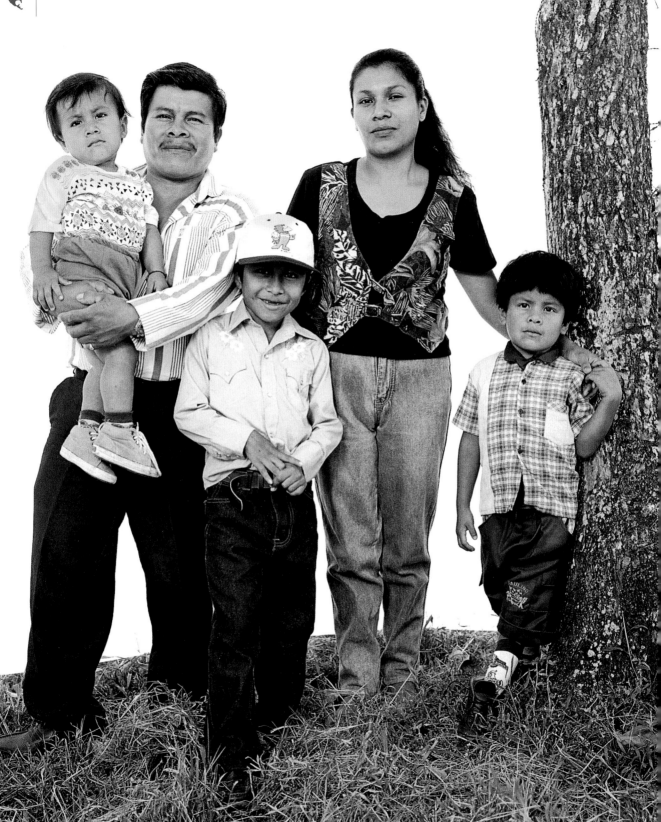

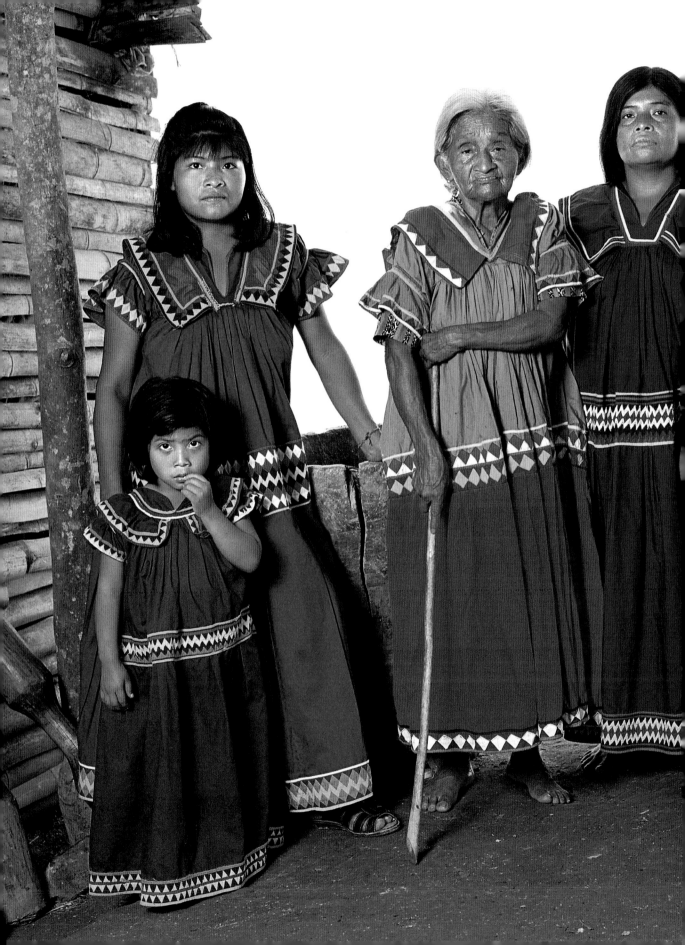

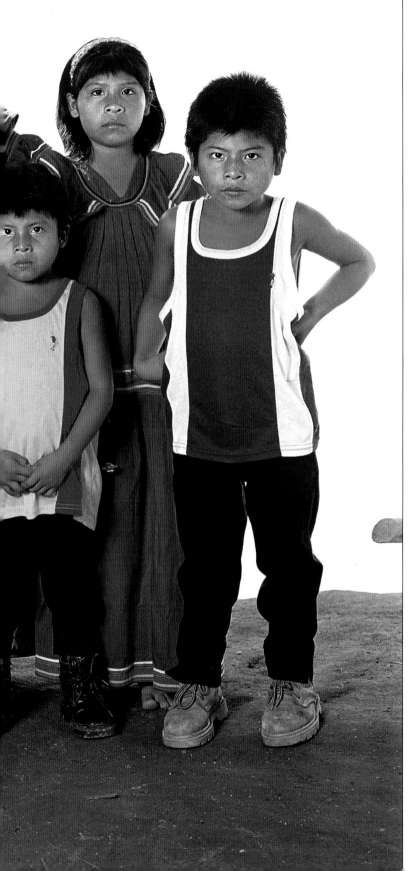

 San Félix,
Panama,
30 December 1998

Die Großmutter, die Mutter und die Kinder leben in sehr einfachen Verhältnissen am Berghang. Die Frauen stellen mit Hilfe einer alten handbetriebenen Nähmaschine indianische Kleider her. Obwohl sie nur sehr wenig Spanisch spricht, gelingt es der 24-jährigen Celia, uns zu verstehen zu geben, dass sie gerne mit uns reisen möchte, womit die 80-jährige Emelida allerdings überhaupt nicht einverstanden war ...

Grandmother, mother and children all live on the mountainside, with very basic creature comforts. The women make Indian dresses with the help of an old manual sewing machine. Celia, who's 24 and speaks very little Spanish, nevertheless manages to get it across that she's ready to go travelling with us, which 80-year-old Emelida didn't agree with at all ...

La grand-mère, la mère et les enfants vivent à flanc de montagne, dans un confort très rudimentaire. Les femmes fabriquent des robes indiennes à l'aide d'une vieille machine à coudre manuelle. Parlant très peu l'espagnol, Célia (vingt-quatre ans) parvient quand même à nous faire comprendre qu'elle est prête à partir en voyage avec nous, ce qu'Emelida (quatre-vingt ans) n'a pas du tout l'air d'apprécier !

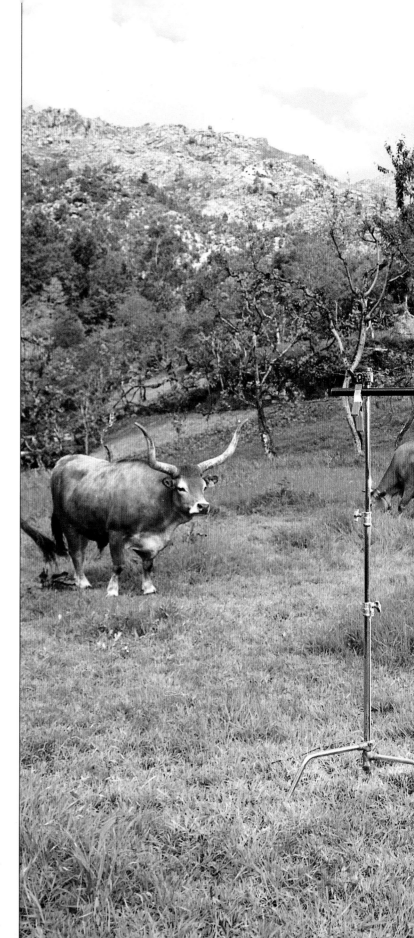

50 Ziegen, 20 Pferde, 15 Kühe und Weinberge, so weit das Auge reicht. „Viel Arbeit und wenig Geld", kommentiert José (77), der hier mit seiner 50-jährigen Nichte lebt. Auf dem Foto ist noch sein Neffe zu sehen, der Elektrotechnik studiert und den beiden in den Semesterferien zur Hand geht.

Fifty goats, 20 horses, 15 cows, and vines all round the house. "Lots of work and not much money," comments 77-year-old José, who lives with his 50-year-old niece. On the day of the photo, his nephew, an electronics student on vacation, was giving them a helping hand.

Cinquante chèvres, vingt chevaux, quinze vaches et des vignes tout autour de la maison! «Beaucoup de travail et pas beaucoup d'argent», nous déclare Jose, soixante-dix-sept ans, qui vit avec sa nièce de cinquante ans. Le jour de la photo, son neveu, étudiant en électronique et en vacances, leur prêtait main-forte.

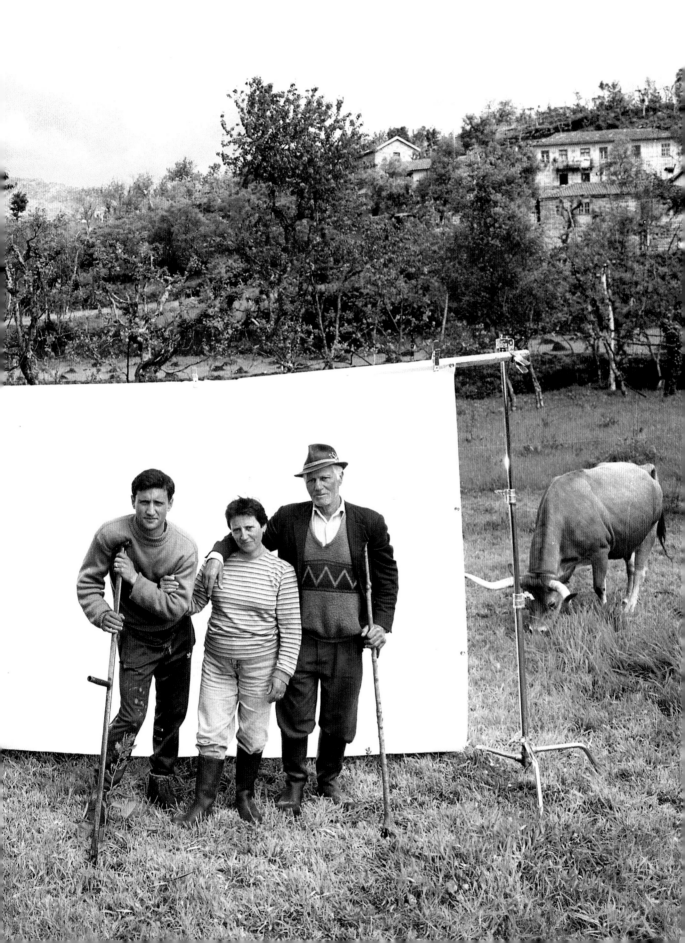

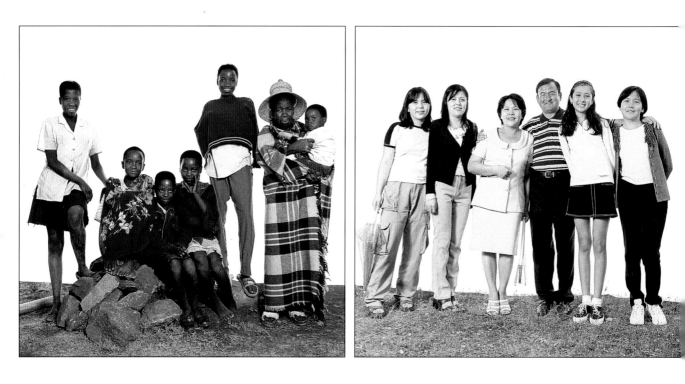

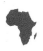

Malealea,
Lesotho,
7 October 1997

Seit ihr Mann bei einem Autounfall auf einer der äußerst gefährlichen Straßen Lesothos ums Leben gekommen ist, schlägt sich Belini mit ihren sechs Kindern allein durch. Ohne die Hilfe der Nachbarn wüsste sie nicht weiter. Sie trägt die landesübliche Kopfbedeckung, deren Form einem Hügel in der Nähe des königlichen Palastes nachempfunden ist.

Since the death of her husband after a car accident on the extremely dangerous road which traverses Lesotho, Belini has been on her own with her six children, and is only able to keep going because of help from her neighbours. She wears the traditional hat, the shape of which represents a hill near the royal palace.

Depuis le décès de son mari, des suites d'un accident de voiture sur la route fort dangereuse qui traverse le Lesotho, Belini est seule avec ses six enfants et ne subsiste que grâce à l'aide de ses voisins. Elle porte le chapeau traditionnel, dont la forme représente une colline située près du palais royal.

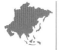

Almaty,
Kazakhstan,
5 September 1999

Diese Familie ist in die frühere Hauptstadt [heute Astana] gezogen, wo die Kinder bessere Ausbildungsmöglichkeiten haben. Die älteste Tochter will Juristin wie ihre Mutter werden, die zweitälteste möchte Zollbeamtin werden, die dritte nach dem Sprachenstudium in Moskau Botschafterin und das Nesthäkchen wird Model oder Tänzerin oder einfach beides. Der Vater dieser jungen Damen arbeitet bei der Bahn und schwärmte uns von seinen Auslandsreisen vor. „Aber das war noch unter den Kommunisten, damals war alles einfacher. Heute sind solche Fahrten undenkbar."

The parents moved to the former capital [now Astana] to get a better education for their children, who have various ambitions. The eldest wants to be a lawyer like her mother, the next to be a customs inspector, the third an ambassadress (after studying at the Institute of World Languages in Moscow) and the youngest a top model or dancer, or maybe both. The father of these girls is a railway official, and told us about his many trips abroad. "But that was before, in the Communist era, when everything was easier. Today it's impossible."

Les parents sont venus habiter la capitale pour offrir une meilleure éducation à leurs enfants, qui se destinent à des métiers divers : l'aînée veut être juriste comme maman, la suivante inspectrice des douanes, la troisième ambassadrice après avoir étudié à l'Institut des langues du monde à Moscou, la dernière top model ou danseuse ou peut-être les deux ! Le papa de ces jeunes filles est agent de chemin de fer et nous a conté ses nombreux voyages à l'étranger. « Mais c'était avant, à l'époque communiste, tout était plus facile, aujourd'hui c'est impossible ! »

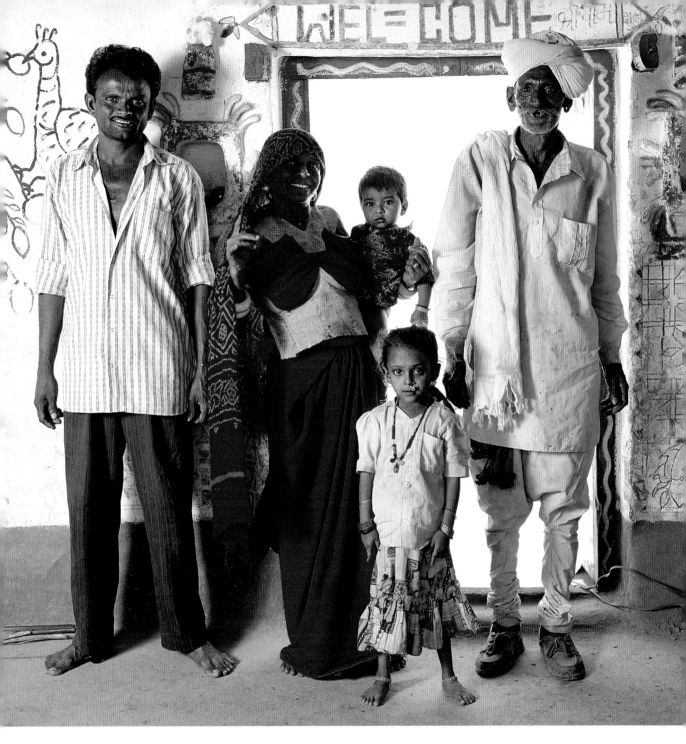

Delvada,
India,
20 October 1999

Diese Bauernfamilie erntet hauptsächlich Erdnüsse, Baumwolle und einige Kokosnüsse. Außerdem hält sie eine Kuh, die sie mit der täglichen Milch versorgt, und einen Büffel, der den Traktor ersetzt. Das Foto zeigt die Eltern mit einem ihrer Söhne und zwei Enkeln, die in der Obhut der Großeltern bleiben, während die Eltern auf dem Feld arbeiten.

They are farmers, planting mainly groundnuts and cotton as well as harvesting a few coconuts. A cow provides them with milk, and a buffalo stands in for a tractor to plough the land. Here they are with one of their sons and two grandchildren, whom they look after while the parents work in the fields.

Agriculteurs, ils plantent surtout des cacahuètes, du coton et récoltent un peu de noix de coco. Une vache leur fournit le lait et un buffle remplace le tracteur pour labourer. Ici avec un de leurs fils et deux petits enfants qu'ils gardent pendant que les parents travaillent aux champs.

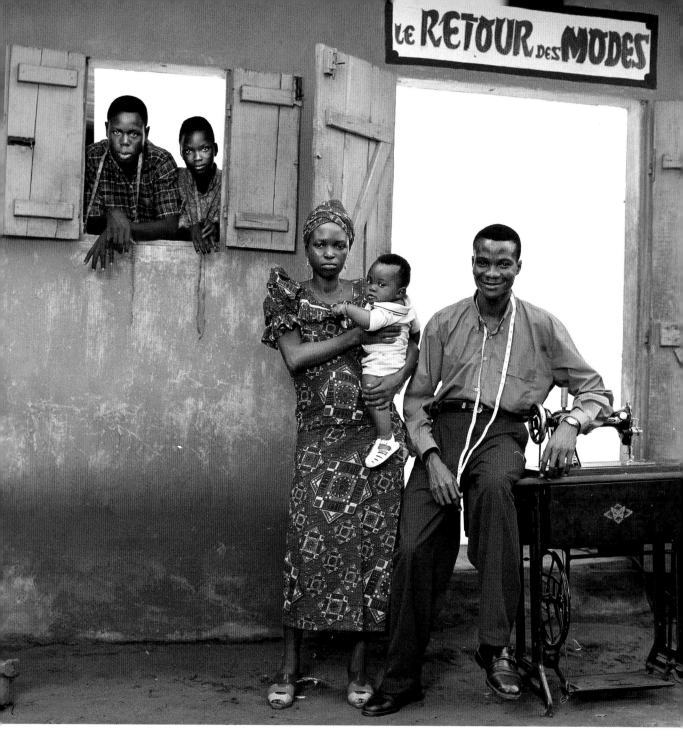

 Abomey,
Benin,
12 July 1997

Denis ist der Inhaber einer Schneiderei direkt an der Hauptstraße. Was er nicht selbst entwirft, kopiert er: „Schließlich kann man nicht immer neue Ideen haben." Er bestand darauf, dass seine beiden Lehrlinge mit aufs Foto kommen, da sie für ihn zur Familie gehören. Als wir ihn fragen, ob er denn nett zu seiner Ehefrau sei, die ihm bei der Arbeit zur Hand geht, antwortet er verschmitzt: „Ich bin so geradlinig, wie eine Nadel läuft …"

Denis owns his own dressmaking workshop on the main street. When he's not creating designs, he's copying, "because you can't be having ideas all the time." He wanted his two apprentice workers to be in the photo, as he regards them as part of his family. When we ask him if he's nice to his wife, who helps him, he answers mischievously: "I'm as straight as a die with her … "

Denis est propriétaire de son atelier de couture situé sur la rue principale. Quand il ne crée pas, il copie: « Parce que on ne peut pas avoir des idées tout le temps! » Il a souhaité que ses deux ouvriers apprentis figurent sur la photo, il les considère comme partie intégrante de la famille. Quand nous lui demandons s'il est gentil avec son épouse qui le seconde, il répond malicieux: « Je file droit comme une aiguille … »

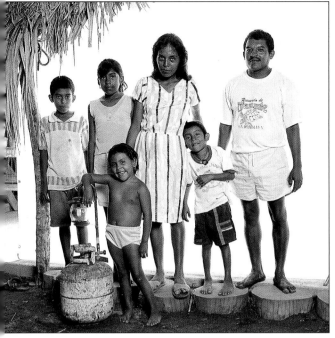
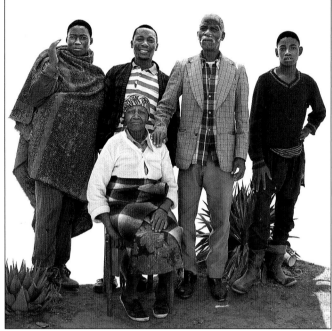

 Playa Ventanilla,
Mexico,
5 December 1998

Als „Krokodilschützer", wie er sich selbst bezeichnet, arbeitet Vicente in einem städtischen Projekt zum Schutz einer vom Aussterben bedrohten heimischen Krokodilart. „Ich glaube nicht, dass die Welt untergeht, wie einige behaupten. Das Jahr 2000 wird ein Jahr wie jedes andere."

Vicente describes himself as a "crocodile conservationist." He's currently working on a municipal project to protect an endangered local crocodile species. "I don't believe the world will end, as some people claim," he says. "2000 will be a year like all the others."

« Conservateur de crocodiles », comme il se définit lui-même, Vicente travaille sur un projet municipal de protection d'un crocodile local menacé d'extinction. « Je ne crois pas à la fin du monde comme certains le prétendent, dit-il, l'an 2000 sera une année comme les autres. »

Malealea,
Lesotho,
7 October 1997

Joseph versichert uns, dass er Priester sei und als solcher 20 Jahre in Südafrika gearbeitet habe. Jetzt lebt er mit seiner Familie in diesem abgelegenen Teil des gebirgigen Königreichs.

Joseph tells us he's a priest and that he did a 20-year stint in South Africa. He now lives with his family in this remote part of the tiny mountain kingdom.

Joseph nous affirme qu'il est prêtre catholique et qu'il a exercé pendant vingt ans en Afrique du Sud. Il vit avec sa famille dans cette région reculée du royaume.

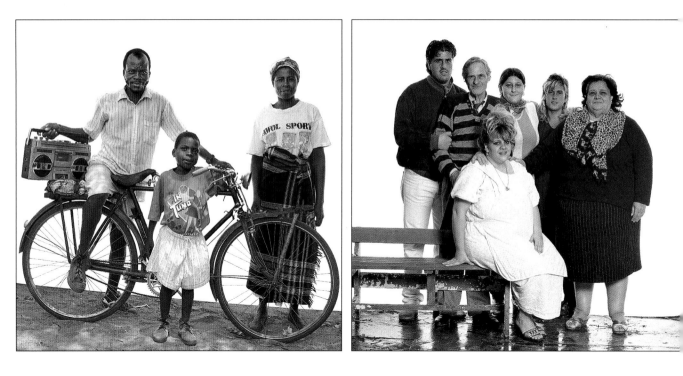

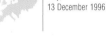

Monkey Bay,
Malawi,
30 October 1997

Neben seiner Familie besitzt Moses zwei weitere Schätze: ein Lastenfahrrad mit Doppelgepäckträger und einen Radiorekorder (momentan wegen leerer Batterien außer Betrieb), von dem er sich nie trennt, auch nicht bei der Arbeit auf dem Feld …

Apart from his family, Moses has two treasures – his Chinese bicycle with a double rack, and a radio-cassette player (currently not working because the batteries are dead), which he carries with him at all times, especially when he's working in the fields …

En dehors de sa famille, Moses a deux richesses : sa bicyclette chinoise à double porte-bagages et un poste de radio-lecteur de cassettes (actuellement hors service à cause des piles vides) dont il ne se sépare jamais, surtout quand il travaille aux champs …

Naples,
Italy,
13 December 1996

Anna und Ernesto haben zwölf Kinder, von denen vier noch im elterlichen Haus leben, inmitten der römischen Ruinen des berühmten Parca Virgiliana, bekannt als Treffpunkt der Liebespärchen von Neapel. Ernesto arbeitet hier seit 16 Jahren als Parkwächter. Die beiden hoffen, dass ihre Kinder noch lange bei ihnen wohnen bleiben – die Chancen dafür stehen gut, denn die ganze Familie schwärmt für die neapolitanische Küche von Mama Anna …

Anna and Ernesto have twelve children, four of whom still live with them at home amid the ruins of the famous Roman Parca Virgiliana, more commonly known as Lovers' Park on account of its popularity with courting Neapolitan couples. Ernesto has been the caretaker of this park for 16 years. They are hoping that their children will remain at home with them for many years to come. The whole family loves Mamma's Neapolitan cooking …

Anna et Ernesto ont douze enfants, dont quatre vivent encore avec eux dans leur pavillon entouré de ruines romaines du célèbre « Parca Virgiliana », plus communément appelé « Parc d'Amour » et très fréquenté par les amoureux de Naples, dont Ernesto est le gardien depuis seize ans. Ils espèrent que leurs enfants resteront encore longtemps avec eux. Toute la famille adore la cuisine napolitaine de mama Anna …

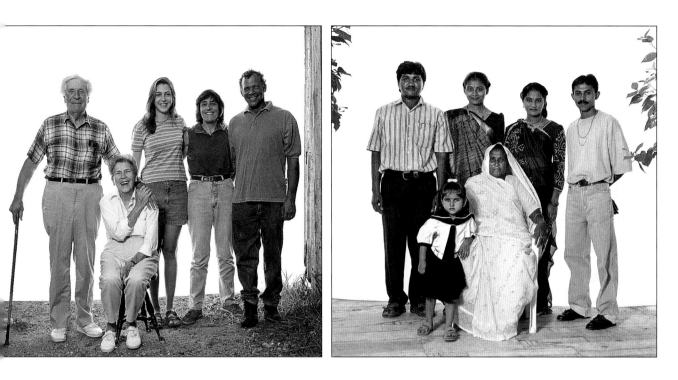

Brookhaven,
New York, USA,
6 September 1998

Sie kennen sich seit der Grundschule … Bill, Eigentümer einer kleinen Marina in der Bucht von Long Island, und Ninon, Schulbusfahrerin, haben sich für das neue Jahrtausend vorgenommen, ihr Leben zu ändern. Allerdings wollen sie in der Gegend bleiben, wo sie ihre gesamte Jugend verbracht haben und wo ihre Eltern wohnen (auf dem Foto Bob und Helen, die Eltern von Bill). Ihre Tochter Anny möchte gern weite Reisen unternehmen, sie hat sich im Peace Corps eingeschrieben und wird in Kürze nach Afrika gehen.

They've known one another since nursery school: Bill, who owns a small marina in Long Island Bay, and school-bus-driver Ninon have decided to change the way they live in the new millennium, but without leaving the area where they spent their childhood and where their parents live (in the picture are Bob and Helen, Bill's parents). Their daughter Anny hankers after foreign travel. She's just joined the Peace Corps and will be off to Africa shortly.

Ils se connaissent depuis la maternelle … Bill, propriétaire d'une petite marina dans la baie de Long Island, et Ninon, conductrice de bus scolaire, ont décidé de changer de vie pour l'an 2000, sans toutefois quitter la région où ils ont vécu toute leur jeunesse et où résident leurs parents (ici Bob et Helen, les parents de Bill). Leur fille Anny a des envies de grands voyages, elle vient de s'engager au Peace Corps pour partir en mission en Afrique.

Patelwadi,
India,
21 October 1999

Obwohl sie selbst keinen Tropfen Alkohol trinken, besitzen sie mehrere Weinläden sowie die Friendship Bar, wo selbst gebrannter Schnaps, Portwein, Rum, Wodka, Whiskey, Gin, Champagner und Bier in Strömen fließen. All das haben sie ihrem Vater zu verdanken, der ihnen bei seinem Tod vor zehn Jahren auch den landwirtschaftlichen Betrieb hinterließ, wo sie heute noch, wie alle Bauern der Gegend, hauptsächlich Erdnüsse anbauen.

They do not drink alcohol, but nonetheless own several wine shops and the Friendship Bar, where alcohol flows freely: locally made liquor, port, rum, vodka, whisky, gin, champagne and beer. Their father, who passed away ten years ago, bequeathed them these businesses, but they have also kept their land and the farm where they produce groundnuts, like all the farmers in this area.

Ils ne consomment pas d'alcool, mais sont propriétaires de plusieurs « Wine shop » et du « Friendship bar » où l'alcool coule à flots : alcool de fabrication locale, porto, rhum, vodka, whisky, gin, champagne et bière ! C'est leur père, décédé il y a dix ans, qui leur a légués, les commerces, ils ont également gardé leurs terres et l'exploitation agricole où ils produisent, comme tous les fermiers des environs, des arachides.

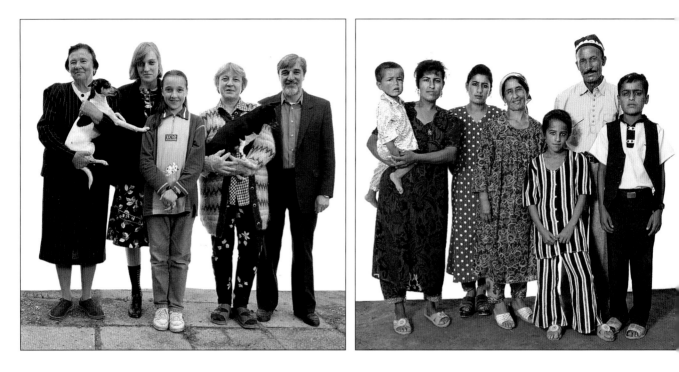

Minsk,
Belarus,
18 July 1998

Die Kolesnikows teilen ihre Begeisterung für die französische Sprache und die frankophonen Länder. Auf Drängen seiner Großmutter hat Vadim Französisch studiert und es nie bereut. Jedes Jahr organisieren sie einen Besuch französischer Studenten in Minsk, um den jungen Weißrussen die Sprache von Voltaire und den jungen Franzosen die Herzlichkeit und Lebensfreude der Weißrussen nahe zu bringen. „Wir würden sehr gern am 10. Kongress der Französischlehrer teilnehmen, der im Jahr 2000 in Paris stattfinden wird."

The Kolesnikovs share a passion for the French language and French-speaking countries. It was Vadim's grandmother who made him study French, and he's never regretted it. Every year they organize a visit by French students to Minsk, to familiarize young people in Belarus with the language of Voltaire and the young French visitors with their hosts' friendliness and *joie de vivre*. "We'd love to attend the 10th conference of French teachers, which is being held in Paris in 2000."

Les Kolesnikova partagent la même passion pour la langue française et les pays francophones. C'est la grand-mère de Vadim qui l'a poussé à étudier le français, et il ne l'a jamais regretté. Tous les ans, ils organisent la venue d'étudiants français à Minsk, pour sensibiliser les jeunes Biélorusses à la langue de Voltaire et les jeunes Français à la cordialité et la joie de vivre des Biélorusses. « Nous aimerions beaucoup assister au 10ᵉ congrès des professeurs de français qui aura lieu justement à Paris en l'an 2000. »

Arabchona,
Uzbekistan,
13 September 1999

Kamal ist einer der Hirten des Dorfs, die insgesamt 500 Schafe hüten. Immer wieder bricht er für mehrere Tage auf, um seine Herde auf saftiges Weideland zu führen.

Kamal is one of the shepherds who tend the village's 500 sheep. He regularly goes off for several days to take the flock to greener pastures.

Kamal est un des bergers qui s'occupent des cinq cents moutons du village. Il s'absente régulièrement, durant plusieurs jours, pour mener le troupeau vers des prairies bien vertes.

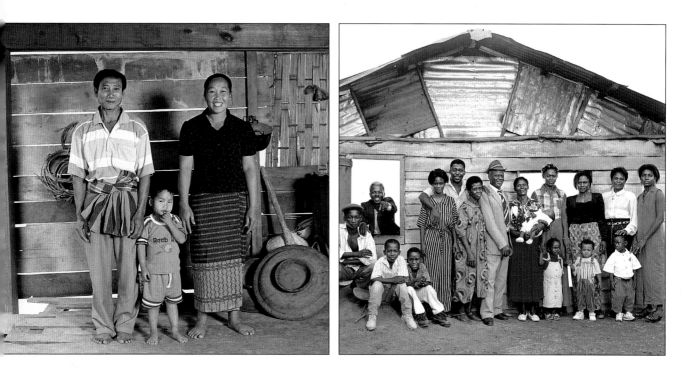

Ban Keit Ngong,
Laos,
30 January 2000

Boun ist als Dorfoberhaupt sehr beliebt. Dreimal wurde er bisher von den 134 Familien des kleinen Bauerndorfs wiedergewählt. Die einzige Schattenseite: Boun und Suem haben keine Kinder bekommen. Daher haben sie sich für das Foto schnell noch einen Großneffen ausgeliehen.

Boun is highly esteemed as village headman, having been re-elected three times by the 134 families in this little village of farmers. The only snag is that Boun and Suem haven't had any children, so for the photo they quickly borrowed a great-nephew.

Boun est un chef de village très estimé, il a été réélu trois fois, par les cent trente-quatre familles de ce petit village d'agriculteurs. Seule ombre au tableau, Boun et Suem n'ont pas eu d'enfants, alors pour la photo ils ont emprunté, vite fait, un petit-neveu.

Ebebiyín,
Equatorial Guinea,
15 August 1997

Guillermo lebt im Kreis seiner acht Kinder, neun Enkelkinder und seiner Geschwister. Der Landwirt erntet gerade eben genug Maniok, um die vielen Münder zu stopfen. Trotzdem kann er sich nicht vorstellen, die Familie auseinander zu reißen. Er gratuliert Präsident Bédié herzlich dazu, sich an dem humanistischen Werk, das *1000 Families* in seinen Augen ist, beteiligt zu haben. Er ist stolz, zu den ausgewählten Familien zu gehören und sein Foto neben Familien aus der ganzen Welt zu sehen.

Guillermo lives surrounded by his eight children, his nine grandchildren and his brothers and sisters. He is a farmer and harvests just enough cassava to feed all these mouths, but despite this he can't imagine the family dispersing. He warmly congratulates President Bédié for taking part in the humanist project represented by the *1000 Families*. He is very proud to be one of the families chosen and to see his photo alongside families from all over the world.

Guillermo vit entouré de ses huit enfants, de ses neuf petits-enfants et de ses frères et sœurs. Agriculteur, il récolte juste assez de manioc pour nourrir toutes les bouches, malgré cela il ne peut imaginer que la famille « s'éparpille ». Il félicite chaleureusement le président Bédié pour sa participation à l'œuvre humaniste que sont les « 1000 Familles », il est très fier de faire partie des familles choisies et de voir sa photo à côté de familles du monde entier.

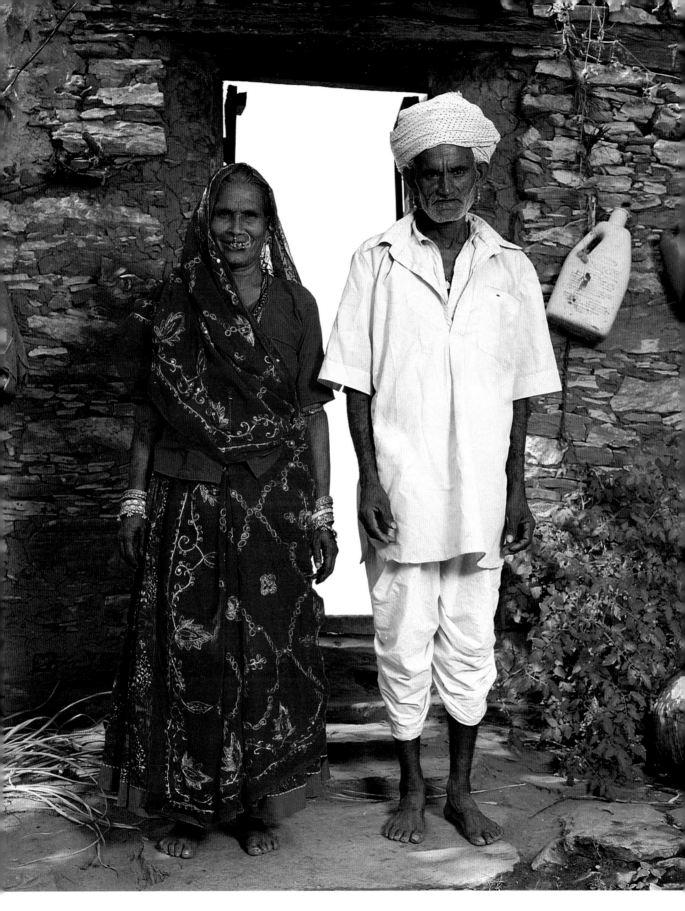

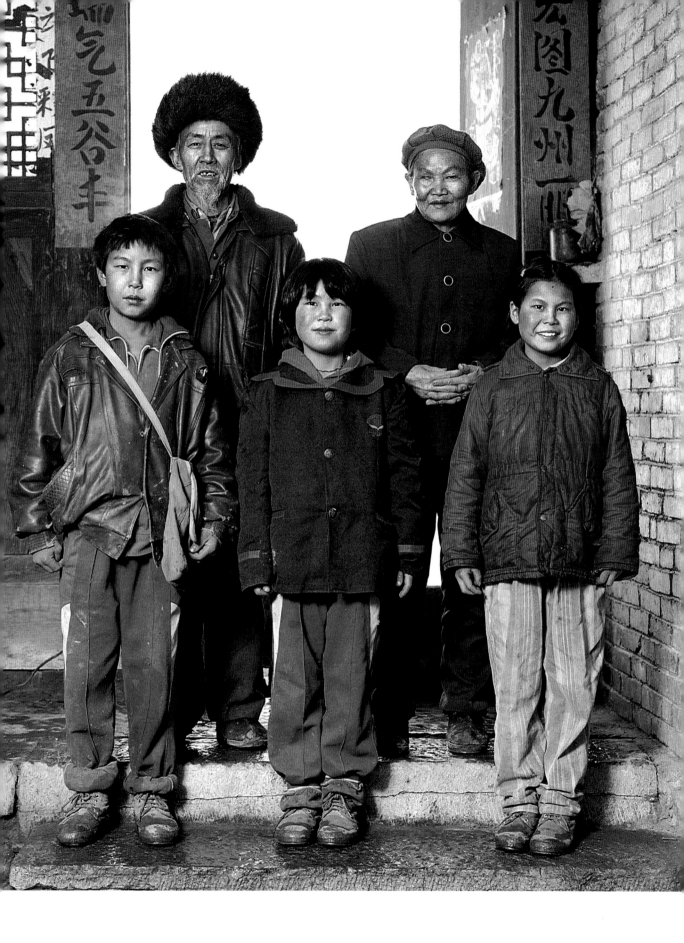

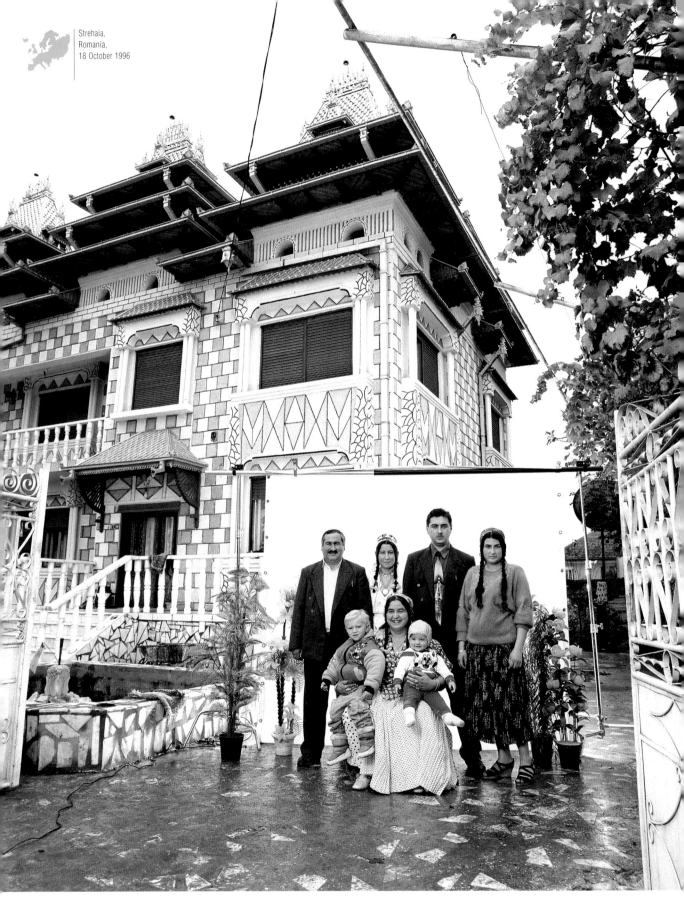

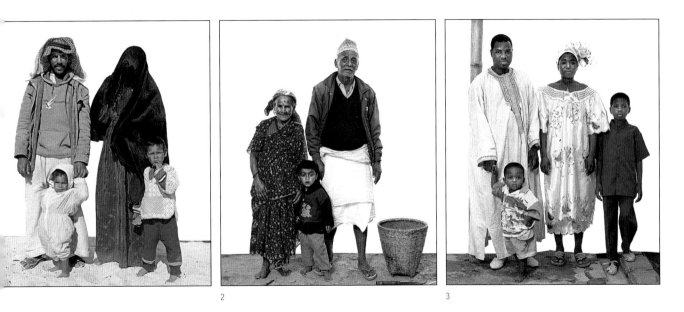

2

3

Nainda und Tamu sind um die 60 und ein glückliches Bauernpaar. Ihre drei Kinder sind alle verheiratet und haben eine feste Arbeit. Der erste ist Lehrer, der zweite Bauer wie sein Vater und die Tochter verkauft Milch auf dem Markt.

Nainda and Tamu, who are about 60 years old, are small farmers and well contented with their life. Their three children are married and have all found work – the first is a teacher, the second a farmer like his father, and the third a milk vendor at the market.

Nainda et Tamu ont environ soixante ans et sont des paysans heureux, leurs trois enfants sont mariés et ont tous trouvé du travail ; le premier est enseignant, le deuxième est fermier comme papa, la troisième est vendeuse de lait au marché.

Sie erinnern sich nicht mehr an das genaue Datum ihrer Hochzeit. „Das ist so lange her", entschuldigt sich Wu Chiu. Da ihr einziger Sohn im Gefängnis sitzt und ihre Schwiegertochter verstorben ist, haben sie die Erziehung ihrer drei Enkelkinder übernommen.

They can't remember the date of their wedding: "It was so long ago," Wu Chiu says, apologetically. Their only son is in prison and their daughter-in-law dead, so they are bringing up their three grandchildren.

Ils ne se rappellent pas la date de leur mariage. « Cela fait si longtemps ! », s'excuse Wu Chiu. Leur fils unique est en prison, leur belle-fille est décédée, alors ce sont eux qui élèvent leurs trois petits-enfants.

Der Großvater ist stolze 38, der Vater gerade mal 20 und der älteste Sohn fünf Jahre alt – für Roma nichts Ungewöhnliches, denn traditionsgemäß heiraten sie mit 14 Jahren. Sie sind die Wohlhabendsten in dieser kleinen Stadt. Ihre Häuser erinnern an indische Paläste. Ihr „Business" betreiben sie in der Familie. Die Visitenkarte von Mihai (20) weist ihn lakonisch als „Manager" aus – ohne jede weitere Präzisierung.

The grandfather is 38, the father 20 and the first son five years old – nothing unusual for Romanian Gypsies, who traditionally marry at the age of 14. They are the wealthiest inhabitants of this small town, where they build luxurious homes resembling Indian palaces. Their "business" is a family affair. The business card of 20-year-old Mihai describes him as "Manager" – but of what? We never found out.

Le grand-père a trente-huit ans, le père vingt ans et le premier fils cinq ans. Les gitans de Roumanie se marient à partir de quatorze ans et sont les habitants les plus fortunés de cette petite ville, où ils construisent des maisons extravagantes ressemblant à des palais indiens. Ils sont dans les « affaires » de père en fils. La carte de visite de Mihai (vingt ans) le présente comme « manager » – mais nous n'avons pas réussi à savoir de quoi !

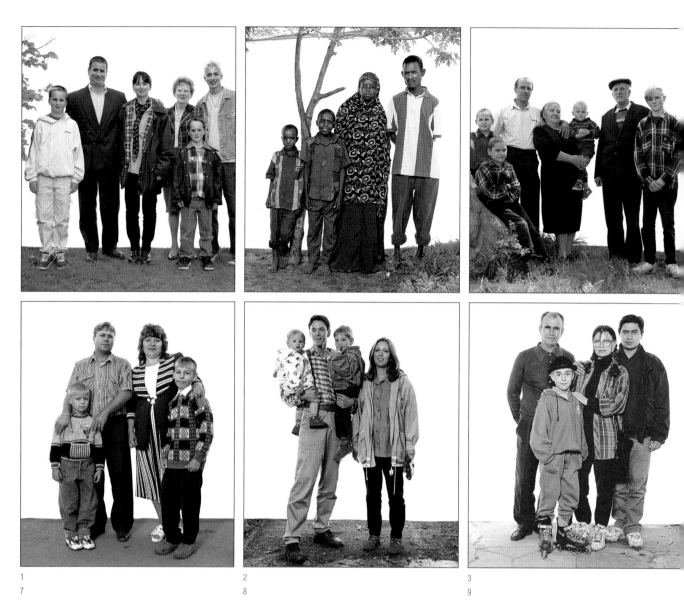

1
7

2
8

3
9

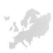

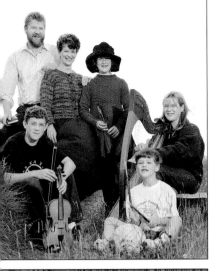

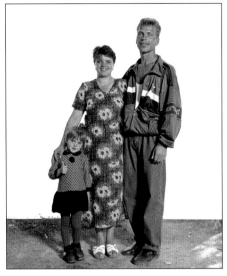

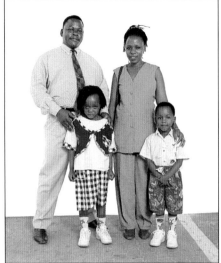

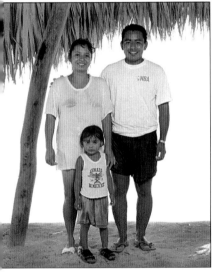

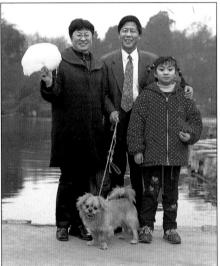

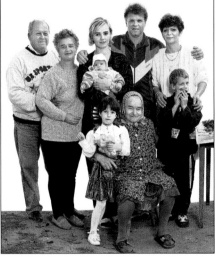

5
11

6
12

5
Talas,
Kyrgyzstan,
7 September 1999

6
Maun,
Botswana,
18 October 1997

11
Guiyang,
China,
5 March 2000

12
Sármellék,
Hungary,
12 October 1996

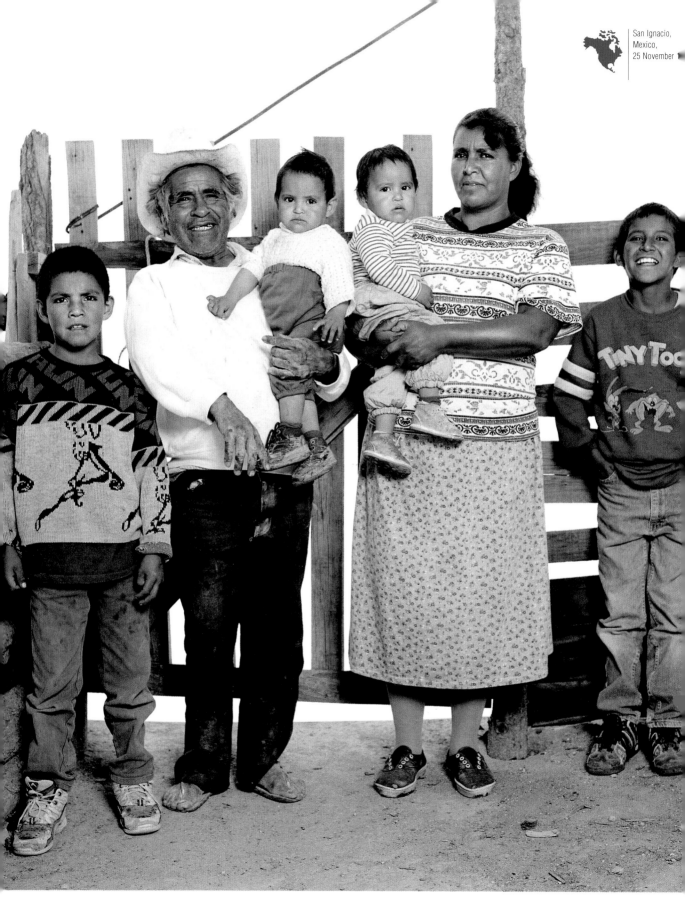

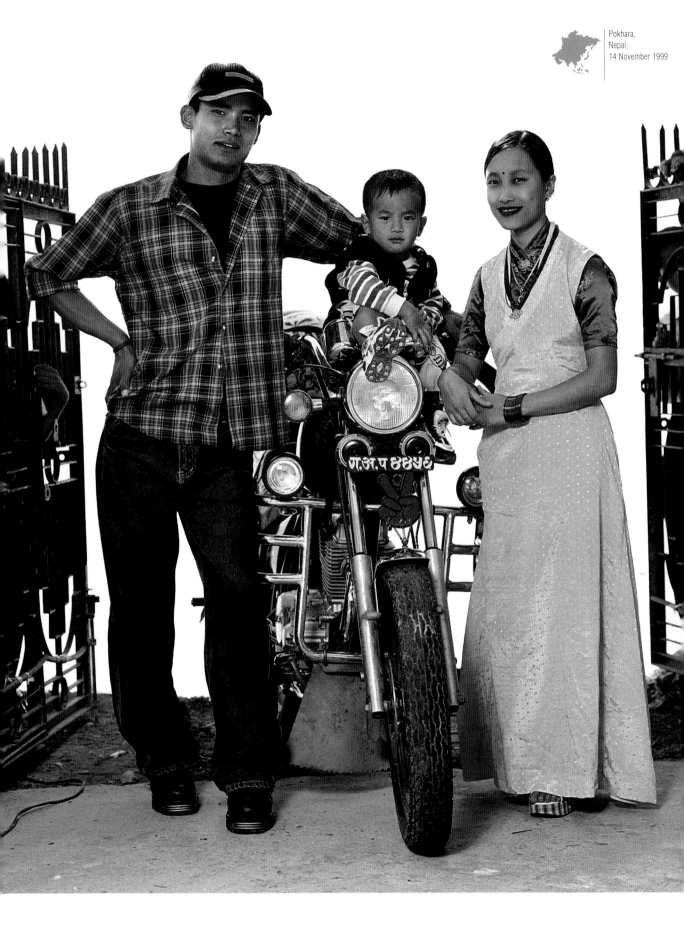

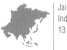
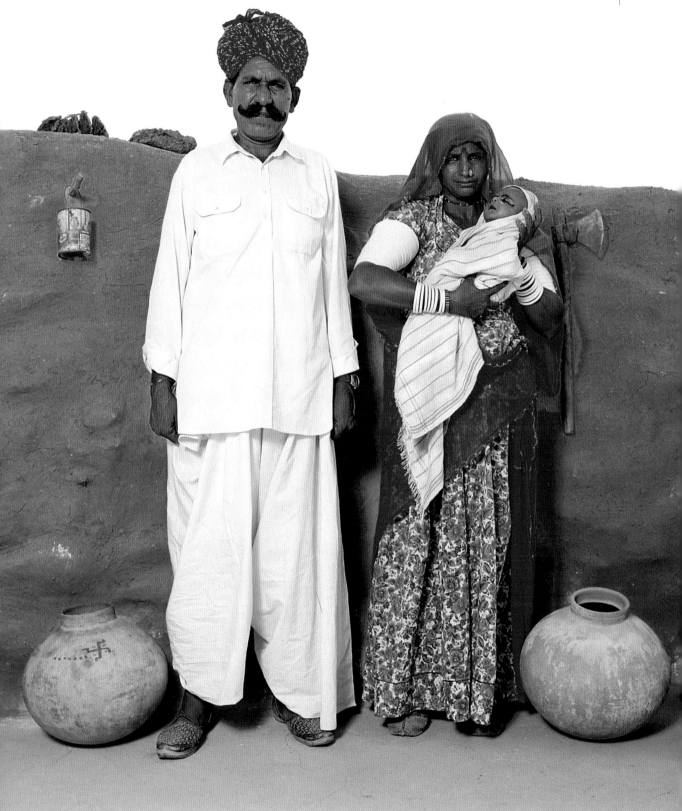

Reyes und Alicia haben bescheidene Wünsche. Sie hoffen, dass der Boden, den sie bestellen, weiterhin genug abwirft, um ihre vier Kinder großzuziehen und sie zur Schule zu schicken, „damit sie eine Schulausbildung erhalten und einmal ein besseres Leben haben."

Reyes and Alicia have simple expectations: that the land they work will continue to give them what they need to raise their four children, and that the children will go to school "to get an education and have a better life," they tell us.

Reyes et Alicia ont des attentes simples : que la terre qu'ils cultivent continue à leur donner de quoi élever leurs quatre enfants et que ceux-ci fréquentent l'école, « pour qu'ils aient de l'instruction et une vie meilleure ! », nous disent-ils.

Sie kannten sich schon als Kinder und ihre Hochzeit war seit langem beschlossene Sache. „Wir sind eine moderne Familie, daher reicht uns ein Kind", sagt Maniprasad. Sie arbeiten beide nicht und leben im Haus der Eltern.

They knew each other as children, and their marriage was planned a long time ago. "We are a modern family, and one child is enough for us," says Maniprasad. They don't work, and they live in the father's house.

Ils se sont connus enfants et leur mariage était prévu depuis longtemps. « Nous sommes une famille moderne et un enfant nous suffit », dit Maniprasad. Ils ne travaillent pas et vivent dans la maison paternelle.

Tolsaram ist ein angesehener Mann: Seit er als Archäologe im Staatsdienst ist, ziehen die Nachbarn den Hut vor ihm. Auf dem Foto zeigt er sich mit Ehefrau und Enkel, auf dessen Mutter wir leider verzichten mussten, da sie ihrem Schwiegervater nur verschleiert entgegentreten darf.

Tolsaram is a respected man. He has managed to land a "government job" in the department of archaeology, which gives him a certain prestige among his neighbours. He poses here with his wife and his grandson, whose mother could not be in the photo because, out of respect for her father-in-law, she has to remain veiled in his presence.

Tolsaram est un homme respecté : il a réussi à obtenir un « poste gouvernemental » dans le département d'archéologie, ce qui lui donne un certain prestige auprès de ses voisins. Il pose ici avec sa femme et son petit-fils, dont la mère n'a pas pu figurer sur la photo car, par respect pour son beau-père, elle doit rester voilée en sa présence.

Sie sind Eigentümer eines Reiterhofs, der viel von Kindern besucht wird. Sie haben 70 Ponys und Pferde, und die Wände im Haus zieren unzählige Trophäen, die ihre Pensionsgäste gewonnen haben. Angela und ihre Schwester Diana sind – mit Freude – sieben Tage die Woche auf dem Hof im Einsatz, während Angelas Mann Danny die Produktion in einer Milchfabrik beaufsichtigt. Ihre Kinder saßen bereits im Sattel, ehe sie laufen konnten.

They own a riding school that is very popular with children. They have 70 ponies and horses, and the walls of their home are covered with the countless trophies won by their pupils. Angela and her sister Diana work – gladly – seven days a week with the horses and riders, while Angela's husband Danny has a job as production supervisor in a dairy factory. Their children were in the saddle before they could even walk.

Ils sont propriétaires d'un centre équestre très fréquenté par les enfants. Ils possèdent soixante-dix poneys et chevaux, et les murs de leur maison sont décorés par les innombrables trophées gagnés par leurs pensionnaires. Angela et sa sœur Diane travaillent – avec plaisir – sept jours sur sept auprès des chevaux et des cavaliers, pendant que Dany, le mari d'Angela, est surveillant de production dans une usine de produits laitiers. Leurs enfants ont commencé à monter à cheval avant même de marcher.

Bardia,
Nepal,
11 November 1999

Bei Einbruch der Dunkelheit kehrte Pusparat mit seinem Elefanten, beladen mit Feuerholz und langen Gräsern für das Dach, zurück. Mit 14 Jahren hatte er eine Ausbildung als *Mahout* [Elefantenführer] angefangen und sechs Jahre später einen „eigenen" Elefanten bekommen, für den er Tag und Nacht verantwortlich ist. Er lebt und arbeitet in einem Elefantenlager, das zum Nationalpark Bardia gehört.

Pusparat returned home at nightfall with his elephant laden with fire wood for the kitchen and long grasses for the roof. He started his apprenticeship as a mahout at the age of 14, and got 'his' elephant six years later. He is in charge of it day and night, and lives and works in an elephant camp belonging to the Bardia National Park.

C'est à la tombée du soir que Pusparat est rentré avec son propre éléphant chargé de bois pour la cuisine et de longues herbes pour le toit. Pusparat a commencé son apprentissage de cornac à l'âge de quatorze ans, et a eu « son éléphant » dont il a la charge jour et nuit six ans plus tard. Il vit et travaille dans un camp d'éléphants appartenant au parc national de Bardia.

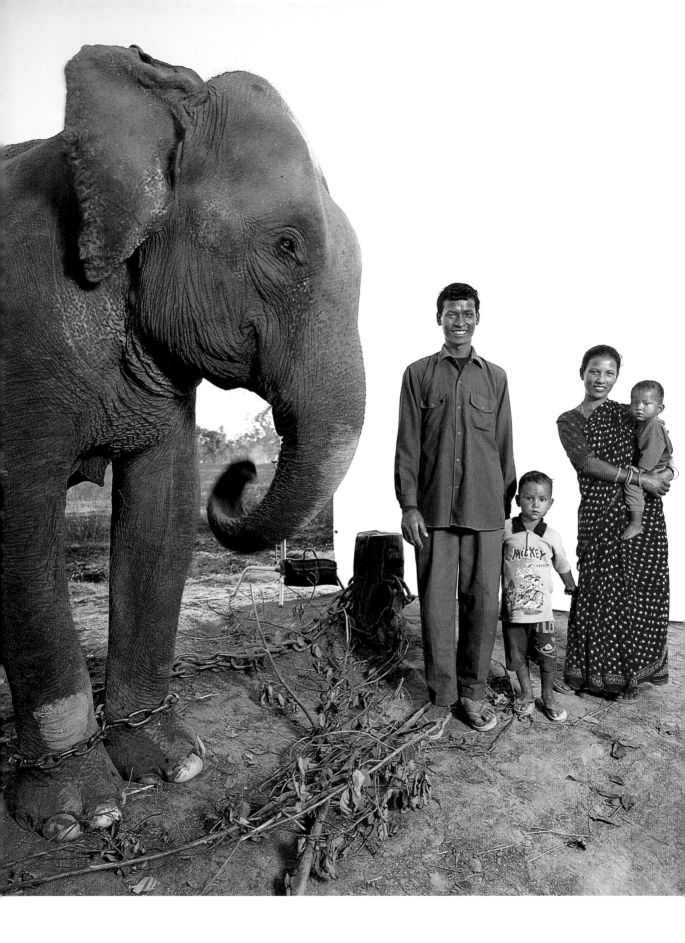

Mohanpura,
India,
29 October 1999

Der 85-jährige Bansi, nur noch Haut und Knochen, hat seinen Frieden mit
der Welt geschlossen: „Das wird das letzte Foto von mir, ich sterbe bald …
eine schöne Erinnerung für meine Kinder." Der ehemalige Erdnussbauer
erinnert sich an die Zeit, als hier das Jagdrevier des letzten Maharadschas
war und der Maharadscha zu Besuch kam. „Er war ein guter Mensch. In
Jahren der Dürre kam er und half uns."

Bansi, who is roughly 85, is all skin and bones, but full of serenity. "This
will be my last photo, as I'll be off soon – it'll be a memento for my children."
A groundnut planter, he remembers the time when the land was a game
reserve belonging to the last maharaja, and he remembers the maharaja's
visits. "He was very kind, and when we had drought problems, he came and
helped us."

Il ne lui reste que la peau sur les os, mais Bansi (quatre-vingt-cinq ans
environ) est plein de sérénité : « Ça sera ma dernière photo, bientôt je par-
tirai … Ce sera un souvenir pour mes enfants ! » Planteur d'arachide, il se
rappelle du temps où la terre était une réserve de chasse du dernier maha-
radja et des visites de celui-ci : « Il était très bon et quand on avait des
problèmes de sécheresse, il venait nous aider. »

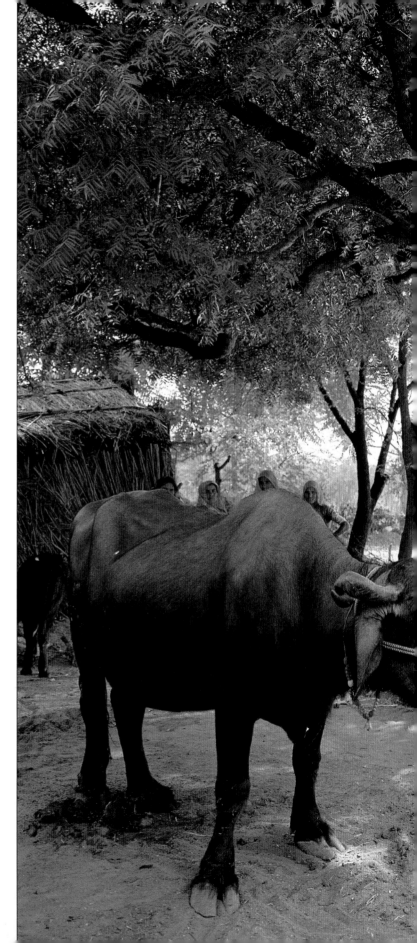

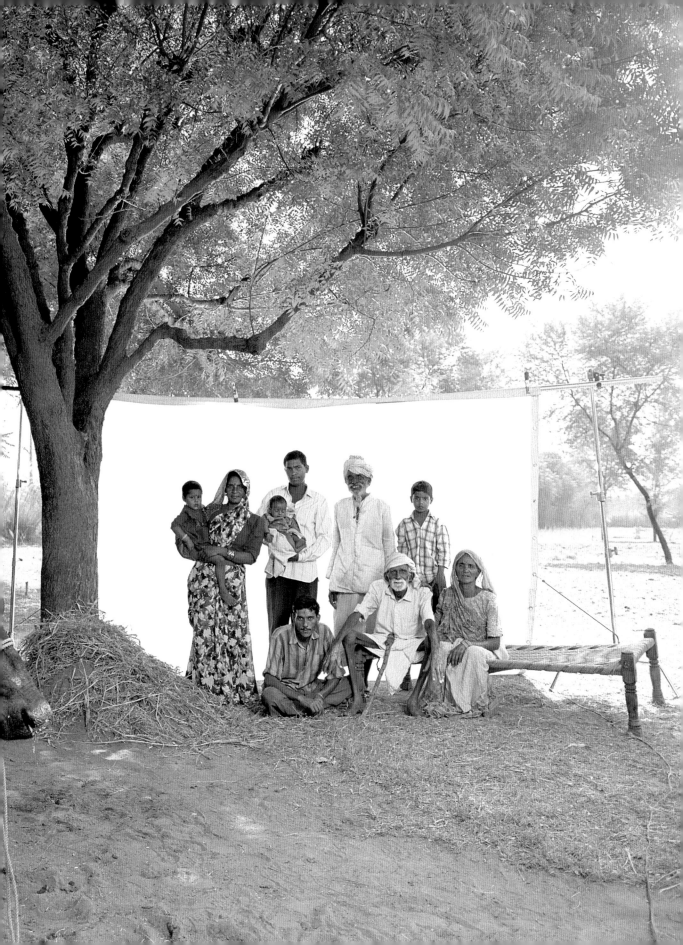

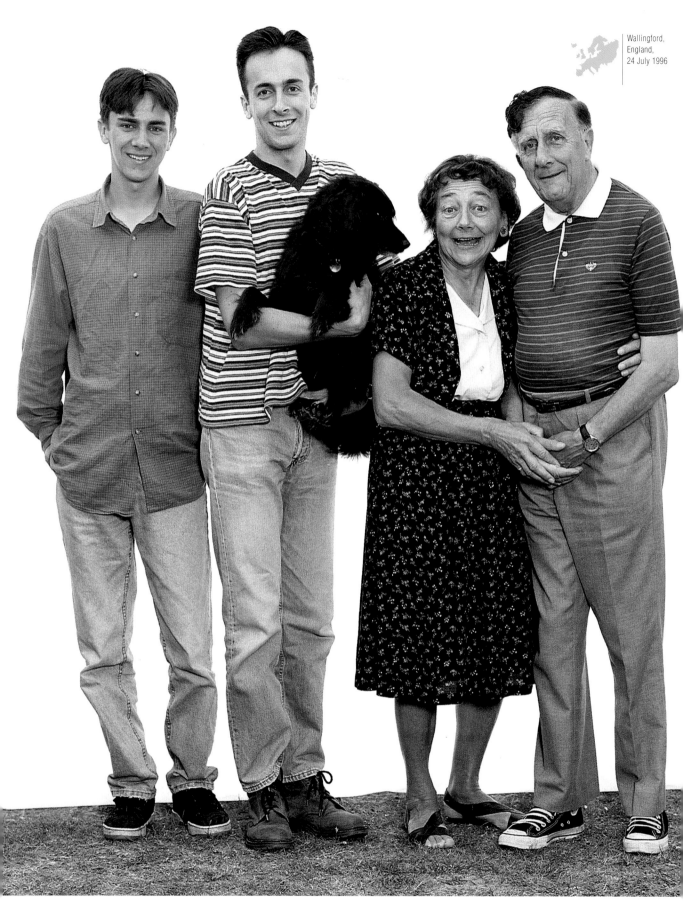

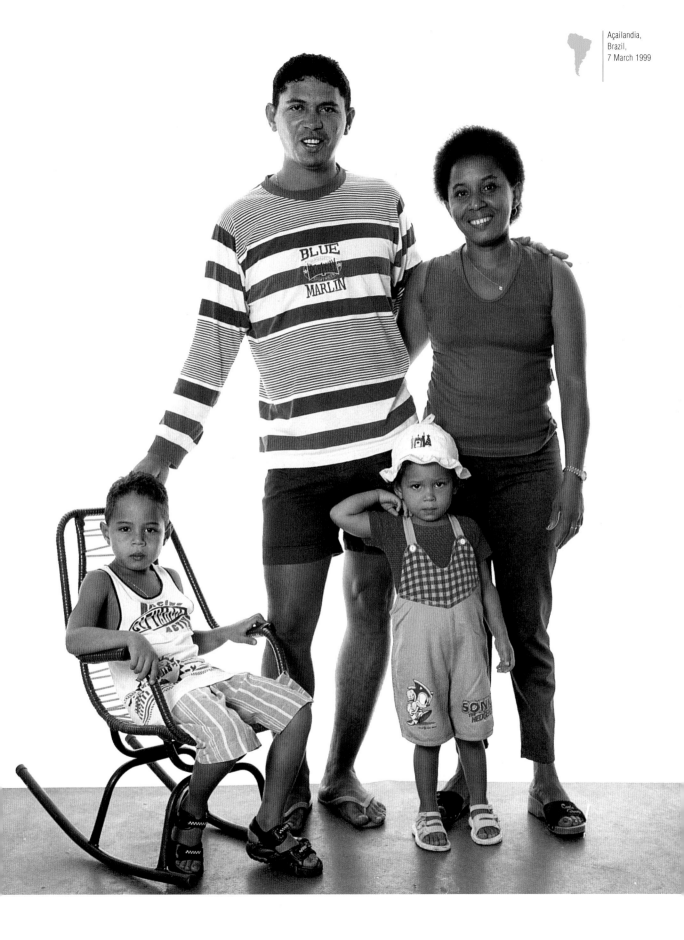

Page 364

Elizabeth und David waren überglücklich über unseren Besuch, denn ihr ältester Sohn Simon ging noch am selben Tag als Englischlehrer ins Ausland und dieses Foto sollte sie an die letzten gemeinsamen Stunden erinnern. Elizabeth ist Laienpriesterin in der Methodistengemeinde des Dorfs, während David, Buchhalter im Ruhestand, mit Hingabe Haus und Garten versorgt.

Elizabeth and David were thrilled by our visit. Their eldest son Simon was leaving that very day to teach English abroad, and for them this photo would be a memento of those last moments. Elizabeth is a lay minister at the village Methodist church, and retired accountant David looks after the home and the garden with his usual meticulous care.

Elisabeth et David étaient ravis de notre visite : Simon, leur fils aîné, partait le jour même enseigner l'anglais à l'étranger et cette photo serait pour eux un souvenir de dernière minute. Elisabeth est pasteur laïque à l'église méthodiste du village et David, s'occupe avec autant de soin de la maison et du jardin, que jadis de ses comptes : il était comptable.

Page 365

„Ich bin der verantwortliche Leiter der Nationalen Buchmesse, die in Manaus stattfindet, und heute ist ein Freudentag, denn meine Frau und meine Kinder sind zu Besuch gekommen", vertraut uns Manuel an, der im siebten Himmel schwebt.

"I'm in charge of the National Book Fair that's held in Manaus. Today is a very happy day because my wife and children have come to see me," Manuel tell us, in seventh heaven.

« Je suis responsable de la Fête Nationale du Livre organisée à Manaus et, aujourd'hui, c'est un jour de joie puisque ma femme et mes enfants sont venus me rendre visite », nous confie Manuel, aux anges.

Libreville,
Gabon,
21 August 1997

„Präsident Bédié ist ein großer Mann, weil er die Güte und die Intelligenz besessen hat, sich an diesem Projekt zu beteiligen. Ich hoffe, dass uns das neue Jahrtausend und die Ausstellung dieser Fotos dazu anregen werden, über die kommenden Jahre nachzudenken!" Otembe ist Journalist bei der Tageszeitung von Libreville und posiert hier mit seiner Frau, ihrem gemeinsamen Kind, seiner Schwester und seiner Nichte.

"President Bédié is a great man because he has had the goodness and intelligence to take part in this project. I hope that the new millennium and the photo exhibition will make us all think about the years to come," Otembe tells us. He works as a journalist on the Libreville daily and is posing here with his wife, their child, his sister and his niece.

« Le président Bédié est un grand homme pour avoir eu la bonté et l'intelligence de participer à ce projet, j'espère que l'an 2000 et l'exposition des photos nous fera réfléchir aux années à venir ! », nous déclare Otembe, journaliste au quotidien de Libreville, qui pose ici avec sa femme, leur enfant, sa sœur, sa nièce et son jounal.

Page 368

Leseratte Francis, von Beruf Stadtplaner, sammelt Zeitungen und Magazine, für deren Lektüre er keine Zeit hatte. Seine zweite Leidenschaft gilt einer einheimischen Spezialität: dem Bordeaux! Die studierte Ethnologin Martine arbeitet heute als Soziologin. Ihre Hobbys sind Schwimmen und Joggen. Die Kinder haben unterschiedliche Berufspläne: Architektur und Sprachen studieren – oder Profifußballer werden! Ihr Appell an die anderen Familien: „Kämpft für die Einhaltung der Menschenrechte und für mehr Toleranz untereinander!"

The bookworm Francis is a town planner and an enthusiastic collector of newspapers and magazines, which he doesn't have time to read. He also appreciates the local speciality, claret! Martine is an ethnologist by training and sociologist by profession, and likes swimming and jogging. Their children have a range of plans, none of them quite definite as yet, that include architect, languages, football champion! "May all families fight for human rights, tolerance and respect for others … " is their message.

Francis, urbaniste, amateur de lecture et grand collectionneur de journaux qu'il n'a pas eu le temps de lire, apprécie également la spécialité locale : le bordeaux! Martine, ethnologue de formation et sociologue de métier, aime la natation et le jogging. Leurs enfants ont des projets variables et pas encore sûrs : architecte, langues, champion de foot! Leur message : « Que toutes les familles se battent pour le respect des droits de l'homme, la tolérance et le respect de l'autre … »

Page 369

„Ich bin Geschäftsführer der landwirtschaftlichen Entwicklungsbank. Diese ist für landwirtschaftliche Projekte und die Bauern da, die nur schwer zu anderen Banken Zugang erhalten." Die Familie? „Wir sind sehr aktiv: Wir stehen um fünf Uhr morgens auf, joggen, spielen Fußball, besuchen die Verwandten und sonntags gehen wir zur Messe." Das neue Jahrtausend? „Das Bestreben, Geld zu verdienen, darf uns nicht davon abbringen, menschlich zu bleiben und unseren Kindern viel Aufmerksamkeit zu schenken."

"I'm manager of the agricultural development bank. It's close to the rural world and peasants who find it difficult to deal with other banks." The family?
"We're very busy: we get up at five in the morning, go jogging, play football, visit the family, and go to Mass on Sunday." The new millennium? "The desire to earn money must neither detract from our humanity nor from keeping watch over our children."

« Je suis gérant de la banque du développement agricole, elle est proche du monde rural et des paysans qui ont du mal à accéder à d'autres banques. » La famille? « Nous sommes très actifs : nous nous levons à cinq heures du matin, faisons du jogging, jouons au foot, rendons visite à la famille et le dimanche nous assistons à la messe. » L'an 2000? « Le désir de gagner de l'argent ne doit pas diminuer la fait d'être humain et attentifs à nos enfants ! »

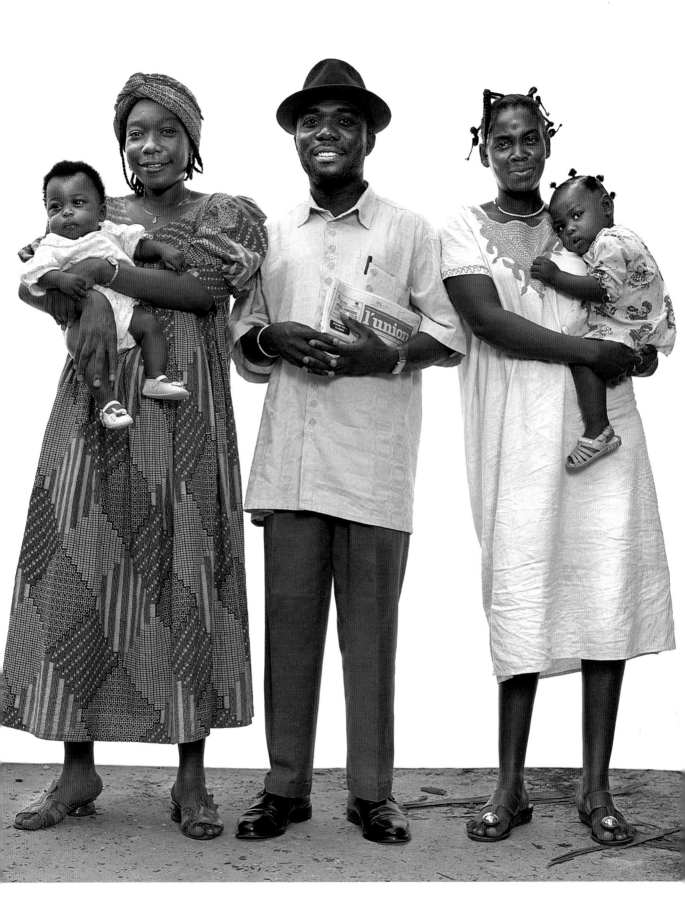

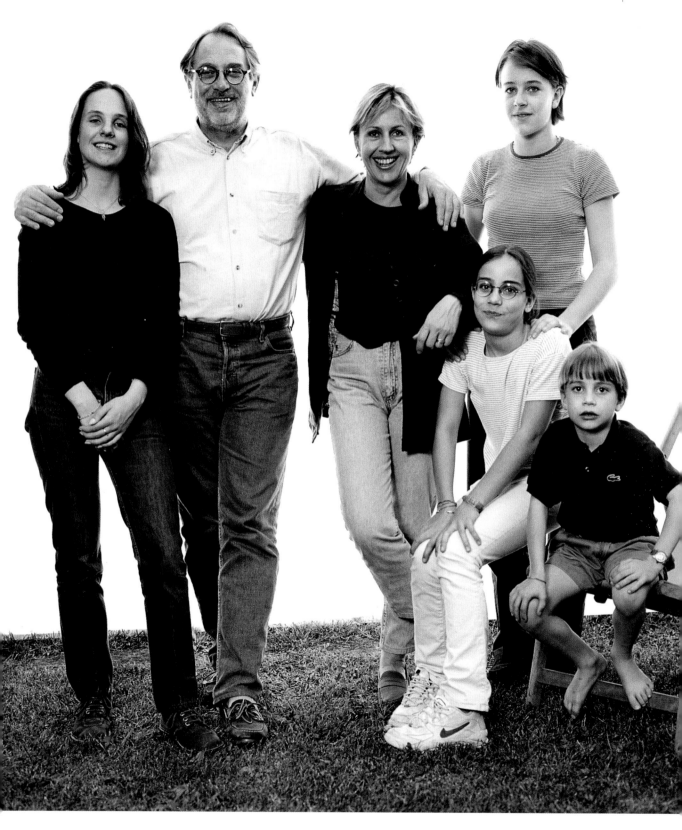

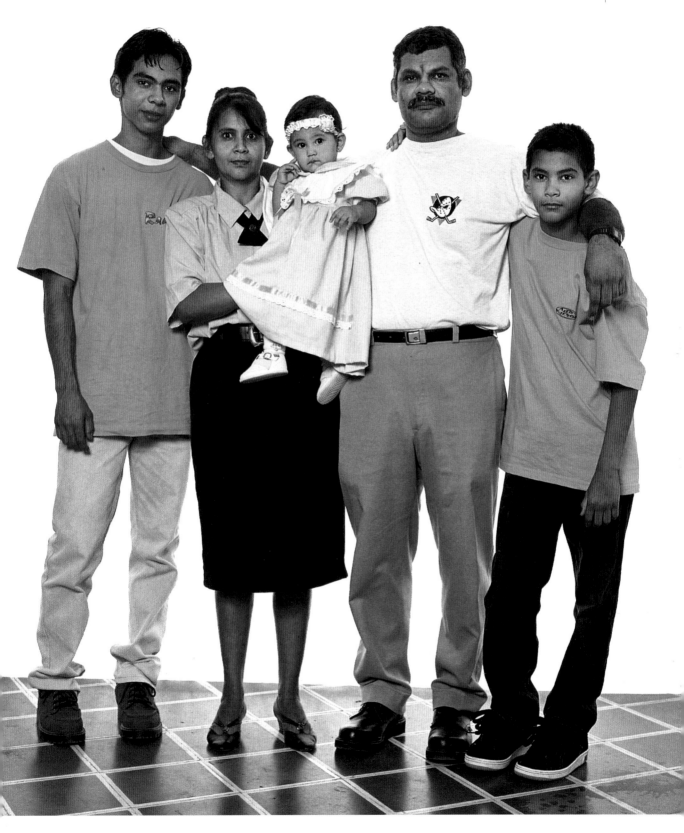

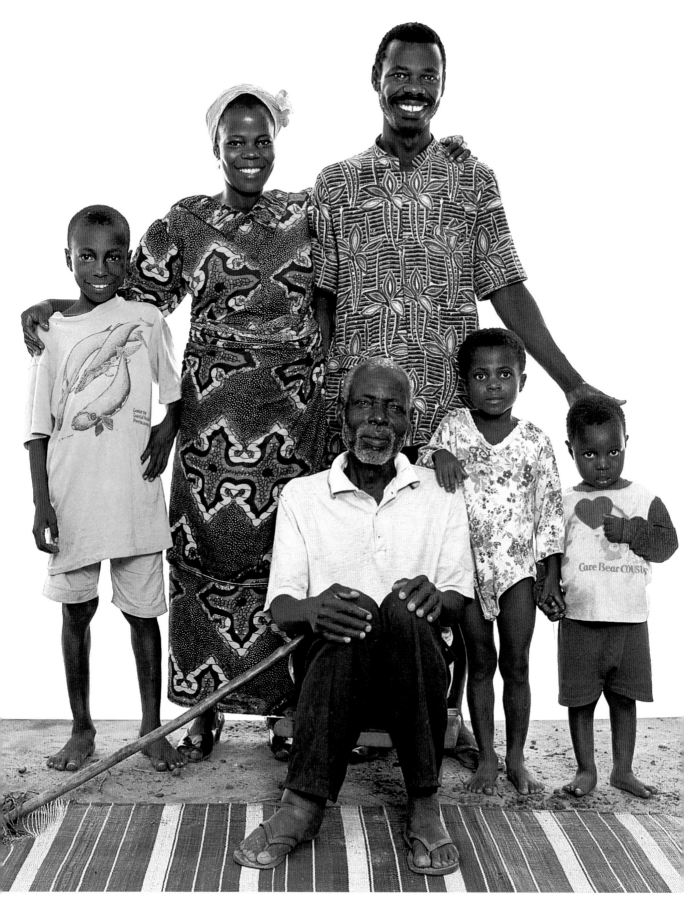

„Präsident Bédié sagt, wir sollen uns der Erde zuwenden, und ich hoffe, dass meine Kinder meine Begeisterung für den Wald teilen. Was du pflanzt, gehört dir – das ist der wahre Reichtum." Kamako ist das Dorfoberhaupt, baut Kokospalmen an und verkündet zugleich die Bibel. Für den Anhänger der protestantischen Glaubensgemeinschaft Assemblée de Dieu ist die Arbeit auf der Plantage zu seiner eigentlichen Religion geworden.

"President Bédié encourages us to turn to the earth. I'd like my children to share my love of the forest. What you plant is yours – it's your real wealth." Kamako is village headman and plants coconut palms the way he spreads the Word. A member of the Assembly of God [a branch of Protestantism], planting has become his true religion.

« Le Président Bédié nous encourage à nous tourner vers la terre, je souhaite que mes enfants partagent ma passion pour le travail de la terre. Ce que tu plantes est à toi, c'est la vraie richesse. » Kamako plante des cocotiers, et prêche la bonne parole à l'Assemblée de Dieu.

Page 372

Die Chemie war ihnen wohl doch zu trocken, denn die beiden haben sich nach dem Studium entschlossen, Hotelbesitzer zu werden. Ihr größter Wunsch: einmal die Stadt ihrer Träume zu sehen – Paris.

Both have chemistry degrees, but have ended up being hoteliers. They'd like to visit the city of their dreams – Paris.

Tous les deux ont fait des études de chimie, pour finalement devenir hôteliers. Ils aimeraient beaucoup visiter la ville de leur rêve : Paris !

Page 373

Kossi, der junge Küchenchef und Familienvater, träumt davon, ein eigenes Restaurant zu besitzen und für seine Familie ein eigenes Haus zu bauen, nur wie? „Alles wird teurer, nur die Löhne steigen nicht! Sagt den Togoern in Frankreich, sie sollen uns nicht vergessen."

Kossi is a young head chef and father. He dreams of owning his own restaurant and above all of building his own family home, but how? "Everything's going up – except wages. Tell the Togolese in France not to forget about us."

Jeune chef cuisinier et père de famille, Kossi rêve de posséder son restaurant et surtout de construire sa propre maison familiale, mais comment ? « Tout augmente ! sauf les salaires. Dites aux Togolais en France qu'ils ne nous oublient pas ! »

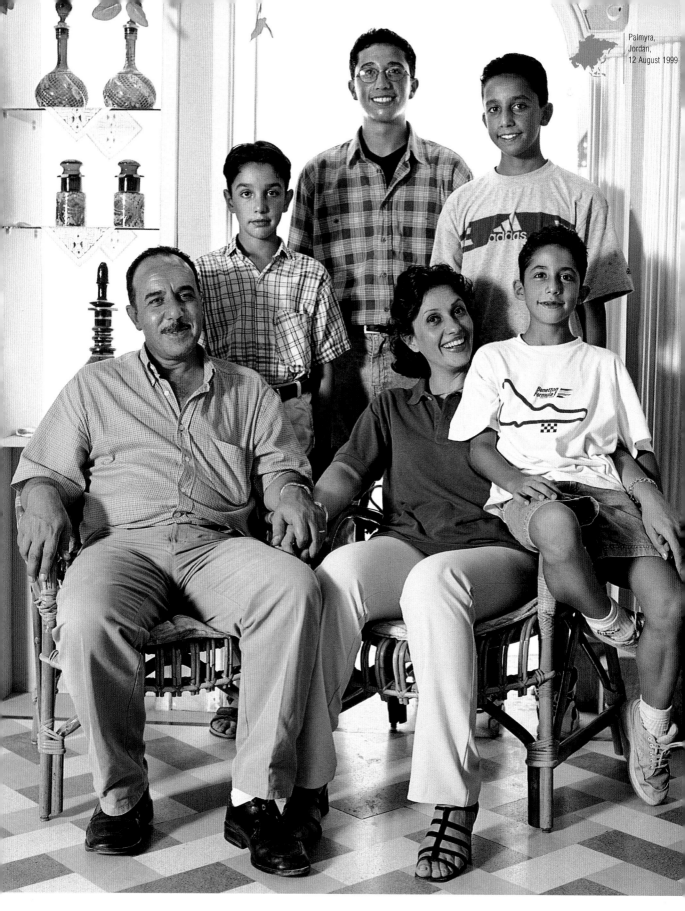

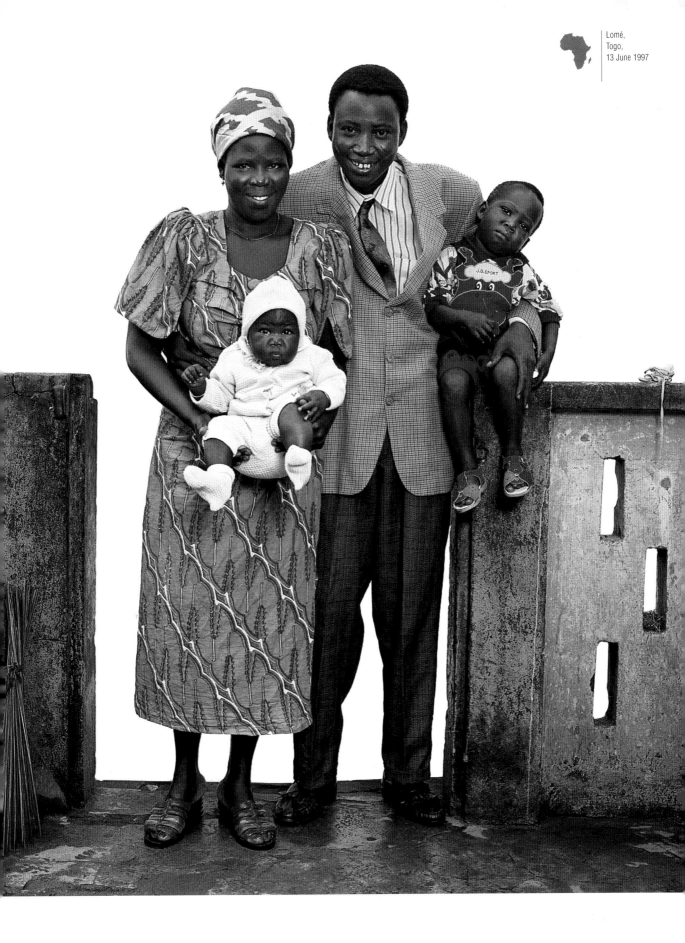

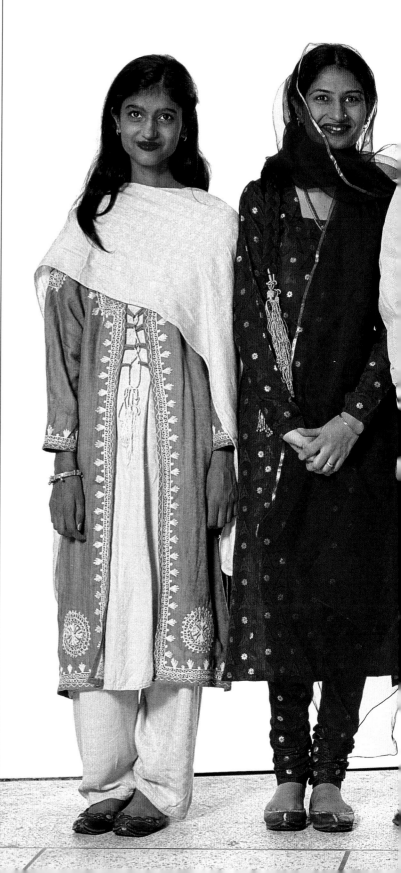

„Wann immer es meine knappe Zeit erlaubt, besuche ich meine Eltern. Sie haben hart für meine Ausbildung gearbeitet und es ist meine religiöse und moralische Pflicht, sie zu unterstützen." Muhammad Ashraf Munir ist Generaldirektor einer Farbenfabrik und stolzer Familienvater. Mit seinem elfjährigen Sohn Mubashar hat er Großes im Sinn: „Ich wünsche mir, dass er einmal Offizier der Luftwaffe wird. Er ist sehr intelligent und fleißig für sein Alter."

"I work all the time. When I do have a free moment, I visit my elderly parents. They worked hard to educate me, and it is my religious and moral duty to look after them," says Muhammad Ashraf Munir, managing director of a paint factory. He is a happy father and family man with ambitious plans for eleven-year-old Mubashar: "I want him to be an officer in the air force. He is very bright and hard-working for his age."

« Je travaille tout le temps, quand j'ai un moment de libre je vais visiter mes vieux parents. Ils ont travaillé dur pour mon éducation et c'est mon devoir religieux et moral de m'occuper d'eux », ainsi parle Muhammad Ashraf Munir, directeur général d'une usine de peinture et père de famille comblé. Il a des projets ambitieux pour Mubashar (onze ans) : « Je veux qu'il soit officier dans l'armée de l'air ! Il est très intelligent et travailleur pour son jeune âge. »

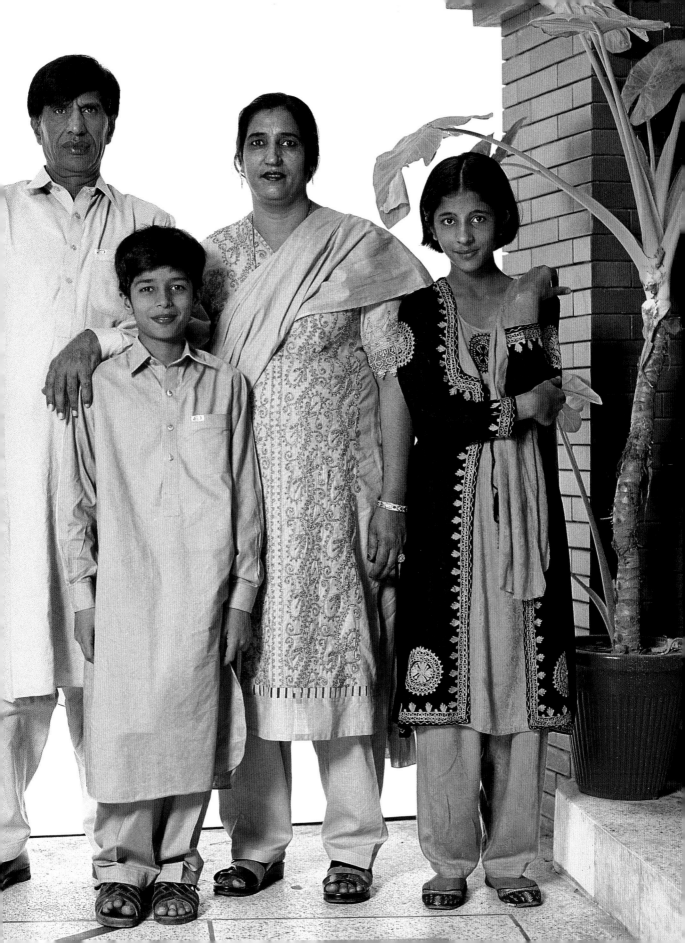

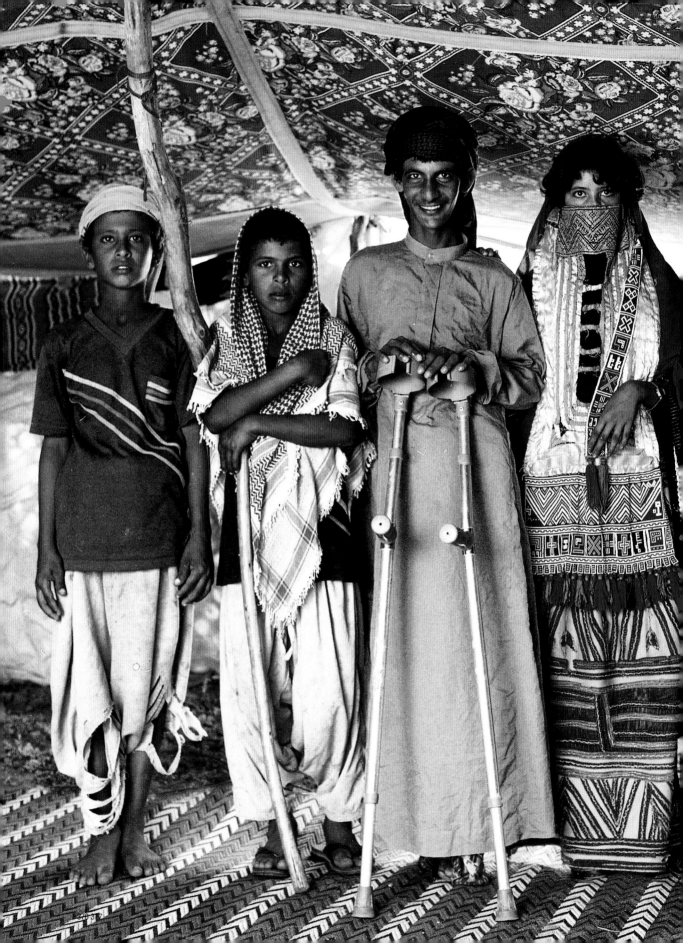

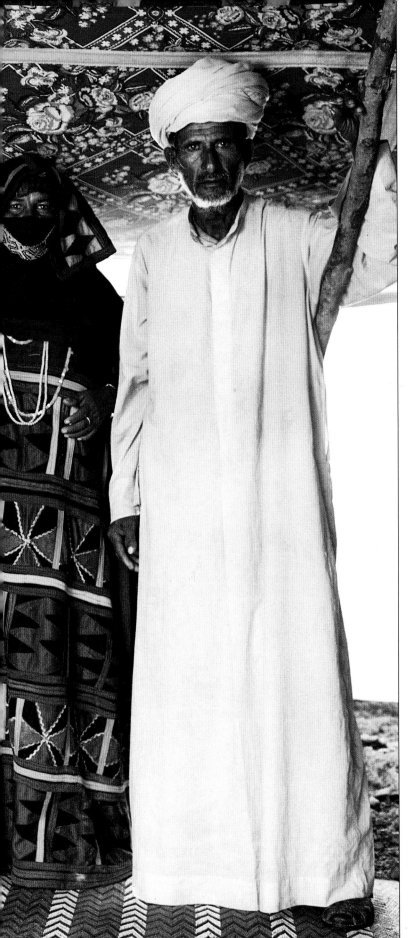

 near Massawa,
Eritrea,
23 December 1997

Die Rashaida, ein Volksstamm aus Saudi-Arabien, sind überzeugte Nomaden und überaus geschäftstüchtig. Süleiman besitzt nur ein Kamel, auf dem er seine wenigen Habseligkeiten von Ort zu Ort transportiert – ein gefährliches Unterfangen in einem Land, das mit Landminen übersät ist. Sein Sohn geht – Folge einer Minenexplosion – an Krücken. Die Familie wollte die Aufnahme möglichst rasch hinter sich bringen, um den vielen Stechmücken zu entkommen …

The Rashaida, an ethnic group originally from Saudi Arabia, are passionate nomads as well as formidable traders and businessmen. Süleyman has just one camel, which carries the tent and tools when they move camp, which is often – but it's very dangerous to keep on the move in a country littered with land-mines. His son still suffers the effects of one of them exploding, and has to get about on crutches. They were in a hurry to be done with the photo session, because there were too many mosquitoes …

Les Rosheida, ethnie originaire d'Arabie Saoudite, sont résolument nomades, tout en étant de redoutables commerçants. Souleiman ne possède qu'un seul chameau qui transporte la tente et les ustensiles lors de leurs fréquents déplacements, qui s'avèrent très dangereux dans un pays parsemé de mines. Son fils a gardé des séquelles de l'explosion de l'une d'elles et doit se déplacer avec des béquilles. Ils étaient pressés d'en finir avec la séance de photos pour quitter l'endroit trop infesté de moustiques …

Ogulkurban war auf dem Heimweg von der Arbeit, als er uns mit wehendem Bart entgegenradelte. Obwohl er längst das Rentenalter erreicht hat, sorgt er auch heute noch dafür, dass die Kostüme der Oper von Aschchabad vor jedem Auftritt tadellos in Ordnung sind. Seine beiden erwachsenen Söhne sind extra mit ihren Familien gekommen, um das Foto komplett zu machen.

We met Ogulkurban, beard blowing in the wind, bicycling back from work. Although he's past retirement age, he still handles the costumes at the Ashkabad Opera, making sure they are in one piece and ready for each performance. His two grown-up sons have come with their families to pose with their parents.

Nous avons rencontré Ogulkurban la barbe au vent, sur sa bicyclette, rentrant du travail. Bien qu'il ait dépassé l'âge de la retraite, il continue de s'occuper des costumes de l'Opéra d'Ashkabad, il veille à ce qu'ils soient complets et à disposition avant chaque représentation. Ses deux grands fils sont venus avec leurs familles pour poser avec les parents.

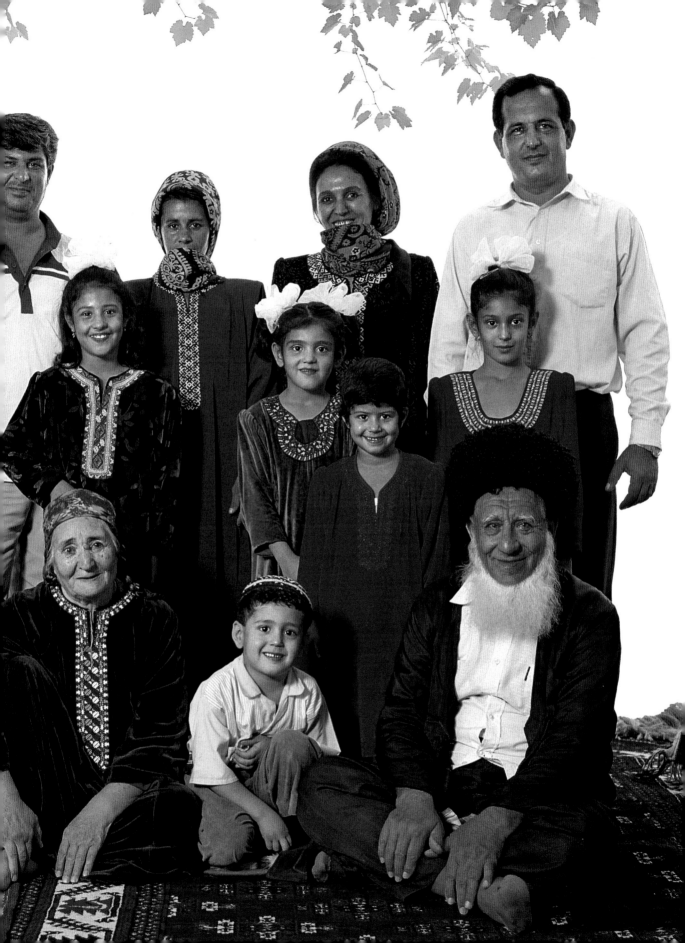

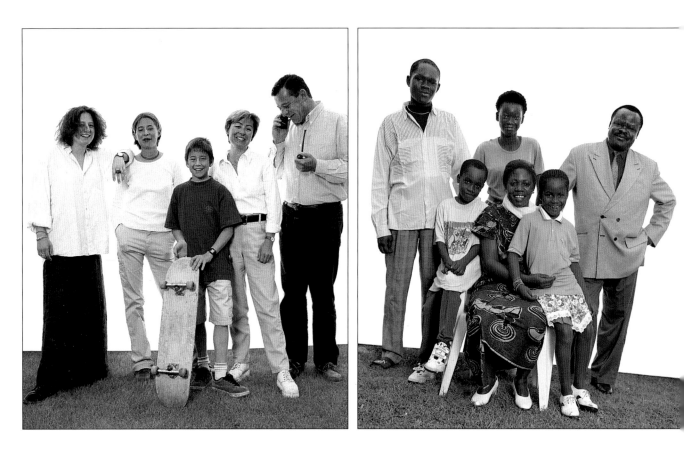

Bordeaux,
France,
10 May 1998

Didier hat früher in der Luftfahrt gearbeitet, wo er an der Entwicklung der „Plasma-Fackel" beteiligt war. Heute ist er Direktor einer Firma, die mit Hilfe dieser „Fackel" Kunststoffabfälle in so genanntes „schwarzes Glas" umwandelt. Seine Frau Marie-Claire trägt kleine Ohrringe aus diesem Material. Sie ist Anwältin bei Gericht. „Mein Beruf nimmt mich sehr in Anspruch, aber die Familie steht immer an erster Stelle …" Und die Zukunftspläne der Kinder: Aurélie (17 und Besitzerin der Pfeife, die ihr Vater sich regelmäßig ausleiht) will „ewig lange studieren", Flore (15) möchte Ärztin werden und Thomas schwankt zwischen Skateboarder, Dichter und Dichter-Ingenieur – Letzteres, um seinem Vater eine Freude zu machen.

Didier used to work in the aerospace industry, where he was involved with the development of the "plasma torch." Then he became director of a company that recycles plastic waste, which is turned into "black glass" by this torch. Marie-Claire wears earrings made of small samples of this glass and is a court solicitor by profession. "My work takes up a lot of my time," she explains, "but the family always comes first." Each of their children has future plans. Aurélie (17 and owner of the pipe her father gave her, which he keeps borrowing back) is reckoning on "many years of study"; Flore (15) wants to be a doctor; and Thomas sees himself as a surfer, poet or poet-engineer (to please his father).

Didier, ancien de l'aérospatiale où il a participé au développement de la «torche à plasma», est devenu directeur d'une société de récupération de déchets en plastique, qui sont transformés en «verre noir» grâce à cette torche. Marie-Claire porte en boucles d'oreilles de petits échantillons de ce matériau. Elle est avouée à la cour et la première femme à occuper cette fonction dans une famille où l'on est avoué de père en fils depuis quatre générations. «Mon activité me prend beaucoup de temps, mais la famille passe toujours avant», précise-t-elle toutefois. Chacun des enfants a des projets pour l'avenir: Aurélie (dix-sept ans et propriétaire de la pipe que son père lui a offert et qu'il emprunte régulièrement) compte «faire de longues études», Flore (quinze ans) veut être médecin, et Thomas se voit surfer, poète ou ingénieur-poète (pour faire plaisir à son père).

Libreville,
Gabon,
20 August 1997

Die Familie Moukassa Tsiba haben wir in der kongolesischen Botschaft in Libreville kennen gelernt. Er ist Konsul, sie arbeitet dort als Sekretärin. Sie wünschen sich dauerhaften Frieden in der Region.

We met the Moukassa Tsiba family at the Congolese Embassy in Libreville. She works as a secretary there and he is a consul. Their wish is for long-lasting peace in the region.

C'est à l'Ambassade du Congo à Libreville que nous avons fait connaissance avec la famille Moukassa Tsiba. Elle y est secrétaire et lui consul. Ils forment le vœu d'une paix durable dans la région.

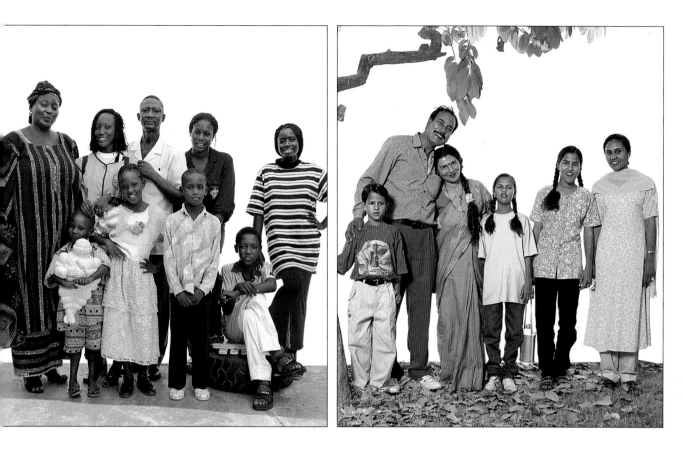

Dakar,
Senegal,
25 April 1997

„Ob arm oder reich, wir müssen im Herzen und im Geiste großzügig sein", sagt Mustafa. Der Reifentechniker führt in seinem Laden alles, was auch anspruchsvolle Kundenherzen höher schlagen lässt. Er arbeitet dort mit seiner Frau, die ihm gelegentlich im Verkauf hilft, aber hauptsächlich für die Buchhaltung zuständig ist. Wir haben einen glücklichen Mann kennen gelernt, der von einer Pilgerreise nach Mekka träumt.

"Whether we're rich or poor, we must all be generous in heart and mind," says Mustafa. He is a tyre specialist, and his shop has a big enough selection of tyres to satisfy his most demanding customers. He works there with his wife, who occasionally helps him with sales but mainly deals with the invoicing. We met a happy man, dreaming of going to Mecca.

« Riches ou pauvres, nous devons être généreux de cœur et d'esprit », nous dit Moustapha. Technicien en pneumatiques, il dispose dans sa boutique de quoi satisfaire, en pneus, les plus exigeants de ses clients. Il y travaille avec sa femme qui l'aide occasionnellement à la vente et s'occupe surtout de la facturation. Nous avons rencontré un homme heureux, qui rêve de se rendre à la Mecque.

Delhi,
India,
31 October 1999

Nach seinem Ausscheiden aus der indischen Armee hat Birbal eine Stelle als Assistent des Sicherheitschefs in einem Luxushotel. Er hat zwei Töchter und einen Sohn, das Mädchen rechts im Bild ist seine Schwester. Er erklärt uns: „Wissen Sie, in Indien entscheiden die Eltern über die Zukunft ihrer Kinder und meine Töchter werden einmal Beamtinnen bei der Polizei oder in der Armee. Das ist bei uns Familientradition." Und der kleine Vikas?
„Oh der, der hat nur Cricket im Kopf!"

Birbal has retired from the Indian army and found a job as assistant to the head of security in a luxury hotel. He has two daughters and a son. The girl on his right is his sister. He tells us: "In India, you know, it's the parents who decide the future of their children, and my daughters will be officers in the police or army. It's a family tradition with us." And little Vikas? "Oh him, all he thinks about is cricket."

Retraité de l'armée indienne, Birbal a repris un travail quasi militaire : assistant du chef de sécurité d'un hôtel de luxe. Deux filles, un garçon ; la jeune fille de droite est sa sœur, il nous dit : « Vous savez en Inde c'est les parents qui décident de l'avenir de leurs enfants et mes filles seront officiers dans la police ou l'armée ! C'est une tradition familiale chez nous. » Et le petit Vikas ? « Oh lui, il ne pense qu'au cricket ! »

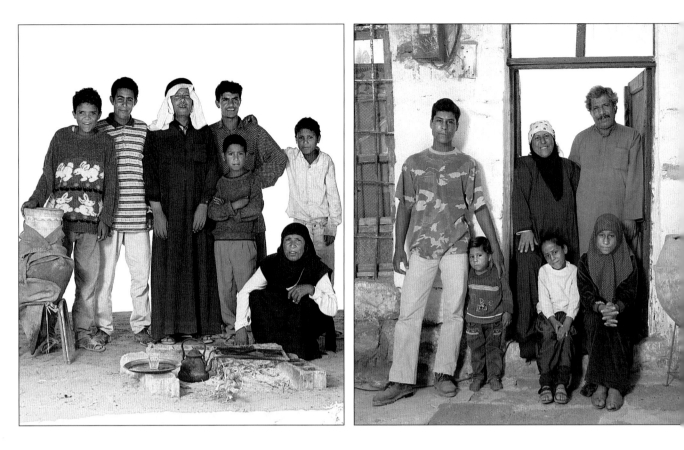

Petra,
Jordan,
10 August 1999

„Meine Kinder wurden in einem Zelt geboren. Meine Frau ist sehr stark, weil sie Fleisch und Joghurt isst", verrät uns der Beduine Ibrahim stolz. Und weiter: „Ich würde mein Zelt für nichts auf der Welt eintauschen. Hier herrscht mehr Demokratie und Frieden als in der größten Villa. Und ich schlafe wie ein Engel."

"My children? They were all born in the tent. My wife is very strong – she eats meat and yoghurt," Ibrahim the Bedouin tells us, adding: "Even if you give me a villa, I'll never leave my tent. There's more democracy and peace here than in a house – and I sleep well."

« Mes enfants ? Ils sont tous nés sous la tente. Ma femme est très forte, elle mange de la viande et des yaourts », nous dit Ibrahim le Bédouin et il poursuit « même si vous me donnez une villa je ne quitterai pas ma tente. Ici il y a plus de démocratie et de paix que dans une maison et j'y dors bien ! »

Bosra,
Syria,
8 August 1999

Diese alteingesessene Bauernfamilie hatte dieses Jahr schwer zu kämpfen. Wegen der anhaltenden Trockenheit musste Nasser einen Teil seiner Schafherde verkaufen. Trotzdem lässt er sich nicht unterkriegen. „Das nächste Jahr wird besser!" Mohammed (17) besucht die Hotelfachschule und wird einmal Chefkoch. Ob er das von seiner Mutter gelernt hat, wollten wir wissen. „Im Gegenteil. Ich bin hier der Lehrmeister!", erklärt er uns schmunzelnd.

The family are farmers by tradition, but it's been a hard year. There's not enough water, and Nasser has had to sell part of his flock of sheep, although he's still optimistic. "Next year will be better." Mohammed (17) is at the hotel-management school, and will become a chef. "Did your mother teach you how to cook?" He replies with a laugh: "Not at all! I'm the one who gives her cookery lessons."

Dans la famille ils sont traditionnellement fermiers et agriculteurs. Cette année est difficile, l'eau manque et Nasser a dû vendre une partie de son troupeau de moutons, mais il reste optimiste : « L'année prochaine sera meilleure. » Mohamed (dix-sept ans) est à l'école hôtelière et sera chef cuisinier. « C'est ta mère qui t'a appris à cuisiner ? » Il répond en riant : « Pas du tout, c'est moi qui lui donne les leçons ! »

Sacrofaro,
Italy,
12 December 1996

Die Deutsche Constanze und der Sizilianer Antonio arbeiten beide als Journalisten und haben kürzlich die ewigen Verkehrsstaus in Rom hinter sich gelassen, um im historischen Dörfchen Sacrofaro, wo die Luft noch gut und die Straße den Fußgängern vorbehalten ist, ein ruhigeres Leben zu führen.

The German Constanze and the Sicilian Antonio are both journalists who fled Rome's traffic jams and set up home in this historic village, where the air is pure and the streets are for pedestrians.

Constanze l'Allemande et Antonio le Sicilien, journalistes tous les deux, ont fui les embouteillages de Rome pour s'installer dans ce village historique où l'air est pur et les rues piétonnes.

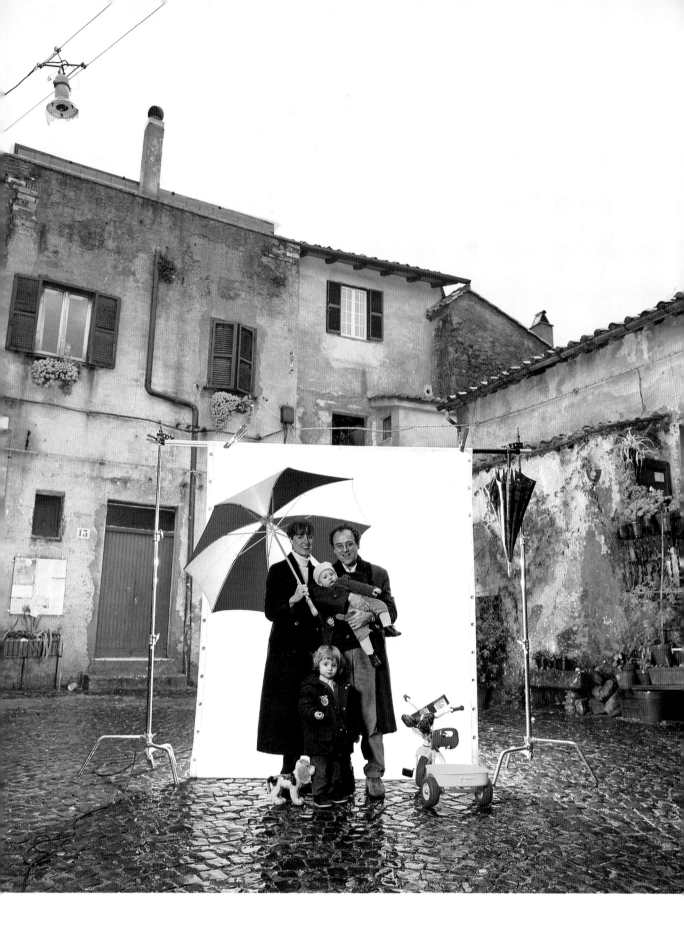

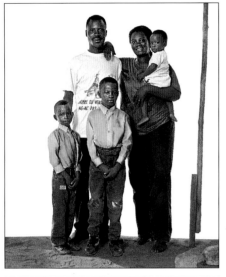 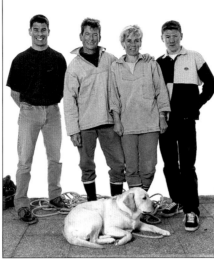 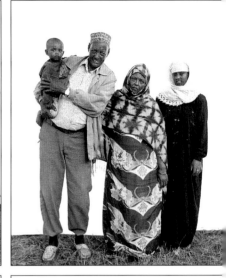

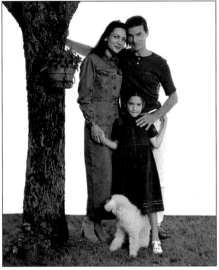 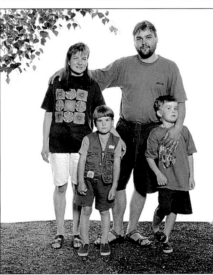 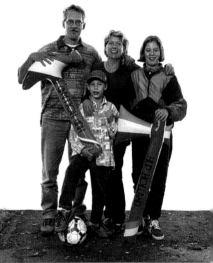

1
7

2
8

3
9

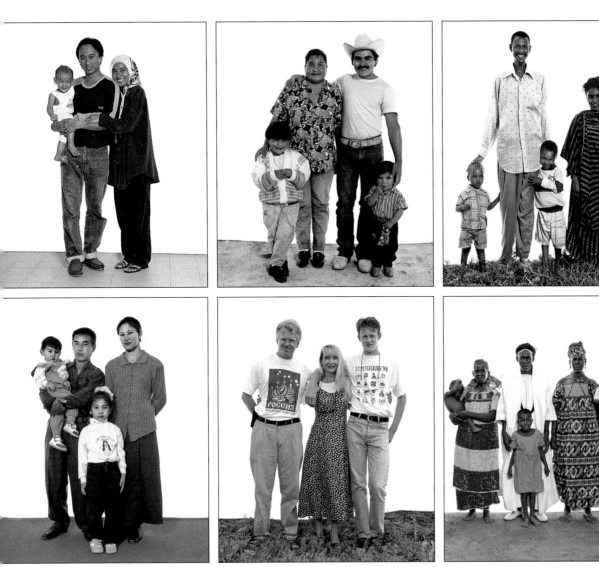

5

11

6

12

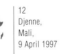

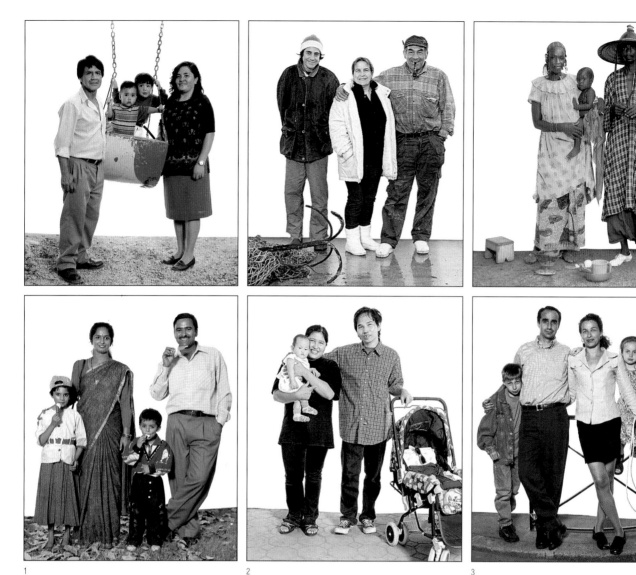

1

7

2

8

3

9

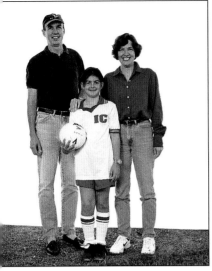
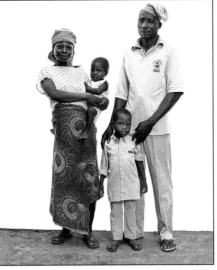
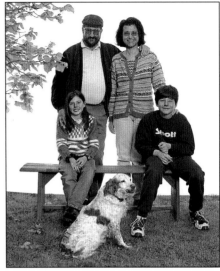

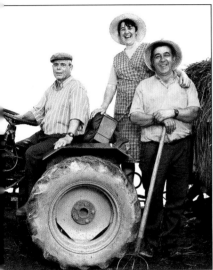
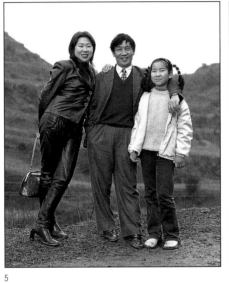
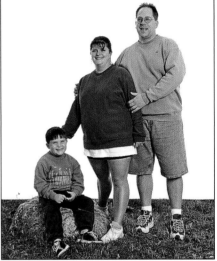

5

6

11

12

5
Ilorin,
Nigeria,
16 July 1997

6
Blois,
France,
3 May 1998

11
Guiyang,
China,
4 March 2000

12
Des Moines,
Iowa, USA,
11 October 1998

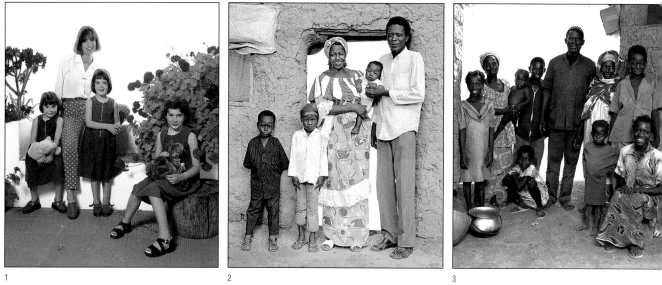

1

2

3

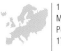

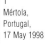

1
Mértola,
Portugal,
17 May 1998

2
Kabalaye,
Chad,
27 July 1997

3
Tortiya,
Ivory Coast,
10 May 1997

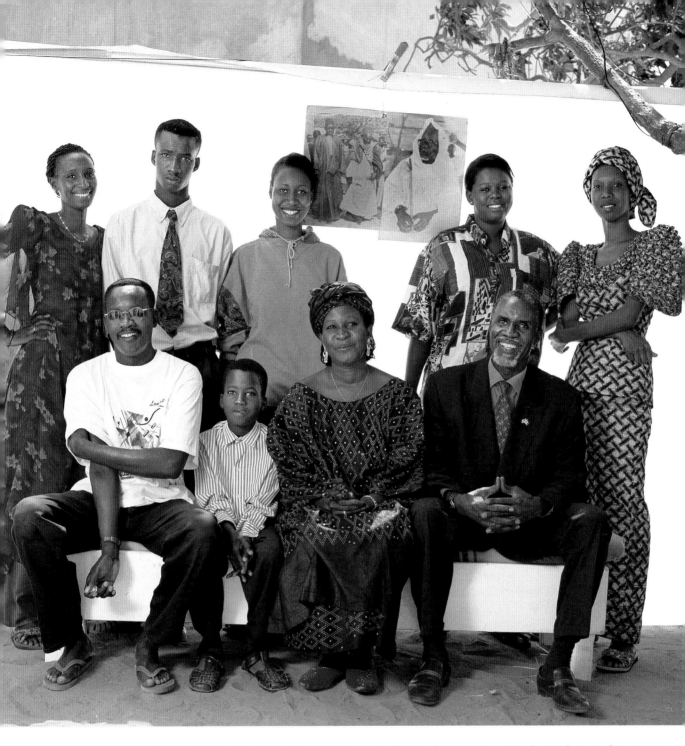

Dakar,
Senegal,
26 April 1997

Der ehemalige Kfz-Mechaniker Habdoul ist heute Protokollbeamter des Präsidenten. Er organisiert bis ins kleinste Detail den Empfang der Staatsgäste, von der Ankunft auf dem Flughafen bis zur Abreise. Als gläubige Moslems erklären sie uns: „Wir beten für Frieden in Afrika und überall auf der Welt.“

Former car mechanic Habdoul is now presidential protocol coordinator. He organizes the reception of state guests down to the last detail, from the moment they arrive at the airport to the moment they leave. As practising Muslims, they tell us: "We preach for unity all over Africa and elsewhere."

Habdoul, ancien technicien en mécanique automobile, est aujourd'hui agent du protocole présidentiel. Il organise dans les moindres détails l'accueil des invités d'État dès leur arrivée à l'aéroport jusqu'à leur départ. Musulmans pratiquants, ils nous déclarent : « Nous prêchons pour l'unité au niveau de l'Afrique et ailleurs. »

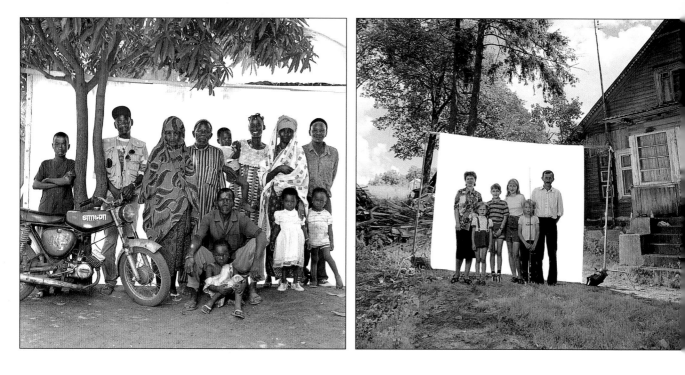

Kankan,
Guinea,
3 May 1997

Kissi hat seine Frau Ouarkia in Marokko kennen gelernt, wo er im Zweiten Weltkrieg auf der Seite der Franzosen gekämpft hat. Sie sind seit 50 Jahren verheiratet und haben vier Kinder. Sei haben zwei Träume: eines Tages auf den Spuren von Ouarkias Wurzeln nach Marokko zurückzukehren, und eine Pilgerreise nach Mekka.

Kissi met his wife Ouarkia in Morocco, where he fought in the French army during the Second World War. They've been married for 50 years, and have fou children. Their dreams: to return to Morocco one day to trace Ouarkia's roots, and to go to Mecca.

Kissi a rencontré sa femme au Maroc, où il a combattu dans l'armée française pendant la Deuxième Guerre mondiale. Mariés depuis cinquante ans, ils ont eu quatre enfants et ont encore deux rêves : retourner un jour au Maroc à la recherche des racines d'Ouarkia et se rendre à la Mecque.

Vilnius,
Lithuania,
16 July 1998

Sie gehören zur polnischen Gemeinschaft, die seit vielen Generationen in Litauen ansässig ist. Die Kinder besuchen eine polnische Schule und sprechen zu Hause Polnisch. Mavian besitzt einen kleinen landwirtschaftlichen Betrieb und seine Familie lebt vom Verkauf der Kartoffeln, Erbsen sowie der Milch, die ihre beiden Kühe geben. Sie wünschen den Familien der ganzen Welt Glück, Gesundheit und ein Minimum an materiellem Wohlstand.

They are part of the Polish community that's been living in Lithuania for many generations. The children go to the Polish school and speak Polish at home. Mavian has a very small farm and they live off selling potatoes, peas and the milk provided by their two cows. They wish all the world's families happiness, good health and basic creature comforts.

Ils font partie de la communauté polonaise installée en Lituanie depuis plusieurs générations. Les enfants fréquentent l'école polonaise et parlent le polonais en famille. Mavian possède une toute petite exploitation agricole et ils vivent de la vente de leurs récoltes de pommes de terre, de petits pois, et du lait fourni par leurs deux vaches. Ils souhaitent beaucoup de bonheur, de santé et un minimum de confort matériel aux familles du monde.

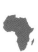

Malealea,
Lesotho,
8 October 1997

Lawrence arbeitet als Wachmann im Supermarkt des Dorfes – ein ungewöhnlicher, aber heiß begehrter Job in einem Land, das mit einer extrem hohen Arbeitslosigkeit zu kämpfen hat. Seine Frau hat eine Teilzeitstelle in der Malealea Lodge und kümmert sich um ihr Kind.

Lawrence is the security guard at the village supermarket. It's a rather unusual job, but one that's much sought after in a country where jobs are few and far between. His wife works a bit at the Malealea Lodge and looks after their child.

Lawrence est gardien de sécurité au supermarché du village. Métier plutôt inattendu mais recherché dans un pays où les emplois sont rares et le chômage omniprésent. Son épouse travaille un peu au Malealea Lodge et prend soin de leur enfant.

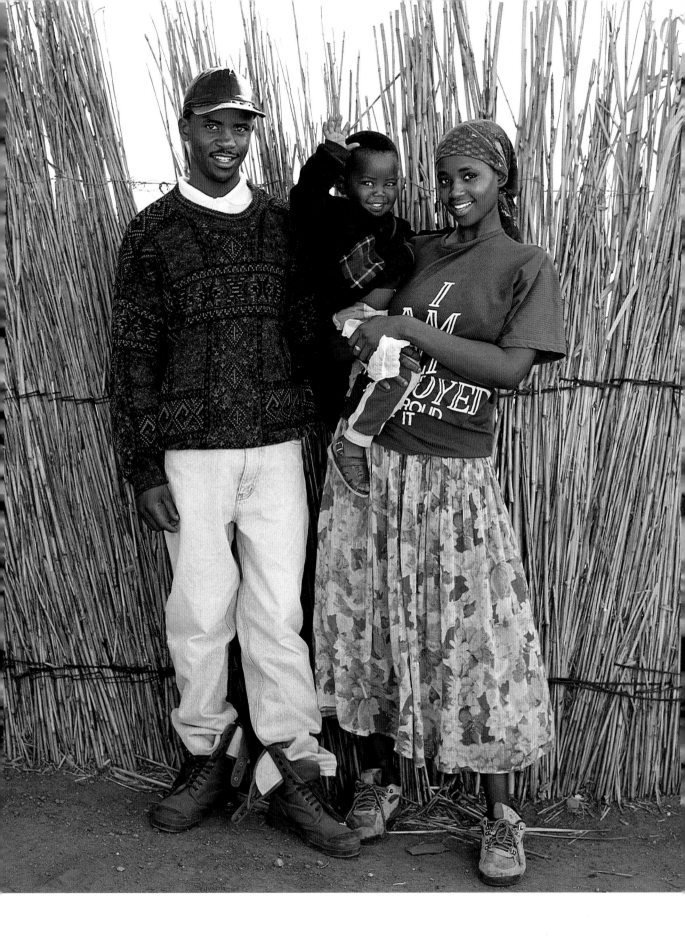

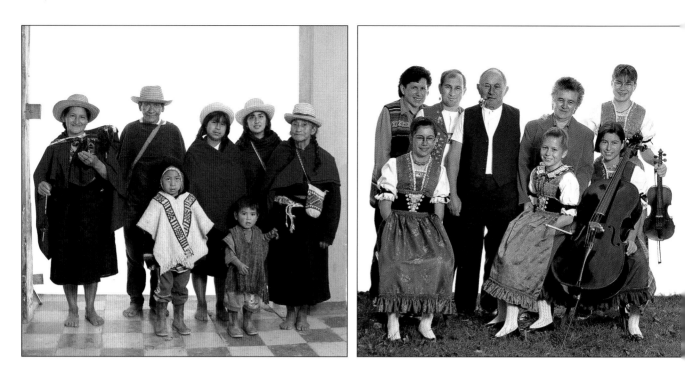

1
Pitayó,
Cauca, Colombia,
17 February 1999

Um dieses Foto machen zu können, mussten wir dem Stadtrat unser Projekt vorstellen und unsere Vorgehensweise vor dem gesamten Dorf erklären. Abelardo und Rosa sind Bauern und leben vom Verkauf ihrer Erzeugnisse. Die Großmutter hilft auf den Feldern und kümmert sich um die Kinder. Die 21-jährige Maribel erzählt uns, was für eine Herausforderung das Jahr 2000 für die Indio-Gemeinden ist. „In meiner Familie sind die alten Bräuche und unsere Sprache verloren gegangen, was uns schadet. Damit wir als Indios unsere eigene Identität nicht vergessen, ist der Schulunterricht jetzt zwei-sprachig. Das gab es zu meiner Zeit leider nicht".

To take this photo, we presented our scheme to the town council and explained our approach to the villagers. Abelardo and Rosa are farmers and live by selling their produce. Grandma works in the fields and looks after the children. Twenty-one-year-old Maribel tells us how important the challenges of the new millennium are for the Indio community: "In my family we've lost our customs and our language, all of which works against us. For us the sake of maintaining the Indios' identity, both languages are taught nowadays in the schools, but when I was at school, that wasn't done."

Pour réaliser cette photo, nous avons soumis notre projet au conseil municipal et expliqué notre projet devant les habitants du village. Abelardo et Rosa sont agriculteurs et vivent de la vente de leurs produits. La grand-mère travaille aux champs et garde les enfants. Maribel (vingt et un ans) nous dit l'im-portance des enjeux de l'an 2000 pour la communauté indienne : « Dans ma famille nous avons perdu nos coutumes et notre langue, ce qui joue contre nous. Pour que nous soyons reconnus en tant qu'Indiens, on enseigne maintenant les deux langues dans les écoles, mais à l'époque où j'ai fait mes études, ça ne se faisait pas. »

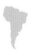

2
Weissbad,
Switzerland,
6 October 1996

Eine Familie, die nur für die Musik lebt. Großvater Sepp ist von Beruf zwar Unternehmer, versteht sich aber vor allem als Komponist und Musiker. Die ganze Familie ist seinem Beispiel gefolgt und tritt regelmäßig als professionelle Musikgruppe bei traditionellen Festen auf.

This is a family that lives for music. Grandfather Sepp is a professional contractor, but above all a musician and composer. The whole family has followed his example and formed a professional group which performs regularly at traditional festivals.

Voilà une famille qui vit pour la musique. Grand-père Sepp est entrepreneur de métier mais surtout compositeur et musicien. Toute la famille a suivi son exemple et ils forment un groupe professionnel qui se produit régulièrement à l'occasion des fêtes traditionnelles.

Kaduna,
Nigeria,
17 July 1997

Wenn der Fernfahrer nicht gerade auf den Straßen Nigerias unterwegs ist, geht Marcus gern mit seinen Brüdern auf die Jagd. Obwohl ihre Waffen recht antiquiert erscheinen, beteuern sie, schon manch guten Fang gemacht zu haben. Seine Mutter und seine Frau kümmern sich um die Kinder, bestellen den Gemüsegarten und sammeln Reisig für das Feuer.

When Marcus is not busy driving trucks around Nigeria, he enjoys hunting with his brothers. Even though their weapons are thoroughly makeshift, they tell us they've bagged some good catches. His mother and his wife look after the children and the vegetable garden, and gather dead wood to keep the fire going.

Quand il n'exerce pas son métier de chauffeur sur les routes du Nigeria, Marcus prend plaisir à chasser en compagnie de ses frères. Bien que leurs armes soient très artisanales, ils nous disent avoir réussi quelques belles prises ! Sa mère et sa femme s'occupent des enfants, du potager, et ramassent le bois mort nécessaire au feu.

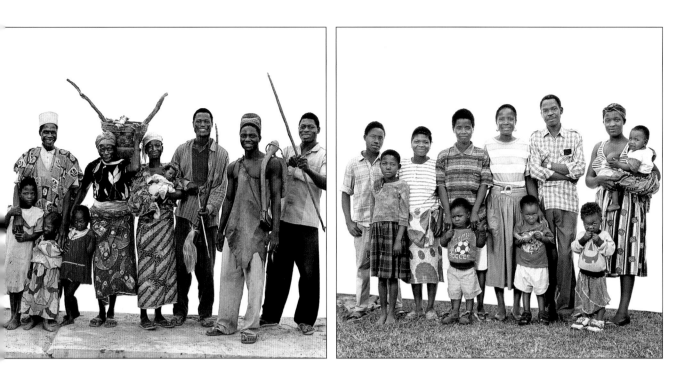

Waku-Kungo,
Angola,
5 September 1997

Lucas ist Fahrer, ein lebensgefährlicher Job in Angola, einem Land, in dem es mehr Landminen als Einwohner gibt. Doch er hat sich sein Lächeln und seine Hoffnung bewahrt, dass das neue Jahrtausend seinem Land Frieden bringen wird.

Lucas is a driver, a high-risk profession in Angola, where there are more land mines than inhabitants. He still smiles, and is still hopeful that the new millennium will usher in a more peaceful state of affairs in his country.

Lucas est chauffeur – métier à haut risque en Angola où il y a plus de mines que d'habitants. Il garde le sourire et l'espoir que l'an 2000 apportera une situation plus pacifique dans son pays.

Page 396

Diese Familie verbringt die Sommerferien im Elternhaus von Kenan, das fernab vom Lärm der Hauptstadt hoch oben in den Bergen liegt und nur zu Fuß erreichbar ist. Sobald sie es sich finanziell erlauben können, wollen sie das ganze Jahr über hier leben.

The family have come to spend their holidays at Kenan's paternal home. The house can be reached only on foot, as it is far from the bustling capital, high up on a mountain. One day, they would like to have the wherewithal to live in it all year round.

Ils sont venus en famille passer leurs vacances dans la maison paternelle de Kenan, accessible uniquement à pied, loin du bruit de la capitale, en haut d'une montagne. Leur souhait est d'avoir un jour les moyens d'y vivre toute l'année.

Page 397

Als wir Vicente und Cristina auf der holprigen Bergstraße, die in ihr Dorf führt, trafen und ihnen anboten, sie mitzunehmen, waren sie gerade auf dem Heimweg mit ihren „Einkäufen" aus der Stadt: einem 100-Liter-Fass aus Metall (in der Mitte durchgetrennt, werden daraus zwei Kochstellen), Werkzeug, einem Seil, einem Wasserkanister und Zucker. Die beiden sind Bauern und pflanzen Mais und Bohnen an. „Cristina spricht kein Spanisch, außer sie hat Maisbier getrunken", neckt Vicente sie. Ob sie noch mehr Kinder wollen …? „Dafür ist der Mais viel zu teuer", wehrt Vicente ab.

When we gave Vicente and Cristina a ride on the mountain track leading to their village, they were coming back from town with their 'shopping' – a 100-litre metal barrel (to make two kitchen stoves once it's cut in half), tools, rope, a can of water and some sugar. They are farmers, growing maize and beans. "Cristina doesn't speak Spanish, except when she's been drinking maize beer," Vicente teases her. As for having more children – "Maize is far too expensive to have any more," he protests.

Quand nous avons pris Vicente et Cristina en stop sur la piste de montagne qui mène à leur village, ils rentraient de la ville avec leurs achats : un tonneau métallique de cent litres (qui donnera deux cuisinières, une fois coupé en son milieu), des outils, une corde, un bidon d'eau et du sucre. Agriculteurs, ils cultivent le maïs et les haricots. « Cristina ne parle pas l'espagnol, sauf quand elle a bu de la bière de maïs », se moque Vicente, avant d'aller à l'école du hameau chercher ses enfants pour la séance de photos. Quant à avoir d'autres enfants … « Le maïs est bien trop cher pour avoir plus d'enfants ! », proteste-t-il.

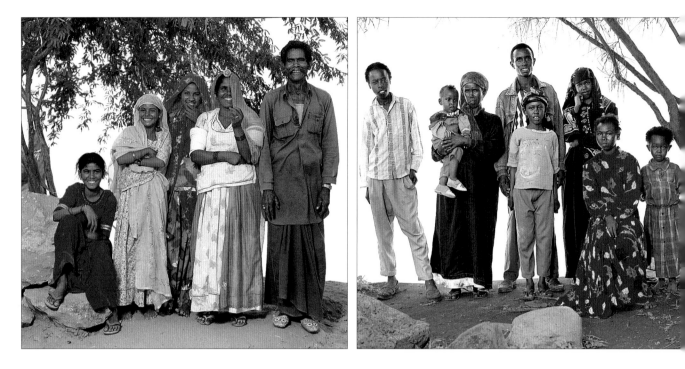

 Jaisalmer,
India,
13 October 1999

Adert verdient das tägliche Brot der Familie, indem er sein Kamel und seinen Karren auf Stundenbasis für Transporte jeglicher Art und über alle Entfernungen vermietet.

Adert feeds his family with the help of his camel and cart, which he hires out by the hour for every kind of transport over any distance.

Adert fait vivre sa famille grâce à son chameau et sa charrette qu'il loue à l'heure pour tous transports et toutes distances.

 Isiolo,
Kenya,
22 November 1997

Während ihr Mann das Vieh hütet, besorgt Fatuma den Haushalt und kümmert sich um die sieben Kinder.

While her husband looks after the cattle, housewife Fatuma takes care of their seven children.

Pendant que son mari garde le bétail, Fatuma, ménagère, s'occupe de leurs sept enfants.

Page 398

Gideon arbeitet in der Textilbranche. Er wurde in Israel geboren und hat eine Weile in Chile gelebt, bevor er sich in Kolumbien niederließ, wo er Linda kennen lernte. Trotz Ausbildung zur Innenarchitektin hat Linda ihre künstlerische Neigung nicht weiter verfolgt, sondern arbeitet als kaufmännische Leiterin bei einer italienischen Bank. Sie sind zwar beide große Kinofans, aber noch lieber geht Gideon mit den Kindern angeln.

Gideon, who was born in Israel and works in textiles, lived in Chile before settling in Colombia, where he met Linda. Despite a lengthy training as an interior designer, Linda has placed her artistic interests on hold and now works as sales manager in an Italian bank. They are both movie fans, but what Gideon likes best of all is taking his children fishing.

Né en Israël, Gideon, qui travaille dans le textile, a vécu au Chili avant de s'installer en Colombie où il a rencontré Linda. Malgré une formation d'architecte d'intérieur, Linda a abandonné son côté artiste pour travailler comme directrice commerciale dans une banque italienne. Ils sont fans de cinéma tous les deux, mais Gideon aime tout autant emmener les enfants à la pêche.

Page 399

Julio fährt regelmäßig in die USA und kauft dort Autos, die er in seiner Werkstatt, in der er auch einen Ersatzteil-Service eingerichtet hat, weiterverkauft. Er träumt davon, zu reisen und Geschäfte mit anderen Ländern zu machen. Seine neueste Idee: eine automatische Autowaschanlage zu eröffnen. Seine Frau Sonia ist Krankenschwester und engagiert sich in einem Verein für verlassene Kinder.

Julio goes regularly to the United States to buy cars, which he sells in his garage, where he's also set up a spare-parts service. He dreams of travelling and doing business with other countries. His latest idea: to open the first automatic car wash in Salvador. His wife Sonia is a nurse and is active in an association for abandoned children.

Julio se rend régulièrement aux Etats-Unis pour acheter des voitures qu'il revend dans son garage, où il a également mis en place un service de pièces détachées. Sa dernière idée est d'ouvrir la première station automatique de lavage de voitures du Salvador. Il rêve de voyager et de faire des affaires avec d'autres pays. Infirmière, sa femme Sonia est préoccupée par l'enfance abandonnée et milite au sein d'une association.

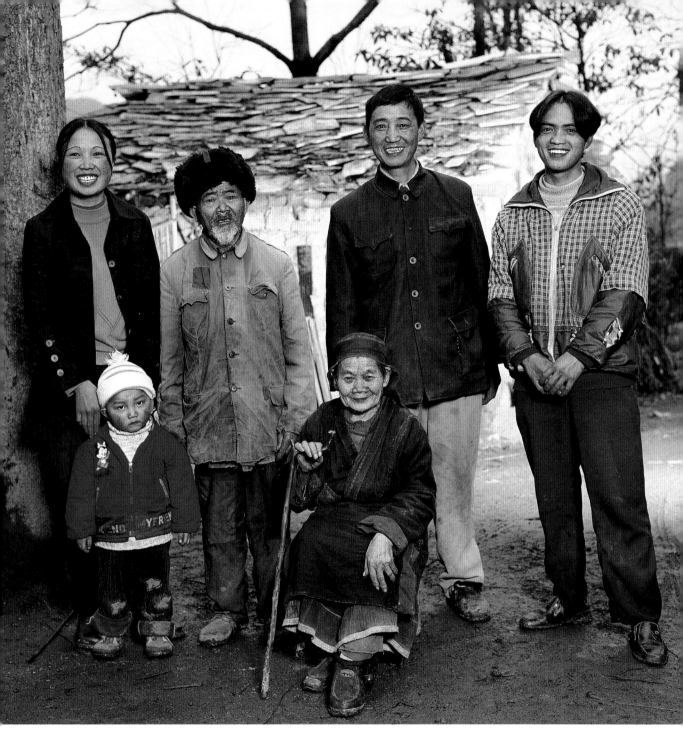

Near Guiyang,
China,
2 March 2000

Die Großeltern, beide 72, sind in dem Dorf geboren, haben mit 17 geheiratet und haben immer hier gelebt. Sie wohnen mit ihren beiden Söhnen, ihrer Schwiegertochter und deren Kind zusammen. Die junge Generation kümmert sich um den kleinen Familienbauernhof und eine Tischlerei, die die Bretter für den Haus- und Möbelbau des Dorfs liefert.

The 72-year-old grandparents were born in the village and have never left the area. They were married at the age of 17, and live with their two sons, their daughter-in-law and her child. The younger people run the small family farm and a carpentry shop which supplies the planks needed for building village houses and furniture.

Les grands-parents (soixante-douze ans) sont nés au village, n'ont jamais quitté la région, se sont mariés à l'âge de dix-sept ans et vivent avec leurs deux fils, leur belle-fille et son enfant. Ce sont les jeunes qui se chargent de la petite ferme familiale et d'une menuiserie qui fournit les planches nécessaires à la construction des maisons et meubles du village.

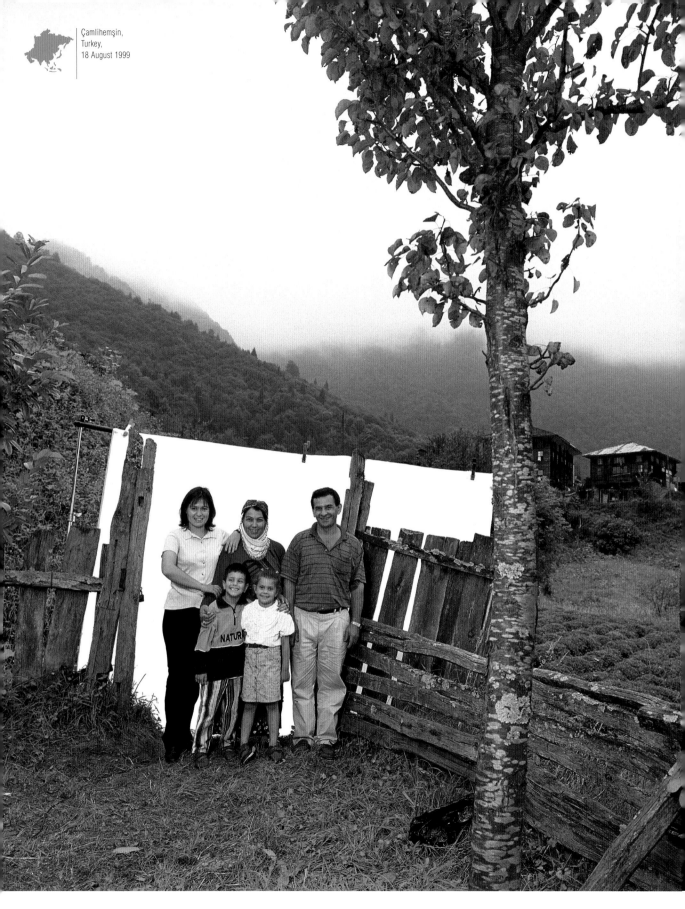

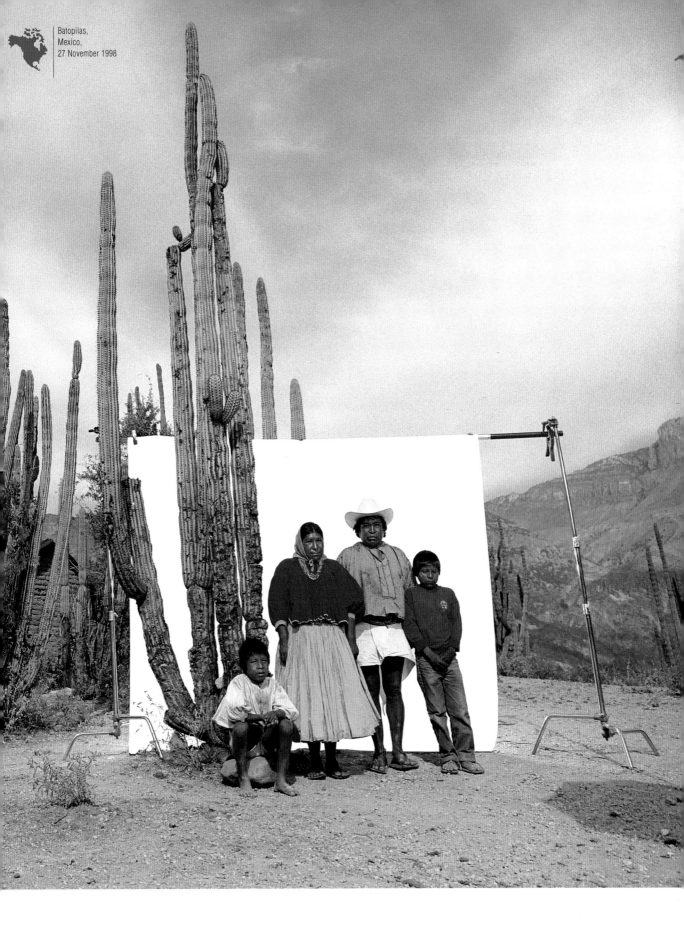

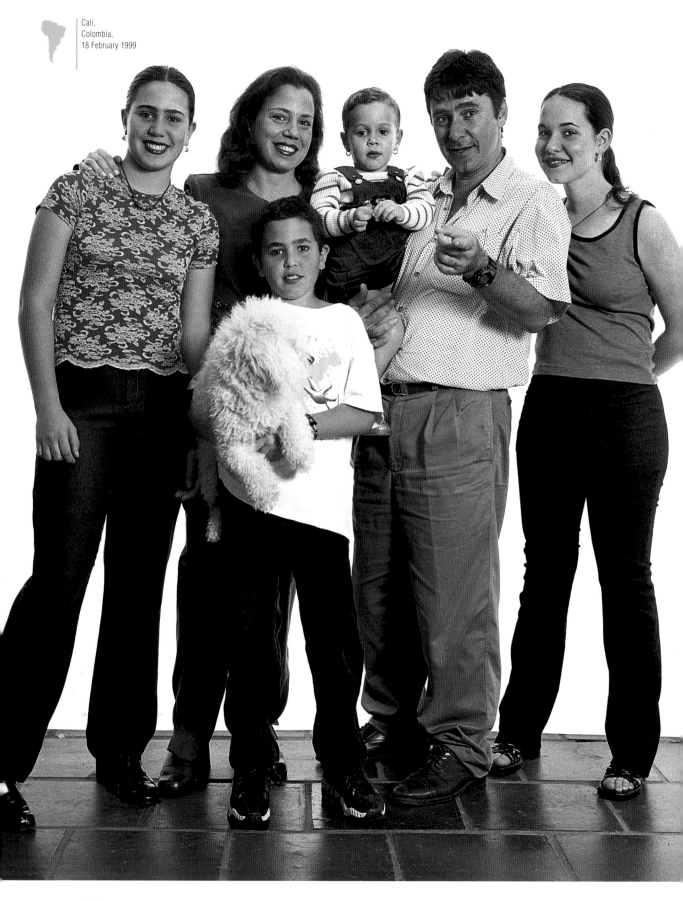

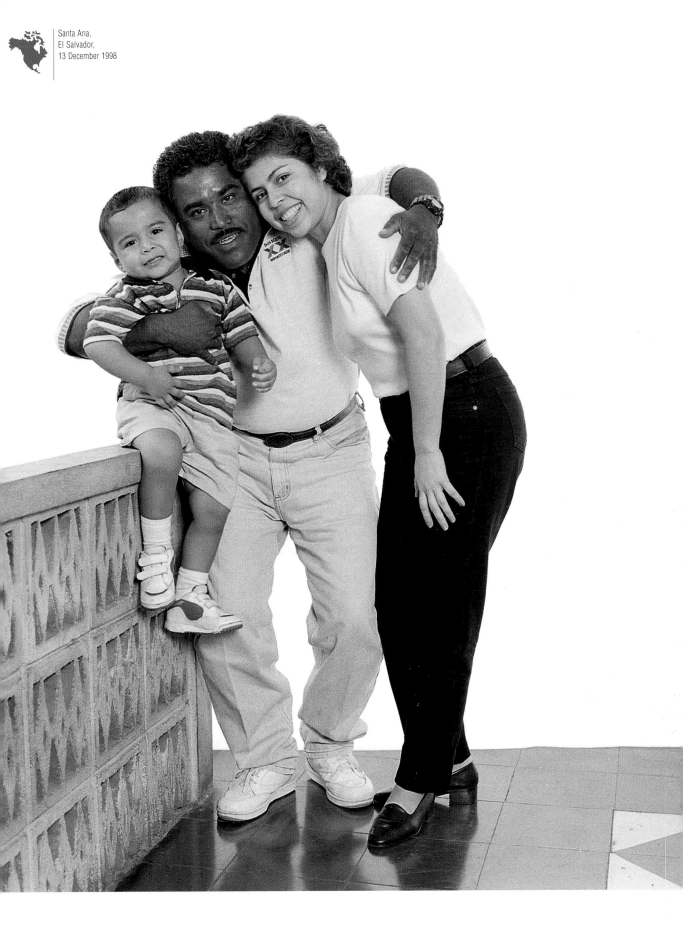

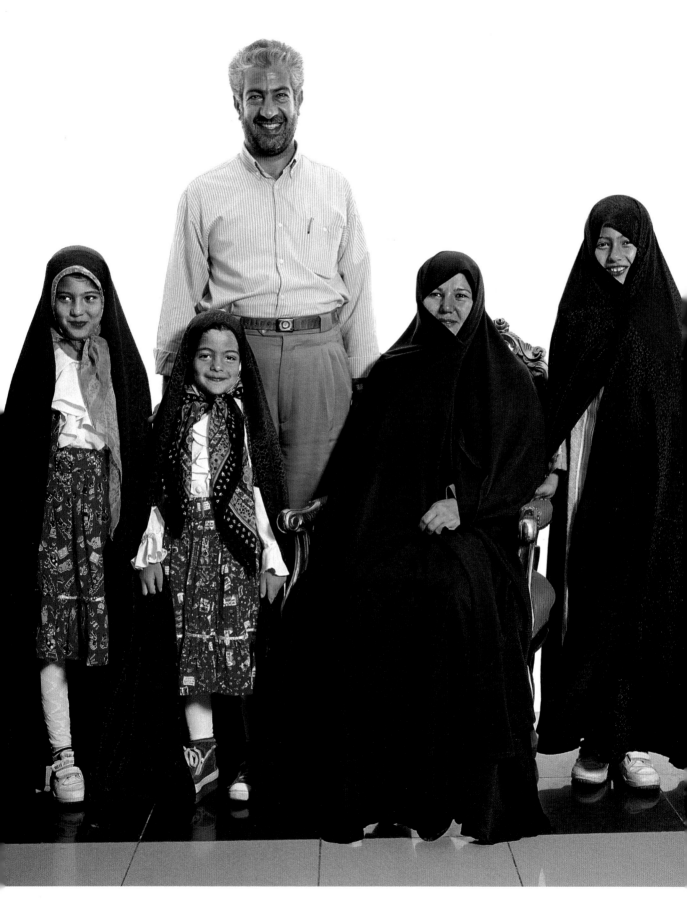

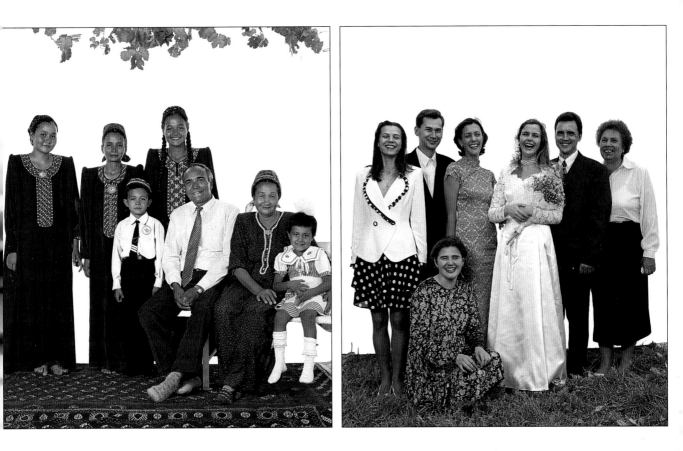

Teheran,
Iran,
18 September 1999

Hossin und Familie reisen selbstverständlich mit der Bahn – das ist der Bahnhofsvorsteher seinem Arbeitgeber schuldig. Wir trafen sie auf ihrer Pilgerreise nach Meschhed im Osten des Landes, wo sie das Grabmal Imam Rezas besuchen wollten.

Hossin is a station master, and so he naturally likes taking his family on the train. We met them during the pilgrimage they were making to the tomb of Imam Reza in Mashhad, in the east of the country.

Chef de gare, Hossin aime naturellement prendre le train en famille. C'est à l'occasion du pèlerinage qu'ils effectuaient sur la tombe d'Emman Rheza à Mashad, à l'est du pays, que nous les avons rencontrés.

Gyami,
Turkmenistan,
15 September 1999

„2000 wird ein goldenes Jahr! Unser Führer und Präsident wird uns den Weg in ein besseres Leben zeigen", davon ist Kurban, Professor für Turkmenisch und turkmenische Geschichte, überzeugt. Er ist seit 35 Jahren verheiratet und zeigt sich umringt von dreien seiner sieben Kinder und zwei Enkelkindern.

"2000 will be a golden year! Our guide and president will lead us to a better life," says Kurban, professor of Turkmen language and history. He has been married for 35 years, and is surrounded by three of his seven children and two grandchildren.

« L'an 2000 sera une année en or! Notre guide et Président nous mènera à une vie meilleure! », affirme Kurban, professeur de turkmène et d'histoire turkmène. Marié depuis trente-cinq ans, il est entouré de trois de ses sept enfants et de deux petits-enfants.

St. Petersburg,
Russia,
10 July 1998

Elena und Sergej wurden von uns im Park der Sommerresidenz von Peter dem Großen verewigt – am Tag ihrer Hochzeit. Ihre Pläne für die nahe Zukunft: zuerst das Ereignis im Kreise der Familie bei einem traditionellen Essen feiern und danach eine Hochzeitsreise, bei der sie auch der alten Großmutter einen Besuch abstatten werden, die bei der Trauung nicht dabei sein konnte. „Und im Jahre 2000 vielleicht ein Baby …", wirft Elena lachend ein.

We immortalized Elena and Sergei on the day of their wedding in the gardens of Peter the Great's summer palace. The immediate future means celebrating the event with the family around a traditional table, then going on a honeymoon, during which they will be visiting their old grandmother, who wasn't able to attend the ceremony. "And then perhaps a baby in 2000 …," adds Elena, with a clap of laughter.

C'est dans le parc de la résidence d'hiver de Pierre le Grand, que nous avons immortalisé, le jour de leur union, Elena et Sergey. Le futur proche, c'est d'abord fêter l'événement en famille autour d'une table traditionnelle, puis effectuer un voyage de noces pendant lequel ils rendront visite à leur vieille grand-mère qui n'a pas pu assister à la cérémonie. « Et peut-être un bébé en l'an 2000 … », ajoute Elena dans un éclat de rire.

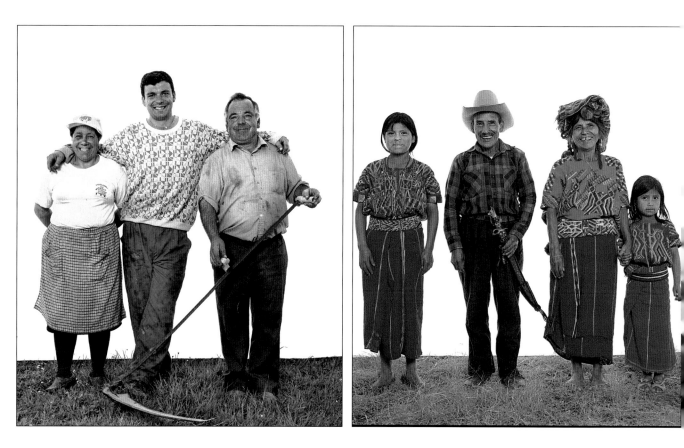

Lugo,
Spain,
14 May 1998

Wir trafen sie auf den Weiden, wo sie das Heu für ihre 20 Kühe und Kälber einbrachten. José und Maria pflanzen darüber hinaus Mais und Gemüse in ihrem Küchengarten an, wobei ihnen ihre Kinder zur Hand gehen. Die Familie lebt seit fünf Generationen in diesem Weiler mit einem Dutzend Häusern und nicht viel mehr Einwohnern. Den 23-jährigen Dionisio schüchterten die inquisitorischen Blicke seiner Eltern so ein, dass er es vorzog, uns nichts über seine Familienpläne für die Zukunft zu erzählen.

We found them in their meadow, busy making hay for their 20 cows and calves. Helped by their children, José and Maria also grow maize and all sorts of vegetables in their kitchen garden. The family has lived for five generations in this hamlet of a dozen houses – and about the same number of inhabitants. Twenty-three-year-old Dionisio was bothered by the inquisitorial way his parents looked at him, and didn't dare tell us about his possible family plans.

Nous les avons trouvés dans leur pré, occupés à faire les foins pour leurs vingt vaches et veaux. José et Maria, aidés de leur fils, cultivent aussi le maïs et font pousser toutes sortes de légumes dans leur potager. Depuis cinq générations, la famille vit dans ce hameau d'une douzaine de maisons qui n'a jamais compté beaucoup plus d'habitants. Dionisio (vingt-trois ans), gêné par le regard inquisiteur de ses parents, n'a pas osé nous répondre sur ses éventuels projets familiaux.

Chichicastenango,
Guatemala,
10 December 1998

„Wir sind wie jede Woche auf den Markt gekommen, um zu verkaufen, aber auch um einzukaufen und Neuigkeiten aus den anderen Dörfern zu erfahren." Sebastián ist Bauer und erntet Äpfel, Avocados und Bohnen, die seine Frau auf dem Markt verkauft.

"Like every week, we've come to the market to sell things, but also to buy things and get news from other villages." Sebastián is a farmer and harvests apples, avocado pears and beans, which his wife sells at the market.

« Comme chaque semaine, nous sommes venus au marché pour vendre, mais aussi pour acheter et prendre des nouvelles des autres villages. » Sebastian est agriculteur et récolte pommes, avocats et haricots que sa femme se charge de vendre au marché.

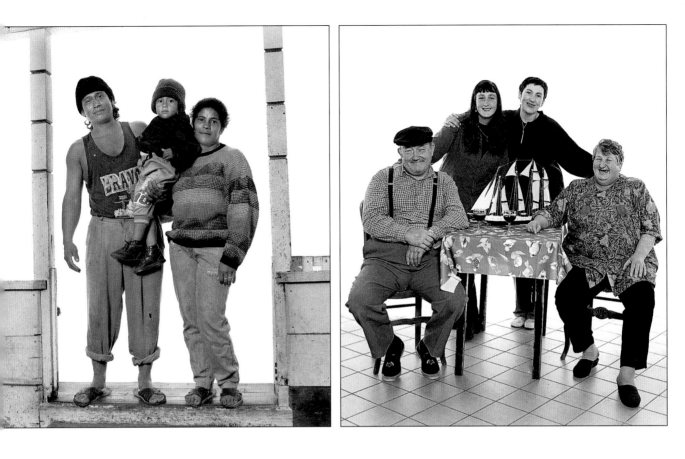

Alto Lino,
Panama,
29 December 1998

Sie haben sich beim Tomatenpflücken kennen gelernt. Als Saisonarbeiter helfen sie zurzeit bei der Kaffee- und Orangenernte. „Das neue Jahrtausend wird auf der ganzen Welt viele wissenschaftliche Neuerungen bringen, doch für mich wird sich nicht viel ändern", meint Giovanni und fügt hinzu: „Liebe deinen Nächsten!"

They met picking tomatoes. As seasonal workers, they're picking coffee and oranges right now. "The new millennium will bring a lot of scientific changes at a worldwide level, but for me that's not going to change a whole lot," Giovanni tells us, adding: "Love your neighbour!"

Ils se sont connus en ramassant des tomates. Travailleurs saisonniers, ils récoltent en ce moment le café et les oranges. « L'an 2000 apportera beaucoup de changements scientifiques au niveau mondial, mais pour moi, ça ne va pas changer grand-chose », nous dit Giovanni, et il conclut: « Aimez votre prochain ! »

Belz,
France,
6 May 1998

In dieser Familie arbeiten die Männer seit Generationen als Fischer. Seit Georges das Steuer seinem Sohn übergeben hat, verbringt der begeisterte Hobby-gärtner die meiste Zeit im Garten. Als Geschäftsfrau ist Éliane schon von Berufs wegen sehr kontaktfreudig. Vor allem die Künstler, die hier Urlaub machen, haben es ihr angetan. Die beiden Töchter helfen ihr im familieneigenen Bistro.

This family has been involved in inshore fishing for several generations. Georges has turned over the rudder to his son, and now spends his time gardening. Shopkeeper Éliane loves meeting people, especially artists visiting the region. Their two daughters help her to run the family bistro.

Dans la famille, ils sont pêcheurs côtiers depuis plusieurs générations. Georges a transmis les rênes à son fils et se consacre désormais au jardinage. Eliane, commerçante, a une grande passion pour les contacts humains et adore rencontrer les artistes en visite dans la région. Leurs deux filles s'occupent du bistro familial.

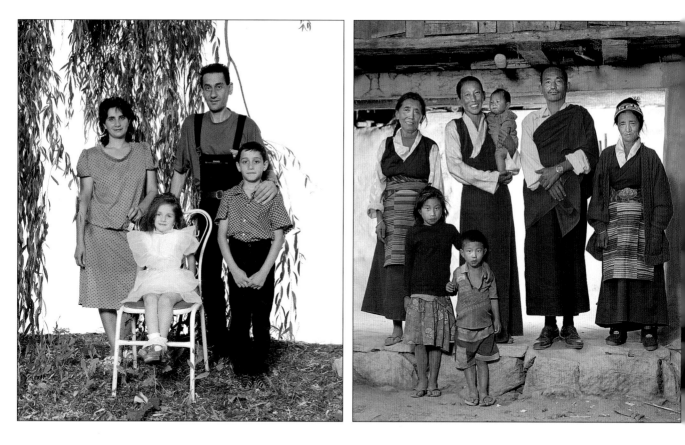

Tsaghkadzor,
Armenia,
25 August 1999

„Wir hoffen, dass sich die wirtschaftliche Lage in Armenien verbessert. Das gibt uns die Kraft weiterzumachen." Harutyun ist Ingenieur für Wasserwirtschaft, arbeitet zurzeit jedoch als Hausmeister in einem staatlich geführten Hotel, in dem nur die „Elite des Landes" logiert.

"We live in hope that the economic situation in our country will get better. Without hope, there is no life." Harutyun is a hydraulic engineer by training, but works in the maintenance department of a government hotel reserved for the country's 'élite'.

« Nous vivons avec espoir ! Sans espoir il n'y a pas de vie. Nous espérons que la situation économique de notre pays s'améliorera. » Harutyun est ingénieur en hydraulique, mais travaille au service maintenance d'un hôtel gouvernemental réservé à « l'élite du pays ».

Tashiding,
Sikkim, India,
20 November 1999

Phurba ist der Direktor der örtlichen Schule. Die Tatsache, dass er seit seinem 15. Lebensjahr buddhistischer Mönch ist, hindert ihn nicht daran, zwei Frauen zu haben.

Phurba is headmaster of the local school. Since the age of 15, he has been a Buddhist monk – but this doesn't stop him having two wives.

Phurba est principal de l'école locale. Moine bouddhiste depuis l'âge de quinze ans, cela ne l'empêche pas d'avoir deux femmes.

Posadas,
Argentina,
26 March 1999

Ramón arbeitet als Cowboy auf einer 10 000 Hektar großen Ranch, wo er sich zusammen mit nur zwei Kollegen um eine 1600-köpfige Rinderherde kümmert. Er träumt von einer eigenen Ranch und sei sie noch so klein. Mariela wird in drei Jahren ihr Philosophiestudium beenden und hofft, dann eine Anstellung als Lehrkraft zu finden.

Ramón works as a cowboy on a ranch of almost 25,000 acres [10,000 ha]. With only two comrades, he watches over 1,600 head of cattle. Ramón dreams of having a ranch of his own some day – even if it's a very small one. Mariela will finish her philosophy studies in three years and then hopes to find a position as a professor.

Ramón est employé cow-boy dans un ranch de 10 000 hectares, il surveille et soigne avec deux autres employés 1600 têtes de bétail. Son rêve est d'avoir son propre ranch, même un tout petit ! Mariela finira ses études de philosophie dans trois ans et espère trouver un emploi de professeur.

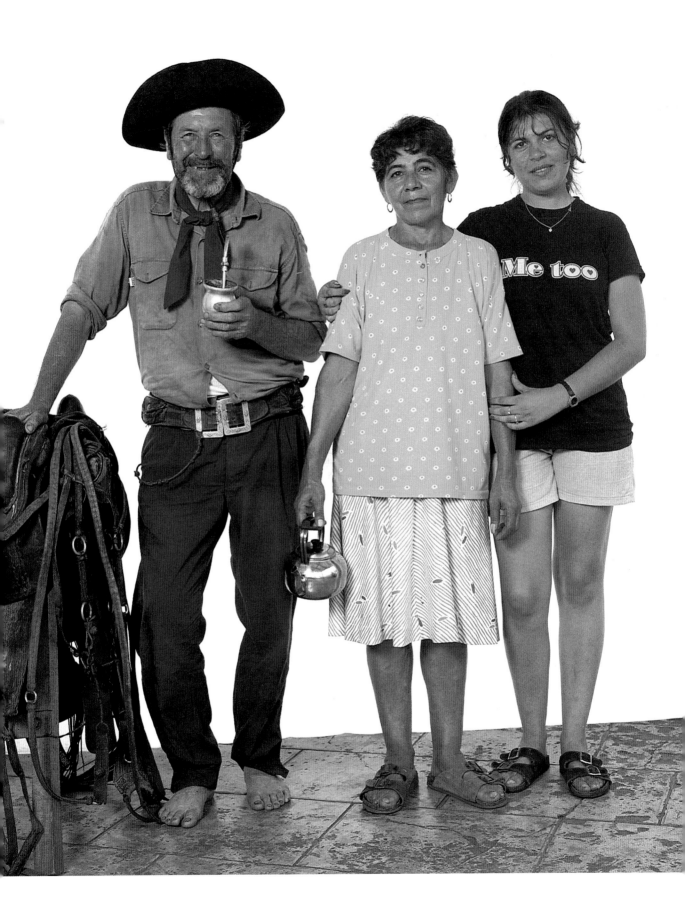

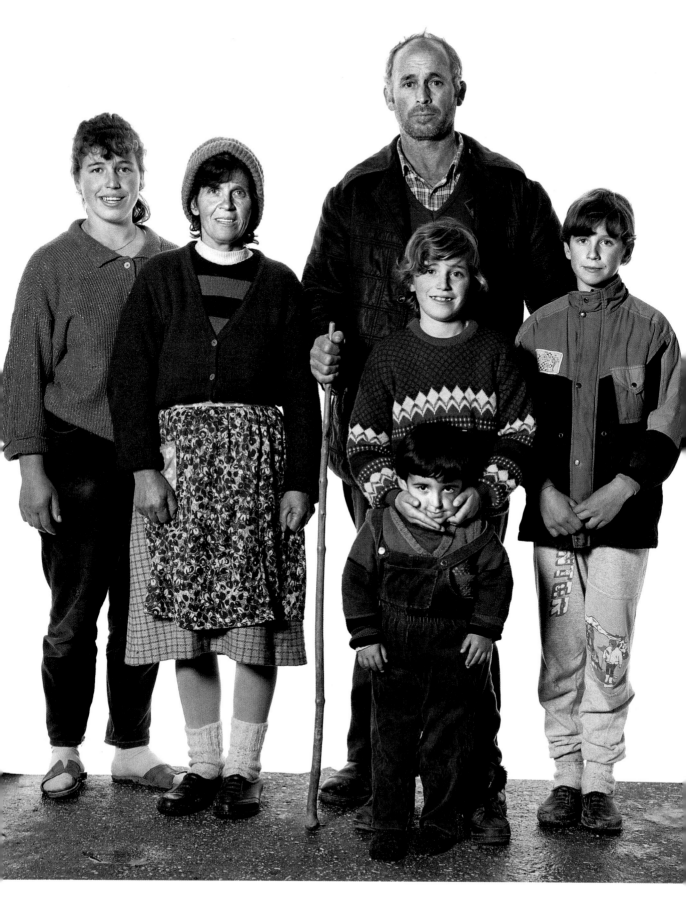

2

3

1
Chanco,
Chile,
17 January 1999

2
Tartu,
Estonia,
12 July 1998

3
Cotonou,
Benin,
12 July 1997

Lepenic,
Albania,
17 December 1996

Er besitzt 50 Schafe, ein nagelneues, voll verklinkertes Haus, jede Menge Sofas und fluoreszierende Plastikpflanzen, einen Kühlschrank, einen Fernseher, eine gigantische Satellitenschüssel und einen Elektrokocher, der mangels Steckdose statt in der Küche im Schlafzimmer steht. Mufit kann gut von den Erzeugnissen seiner Herde – Käse, Joghurt und Butter – leben. Er hofft, seine Herde bald vergrößern zu können, und zählt auf die Hilfe seiner Kinder im Schafstall.

He has 50 sheep, a new home tiled throughout, an abundance of sofas, fluorescent plastic plants, a fridge, a TV, a huge satellite dish and an electric hotplate that's hooked up in the bedroom because there isn't a socket in the kitchen. Mufit makes a good living from the cheese, butter and yoghurt he produces. He's hoping to increase his flock, and he's relying on his children to help him in the sheepfold.

Il possède cinquante moutons, une maison neuve tout en carrelage, des sofas en pagaille, des plantes fluorescentes en plastique, un frigo, une télé, une parabole géante et un réchaud électrique branché dans la chambre à coucher par manque de prise dans la cuisine. Mufit gagne très bien sa vie grâce au fromage, au beurre et aux yoghourts qu'il fabrique. Il espère augmenter son troupeau et compte sur ses enfants pour l'aider à la bergerie.

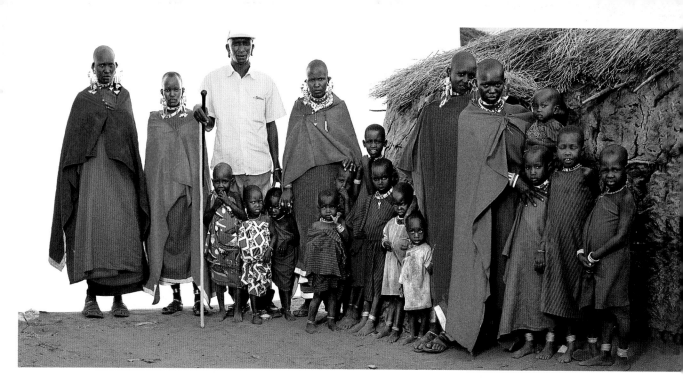

 Longido,
Tanzania,
11 November 1997

 Kyoto,
Japan,
24 February 2000

Der Architekt und die Innenarchitektin ergänzen sich perfekt. Die zwölfjährige Rina träumt davon, Stewardess zu werden, „um die Welt zu sehen", und Hideaki (17) wird trotz seiner Liebe zu Klavier und Gitarre in die Fußstapfen seines Vaters treten und Architekt werden. Ihr gemeinsames Hobby ist es, sich amerikanische Filme auf Video anzuschauen.

An architect and interior designer, they complement one another to perfection. Twelve-year-old Rina dreams of being a flight attendant "so I can see the world," and despite his love for guitar and piano, Hideaki (17) will be following his father as an architect. Their common hobby is watching American films on video.

Architecte et décoratrice d'intérieur, ils se complètent à merveille. Rina (douze ans) rêve d'être hôtesse de l'air « pour aller voir le monde » et Hideaki (dix-sept ans), malgré son amour pour la guitare et le piano, suivra son père et deviendra architecte. Leur hobby commun est de regarder les films américains en vidéo.

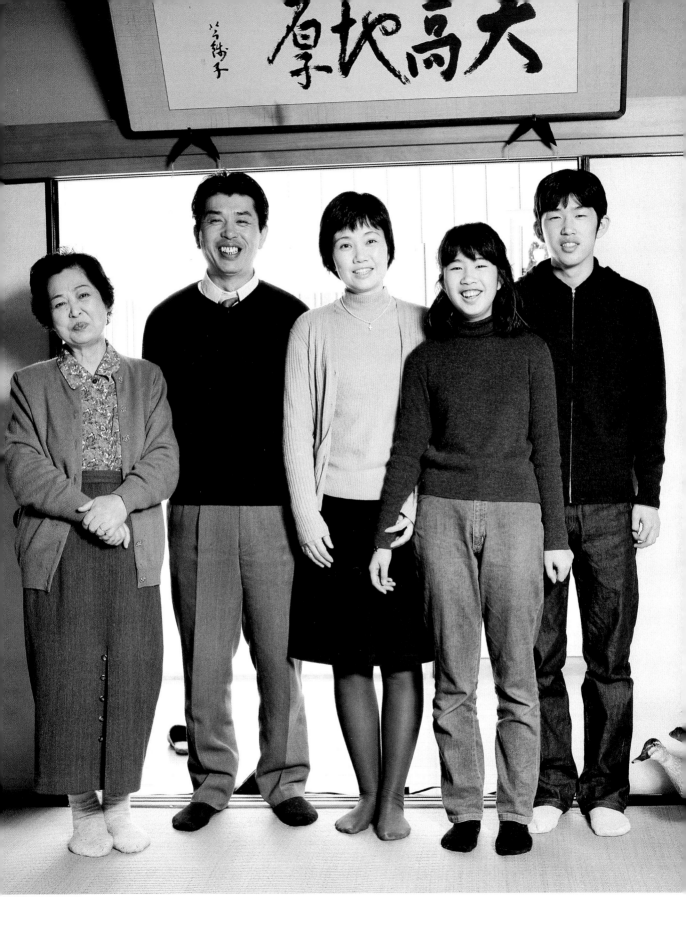

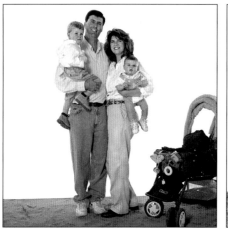
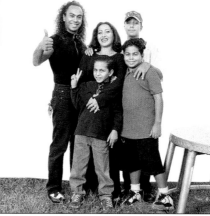
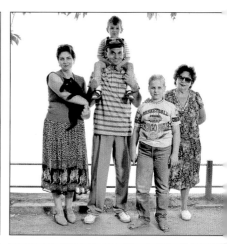

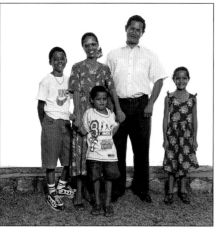
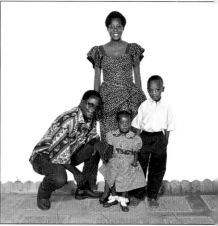

1
7

2
8

3
9

	1 Durand, Michigan, USA, 12 November 1998		2 Atlanta, Georgia, USA, 14 October 1998		3 Saratov, Russia, 31 August 1999		4 Lagos, Nigeria, 14 July 1997
	7 Kariba, Zimbabwe, 26 October 1997		8 Lusaka, Zambia, 24 October 1997		9 Abidjan, Ivory Coast, 21 May 1997		10 Chittagong, Bangladesh, 27 November 1999

Page 414

„Mein sehnlichster Wunsch ist es, dass das ganze Dorf zum muslimischen Glauben übertritt, denn dann stünde mir der Weg ins Paradies offen." So könnte man die Hoffnungen zusammenfassen, die der Imam der Moschee von Sangha für die Zukunft hegt ...

"My dearest wish is that the whole village should convert to Islam; that way I could go to heaven." This sums up the hopes for the future nurtured by the imam of the mosque at Sangha ...

« Mon souhait le plus cher est que tout le village se convertisse à la religion musulmane, je pourrais ainsi aller au paradis. » C'est le résumé des espoirs que nourrit l'Imam de la mosquée de Sangha sur l'avenir.

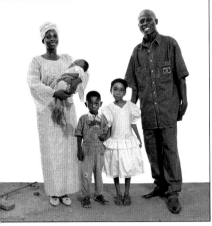
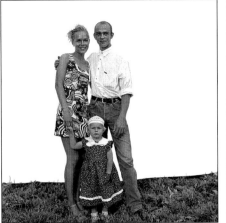
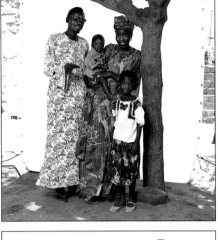

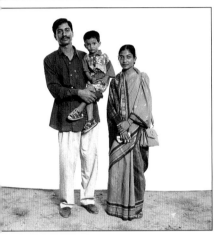
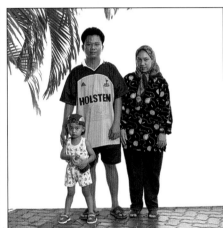
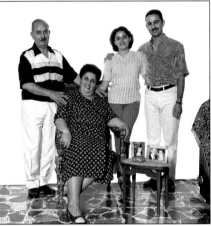

5
11

6
12

Page 415

Dick und Jeanne sind das ganze Jahr unterwegs. Sie reisen quer durch die USA von einem Wohnwagentreffen zum nächsten, „immer der Sonne hinterher". Sie haben ihr ganzes Leben in Caravans und Campingbussen verbracht. „Unser Sohn wurde vor 43 Jahren in unserem zweiten Caravan geboren. In 46 Ehejahren hatten wir 36 Gefährte – und nie ein Zelt!", erinnert sich Jeanne. Fehlt ihnen ein festes Haus nicht? „In einem Haus bekommen wir Heimweh", ruft Dick aus.

Dick and Jeanne are 'sun birds', traversing the length and breadth of the United States in pursuit of the sun and attending camper meetings throughout the year. Their life is lived in homemobiles: "Our son was born 43 years ago in our second camper. This is our 36th camper in 46 years of marriage – and never a tent," adds Jeanne. Don't they miss having a house? "In a house we get homesick," exclaims Dick.

Dick et Jeanne voyagent à plein temps. Ils sillonnent les Etats-Unis de long en large en « suivant le soleil » et les meetings caravaniers tout au long de l'année. Leur vie se déroule de caravanes en bus ou *mobile-homes*: «Notre fils est né il y a quarante-trois ans dans notre deuxième caravane. Nous en sommes à notre trente-sixième véhicule en quarante-six ans de mariage, et jamais de tente!», ajoute Jeanne. La maison ne leur manque-t-elle pas? « A la maison, on a le mal du pays!», s'exclame Dick.

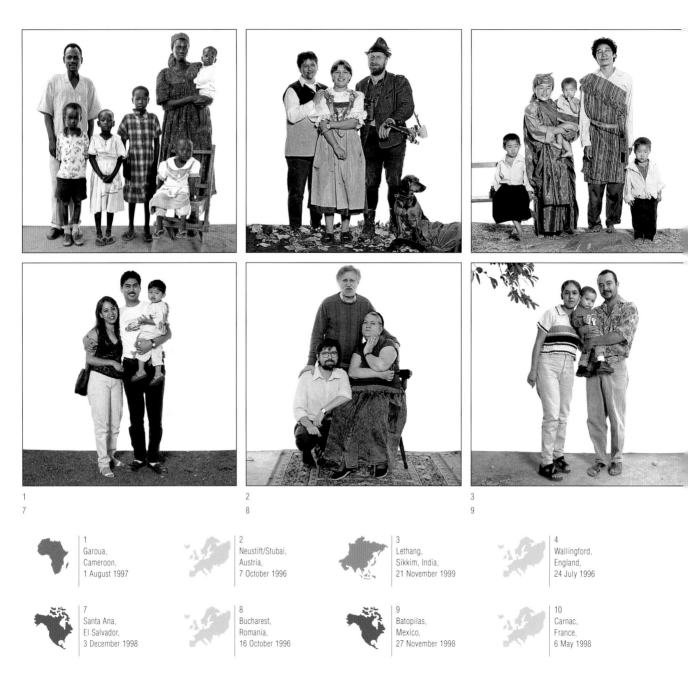

1
7

2
8

3
9

1
Garoua,
Cameroon,
1 August 1997

2
Neustift/Stubai,
Austria,
7 October 1996

3
Lethang,
Sikkim, India,
21 November 1999

4
Wallingford,
England,
24 July 1996

7
Santa Ana,
El Salvador,
3 December 1998

8
Bucharest,
Romania,
16 October 1996

9
Batopilas,
Mexico,
27 November 1998

10
Carnac,
France,
6 May 1998

Page 416

Der Maler und Musiker Daven, ein echter Apache, fand seine Frau im Katalog! Tatsächlich ist Jill, Model und Schauspielerin mit indianischen, deutschen und irischen Wurzeln, in Santa Fe sehr bekannt, wo ihre Modefotos zahlreiche Magazine und Kataloge zieren. Als Daven sie in der Stadt sah, bat er sie zunächst, für ihn Modell zu stehen und – wenig später – seine Frau zu werden. Heute würde Jill gern ein Theaterstück für die Kinder in den Indianerreservaten schreiben und aufführen. Zusammen nehmen sie oft an *Powwows* teil. Laut Jill sind die Apachen begnadete Tänzer.

Painter and musician Daven, who is 100% Apache, found his wife in a catalogue! Model and actress Jill – whose ancestry is a mixture of Native American, German and Irish – is well known in Santa Fe, where her fashion photos grace many magazines and catalogues. Daven met her in town and asked her first to pose for him – and shortly thereafter to marry him. Today Jill would like to write and present a play for the children on Indian reservations. They go to lots of powwows together. Jill considers the Apache to be outstanding dancers.

Daven, 100 % Apache, peintre et musicien, a trouvé sa femme dans un catalogue ! En effet Jill, mannequin et actrice d'origine indienne d'Amérique, allemande et irlandaise, est connue à Santa Fé où ses photos de mode illustrent de nombreuses publications. Daven, l'ayant reconnue en ville, lui a demandé de poser pour lui … pour l'épouser peu après. Aujourd'hui, Jill aimerait écrire et jouer une pièce pour les enfants des réserves indiennes. Ensemble, ils assistent à de nombreux pow-wows. Selon Jill, les Apaches sont des danseurs exceptionnels.

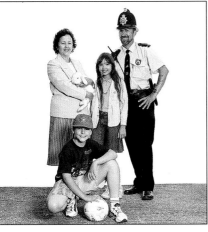
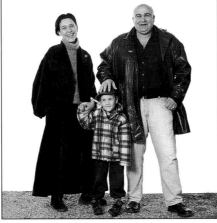
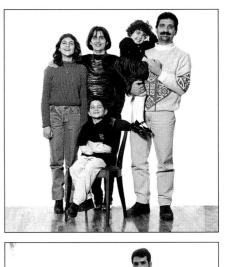

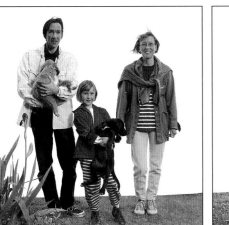

0
11

5
11

6
12

5
Siena,
Italy,
11 December 1996

6
Seres,
Greece,
2 January 1997

11
Kampong Ayer,
Brunei,
24 December 1999

12
Mashhad,
Iran,
18 September 1999

Page 417

Bernadette ist Geschäftsfrau, sie besitzt zwei Läden. Vor fünf Jahren lernte sie einen jungen Agraringenieur, der sich auf Bewässerungstechnik spezialisiert hatte, kennen und heiratete ihn. Sie ist zum Islam, der Religion ihres Mannes, konvertiert, um die Harmonie zwischen den Eheleuten zu bewahren. „Ich bete darum, dass der Frieden an der Elfenbeinküste erhalten bleibt und dass Gott uns vor schlimmen afrikanischen Krankheiten behütet." Vor unserer Abfahrt grüßt sie alle Familien in der Welt brüderlich.

Bernadette is a businesswoman with two shops. Five years ago she met the young agronomist specializing in irrigation who would become her husband. She converted to Islam, her husband's religion, to preserve the harmony of their relationship. "I pray that peace will continue in the Ivory Coast, and that God will protect us from serious African diseases." Before we leave she sends a sisterly greeting to all the families in the world.

Bernadette est commerçante, elle possède deux magasins. Il y a cinq ans, elle rencontre un jeune ingénieur agronome, spécialisé en irrigation, qui deviendra son mari. Mᵐᵉ Kamara s'est convertie à l'islam, la religion de son mari, pour «conserver» l'harmonie de son couple. «Je prie pour que la paix continue en Côte d'Ivoire et que Dieu nous protège des graves maladies africaines.» Avant notre départ, elle tient à saluer fraternellement toutes les familles du monde.

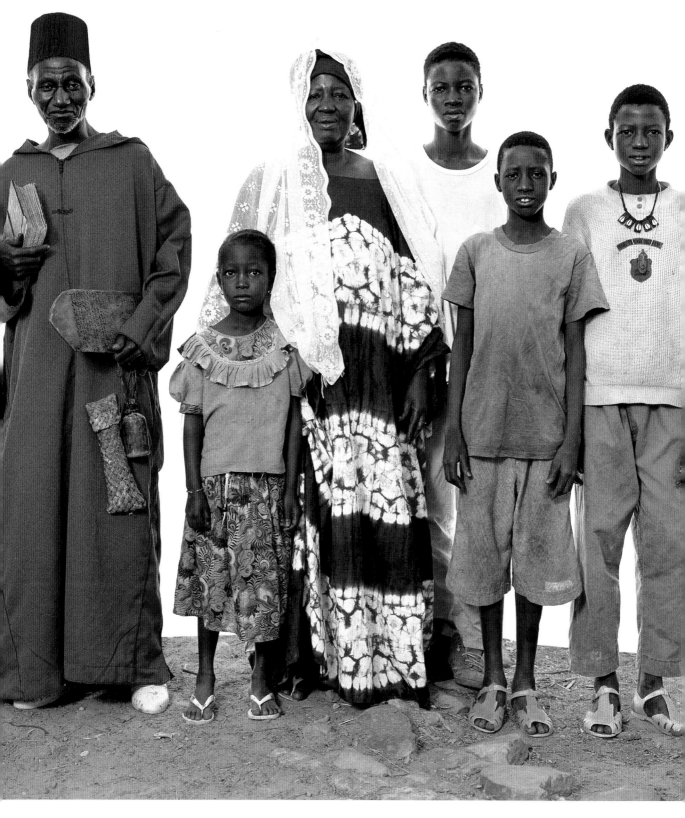

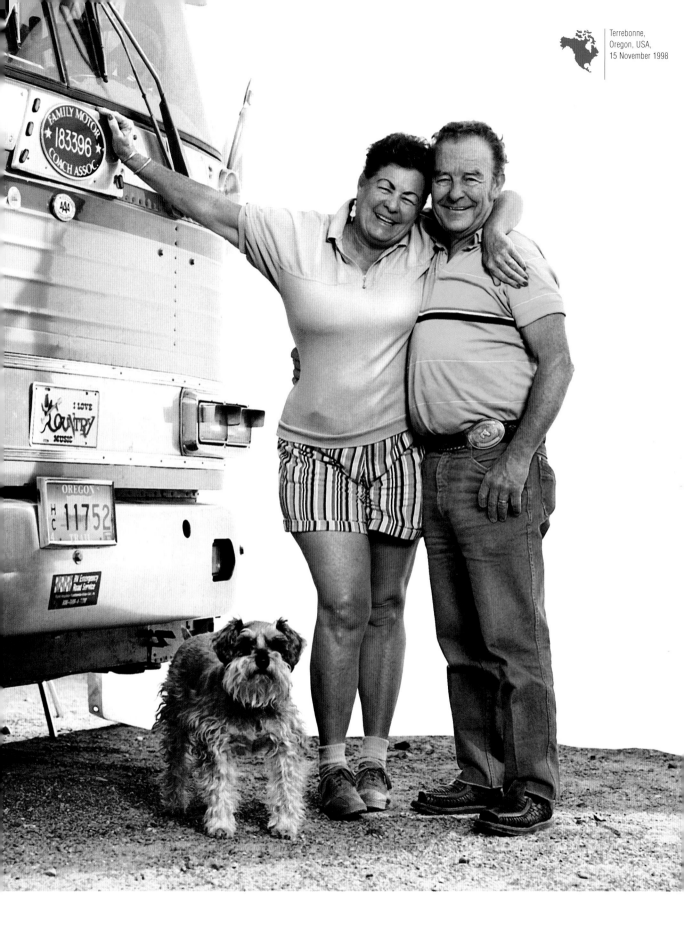

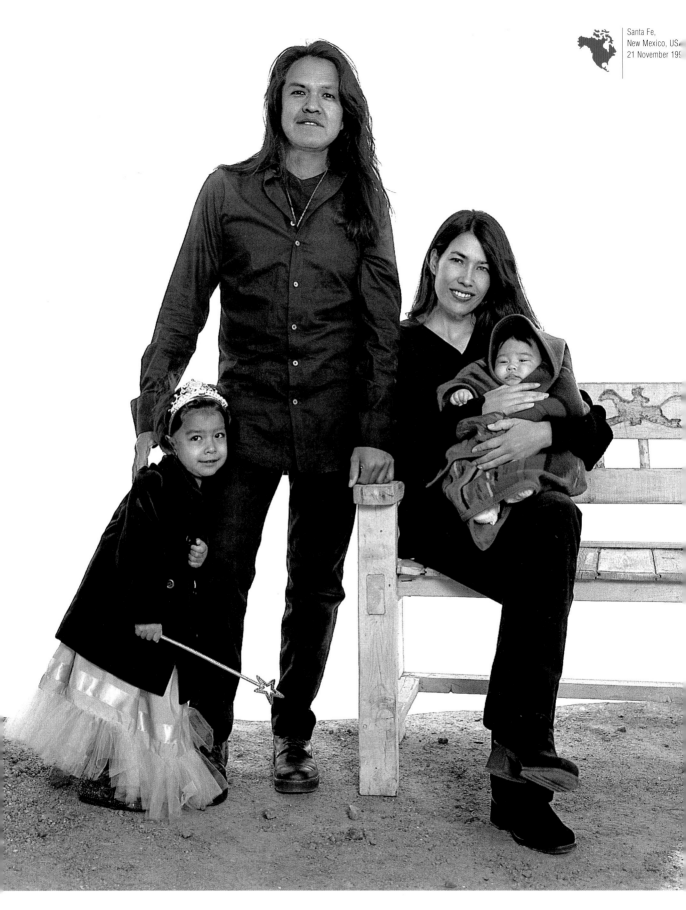

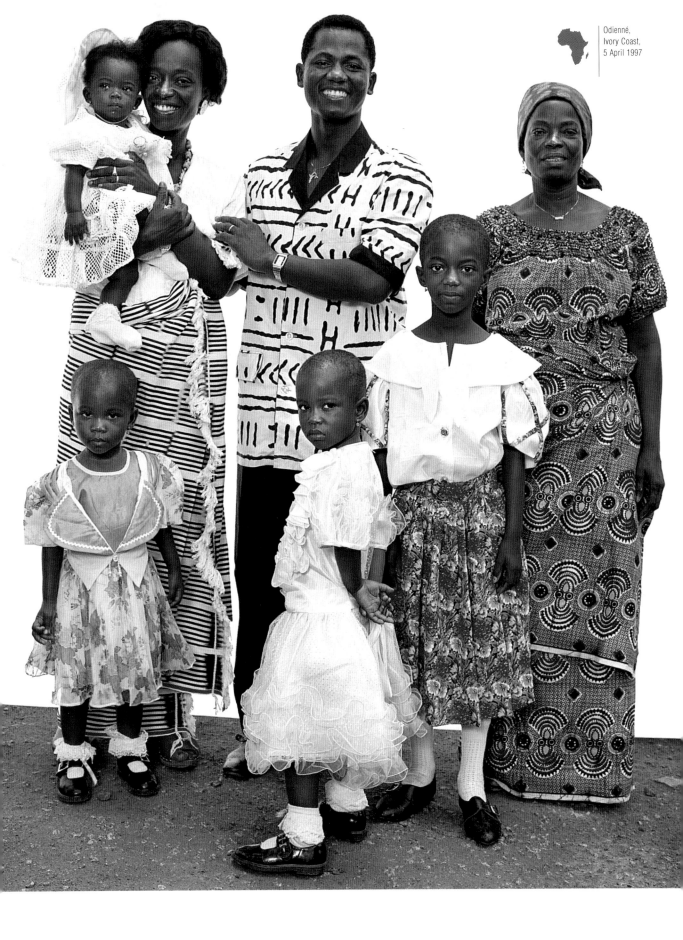

Abomey,
Benin,
11 July 1997

Abel, dessen Visitenkarte ihn als „den Mann, der seine schöpferischen Kräfte unter Beweis stellt", ausweist, ist der Sohn des Königs von Dahomey. Er entwirft Muster für traditionelle Wandbehänge, die seine Frau, wenn sie fertig sind, säumt. „Mein Sohn wird diese Tradition ebenfalls weiterführen, ich habe ihm schon einiges beigebracht. Wenn mehr Touristen hierher kämen, würde das Geschäft besser laufen, aber ich mag meinen Beruf sehr, daher mache ich weiter." Für Abel ist das Jahr 2000 ein Jahr wie jedes andere – solange die Leute nicht vergessen vorbeizukommen, um sich seine Wandbehänge anzuschauen.

Abel, whose business card proclaims him as "the man who demonstrates his own creative strengths," is the son of the king of Dahomey. As dictated by family tradition, he has become a tapestry-maker; he creates the patterns for his own wall hangings, and his wife finishes them by making the hems. "My son will be a tapestry-maker, too. I've already started introducing him to the craft. If there were more tourists, business would be better … but I like my trade a lot, so I keep going." 2000 is a year like any other for Abel – just don't forget to come and see his wall hangings.

Abel, l'artiste, dont la carte proclame « l'homme dit ses propres forces », est le fils du roi de Dahomey. Comme le veut la tradition familiale, il sera tapissier ; il crée ses propres modèles de tentures et sa femme les finit en faisant les ourlets. « Mon fils sera tapissier aussi, j'ai déjà commencé à lui montrer. S'il y avait plus de touristes, le commerce marcherait mieux, mais j'aime beaucoup mon métier alors je continue. » L'an 2000 est une année comme une autre pour Abel, il faut juste ne pas oublier de venir voir ses tentures.

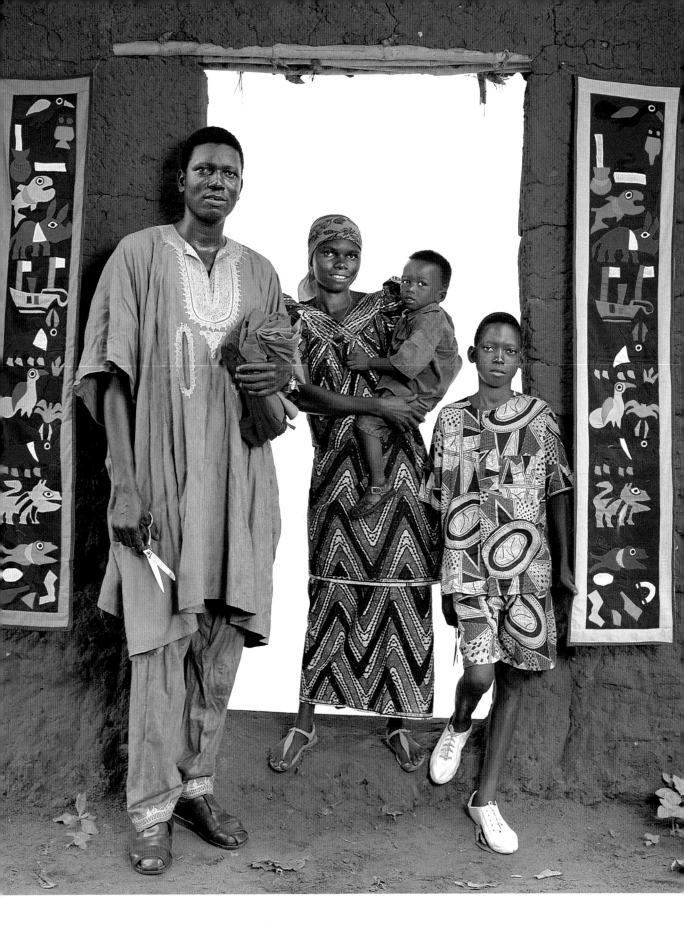

Listrac-Médoc,
France,
10 May 1998

Ausnahmsweise durfte auch die kleine Maelis ein Gläschen 1990er Château Fourcas-Dupré trinken, um auf das Familienfoto anzustoßen! „Guter Wein wird aus guten Trauben gemacht!", lautet das Motto von Patrice, dessen Urgroßvater einst den Grundstein dieser Winzerdynastie legte, als er in Tunesien Weinberge anlegte. Das neue Jahrtausend? „Jeder hat sein Schicksal selbst in der Hand und sollte sich nicht scheuen, Verantwortung zu übernehmen!"

Even Maelis, the young daughter, was allowed a glass of 1990 Château Fourcas-Dupré to drink a toast to the family photo! "With good grapes you make good wine!" is the key to Patrice's philosophy. His great grandfather started in wine by planting a vineyard in Tunisia. The new millennium? "God helps those who help themselves! Let's be responsible!"

Même Maelis, la petite fille, a eu droit à un verre de Château Fourcas-Dupres 1990 pour trinquer à la photo de famille! « Avec du bon raisin, on fait du bon vin! » : c'est une phrase clef de la philosophie de Patrice, dont l'arrière-grand-père a débuté dans le vin en Tunisie en créant un vignoble. Le nouveau millénaire : « Aide-toi et le ciel t'aidera! Soyons responsables! »

San Francisco,
California, USA,
10 November 1998

„Das Fotografieren ist meine Droge, genau wie das Leben im Freien, Camping und Waldwanderungen", so Eric, Erotik- und Fetischfotograf. Seine Scheidung und die neue Situation als allein erziehender Vater zweier Töchter hat sein Leben verändert: „Ich habe kochen gelernt (Nudeln …) und bleibe nicht mehr die ganze Nacht weg auf der Suche nach einem potenziellen Model." In seiner Freizeit kümmert er sich um seine Töchter und versucht, seine Freundin zu bändigen!

"Photography is my drug, as is the outdoor life, camping and hiking in the forest," says Eric, a photographer specializing in erotic fetishism. His divorce and his new situation as a single father looking after his two daughters have changed his life: "I've learnt how to cook (pasta …), and I don't go out all night now looking for a potential model." When he has some spare time, he looks after his girls and tries to tame his girlfriend!

« La photo, c'est ma drogue, tout comme la vie en plein air, le camping et les randonnées en forêt », dit Eric, photographe spécialisé en fétichisme érotique. Son divorce et sa nouvelle situation de père seul en charge de ses deux filles ont changé sa vie : « J'ai appris à cuisiner (des pâtes …) et je ne sors plus les nuits entières à la recherche d'un modèle potentiel. » Quand il a du temps libre, il surveille ses filles et essaie de dompter sa petite amie!

Minsk,
Belarus,
18 July 1998

Stanislawa (Mitte), hier mit ihrer Mutter, einem Onkel und einem ihrer Brüder mit Frau und Kindern, war in der Familien-Datscha zu Besuch. Die Ballett-liebhaberin arbeitet am Ticketschalter der Oper. Das Tolle daran ist, dass sie so ihre Idole aus nächster Nähe sehen kann. Ihr Traum: die westlichen Länder zu bereisen.

Stanislava (in the middle), surrounded by her mother, an uncle and one of her brothers with his wife and children, is visiting the family dacha. She loves ballet, and works in the ticket office at the opera. She is thrilled with the job, which gives her a chance to see her idols close up. Her dream is to visit western countries.

Stanislava (au centre), entourée de sa mère, un oncle et un de ses frères avec femme et enfants, est en visite à la datcha familiale. Elle adore la danse et travaille à l'opéra, à la billetterie. Elle est ravie de ce travail qui lui permet de voir ses idoles de près! Son rêve: visiter les pays de l'Ouest.

Hoi An,
Vietnam,
6 February 2000

„Zweiräder" sind das bevorzugte Transportmittel in Vietnam. Daher hat Ngo einen Mopedverleih für Touristen und Einheimische aufgemacht. Seine Frau geht ihm zur Hand und die Geschäfte laufen ausgezeichnet. Phue (19) würde gern im Ausland studieren, um sein Englisch zu perfektionieren, und Due (13) träumt davon, Lehrer zu werden.

'Two-wheelers' are the favourite means of transport in Vietnam. So Ngo has set up a motorbike rental service for scooters for tourists and locals alike. His wife helps him and business is very good. Phue (19) would like to study abroad to perfect his English, and Due, who is 13, dreams of becoming a school teacher.

« Les deux roues » sont le moyen de transport favori au Viêt-nam. Ngô a donc créé un service de location de petites motos pour touristes et locaux. Sa femme l'assiste et les affaires marchent très bien. Phue (dix-neuf ans) voudrait étudier à l'étranger pour perfectionner son anglais et Dué (treize ans) rêve de devenir instituteur.

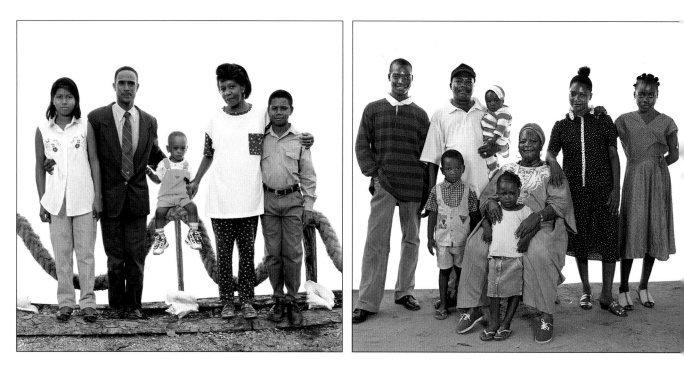

Bocas del Toro,
Panama,
5 January 1999

Rita ist Angestellte im Landwirtschaftsministerium und für die Reisfelder und Bananenplantagen auf der Insel Bocas del Toro zuständig. „Pablo ist Mecha-niker und zurzeit arbeitslos. Er tut, was er kann, er angelt und wir essen den Fisch …"

Rita is employed at the Ministry of Agriculture and deals with the rice and banana plantations on Bocas del Toro island. "Pablo is an out-of-work mechanic. He does whatever he can. He goes fishing and we eat the fish … "

Rita est employée au ministère de l'Agriculture et s'occupe des plantations de riz et de bananes de l'île de Bocas del Toro. « Pablo est mécanicien sans emploi, il fait ce qu'il peut, il pêche et ramène des poissons à la maison … »

Garoua,
Cameroon,
1 August 1997

N'Guizaya hat drei Kinder und drei Enkelkinder. Die Kauffrau verkauft alkoholische Getränke, um für den Unterhalt ihrer Familie zu sorgen. „Viele Leute glauben, ihre Situation würde sich im neuen Jahrtausend verändern, aber das glaube ich nicht. Warum warten, um seine Träume zu verwirklichen? Das Leben ist hart, und wenn man heute schon glücklich sein kann, warum nicht? Ich hätte gern schon jetzt ein anderes Haus!"

N'Guizaya has three children and three grandchildren. She is a trader, selling alcoholic beverages to help cover the family's needs. "A lot of people think the new millennium will change things for them, but I don't agree. Why wait to realize your dreams? Life is hard, so if you can live happily right now, straightaway, why not? As far as I'm concerned, I'd like another house now!"

N'Guizaya a trois enfants et trois petits-enfants. Commerçante à Garoua (Nord Cameroun), elle vend des boissons alcoolisées pour subvenir aux besoins de sa famille. « Beaucoup de gens pensent que l'an 2000 changera leur situation, je ne suis pas d'accord. Pourquoi attendre pour réaliser ses rêves. La vie est dure, alors si on peut vivre heureux maintenant, tout de suite, pourquoi pas? Moi c'est maintenant que je voudrais une autre maison ! »

Buzet,
Belgium,
15 June 1998

Die beiden sind sich zum ersten Mal in der Kirche begegnet, „woraufhin ich fleißig die Sonntagsgottesdienste besuchte", erzählt Marie-Hélène. Als Mode-ratorin einer Fernsehsendung für junge Eltern schöpft sie aus dem Erfahrungsschatz ihrer eigenen kleinen Familie. Das Paar gönnt sich jedes Jahr eine romantische Reise ohne die Kinder. Als das Foto entstand, suchten sie gerade „nach etwas Besonderem für Silvester 2000".

They met at Mass when they were teenagers: "After that, I was really motivated to go to all the Sunday services," says Marie-Hélène. She presents a TV programme for young parents, drawing lots of inspiration from her own little family. Every year they organize another honeymoon without the children. At the time of our photo, they were looking for a New Year's Eve idea that would be "a bit special" for the new millennium.

Adolescents, ils se sont rencontrés à la messe, « ce qui m'a beaucoup motivée pour assister à tous les offices du dimanche », raconte Marie-Hélène. Elle présente une émission télé pour jeunes parents et trouve beaucoup d'inspiration dans sa propre petite famille. Ils s'organisent chaque année une nouvelle lune de miel sans les enfants. Ils cherchaient à cette époque une idée de réveillon « un peu » particulière pour l'an 2000.

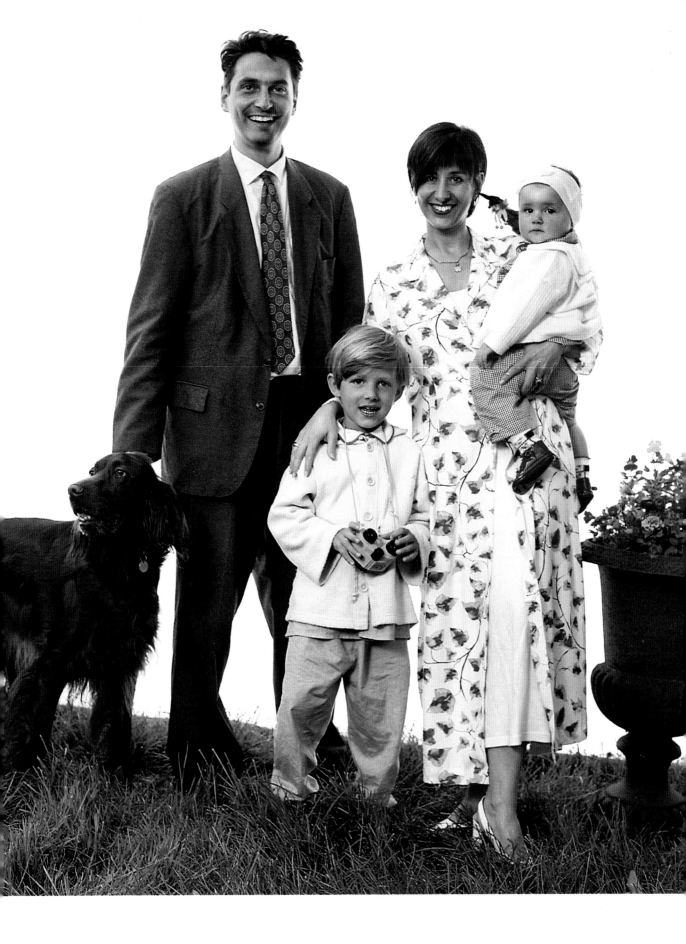

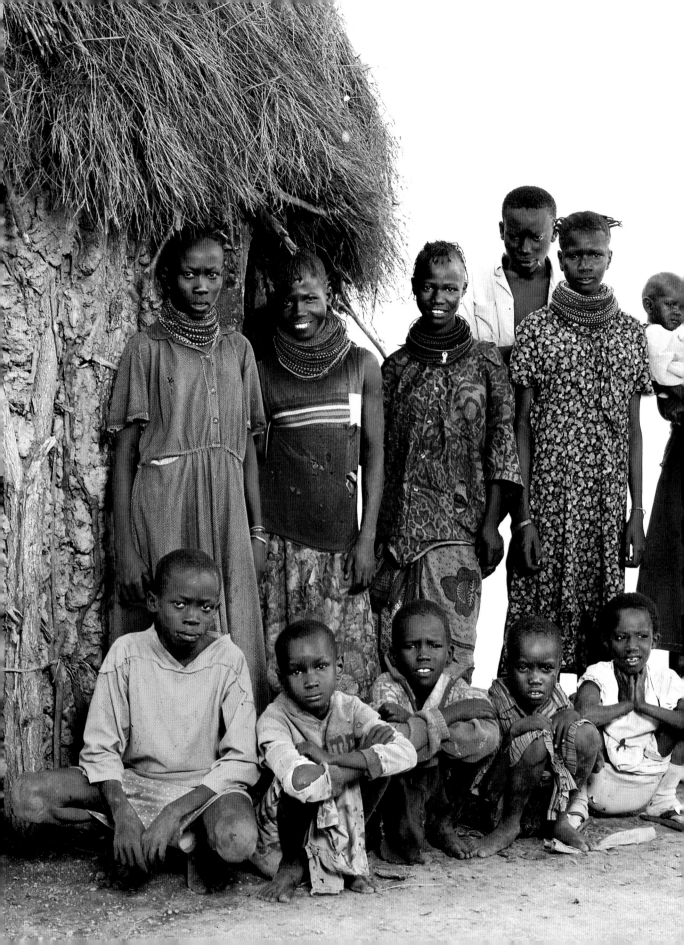

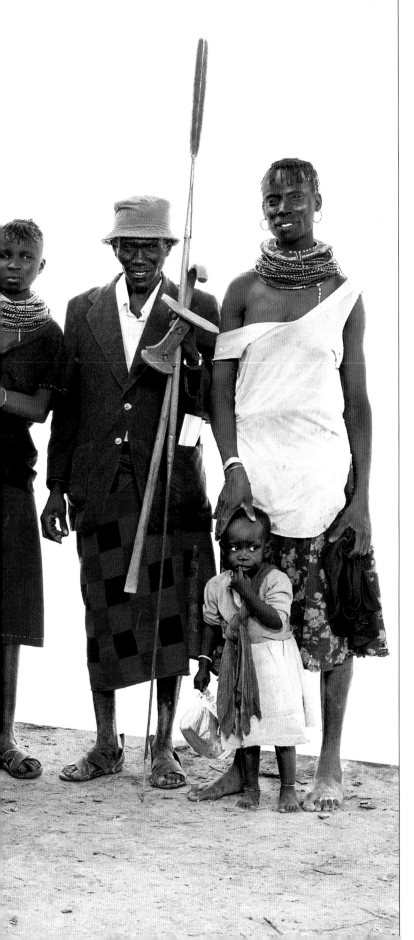

Gome kam gerade vom Wochenmarkt, als sich unsere Wege kreuzten. Wie alle Turkana war er mit Hirtenstab, Lanze und „Kopfkissen" unterwegs. Er hat zwei Frauen und „so um die" zwölf Kinder, außerdem ein paar Kühe. Die Familie lebt von der Milch, die sie geben, und von dem Gemüse, das er neben seinen beiden Hütten anbaut.

Gome was coming back from the weekly market when we bumped into him on the track. Like all Turkhana, he always walks with his herdsman's stick, his spear, and his "dream rest" or "pillow." He has two wives and "about" twelve children. He also owns a few cows. They live off the milk these cows provide and the vegetables he plants beside his two huts.

Gome revenait du « marché en ville » quand nous l'avons rencontré sur la piste. Comme tous les Turkhana, il se déplace avec son bâton de berger, sa lance et son « support de rêve » ou « oreiller ». Il a deux femmes et « environ » douze enfants. Il possède également quelques vaches, ils vivent du lait qu'elles fournissent et des légumes qu'il plante à côté de ses deux cases.

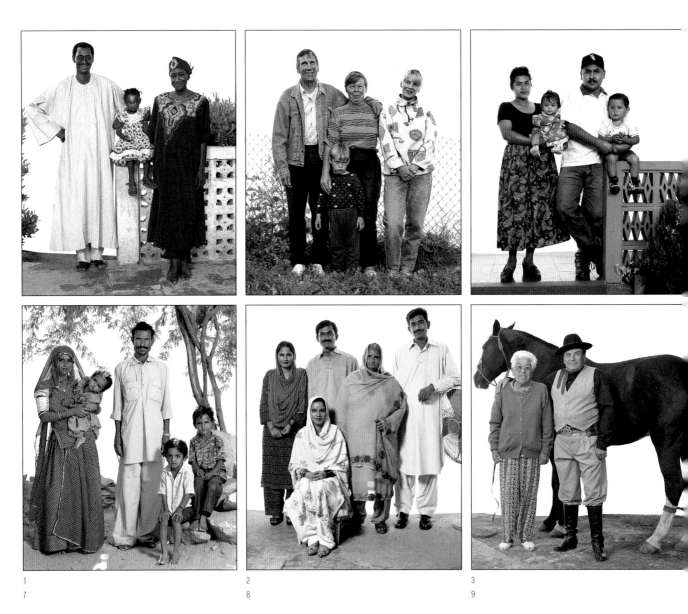

1
7

2
8

3
9

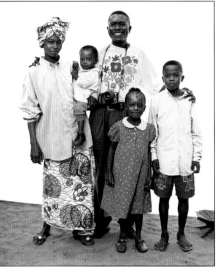
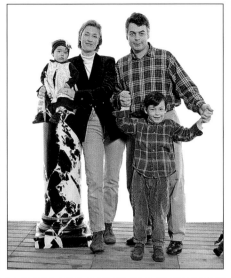
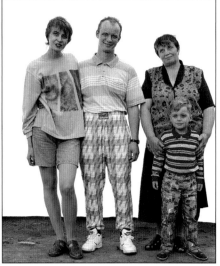

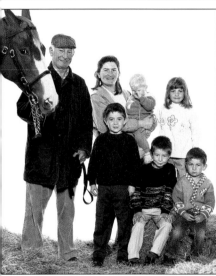

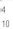

4
10

5
11

6
12

5
Paris,
France,
5 March 1998

6
Minsk,
Belarus,
19 July 1998

11
Fresnay-en-Retz,
France,
4 February 2000

12
Melaka,
Malaysia,
2 January 2000

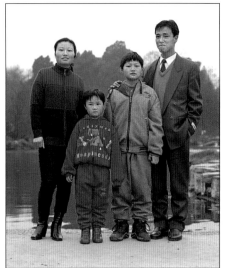

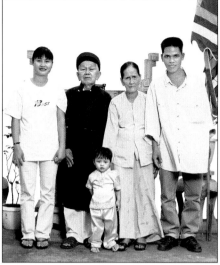

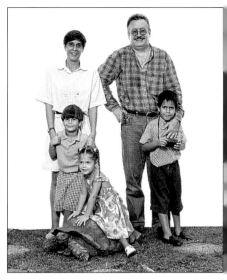

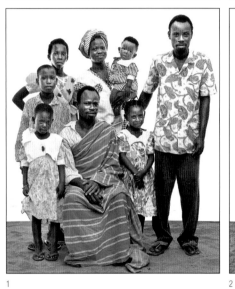

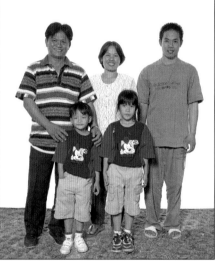

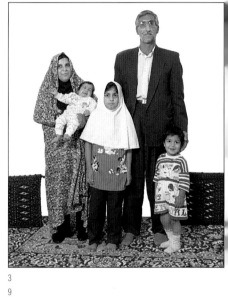

1
7

2
8

3
9

 1
Guiyang,
China,
5 March 2000

 2
Hoi An,
Vietnam,
6 February 2000

 3
Abidjan,
Ivory Coast,
1 March 1997

 4
Cape Town,
South Africa,
30 September 1997

 7
Grand-Bassam,
Ivory Coast,
7 March 1997

 8
Chiang Mai,
Thailand,
16 January 2000

 9
Boshruyeh,
Iran,
19 September 1999

 10
near Skopje,
Macedonia,
5 January 1997

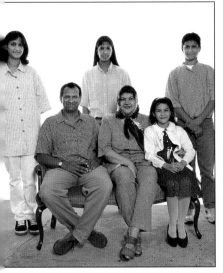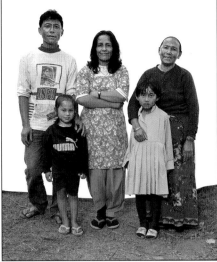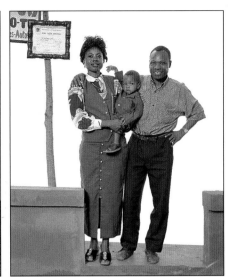

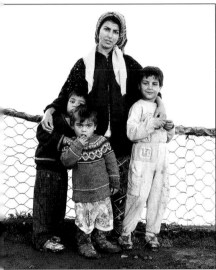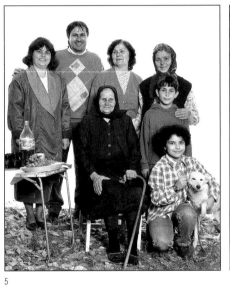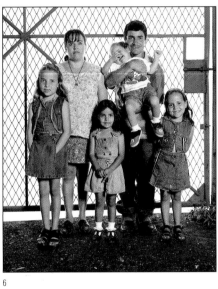

0

5

11

6

12

 5
Darjeeling,
India,
18 November 1999

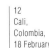 6
Abomey,
Benin,
12 July 1997

 11
Măgurele,
Romania,
17 October 1996

12
Cali,
Colombia,
18 February 1999

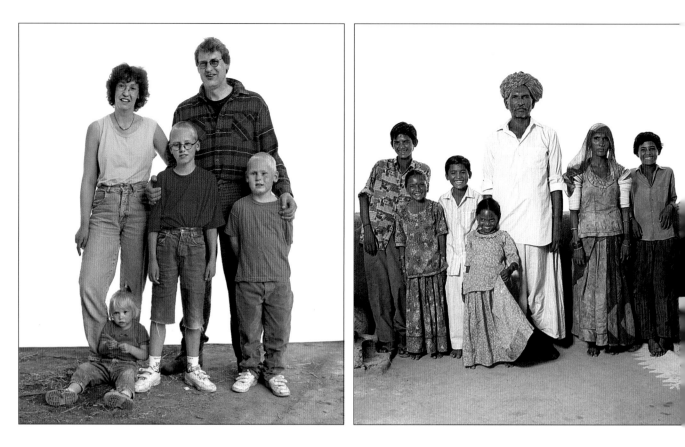

Rumpt,
The Netherlands,
19 June 1998

Es ist ein langer Arbeitstag für Willem, Bea und die drei Kinder, bis alle Schafe, Kaninchen, Hunde, Katzen, Hühner und die 50 Kühe, die täglich 2000 Liter Milch geben, versorgt sind. Bea ist zwar in der Stadt aufgewachsen, würde aber das Landleben für nichts in der Welt eintauschen. Ihre Familie und die Natur, mehr braucht sie nicht. Ungeduldig wartet sie auf das Wochenende, um mit Willem im Nachbardorf das Tanzbein zu schwingen.

The daily round for Willem, Bea and their three children involves looking after their sheep, rabbits, dogs, cats, chickens and the 50 cows which produce 2,000 litres of milk a day. Once a city girl, Bea wouldn't change her 'country' life, surrounded by her family and nature, for anything in the world. She's looking forward impatiently to the weekend, when she and Willem are going dancing at the dance hall in the next village.

S'occuper des moutons, des lapins, des chiens, des chats, des poules, et des cinquante vaches qui donnent 2000 litres de lait par jour, tel est le quotidien de Willem, Bea et leurs trois enfants. Bea, d'origine citadine, ne changerait pour rien au monde sa vie de «campagnarde» entourée de sa famille et de la nature. Elle attend avec impatience le week-end pour aller danser avec Willem au bal du village voisin.

Jaisalmer,
India,
13 October 1999

„Das Handwerk liegt uns im Blut, seit etwa 100 Jahren sind wir Schmiede. Meine Söhne packen schon mit an, außer dem Kleinen, der geht noch zur Schule. Wenn er keine andere Arbeit findet, wird auch er Schmied wie seine Brüder", sagt Deepa. Die ganze Familie arbeitet unter einer einfachen Plane. Seine Frau bedient den Blasebalg, die Kinder wechseln sich mit dem Hammer ab und er gibt den verschiedenen Feld- und Hauswerkzeugen ihre endgültige Form.

"My family have been blacksmiths for 100 years or so. My boys are already working with me, apart from the youngest, who is at school and will I hope find a job – otherwise he'll be a blacksmith like his brothers," says Deepa. The whole family works under a simple tarpaulin. His wife works the bellows, and his children take it in turns with the hammer while their father fashions all the different farm and household tools.

« Nous sommes forgerons dans la famille, depuis peut-être cent ans. Mes garçons travaillent déjà avec moi, sauf le petit dernier qui fréquente l'école et qui, j'espère, trouvera un travail, sinon il sera forgeron comme ses frères », ainsi parle Deepa. Installé sous une simple bâche, il travaille en famille : sa femme actionne le soufflet, ses enfants se relaient à la masse et lui donne une forme aux multiples outils agricoles et domestiques.

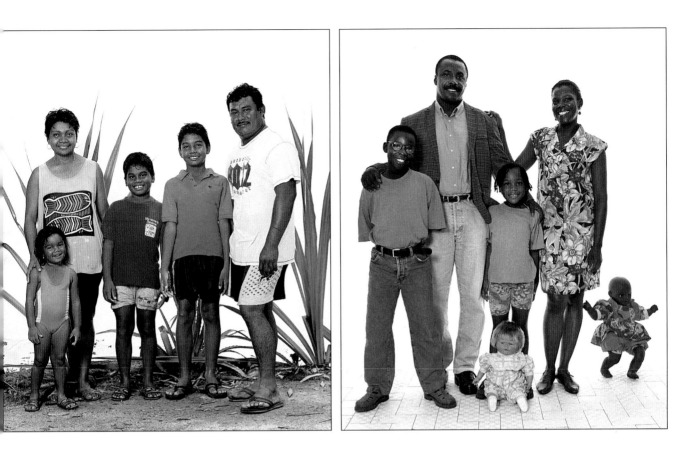

Playa Corona,
Panama,
25 December 1998

„Im Jahr 2000 besuchen wir Disneyland." Jorge, selbstständiger Mechaniker, und Maritza, Bankangestellte, sind gekommen, um Weihnachten mit der Familie am Strand zu verbringen.

"In 2000, we're going to visit Disneyland." Mechanic Jorge, who is self-employed, and bank employee Maritza have come to spend Christmas Day on the beach with the family.

« En l'an 2000, nous irons visiter Disneyland ! » Jorge, mécanicien à son compte et Maritza, employée de banque, sont venus passer le jour de Noël à la plage et en famille.

Libreville,
Gabon,
20 August 1997

„Ein Gabuner ist stolz darauf, Gabuner zu sein." Nach ihrem Studium in Frankreich sind Justine und Léopold nach Gabun gegangen und arbeiten dort als Juristin und Lehrer.

"Gabonese and proud of it." After studying in France, Justine and Léopold settled in Gabon, where they work as lawyer and teacher respectively.

« Gabonais et fiers de l'être », après avoir fait des études en France, Justine et Léopold se sont installés au Gabon, où ils exercent comme juriste et enseignant.

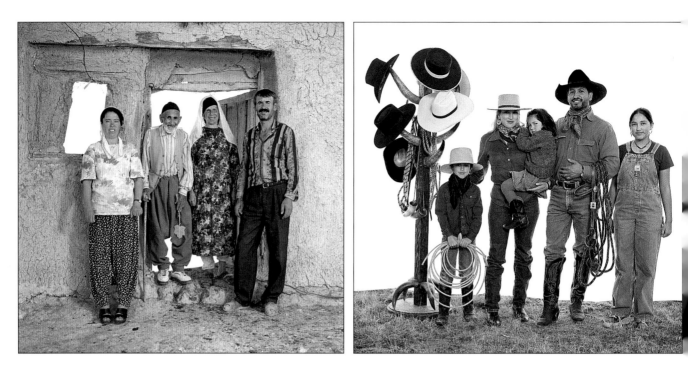

Sarikiz,
Turkey,
16 August 1999

90 Jahre hat er auf dem Buckel, in seinem Mund prangt ein einsamer Zahn, aber ansonsten ist Bauer Osman kerngesund. Bevor der Hanfanbau verboten wurde, war Haschisch seine Haupteinnahmequelle. Danach versuchte er es mit Weizen, später mit der Schaf- und Ziegenzucht, um schließlich Aprikosen anzubauen wie alle anderen Bauern der Gegend.

Osman is 90 or thereabouts, with one or maybe two teeth left, but he's in good health. As a farmer, he started out by growing hashish, which has since been banned. Over the years, he tried his luck with wheat, then sheep and goats. He finally settled on apricots, like everybody in these parts.

Environ quatre-vingt-dix ans, une dent peut-être deux, mais en pleine santé, Osman agriculteur a débuté avec le « haschich », prohibé depuis. Durant des années, il a essayé la culture du blé, puis l'élevage de moutons ou de chèvres. Il s'est finalement mis à l'abricot, comme toute la région.

Santa Fe,
New Mexico, USA,
20 November 1998

Vor 17 Jahren haben sich der Architekt Pedro und Sarah, zweisprachige Lehrerin an der öffentlichen Schule von Santa Fe, Hals über Kopf ineinander verliebt. Drei Kinder später haben sie große Pläne für das Jahr 2000. Sie möchten ihr 120 Jahre altes Haus auf ihrem Anwesen in Colorado renovieren, um dort mit ihren Pferden, Kühen und Hunden zu leben. Am Wochenende reiten sie gern mit der ganzen Familie aus und genießen das Cowboyleben zusammen mit Freunden aus der Umgebung … Unnötig zu erwähnen, dass Pedro Cowboyhüte sammelt.

Architect Pedro and Sarah, a bilingual teacher at the Santa Fe public school, fell in love at first sight 17 years ago. Three children later, they've got a big project for 2000, which is to restore their Colorado house (it's 120 years old) and live there surrounded by their horses, cows and dogs. At weekends the family goes riding, and they enjoy leading a cowboy life with their local friends … Do we really need to add that Pedro collects cowboy hats?

Dix-sept ans déjà que Pedro, architecte, et Sarah, institutrice bilingue à l'école publique de Santa Fé, ont eu le coup de foudre. Trois enfants plus tard, ils nourrissent un grand projet pour l'an 2000 : restaurer leur maison du Colorado, vieille de cent vingt ans, pour y vivre entourés de leurs chevaux, vaches et chiens. Le week-end, ils montent à cheval en famille et se plaisent à mener une vie de cow-boy avec leurs amis de la région. Est-il nécessaire de préciser que Pedro est collectionneur de chapeaux de cow-boys ?

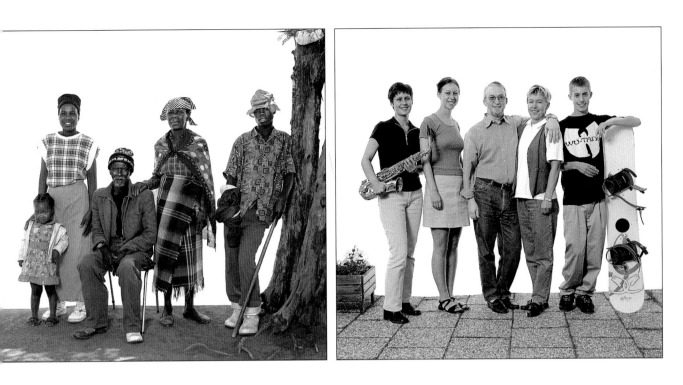

Malealea,
Lesotho,
7 October 1997

Ketetsa wurde 1930 in Malealea geboren. Nach 30 Jahren in den Diamantenminen von Johannesburg lebt er wieder auf dem Land und hegt und pflegt seinen kunterbunten Gemüsegarten, in dem er Linsen, Erbsen, Bohnen und Karotten zieht … Sein Sohn versorgt die vier Kühe der Familie, während seine Frau die Ernte auf dem Rücken des Esels zu den umliegenden Märkten bringt. Ketetsas träumt davon, wieder eine feste Arbeit zu finden.

Ketetsa was born in the village of Malealea in 1930. After 30 years in the diamond mines of Johannesburg, he returned home to work his vegetable garden, where lentils, peas, beans and carrots grow higgledy-piggledy … His son keeps an eye on their four cows, while his wife takes the harvest by donkey to the markets in the area. Ketetsa longs to find steady work again.

Né au village de Malealea en 1930 et après trente années passées dans les mines de diamants de Johannesburg, Ketetsa est revenu au pays, pour cultiver son jardin potager où poussent pêle-mêle, lentilles, petits pois, haricots, carottes … Son fils garde leurs quatre vaches et sa femme vend, à dos d'âne, la récolte aux marchés des alentours. Il rêve de retrouver un travail.

Arvidsjaur,
Sweden,
4 July 1998

Die Westerlunds widmen sich den Ärmsten der Armen. Die sozialen und ökonomischen Probleme am Ende dieses Jahrtausends machen sie betroffen und nachdenklich. Gun-Britt arbeitet für eine Organisation, die Arbeitslose unterstützt, und Ulf ist Verwalter eines Pflegeheims. Die Familie geht vielen Hobbys nach: Saxophon, Snowboard, Motorschlitten, Angeln, Tiefschneefahren – und Wintergolf auf dem gefrorenen See (mit roten Bällen!).

The Westerlunds devote their energies to the destitute. They are very concerned with every sort of social and economic issue at the end of this millennium. Gun-Britt works for an agency that helps unemployed people, and Ulf manages a live-in health care centre. Their family has all sorts of leisure activities which include the saxophone, snowboarding, snowmobiles, fishing, cross-country skiing – and winter golf on the frozen lake (with red balls!).

Les Westerlund se consacrent aux plus démunis, ils se sentent très concernés par tous les problèmes sociaux et économiques de cette fin de millénaire. Gun-Britt travaille pour un organisme de soutien aux personnes sans emploi et Ulf est gestionnaire de centres de soins. Leur famille a des hobbies multiples : saxophone, snowboard, motoneige, la pêche, le ski de fond. Et le golf d'hiver sur le lac gelé (avec des balles rouges !).

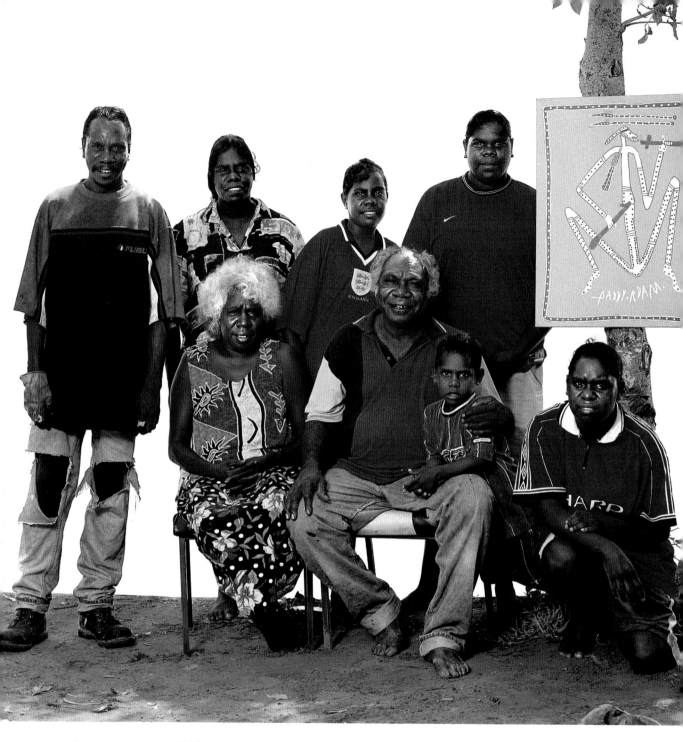

Katherine,
Australia,
21 December 1999

„Ich habe über 6000 Bilder gemalt, ich kenne mein Alter nicht, aber als der Krieg ausbrach, war ich neun Jahre alt. Meine Bilder sind die Erinnerung und die Tradition, die ich an die Kinder weitergebe. In den letzten Jahren hat sich das Leben sehr zum Besseren verändert, heute sind Schwarze und Weiße gleich. Früher haben wir kein Wort miteinander gesprochen", erinnert sich Paddy, dessen Bilder in den Museen und Galerien der ganzen Welt zu sehen sind.

"I've painted more than 6,000 pictures. I don't know how old I am, but when war broke out, I was nine. My paintings are the memory and tradition that I am handing down to the children. Life has changed in the last few years. It's much better today – it doesn't matter whether you're black or white. In the old days we didn't talk to each other." This is how Paddy, whose pictures are exhibited in museums and galleries all over the world, tells us about a chunk of his life.

« J'ai peint plus de six mille tableaux, je ne sais pas l'âge que j'ai, mais au moment de la guerre j'avais neuf ans. Mes peintures, c'est la mémoire et la tradition que je transmets aux enfants. Ces dernières années, la vie au quotidien a changé, aujourd'hui c'est beaucoup mieux, blancs et noirs c'est pareil ! Avant on ne se parlait pas », c'est ainsi que Paddy, dont les tableaux sont exposés dans les musées et galeries à travers le monde, nous conte un morceau de sa vie.

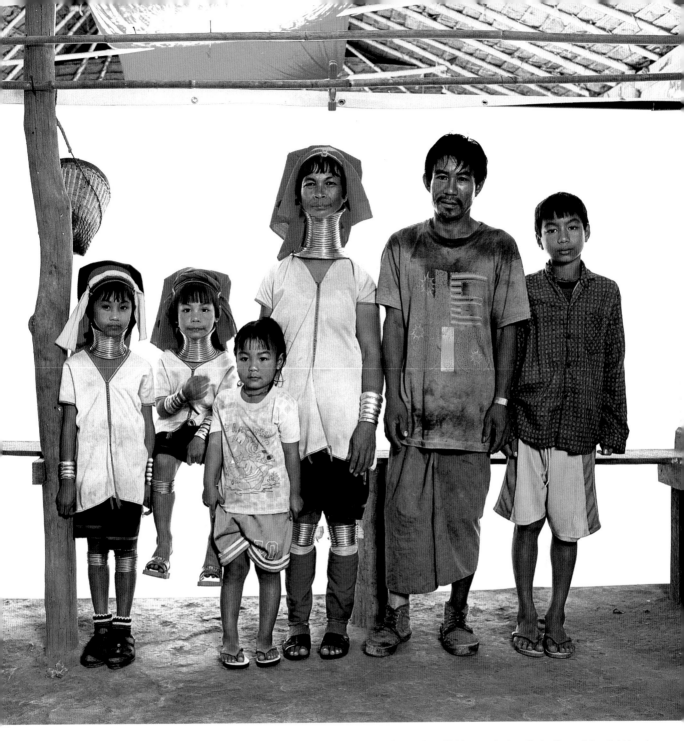

Muang,
Thailand,
17 January 2000

Die kleine Volksgruppe der „Giraffenfrauen" lebt im Norden Thailands. Seitdem sie vor 20 Jahren aus dem benachbarten Birma geflohen sind, leben sie hier in kleinen Dörfern vorwiegend vom Tourismus. Es ist Mama Mulos Aufgabe, ihren Töchtern die Halsringe (genau genommen eine Spirale) anzulegen.

A small population of 'giraffe women' live in northern Thailand. Having fled neighbouring Burma 20 years ago, they now reside in small village camps and earn a living from tourism. Mother Mulo is responsible for fixing the rings (actually a spiral) on the necks of her daughters.

Le petit peuple des « femmes girafes » vit dans le nord de la Thaïlande. Réfugié de la Birmanie voisine depuis vingt ans, il est installé dans de petits camps-villages et gagne sa vie grâce au tourisme. C'est maman Mulo qui est chargée de l'installation des anneaux (en fait une spirale) au cou de ses filles.

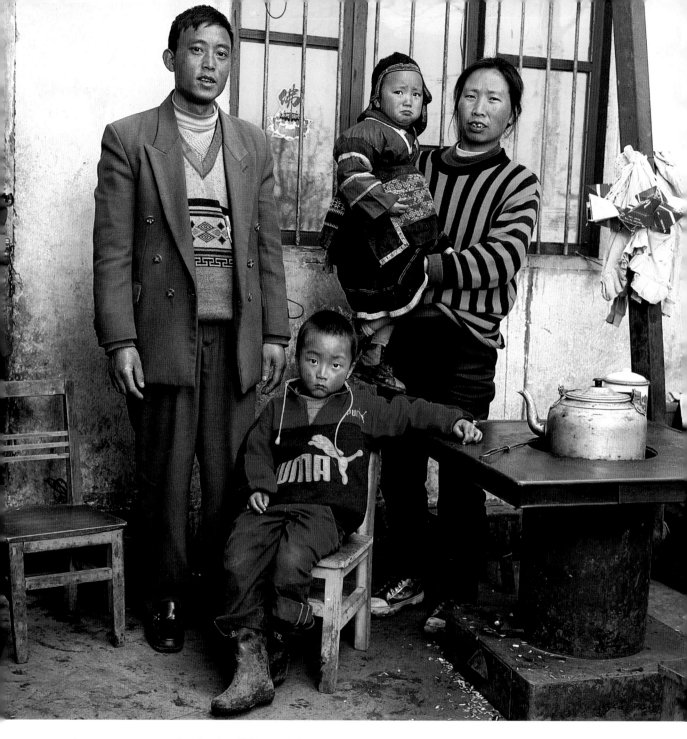

near Guiyang,
China,
2 March 2000

Chang Peng kann wirklich stolz sein. Seit 1988 ist er Bürgermeister des Dorfs und wurde schon dreimal wiedergewählt. Wie die meisten Dorfbewohner besitzt er einen Büffel, ein Schwein, ein paar Hühner und Enten und ein Reisfeld, um für den Unterhalt der Familie zu sorgen.

Chang Peng has plenty to be proud of – since 1988 he has been village headman, a position to which he has been re-elected three times. Like most of the villagers, he has a buffalo, a pig, a few chickens and ducks, and a paddy field to meet the needs of his family.

Chang Peng a de quoi être fière: depuis 1988, il est le chef du village, poste auquel il a été réélu trois fois! Comme la plupart des habitants, il possède un buffle, un porc, quelques poules et canards, et une rizière pour subvenir aux besoins de sa famille.

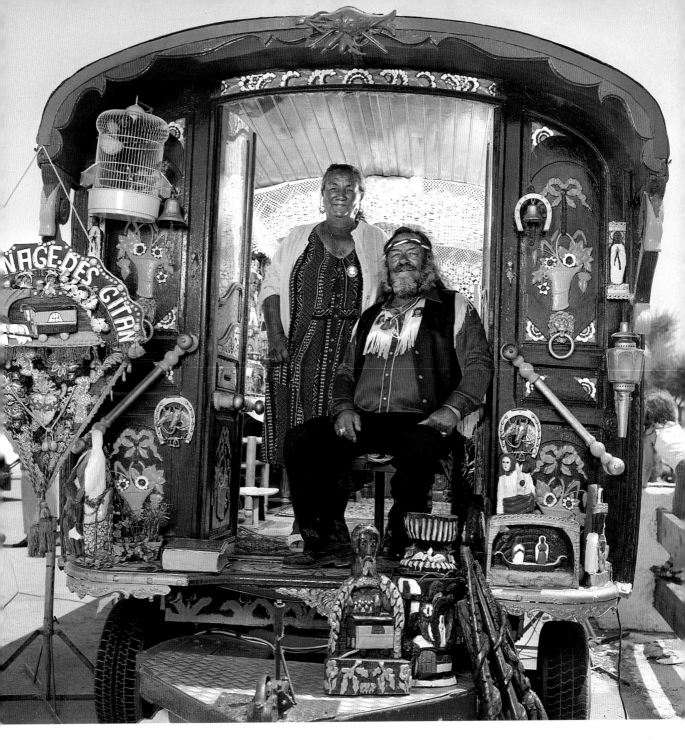

Saintes-Maries-de-la-Mer,
France,
25 May 1998

Pépé La Fleur ist „König der Roma". Er schlichtet Streitigkeiten, verhandelt mit den Behörden und trifft Entscheidungen für die Gemeinschaft. Ihm gebührt die Ehre, bei der Prozession von Saintes-Maries-de-la-Mer die Bibel zu tragen, zur Seite der Heiligen Sarah, der Schutzpatronin der Roma. Im Jahr 2000 feiern er und seine Frau goldene Hochzeit im Kreise ihrer 13 Kinder und 70 Enkelkinder, wenn es bis dahin nicht noch mehr geworden sind ...

Pépé La Fleur is "King of the Roma." It's in this capacity that he settles disagreements, negotiates with public bodies and takes decisions for the community. He has the privilege of carrying the Bible beside the statue of St. Sara, patron saint of the Roma, during the Saintes-Maries-de-la-Mer procession. In 2000, his wife and he will be celebrating their golden wedding anniversary with their 13 children and 70 grandchildren – the numbers may well rise between now and then ...

Pierre La Fleur, dit Pépé, est le roi des Gitans. Il tranche les discordes, négocie avec l'administration et prend les décisions pour la communauté. Il regrette que les roulottes soient tractées par des voitures et dit en plaisantant (à moitié): « Aujourd'hui, quand on crève une roue, il faut réparer, alors que dans le temps, quand un cheval se cassait une jambe, on le mangeait ! » En l'an 2000, sa femme et lui fêteront leurs noces d'or en présence de leurs treize enfants et soixante-dix petits-enfants dont le nombre risque d'augmenter d'ici là.

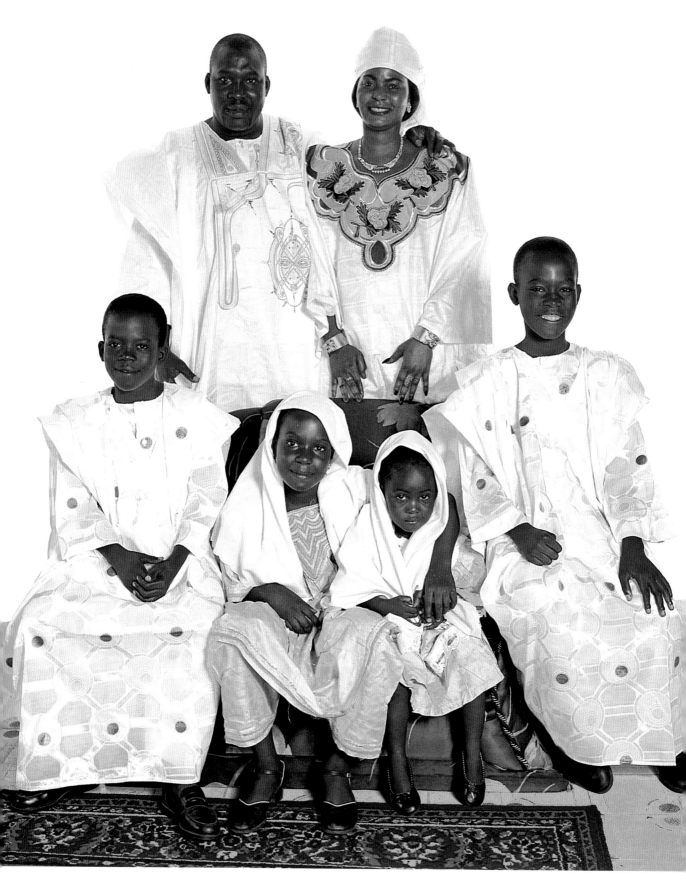

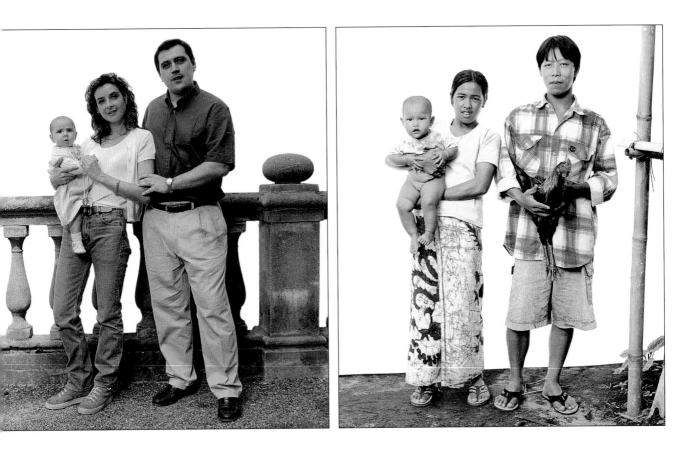

Cotonou,
Benin,
14 June 1997

„Polygamie ist schlecht für die Familie!", erklärt Amadou, der monogame Unternehmenschef. Der überaus zufriedene Mann hat mit seiner Frau Malinatou vier Kinder. „Man kann sehr wohl ohne Geld leben, aber nicht ohne Familie, auch wenn das einige überraschen mag." Für das neue Jahrtausend wünscht er sich „eine gute Ausbildung für meine Kinder, aber auch, dass die westlichen Industriestaaten Afrika entdecken, das wahre Afrika!" Amadou plant, sich ein Ferienhaus in Deutschland zu kaufen. Und eine Pilgerreise nach Mekka mit seiner Frau.

"Polygamy is bad for the family," declares Amadou, a monogamist and company director. He is man who has everything he wants, including four children by his wife Malinatou. "You can live without money, but not without a family, which may seem surprising to some people." His wish for 2000: "A sound education for my children, but I'd also like Westerners to discover Africa, and get in touch with reality." Amadou plans to buy a holiday home in Germany. And to make a journey to Mecca with his wife.

« La polygamie, c'est négatif pour la famille! », déclare Amadou, monogame et directeur de société. Homme comblé, il a quatre enfants de sa femme Malinatou. « On peut vivre sans argent mais pas sans famille, ce qui peut paraître étonnant à certains » Son vœu pour l'an 2000 : « De bonnes études pour ses enfants mais aussi que les occidentaux découvrent l'Afrique, qu'ils touchent à la réalité. » Amadou projette d'acheter une maison de vacances en Allemagne! Et un voyage à la Mecque avec sa femme.

Olot,
Spain,
23 May 1998

Unter der Woche arbeiten die beiden in einer Anwaltskanzlei in Barcelona. Am Wochenende fahren sie dann in ihre Heimatstadt Olot, wo sie ein Modegeschäft besitzen. Antoni und Viviana wollen in Zukunft viel reisen – und einfach glücklich sein!

They work as lawyers in Barcelona all week. At weekends, they run a clothing shop in Olot, the village where they were born. Antoni and Viviana see their future in terms of travel – and simply being happy!

Ils exercent leur métier d'avocats à Barcelone la semaine. Le week-end, ils tiennent un magasin de vêtements à Olot, leur ville d'origine. Antoni et Viviana voient leur futur en voyages et … heureux!

Bali,
Indonesia,
10 December 1999

„Im neuen Jahrtausend möchten wir noch ein Kind", verkünden sie wie aus einem Munde. Komang erwartet voller Ungeduld das Wochenende, weil er dann zu den Hahnenkämpfen gehen will und darauf hofft, mit einem saftigen Gewinn nach Hause zu kommen.

"We'd like another child in the new millennium," they both say. Komang can hardly wait for the weekend – he's going to the cock fights and hopes to come home with a substantial win.

« En l'an 2000, nous aimerions un autre enfant », déclarent-ils à l'unisson. Komang attend le week-end avec impatience : il participera aux combats de coqs et pariera sur son favori!

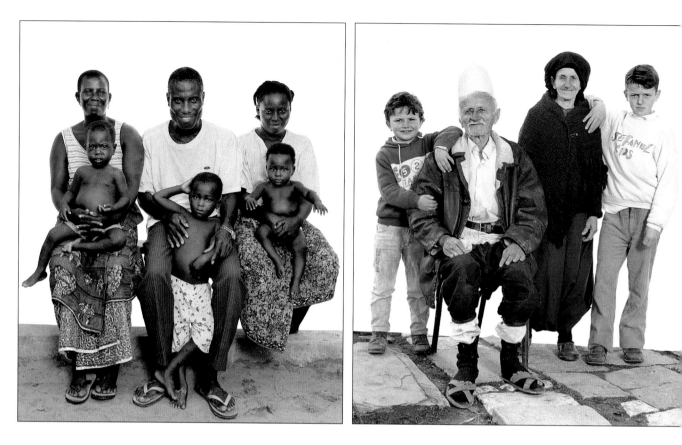

Assinie,
Ivory Coast,
25 May 1997

Familie Amessan ist rund um die Uhr im Einsatz. Vater Gnoan arbeitet nachts als Wachmann, tagsüber als Fischer. Seine Frau führt ein Restaurant und verkauft nebenbei „afrikanische Heilmittel", wie sie es nennt. Für die Zukunft wünschen sich die beiden, dass „unsere Kinder einen Beruf erlernen und uns unterstützen, wenn sie an der Reihe sind". Der Jahrtausendwende sehen sie mit gemischten Gefühlen entgegen: „Wir fürchten uns vor dem Weltuntergang, den uns die Bibel voraussagt. Möge Gott uns beistehen."

The Amessan family work non-stop. Gnoan, the father, is a security guard by night and a fisherman by day. His wife runs a restaurant and on the side sells medicines – "an African chemist's shop," she says. Their hope for the future is that "our children complete their studies and look after us when their turn comes." They are treating the new millennium with caution. "The Bible predicts the end of the world, so we're praying that it won't be too terrible, and that God will help us."

La famille Amessan travaille sans relâche. Gnoan, le père, est gardien la nuit et pêcheur le jour. Sa femme tient un restaurant et vend des médicaments, « la pharmacie africaine », précise-t-elle. Leur souhait pour l'avenir : « Que nos cinq enfants réussissent leurs études et s'occupent de nous à leur tour. » Ils abordent l'an 2000 avec prudence : « La Bible prévoit la fin du monde, nous prions pour que cela ne soit pas trop terrible et que Dieu nous vienne en aide. »

Lepenic,
Albania,
17 December 1996

Meshtane und Senani feiern im Jahr 2000 ihre goldene Hochzeit. Seit sie die Bewirtschaftung des Hofes aufgegeben haben, leben sie vom Obst und dem Gemüse aus ihrem Garten. Außerdem ziehen sie ihre beiden Enkelkinder groß, deren Eltern in der Stadt nach Arbeit suchen …

Meshtane and Senani will celebrate their golden wedding anniversary in 2000. They are retired farmers, now living off the fruit and vegetables from their garden. They also look after their two grandchildren, whose parents are in the city looking for work …

Mestane et Senani fêteront leurs noces d'or en l'an 2000. Agriculteurs retraités, ils vivent aujourd'hui des légumes et fruits de leur jardin. Ils s'occupent également de leurs deux petits-enfants, dont les parents sont partis en ville à la recherche d'un travail.

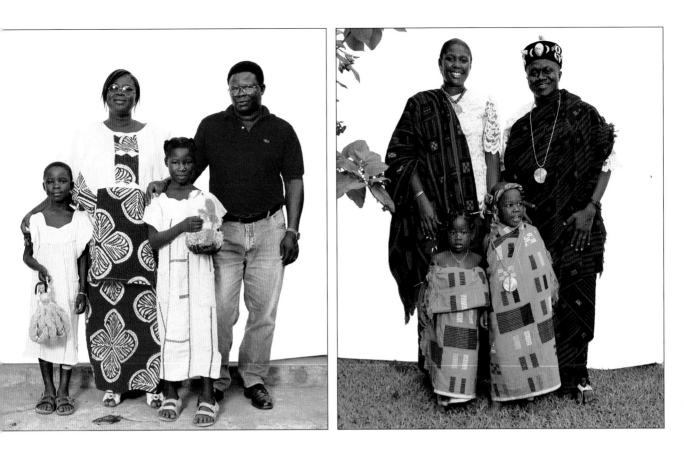

Ferké,
Ivory Coast,
14 May 1997

Étienne richtet Kantinen für Schulkinder aus armen Verhältnissen ein, in denen sie täglich kostenlos eine ausgewogene Mahlzeit erhalten. Dieses breit angelegte Ernährungsprogramm ermutigt auch mittellose Familien, ihre Kinder zur Schule zu schicken. Der ehemalige Lehrer, Chevalier de l'Ordre du Mérite sportif ivoirien [eine Auszeichnung für Verdienste um den Sport], setzt sich mit Leib und Seele für eine bessere Ernährung der Kinder an der Elfenbeinküste ein. „Vielleicht hat sich die Situation bis zum neuen Jahrtausend verbessert, dann können wir uns die Hände reichen."

Étienne sets up canteens for underprivileged schoolchildren. In this way, they get a balanced meal every day, free of charge. This huge food programme also encourages poor families to register their children at school. A *Chevalier de l'Ordre du Mérite sportif ivoirien* [Ivory Knight of the Order of Merit in Sport], ex-teacher Étienne devotes all his time to improving the nourishment of Ivory Coast children. "Tensions may possibly have eased by 2000, so we'll be able to shake hands."

Etienne crée des cantines pour les enfants scolarisés défavorisés. Ainsi, chaque jour, un repas équilibré leur est servi gratuitement. Ce vaste programme nutritionnel incite également les familles démunies à inscrire leurs enfants à l'école. Chevalier de l'Ordre du Mérite du Sportif Ivoirien, ancien instituteur, il se dévoue entièrement au développement nutritionnel des enfants de Côte d'Ivoire. « Les tensions seront peut-être apaisées d'ici l'an 2000, alors nous pourrons nous donner la main. »

Abidjan,
Ivory Coast,
5 June 1997

Ernest hatte das Glück, Dominique bei einer Exkursion kennen zu lernen. Inzwischen ist sie die Mutter seiner beiden Kinder. Gemeinsam betreiben sie ein Restaurant in Abidjan. „Das Restaurant ist nur ein Hobby." Tatsächlich studiert Dominique Pharmazie und Ernest ist Leiter des technischen Wartungsdienstes des städtischen Busbetriebs von Abidjan. „Das Jahr 2000 wird ein ganz besonderes Jahr; die Menschen müssen sich für mehr Gerechtigkeit, Solidarität und Liebe einsetzen. Nur so können wir Erfüllung finden."

Ernest had the good luck to meet Dominique on an outing. Since then she has borne him two children and they run a restaurant together in Abidjan. "The restaurant is only a hobby." As it happens, Dominique is studying pharmacy and Ernest is head of the Technical Maintenance Department for Abidjan's city buses. "2000 will be a special year. People have got to take action for justice, solidarity and love. Only so can we attain a state of fulfilment."

Ernest a eu le bonheur de rencontrer Dominique lors d'une excursion. Depuis, elle est la mère de ses deux enfants. Ensemble, ils tiennent un restaurant dans le quartier chic d'Abidjan : La Riviera. « Le restaurant est une activité secondaire, nous espérons une meilleure situation dans l'avenir. » En effet, Dominique poursuit parallèlement des études en pharmacie et Ernest est responsable du Service technique de l'entretien des transports d'Abidjan. « L'an 2000 sera une année particulière, il faut que les peuples agissent dans le sens de la justice, la solidarité et l'amour. Ainsi, nous atteindrons la plénitude. »

Bali,
Indonesia,
13 December 1999

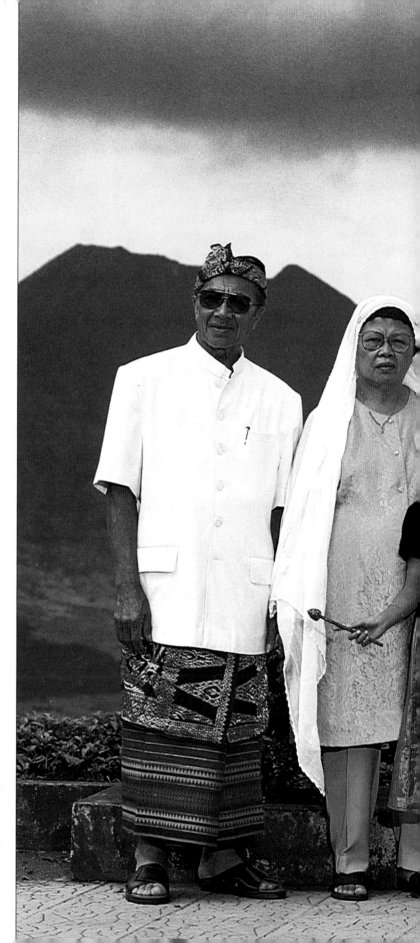

Wir trafen Ratna, ihren Mann Putra, die beiden Kinder, den Onkel und die
Tante auf dem Weg zu einer Hochzeitsfeier. Das neue Jahrtausend? „Mein
Mann und ich hätten gern noch ein Kind, einen Jungen. Das ist in unserer
Kultur sehr wichtig … und meine Eltern wären überglücklich."

We met Ratna, her husband Putra, their two children, uncle and aunt as they
were going to a wedding ceremony. The new millennium? "My husband and
I would like another child, a boy – it's very important in our culture, and my
parents would be so happy."

Nous avons rencontré Ratna, son mari Putra, leurs deux enfants, oncle et
tante alors qu'ils se rendaient à une cérémonie de mariage. L'an 2000?
« Moi et mon mari aimerions un autre enfant, un garçon! C'est très impor-
tant dans notre culture … et mes parents seraient tellement contents. »

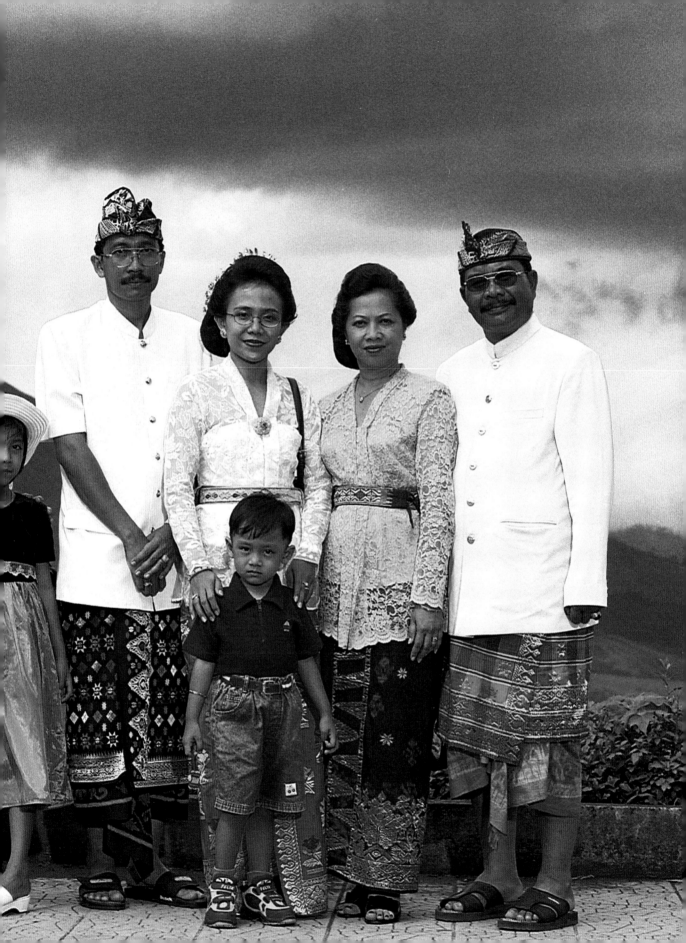

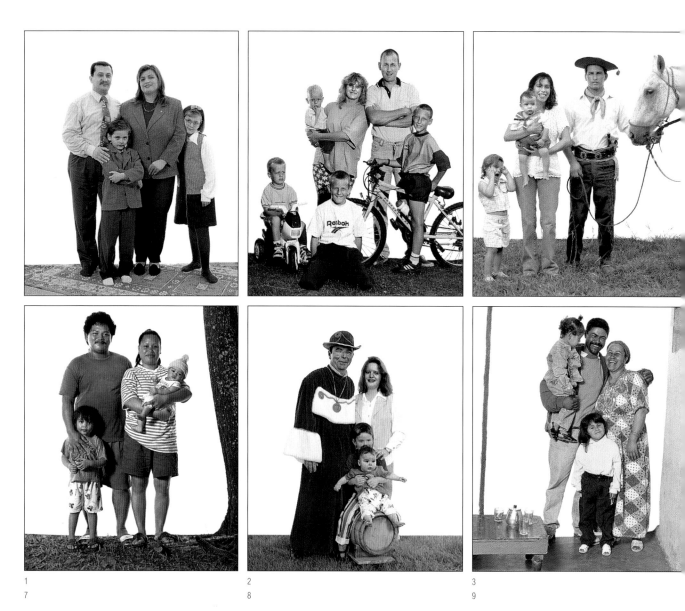

1

7

2

8

3

9

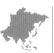

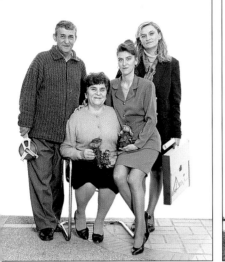

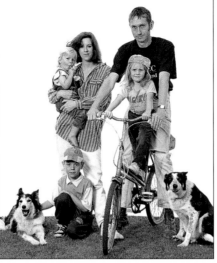

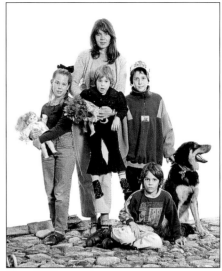

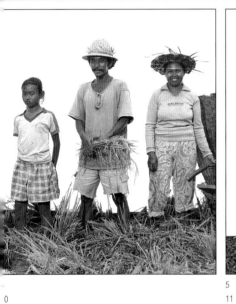

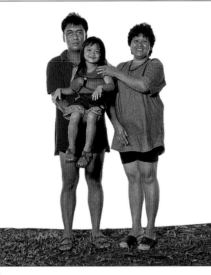

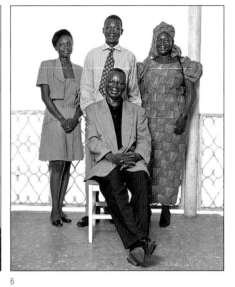

5
Biggar,
Scotland,
6 August 1996

6
Lodano,
Switzerland,
4 October 1996

11
Miri,
Malaysia,
December 1999

12
Abidjan,
Ivory Coast,
24 May 1997

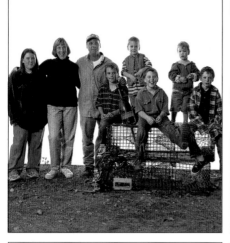
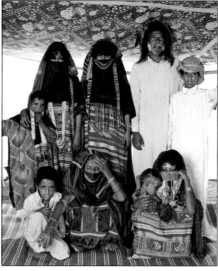
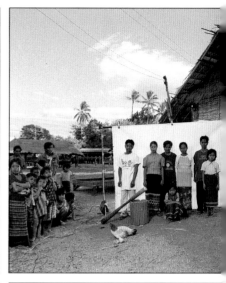
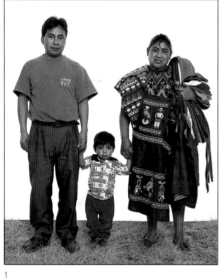
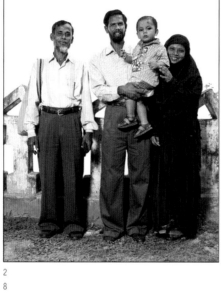
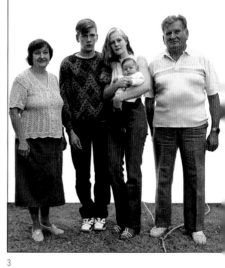

1

2

3

7

8

9

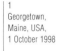 1
Georgetown,
Maine, USA,
1 October 1998

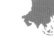 2
Massawa,
Eritrea,
23 December 1997

 3
Ban Tao Soung,
Laos,
30 January 2000

 4
Hua Hin,
Thailand,
11 January 2000

 7
Chichicastenango,
Guatemala,
10 December 1998

 8
Chittagong,
Bangladesh,
27 November 1999

 9
Langstini,
Latvia,
14 July 1998

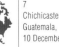 10
Memphis,
Tennessee, USA,
18 October 1998

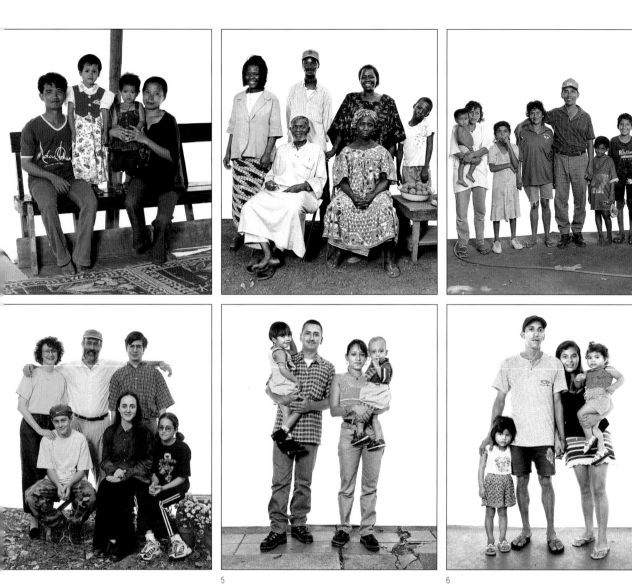

5
11

6
12

 5
Ferké,
Ivory Coast,
16 May 1997

 6
La Libertad,
El Salvador,
12 December 1998

 11
San Gil,
Colombia,
21 February 1999

 12
Castanhal,
Brazil,
6 March 1999

Delvada,
India,
20 October 1999

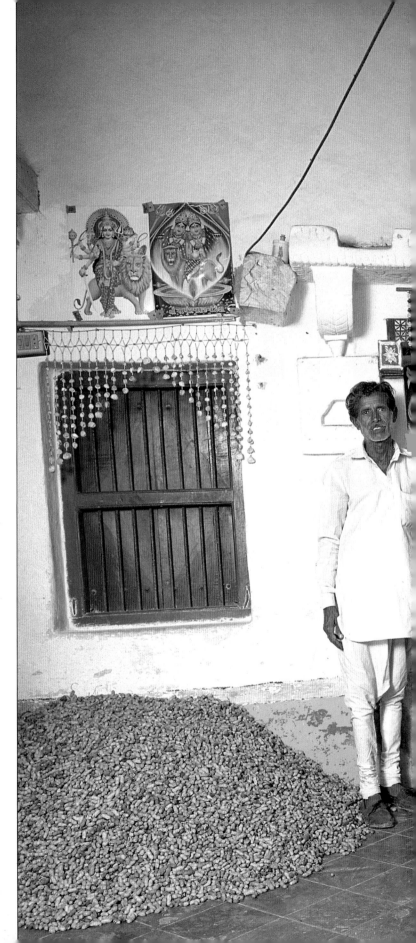

Ramhira, hier mit seiner Frau, ihren vier Töchtern und seiner Mutter, besitzt neben zwölf Kühen und zwei Büffeln eine der größten Erdnussplantagen des Dorfs, was ihn zu einem angesehenen Mann macht. Außerdem kann er ein paar Brocken Englisch, die er als Hirte beim Schmökern aufgeschnappt hat. Der gläubige Hindu erzählte uns von seinen Pilgerfahrten zu den heiligen Stätten im Norden Indiens und in Nepal.

Surrounded by his four girls, his mother and his wife, Ramhira is a highly respected farmer, with one of the largest groundnut plantations in the village. He also owns twelve cows and two buffaloes – and speaks a few words of English learnt as a child from a book he used to leaf through as he watched the cows. He is very religious and tells us of his pilgrimages to Hindu holy places in northern India and Nepal.

Entouré de ses quatre filles, de sa mère et de sa femme, Ramhira est un fermier très respecté. Il possède l'une des plus grandes plantation de cacahouètes du village, il est aussi propriétaire de douze vaches et de deux buffles – et parle quelques mots d'anglais appris grâce à un livre qu'enfant il feuilletait en gardant les vaches. Très religieux, il nous parle de ses pèlerinages effectués dans les lieux saints hindous au nord de l'Inde et jusqu'au Népal.

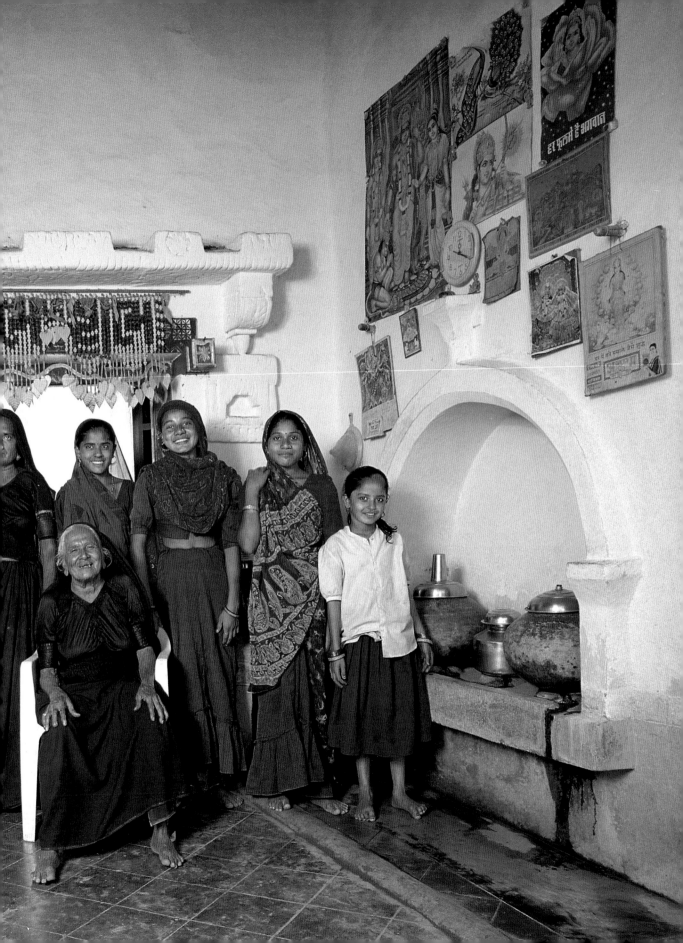

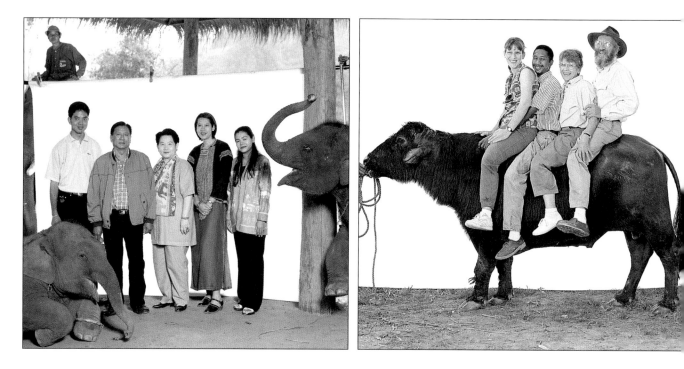

Chiang Mai,
Thailand,
22 January 2000

„Mein Vater ist einmalig im Universum! Er hat 117 Elefanten und einen Mercedes", verkündet Anchalee. Der ehemalige Gärtner Choochart, ein großer Tier- und Pflanzenfreund, hatte vor 22 Jahren die Idee, einen Elefantenpark zu eröffnen. Inzwischen ist daraus ein Familienunternehmen mit 300 Mitarbeitern und 300 Hektar Weideland mit Gras, Bananen und Zuckerrohr geworden. Jeden Tag kommen Hunderte Besucher hierher, um sich die Elefantendressur anzuschauen und auf dem Rücken der Dickhäuter durch den Dschungel zu reiten.

"My father is totally unique! He has 117 elephants and a Mercedes," announces Anchalee. A former gardener who loves animals and plants, Choochart had the idea 22 years ago of setting up an elephant park. Today it is a family business with 300 employees and 750 acres [300 ha] of fodder crops – grass, bananas and sugar cane. Hundreds of visitors a day come to see the training show and have elephant rides in the jungle.

« Mon père est unique ! Il a 117 éléphants et une Mercedes » annonce Anchalee. Ancien jardinier aimant la faune et la flore, Choochart eu l'idée, il y a vingt-deux ans, de fonder un parc d'éléphants. C'est, aujourd'hui, une entreprise familiale de 300 employés, 300 hectares de nourritures : herbes, bananes, canne à sucre. Des centaines de visiteurs par jour, venus voir un spectacle de dressage et faire des promenades à dos d'éléphant dans la jungle.

Carúpano,
Venezuela,
27 February 1999

Heute ist ein wichtiger Tag für Elisabeth – obwohl sie schon 35 Jahre hier lebt, reitet sie zum ersten Mal auf einem Büffel. Wilfried, ehemaliger Entwicklungshelfer, steckt voller Ideen: Er hat eine Landwirtschaftsschule gegründet, einen botanischen Garten, zwei Hotels und eine Wasserbüffelzucht. Vor 23 Jahren begann er mit drei Tieren, mittlerweile umfasst die Herde 700 Stück und die Ranch ist sogar auf den Landkarten Venezuelas verzeichnet. Sein unerschöpflicher Vorrat an Ideen und Projekten lässt Wilfried seiner Devise treu bleiben: „Schützt die Natur und schafft Arbeitsplätze!" Ihre Tochter Sabine und deren Mann Joël unterstützen sie bei der Arbeit.

This is an important day for Elisabeth – it's the first time she's ever ridden a buffalo, even though she's lived here for 35 years. Wilfried, formerly involved with a German development organization and a man abounding in ideas, has established a school of agriculture, a botanical garden, two hotels and a water-buffalo ranch. He started out with three buffaloes 23 years back, and now the ranch numbers 700 head and is featured on Venezuelan road maps. Loaded with plans and projects, Wilfried sticks by his motto: "Protect nature and create jobs." Their daughter Sabine and her husband Joël work with them. The whole family feels Venezuelan through-and-through.

C'est une journée importante pour Elisabeth – c'est la première fois qu'elle monte sur un buffle ! Pourtant, elle vit ici depuis trente-cinq ans avec Wilfried, homme d'initiative : une école d'agriculture, un jardin botanique, deux hôtels et un ranch de buffles d'eau, sans compter les multiples projets fidèles à sa devise « Conserver la nature et créer des emplois ! » Commencé avec trois bêtes, il y a vingt-trois ans, le ranch compte aujourd'hui 700 têtes et est une attraction internationale. Leur fille, Sabine, et son mari Joël (assis à l'avant), travaillent avec Wilfried sur le ranch. Toute la famille se sent vénézuélienne de cœur.

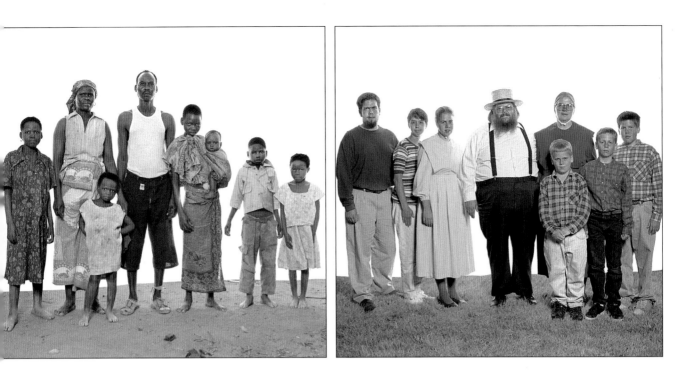

Tete,
Mozambique,
28 October 1997

Bauer Enriques und seine Frau träumen von einem Haus, das groß genug für sie und ihre sechs (oder mehr?) Kinder ist.

Enriques is a farmer. He and his wife both dream of having a big house for their six – or more? – children.

Agriculteurs, Enriques et sa femme rêvent d'avoir une grande maison pour leurs six enfants – ou plus?

Lancaster,
Pennsylvania, USA,
10 September 1998

„Das sind die besten Eltern, die ich je hatte", versichert uns der siebenjährige Don Jr. Die Mennoniten-Familie arbeitet im lokalen Tourismusgeschäft: Don organisiert Urlaubsreisen für Leute, die das Leben und die Traditionen der Amish kennen lernen möchten, und Florence ist Fremdenführerin in Teilzeit … „und Mutter in Vollzeit", fügt sie hinzu. Ihre Botschaft: „Gott hat die Familie erschaffen; sie war die allererste Institution auf Erden und wir hoffen, dass sie so lange besteht, wie sich die Erde dreht."

"They're the best parents I ever had," announces seven-year-old Don Jr. This Mennonite family works in the local tourist industry. Don organizes trips for tourists who want to get to know about Amish life and traditions. Florence is a part-time guide … "and a full-time mother," she adds. Their message: "God created the family; it was the very first institution on earth, and we're hoping that it'll exist as long as the world keeps going."

« C'est les meilleurs parents que j'ai jamais eu! » nous dit Don Jr. (7 ans). Cette famille de Mennonites travaille dans le tourisme local. Don organise des voyages pour touristes désireux de connaître la vie et les traditions des « Amish », Florence est guide à temps partiel … « et mère à temps plein » dit-elle. Leur message: « Dieu a créée la famille, elle était la toute première institution sur la Terre, et nous espérons qu'elle existera aussi longtemps que la terre tournera! »

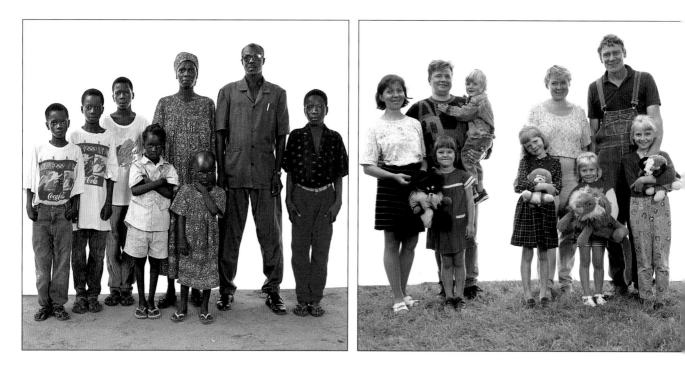

Garoua,
Cameroon,
1 August 1997

Jean ist Lehrer an der katholischen Missionsstation von Garoua. Er ist seit 1983 mit seiner Frau verheiratet, die gerade ihr siebtes Kind erwartet. Sie leben zurzeit in einem Bungalow der Schule, aber Jean denkt an ein eigenes Haus mit etwas mehr Komfort für seine Familie. Er sagt: „Das Leben ist für alle beschwerlich, aber welchen Sinn hat das Leben ohne Familie?"

Jean teaches at the Garoua Catholic Mission. He's been married since 1983, and his wife is expecting their seventh child. For the time being they are living in a school bungalow; Jean wants to have a real house to make his family comfortable and tells us: "Life is difficult for everybody, but what does life mean if you don't have a family?"

Jean est instituteur à la mission catholique de Garoua. Il est marié depuis 1983 et sa femme attend leur 7ème enfant. Pour l'instant, ils vivent dans un bungalow de l'école – Jean a en tête d'avoir une vraie maison pour le confort de sa famille et nous dit: « La vie est difficile pour tout le monde, mais quel sens a la vie quand on a pas de famille? »

Riga,
Latvia,
14 July 1998

Die beiden Schwestern haben es sich zur Gewohnheit gemacht, den Sommer mit ihren Ehemännern, den Kindern und deren Puppen auf dem Land zu verbringen. Sie gehen so unterschiedlichen Berufen nach wie Musikerin und Möbeltischler, Angestellter und Hausfrau, aber ihre Liebe zur lettischen Musik und Folklore verbindet sie. Jeva und Janis (links) haben sich übrigens bei einem Musikfestival kennen gelernt und Ilse und Eylis bei einem Volkstanzabend. Wir wünschen ihnen noch viele gemeinsame Sommer mit Sonne und Gesang.

The two sisters with their husbands, their children and their children's dolls have taken to spending summers in the country with the family. They have very different jobs: musician, cabinet-maker, clerk and housewife, but their love of Latvian music and folklore is what binds them together. As it happens, Jeva and Janis (on the left) met at a song festival, and Ilse and Eylis met during an evening of folk-dancing. We wish them many summers filled with song and sun.

Les deux sœurs avec leurs maris, leurs enfants et leurs peluches ont pris l'habitude de passer l'été en famille à la campagne. Ils exercent des métiers très différents, musicienne, ébéniste, employé et femme au foyer mais leur amour de la musique et du folklore Letton les lie. Jeva et Janis (à gauche) se sont d'ailleurs rencontrés à l'occasion d'un festival de chanson, et Ilse et Eylis à l'occasion d'une soirée de danse folklorique. Nous leur souhaitons beaucoup d'étés remplis de chants et de soleil!

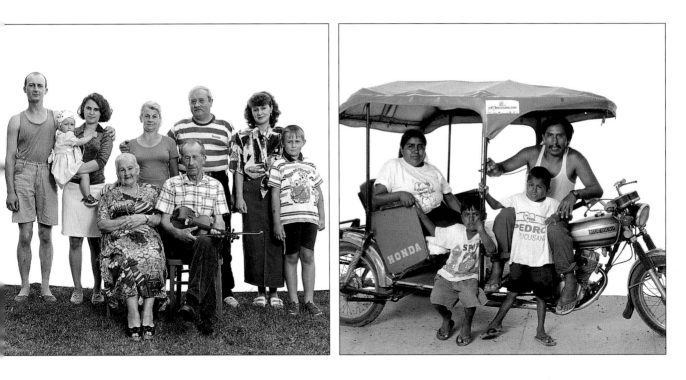

Katowice,
Poland,
25 July 1998

Als Erstes zeigten sie uns das Foto, das anlässlich ihres 50. Hochzeitstags gemacht wurde, zusammen mit all den anderen Paaren aus der Region, die in dem Jahr Goldene Hochzeit feierten. „Es ist sogar vom polnischen Präsidenten signiert!" Auf ihr neues, großes Haus sind sie besonders stolz: „Hier leben drei Familien, alle mit eigenem Badezimmer und separatem Eingang!"

First they showed us the photo taken for their 50th wedding anniversary together with all the other couples in the area who celebrated their golden wedding over the year. "It's even signed by the Polish president." They're very proud of their large new house and explain: "There are three families, three bathrooms and three separate front doors."

Ils nous ont d'abord montré la photo de leur 50ème anniversaire de mariage, réalisée en compagnie de tous les autres couples de la région fêtant leurs noces d'or dans l'année. « Il y a même la signature du Président polonais ! » Très fiers de leur nouvelle et grande maison, ils énumèrent : « Il y a 3 familles, trois salles de bains, trois entrées séparées ! »

Pucusana,
Peru,
7 February 1999

Eddy ist Taxifahrer und Cesare besitzt einen Süßwarenstand auf Rädern und verkauft Süßigkeiten und Eis an die Besucher des Badeortes. „Wir hoffen, dass wir im Jahr 2000 immer noch genug zum Leben haben", sagen sie ein bisschen besorgt.

Eddy is a taxi driver, and Cesare has a candy cart from which she sells sweets and ice creams to visitors in the seaside resort. "We're hoping we'll still have all the basics in 2000," they say, a little anxiously.

Eddy est chauffeur de son taxi, Cesaré possède un *chariot de gourmandises* où elle vend sucreries et glaces aux visiteurs de cette station balnéaire. « Nous espérons ne pas manquer de l'essentiel en l'an 2000 » disent-ils un peu inquiets.

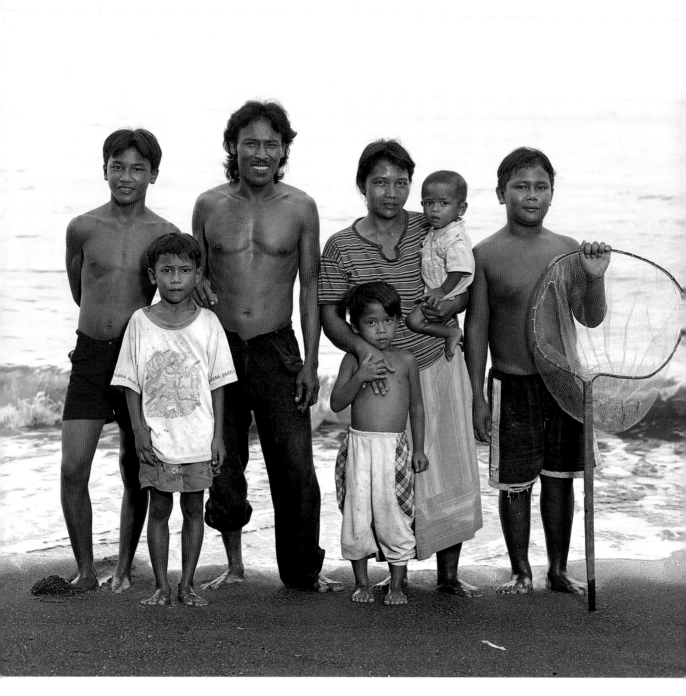

Bali,
Indonesia,
15 December 1999

Mit seiner Angel und einer winzigen Barke fährt Putu allein hinaus zum Thunfischangeln. An guten Tagen bringt er bis zu 20 Fische heim, die seine Frau auf dem Markt verkauft.

Putu sets off on his own, with his line and a tiny boat, to fish for tuna. On good days he brings back up to 20 fish, which his wife sells at the market.

Putu part seul, avec sa ligne et une minuscule barque à la pêche au thon. Les bons jours, il ramène jusqu'à 20 poissons, que sa femme vend au marché.

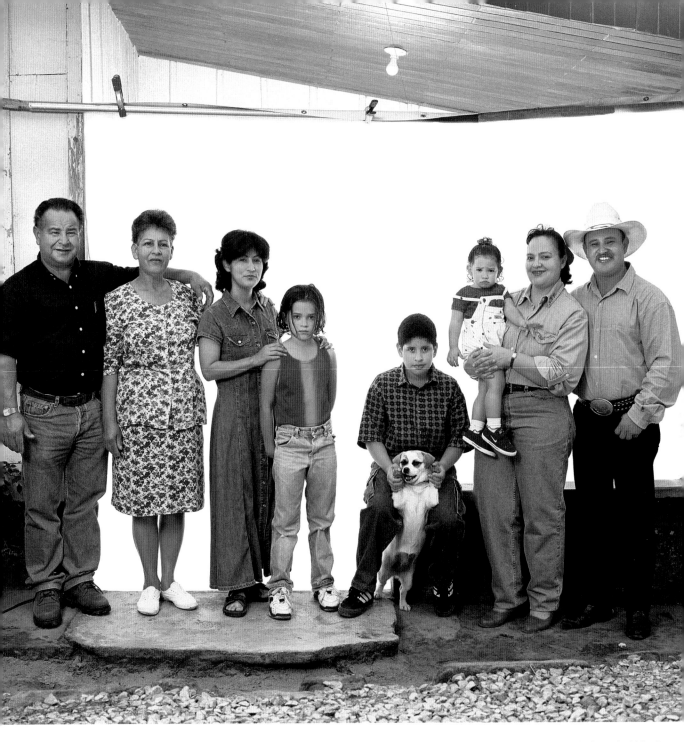

Volcán,
Panama,
1 January 1999

Großeltern, Eltern und Kinder haben sich zum ersten Mittagessen im neuen Jahr zusammengefunden. Der Großvater ist Aufseher in einer großen Molkerei, der Sohn Ricardo betreut als Tierarzt mehrere Bauernhöfe in der Nachbarschaft. Seine Frau Carmen ist Zahnärztin und hofft, bald ihre eigene Praxis zu eröffnen. Vor allem aber würde sie gern ihre Eltern in Venezuela besuchen, damit sie endlich ihre Enkelin Shantal kennen lernen.

Grandparents, parents and children all gathered for the first lunch of the new year. Grandfather supervises the labourers on a large dairy farm. Ricardo, the son, is a vet and works on several nearby farms. Carmen, his wife, works in dental medicine and hopes to open her own surgery soon, but above all, she'd like to visit her parents in Venezuela, to show them her daughter Shantal.

Les grands-parents, parents et enfants se sont retrouvés pour le premier déjeuner de la nouvelle année. Le grand-père supervise les ouvriers, dans une grande ferme laitière. Ricardo, le fils, est vétérinaire et s'occupe de plusieurs fermes voisines. Carmen, son épouse, travaille dans la médecine dentaire et espère ouvrir son propre cabinet bientôt, mais avant tout elle voudrait rendre visite à ses parents au Vénézuela pour leur présenter sa fille Shantal.

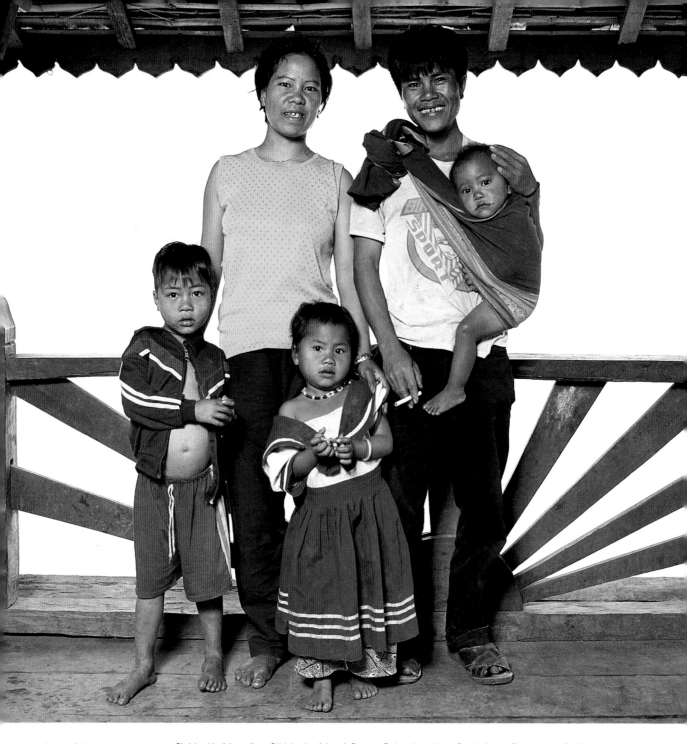

Sie leben kärglich von ihrem Stück Land, auf dem sie Bananen, Zuckerrohr und etwas Gemüse für den Eigenbedarf der Familie anbauen.

They live frugally off their plot of land, where they harvest bananas, sugar cane, and a few vegetables for their family meals.

Ils vivent chichement de leur bout de terrain où ils récoltent bananes, canne à sucre et quelques légumes pour la consommation familiale.

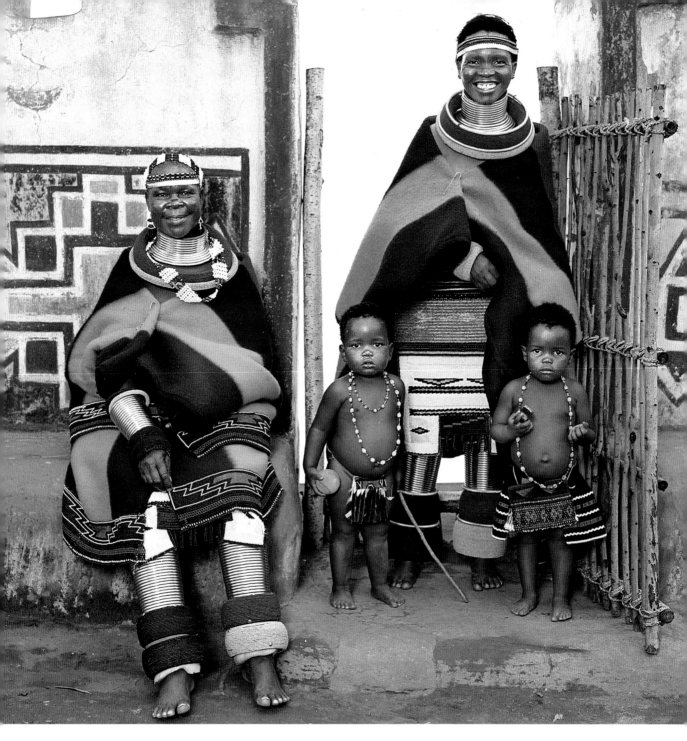

near Middelburg,
South Africa,
9 October 1997

Das Volk der Ndebele, weltweit berühmt für die kunstvolle Bemalung seiner Häuser, ist bis auf eine kleine Gruppe ausgestorben, die in einem Reservat als Touristenattraktion lebt. In ihrer Stammestracht arbeiten sie das ganze Jahr über an den Wandmalereien eines Vorzeigehauses, in dem Andenken und Erfrischungsgetränke verkauft werden. Sie unternehmen Promotiontouren quer durch Europa, Asien und die USA, und die Bücher über ihr Kunsthandwerk verkaufen sich in allen Metropolen der Welt.

The Ndebele, known throughout the world for the decorative painting of their houses, no longer exist, except in a park where they live in a kind of display case for tourists. Dressed in the traditional style, they spend the entire year touching up a demonstration house where there is a shop selling souvenirs and fizzy drinks. They go on promotional trips to Europe, Asia and the United States, and books about their decorative art are sold in all the world's capitals.

Les N'Debele, mondialement connus pour la peinture décorative de leurs maisons, n'existent plus, sauf dans un parc où ils vivent en vitrine pour les touristes : habillés à l'ancienne et retouchant à longueur d'année une maison témoin qui abrite une boutique de souvenirs et de boissons gazeuses. Ils font des voyages promotionnels en Europe, Asie et Etats Unis, les livres sur leur art décoratif se vendent dans toutes les capitales du monde.

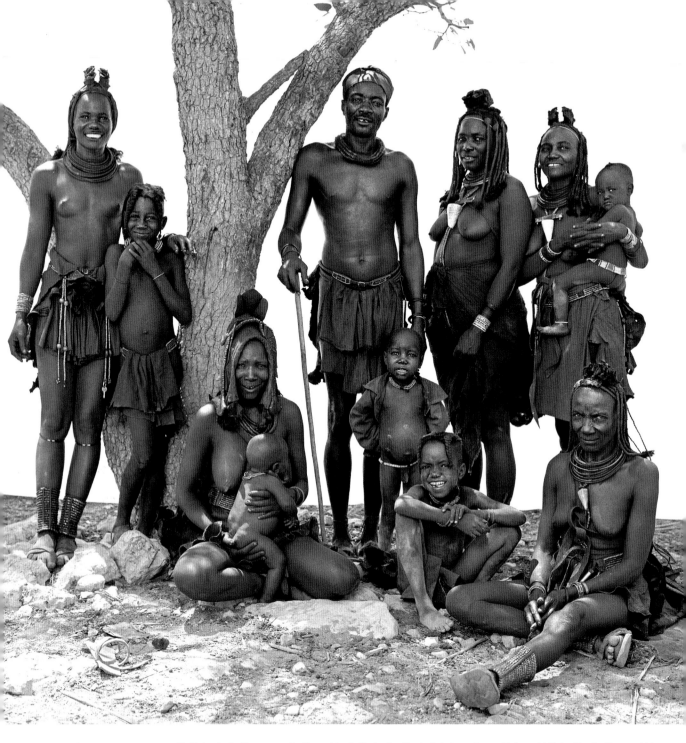

 near Opuwo,
Namibia,
12 September 1997

Die Himba, ein den Herero verwandter Stamm, leben im Norden Namibias im Umkreis von Opuwo. Sie legen viel Wert auf ihre Traditionen und lehnen jede Art „moderner Zivilisation" rundweg und ohne jedes Bedauern ab. Sie leben ausschließlich von der Viehzucht. Das Oberhaupt dieser Himba-Familie hat von dem Moment an kein Wort mehr mit mir geredet, als ich ihm dummerweise gestand, kein einziges Stück Vieh zu besitzen, nicht einmal ein Huhn.

The Himba (a tribe closely related to the Herero) live in northern Namibia, around Opuwo. They live in an extremely traditional way and reject 'modern civilization' outright (and with no regrets). They only rear cattle and grow no crops. The head of this Himba family didn't say another word to me once I'd foolishly told him that I didn't own any livestock, not even a chicken.

Les Himba, tribu proche des Herero, habitent dans le nord de la Namibie, aux alentours d'Opuwo. Ils vivent d'une manière extrêmement traditionnelle et refusent en bloc et sans regret « la civilisation moderne ». Ils réduisent des pierres en poudre et s'en recouvrent entièrement, ce qui les protège du soleil, des moustiques et leur donne cette teinte rouge. Ils sont éleveurs et ne cultivent pas la terre. Le chef de cette famille ne m'a plus adressé la parole, après que je lui ai bêtement avoué ne posséder aucune tête de bétail, pas même un poulet.

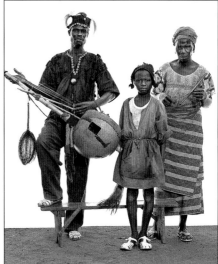

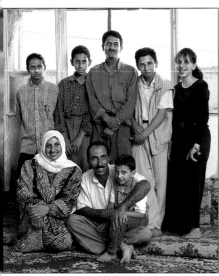

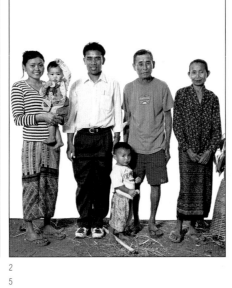

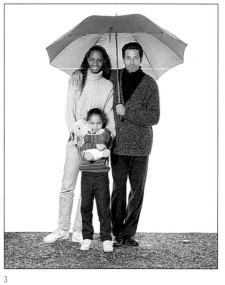

1

4

2

5

3

6

1
Bogotá,
Colombia,
20 February 1999

2
Loja,
Ecuador,
12 February 1999

3
Man,
Ivory Coast,
2 April 1997

4
Wadi Musa,
Jordan,
10 August 1999

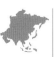
5
Pakse,
Laos,
29 January 2000

6
Siena,
Italy,
9 December 1996

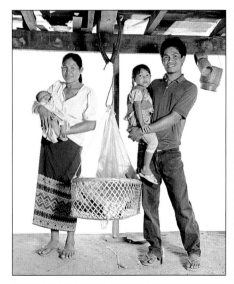
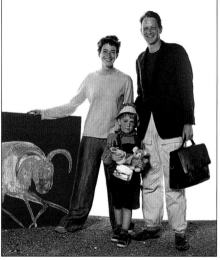
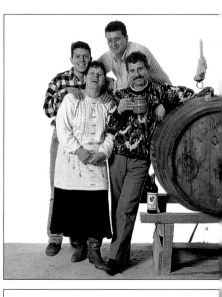
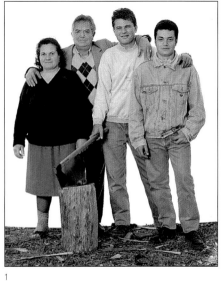
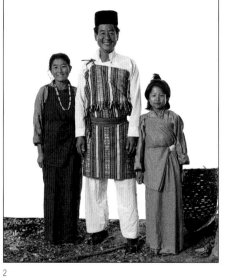
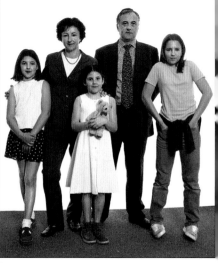

1

2

3

7

8

9

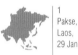 1
Pakse,
Laos,
29 January 2000

 2
Copenhagen,
Denmark,
24 June 1998

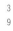 3
Melnik,
Bulgaria,
3 January 1997

 4
Cudillero,
Spain,
13 May 1998

 7
Milo,
Italy,
15 December 1996

 8
Chawang,
Sikkim, India,
22 November 1999

 9
Bordeaux,
France
11 May 1998

 10
Buenos Aires,
Argentina,
3 April 1999

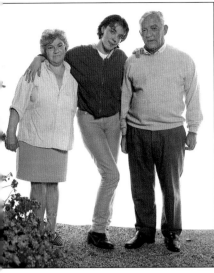

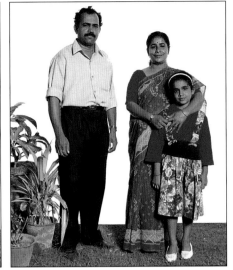

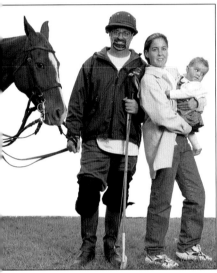

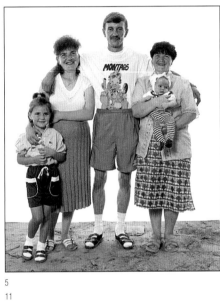

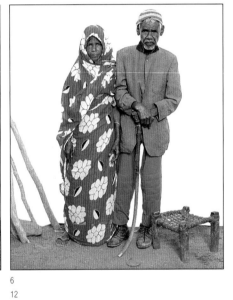

4

11

5

11

6

12

 5
Udaipur,
India,
25 October 1999

 6
Bucharest,
Romania,
16 October 1996

 11
Lvov,
Ukraine,
23 July 1998

12
near Keren,
Eritrea,
19 December 1997

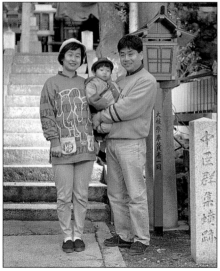
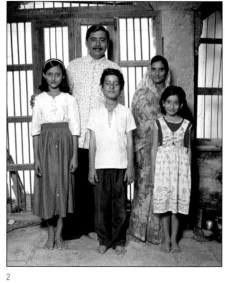
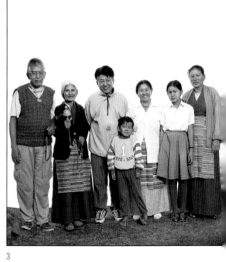

1

2

3

1
Kyoto,
Japan,
24 February 2000

2
Jaisalmer,
India,
13 October 1999

3
Pokhara,
Nepal,
15 November 1999

Page 463

Flugzeugkapitän und Arzt – das sind die Traumberufe von Adam, acht, und Islam, sieben Jahre alt. Der Vater der beiden arbeitet seit seinem Studium in den USA beim städtischen Amt für Denkmalschutz. Seine Botschaft: „Ich hoffe, dass 2000 ein gutes Jahr für Jordanien und für die ganze Welt wird."

Adam, who's eight, and Islam, who's seven, dream of being a pilot and a doctor, respectively. After studying in the United States, their father got a job as administrator of the Petra conservation board. His hope for the future is that "2000 will be a good year for the whole earth, not just Jordan."

Pilote d'avion et docteur, ce sont les deux métiers que rêvent d'exercer Adam 8 ans, et Islam 7 ans. Leur père, après des études aux Etats-Unis, est devenu Administrateur du conseil de préservation de Petra. Son vœu pour l'avenir : « J'espère que l'an 2000 sera une bonne année pour la terre entière et pas seulement pour la Jordanie. »

Page 464

In guten Monaten verdienen Taron und Indra bis zu 2 000 Rupien (ca. 50 US-Dollar), abzüglich der Materialkosten und der Gewerbesteuer, die sie für ihre Werkstatt in der Straße der Schmiede entrichten müssen. Er fertigt Messer und Werkzeuge, während sie sich um den Verkauf und die Finanzen kümmert.

In good months Taron and Indra can earn 2,000 rupees (c. $50), less the cost of raw materials and taxes they have to pay for their premises in the blacksmiths' street. He makes knives and tools, while she looks after the sales side and the family finances.

Les bons mois, Taron et Indra peuvent gagner 2000 roupies (50 US$), moins la matière première et les taxes dont ils doivent s'acquitter pour être installés dans la rue des forgerons. Lui fabrique couteaux et outils, elle s'occupe de la vente et des finances familiales.

Page 465

Der Stolz des Schäfers Adamou sind einige Stück Vieh. Er hat zwei Frauen und ein Kind. Das Nomadenleben macht es den Kindern des Stammes unmöglich, eine Schule zu besuchen, aber Adamou hofft, dass seine Kinder eines Tages die Möglichkeit zum Schulbesuch haben werden.

Adamou is a herdsman, and very proud of the wealth represented by his several head of cattle. He has two wives and one child. The nomadic life prevents the children of the tribe from attending school, but he hopes that one day his children will have the chance to go to school.

Berger, Adamou est riche de plusieurs têtes de bétail dont il tire une grande fierté. Il a deux femmes et un enfant. La vie de nomade empêche les enfants de la tribu de fréquenter l'école, mais il espère qu'il aura un jour la possibilité d'instruire les siens.

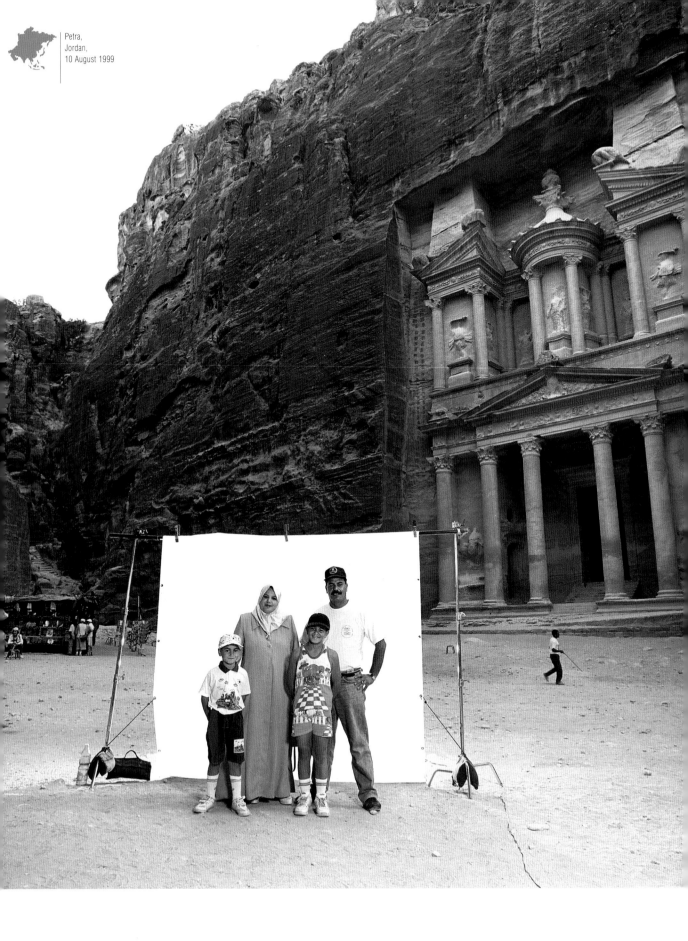

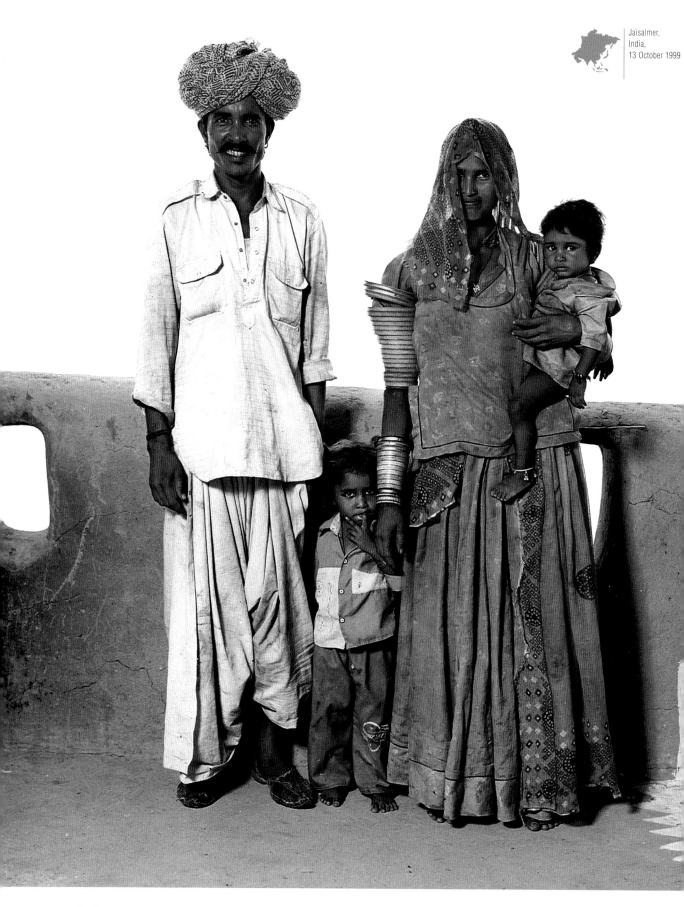

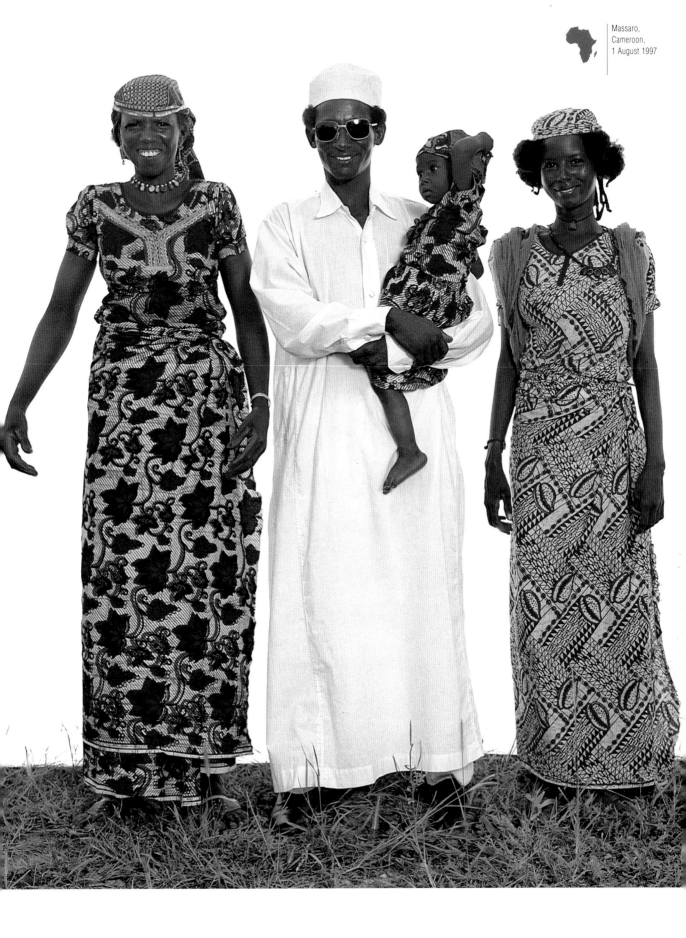

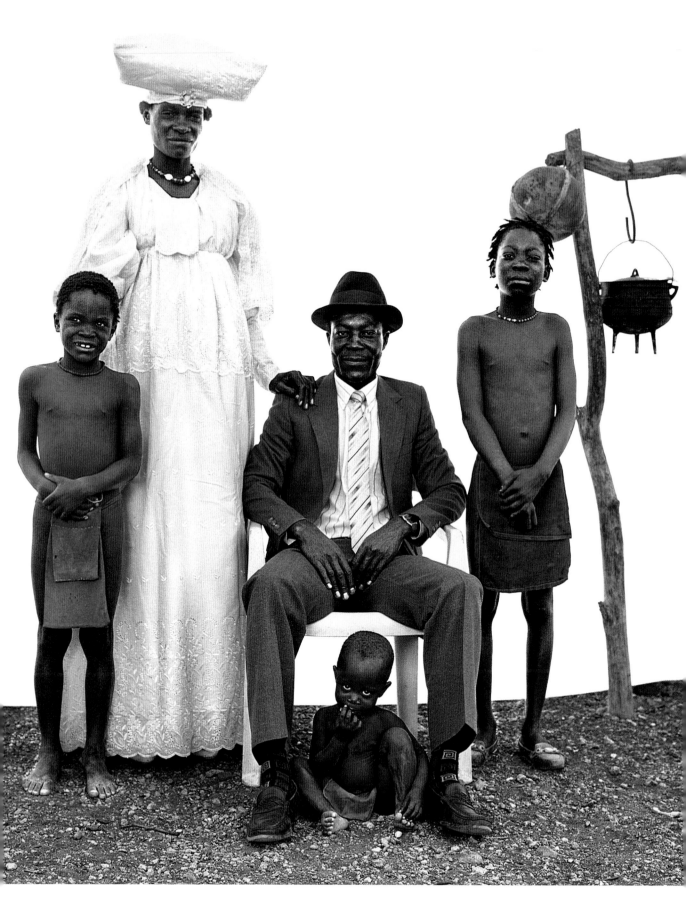

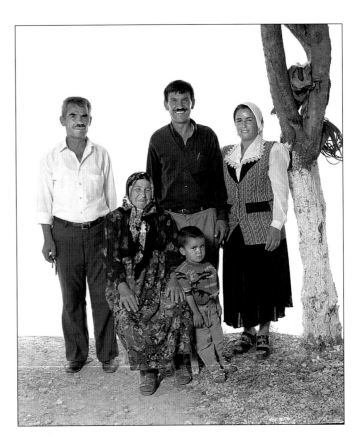

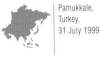

Near Opuwo,
Namibia,
12 September 1997

Maverek ist Herero und stolz darauf. Der Besitzer und Hirte einiger Kühe und Ziegen lebt kärglich, aber er schickt seine Kinder ins Nachbardorf zur Schule. Sein Wunsch für das neue Jahrtausend: „Dass es viel regnet, damit alles grünt …"

Maverek is Herero and proud of it. As owner and herdsman of his handful of cows and goats, he lives frugally, but manages to send his children to school in the next village. His hopes for the new millennium: "That it rains a lot, and everything turns green … "

Maverek est Herero et fier de l'être. Propriétaire et berger de quelques vaches et chèvres, il en vit chichement, mais envoie ses enfants à l'école du village voisin. Son vœu pour l'an 2000: « Qu'il pleuve beaucoup, pour que tout devienne vert ! »

Pamukkale,
Turkey,
31 July 1999

40 Jahre Ehe, ein Sohn, eine Schwiegertochter und ein Enkelkind – die beiden Alten leben und arbeiten glücklich Seite an Seite mit ihren Nachkommen. Seit Generationen sind sie Bauern und pflanzen hauptsächlich Tabak und Anis an, aus dem Raki, das türkische Nationalgetränk, gebrannt wird, außerdem Mais und verschiedene Gemüse für den Eigenbedarf. Für das neue Jahrtausend schlagen sie uns eine Art Rollentausch vor: „Ihr versorgt unseren Hof und wir fahren nach Frankreich!"

Forty years of marriage, a son with a wife and child – one family living in neighbouring houses and working together. They have been farmers for ever and a day, planting tobacco, aniseed (used to make the national drink raki), maize and vegetables for family consumption. Their idea for the new millennium is: "You come and look after our farm, and we'll go to France!"

40 ans de mariage, un fils, une belle-fille, un petit-fils, une famille qui vit dans deux maisons voisines et travaille ensemble. Paysans depuis toujours, ils plantent du tabac et de l'anis qui sert à la fabrication de la boisson nationale le Raki, du maïs et des légumes pour la consommation familiale. Ils nous proposent un échange: « Vous vous occupez de la plantation et nous allons à Paris ! »

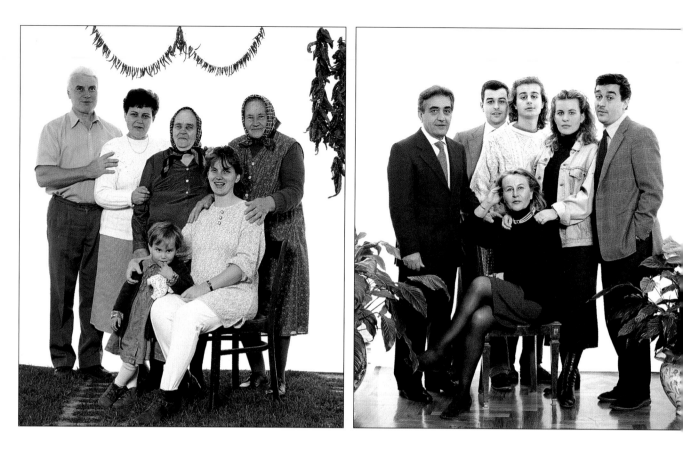

Sármellék,
Hungary,
12 October 1996

Szabó, der Dorfbürgermeister, fühlt sich in der Minderheit im Kreise „seiner" fünf Frauen, die fünf Generationen umspannen und das lebende Gedächtnis des Ortes sind.

Szabó, mayor of the village, feels in a minority amidst "his" five women, representing five generations. They are the village's living memory.

Szabó, maire de son village, se sent minoritaire entouré de « ses » cinq femmes qui représentent cinq générations. Elles sont la mémoire vivante du village.

Naples,
Italy,
12 December 1996

Vater Elio Ambrosio ist auch beruflich der Chef seiner drei Sprösslinge, mit denen er gemeinsam eine Agentur für Kommunikation betreibt. Andrea hat aus Solidarität mit ihrem Verlobten eine Jeansjacke angezogen, da er als Einziger keinen Anzug trägt.

Elio Ambrosio runs a family business, a communications agency where he works with his three children. Andrea has slipped on a denim jacket out of solidarity with her fiancé, the only person not wearing a suit.

Elio est à la tête d'une entreprise familiale, une agence de communication où il travaille avec ses trois enfants. Andrea a enfilé un blouson en jean par solidarité avec son fiancé, le seul qui ne porte pas de costume.

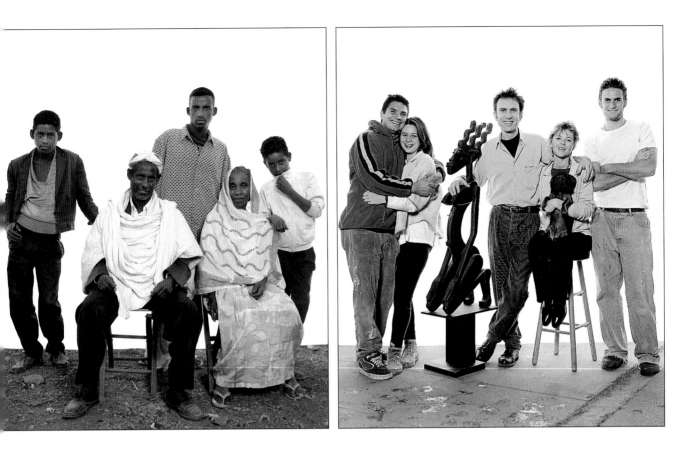

Aksum,
Ethiopia,
16 December 1997

North Hollywood,
California, USA,
13 November 1998

Scheich Abder Nour Hossein besitzt zwei Webstühle, an denen sich die ganze Familie abwechselt, damit die Produktion nicht stillsteht ...

Sheikh Abder Nur Hossein has two looms at which the whole family work in shifts to keep production going non-stop ...

Cheik Abder Nour Hossein, possède deux métiers à tisser sur lesquels toute la famille se relaie, pour ne pas interrompre la production ...

„Wir sind ein Familienunternehmen und tun, was uns Spaß macht", so die schöne Devise von Antoine, Bildhauer und Komponist, und seiner Frau, einer Malerin. In ihrem Designstudio stellen sie die Ausstattung für Filmproduktionen her. Ihre Überzeugung: „Jede Familie muss einzigartig bleiben, nur so können die Traditionen erhalten werden, die uns alle bereichern."

"We work as a family and do what we like doing" is Antoine's splendid motto. He's a sculptor and composer, while his wife's a painter. Together they've set up a design studio which makes sets for the film industry. They tell us: "Every family must remain genuine; that's how traditions survive and enrich us all."

« On travaille en famille et on fait ce qu'on aime faire » belle devise d'Antoine, sculpteur compositeur et de sa femme peintre. Ils ont ouvert un studio de design où ils réalisent des décors pour le cinéma. « Chaque famille doit garder son authenticité, ainsi survivent les traditions nous permettant de nous enrichir mutuellement » nous disent-ils.

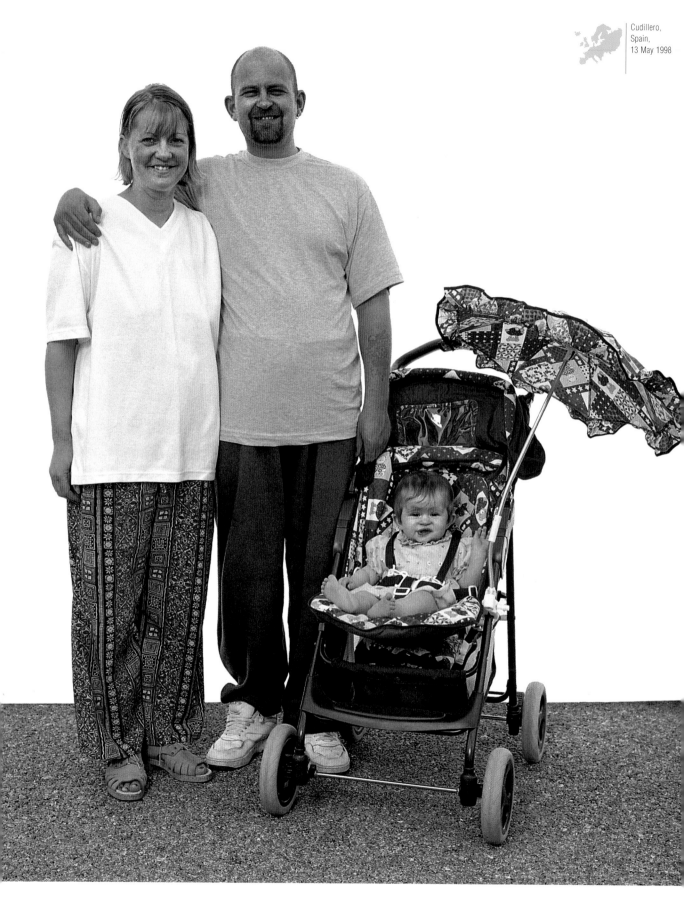

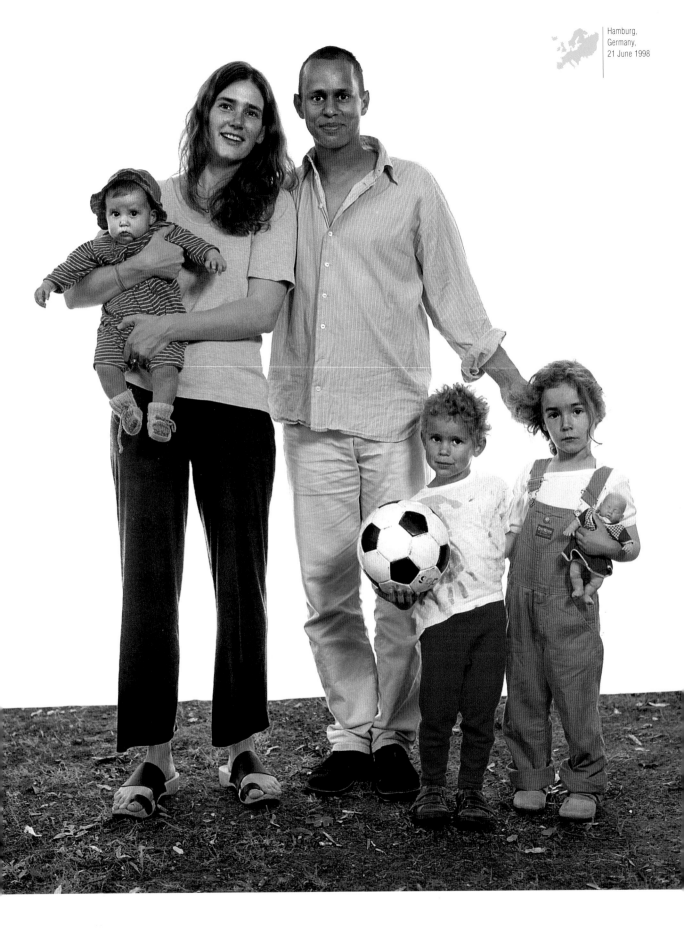

Page 470 Diese britische Familie haben wir auf ihrer Rundreise durch Spanien getroffen. Paul, Bergarbeiter und zurzeit ohne Arbeit, und Claire, Hausfrau, hoffen, dass ihre Ersparnisse ausreichen, um mit dem Campingbus die gesamte Mittelmeerküste zu erkunden. Ihre Philosophie: „Genieße den Tag, denk nicht an morgen." Für das Jahr 2000 wünschen sie sich ein zweites Kind, „hoffentlich ein Junge!"

When we met this English family, they were travelling round Spain in a camper. Unemployed coal miner Paul and housewife Claire are hoping that their savings will last long enough to tour the whole Mediterranean. "Don't worry about tomorrow, just enjoy every day" is their philosophy. By 2000, they'd like a second child, "a boy, we hope!"

Quand nous avons rencontré cette famille anglaise, elle circulait en Espagne à bord d'un camping-car. Paul, mineur de charbon au chômage, et Claire, femme au foyer, espèrent que leurs économies vont durer assez longtemps pour visiter toute la Méditerranée. Leur philosophie : « *Don't worry about tomorrow, just enjoy every day.* » Pour l'an 2000, ils souhaitent un deuxième enfant, « *hopefully a boy!* ».

Page 471 „Die Frage nach dem Jahr 2000 habe ich mir schon vor 15 Jahren gestellt. Heute bin ich vollkommen glücklich: Ich habe eine Frau und fantastische Kinder", erklärt uns Sacha. Seine Mutter stammt aus Burundi, er wuchs in Deutschland auf, wo er auch Ethnologie studierte. Mittlerweile arbeitet er als Journalist beim Fernsehen. „Ich mag Fußball und Musik, komme aber zeitlich kaum dazu." Seine Frau Annette ist Hebamme und hat ihre Kinder zu Hause auf die Welt gebracht. Ihr Traum: „Eine Hütte an der Ostsee, selbst wenn es weder Wasser noch Strom gibt."

"I started wondering about the new millennium 15 years ago. Today, I'm a very lucky man – I've got a wonderful wife and children," Sacha tells us. Originally from Burundi on his mother's side, he grew up and studied ethnology in Germany, where he's a TV journalist. "I like football and music, but I have hardly any time for either." Midwife Annette decided to have her children at home. Her dream is to have "a cabin near the Baltic, even if there's no water or electricity."

« Je me suis posé la question de l'an 2000 il y a déjà quinze ans. Aujourd'hui je suis comblé, j'ai une femme et des enfants formidables », nous dit Sacha. Originaire du Burundi par sa mère, il a grandi et fait ses études d'ethnologue en Allemagne où il est journaliste à la télévision. « J'aime le foot, la musique, mais n'ai guère le temps de pratiquer. » Annette, sage-femme, a choisi de mettre au monde ses enfants à la maison. Son rêve : « Une case près de la mer Baltique, même sans eau ni électricité. »

Page 473 „Ohne meine Kinder wäre ich unglücklich, sie bringen Wärme in mein Leben." Catherine, Lehrerin in Yamoussoukro, erzieht ihre vier Kinder allein. Sie ist von einem polygamen Mann geschieden, da sie als einzige seiner Frauen berufstätig war, was zu Eifersüchteleien untereinander führte. Als überzeugte Protestantin hofft sie, dass Gott ihr Leben bis ins neue Millennium dauern lässt. Sie fragt sich: „Wird die Welt ein besserer oder schlechterer Platz zum Leben werden?"

"If I didn't have any children, I'd be very unhappy. They bring warmth into my life." Catherine teaches in Yamoussoukro and brings up her four children on her own. She is divorced from her polygamous husband because, as the only wife that worked, she stirred up jealousy among the other wives. As a committed Protestant, she hopes that God will let her live to the new millennium. She wonders: "Will the world become a better or a worse place to live?"

« Si je n'avais pas d'enfants, je serais très malheureuse. Ce sont eux qui donnent la chaleur. » Catherine, enseignante à Yamoussoukro, élève seule ses quatre enfants. Divorcée d'un mari polygame, elle était la seule femme active, ce qui suscitait bien des jalousies de la part des autres épouses. Protestante convaincue, elle espère que Dieu lui prête vie jusqu'en l'an 2000. Elle s'interroge : « Le monde sera-t-il meilleur ou bien pire ? »

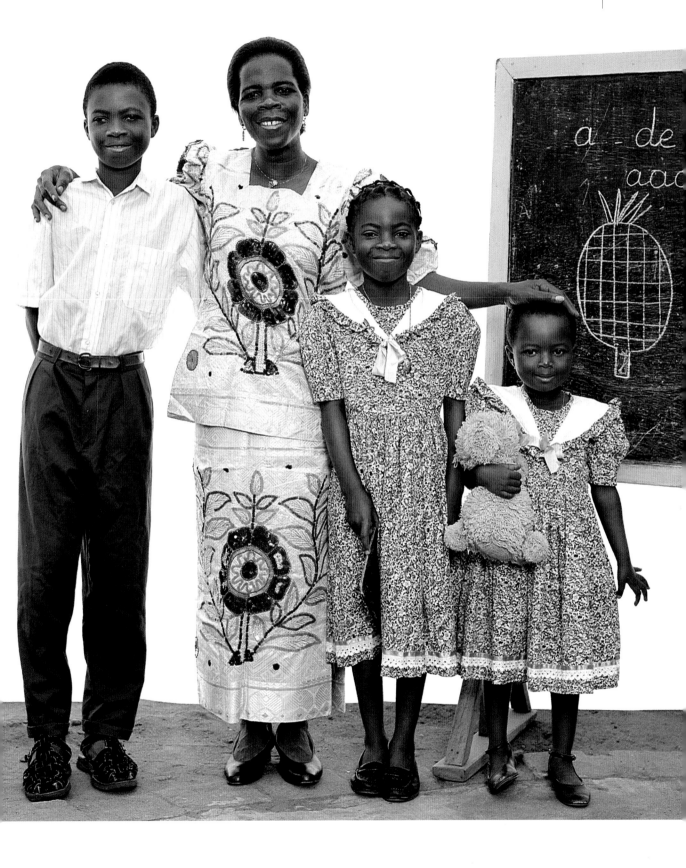

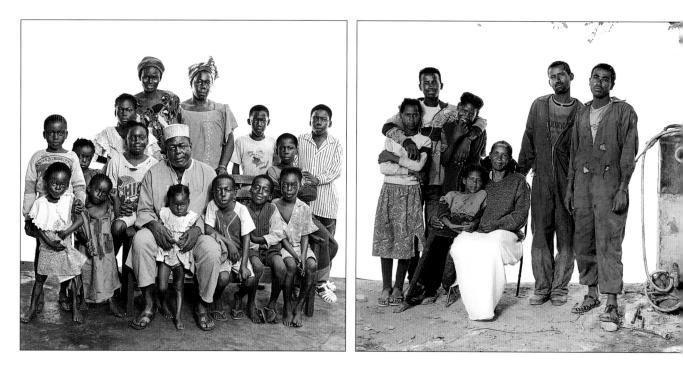

Man,
Ivory Coast,
2 April 1997

Die Familie des Antiquitätenhändlers besteht aus drei Frauen, zwölf Kindern und einer Schar Ziegen. Mohammad ist nicht oft zu Hause, auf der Suche nach außergewöhnlichen Stücken für seinen Laden klappert er im ganzen Land die Dörfer ab. Mohammad sieht leicht deprimiert aus: Seine dritte, jüngste und schönste Frau hat sich geweigert, mit seinen beiden anderen Frauen fotografiert zu werden.

The family of the antique dealer consists of three wives, twelve children and a flock of goats. Mohammad is not often home, because he is off bargain-hunting all over the country, looking for outstanding pieces for his store. Mohammad looks slightly depressed: his third wife – the youngest and most beautiful – refused to be photographed with his other wives.

La famille du président des antiquaires est composée de trois femmes, 12 enfants et d'une ribambelle de chèvres. Mohamed est légèrement déprimé, sa troisième femme la plus jeune et la plus belle a refusé de se faire photographier en compagnie des deux autres. Mohamed n'est pas souvent chez lui, il chine dans tout le pays à la recherche de pièces exceptionnelles pour sa boutique. Ses vœux pour l'an 2000: « Inch Allah, je serai ici en Côte d'Ivoire, qui est un bon pays, mais mon plus grand souhait est que mes enfants connaissent un jour leur pays d'origine: le Nigeria. »

Mekele,
Ethiopia,
13 December 1997

Das archaisch anmutende Werkzeug täuscht: Kuflam und sein Bruder sind hervorragende Kfz-Mechaniker. In ihrer Werkstatt konnten sie ihr Talent an unserem Landrover unter Beweis stellen – vermutlich das neueste Automodell, das ihnen je unter die Finger gekommen ist ...

Despite their rustic equipment, Kuflam and his brother are both gifted mechanics. They have their own garage, where they had a chance to exercise their skills on our Land Rover, which was probably the newest vehicle they'd ever seen ...

Malgré leur équipement rustique, Kuflam et son frère sont deux mécaniciens talentueux. Ils ont un garage où ils ont pu exercer leur génie sur notre Landrover qui était, probablement, la voiture la plus récente qu'ils aient jamais vue.

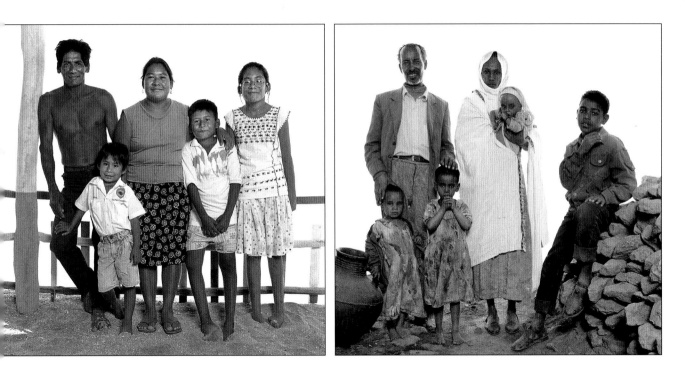

Puerto Ángel,
Mexico,
5 December 1998

„Es müsste viel mehr kulturellen Austausch zwischen den Ländern geben", beharrt Victoriano, der Fischer. Er hat ein kleines Strandrestaurant für Touristen eröffnet, in dem Isabel aus seinem Fang leckere Gerichte zaubert. Zusätzlich ziehen sie Bananen und Gemüse in ihrem Garten, um den sie sich mit Hingabe kümmern.

"There must be more cultural exchanges between countries," insists Victoriano, a fisherman by trade. He's opened a small restaurant for tourists on the beach, where his catch is transformed by Isabel into delicious meals. They also have a garden where they lovingly grow bananas and vegetables.

« Il faut plus d'échanges culturels entre les pays » insiste Victoriano, pêcheur de métier. Il a également ouvert « un petit restaurant pour touristes » sur la plage où son butin de pêche est transformé par Isabel en repas délicieux. Ils ont également un jardin où poussent bananes et légumes, dont ils s'occupent avec talent.

Aksum,
Ethiopia,
15 December 1997

Die alte Hauptstadt Aksum, seit dem vierten Jahrhundert das religiöse Zentrum der koptischen Kirche, ist die Heimat von Mullegeta. Hier arbeitet er als Ticketverkäufer im städtischen Museum, dessen Pforten während unserer Aufnahmen geschlossen blieben. Seine Frau verkauft ein selbst gebrautes alkoholisches Getränk, dessen Rezept ihr Geheimnis bleibt. Die Ausbildung seiner Kinder liegt Mullegeta so sehr am Herzen, dass er sie mit uns nach Frankreich schicken wollte!

Mullegeta was born in Aksum, the ancient capital of Ethiopia and a centre of the Coptic Ethiopian Church since the 4th century. He sells tickets at the Aksum museum, where the doors remained closed during our photo session. At home his wife makes and sells an alcoholic drink made from a secret recipe. Educating their four children means a lot to Mullegeta, and he even suggested we take them all with us to make sure they get a "better" education!

Mullegeta est né à Axum, ancienne capitale d'Ethiopie et centre religieux orthodoxe. Il est vendeur de tickets au musée d'Axum dont il a fermé les portes le temps de notre photo. Sa femme fabrique et vends à domicile une boisson alcoolisée dont elle a le secret. L'éducation de ses quatre enfants est si important pour Mullegeta qu'ils nous a proposé de les emmener avec nous, pour leur assurer une « meilleure » scolarité.

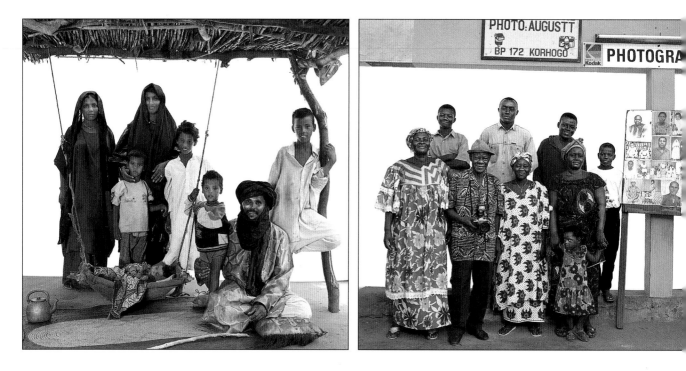

Tabalak,
Niger,
19 July 1997

„Ich spreche Französisch, weil ich fünf Jahre zur Schule gegangen bin", erklärt uns Gazalah. Obwohl er vor einem Jahr mit den Seinen nach Tabalak in ein Haus gezogen ist, behält er sein traditionelles Zelt aus Tierhäuten, in dem die Familie den Tag beim Plausch und Pfefferminztee verbringt. „Es ist nicht immer einfach. Ich hätte gern mehr Tiere – Kühe und Kamele –, andererseits möchte ich nicht, dass meine Kinder auch Viehzüchter werden und wünsche mir daher, dass sie etwas lernen."

"It's because I went to school for five years that I speak French," Gazalah tells us. Although he's been living for a year with his family in a house in Tabalak, he still keeps his traditional tent made of hides, where the family spends the day chatting and drinking mint tea. "It's not always easy. I'd like to have more animals – cows and camels – but I wouldn't like my children to be livestock farmers when their turn comes, so that's why I want them to study."

« C'est parce que je suis allé à l'école pendant 5 ans que je parle français » nous annonce Gazalah. Bien que installé dans une maison depuis un an, il à tout de même conservé sa tente traditionnelle en cuir, où la famille passe la journée à papoter et à boire du thé à la menthe. « C'est pas toujours facile. J'aimerais plus d'animaux, des vaches et des chamelles mais je ne souhaite pas que mes enfants soient éleveurs, je préfère qu'ils fassent des études. »

Korhogo,
Ivory Coast,
13 May 1997

Nach drei Jahren hatte er das Geld für eine Rolleiflex zusammengespart. Das war der Anfang der Fotografenlaufbahn von Augustt. Inzwischen wurde er in Paris, in Abidjan, in Bamako und im Guggenheim Museum ausgestellt. „Ich würde gern Jugendliche in diesem wunderbaren Beruf ausbilden."

Three years' savings for a Rolleiflex – that was the beginning of Augustt's career. Today his photographs appear in Paris, Abidjan, Bamako, and the Guggenheim Museum in New York. But Augustt is still modest and hospitable: "I'd like to train young people in this wonderful profession."

Trois ans d'économie et 80 000 CFA (en 1995) pour un Rolleiflex. C'est le début de la carrière de photographe professionnel d'Auguste, propriétaire du « Studio du Nord » à Korhogo. Aujourd'hui exposé à Paris, au Centre Georges Pompidou, à Abidjan, au Centre culturel français, aux Deuxièmes rencontres de Bamako, et à New York, au Guggenheim Museum, Auguste est resté l'homme modeste et accueillant qui continue son travail avec le même bonheur. « Je souhaite former des jeunes à ce merveilleux métier. » C'est son vœu pour le présent et pour l'avenir.

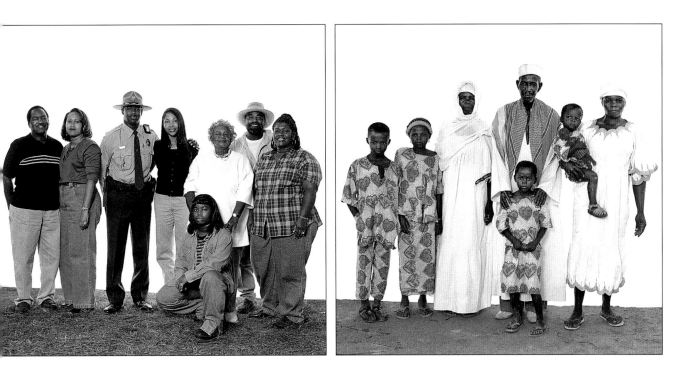

Memphis,
Tennessee, USA,
17 October 1998

Marker posiert in Uniform mit seiner Verlobten (Mitte), seinem Vater, seiner Schwiegermutter, Großmutter und Cousins. Sein Kindheitstraum hat sich erfüllt. Heute trägt er die Verantwortung für einen Nationalpark. Er will heiraten und drei Kinder bekommen.

Marker is in uniform, posing with his fiancée (center), his father, his fiancée's mother, his grandmother and cousins. His dream of becoming a park ranger has come true, and he sees the future through rose-tinted glasses: He wants to get married and have three children in a row.

Markee qui pose en uniforme avec sa fiancée (au centre) entouré de son père, sa belle-mère, sa grand-mère et de trois cousins, est un homme heureux. Son rêve d'enfance s'est réalisé : il est devenu *parc ranger*. Il voit la vie en rose, veut se marier et avoir très vite trois enfants.

Ouangolodougou,
Ivory Coast,
4 May 1997

Sako ist der erste Imam der erst 1989 gegründeten Moschee, die noch nicht fertig gestellt wurde. Sako hätte gern genügend Geld für eine eigene Schule, da die Kinder zurzeit 15 Kilometer bis ins Nachbardorf laufen müssen.

Sako is the first imam of the mosque, which opened in 1989 but is still unfinished. He would also like enough money for a school: the children walk 9–10 miles (15 km) to school in the next village.

Sako est l'imam de la mosquée depuis sa création en 1989. Bâtie par les habitants du village, elle est restée inachevée faute de moyens. Sako aimerait aussi avoir une école, pour l'instant les enfants doivent aller au village voisin à 15 kilomètres de là.

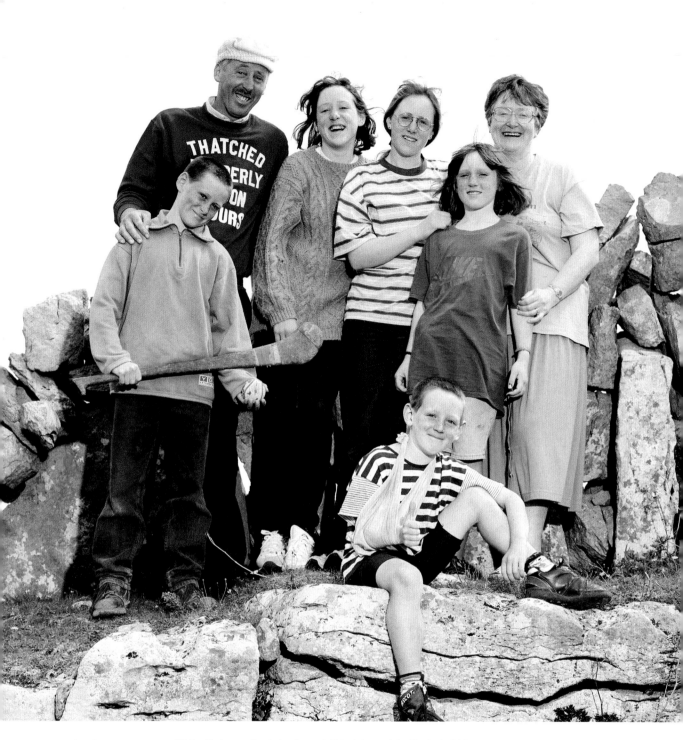

Inis Thiar,
Ireland,
31 July 1996

Mit dem Pferdewagen, dem einzigen Transportmittel auf dem autofreien Eiland, zeigt Stiofan den Besuchern seine Heimat. Er und seine Frau sind den irischen Traditionen sehr verhaftet und würden ihre Insel niemals verlassen. Jeden Sommer beherbergt Anne Studenten aus aller Welt und erteilt an diesem magischen Ort Unterricht in der gälischen Sprache.

Stiofan gives guided tours of his island along stone-walled lanes in a horse-drawn cart, the only means of transport in this car-free place. He and his wife are very attached to Irish traditions, and nothing in the world would induce them to leave their isle. Every summer, Anne takes in students from every corner of the globe and teaches them Gaelic in this enchanted spot.

Stiofan fait visiter son île, par les chemins bordés de pierres, avec une charrette à cheval, seul moyen de transport sur cette terre sans voitures. Son épouse et lui sont très attachés à la tradition irlandaise et ne quitteraient leur île pour rien au monde. Anne reçoit chaque été des étudiants venus du monde entier pour leur enseigner le gaélique dans ce lieu magique.

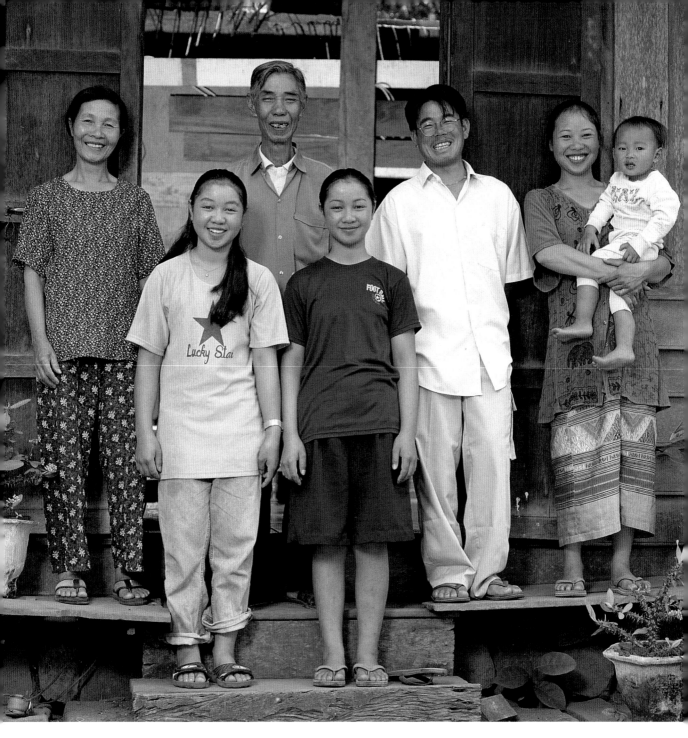

Ban Ban,
Laos,
30 January 2000

Mit 63 Jahren startete Vien Van Long 1992 seine Tee- und Kaffeeplantage. Heute sichern seine Töchter und sein Schwiegersohn die Nachfolge, er selbst kümmert sich nur noch um seine heiß geliebten Durians – igelartige Stachelfrüchte mit „Zwiebeleis"-Geschmack –, die die Asiaten so sehr schätzen.

Vien Van Long started a tea and coffee plantation in 1992 at the age of 63. Today, his daughters and his son-in-law have taken over from him, and he just tends his precious durian, a hedgehog-like fruit tasting like onion-flavoured ice cream, which Asians are crazy about.

Vien Van Long a démarré une plantation de thé et café en 1992, à l'âge de 63 ans. Aujourd'hui ce sont ses filles et son gendre qui assurent la relève, lui ne s'occupe que de ses chers *durians*, fruits qui ressemblent à des hérissons, avec un goût de *glace à l'oignon* dont les asiatiques raffolent.

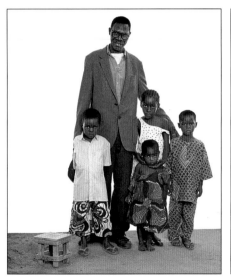
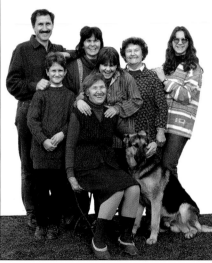
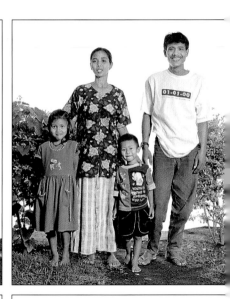

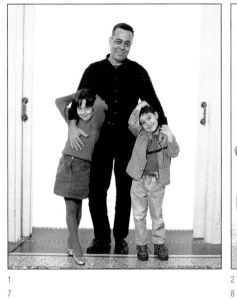

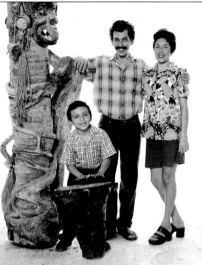

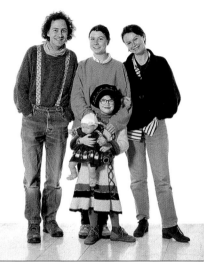

1

7

2

8

3

9

1
Pointe-Noire,
Congo,
28 August 1997

2
Rila,
Bulgaria,
4 January 1997

3
Ubud,
Bali, Indonesia,
10 December 1999

4
Lower Chapel,
Wales,
26 July 1996

7
Rabat,
Morocco,
14 February 1997

8
Boca de Tomatlán,
Mexico,
2 December 1998

9
Nantes,
France,
3 April 1997

10
Boundiali,
Ivory Coast,
13 May 1997

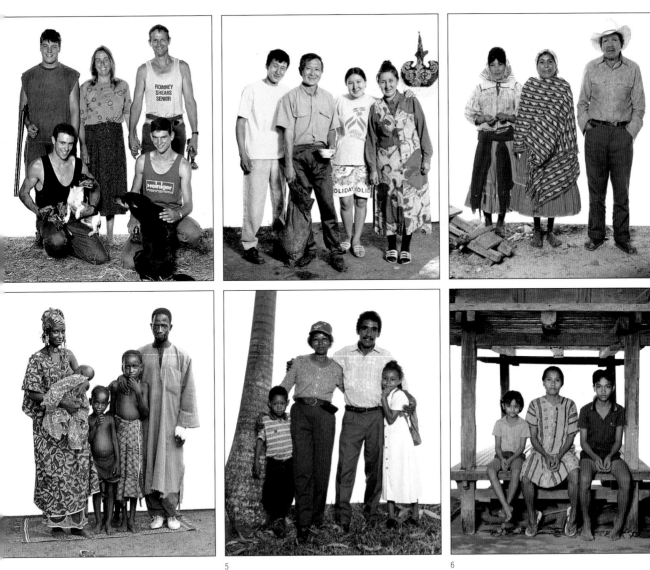

5
11

6
12

5
Bishkek,
Kyrgyzstan,
7 September 1999

6
San Ignacio,
Mexico,
24 November 1998

11
Puerto Ordaz,
Venezuela,
28 February 1999

12
Bali,
Indonesia,
15 December 1999

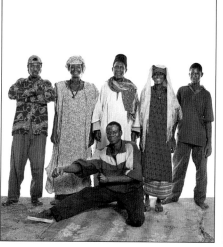
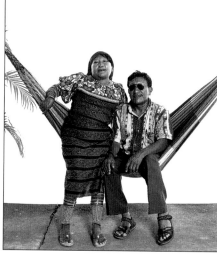
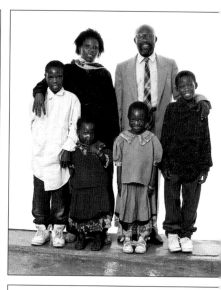

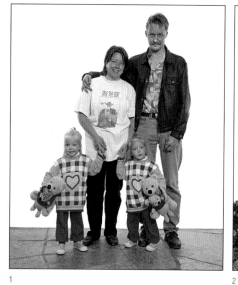
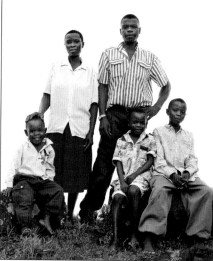
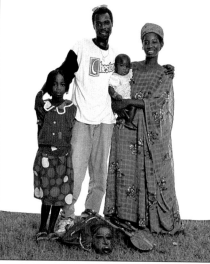

1
4

2
5

3
6

1
Sirmou,
near Djénné, Mali,
10 April 1997

2
El Valle,
Panama,
27 December 1998

3
Iringa,
Tanzania,
4 November 1997

4
Trondheim,
Norway,
1 July 1998

5
Mbale,
Uganda,
15 November 1997

6
Ziguinchor,
Senegal,
28 April 1997

Belfast,
Northern Ireland,
2 August 1996

Wir haben Sean und Colleen an ihrem Hochzeitstag kennen gelernt. Die Feier fand im Balmoral Hotel statt, wo Sean als Chefkoch arbeitet. Auf die Frage, wie viele Kinder sie haben wollen, antworten sie unisono: „Eine Fußballmannschaft!" Da wünschen wir ihnen viele Treffer …

We met Sean and Colleen on their wedding day. The reception was being held at the Balmoral Hotel, where Sean used to work as a chef. When asked how many children they planned on having, they chimed in unison: "A football team!" We hope they score lots of goals …

Nous avons rencontré Sean et Colleen le jour de leur mariage dont la réception se tenait au Balmoral Hotel où Sean a travaillé comme chef cuisinier. Questionnés sur le nombre d'enfants qu'ils souhaitent avoir, ils répondent en chœur : « Une équipe de foot ! » Nous leur souhaitons beaucoup de buts …

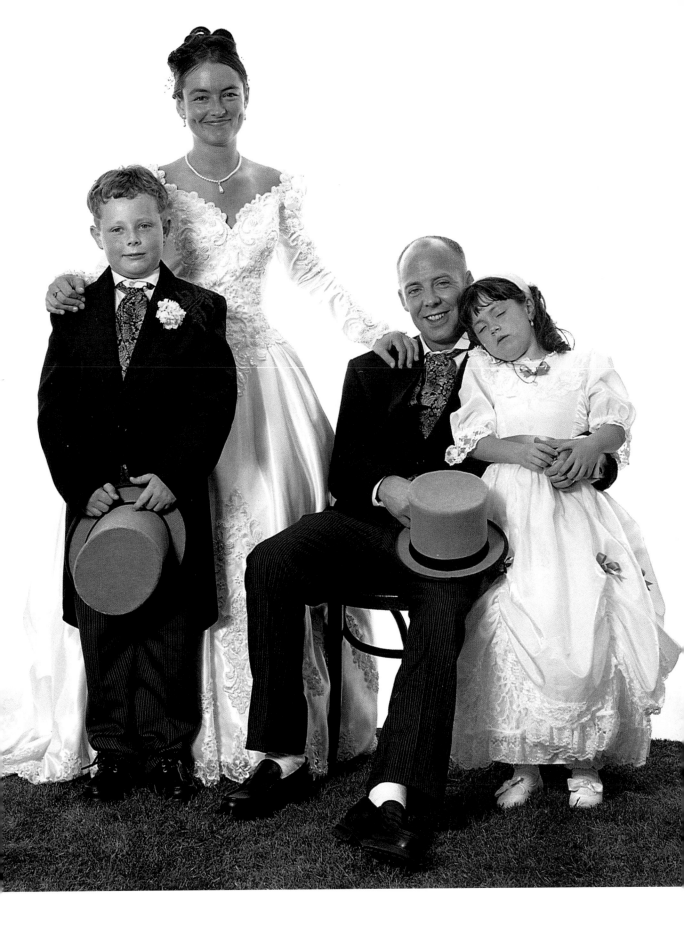

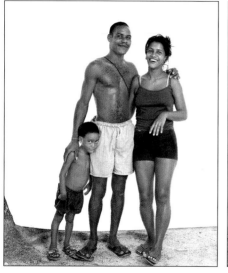
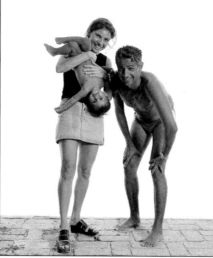
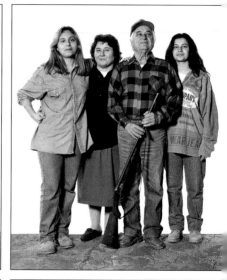

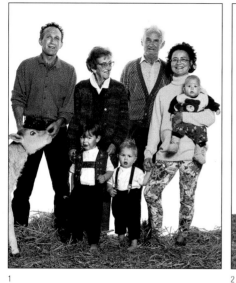
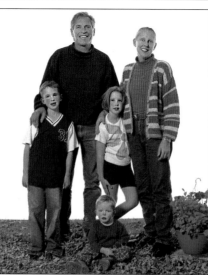
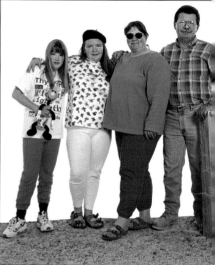

1
4

2
5

3
6

1
Rio de Janeiro,
Brazil,
21 March 1999

2
Maceió,
Brazil,
14 March 1999

3
Galaxidi,
Greece,
19 December 1996

4
Weissbad,
Switzerland,
6 October 1996

5
Gillette,
Wyoming, USA,
24 October 1998

6
Riverside,
California, USA,
15 November 1998

Seremban,
Malaysia,
2 January 2000

Die zweieiigen Zwillinge sind sich über ihre Zukunft einig: Sie werden Wissenschaftler. Im Augenblick helfen sie gern ihrer Mutter in der Küche. Ihre Schwester Shantana Dewi verfolgt nicht weniger hohe Ziele: „Ich werde später Ärztin, im Moment zeichne ich gern und helfe manchmal meiner Mutter." Glückliche Eltern!

They are not identical twins, but the two of them are agreed about their future – they will be scientists. For the time being they enjoy helping their mother in the kitchen. Their sister Shantana Dewi is just as serious: "I'm going to be a doctor later on, but at the moment I love drawing, and sometimes I help my mother." Lucky parents!

En vrais faux-jumeaux, les deux petits sont d'accord sur leur avenir: ils seront scientifiques. Pour le moment, ils aiment aider leur mère et faire des coloriages. Leur sœur Shantana Dewi n'est pas moins sérieuse: «Plus tard, je serai médecin, pour le moment j'adore dessiner et quelquefois j'aide ma mère.» Heureux parents!

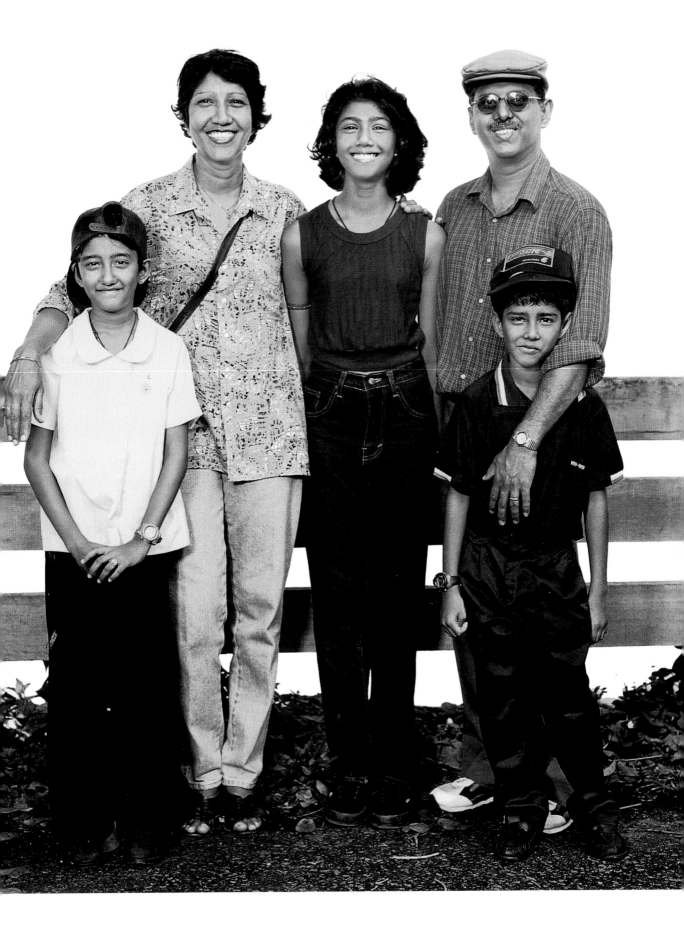

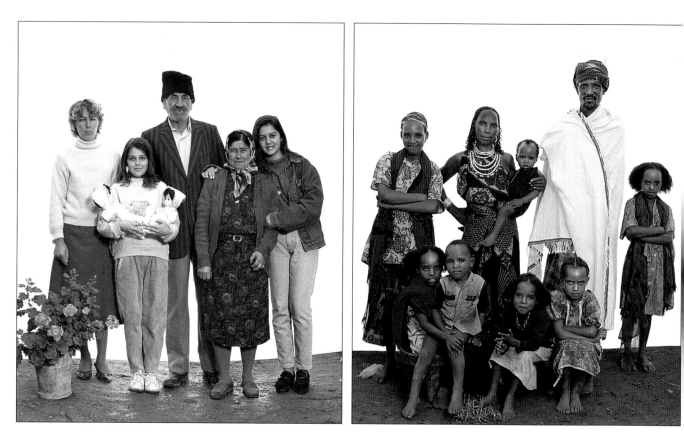

Butoieşti,
Romania,
18 October 1996

Nicolae und Petria leben seit ihrer Heirat auf diesem kleinen Hof, den sie von den Eltern geerbt haben, und bauen Wein, Obst und Gemüse an. Auch die Schwiegertochter und die beiden Enkelkinder wohnen hier. Die Mädchen gehen zur Schule und möchten „in der Stadt arbeiten, wenn sie groß sind".

Nicolae and Petria have spent their whole lives in the house inherited from their parents; they have a few vines, and grow fruit and vegetables. Their daughter-in-law and granddaughters live with them. The girls go to school and are hoping "to find work in town when they grow up."

Nicolae et Petria ont vécu toute leur vie dans la maison héritée de leurs parents. Ils ont quelques vignes, des arbres fruitiers et un potager. Leur belle-fille et petites-filles vivent avec eux, ces dernières quand elles seront grandes espèrent « trouver du travail en ville ».

Marsabit,
Kenya,
24 November 1997

In seiner Eigenschaft als gewähltes Dorfoberhaupt schlichtet Guracha Harsama Meinungsverschiedenheiten innerhalb der Dorfgemeinschaft. Außerdem hält er ein paar Rinder, bestellt ein Stück Land und verkauft einen Teil der Ernte auf dem Markt. Er will, dass seine Kinder eine gute Ausbildung bekommen, und tut sein Bestes, um sie in die Schule zu schicken …

Guracha Harsama has been elected village headman by the inhabitants, and takes care to sort out any disputes that may arise among them. He owns cattle and also cultivates a bit of land, selling off part of the harvest. He really wants his children to attend school, and he's doing his best to make sure they do.

Guracha Harsama, a été élu chef de village par les habitants. A ce titre, il prend soin de résoudre les conflits pouvant survenir entre eux. Il possède du bétail et cultive la terre dont il vend une partie de la récolte. Il tient à ce que ses enfants soient scolarisés et « fait ce qu'il faut pour cela. »

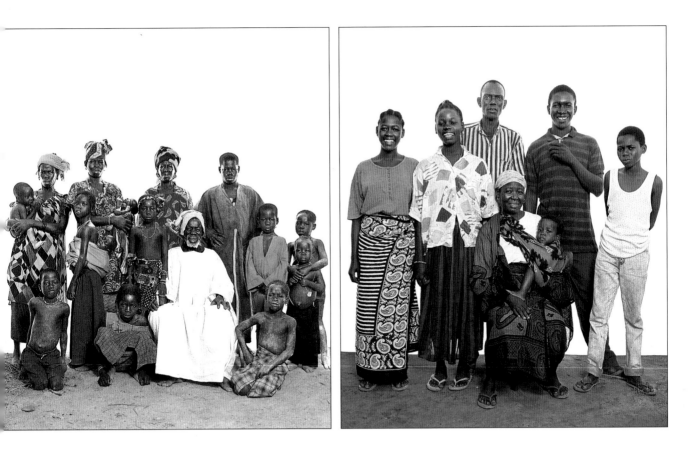

Sirmou,
near Djénné, Mali,
10 April 1997

Mit 72 Jahren arbeitet Fifi noch immer auf seinem Feld. Als Dorfoberhaupt ist es an ihm, für alle Probleme eine Lösung zu finden. Seine Hauptsorge gilt der Landwirtschaft, genauer gesagt, der Dürre und den veralteten Maschinen der Bauern. Er bietet uns an, Paris zur Partnerstadt seines Dorfs zu machen, „um miteinander zu reden und neue Ideen zu entwickeln …" Er kennt die Franzosen gut: „Ich bin losgezogen, um an eurer Seite zu kämpfen, aber ich war kaum bis Dakar gekommen, als es hieß, der Krieg sei zu Ende", erzählt er uns. Fifi lebt zusammen mit seinen beiden Frauen, die er vor 55 beziehungsweise 40 Jahren geheiratet hat.

Fifi is 72 and still working in his fields. As village headman, it is his task to find solutions to every problem. His main concerns have to do with farming and more particularly with drought and inadequate machinery. He suggests twinning Paris with his village "to discuss and find new ideas … " He knows the French well, "I went off to fight the war alongside you, but as soon as I got to Dakar to enlist, they told me the war was over," he tells us. Fifi lives with his two wives, whom he married 55 and 40 years ago respectively.

A 72 ans, Fifi travaille encore dans son champs. En tant que chef de village, il doit trouver des solutions à tous les problèmes. Ses principales préoccupations concernent l'agriculture, plus particulièrement la sécheresse et un matériel inadapté. Il nous propose de jumeler Paris avec son village «pour discuter et trouver des idées nouvelles … » Il connaît bien le français, «je suis parti pour faire la guerre à vos côtés, mais à peine arrivé à Dakar pour m'enrôler, la guerre était finie! » nous dit-il. Fifi vit avec ses deux femmes, épousées respectivement il y a 55 ans et 40 ans.

Bagamoyo,
Tanzania,
7 November 1997

Als Wachmann verdient Johnny gerade genug, um seine kinderreiche Familie über Wasser zu halten. Trotzdem lassen sie sich nicht unterkriegen und sehen optimistisch in die Zukunft: „2000 wird alles besser!"

Johnny is a security guard, but isn't finding it easy to meet all the needs of his large family, even though the family seems happy and optimistic about the future. "By 2000 everything will be better!"

Johnny est gardien de sécurité et gagne tout juste assez pour la survie de sa famille. Cette situation ne le décourage pas, il reste optimiste pour l'avenir: «En l'an 2000 tout ira mieux! » dit-il.

Tabou,
Ivory Coast,
1 June 1997

„Zuerst sollte man für seine Familie da sein, dann für den Rest der Welt."
Jonasse ist Dorfoberhaupt, Plantagenbesitzer, vor allem aber Pastor der
Kirche der Zwölf Apostel [eine protestantische Glaubensgemeinschaft]. Er
hat zu Hause einen Altar errichtet, wo er auch die Gläubigen empfängt. Auf
die Frage, ob für einen Christen vier Frauen nicht zu viel des Guten seien,
antwortet er mit einem Bibelzitat: „Bleib wie du warst, als der Herr dich
gerufen hat." Seine Erklärung: „Ich hatte bereits vier Ehefrauen, als ich kon-
vertierte, und habe sie behalten." Inzwischen haben 24 Kinder das Licht der
Welt erblickt. Jonasse hofft, bis zum Jahr 2000 genug Geld für den Bau
einer Kirche aufgetrieben zu haben.

"First, you must be good to your family, then to the rest of the world."
Jonasse is the village headman and a planter, but most important of all, he's
the priest at the Church of the Twelve Apostles [a branch of Protestantism].
He's set up an altar in his home, where he welcomes the faithful. In answer
to the question "Isn't having four wives a bit excessive for a Christian?" he
quotes the Bible: "Stay as you were when the Lord called you," and adds:
"I had four wives before I converted, and I've kept them." In the meantime
there've been 24 children. Jonasse is hoping to find the money to build his
church by 2000.

« Il faut d'abord être bon avec sa famille, puis avec le reste du monde. »
Jonasse est chef de village, planteur et avant tout, pasteur de l'Eglise des
Douze Apôtres (branche du protestantisme). Il a installé un autel chez lui,
et y reçoit les fidèles. À la question : « Quatre femmes pour un chrétien,
n'était-ce pas excessif ? », il répond en citant la Bible : « Restez tel que vous
étiez quand le Seigneur vous a appelé » et précise : « J'avais 4 épouses
avant de me convertir, je les ai gardées ». Entre-temps, 24 enfants ont vu le
jour ! Jonasse espère trouver les moyens de construire son temple, pour
l'an 2000.

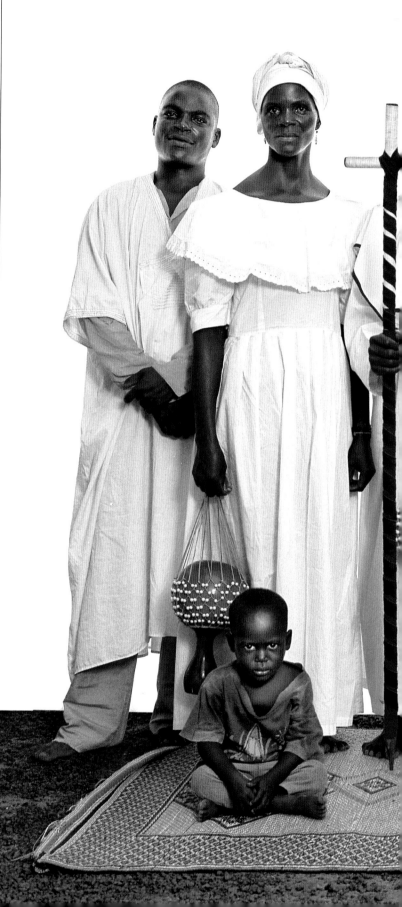

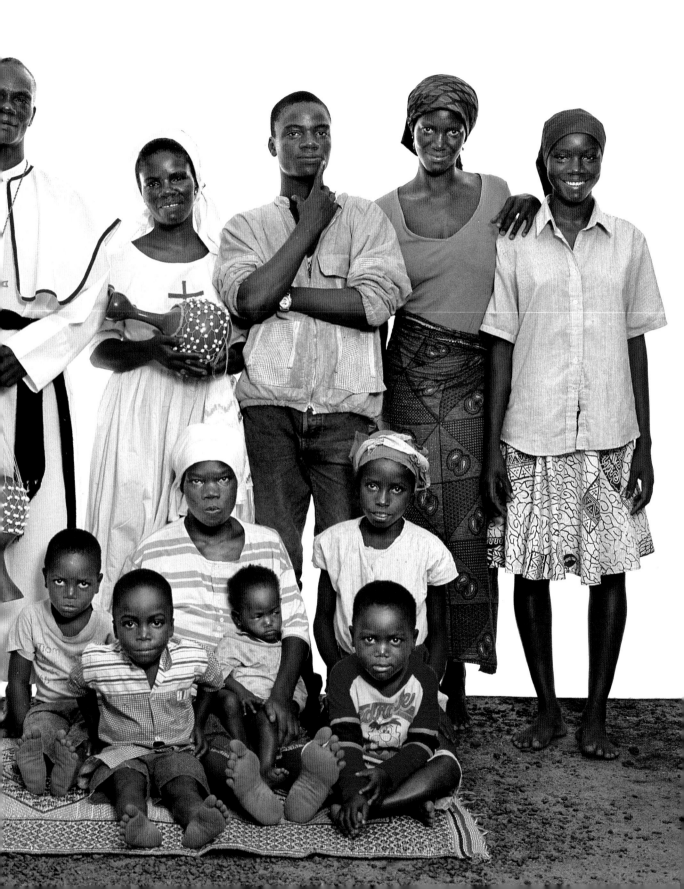

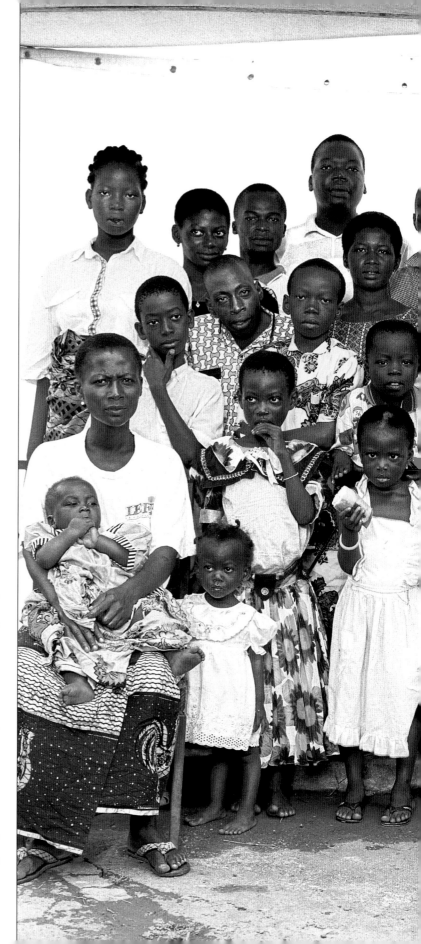

Vier Frauen, 47 Kinder und 65 Hektar Kakao und Kaffee – das ist die Erfolgs-
statistik von Léon, Plantagenbesitzer aus Zarnou. Sein Stolz vermischt sich
ein wenig mit Sorge. Er gibt offen zu, sich von den Ereignissen etwas über-
rannt zu fühlen. „Ich habe Angst, noch mehr Kinder in die Welt zu setzen,
denn meine Kinder bekommen auch schon Kinder und alles bleibt an mir
hängen!" Für das neue Jahrtausend hat er eine Bitte an Präsident Bédié:
„Helfen Sie mir bitte, diese große Familie zu ernähren."

Four wives, 47 children and 160 acres [65 ha] of cocoa and coffee – this is
the tally of Zarnou planter Léon's achievements. His pride is tinged with a
certain anxiety, and he readily confesses to feeling slightly overwhelmed by
things. "I'm afraid of having more children, because my own children are
already having children and it all ends up on my plate." For 2000, he has a
request for President Bédié: "I am asking you to help me to sustain this
large family."

Quatre femmes, 47 enfants et une plantation de cacao et de café de 65 hec-
tares. C'est le palmarès de Léon, planteur à Zarnou. À sa fierté se mêle une
certaine anxiété et il s'avoue volontiers un peu débordé par les événements.
«J'ai peur de faire encore des enfants, mes propres enfants font déjà des
enfants et tout cela tombe sur moi!» Pour l'an 2000, il adresse une requête
au Président Bédié: «Je vous demande de m'aider à faire vivre toute cette
grande famille».

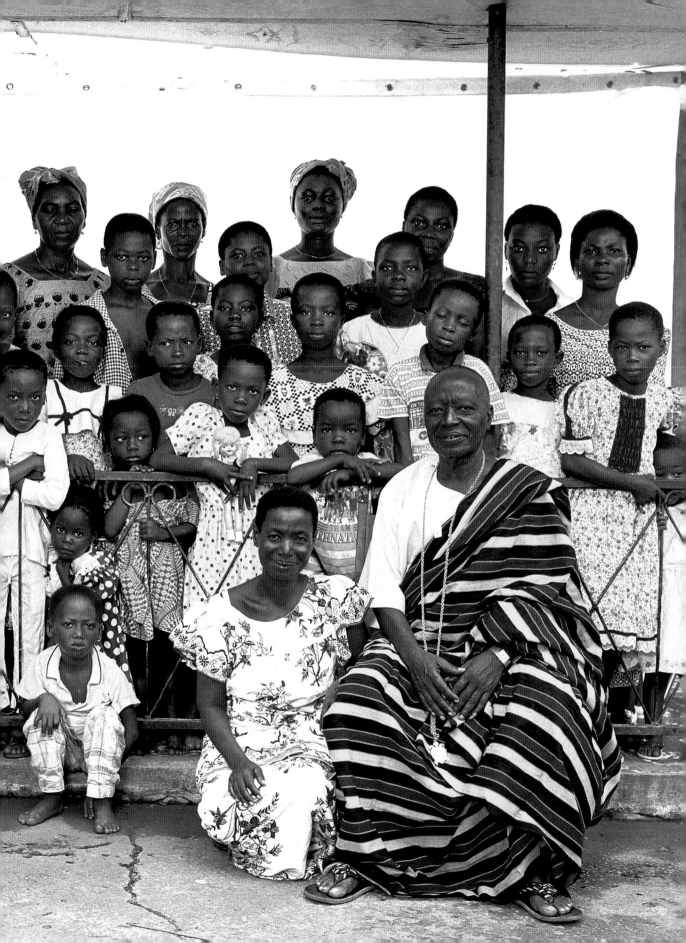

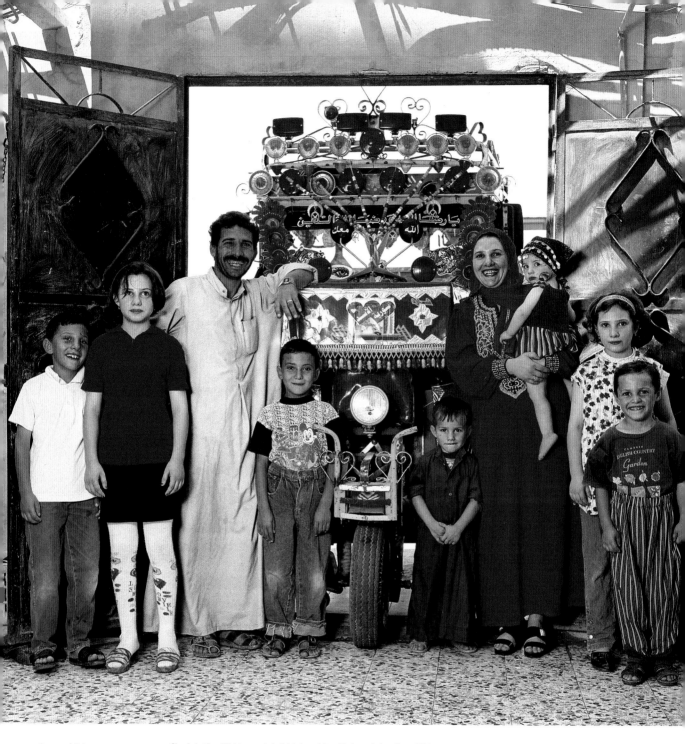

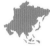

Palmyra,
Syria,
12 August 1999

Sie sind seit zwölf Jahren verheiratet, haben sieben Kinder und eine eigene Wohnung. Hamed und sein Vater betreiben eine Art Spedition. Mit zwei aufwändig hergerichteten Dreirädern transportieren die beiden „alles Mögliche": Waren, Passagiere, Schafe – nacheinander und auch mal mit ein und derselben Fuhre.

They've been married for twelve years, have seven children, a flat, and two three-wheelers which they share with Hamed's father and which he has lavishly decorated. The three-wheelers are used for "all kinds of transport": goods, passengers, sheep – the whole lot, jointly or severally.

Ils sont mariés depuis douze ans ont sept enfants, un appartement et en association avec le père d'Hamed deux tricycles richement décorés. Ils servent au « transports en tous genres », marchandises, passagers, moutons, le tout séparément ou en même temps !

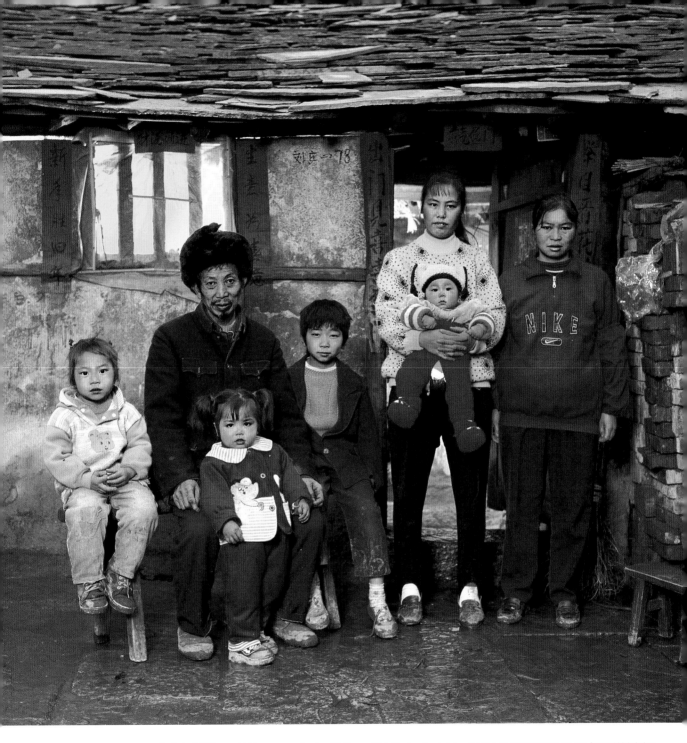

near Guiyang,
China,
3 March 2000

Großvater ist Witwer und lebt zusammen mit seinen Töchtern und Enkelkindern. Er arbeitet noch immer im Kohlebergwerk, wo sein Sohn 1999 bei einer Gasexplosion ums Leben kam. Außerdem baut er Salat, Weißkohl und Karotten an, um die tägliche Kost der Familie etwas zu bereichern.

Grandfather is a widower who lives with his daughters and grandchildren. He still works in a coal mine, where his son was killed in a gas explosion in 1999. He also grows lettuces, white cabbages and carrots to make his family's daily meals a little tastier.

Grand-père est veuf, il vit avec ses filles et petits-enfants. Il travaille toujours dans une mine de charbon où, son fils a été tué dans une explosion de gaz en 1999. Il cultive aussi des salades, choux blancs et carottes pour améliorer un peu l'ordinaire de la famille.

Udaipur,
India,
24 October 1999

Großpapa hat den grünen Daumen: Seit er seinen führenden Posten im Landwirtschaftsministerium Jüngeren überlassen hat, berät er fachkundig und unentgeltlich rund um den Garten. Nachbarn, Vereine und sogar die Stadt informieren sich bei ihm, welche Pflanzen im jeweiligen Garten oder Park am besten gedeihen. Ganz in der Tradition des Jainismus lebt diese naturverbundene Familie mit vier Generationen unter einem Dach. „Pflanzen sind wie Kinder – sie brauchen ständig Zuwendung", weiß der Großvater.

Grandpa has 'green fingers'. He is a retired director of the Ministry of Agriculture who now works as an unpaid consultant in gardening, horticulture and pest control. He advises private individuals, companies and the city council about what plants to use in their gardens and parks. In keeping with the Jain tradition, the family – all of them great nature lovers – live together, four generations side by side. "Plants are like children. You have to look after them all the time," says Grandpa by way of conclusion.

Grand-père a la *main verte*, directeur retraité du ministère de l'agriculture, il est maintenant consultant bénévole en jardinage, horticulture et désinfection (*pest control*). Il conseille les particuliers, les sociétés et la ville sur les plantes a utiliser dans les jardins et parcs. Suivant la tradition du Jaïnisme la famille vit ensemble, quatre générations se côtoient, toutes passionnées de nature et de plantes. « Les plantes c'est comme les enfants, il faut s'en occuper tout le temps » conclut le grand-père.

Pointe-Noire,
Congo,
28 August 1997

Dombo ist im Hotelgewerbe tätig und macht sich große Sorgen um die Zukunft seines Landes. Er hat sieben Kinder und fragt sich, ob es vernünftig ist, noch mehr zu bekommen. Er hätte sehr gern einen Briefpartner in Europa, um sich über „all dies" auszutauschen.

Dombo works in the hotel business and is very worried about the future of his country. He has seven children, and is wondering if it is sensible to have any more. He would really like to find a European correspondent to swap ideas about "all this."

Dombo travaille dans l'hôtellerie et se fait beaucoup de soucis pour l'avenir de son pays. Il a sept enfants et se demande si il est bien raisonnable d'en avoir davantage. Il aimerait trouver un correspondant Européen pour échanger des idées sur « tout ça ».

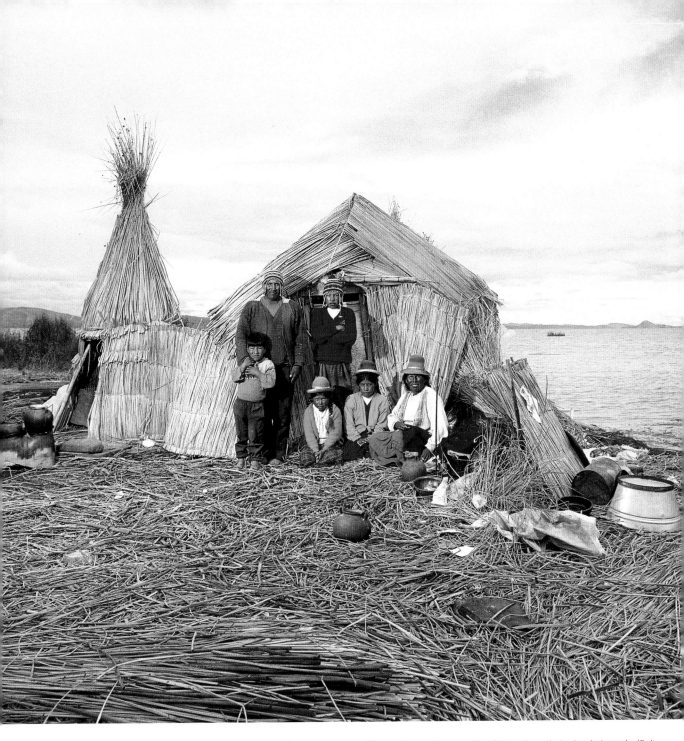

Lake Titicaca,
Peru,
29 January 1999

Félix ist Fischer und verkauft einen Teil seines Fangs auf dem Markt von Puno. „Ich konnte nicht zur Schule gehen und wünsche mir, dass meine Kinder studieren können." Seine Familie lebt auf einer schwimmenden Insel, die genau wie ihr Haus und ihr Boot aus dem Schilf ist, das am Seeufer wächst.

Félix is a fisherman and sells part of his catch at Puno market. "I didn't have the money to go to school, but I'd like my children to be able to study," he says wistfully. He and his family live on a floating island which, like their hut and his boat, is made of reeds growing around the lake.

Felix est pêcheur et vend une partie de son butin au marché de Puno. « Je n'ai pas eu les moyens d'aller à l'école et j'aimerais que mes enfants puissent étudier », espère-t-il. Sa famille vit sur une île flottante qui, comme la case et le bateau, est constituée des roseaux qui poussent autour du lac.

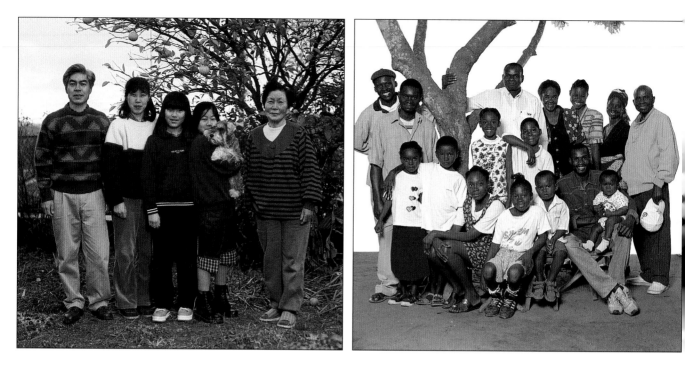

Otsu,
Japan,
27 February 2000

Jun ist Feuerwehrmann und Miho Klavierlehrerin. Ihre Hobbys? „Meine Hobbys sind Einkaufen, Küche und Haushalt", antwortet Miho lachend, „und mein Mann geht angeln und fängt winzige Fischlein, die gerade für ein Sashimi reichen!" Ihre elfjährigen Zwillinge weichen „Lucky", der Großmutter, nicht von der Seite. Sie war gerade bei der Gartenarbeit und hat die Gartenschere erst gar nicht aus der Hand gelegt, sondern versteckt sie hinter ihrem Rücken.

Jun is a fireman and Miho teaches piano. Their hobbies? "For me, shopping, cooking and housekeeping," replies Miho with a laugh, "and my husband goes fishing and comes back with tiny fish which are barely big enough for a sashimi." Their eleven-year-old twins are inseparable from 'Lucky', their grandmother. She was in the middle of gardening and didn't even put down her secateurs, which she kept hidden behind her back.

Jun est pompier et Miho professeur de piano. « Nos hobbys ? Moi c'est le shopping, la cuisine et le ménage ! » répond Miho en riant « et mon mari va à la pêche et attrape de tous petits poissons, tout juste bon pour un sashimi ! » Leurs jumelles (11 ans) sont inséparables de « Lucky » leur chien. La grand-mère, en plein jardinage, n'a même pas posé son sécateur qu'elle tient caché derrière son dos.

Pointe-Noire,
Congo,
28 August 1997

Nachdem er in Gabun in der Direktion eines Reisebüros gearbeitet hat, ist Jean-Philippe in sein Heimatland zurückgekehrt, wo er heute ein Hotel leitet. Er träumt von einem Afrika, das „in die europäischen Fußstapfen tritt und seinem Volk das Existenzminimum ermöglicht, um anständig leben zu können. Aber Afrika hat nicht den Willen, sich zu verbessern, und die Art und Weise, wie uns manche Länder helfen, ist nicht immer die richtige. Wir müssen diese Hilfe mit den vorhandenen afrikanischen Ressourcen kombinieren."

After working in Gabon managing a travel agency, Jean-Philippe returned to his own country, where he runs a hotel. He dreams of an Africa which "follows in Europe's footsteps and gives its people the minimum they need to live for a decent life. But Africa doesn't have the will to improve, and the way some countries help us isn't always the right way – we must combine that help with African skills."

Après avoir travaillé au Gabon à la direction d'une agence de voyage, Jean-Philippe est revenu au pays où il administre un hôtel. Il rêve d'une Afrique qui « suive les traces de l'Europe et donne le minimum vital à son peuple, pour une vie décente. Mais l'Afrique n'a pas la volonté de s'améliorer et la façon dont nous aident certains pays n'est pas toujours la bonne, il faut y associer les compétences Africaines ! »

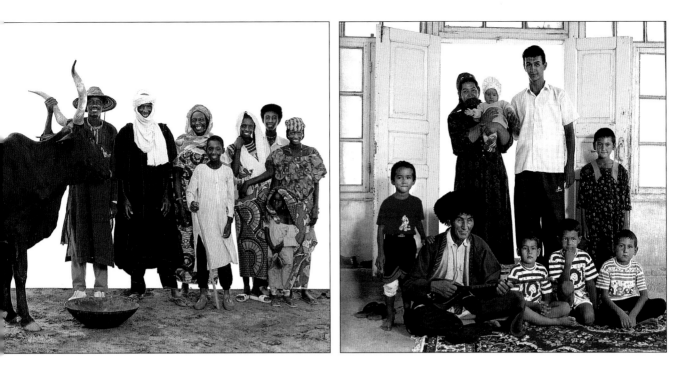

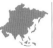

Besseta,
Niger,
20 July 1997

Die Schäfer vom Volk der Fulbe sind immer unterwegs und schlafen unter freiem Himmel, entweder auf behelfsmäßigen Betten oder ganz einfach auf dem Boden. Ihre „roten Kühe" [Zebus] sind sehr imposant, aber harmlos; sie liefern die nötige Milch für die tägliche Mahlzeit: eine Suppe aus Hirse und Milch. Ihr Wunsch: „Das Foto sofort zu bekommen!"

Fulani herdsmen are forever on the move, sleeping under the stars on rudimentary 'beds' or simply on the ground. Their 'red cows' [zebus] seem very imposing, but they are in fact harmless; they provide the milk that's needed to make the daily dish: a soup that's a mixture of millet and milk. The herdsmen's wish? "To have their photo right away."

Les bergers peuls se déplacent sans cesse et dorment à ciel ouvert sur des couchages rudimentaires ou tout simplement par terre. Leurs « vaches rouges » (zébus) sont très impressionnantes mais inoffensives, elles leur fournissent le lait nécessaire à la préparation du plat quotidien : mil et lait mélangés en soupe. Leur souhait est de « recevoir notre photo tout de suite ! ».

Mir Daihan,
Turkmenistan,
16 September 1999

Muhammet, von Beruf Lehrer wie sein Vater, der eine Musikschule leitet, ist glücklicher Besitzer einer Videokamera, mit der er sämtliche Hochzeiten und Familienfeste der Umgebung verewigt. Der stolze Vater von zwei Söhnen und einem vier Monate alten Töchterchen wünscht sich ein zweites Mädchen – damit „das Gleichgewicht der Geschlechter wieder stimmt."

Muhammet is a teacher like his father, who runs the music school, but also the happy owner of a video camera. He films all the local weddings and family gatherings. As the proud father of two boys and a four-month-old daughter, he would like another daughter to "balance the sexes."

Enseignant, comme son père qui est directeur de l'école de musique, Muhammet est aussi vidéo-amateur. Il réalise toutes les vidéos des mariages et fêtes familiales des alentours. Heureux père de deux garçons et d'un petite fille de quatre mois, il aimerait une autre fille pour « l'équilibre des sexes ».

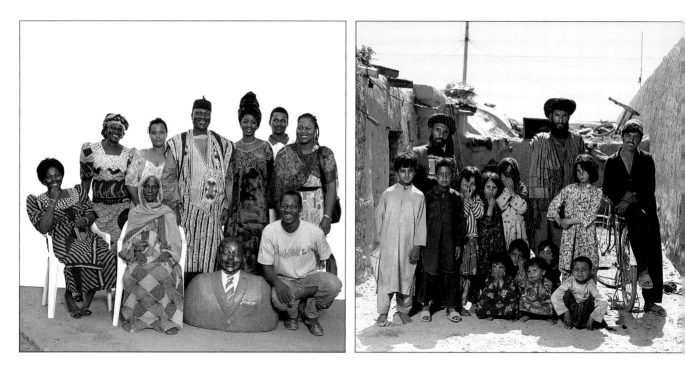

Korhogo,
Ivory Coast,
12 May 1997

Der Vorsitzende der ivorischen Transportarbeitergewerkschaft ist ein Nachkomme der Gründer und Könige von Korhogo. Stolz stellt er uns seine Verlobte und seine Kinder vor. Er bestand darauf, dass die Büste seines Freunds und Idols Henri Kohan Bédié, des Staatspräsidenten, mit aufs Familienfoto kommt.

Heir to the founders and kings of Korhogo, the chairman of the Ivory Coast Transporters' Union proudly introduces us to his fiancée and children. He insists that the bust of his friend and idol, president Henri Kohan Bédié, be included in the family portrait.

Héritier des fondateurs et rois de Korhogo, le Président du Syndicat des Transporteurs de Côte d'Ivoire nous présente avec fierté sa fiancée et ses enfants. Il insiste pour que le buste de son ami et idole, H. K. Bédié, fasse partie du portrait de famille.

Quetta,
Pakistan,
3 October 1999

Fazil Mahmed lebt mit Frau (die wir leider nicht zu Gesicht bekamen), Kindern, Onkel und Bruder in einem Vorort von Quetta. Die Flüchtlingsfamilie hofft auf baldigen Frieden in Afghanistan, damit sie wieder in ihre Heimat zurückkehren kann.

Fazil Mahmed lives with his wife (who stayed out of sight), his children, his uncle and his brother in a suburb of Quetta. They are Afghan refugees. His hope is that peace will be restored in Afghanistan, so that he can go back there with his family.

Réfugiés Afghans, Fazil Mahmed vit avec ses enfants (les femmes restent invisibles), son oncle et son frère dans une banlieue de Quetta. Son espoir est que la paix revienne un jour en Afghanistan pour qu'il puisse y retourner.

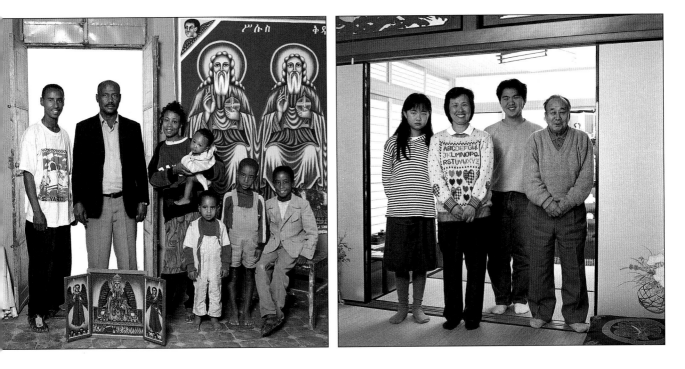

Aksum,
Ethiopia,
16 December 1997

Fssha ist der jahrhundertealten Familientradition treu geblieben: Er malt Bilder mit religiösen und historischen Motiven. Einer seiner Söhne und seine Tochter – vermutlich die einzige Malerin in ganz Äthiopien – helfen ihm bereits, die riesigen Ikonen und Bilder, die die zahlreichen Kirchen und Klöster von Aksum in Auftrag geben, fertig zu stellen. Allerdings sind sie immer noch auf der Suche nach einer Farbe, die dem Klima standhält. Ihr gemeinsamer Traum: eine Ausstellung in Europa!

Fssha, remaining faithful to a family tradition going back several generations, paints religious and historical subjects. Two of his children – including his daughter, who is probably the only woman painter in the whole of Ethiopia – already help him to make huge icons and pictures commissioned by churches and monasteries, which are plentiful in this ancient Ethiopian capital and religious centre. The family's major problem is finding paint that will stand up to the climate. Their shared dream is to exhibit in Europe!

Fssha est resté fidèle à la tradition familiale depuis plusieurs générations : la peinture religieuse et historique. Deux de ses enfants, dont sa fille – qui est probablement la seule femme peintre de toute l'Ethiopie – l'aident déjà à la réalisation des icônes et tableaux géants commandés par les églises et monastères, très nombreux dans cette ancienne capitale et centre religieux d'Ethiopie. Leur gros problème est de trouver de la peinture résistant au climat. Ils rêvent d'exposer en Europe !

Kyoto,
Japan,
24 February 2000

Die elfjährige Eri hasst Familienfotos, sie spielt lieber Klavier oder macht Schulaufgaben. Ihr großer Bruder arbeitet in einer traditionellen Töpferwerkstatt und seine Eltern brennen darauf, nach Europa zu fahren. Na dann, bis bald!

Young Eri, who's eleven, hates family photos, preferring the piano and studying. Her elder brother works in a traditional pottery studio, while his parents are eager to visit Europe. See you soon!

La jeune Eri (11ans) déteste les photos de famille, elle préfère le piano et les études ! Son grand frère travaille dans un atelier de poterie traditionnelle et ses parents sont impatients de visiter l'Europe ! A bientôt !

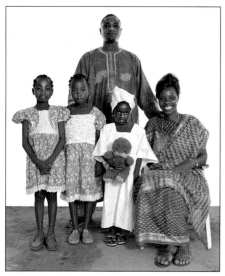

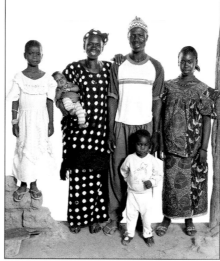

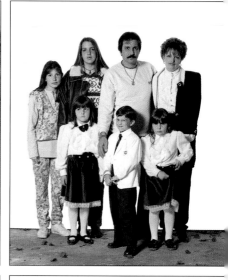

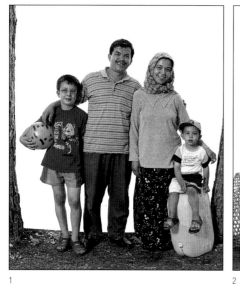

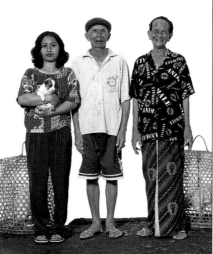

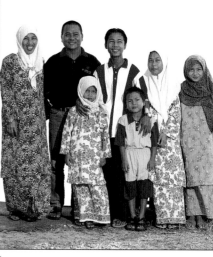

1

7

2

8

3

9

1
Soubré,
Ivory Coast,
1 June 1997

2
Botou,
Senegal,
18 April 1997

3
Galaxidi,
Greece,
19 December 1996

4
Sakhalin Island,
Russia,
31 August 1999

7
Denizli,
Turkey,
1 August 1999

8
Bali,
Indonesia,
14 December 1999

9
Beserah,
Malaysia,
5 January 2000

10
Keren,
Eritrea,
19 December 1997

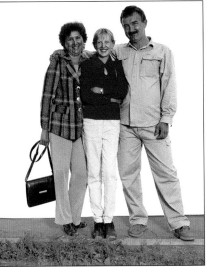

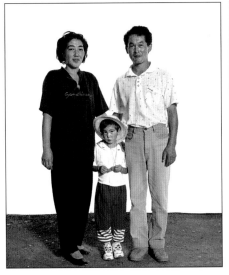

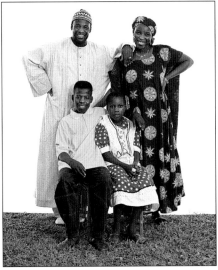

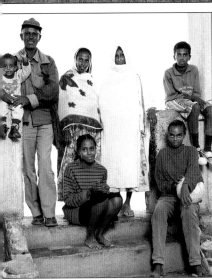

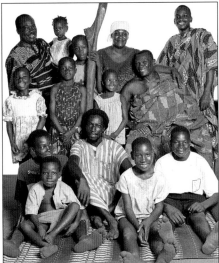

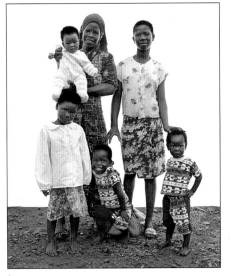

0

5
11

6
12

5
Bishkek,
Kyrgyzstan,
7 September 1999

6
Abidjan,
Ivory Coast,
30 March 1997

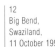
11
Tiegba,
Ivory Coast,
11 March 1997

12
Big Bend,
Swaziland,
11 October 1997

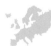

Boulogne,
France,
5 March 1998

Jean-Pascal, Verleger von medizinischen Fachzeitschriften, ist trotz seiner Vorliebe für ferne Länder, Abenteuer und Motocross ein echter Familienmensch: „Zu Hause tanke ich auf, auch wenn nicht immer alles eitel Sonnenschein ist", erklärt er. Valérie hat ihre Karriere als Immobilienmaklerin an den Nagel gehängt, um die gemeinsamen Kinder aufzuziehen. Die beiden ‚Großen' Alexandre und Nicolas besuchen noch das Gymnasium und ziehen sich nach dem letzten Schrei an.

An editor of medical journals and a keen traveller, lover of adventure and trail bike enthusiast, Jean-Pascal is also a devoted dad. "My family is a great source of hope and happiness as well as my biggest worry!" he says. Valérie has given up her property business job to look after the children full-time. Alexandre and Nicolas are still at secondary school and keep up with the latest fashions.

Editeur de revues médicales et grand amateur de voyages, d'aventures et de motos « tout terrain », Jean-Pascal est aussi un père de famille attentif : « La famille est ma plus grande source d'espoir, de bonheur et d'inquiétude » dit-il. Valérie a quitté son travail dans l'immobilier pour se consacrer aux enfants. Les deux « grands » Alexandre et Nicolas sont encore au lycée et suivent la mode de très près.

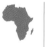

Ouahigouya,
Burkina Faso,
13 April 1997

Sehou geht am Stock und weigert sich partout, sich von irgendjemandem helfen zu lassen. Sein Blick zeugt von einem lebhaften Geist. Sein Sohn Sekou dolmetscht für uns. „Mein Großvater ist 120 Jahre [!] alt. Während des Zweiten Weltkriegs hat er die Rekrutierung von Freiwilligen organisiert – 30 Männer hat er in den Krieg geschickt", erzählt er uns stolz. Seine Söhne sorgen für den Unterhalt der Familie, Sekou ist Schuhputzer. Das Haus, das der „Alte" gebaut hat, wird dem Sohn gehören, der als Erster das Dach bezahlen kann. Sekou hofft, dass er derjenige sein wird, aber bis es so weit ist, spart er erst einmal auf eine Matratze.

Sehou walks with a stick and refuses to be helped by anyone. His eyes reveal the liveliness of his mind. His son Sekou acts as our interpreter. "My grandfather is 120 years [!] old. It was his job to recruit volunteers in the Second World War – he managed to get 30," he tells us proudly. His sons work to feed the family, and Sekou shines shoes. The 'old man' has built a house which will belong to the first of his sons to put a roof on it. Sekou hopes he will be the one, but meanwhile he is saving to buy his mattress.

Sehou marche avec une canne et refuse l'aide de quiconque. Son regard dénote la vivacité de son esprit. C'est son fils Sekou, qui fait l'interprète pour nous. « Mon grand-père a cent vingt ans ! C'est lui qui s'est occupé du recrutement des volontaires pendant la Seconde Guerre mondiale : il a réussi à en faire partir trente », nous précise-t-il avec fierté. Depuis, il s'occupe de la maison des anciens combattants à Ouahigouya. Ce sont ses fils qui travaillent pour faire vivre la famille, Sekou est cireur de chaussures. Le « vieux » a construit une maison, elle appartiendra au premier de ses fils qui pourra y faire mettre un toit, Sekou espère être celui-là, mais en attendant il économise pour s'acheter son matelas.

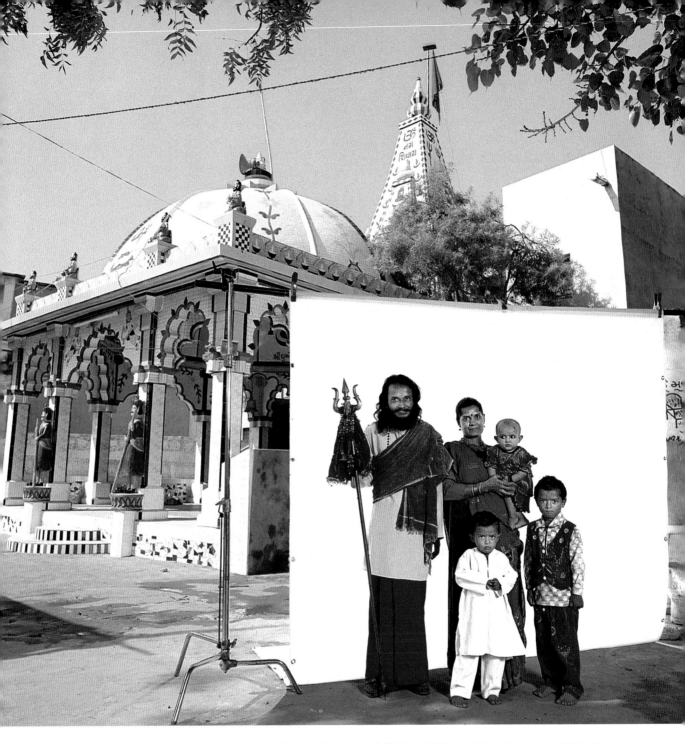

Diu,
India,
21 October 1999

Ramesh steht im Dienste der Götter: Eine seiner Aufgaben ist es, die Gläubigen mit Hilfe einer elektrischen Trommel zu den täglichen Gebeten in den Tempel zu rufen. Er lebt mit seiner Familie im Tempelbereich.

Ramesh has chosen a life of prayer. He works at the village temple, and at set times every day he summons the faithful to prayers with the help of an electric drum. He lives with his family in the temple compound.

Ramesh a choisi une vie de prière; attaché au temple du village et assisté d'un tambour électrique, il appelle les fidèles à heures fixes pour les prières quotidiennes. Il vit avec sa famille dans l'enceinte même du temple.

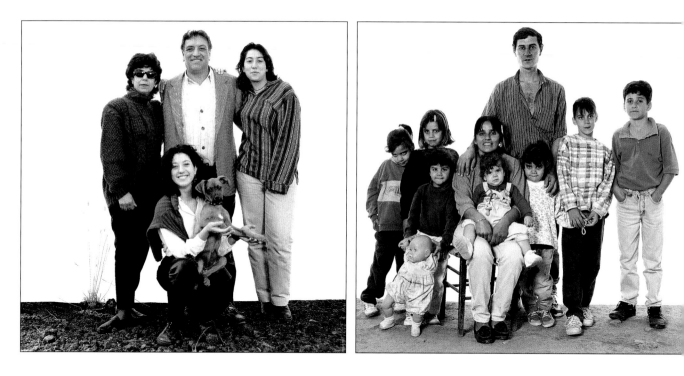

Rein zufällig stand genau hier, wo wir Camillo und seine Familie fotografieren wollten, einmal das alte Haus der Familie, bevor es 1971 beim Ausbruch des Ätna unter einer 15 Meter dicken Lavaschicht begraben wurde. Dieses Ereignis hat die ganze Familie ziemlich mitgenommen, und es verging einige Zeit, bis sich die Lage wieder entspannt hatte … Camillo ist für die technische Wartung des Universitätsgebäudes zuständig, seine Frau Dina führt den Haushalt und zaubert täglich kleine und große sizilianische Leckereien auf den Tisch, die wir ausgiebig gekostet haben.

The spot we chose quite by chance to photograph Camillo and his family, a few miles from their home, turned out to be the place where their house was buried under 50 feet [15 m] of lava when Mount Etna erupted in 1971. This coincidence took the whole family quite aback, and it took us a while to re-establish a relaxed atmosphere … Camillo is in charge of maintenance at the university. Housewife Dina is always busy preparing little Sicilian-style dishes, which we highly appreciated.

Le lieu que nous avons choisi par hasard pour photographier Camillo et sa famille, à quelques kilomètres de chez eux, se trouve être celui où leur maison a été ensevelie sous quinze mètres de lave lors de l'éruption de l'Etna en 1971. Cette coïncidence causa un choc à toute la famille et il nous a fallu un peu de temps pour recréer une ambiance décontractée … Camillo est responsable de la maintenance à l'université. Dina, femme au foyer, est très occupée à mijoter de petits plats dans la tradition sicilienne que nous avons pu goûter avec beaucoup de plaisir.

25 Stühle pro Tag, sechs Tage die Woche, das ist das Pensum von Carlos und Mirta, die Sitze für Stühle und Hocker im Auftrag einer Möbelfabrik in der Gegend flechten.

Twenty-five chairs a day, six days a week is the output of Carlos and Mirta, who weave rush seats and stools for a local furniture manufacturer.

Vingt-cinq chaises par jour, six jours sur sept, c'est la cadence de Carlos et Mirta, rempailleurs de chaises et de tabourets pour un fabricant de meubles de la région.

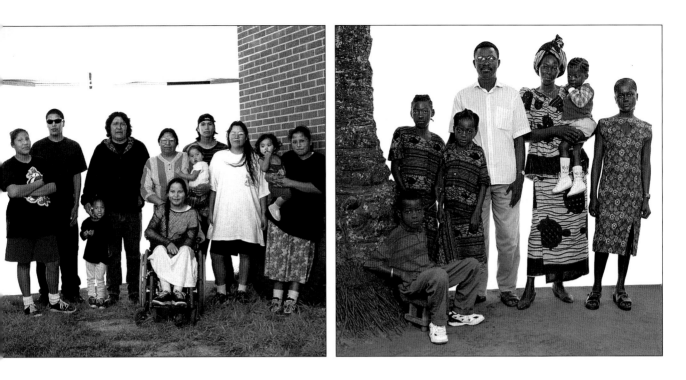

Interior,
South Dakota, USA,
22 October 1998

„Das Jahr 2000 bedeutet mir nicht mehr als jedes andere Jahr. Ich bin hier geboren und in all den Jahren hat sich das Leben für unser Volk nicht spürbar verbessert, es ist noch immer sehr beschwerlich. Daher gelten meine Träume und Wünsche für die Zukunft natürlich meinen Kindern und den indianischen Völkern."

"2000 doesn't mean any more than any other year. I was born here, and for all these years I haven't seen much improvement in the way our people live; it's still just as hard. So obviously, for the future, my dreams and wishes go to my children and the Indian people."

« L'an 2000 ne représente rien de plus que n'importe quelle autre année. Je suis né ici et durant toutes ces années, je n'ai pas vu la vie de notre peuple s'améliorer sensiblement, elle est toujours aussi difficile. Alors évidemment, pour le futur mes rêves et mes souhaits vont à mes enfants et au peuple indien. »

Pointe-Noire,
Congo,
28 August 1997

Aimé erhofft sich viele Dinge für die Zukunft seines Landes: „dauerhaften Frieden, weniger Armut und eine Senkung der Geburtenrate". Er bewundert Bernard Kouchner (Gründer von Médécins sans frontières), dessen Ideen er im Kongo gern vorantreiben würde.

Aimé has a whole lot of hopes for the future of his country: "lasting peace, less poverty, fewer births." He confesses to being an admirer of Bernard Kouchner (founder of Médécins sans frontières), whose ideas he would like to get across in Congo.

Aimé espère beaucoup de choses pour l'avenir de son pays, « une paix durable, un frein à la misère, une diminution de la natalité ». Il voue une grande admiration à Bernard Kouchner, dont il voudrait promouvoir les idées au Congo.

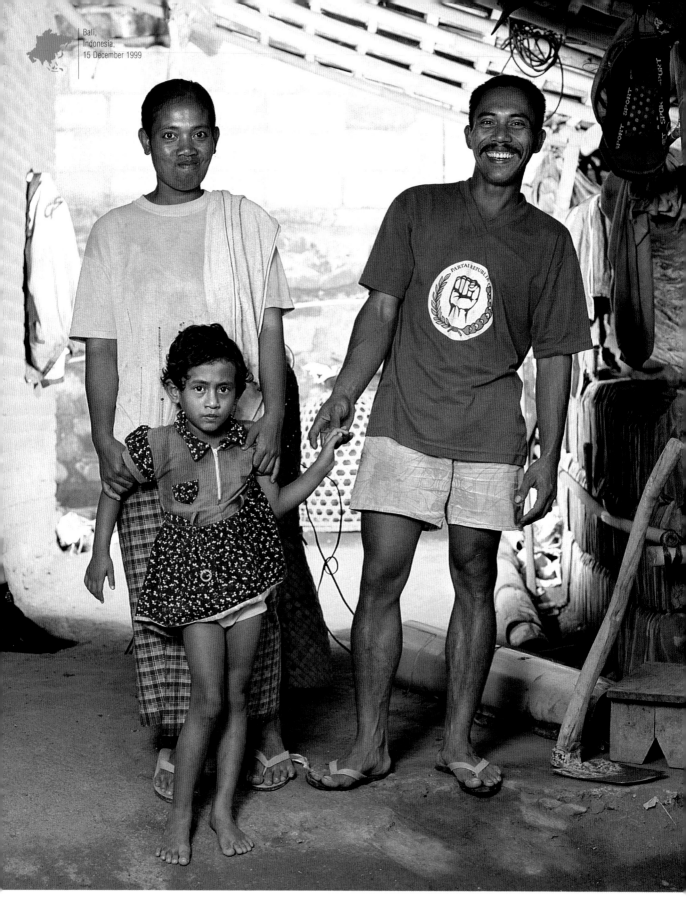

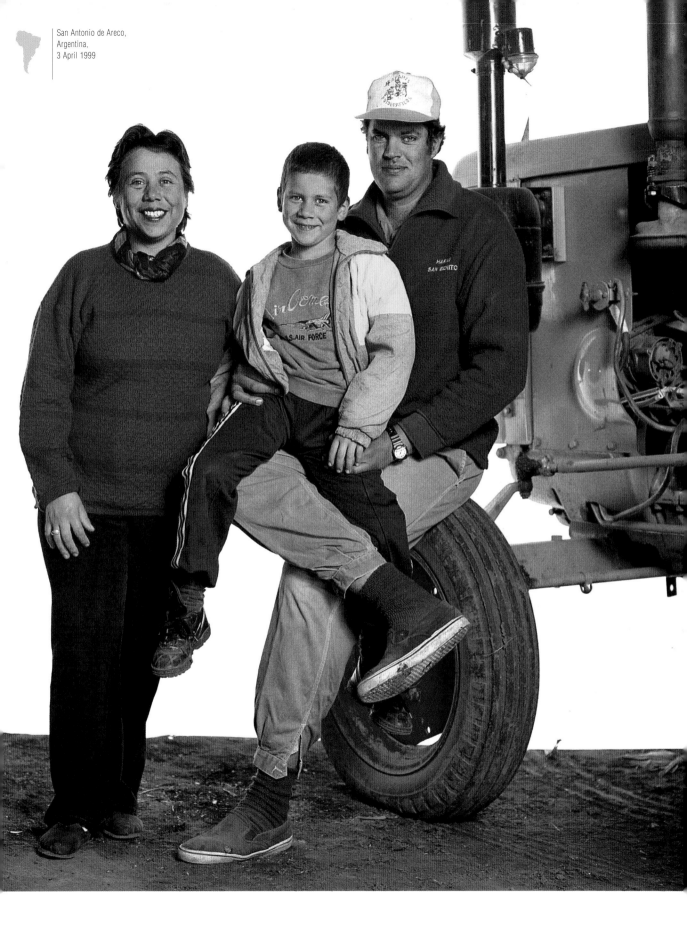

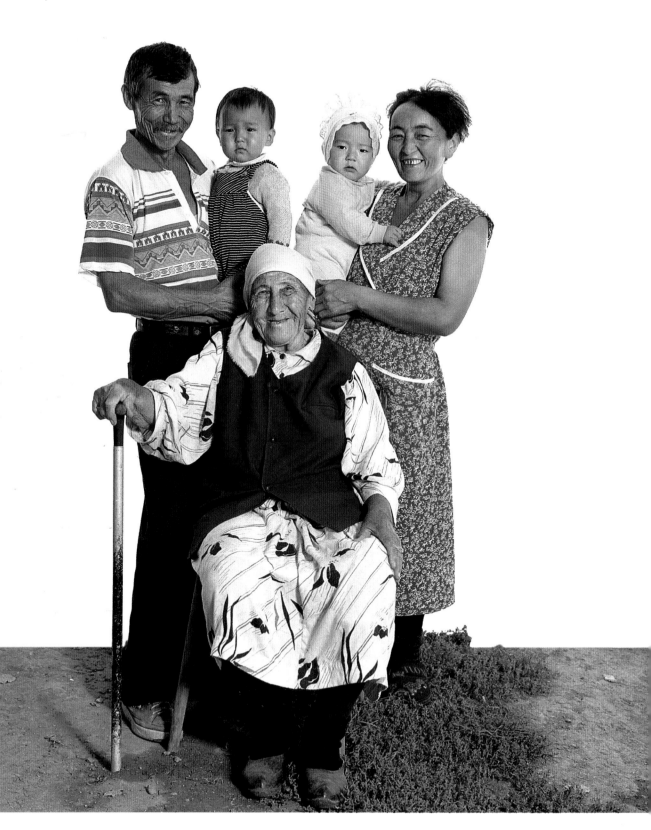

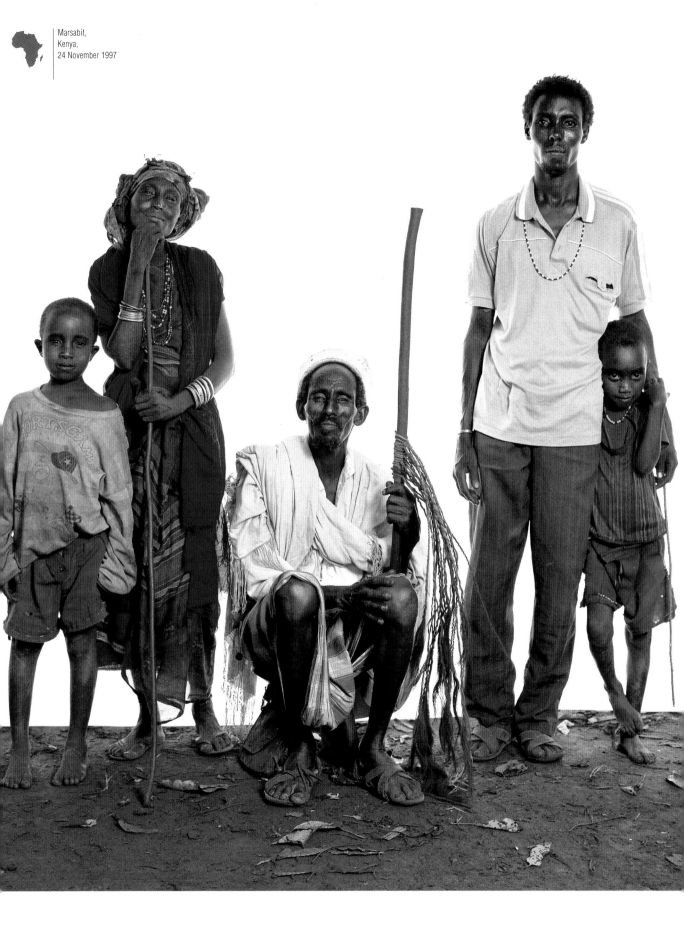

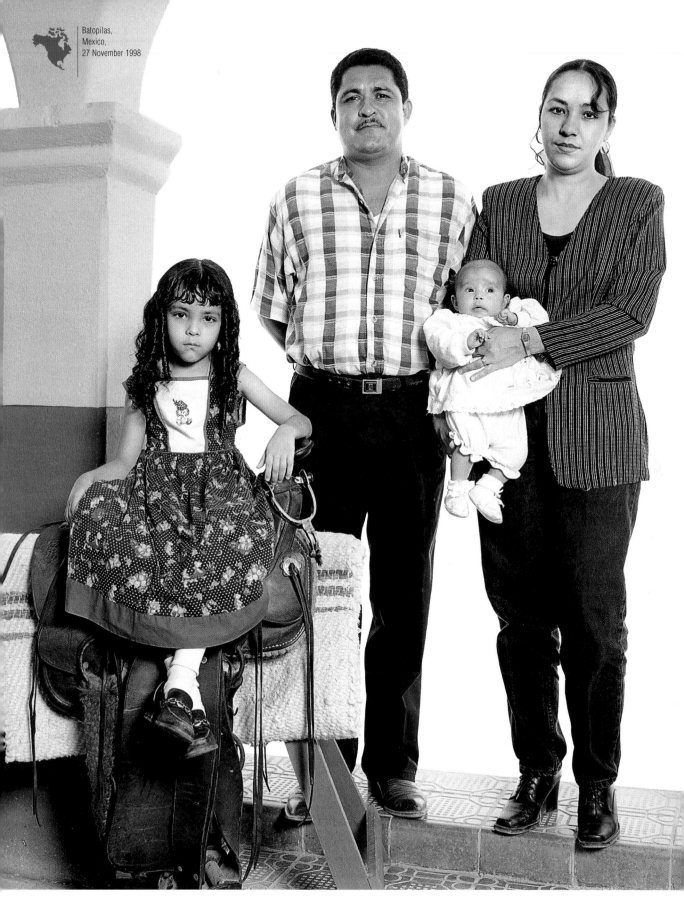

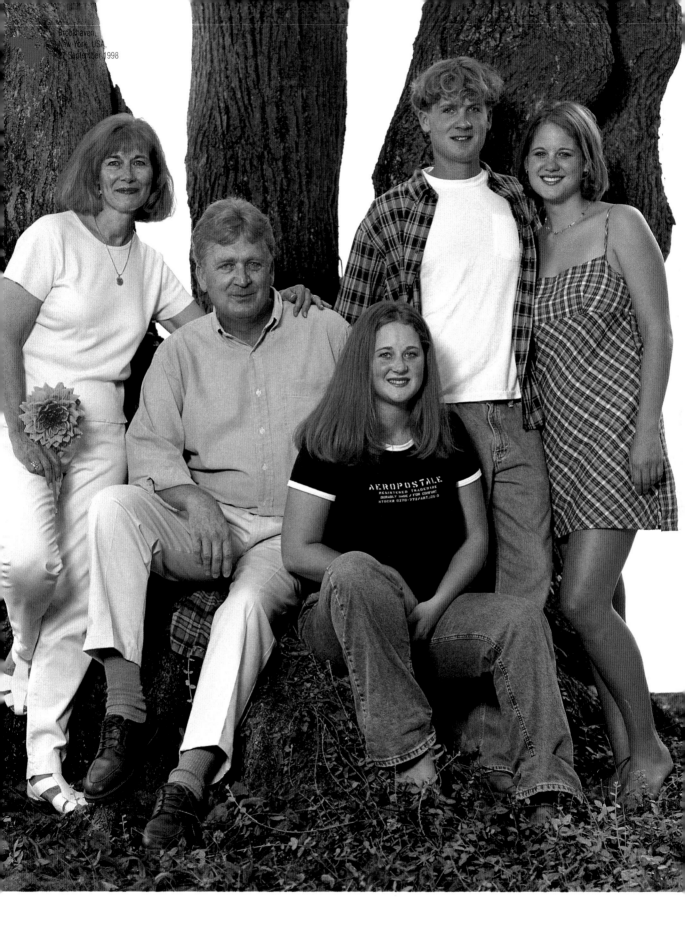

Der Tagelöhner Made Sudi besitzt neben seinem Gemüsegarten und einigen Bananenstauden auch ein Schwein und mehrere Hähne, die für die Beerdigungsfeier seiner beiden verstorbenen Kinder vorgesehen sind.

Made Sudi is a day labourer, but also owns a vegetable garden and a few banana trees. In addition he has a pig and several cocks, intended for the funeral ceremony of his two deceased children.

Journalier, propriétaire d'un potager et de quelques bananiers, Made Sudi possède également un cochon et des coqs destinés à la cérémonie funéraire de ses deux enfants décédés.

Projekte haben sie viele: ein Haus, ein Schwesterchen für Nicolas, einen eigenen Bauernhof und nach Australien auswandern … Bis dahin ist Marcelo auf einer riesigen Farm angestellt und Silvina leitet das Fremdenverkehrsamt von San Antonio.

They've got plans galore – to build their own home, produce a little sister for Nicolas, have their own farm and emigrate to Australia. In the meantime, Marcelo works on a huge farm and Silvina runs the San Antonio tourist office.

Des projets, ils en ont plein : construire leur maison, faire une petite sœur pour Nicolas, avoir leur propre ferme, émigrer en Australie … En attendant, Marcelo est employé dans une ferme gigantesque et Silvina dirige l'office du tourisme de San Antonio.

Bachytjan fährt „alles, was Räder hat". In der übrigen Zeit bestellt er seinen Gemüsegarten und versorgt seine Kuh und die beiden Schafe. Seine Frau und die Großmutter spinnen Wolle und stricken daraus dicke Socken für die ganze Familie, denn der Winter ist nicht mehr weit!

Bakhytjan "drives anything that moves," but he also tends to his kitchen garden, his cow and two sheep. His wife and the grandmother will spin the wool and then knit socks for the whole family. Winter is on its way!

Bakhytjan est « chauffeur de tout ce qui roule » mais il s'occupe également de son potager, de sa vache, de deux moutons qu'il vient de tondre et dont sa femme et la grand-mère vont filer la laine, puis tricoter des chaussettes pour toute la famille. L'hiver approche !

Der 65-jährige Guyo hat im Ältestenrat des Dorfes eine gewichtige Stimme. Ansonsten besitzt er „ein bisschen Vieh und ein Gemüsegärtchen". Das wichtigste für ihn? „Frieden, Liebe und Zusammenhalt." Nach kurzem Überlegen fügt er hinzu: „Solange wir genug zu essen haben, ist das Leben einfach schön!"

Sixty-five-year-old Guyo is an important member of the village council of elders. He says he has "just a few head of cattle and a tiny little vegetable garden." The most important thing? "Peace, love and unity," and after a moment's thought: "As long as we've got enough to eat, life's fine."

Guyo, soixante-cinq ans, est un membre important du conseil des « anciens » du village. Il dit avoir « un tout petit peu de bétail » et « un tout petit potager » « Le plus important ? La paix, l'amour, et l'unité » et après une courte réflexion : « Tant que nous avons à manger la vie est belle ! »

Sie unterrichten beide an der örtlichen Schule und sind glückliche Besitzer eines charmanten Hotels, das sie drei Jahre lang renoviert haben. „Die Familie ist das A und O, sie gibt dem Leben einen Sinn."

They teach at the local school, and are the happy owners of a charming hotel, which they've been restoring for three years. "The family is what matters – it's what gives a meaning to life."

Ils sont enseignants à l'école locale, et heureux propriétaires d'un hôtel charmant, qu'ils ont restauré durant trois ans. « La famille, c'est l'essentiel, elle donne un sens à la vie. »

„Wir werden zur ersten Ausstellung der *1000 Families* nach Europa kommen, und wenn ich deswegen meinen Job verliere", beteuert Mary, Lehrerin, Mutter und Ehefrau – „nicht unbedingt in dieser Reihenfolge". Steve begann seine berufliche Laufbahn als Sozialarbeiter, wechselte aber schon bald in einen Handwerksberuf. Heute ist er Zimmermann: „Menschen lassen sich nur schwer verändern. Aber mit meinen Händen kann ich in kürzester Zeit einen Stapel Bretter in ein Haus verwandeln. Das ist etwas Konkretes!" Für Chris, Kathy und Sarah sind ihre Eltern „the best!"

"We'll come to the first exhibition of the *1000 Families* in Europe, even if I have to give up my job," says Mary, schoolteacher, mother and wife ("not necessarily in that order"). Steve, who started out his professional life as a social worker, quickly switched to manual work. Today he is a carpenter: "People are too hard to change. At least with my own hands, I can turn a pile of planks into a house in just a few days. That's something real." For the time being, Chris, Kathy and Sarah think their parents are "the best!"

« Nous viendrons à la première exposition des 1000 familles en Europe, même si je dois perdre mon emploi », affirme Mary institutrice, mère et épouse, « pas forcément dans cet ordre » Steve, qui a commencé sa vie professionnelle en tant qu'assistant social, s'est vite reconverti dans le travail manuel. Il est aujourd'hui menuisier : « Les gens sont trop difficiles à bouger. Au moins, avec mes mains, je peux transformer en quelques jours une pile de planches en maison ! Ça, c'est concret ! » Steve et Mary espèrent pouvoir voyager un peu plus, une fois que les enfants auront quitté le nid. Pour l'instant, Chris, Kathy et Sarah pensent que leurs parents sont « *the best!* » « Soyez moins égoïstes et donnez plus aux autres », conclut Steve.

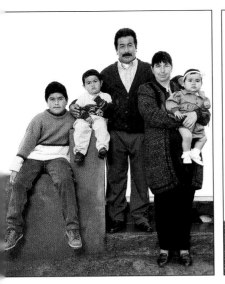 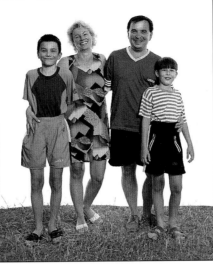 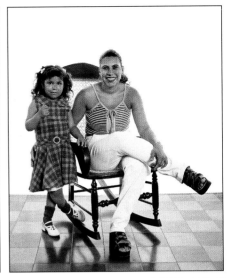

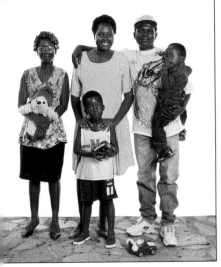 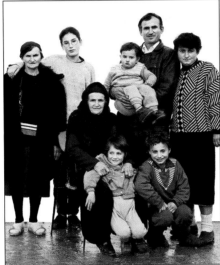 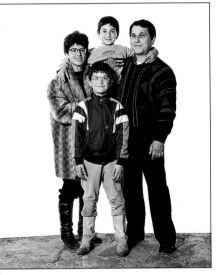

2
5

3
6

1
Silvia,
Cauca, Colombia,
17 February 1999

2
Zakopane,
Poland,
25 July 1998

3
Granada,
Nicaragua,
16 December 1998

4
Kariba,
Zimbabwe,
26 October 1997

 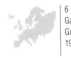
5
Lepenic,
Albania,
17 December 1996

6
Galaxidi,
Greece,
19 December 1996

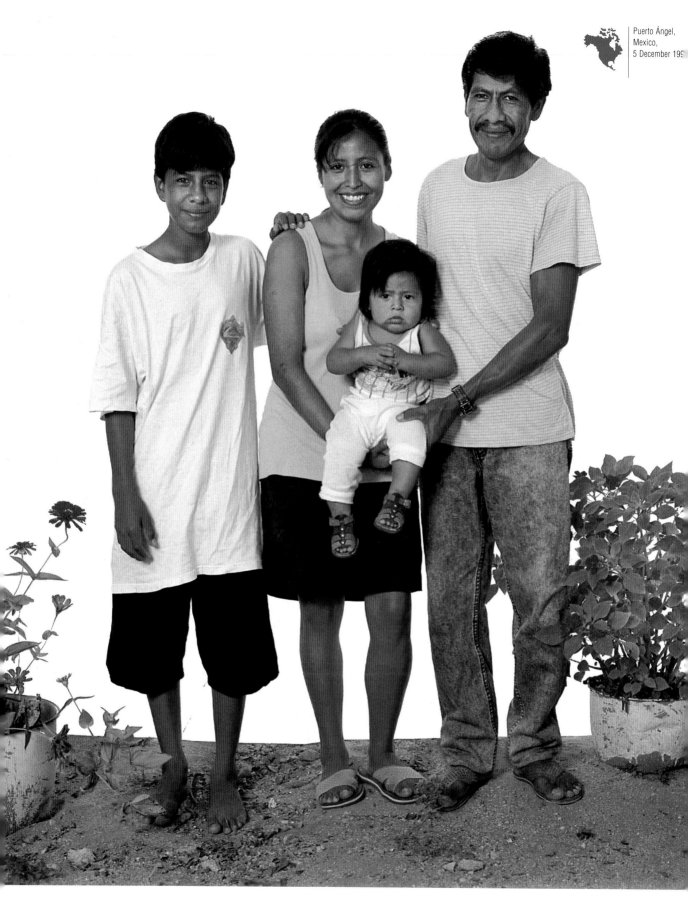

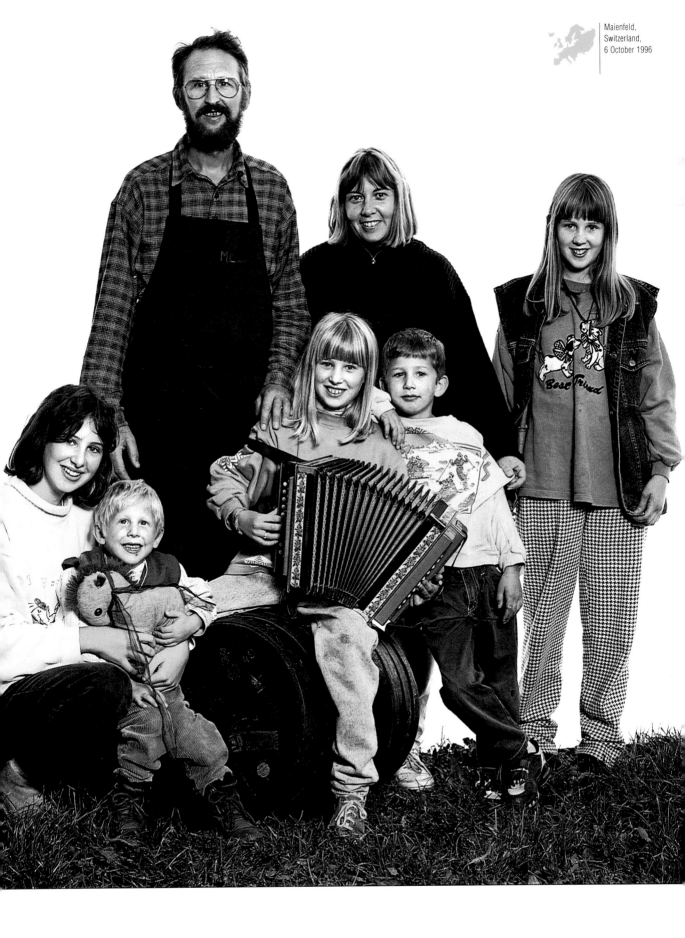

North Hollywood,
California, USA,
14 November 1998

Max möchte Paläontologe werden und Martin, das Skelett, ist sein bester Freund. Sein Vater ist ein „genialer Bastler", er entwickelt und realisiert Spezial-effekte für Walt Disney. In seiner Werkstatt, einer wahren Ali-Baba-Höhle, hat auch Martin, das Skelett, das Licht der Welt erblickt. Cristina stammt aus Argentinien und ist zweisprachige Lehrerin an einer Grundschule für lateinamerikanische Immigrantenkinder, die noch nicht lange im Land sind. Ihr Rat: „Nehmt euch Zeit zum Spielen."

Max wants to be a palaeontologist and Martin-the-skeleton is his best buddy. His father's a "genius with his hands," and designs and makes special effects for Disney. His workshop, which is like Ali Baba's cave, is where Martin-the-skeleton, was created. Cristina, originally from Argentina, is a bilingual teacher at a primary school attended by recent South American immigrant children: "Find time to play," is their advice.

Max veut devenir paléontologue et Martin le squelette est son meilleur ami. Son père est un « bricoleur de génie » : il conçoit et réalise des effets spéciaux pour Disney. Son atelier, véritable caverne d'Ali-Baba, est le lieu où Martin le squelette a vu le jour. Cristina, originaire d'Argentine, est institutrice bilingue dans une école primaire fréquentée par des enfants d'immigrants récents latino-américains. Leur conseil : « Trouvez le temps de jouer ! »

Tete,
Mozambique,
28 October 1997

Fernando hat keinen Beruf erlernt, beginnt aber bald eine Ausbildung zum Krankenpfleger. Bis dahin tut er sein Bestes, um seine Familie zu ernähren.

Fernando doesn't have a trade, but he's enrolled at the training centre to get a nursing diploma. Meanwhile, he does his best to feed his family.

Fernando n'a pas de métier, mais il s'est inscrit au centre de formation pour obtenir un diplôme d'infirmier. En attendant il fait de son mieux pour faire vivre sa famille.

Page 514

„Ich würde gern in die USA gehen, zehn Monate dort arbeiten, viel Geld verdienen, nach Hause kommen und nie wieder von hier weggehen." Gregorio hat schon sehr jung angefangen zu arbeiten, da seine Mutter starb, als er noch ein Kind war. Celustia und er lieben den Strand, wo sie die Sonntage bei Salsa-Rhythmen aus dem obligatorischen Kassettenrecorder verbringen.

"I'd like to go the United States, work ten months, make lots of money, come back and never leave again." Gregorio started working when he was very young, because his mother died while he was still a child. He and Celustia love the beach, where they spend Sundays relaxing, accompanied by the inevit-able radio-cassette player blasting out salsa.

« J'aimerais aller aux Etats-Unis, travailler dix mois, revenir et ne plus jamais y retourner » Gregorio a commencé à travailler dès son plus jeune âge, sa mère étant morte quand il était encore enfant. Avec Celustia, ils adorent la plage où ils se prélassent volontiers le dimanche, au son de l'inévitable radio-cassette qui diffuse de la salsa.

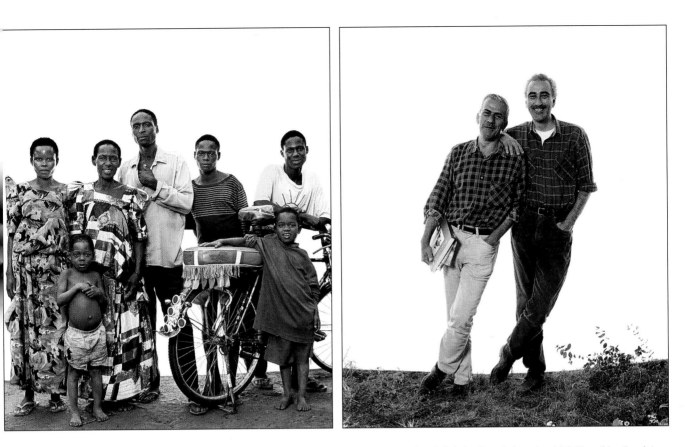

Zwei Frauen, vier Kinder, drei Fahrräder. Kaima und seine beiden Söhne betreiben ein Taxiunternehmen der besonderen Art. Auf ihrem liebevoll verzierten Fahrrad-Taxi transportieren sie die Fahrgäste zu einem Spottpreis. Zur Arbeit radeln sie 40 Kilometer in die Stadt.

Two wives, four children, and three bicycles. Kaima and his two sons are "taxi-bike" drivers. Using the baggage-rack fitted with a large, prettily decorated cushion, they transport their customers for a quarter. Morning and evening, they travel 40 kilometres [25 miles] to town and back.

Deux femmes, quatre enfants, trois vélos. Kaima et ses deux fils sont chauffeurs de « taxiclette », sur leurs porte-bagages agrémentés d'un gros coussin, joliment décoré, ils transportent les clients n'importe où, en ville ou ailleurs, pour 1 franc. Tous les jours, ils parcourent quarante kilomètres pour se rendre en ville ou retourner chez eux.

Die beiden haben sich vor zehn Jahren kennen gelernt. Miguels Französischkenntnisse sind ein Nebenprodukt seiner Lieblingsbeschäftigung, der Lektüre von Comicheften. Seinen Jugendtraum, Maler zu werden, hat er für ein Studium der Anthropologie aufgegeben. Momentan arbeitet er an einem Buch über Brasilien, das 2000 erscheinen soll. „2000 ist mein 40. Geburtstag und der 500. Jahrestag der Entdeckung Brasiliens!" Antonio, begeisterter Hobbygärtner, hat bereits ein Buch über Wallfahrtsorte in Portugal verfasst.

They met ten years back. Miguel learned French from reading comic-strips, his favourite pastime. He wanted to be a painter, but became an anthropologist, and is writing a book about Brazil for the year 2000, when "I'll be 40, and it's the 500th anniversary of the discovery of Brazil." Antonio, a keen gardener, has written a book about pilgrim goals in Portugal. Miguel says of his companion: "He's a dreamer – he doesn't really belong in this century!"

Ils se sont rencontrés il y a dix ans. Miguel a appris le français par les bandes-dessinées, son passe-temps favori. Il voulait être peintre mais est devenu anthropologue et prépare un livre sur le Brésil qu'il espère avoir achevé pour l'an 2000. « L'an 2000 ? C'est l'année de mon 40ᵉ anniversaire et le 500ᵉ de la découverte du Brésil ! Antonio est l'auteur d'un livre sur les lieux de pèlerinages au Portugal et se passionne pour le jardinage. Son compagnon dit de lui : « C'est un rêveur, il n'est pas vraiment de ce siècle ! »

Markus ist spät zum Weinanbau gekommen. Er hat viele Jahre als Mechaniker gearbeitet. Sonja lernte er während der Ferien kennen, die sie regelmäßig als Erntehelferin in seinem Dorf verbrachte. Vor 15 Jahren haben sie ihre ersten Rebstöcke gepflanzt. Für ihre Hobbys – Musizieren mit der ganzen Familie und (für Markus) die Gamsjagd – bleibt ihnen nur wenig Zeit.

Now a winegrower, Markus worked as a mechanic for many years. Sonja met him during the holidays she regularly spent in the village to help with the grape harvest. They planted their vines with their own hands 15 years ago and have little spare time for their favourite pastimes, which are making music together as a family and (for Markus) hunting chamois.

Aujourd'hui vigneron, Markus a longtemps été mécanicien. Sonja a fait sa connaissance durant les vacances qu'elle passait régulièrement au village pour participer aux vendanges. Ils ont planté eux-mêmes leurs pieds de vignes, il y a quinze ans, et ont peu de temps libre pour leurs loisirs préférés : la musique en famille et la chasse au chamois pour Markus.

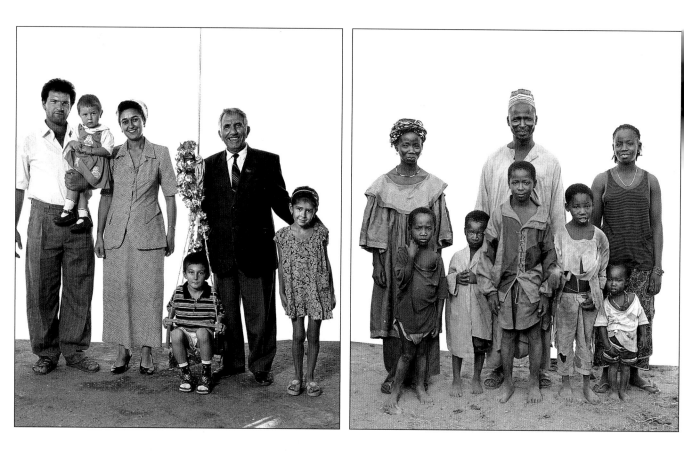

Als Delegierter nahm Kamil an den Feierlichkeiten zum 75. Jahrestag der Gründung der Republik Türkei teil und trägt stolz seinen Orden. Der damals Sechsjährige wurde mit seiner Familie nach Usbekistan zwangsumgesiedelt, wo er seither lebt. „Ich habe zwei Vaterländer, die Türkei und Usbekistan. Ganz gleich, wo wir auch leben, wir Türken müssen zusammenhalten und unsere Kultur bewahren."

Kamil was a delegate at the festivities commemorating the 75th Anniversary of the Turkish Republic, and proudly wears the medal. He was forcibly resettled to Uzbekistan at the age of six, along with his family and has lived in Uzbekistan ever since. He says: "I have two homelands, Turkey and Uzbekistan, and I should like to say to Turks all over the world that we really must all hold together and make sure our culture lasts."

Délégué aux festivités commémoratives des soixante-quinze ans de la République de Turquie, dont il porte fièrement la médaille, Kamil est aussi président de la communauté turque d'Ouzbékistan. Déporté à l'âge de six ans, avec quelques rares membres de sa famille, il vit depuis en Ouzbékistan et dit: « J'ai deux patries, la Turquie et l'Ouzbékistan et je voudrais dire aux Turcs du monde entier que nous devons bien nous entendre et pérenniser notre culture ! »

Oustase unterrichtet im Dorf den Koran. Er wünscht sich die Einrichtung zahlreicher Schulen in Gambia, damit möglichst viele Kinder den Islam entdecken. Seine beiden Frauen kümmern sich um den Nachwuchs und die tägliche Arbeit.

Oustase teaches the Koran in the village. He's hoping lots of schools will be built in Gambia so that as many children as possible will discover Islam. His two wives take care of the children and the daily routines.

Oustase enseigne le Coran au village. Il souhaite le développement du nombre d'écoles en Gambie pour que le plus d'enfants possible découvrent l'Islam. Ses deux femmes s'occupent des enfants et de la vie quotidienne.

„Wir leben hier mehr vom Tourismus als von der Landwirtschaft", erklärt uns Josef, der uns nach seinem Arbeitstag auf seinem großen Traktor entgegenkam. Er und seine Frau Anna-Marie leben vom Verkauf der Erzeugnisse ihres Bauernhofes – Butter, Eier, Brot – und der Vermietung von Zimmern in ihrem herrlichen Chalet.

"In these parts we live more off tourism than farming," Josef tells us. We bumped into him returning from his fields on his large tractor. He and his wife Anna-Marie sell farm produce – butter, eggs, and bread – and rent out guest rooms in their magnificent chalet.

« Dans la région nous vivons plus du tourisme que de l'agriculture », nous dit Josef que nous avons croisé, rentrant des champs sur son gros tracteur. Avec Anna-Marie, sa femme, ils vendent les produits de la ferme: beurre, œufs, pain et louent des chambres d'hôte dans leur magnifique chalet.

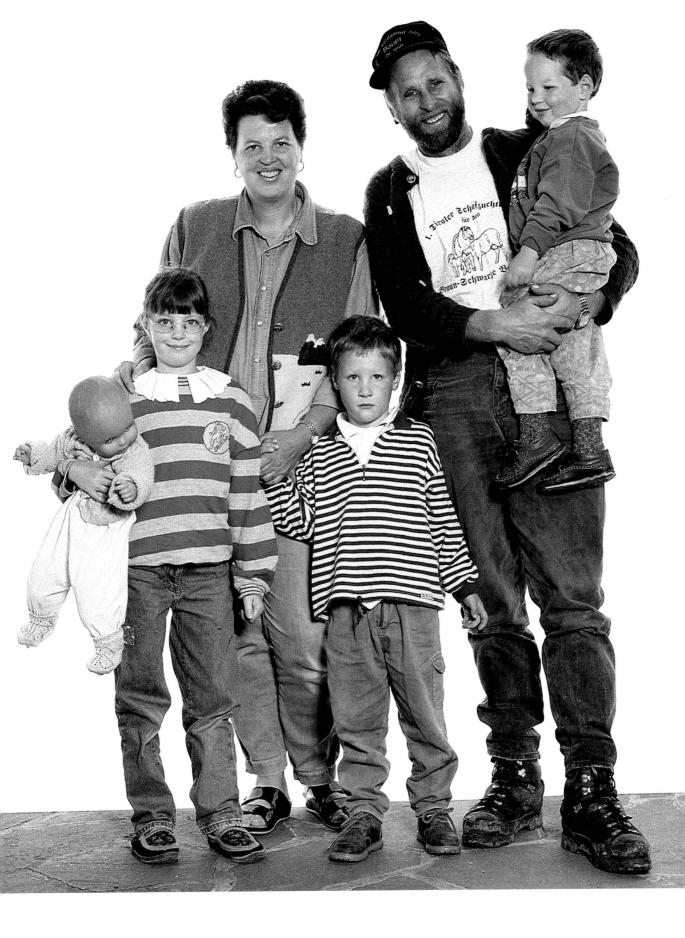

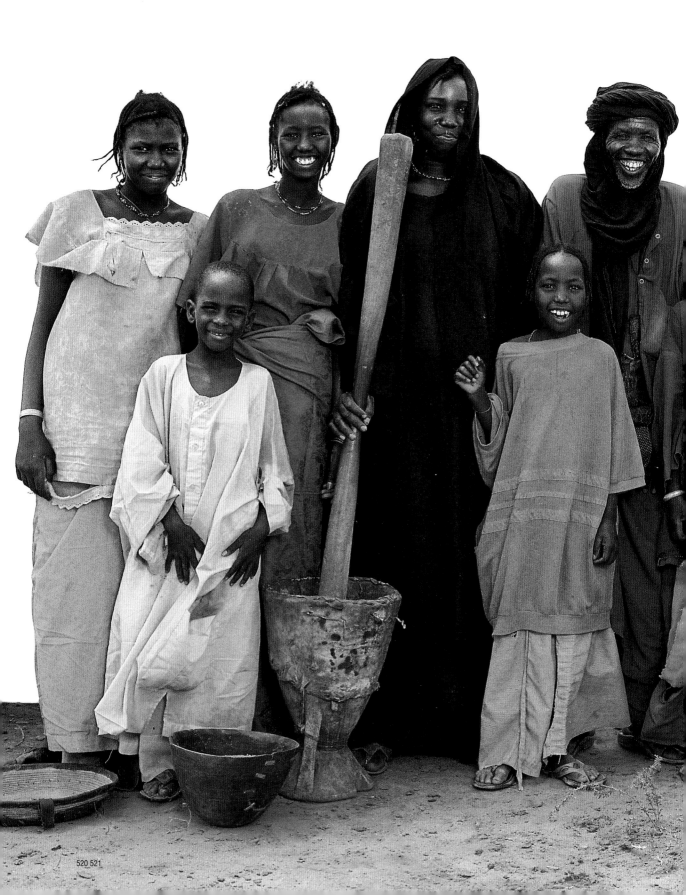

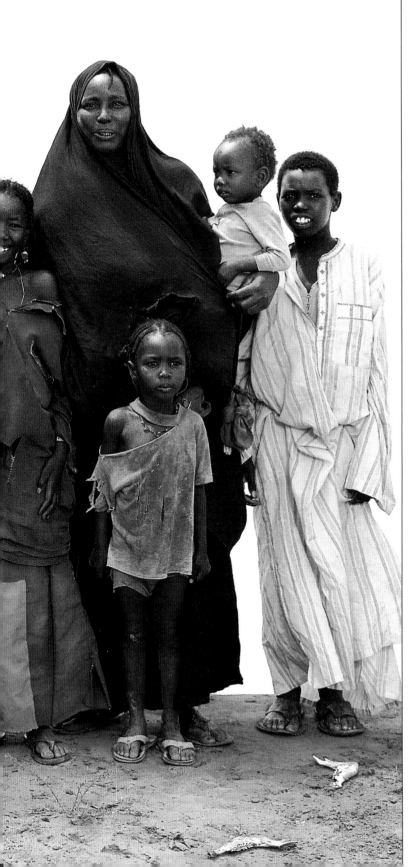

Mit seiner Familie und seiner Herde zieht der Nomade Souleyman von einer
Wasserstelle zur anderen. Das Nomadenleben befreit sie jedoch keineswegs
von der Steuer. Jedes Mal, wenn sie auf einem Markt ihre Produkte verkau-
fen möchten, müssen sie einen bestimmten Betrag, entsprechend der
Anzahl ihrer Kamele, entrichten.

Souleyman is a nomadic herdsman who moves about with his family
and livestock from one watering hole to the next. The nomadic way of life
doesn't exempt them from paying tax, so they make a contribution worked
out on the basis of the number of camels every time they want to go to a
market to sell their produce.

Berger nomade, Souleyman se déplace avec sa famille et son troupeau
au gré des points d'eau. La vie nomade ne les dispense pas d'impôts, ils
payent une contribution calculée sur le nombre de chameaux à chaque
fois qu'ils veulent accéder à un marché pour y vendre leurs produits.

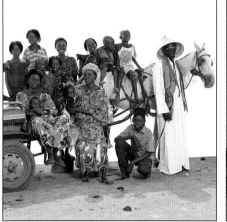
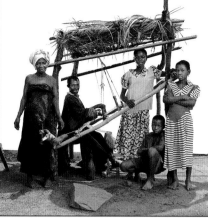
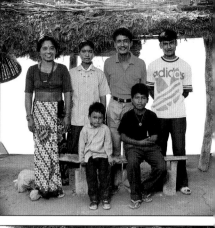

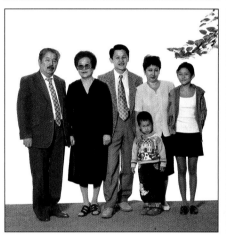
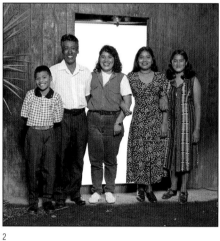
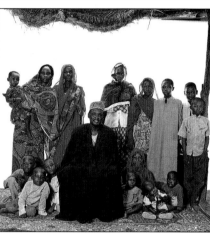

1

4

2

5

3

6

 1
Tambacounda,
Senegal,
19 April 1997

 2
Godofuma,
Ivory Coast,
4 April 1997

 3
Bardia,
Nepal,
11 November 1999

 4
Almaty,
Kazakhstan,
9 September 1999

 5
San Pedro El Alto,
Guatemala,
9 December 1998

 6
Mani,
Chad,
26 July 1997

 Massaro,
Cameroon,
1 August 1997

Sie erklärten sich nur deshalb bereit, vor unsere Kamera zu treten, weil sie sich anschließend auf dem Polaroid bewundern wollten. Die Bororo sind wirklich ein außergewöhnliches Volk: Es sind die jungen Männer, die sich schminken, frisieren und überaus eitel sind, was ihre Kleidung angeht. Wenn sie ihre Hütten in der Nähe einer Stadt aufbauen, dann nicht nur, damit die Frauen auf dem Markt die Milch ihrer Buckelrinder feilbieten können, sondern auch, damit die Männer Gelegenheit haben, Schminke und vor allem Spiegel – ein absolutes Muss für die Bororo – zu kaufen, Hand in Hand umherzuschlendern und sich in den Außenspiegeln der wenigen Autos zu betrachten.

They only agreed to pose for us so that they could look at themselves in the Polaroid afterwards. The Bororo are definitely a people who are out of the ordinary: the young men wear make-up, style their hair and dress extremely stylishly. If they build their huts close to a town, it's not only so that the village women can take the milk from their zebus to the market, but also so that the men can buy make-up and, most importantly, mirrors (absolutely crucial for the Bororo), and stroll hand in hand through town, gazing at themselves in the side mirrors of the infrequently passing vehicles.

Ils ont accepté de poser pour nous seulement pour pouvoir se regarder sur le polaroïd après. Les Bororo sont décidément un peuple à part: les hommes jeunes se maquillent, se coiffent et s'habillent avec un coquetterie extrême. S'ils installent leurs cases près d'une ville, c'est pour vendre le lait de leurs zébus au marché (travail des femmes), mais également pour acheter du maquillage et surtout des miroirs (le must des Bororo), flâner main dans la main et se mirer dans les rétroviseurs de rares voitures (travail des hommes).

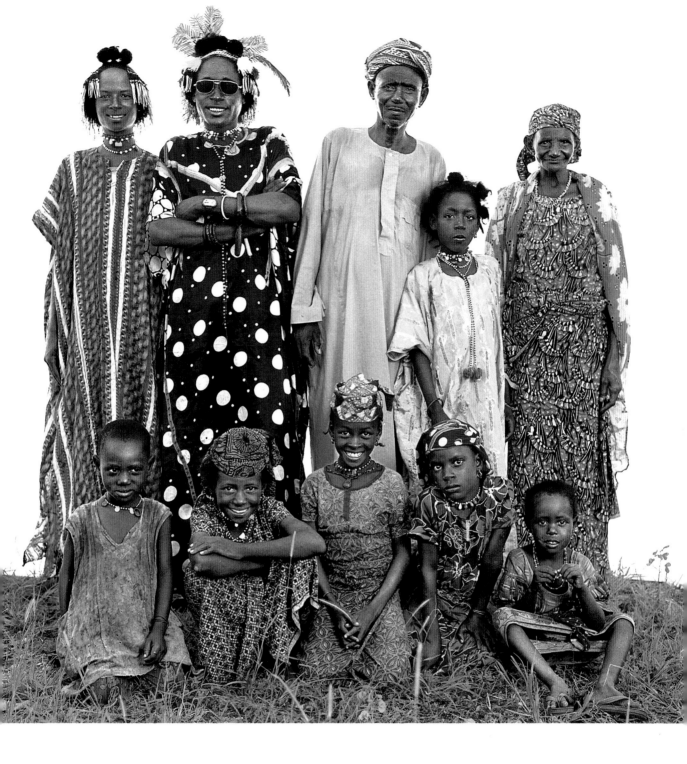

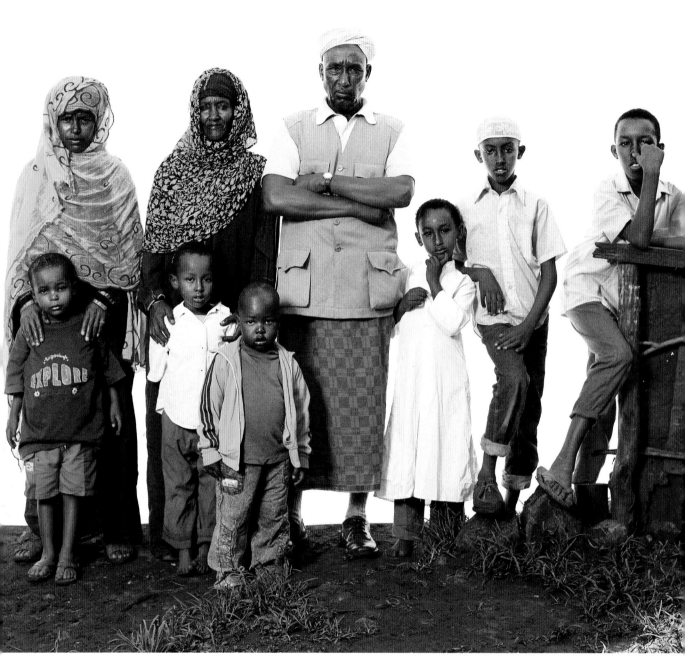

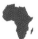

Isiolo,
Kenya,
22 November 1997

Der ehemalige Polizist hat ein erstaunliches Hobby: Er hütet für sein Leben gern seine Herde, d. h. seine drei Kühe. Um das monatliche Einkommen aufzubessern, züchtet er Tauben, die seine Frau auf dem Markt verkauft.

The former police officer has a pastime which is unexpected, to say the least – he loves watching over his livestock, which consists of three cows. To supplement his income, he breeds pigeons, which his wife sells at the market.

L'ex-officier de police a un passe-temps favori pour le moins inattendu: il aime garder son bétail qui comprend trois vaches. Pour arrondir ses fins de mois, il élève des pigeons que sa femme vend au marché.

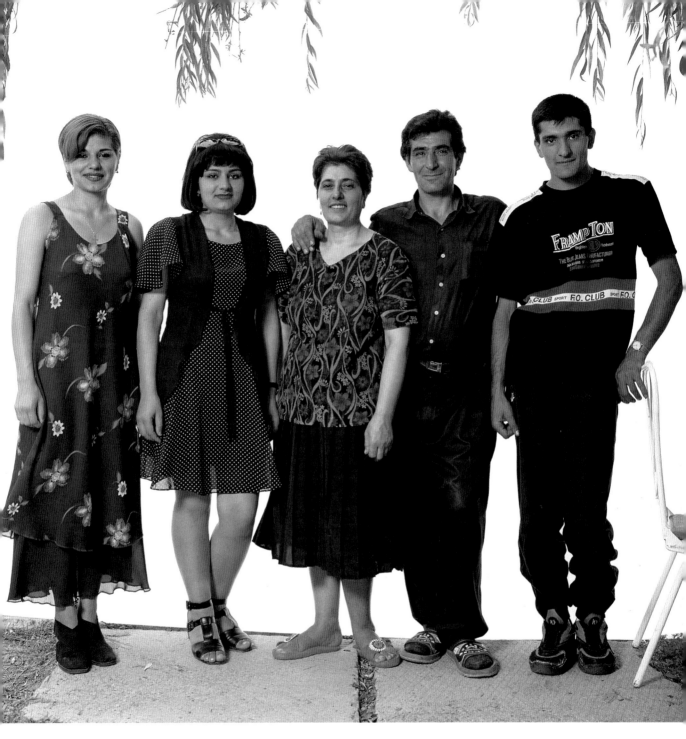

Tsaghkadzor,
Armenia,
25 August 1999

Vaginak war Vorsteher des Rangierbahnhofs, bis die Strecke stillgelegt wurde. Seitdem arbeitet er als Portier in dem Hotel, in dem seine Frau Köchin ist. Arman (22) hat nach dem Militärdienst angefangen, wie seine jüngere Schwester Aghavni (19) Jura zu studieren. Anusch (18) ist mit Leib und Seele Friseuse und ich entging einem neuen Haarschnitt nur, weil sie gerade keine Schere zur Hand hatte-

Vaginak lost his job as manager of the marshalling yard when the railway closed. Since then, he has worked as a security guard at the hotel where his wife has a job as cook. Arman (22) has finished military service and is now studying law, like his 19-year-old sister Aghavni. Anush (18) loves being a hairdresser, and I only escaped an impromptu haircut because she couldn't find any scissors.

Chef de la gare de triage, Vaginak a perdu son poste à la fermeture du chemin de fer. Depuis il est gardien de l'hôtel où sa femme travaille comme cuisinière. Arman (vingt-deux ans) a fini son service militaire et poursuit des études de droit tout comme sa sœur Aghavni (dix-neuf ans). Anush (dix-huit ans) adore son métier de coiffeuse et c'est seulement l'absence de ciseaux qui m'a sauvé d'une séance de coupe improvisée.

Tasik Chini,
Malaysia,
6 January 2000

Samah ist Besitzer einer fünf Hektar großen Plantage mit Kautschukbäumen, die den Rohstoff für die Herstellung von Gummi liefern, und zapft jeden Morgen die Milch der Bäume ab. Eltern, Kinder und Enkelkinder leben alle zusammen im Elternhaus in ihrem Eingeborenendorf.

Samah owns twelve acres [5 ha] planted with *hevea* trees, which provide the raw material for rubber. He taps the latex from them every morning. Here we see the parents, children and grandchildren – everybody lives in the paternal home in the aboriginal village.

Propriétaire de cinq hectares plantés d'hévéas, qui fournissent la matière première nécessaire à la fabrication du caoutchouc, Samah prélève tous les matins la sève de ses arbres. Ici, les parents, enfants et petits-enfants : tout le monde vit dans la maison paternelle dans le village aborigène.

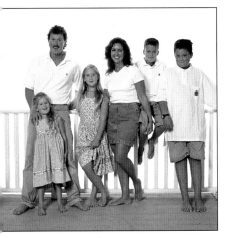

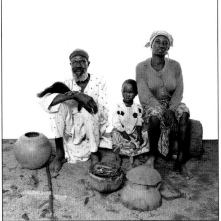

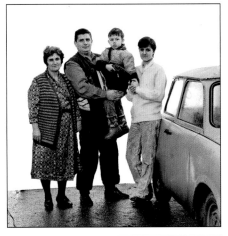

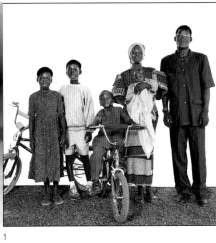

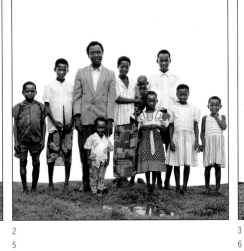

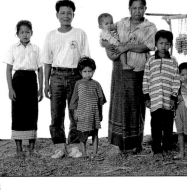

1

2

3

4

5

6

1
Brookhaven,
New York, USA,
12 September 1998

2
Roumsiki,
Cameroon,
30 July 1997

3
Rila,
Bulgaria,
4 January 1997

4
Tortiya,
Ivory Coast,
11 May 1997

5
Mbale,
Uganda,
15 November, 1997

6
Ban Tao Soung,
Laos,
30 January 2000

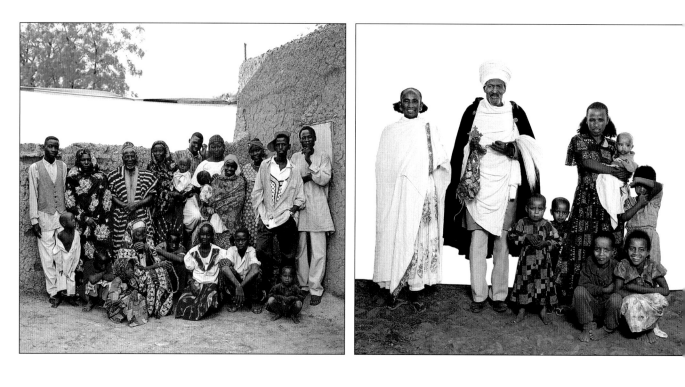

 Zinder,
Niger,
22 July 1997

Adel verpflichtet! Der Notable und erste Berater des Sultans von Zinder hat eine Familie, die seiner Stellung alle Ehre macht. Das Familienoberhaupt hat seine bäuerliche Abstammung jedoch keineswegs vergessen und lässt seine Frauen und Kinder die Felder bestellen …

Noblesse oblige – the honourable notable and chief counsellor to the Sultan of Zinder has a family that befits his position. To feed his tribe, the chief counsellor hasn't forgotten his farming origins, however, and gets his wives and children to work the fields …

Noblesse oblige, l'honorable notable et premier conseiller du Sultan de Zinder a une famille correspondant à son poste. Pour nourrir sa tribu, le premier conseiller n'a pas oublié son origine de cultivateur et fait travailler ses champs par ses femmes et enfants …

Aksum,
Ethiopia,
15 December 1997

Das Kloster der Heiligen Maria in Aksum (Äthiopiens antike Hauptstadt und Zentrum der koptischen Kirche) beherbergt 144 Mönche, die die schützenden Mauern niemals verlassen und die Nächte beim Gebet verbringen. Kutham, ihr geistiges Oberhaupt, lebt mit seiner Familie außerhalb des Klosters. Sein größter Wunsch ist es, genügend Geld aufzutreiben, um die religiösen Gemälde im Kirchenschiff restaurieren zu lassen. Der Ziegenschwanz in seiner Hand ist nicht etwa ein orthodoxer Kultgegenstand, sondern ein Fliegenwedel …

St. Mary's Monastery in Aksum (Ethiopia's ancient capital and Coptic religious centre) is home to 144 monks; they never leave the monastery confines and spend their nights in prayer. Kutham is their spiritual director and lives outside with his family. His wish is to find enough money to restore the religious pictures decorating the nave of his church. The goat's tail he carries is not an object of Christian worship, but a fly swatter …

Au monastère Sainte-Marie d'Axum (ancienne capitale d'Ethiopie et centre religieux orthodoxe) vivent cent quarante-quatre ermites, qui ne quittent jamais l'enceinte du monastère et passent leurs nuits en prières. Kutham est leur grand prêtre et vit à l'extérieur avec sa famille. Son vœux est de trouver de l'argent pour restaurer les tableaux religieux qui décorent la nef de son église. La queue de chèvre qu'il tient à la main n'est pas un objet de culte orthodoxe mais un chasse-mouche …

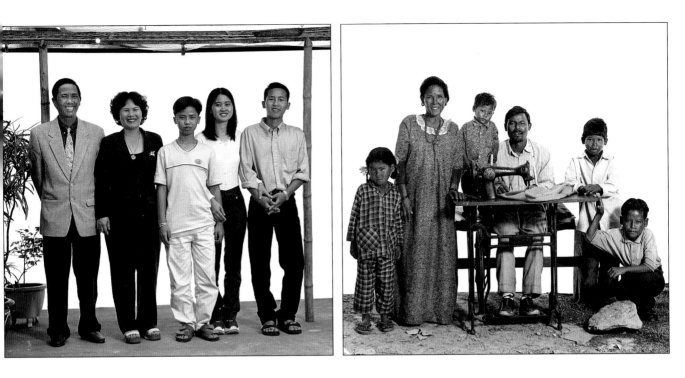

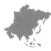

Hoi An,
Vietnam,
6 February 2000

Do ist Direktor einer Schweineschlachterei (Schweinefleisch wird in der vietnamesischen Küche am meisten verwendet) und seine Frau verkauft Fleisch in ihrem Geschäft. Die Kinder wollen lieber studieren, und die beiden Ältesten haben auch schon konkrete Vorstellungen: Der Junge möchte Arzt werden und das Mädchen Lehrerin.

Do runs a slaughterhouse for pigs, and his wife Ngo sells the meat (pork being the most widely used meat in Vietnamese cooking) in her shop. The children are happier studying, and the two eldest ones already know pretty well what they want to be – the boy a doctor, the girl a teacher.

Dô est à la tête d'un abattoir pour cochons, c'est la viande la plus utilisée dans la cuisine vietnamienne, sa femme Ngô en vend dans sa boutique. Les enfants préfèrent les études et les deux aînés ont déjà une idée précise : docteur pour le garçon et enseignante pour la fille.

Tashiding,
Sikkim, India,
21 November 1999

Harikumar sitzt mit seiner Nähmaschine draußen am Rand der Piste, die durch das Dorf führt. Der gebürtige Nepalese hat sich mit Frau und Kindern hier niedergelassen und näht Kleider für die Dorfbewohner.

Harikumar has set up shop with his sewing machine outdoors beside the track that runs through the village. Originally from Nepal, he has come to live here with his wife and children to make clothes for the townspeople.

Harikumar est installé, avec sa machine à coudre, en plein air au bord de la piste qui traverse le village. Originaire du Népal, il est venu s'installer ici, avec femme et enfants, pour s'occuper des vêtements des habitants du bourg.

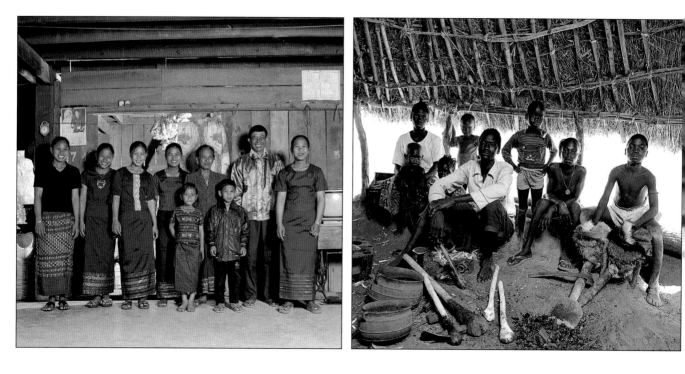

Ban Keit Ngong,
Laos,
30 January 2000

Boun Sene ist einer der reichsten und glücklichsten Männer des Dorfs. Er hat sechs schöne Töchter (zwei davon bereits verheiratet), ein Lebensmittel-geschäft, einen Büffel, Reisfelder und einen Elefanten, der „gerade in den Wald zum Mittagessen gegangen ist", wie er hinzufügt.

Boun Sene is one of the wealthiest and happiest men in the village – six very beautiful daughters (two of them already married), a grocery shop, a buffalo, paddy fields, and an elephant "that's gone off to the forest for lunch," he adds.

Boun Sene est un des hommes les plus riches et heureux du village : six très belles filles (dont deux déjà mariées), un magasin d'épicerie, un buffle, des rizières et un éléphant « parti déjeuner dans la forêt », précise-t-il.

Gabú,
Guinea-Bissau,
29 April 1997

Mamadou hat seinen Beruf beim Schmied des Nachbardorfs gelernt und dann seine eigene Werkstatt eröffnet. Mit seinen beiden Frauen und den fünf Kindern ist er eine wichtige und unumgängliche Persönlichkeit in einem Dorf, in dem landwirtschaftliche Geräte (Hacken, Spaten, Schaufeln usw.) unentbehrlich sind.

Mamadou has set up his own forge after learning his trade from the blacksmith in the next village. With two wives and five children, he is an important and vital figure in his village, where farm tools (axes, spades and shovels) are indispensable.

Mamadou a créé son atelier après avoir appris son métier chez le forgeron du village voisin. Avec deux femmes et cinq enfants, il est un personnage important et incontournable dans son village où l'outil agricole (hache, bêche, pelle) est vital.

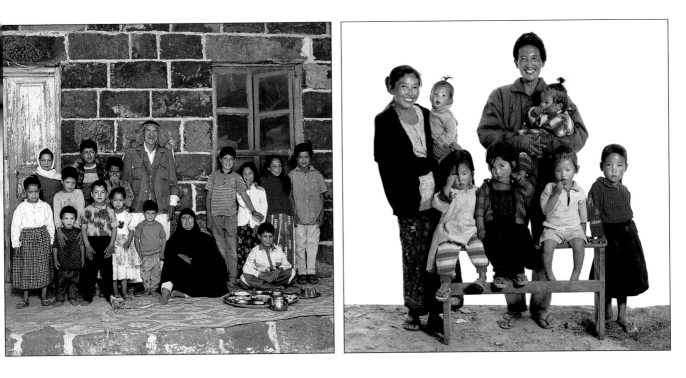

Bosra,
Syria,
8 August 1999

Atie Mohammed hat mit 13 geheiratet und ist heute glücklicher Großvater. „Ich bin seit 27 Jahren Bürgermeister, bin nach Mekka gepilgert, besitze etwas Land, zwei Kühe, 60 Schafe, zwei Traktoren und alle Kinder auf dem Foto sind meine Enkel." Auf die Frage, ob er im Flugzeug nach Mekka Angst hatte, antwortet er uns: „Überhaupt nicht. Das war wie auf meinem Traktor, nur sehr viel bequemer!"

Atie Mohammed was married at 13, and today he's a happy grandfather. "I've been mayor of the village for 27 years, I've done my pilgrimage to Mecca, I've got fields, two cows, 60 sheep and two tractors – and all the children in the photo are my grandchildren." Was he afraid when he flew to Mecca? – "Not at all, it was like on my tractor, only a lot more comfortable."

Atie Mohamed s'est marié à l'âge de treize ans, il est aujourd'hui un grand-père comblé : «Je suis maire du village depuis vingt-sept ans, j'ai fait mon pèlerinage à La Mecque, j'ai des champs, deux vaches, soixante moutons, deux tracteurs, et tous les enfants sur la photo sont mes petits-enfants!» Pour vous rendre à La Mecque, avez-vous eu peur en avion? «Pas du tout, c'était comme sur mon tracteur, mais beaucoup plus confortable. »

Tashiding,
Sikkim, India,
21 November 1999

Palden unterrichtet die 237 Kinder aus der Umgebung in Lepcha, der tibetobirmanischen Ursprache Sikkims. Er und seine Frau haben sechs Kinder und finden das völlig ausreichend. In ihrer Freizeit bestellen sie ihre Mais- und Hirsefelder.

Palden teaches Lepcha, the original language of Sikkim, to the 237 local children. He and his wife have six of their own, and reckon that's enough. When they have any spare time, they tend their fields, where they grow maize and millet.

Palden enseigne le lepcha, la langue d'origine du Sikkim, aux deux cent trente-sept enfants du coin. Lui et sa femme en ont six et trouvent que ca suffit comme ça! Quand ils ont du temps libre, ils s'occupent de leurs champs où ils cultivent du maïs et du mil.

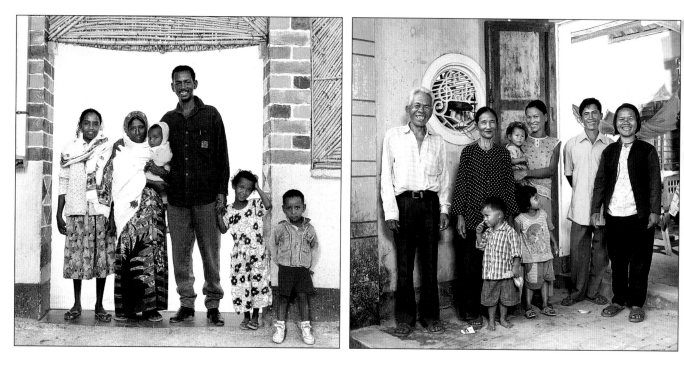

Keren,
Eritrea,
19 December 1997

Bevor er mit seiner Familie nach Eritrea geflüchtet ist, hat Ghirmai im Sudan als Krankenpfleger in einer US-amerikanischen Klinik gearbeitet, heute arbeitet er im örtlichen Krankenhaus.

Before he and his family took refuge in Eritrea, Ghirmai was a nurse in an American clinic in Sudan. Today he has a job in the local long-term health care centre.

Avant de se réfugier avec sa famille en Erythrée, Ghirmai était infirmier dans une clinique américaine au Soudan. Il travaille aujourd'hui à l'hôpital local.

Hoi An,
Vietnam,
5 February 2000

Than Tams größte Sorge sind die häufigen Überschwemmungen, die regelmäßig sein Feld, seinen Garten und das Erdgeschoss seines Hauses verwüsten. Dann ist seine Familie gezwungen, sich im oberen Stock einzurichten, bis das Hochwasser wieder zurückgeht.

Than Tam and his family have one major worry – the frequent and destructive floods which inundate his fields, his vegetable garden and the ground floor of his house. His family is forced to retreat to the upper floor until the water goes down.

Thân Tâm et sa famille ont un souci majeur: les inondations fréquentes et dévastatrices qui envahissent régulièrement son champ, son potager et le rez-de-chaussée de sa maison. Ce qui oblige sa famille à s'installer au premier étage en attendant la décrue.

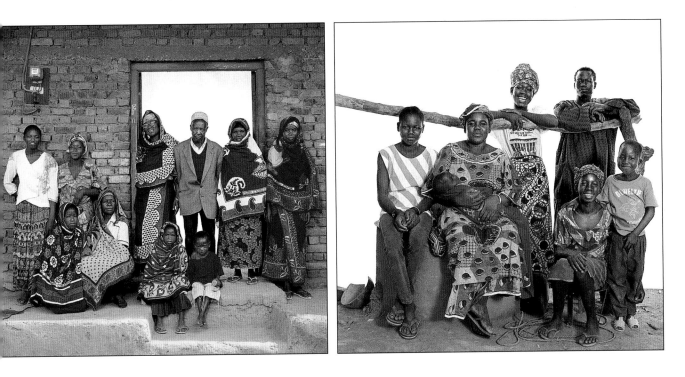

Iringa,
Tanzania,
3 November 1997

Abdal hat viel erlebt und gesehen: Seine Arbeit als Busfahrer hat ihn über Kenia bis nach Uganda geführt. Jetzt, im Alter, führt er ein eher geruhsames Leben im Kreise seiner zwei Frauen, seiner Kinder und Enkelkinder, aber er wollte uns unbedingt seine Fahrkünste am Steuer unseres Wagens beweisen – wir haben höflich abgelehnt. Sein einziger Wunsch ist, dass der Ertrag der Felder die Familie ernährt.

Abdal has had an adventurous life because he used to be a bus driver, and his routes took him across Kenya all the way to Uganda. He's retired now, and leads a quieter life with his two wives, children and grandchildren, but he insisted on showing us his driving talents with our car … we refused politely. All he hopes, God willing, is that his fields will produce enough to feed everyone.

Abdal a mené une vie aventureuse : il était chauffeur de bus et ses trajets le menaient jusqu'au Kenya en passant par l'Ouganda. Maintenant retraité, il mène une vie plus paisible entouré de ses deux femmes, enfants et petits-enfants, et espère seulement que, grâce à Dieu, ses champs produiront suffisamment pour nourrir tout le monde.

Ségou,
Mali,
8 April 1997

Gaousso ist Aufseher in der Tapisserie von Nieleni und der einzige Mann im Unternehmen. 74 Frauen, darunter seine eigene, arbeiten hier; sie spinnen und färben Wolle und weben Teppiche. Wir vereinten die ganze Familie um den Brunnen herum, aber Gaoussos Frau weigerte sich, dort Platz zu nehmen, aus Angst, der Kleinste könnte herunter fallen. „Was bedeutet die Familie für Sie?" – „So wie du von jemandem abstammst, willst du, dass andere von dir abstammen, das ist der Sinn der Familie."

Gaousso is the security guard at the Nieleni carpet works, the only man in the factory. Seventy-four women, including his own wife, work there, spinning and dyeing yarn, and weaving rugs and carpets. We gather the whole family around the well, but Madame refuses to sit on it, terrified at the idea of dropping their youngest child into it. The children hurriedly cover it up. "What does the family mean for you?" – "You come from someone, so you want other people to come from you – that's what family means."

Gaousso est le gardien de la « tapisserie de Nieleni », c'est le seul homme de l'usine! Soixante-quatorze femmes, dont la sienne, y travaillent pour filer la laine, la teindre et tisser les tapis. Nous réunissons toute la famille autour du puits, mais Madame refuse de s'y asseoir, effrayée à l'idée d'y laisser tomber le petit dernier. Les enfants s'empressent de le recouvrir. « Que signifie pour vous la famille? » « Si tu viens de quelqu'un tu souhaites que d'autres personnes viennent de toi, c'est ça le sens de la famille. »

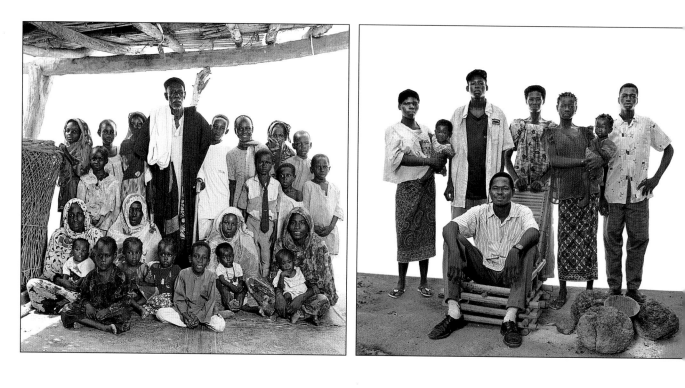

Mani,
Chad,
26 July 1997

Alhadji Koubou Sale ist der Stellvertreter des Sultans in seinem Dorf und hat den Titel eines Notablen. Mit seinen 77 Jahren bestellt er immer noch seine Felder, auf denen er Erdnüsse, Mais und Reis anbaut. Für ihn ist eine Familie ohne Kinder keine Familie, er für seinen Teil hat 18 Sprösslinge …

Alhadji Koubou Sale is the sultan's representative in his village, which means he has the title of 'notable'. He is also a farmer and, at the age of 77, still keeps an eye on his land, growing groundnuts, maize and rice. For him, there's no such thing as a family without children – and he's got 18 …

Alhadji Koubou Sale est le représentant du sultan dans son village, ce qui lui confère le titre de notable. Il est également cultivateur et à soixante-dix-sept ans, il veille toujours sur ses terres où poussent arachide, maïs et riz. Pour lui, il n'y a pas de famille sans enfants, pour sa part il en a dix-huit.

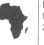

Bouna,
Ivory Coast,
29 May 1997

Die Lobi-Bauern haben den Ruf, fleißige Arbeiter zu sein. Fast die gesamte Nahrungsmittelproduktion im Verwaltungsbezirk Bouna liegt in ihren Händen. Dah ist einer von ihnen; mit seinen Frauen, Brüdern und Kindern arbeitet er auf den Feldern. „So Gott will, werden die Kinder zur Schule gehen, ansonsten müssen sie aufs Feld", sagt Dah. Es scheint so, als habe Gott nicht gewollt!

Lobi planters are renowned as energetic workers. They provide almost all the food for the district of Bouna. Dah is one of them, working the fields together with his wives, brothers and children. "The children will go to school if God so wills; if not, they'll go to the fields," Dah announces. It looks as if God hasn't so willed.

Les planteurs lobi ont la réputation d'être des travailleurs courageux. Ils fournissent la quasi-totalité de la nourriture du département de Bouna. Dah est l'un d'entre eux, il travaille avec femmes, frères et enfants. « Les enfants iront à l'école si Dieu le veut, sinon ils iront aux champs », annonce Dah. Il semblerait que Dieu n'ait pas voulu !

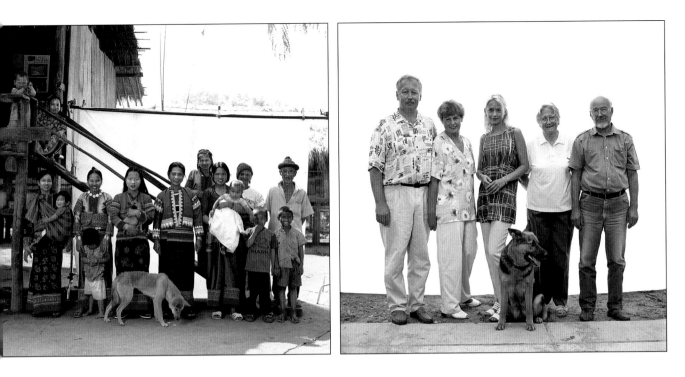

Chiang Dao,
Thailand,
19 January 2000

Die Großeltern, hier mit ihren Töchtern und Schwiegertöchtern, haben sich „zur Ruhe gesetzt" und die Felder ihren Söhnen überlassen. Nun ist es an ihnen, mit dem Anbau von Reis und Mais für die Familie zu sorgen.

The grandparents, shown here with their daughters and daughters-in-law, have 'retired' and left their fields to their sons, who have taken over feeding the family with the rice and maize they grow.

Les grands-parents, ici avec leurs filles et belles-filles, ont pris leur « retraite » et laissé leurs champs à leurs fils qui continuent de faire vivre la famille grâce au riz et maïs.

Tartu,
Estonia,
12 July 1998

Drei Generationen unter einem Dach, ein und dieselbe Botschaft – an alle Familien: „Peace and Love". In zwei großen Gewächshäusern züchten die Großeltern Rosen, die sie auf dem Markt von Tartu verkaufen. Vello leitet die Lkw-Werkstatt einer Spedition und Helgi arbeitet als Chemikerin in einem Forschungslabor. Englischlehrerin Kristi war unsere Dolmetscherin. In den Ferien hilft sie in einem Reisebüro aus und träumt dabei von fernen Ländern …

Three generations under the same roof, with the same message to all families: "Peace and Love." The grandparents love roses, and grow them in two large greenhouses (vital in Estonia because of the climate), then sell them at Tartu market. Vello supervises the truck maintenance department in a transport firm Helgi is a chemist in a research laboratory. English teacher Kristi acted as our interpreter. In the holidays she works at a travel agency, and dreams of faraway, exotic lands …

Trois générations sous le même toit, avec le même message aux familles : « Peace & Love ». Endel et Aino, les grands-parents, adorent les roses, ils les cultivent dans deux grandes serres avant de les vendre au marché de Tartu. Vello supervise l'atelier d'entretien de camions d'une société de transports, Helgi est chimiste dans un laboratoire de recherche. Kristi a été notre interprète en sa qualité de prof d'anglais. Pendant ses vacances elle travaille dans une agence de voyages et rêve de contrées exotiques et lointaines …

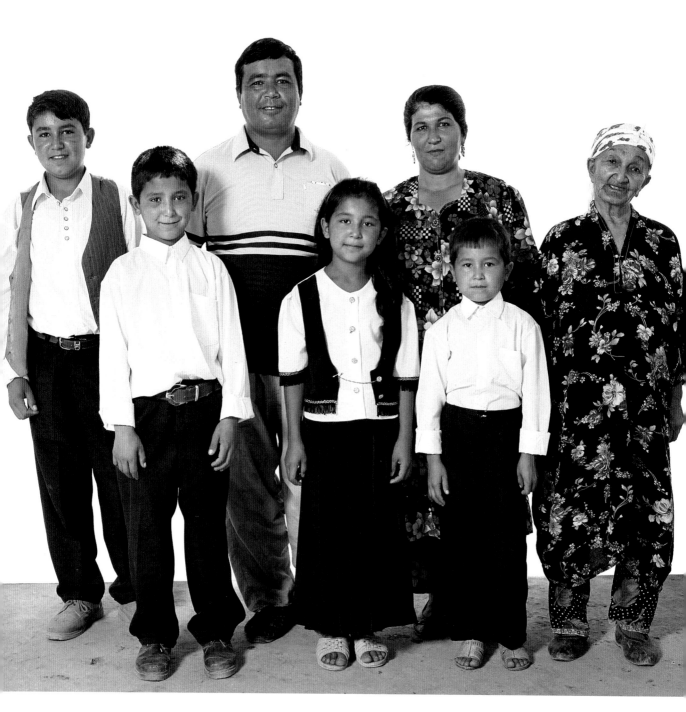

Arabchona,
Uzbekistan,
13 September 1999

Obwohl er sein Biologiestudium mit Auszeichnung abgeschlossen hat, ist Narboy Chef der örtlichen Polizei geworden. Da er mit der Landwirtschaft groß geworden ist, bestellt er in seiner Freizeit weiterhin Baumwollfelder und einen großen Gemüsegarten. Seine Großmutter, ehemals Kindergärtnerin, geht ihm dabei zur Hand.

Despite being a brilliant student of biology, Narboi has become head of the police brigade. He retains a strong childhood attachment to farming and still works his land, where he grows cotton and has a large vegetable garden. His grandmother, who used to teach in the kindergarten, always lends a helping hand in the fields.

Malgré de brillantes études de biologie, Narboy est devenu chef de la brigade de police. Il conserve de son enfance un fort attachement à la ferme et travaille encore ses terres où il cultive du coton et un grand potager. La grand-mère qui était maîtresse au jardin d'enfants donne toujours un petit coup de mains aux champs.

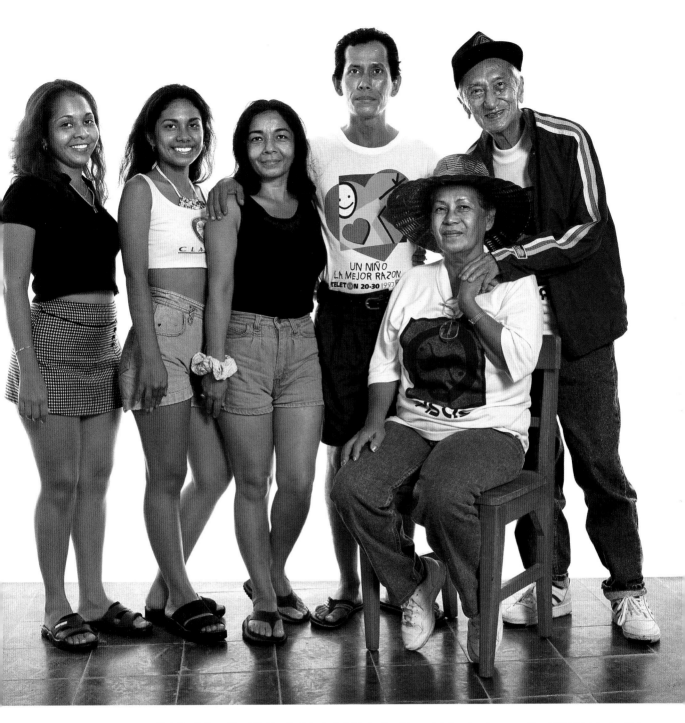

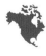

Panama City,
Panama,
27 December 1998

Die beiden Töchter – 23 und 20 Jahre alt – treten in die Fußstapfen ihres Vaters und studieren Ingenieurswesen. Mama ist Verkäuferin in einer Mode-boutique. Vicente, der Großvater, ist chinesischer Herkunft und kam als kleiner Junge mit seinen Eltern nach Panama, wo sein Vater wie Zigtausende Chinesen beim Bau des Kanals arbeitete.

Their two daughters, 23 and 20 respectively, are following in their father's footsteps and studying engineering. Mummy is a sales assistant in a fashion store. Vicente, the grandfather of Chinese extraction, came to the Panama with his parents when he was a toddler. His father was one of the many Chinese to work on the canal construction.

Les deux filles – vingt-trois et vingt ans – marchent sur les pas de leur père et poursuivent des études d'ingénieur ... Maman est vendeuse dans une boutique de mode. Vicente, le grand-père d'origine chinoise, est arrivé tout petit en Amérique avec ses parents.

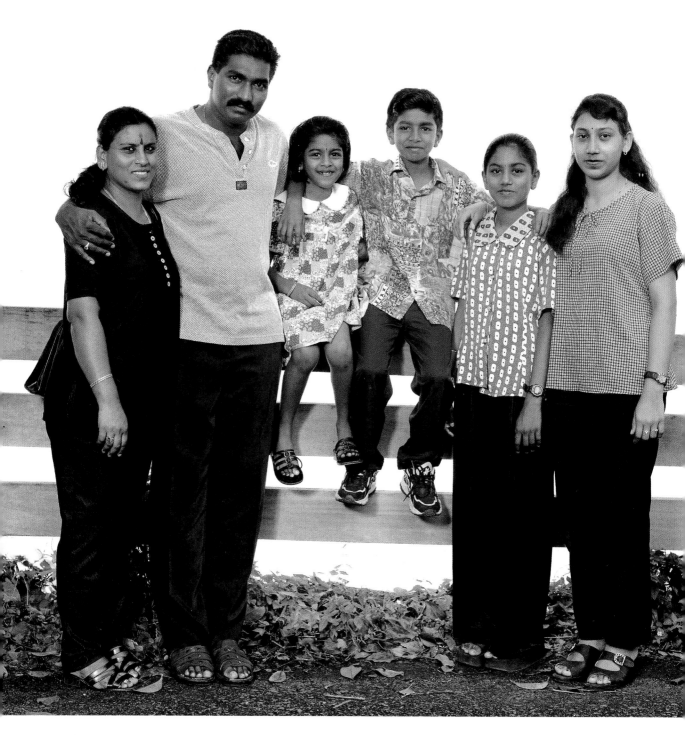

Melaka,
Malaysia,
2 January 2000

Die beiden großen Mädchen sehen sich bereits als Anwältin beziehungsweise Lehrerin. Vater Subramaniam ist Kraftfahrer und Mama kümmert sich um das Haus und die Kinder. Sie spielen gern Federball und sind begeisterte Schwimmer. In jeder freien Minute geht es an den Strand.

The two elder daughters already see themselves as a lawyer and teacher. Father Subramaniam is a truck driver, while the mother looks after the children and the home. The family like badminton and swimming – and go to the beach whenever they can.

Les deux grandes filles se voient déjà en avocate et institutrice. Papa Subramaniam est chauffeur de poids lourd et maman s'occupe des enfants et de la maison. Ils aiment le badminton et la natation. Dès qu'ils le peuvent, ils filent à la plage.

Grand-Bassam,
Ivory Coast,
7 March 1997

„Grand-Bassam ist meine Heimatstadt, meine Kinder und Enkelkinder sind hier geboren", erzählt uns die alte Frau. Auch mit 70 verkauft sie noch ihren Schmuck auf dem Markt. Ihre Söhne arbeiten mal als „Pflanzer, mal als Fahrer von diesem und jenem", je nachdem, was sich gerade bietet.

"I was born in Grand-Bassam, so were my children and grandchildren," declares the 'old lady', who is 70. She's still selling jewellery at the market. Her sons meanwhile are "planters of this and that" and "drivers of this and that." That way they can take up a whole raft of job offers.

« Je suis née à Grand Bassam, mes enfants et petits-enfants aussi », proclame la « vieille », âgée de soixante-dix ans. Elle continue à vendre des bijoux sur le marché. Quant à ses fils, ils sont soit « planteurs de tout », soit « chauffeurs de tout » ! Ils peuvent ainsi répondre à un large spectre d'offres d'emploi.

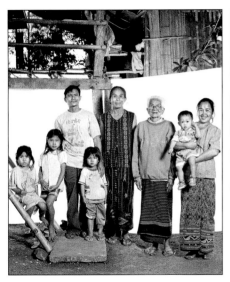
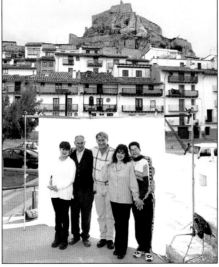
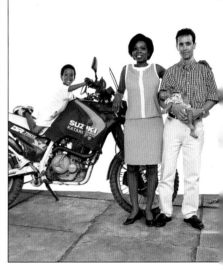

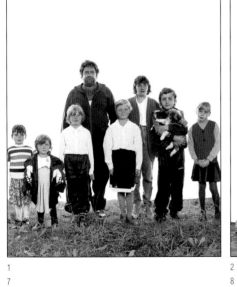
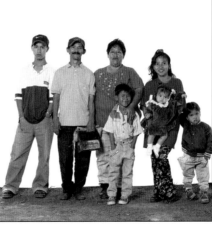
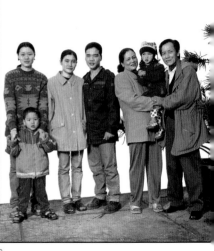

1

7

2

8

3

9

1
Pakse,
Laos,
29 January 2000

2
Morella,
Spain,
20 May 1998

3
Cotonou,
Benin,
15 June 1997

4
Ban Keit Ngong,
Laos,
30 January 2000

7
Minsk,
Belarus,
17 July 1998

8
Loja,
Ecuador,
12 February 1999

9
Hue,
Vietnam,
4 February 2000

10
Bali,
Indonesia,
15 December 1999

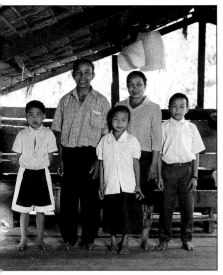

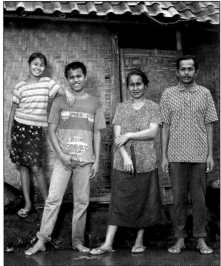

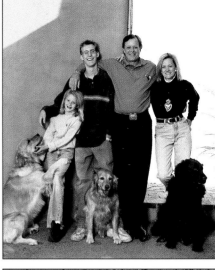

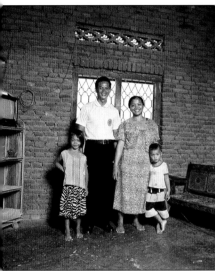

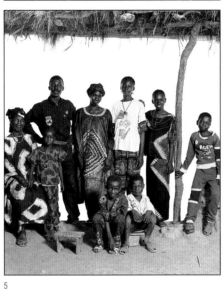

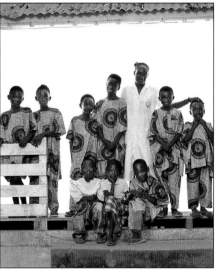

4
10

5
11

6
12

 5
Kintamani,
Bali, Indonesia,
14 December 1999

6
Santa Fe,
New Mexico, USA,
22 November 1998

 11
Botou,
Senegal,
18 April 1997

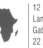 12
Lambaréné,
Gabon,
22 August 1997

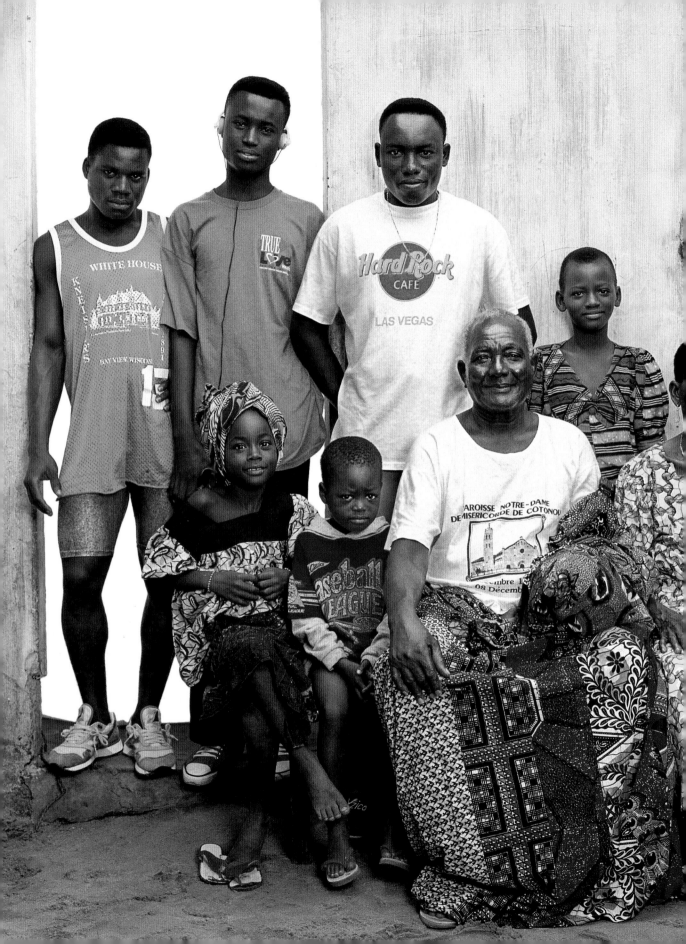

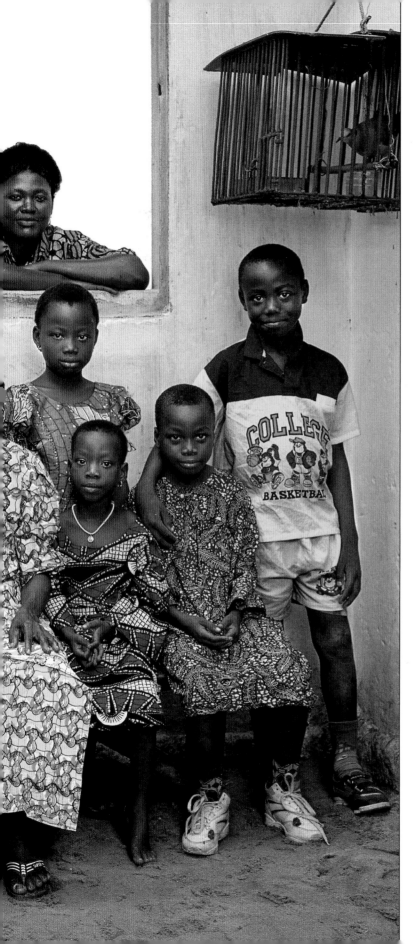

Nach dem Fototermin sagte Houessou: „Ich möchte, dass das Bild unserer Familie neben dem einer amerikanischen zu sehen ist, denn die haben einen ausgeprägten Gemeinschaftssinn und das ist gut." Obwohl er gläubiger Katholik ist, hat er vier Frauen, die ihm, wenn er sich nicht verzählt hat, 39 Kinder geschenkt haben. Um die ganze Sippe zu ernähren, baut er, neben seiner Arbeit als „Chef du quartier" und Mechaniker, 15 Kilometer von Cotonou entfernt Maniok und Mais an.

At the end of the photo session, Houessou told us: "I'd like our photo to be shown next to an American family; they have a strong sense of society, and that's good." Houessou is the only child of a father who had two wives. A faithful Catholic, he nonetheless has married four wives, who, if he's counted properly, have given him 39 children. To feed this tribe, he grows cassava and maize ten miles [15 km] from Cotonou, on top of working as a mechanic and being head of his neighbourhood.

La photo de famille terminée, Houessou nous a déclaré : « J'aimerais être exposé à côté d'une famille américaine, ils ont le sens du social, c'est bon ça ! » Fils unique d'un père qui avait deux épouses, Houessou, catholique, a choisi lui d'avoir quatre femmes qui lui ont donné, s'il les a bien comptés, trente-neuf enfants. Pour nourrir cette tribu, en dehors de son travail de mécanicien et de chef du quartier, il cultive manioc et maïs à quinze kilomètres de Cotonou.

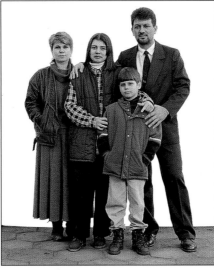
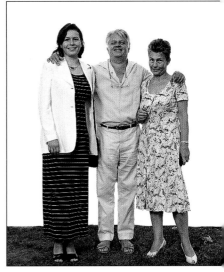

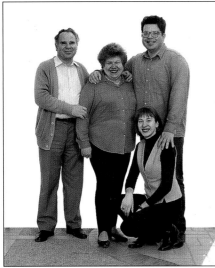
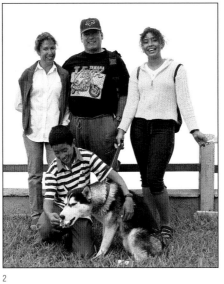
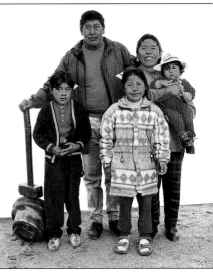

1

7

2

8

3

9

1
Chichicastenango,
Guatemala,
10 December 1998

2
Rila,
Bulgaria,
4 January 1997

3
Prague,
Czech Republic,
29 July 1998

4
Yeghegnadzor,
Armenia,
24 August 1999

7
Skopje,
Macedonia,
6 January 1997

8
Iquique,
Chile,
14 January 1999

9
Uyuni,
Bolivia,
23 January 1999

10
Nouamkar,
Mauritania,
21 February 1997

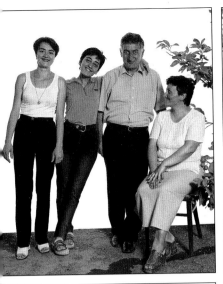

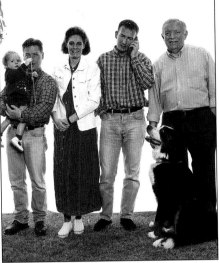

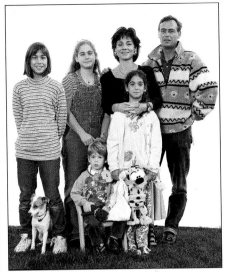

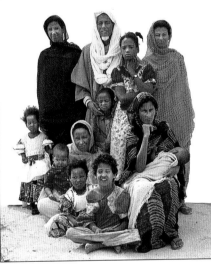

4

10

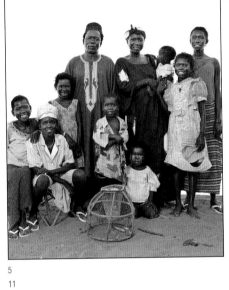

5

11

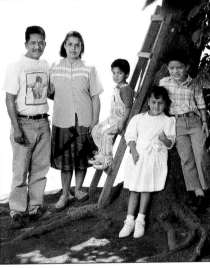

6

12

5
Lasne,
Belgium,
14 June 1998

6
Pully,
Switzerland,
23 October 1996

11
Geni-Ségou,
Mali,
8 April 1997

12
Boquete,
Panama,
29 December 1998

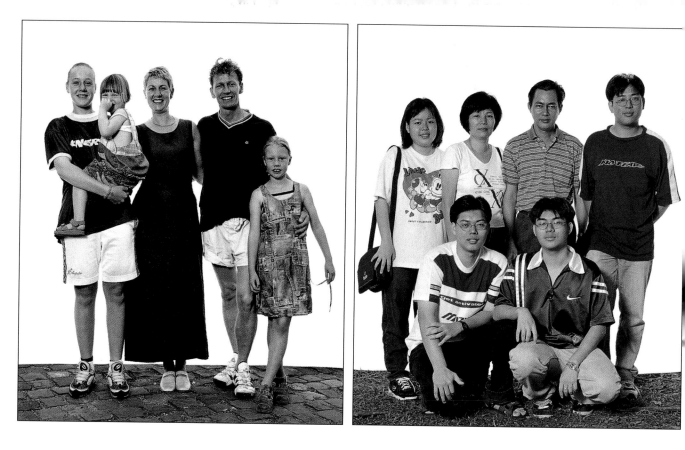

Harlingen,
The Netherlands,
20 June 1998

Wir haben Bart und Nelly auf ihrer „Terrasse" angesprochen – einem ausgedienten, umgebauten Rettungsboot, auf dem die Familie ihre Sonntagnachmittage verbringt. Nach 18 Jahren Ehe turteln die beiden immer noch wie frisch Verliebte, während sie ihre zweite Hochzeitsreise rund um die Welt planen …

We encountered Bart and Nelly on their lifeboat converted to a pleasure craft. It acts as their terrace, because their house 50 feet [15 m] away doesn't have one. This is where they spend Sunday afternoons with the family. Married for 18 years and very close, they're planning to travel round the world by way of a second honeymoon …

« Faites en sorte que notre photo soit à côté d'une famille africaine! », tel est le souhait de Bart et Nelly. Nous les avons « abordés » sur leur bateau de sauvetage en mer, transformé en bateau de plaisance … Il leur sert de terrasse, qui manque à leur maison à quinze mètres de là, ils y passent le dimanche après-midi en famille. Dix-huit ans de mariage et très complices, ils projettent de faire le tour du monde en guise de seconde lune de miel.

Miri,
Malaysia,
28 December 1999

„Das neue Jahrtausend? Keep going in peace!", ertönt es im Chor. Eine fleißige Familie: Der Vater ist Unternehmer, die Mutter Kindergärtnerin, zwei der Söhne Ingenieure, der dritte angehender Geschäftsmann, die Tochter künftige Buchhalterin. Sie sollten einen Familienbetrieb aufziehen!

They both say: "The new millennium? Keep going in peace." They are a very busy family – the father is a contractor, the mother runs a kindergarten and two sons are engineers. Their daughter is going to be an accountant, while their third son is becoming a businessmen – a perfect set-up for a family business.

Ils disent en chœur : « L'an 2000 ? Keep going in Peace! » Une famille très active : papa est entrepreneur, maman maîtresse dans un jardin d'enfants, les trois garçons ingénieurs et futurs « buisiness man », la fille future comptable. De quoi monter une affaire familiale!

Bohuslav,
Ukraine,
21 July 1998

Nach seiner Konvertierung zum Protestantismus verlor Vasile seine Stelle in der Armee, weil er sich aus religiösen Gründen weigerte, eine Waffe zu tragen. Er ist arbeitslos gemeldet und spekuliert darauf, Arbeit in einer Fabrik zu finden. Allerdings ist er wenig zuversichtlich. Tatjana erwartet ihr viertes Kind und hofft, dass es ein Mädchen wird. Drei Botschaften möchten sie den Familien der Welt übermitteln: „Habt viele Kinder. Diese sollen sich um ihre Eltern kümmern und in der Familie soll Frieden herrschen. Glaubt an Gott!"

A very devout convert to Protestantism, Vasile lost his job in the army because he refused to carry a weapon. Now on the dole, he's hoping to find work in a factory, but he's not very optimistic. Tatiana is expecting a fourth child – hopefully a little girl. They have three messages to pass on to the families of the world: "Have lots of children. May they take care of their parents, and may peace reign in the family. Believe in God!"

Converti au protestantisme, très croyant, Vasile a refusé de porter une arme et a perdu son poste dans l'armée. Inscrit au chômage, il compte trouver un travail dans une usine mais n'est pas très optimiste. Tatyana attend un quatrième enfant en espérant une petite fille. Ils ont trois messages à transmettre aux familles du monde : « Ayez de nombreux enfants. Que ceux-ci prennent soin de leurs parents et que la paix règne dans la famille! Croyez en Dieu! »

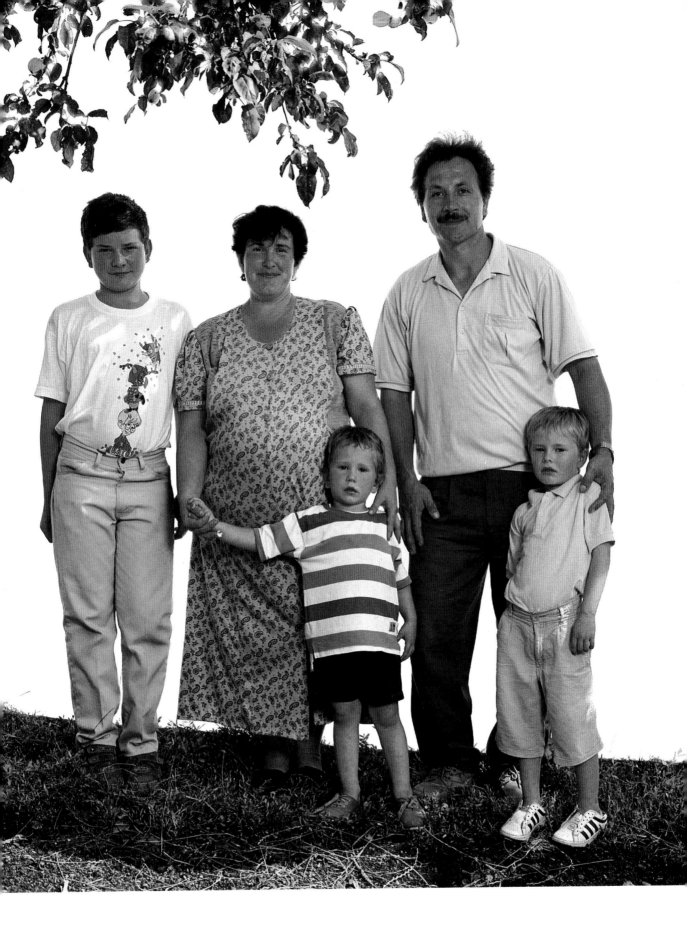

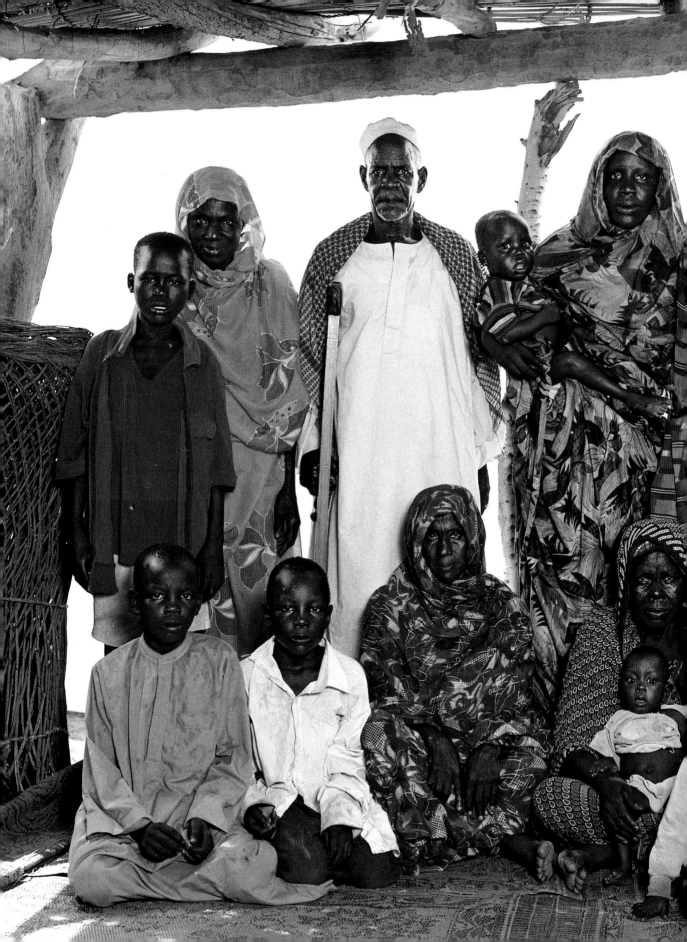

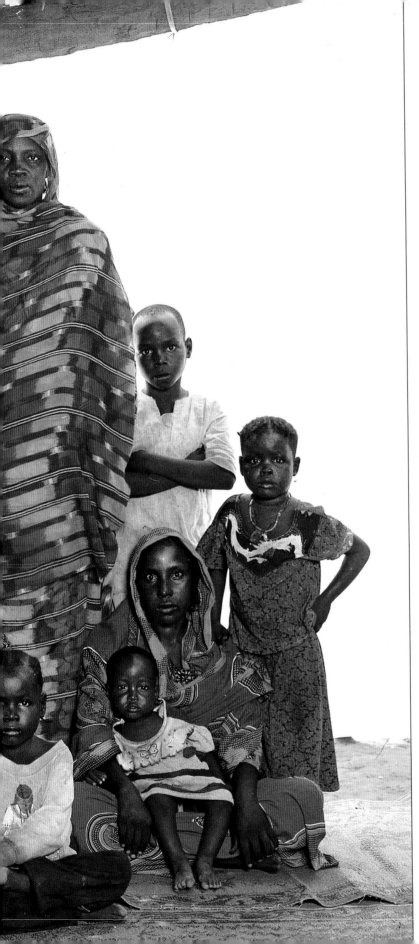

Der 67-jährige Magra, einer der Notablen des Sultan, hat vier Frauen und unzählige Kinder, die alle unter seinem wachsamen Auge auf dem Feld arbeiten. Er kuriert gerade eine böse Beinverletzung aus und kann ihnen daher nicht so helfen, wie er gern möchte. Seine Verletzung lässt ihn die Dinge ziemlich schwarz sehen und hält ihn davon ab, Pläne für die Zukunft zu machen: „Mit meinem gebrochenen Bein bin ich vielleicht morgen schon tot. Das neue Jahrtausend erlebe ich nur, so Gott will."

Sixty-seven-year-old Magra, one of the sultan's notables, has four wives and lots of children. They all work the land under his watchful eye. He is nursing a nasty wound on his leg and can't help them the way he'd like to. His wound makes him a little bit pessimistic and stops him planning for the future. "With my broken leg I could be dead tomorrow; so I'll see the new millennium in if God wills."

Notable du sultan, âgé de soixante-sept ans, Magra a quatre femmes et de nombreux enfants. Tous travaillent la terre sous son œil vigilant. Il soigne une vilaine blessure à la jambe et ne peut les aider comme il le voudrait. Blessure qui le rend un brin pessimiste et l'empêche de se projeter dans l'avenir « avec ma jambe cassée, je serai peut-être mort demain, alors l'an 2000, je le verrais si Dieu le veut ».

Index

Australia	**A**	Australia	028, 048, 060, 147, 229, 261, 291, 292, 434		

Europe

A	Albania	256, 406, 440, 513, 519	**I**	Ireland	057, 196, 224, 256, 427, 478, 482
	Austria	225, 412, 502		Italy	024, 217, 229, 289, 346, 383, 386, 413, 459, 460, 468, 504
B	Belarus	316, 348, 354, 421, 427, 540	**L**	Latvia	179, 446, 453
	Belgium	108, 132, 224, 226, 423, 545		Lithuania	035, 229, 231, 304, 390
	Bulgaria	199, 229, 460, 480, 527, 544	**M**	Macedonia	429, 445, 544
C	Czech Republic	228, 286, 290, 544	**N**	Netherlands, The	131, 136, 325, 354, 384, 430, 546
D	Denmark	032, 088, 169, 460		Norway	228, 328, 332
E	Estonia	025, 407, 426, 535	**P**	Poland	154, 208, 333, 453, 513
F	Finland	049, 207, 225, 237, 332, 384		Portugal	290, 340/341, 388, 474, 517
	France	050, 069, 111, 132, 206, 227, 246, 354, 368, 380, 384, 386, 387, 403, 413, 420, 427, 437, 444, 460, 480, 502	**R**	Romania	056, 072/073, 147, 225, 352, 354, 412, 429, 461, 486
G	Germany	109, 138, 249, 144/145, 291, 471		Russia	028, 029, 046, 059, 085, 255, 289, 293, 333, 385, 401, 410, 411, 501
	Great Britain		**S**	Slovakia	246, 254
	- England	053, 332, 359, 364, 413, 444		Spain	227, 387, 402, 439, 461, 470, 540
	- Northern Ireland	483		Switzerland	107, 146, 289, 330, 393, 445, 484, 515, 545
	- Scotland	123, 201, 355, 445		Sweden	289, 333, 433
	- Wales	147, 289	**U**	Ukraine	048, 052, 192, 254, 461, 547
	Greece	101, 413, 484, 500, 502, 513	**Y**	Yugoslavia	013, 120/121
H	Hungary	014, 140, 253, 290, 291, 355, 468			

North and Central America

C	Canada	071, 145, 212		- Iowa	010, 012, 016, 044, 198, 318, 387
	Costa Rica	074, 181, 200, 331		- Kansas	291
E	El Salvador	268, 369, 399, 412, 426, 447		- Maine	065, 073, 446
G	Guatemala	402, 446, 522, 544		- Michigan	410
M	Mexico	110, 158/159, 186, 226, 263, 269, 345, 355, 356, 385, 397, 412, 475, 480, 481, 510, 514		- Missouri	023, 139
				- New Mexico	082, 092/093, 128, 156, 197, 416, 433, 541
N	Nicaragua	028, 108, 176/177, 499, 513		- New York	017, 019, 021, 029, 042, 051, 242, 257, 288, 347, 511, 527
P	Panama	068, 081, 147, 178, 203, 221, 224, 227, 298, 337, 338/339, 403, 422, 431, 455, 482, 537, 545		- Oregon	415
				- Pennsylvania	038/039, 450
U	USA			- South Dakota	020, 328, 505
	- California	083, 226, 421, 469, 484, 516		- Tennessee	066, 280, 387, 447, 477
	- Florida	096/097, 150, 229, 267, 272, 286, 288, 332		- Wyoming	014, 071, 104, 105, 484
	- Georgia	410			

South America

A	Argentina	036/037, 113, 245, 324, 405, 426, 444, 461, 504, 507		Colombia	067, 130, 198, 210, 253, 392, 398, 429, 447, 459, 513
B	Bolivia	213, 242, 282, 306, 326, 475, 544		Costa Rica	181, 200, 330
	Brazil	029, 181, 226, 288, 290, 305, 317, 333, 365, 447, 484	**E**	Ecuador	240, 291, 308, 386, 459, 540
			P	Peru	219, 220, 266, 267, 452, 495
C	Chile	116, 174/175, 180, 262, 328, 407, 544	**V**	Venezuela	172/173, 204, 205, 310/311, 451, 481

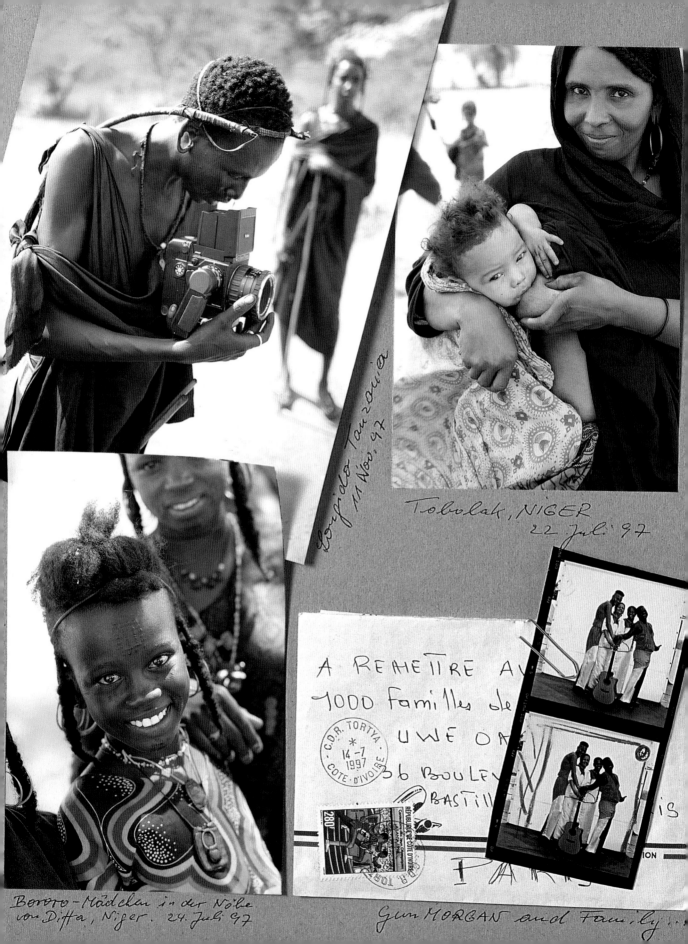

Sovido, Tanzania
11 Nov. 97

Tobolak, NIGER
22 Juli 97

Bororo-Mädchen in der Nähe
von Diffa, Niger. 24. Juli 97

Gum MORGAN and Family...

A REMETTRE AV
1000 familles de
UWE OA
b BOULE
BASTILL
is

C.D.R. TORTYA
★
14-7
1997
COTE·D'IVOIRE

280F
RÉPUBLIQUE DE CÔTE D'IVOIRE

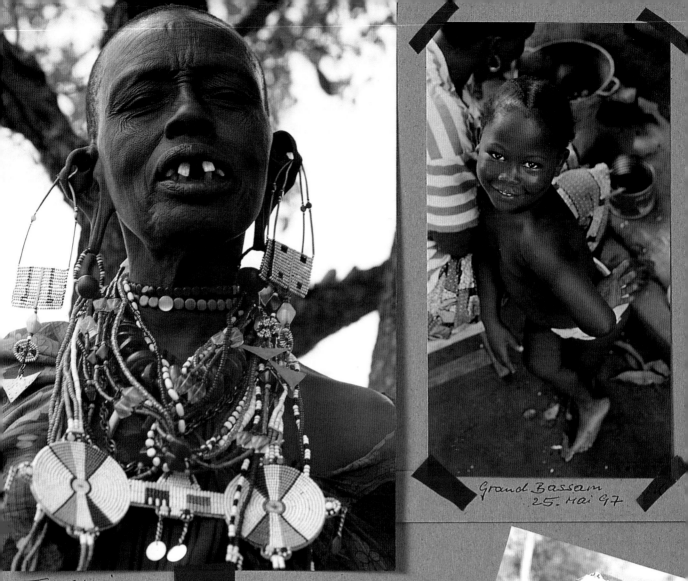

TANSANIA Nov. 97

Grand Bassam
25. Mai 97

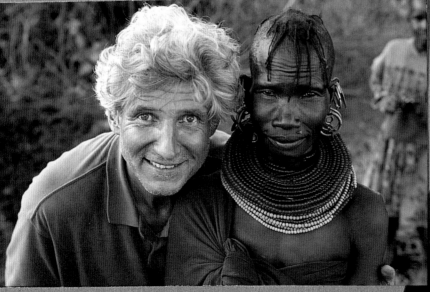

KENIA, 17 Nov. 97

COUNTRY __BOTSWANA__

DATE __17 / 10 / 97__

NAME __ELIAS A. MODIGAH__

DATE OF MARIAGE ___1966___

ADRESS _____

Ghansi

Dez '97

29

Property worth thousands of pula lost in house fire

By BOPA Reporter

Property worth over P300 000 was destroyed when a house belonging to Pastor Elias Modigah of the Seventh Day Adventist Church caught fire recently.

Pastor Modigah told BOPA in an interview

that among the property destroyed were 17 suits, a shot-gun and three sewing machines valued at P65 000.00.

The incident occurred on December 28, a few days after his daughter's marriage.

He also lost various

precious documents which included, passports and Omang cards.

The married couple lost a cake worth P1 500 and a bunch of flowers worth P1 200.

The cause of the fire is still being investigated.

LARE TO PARTICI...
M THE YEAR 2000 » AND HEREBY AU...
RODUCTION OF THE PHOTOGRAPHS TAKEN TODA...

__17 / 10 / 97__ PLACE __GHANSI__

TURE

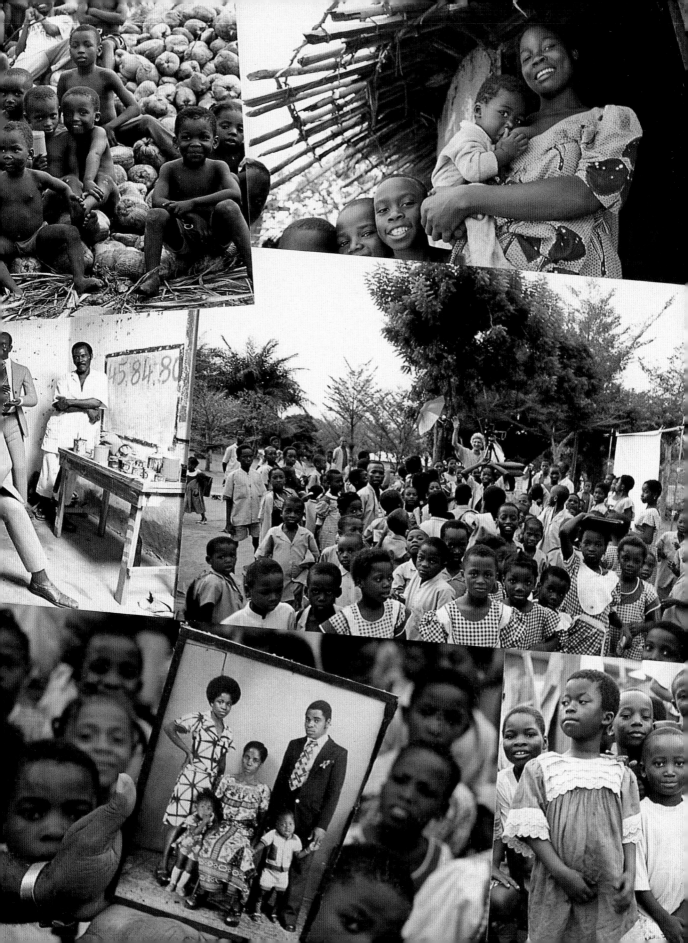

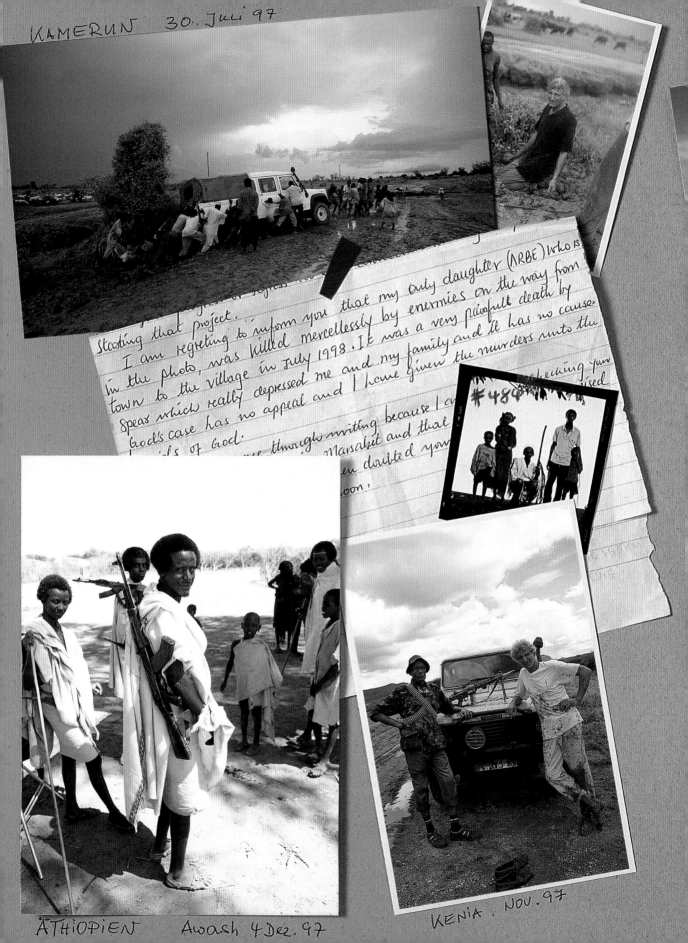

KAMERUN 30. Juli 97

starting that project.

I am regreting to inform you that my only daughter (ARBE) who is in the photo, was killed mercellessly by enermies on the way from town to the village in July 1998. It was a very painfull death by spear which really depressed me and my family and it has no cause. God's case has no appeal and I have given the murders into the hands of God.

...through writing because I a... ...Marsabit and that ...en doubted you... ...oon.

#484

ÄTHIOPIEN Awash 4 Dez. 97

KENIA. Nov. 97

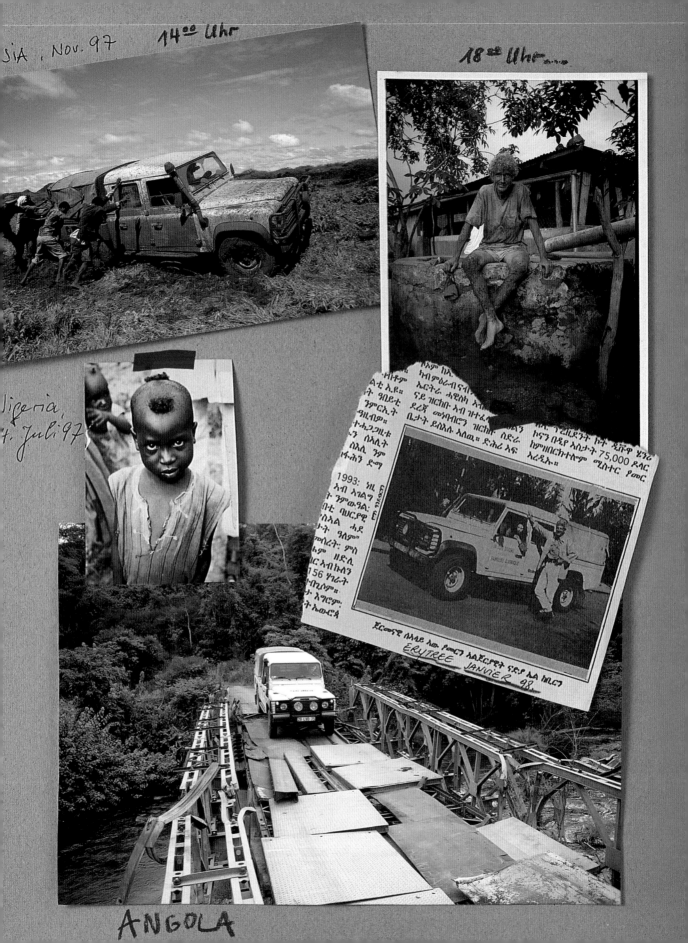

SIA . Nov. 97 14⁰⁰ Uhr

18⁰⁰ Uhr...

Liberia,
4. Juli 97

ERYTREE
JANVIER 98.

ANGOLA

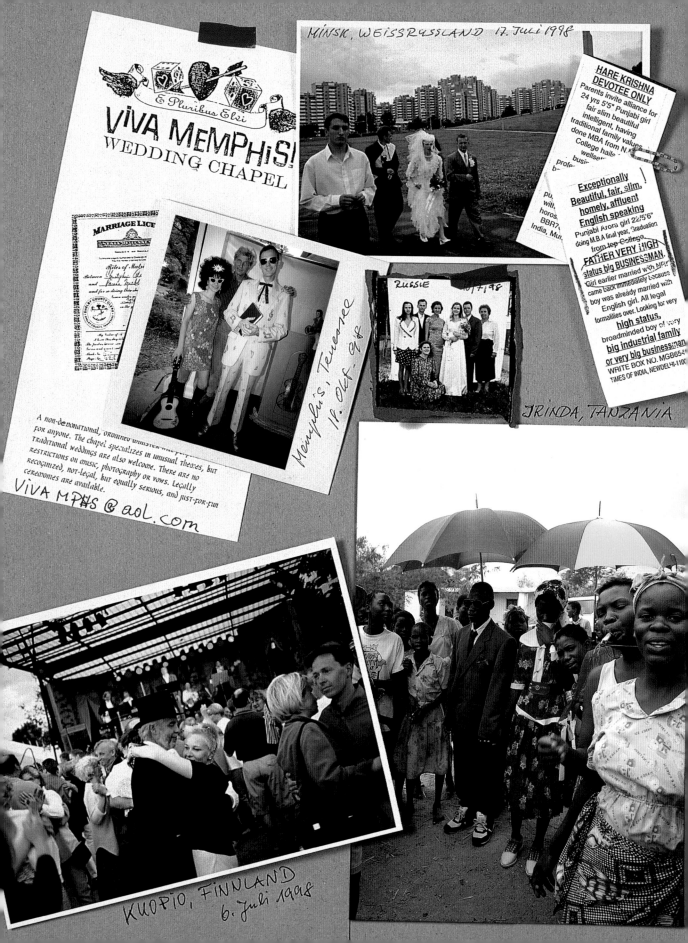

MINSK, WEISSRUSSLAND 17. Juli 1998

E Pluribus Elvi

ViVA MeMPHiS!
WEDDING CHAPEL

MARRIAGE LICE...

Rites of Matri...
Between ... Gh...
and ... Sm...

Memphis, Tennessee 18. Okt. 98

RUSSIE 10/7/98

IRINDA, TANZANIA

A non-denominational, ordained minister will perform...
for anyone. The chapel specializes in unusual theme...
traditional weddings are also welcome. There are no
restrictions on music, photography or vows. Legally
recognized, not-legal, but equally serious, and just-for-fun
ceremonies are available.

ViVA MPHS @ aol.com

KUOPIO, FINNLAND
6. Juli 1998

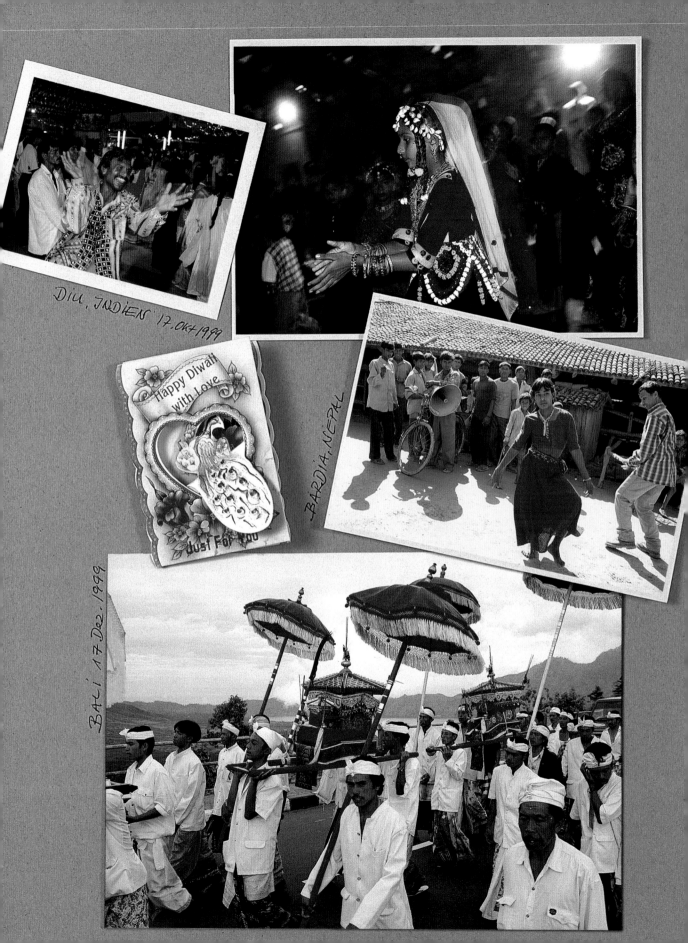

DIU, INDIEN 17. Okt. 1999

Happy Diwali with Love

Just For You

BARDIA, NEPAL

BALI 17. Dez. 1999

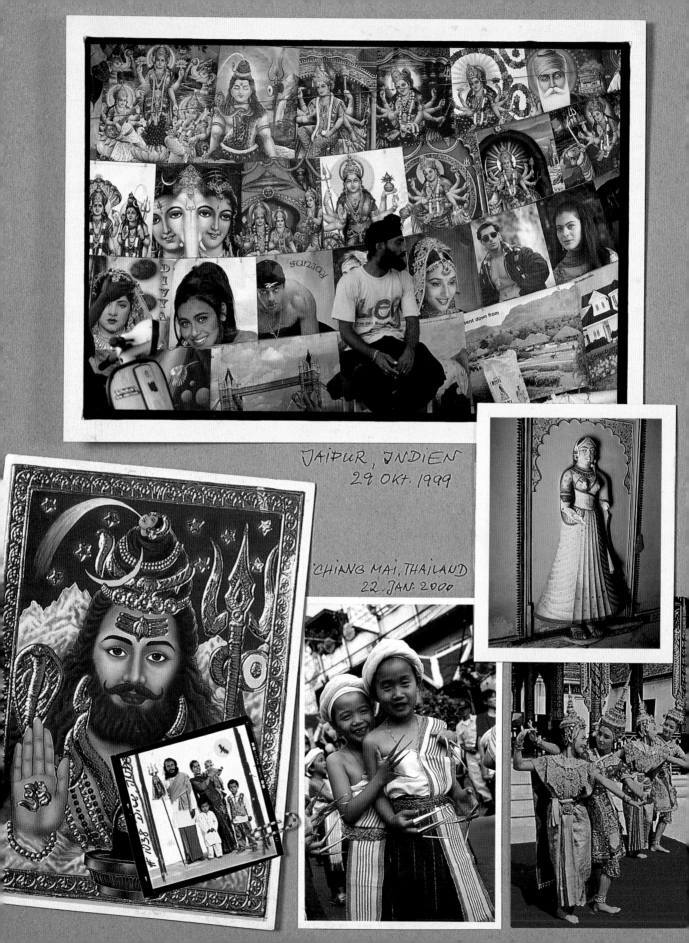

JAIPUR, INDIEN
29. Okt. 1999

CHIANG MAI, THAILAND
22. JAN. 2000

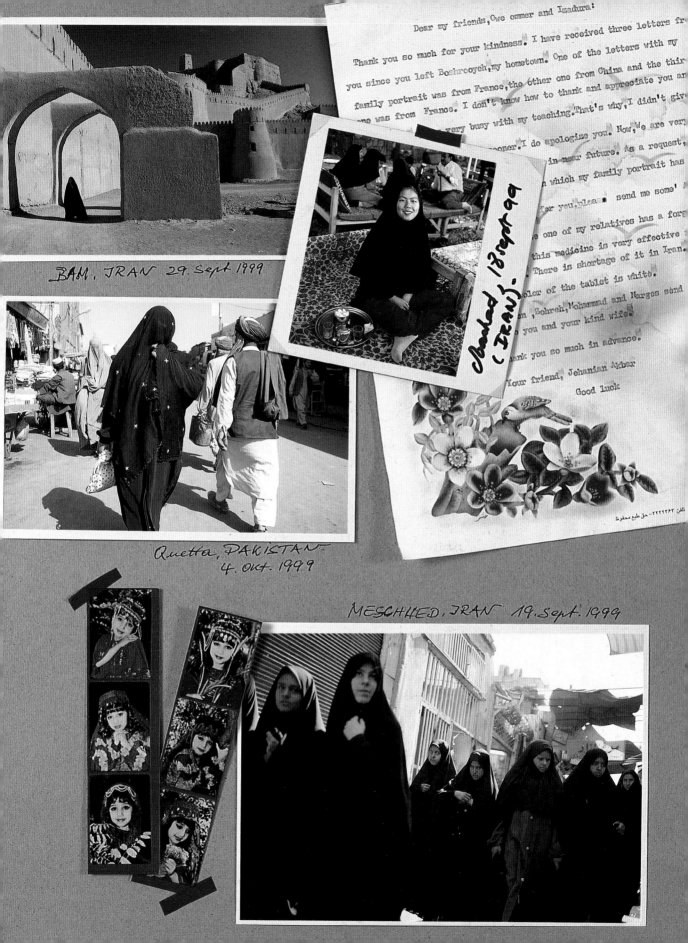

BAM, IRAN 29. Sept. 1999

Shahhad 18 Sept 99 (IRAN)

Quetta, PAKISTAN 4. Oct. 1999

MESCHHED, IRAN 19. Sept. 1999

Dear my friends, Owe ommer and Izadura:

Thank you so much for your kindness. I have received three letters fr
you since you left Boshrooyeh, my hometown. One of the letters with my
family portrait was from France, the other one from China and the thir
 one was from France. I don't know how to thank and appreciate you an
very busy with my teaching. That's why, I didn't giv
sooner. I do apologize you. Now, We are very
in near future. As a request,
which my family portrait has
for you, please send me some'
one of my relatives has a forg
this medicine is very effective
There is shortage of it in Iran.
color of the tablet is white.
Zohreh, Mohammad and Narges send
o you and your kind wife
ank you so much in advance.
Your friend, Jehanian Akbar
Good luck

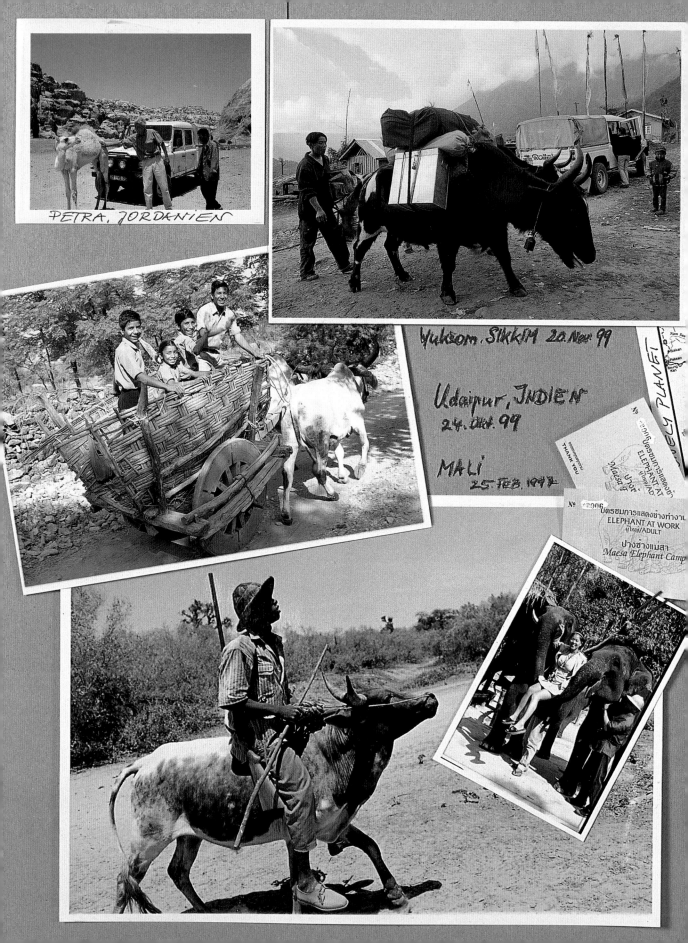

PETRA, JORDANIEN

Yuksom. SIKKIM 20. Nov. 99

Udaipur, INDIEN
24. Okt. 99

MALI
25. FEB. 1992

LONELY PLANET

ELEPHANT AT WORK
ADULT

Maesa Elephant Camp

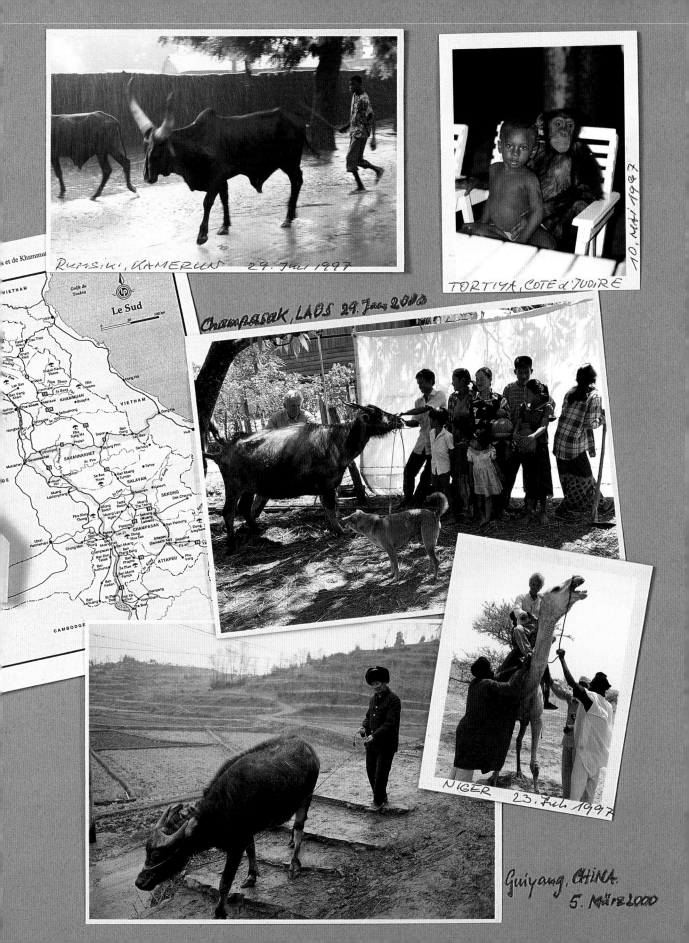

RUMSIKI, KAMERUN 29. Juli 1997

TORTIYA, CÔTE d'IVOIRE 10. Mai 1997

Champasak, LAOS 29. Jan. 2000

NIGER 23. Juli 1997

Guiyang, CHINA 5. März 2000

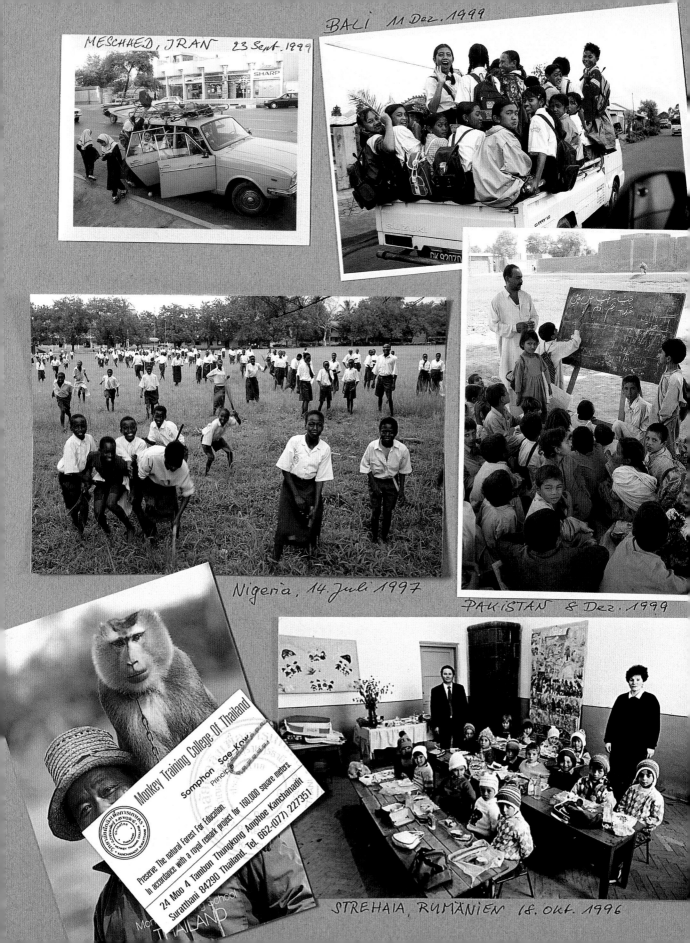

MESCHHED, JRAN 23 Sept. 1999

BALI 11 Dez. 1999

Nigeria, 14. Juli 1997

PAKISTAN 8 Dez. 1999

Monkey Training College Of Thailand

Somphon Sae-Kow

Principal

Preserve The Natural Forest For Education
In accordance with a royal repark project for 160.000 square meters.

24 Moo 4 Tambon Thungkong Amphoe Kanchanadit
Suratthani 84290 Thailand. Tel. 662-(077) 227351

THAILAND

STREHAIA, RUMÄNIEN 18. Okt. 1996

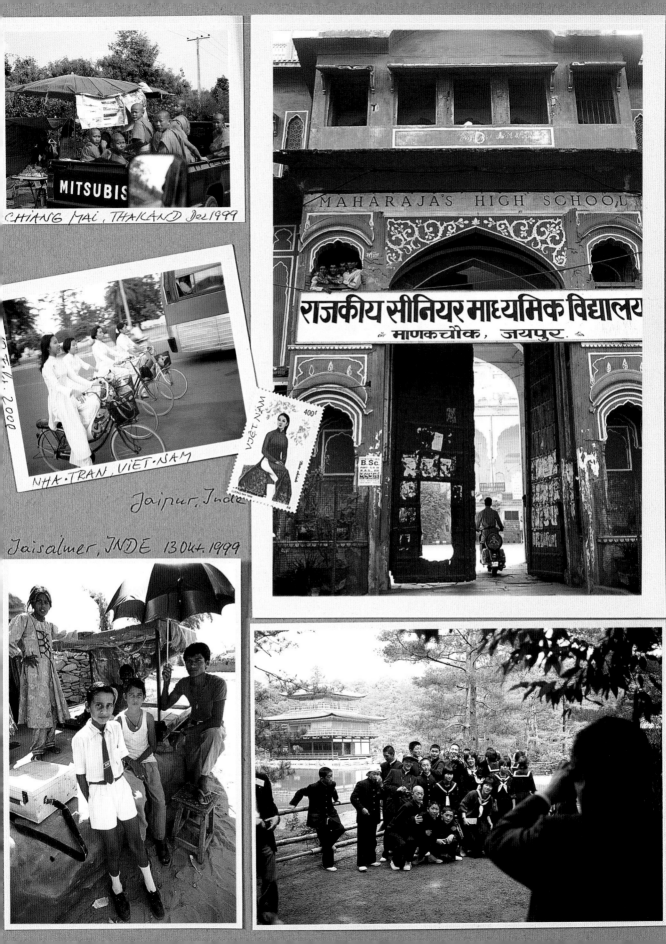

CHIANG MAI, THAILAND Dec 1999

MITSUBIS

NHA·TRAN, VIET·NAM

VIET NAM 400đ

Jaipur, Inde

Jaisalmer, INDE 13 Oct 1999

MAHARAJA'S HIGH SCHOOL

राजकीय सीनियर माध्यमिक विद्यालय

माणकचौक, जयपुर.

B.Sc.

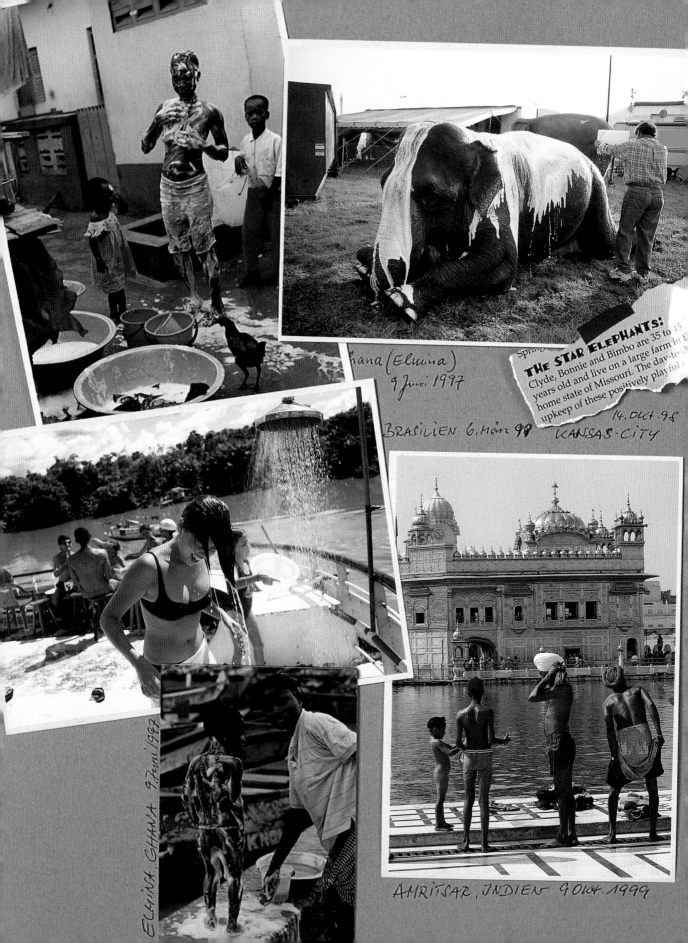

hana (Elmina)
9 Juni 1997

THE STAR ELEPHANTS:
Clyde, Bonnie and Bimbo are 35 to 45
years old and live on a large farm in t
home state of Missouri. The day-to-
upkeep of these positively playful

BRASILIEN 6. März 98

14. Oct. 98
KANSAS-CITY

ELMINA, GHANA 9 Juni 1997

AMRITSAR, INDIEN 9 Oct. 1999

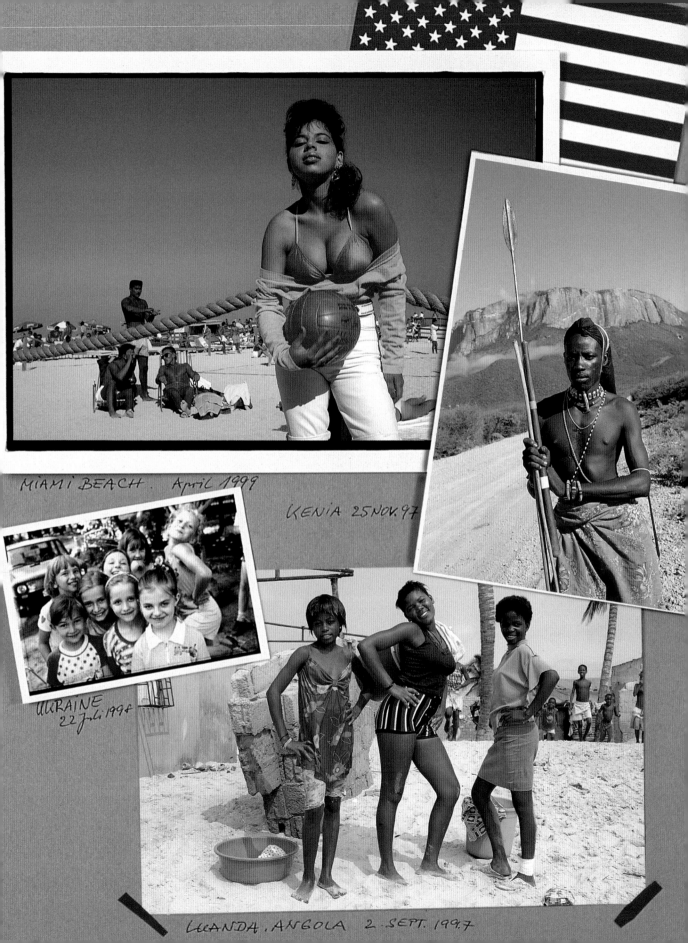

MIAMI BEACH. April 1999

KENIA 25 NOV. 97

UKRAINE 22 Juli 1994

LUANDA, ANGOLA 2. SEPT. 1997

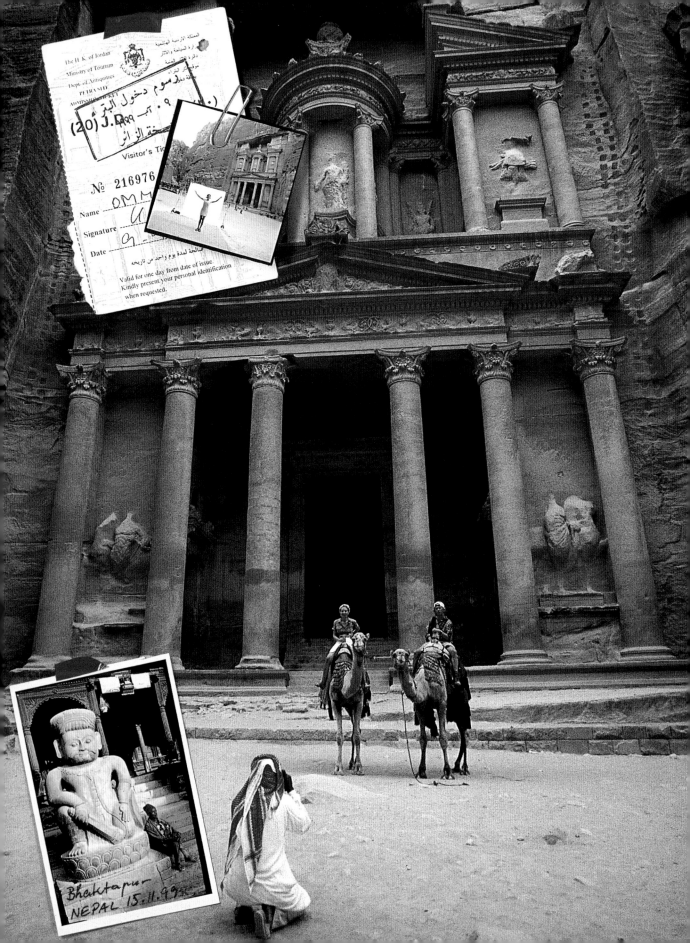

PETRA, JORDANIEN 10.AUG. 1999

18. Aug. 1999

Hopa, TÜRKEI

Diu, INDIEN 21. Okt. 1999

Jaisalmer, INDIEN 14. Okt. 1999

ECUADOR. 12 Feb. 1999

66 60 HK

Cochon de l'Equateur
plus mort que vif

BALI. 14. Dez. 1999

TÜRKEI 15. Juli 1999

Hopa, TÜRKEI
18. Aug. 199

...bad, Schweiz
6. Okt. 1996

LAOS 30. Jan. 2000
CHINA 3 März 2000
IRAN 19 Sept 1999

RED SEA COOPRATIVE
GURGUSUM BEACH HOTEL
Sunbathing Chair & Umbrella
TICKET
№ 11639
Birr 10

Ägypten 3. Jan. 1999

Tbilisi, Georgien
20. Aug 1999

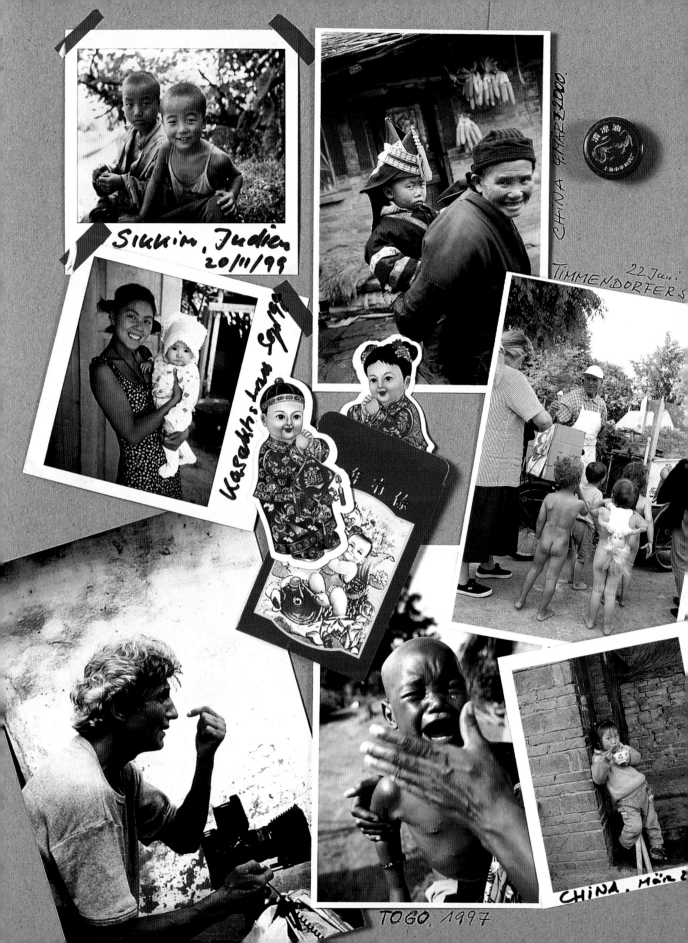

Sikkim, Judien
20/11/99

CHINA 9. MARZ 2000.

Kasakhstan Sep 97

TIMMENDORFERS
22 Juni

TOGO, 1997

CHINA, Mär

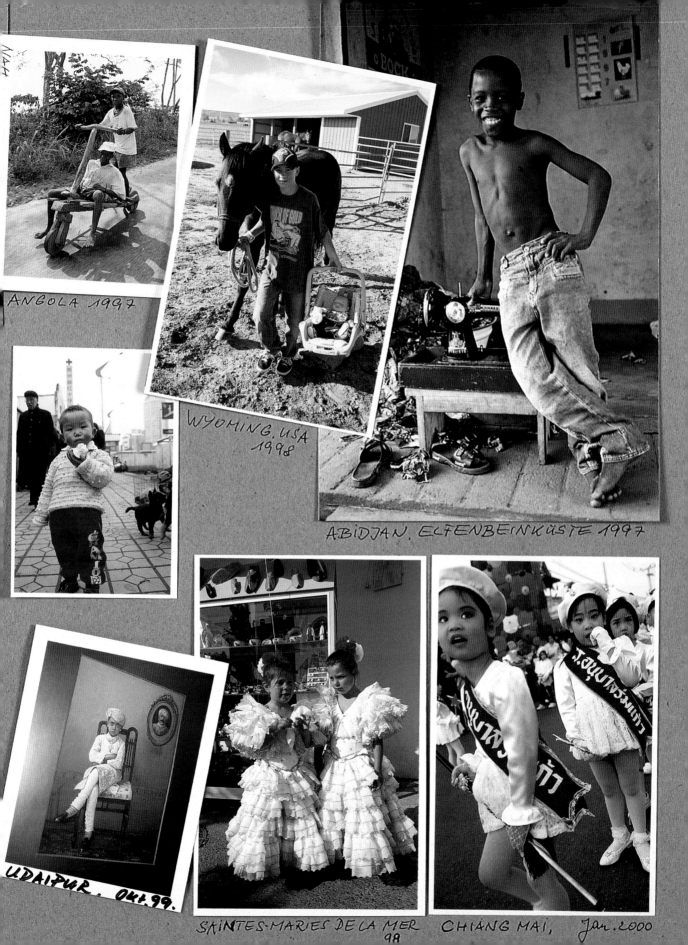

ANGOLA 1997

WYOMING. USA
1998

ABIDJAN. ELFENBEINKÜSTE 1997

UDAIPUR. Okt. 99.

SAINTES-MARIES DE LA MER
98

CHIANG MAI, Jan. 2000

Für Isadora

Dank / Thanks / Merci

Aminata, Bamako, Mali
André and Monique, Abidjan, Ivory Coast
Archie, Westport Island, ME, USA
Barbara, California, USA
Bart and Steffi, Saigon, Vietnam
Brijendra and Dawn, New Delhi, India
Camillo and Dina, Sicily, Italy
Claude, Abidjan, Ivory Coast
David and Esther, Libreville, Gabon
Dominique and Maya, Abidjan, Ivory Coast
Eddy, Paris, France
Edouard, London, England
Eric, San Francisco, USA
Faouzia and Karim, Cotonou, Benin
Frédérique, Paris, France
Geneviève, Paris, France
Geraldine, Rio Caribe, Venezuela
Hacen and Helen, Paris, France
Hassain, Chittagong, Bangladesh
Helmut and Ingrid, Germany
Ingrid and Peter, Germany
Jean-François and Estelle, Abidjan, Ivory Coast
John, Isle of Skye, Scotland
José, New York, USA
José, Volcán, Panama
Julio, San Salvador, El Salvador
Jürgen and Maria, Bocas del Toro, Panama
Keti, Georgia
Kim, Denmark
Klaus, Windhoek, Namibia
Klaus, Yaoundé, Cameroon
Laura, Kansas City, USA
Liu Bao and Wang Cheng, Guiyang, China
Mamadu, Ivory Coast
Marco and Martín, Cuzco, Peru
Maria, Stuttgart, Germany
Marie-France, Malaysia
Martine and Francis, Bordeaux, France
Matchek, Cracow, Poland
Michele, Costa Rica
Mimi, Miami, USA
Monique, Libreville, Gabon
Nattapong and Lumpum, Chiang Mai, Thailand
Nicolas and Tina, Copenhagen, Denmark
Olivier and Oya, Paris, France
Olivier and Melanie, Nîmes, France

Pedro, Santa Fe, USA
Pontus, Sweden
Queen Bee, Memphis, USA
Said, Massawa, Eritrea
Samir and Mina, Brussels, Belgium
Sergio, Posadas, Argentina
Simona and Alessandro, Stia, Italy
Slavka and Dimitri, Bulgaria
Stephen and Jasmine, Katherine, Australia
Steve and Daphne, New Hampshire, USA
Steve and Mary, Brookhaven, NY, USA
Steve, Cali, Colombia
Tatiana, Kiev, Russia
Tony and Nathalie, Santa Fe, USA
Tu Yi and Chu Zhun Yu, Guiyang, China
Vadim and Vitalia, Minsk, Belarus
Valérie and Jean-Pascal, Paris, France
Vincent, Arles, France
Wolfgang, Cologne, Germany
Wolfgang S., Braunschweig, Germany
Zefer and Emel, Turkey
Zorica, Paris, France

Assistenten
Europa, Aurélie Godineau
Afrika, Nadia Elkebir
Amerika, Bettina Trias
und natürlich meine rechte (und linke) Hand:
Zorica Rozier

Ein ganz besonderer Dank geht an die Partner
der *1000 Families – Das Familienalbum des
Planeten Erde:*
- Rollei fototechnic für die großzügige finanzielle
 Unterstützung und die ausgezeichnete Rollei
 6008 integral, die vier lange Jahre Wind und
 Wetter, Hitze und Staub standgehalten hat,
- Picto, Paris, die nicht nur Tausende von Filmen
 entwickelt, sondern auch die Vergrößerungen
 der Fotos von allen abgebildeten Familien
 gespendet haben,
- die Republik Elfenbeinküste, die sich an der
 Finanzierung unserer elfmonatigen Reise durch
 Afrika beteiligt hat,
- Kodak, die für unsere Asienreise 1200 Filme
 gestiftet haben.

Assistants
Europe, Aurélie Godineau
Africa, Nadia Elkebir
the Americas, Bettina Trias
and naturally my right (and left) hand:
Zorica Rosier

A special thanks goes to the partners of *1000
Families – The Family Album of Planet Earth:*
- Rollei fototechnic for their generous financial
 support and the excellent Rollei 6008 integral
 which kept on the job through wind and weather,
 heat and dust, for four long years
- Picto, Paris, which not only developed thou-
 sands of rolls of negatives, but also donated
 enlargements for all of the families in the project
- The Republic of the Ivory Coast, which co-
 financed our eleven-month African journey
- Kodak, which donated 1200 rolls of film to the
 project

Assistantes
Europe, Aurélie Godineau
Afrique, Nadia Elkebir
Les Amériques, Bettina Trias
Et naturellement mon bras droit (et gauche),
Zorica Rozier

Un très grand merci aux partenaires de « L'Album
de Famille »
- Rollei fototechnic, pour sa généreuse participa-
 tion financière et l'excellent Rollei 6008 qui a
 survécu à quatre années de voyages, de cha-
 leur, d'humidité et de poussière sans jamais
 montrer de faiblesse.
- Picto Paris, qui a développé des milliers de
 films et offert des tirages à chacune des 1251
 familles photographiées.
- La République de Côte d'Ivoire, qui a contribué
 au financement de notre voyage en Afrique.
- Kodak, qui nous a offert les pellicules pour
 notre voyage en Asie.

Imprint

To stay informed about upcoming TASCHEN titles, please request our magazine at www.taschen.com/magazine or write to TASCHEN, Hohenzollernring 53, D–50672 Cologne, Germany, contact@taschen.com, Fax: +49-221-254919. We will be happy to send you a free copy of our magazine which is filled with information about all of our books.

Design by Andy Disl, Cologne
Editing and coordination by Nina Schmidt, Cologne
German translation by Andrea Honecker
and Alexandra Bootz, Cologne
English translation by Simon Pleasance, Lagrasse

Printed in Italy
ISBN 3–8228–6213–4